The Visual Arts
in Washington, D.C.

The Visual Arts in Washington, D.C.

A History Since 1900

BRETT L. ABRAMS

McFarland & Company, Inc., Publishers
Jefferson, North Carolina

ISBN (print) 978-1-4766-8702-5
ISBN (ebook) 978-1-4766-4529-2

Library of Congress and British Library
Cataloguing data are available

Library of Congress Control Number 2022013793

On the cover: Clark Fox (Michael Clark), *George Washington*,
1985–2007. Oil on canvas, 40" × 30" (courtesy of the artist)

Printed in the United States of America

*McFarland & Company, Inc., Publishers
Box 611, Jefferson, North Carolina 28640
www.mcfarlandpub.com*

Table of Contents

Preface

Trained as a cultural, urban historian of the United States, I have always been interested in the country's major cities. At first, I wrote about Los Angeles and its popular culture industry. Over the first decade that I lived in Washington, D.C., I slowly became involved with the historical society and eventually joined the committee that organized the annual D.C. History Conference.

Over the years of listening to different academics and amateurs presenting their findings, several topics continually grabbed my attention. I liked the architecture and social history presentations that focused on where different people lived and played. When you live in a place long enough, you begin to hear things about businesses that don't exist anymore. You look at buildings squeezed into small spaces that look very little like all those surrounding them. Cities need constant change, and this appeared in the landscape.

After tons of this stimulation, I embarked on a book about Washington, D.C., and its built and proposed stadiums and Olympic venues. That provided endless joy during the process and provides it even today when I pass locations such as Hains Point or R.F.K. Stadium, where the city government planned to hold Olympic events in 1916 and 2012.

I next explored the relationship of the city to one of its sports. I examined the 75 years of D.C.'s teams in professional basketball. As I did, I saw the different types of places that served as their home fields and their locations around the city. The book came out when the D.C. Preservation League reached a point in its efforts to preserve Uline Arena, a home stadium for the team during the 1940s through the 1970s.

When I went to west Dupont Circle, which contained bars and cafes that catered to gay and lesbian clientele during the 1990s, I had no idea that twenty years earlier, commercial art galleries and cooperatives filled the Victorian homes that remained standing. They had supplanted empty storefronts, cheap eateries, and topless bars in dumpy and rundown three-story brick structures and forged Washington, D.C.'s first art district, dubbed the "P Street Strip," by the art critics of the major newspapers, including Paul Richard and Benjamin Forgey.

What precipitated the dissolution of this arts district? Where did these businesses go? As I became involved in the area's art world, I ran into a range of people with whom I started friendships. Several had lived in the city for years and knew pieces of the story of this area. But few knew that much about the story or any of the specific details. Their curiosity about the subject did not last long. Several of the artists with whom I spoke often found themselves trapped in a cycle of

comparing this city's art market to that of New York City. It turned out that artists in the city have been doing that for years. As I had with professional basketball, I chose to examine a single cultural industry in the city and see where it led. The result is this book.

Introduction

Washington's Innovative Visual Arts Community

"The block of galleries is solid evidence of the fact that [Washington] D.C. has become the second art city on the East Coast." Newspaper critic Benjamin Forgey presumably thought that the city already outpaced Boston, Philadelphia, and Baltimore in its museums. When he wrote that assessment of the gallery scene in the early 1970s, he witnessed the conversion of a dumpy brick building housing a pet shop into three floors of a bustling gallery. Another occupied what had been a topless bar. As the city forged its first art district called the "P Street Strip," it became apparent to Forgey that Washington also outdistanced these similar-sized cities in artists and galleries.

Forgey's assessment featured three factors that were central to this book. The art critic observed the vibrancy of the city's local visual arts culture. He noted that this art culture exerted influence on the regional and national art worlds. He observed how the artists and arts businesses shaped the environment of the neighborhoods into which they moved. Frequently, as art world members entered these areas, they gave those neighborhoods a vibrancy and *cachet* that led to the transformation of these places into more upscale neighborhoods.

Most large cities consist of the "local city" and the city within the broader urban context, known as a "regional city." As the federal government seat, Washington additionally contains an "international city" and a "federal city." These four cities don't create a unified entity but constitute a complex arrangement of interest groups and dynamic demographic groupings of people that exist independently and interdependently with one another at various times.

The critic did not focus on either the international city or the federal city. The global city consisted of the physical buildings that the foreign governments used in the District, usually both the embassies and the consulates. The people included the diplomats, staff, and, less frequently, foreign dignitaries in Washington on official business. The federal city had all that the federal government owned and used inside the District of Columbia and metropolitan region. Its people staff the government's departments, bureaus, and agencies.

Each of these cities provided distinct art worlds. The international city's art included their home country's artist exhibitions in their embassy buildings. These shows formed a part of Washington's larger art community and competed for some of its members' attention. Cultural attachés and similar staff members provided the

person power to make the shows happen. Occasionally, international city members have joined forces with some local arts community members, such as galleries, to create unique art events.

The federal art world included one undeniable member and a surprise one, too. The surprise element included all the statues on the many federal reservations and parks around Washington itself. These pieces were sculptures, in cases such as Daniel Chester French's Lincoln inside the Lincoln Memorial and Henry Shrady's Ulysses S. Grant Memorial, and magnificent works of art. More obviously, the federal art world included the Smithsonian museums. Additional collections of art appear in the Capitol buildings and the Library of Congress.

The marvelous collections and the exhibitions that these institutions have held over the years drew significant attention and interest. The quantity, size, and scope of these efforts created what one respondent called "the arts industrial complex." Only the presence of numerous top-notch museum professionals working in these institutions enabled this complex to operate. Thus, the federal city's art world had drawn many arts people to Washington over the years.

Members in the federal art world interacted with the local arts community. Sometimes a federal art city member arranged for a show in the federal art space that included a local artist or two. More often, federal members served as curators or judges for a local city gallery or nonprofit exhibition space. Many times, a member of the federal city arts community joined the local arts community, either exhibiting their work or running a gallery after retiring from federal service. The influence and influx of these members added to making Washington's local arts communities very interesting and innovative.

By the late 1960s and early 1970s, some notable thinkers in the art world excitedly observed Washington's local art community's innovation and declared the community special. Barbara Rose and Andrew Hudson both wrote glowing assessments of the District's cultural stature. These thoughts compared Washington positively against Chicago or San Francisco's regionalism and perceived Washington as striving to catch up to New York.

Forgey did not compare Washington's visual art world to the ones in other cities. Many artists and other art community members often unfavorably compared Washington to New York City. Artists and galleries focused on sales and notoriety often found Washington's art world wanting. They observed that artists and galleries had a better chance of gaining greater earnings and fame in New York.

Indeed, New York maintained the art publications, galleries, alternative spaces, and collector base to offer more significant material success opportunities. Washington, D.C., later New York, gallerist Max Protetch described New York City as "a sort of permanent art fair." The art world was significantly larger because New York had a considerably larger population. A decade later, artist Sidney Lawrence tired of the comparison. Tongue in cheek, he listed each city's irritants in two columns and suggested that you determine where to live based upon which columns items bothered you more. "But for God's sake, let's stop bitching about Washington." *The Visual Arts in Washington, D.C.*, also did not spend time comparing and ranking the art scenes in cities.[1]

A small number of books have documented aspects of the Washington art scenes. Earlier books have done a fantastic job documenting the collections of single individuals, like those of Duncan Phillips and Peggy Cooper Cafritz. This book

discusses these remarkable individuals, with a focus on those Washington-based artists that they collected. This book also features the numerous collectors who bought from a range of artists and established art foundations, created a collection during their years of running a gallery, and started a government program involving the arts.

The few books on Washington-based artists featured a single painter's works, such as those of a Washington Color Field member. In these, a more comprehensive range of artists, who constituted the city's complex art communities, received attention and a voice. For them, the arts hold a special place, providing them and others with additional fun than the daily routine. The commentary on these artists' work in this book also differs significantly from the art history books because it comes from critics who were contemporaries in many cases. It captures the early years of most of the artists and documents the progressions of these artists' works.

Most of the area's nonprofit galleries have self-published some catalogs and anniversary publications that contain some history of the institutions. These documents provided glimpses into the galleries. They often omitted types of information and stories that offered a more in-depth look both at the institutions and at the local and regional art worlds.

The federal city art institutions have published a wealth of books that extensively document most of their exhibitions and collections. There was no value in expending time on that in this book. Instead, this book will examine the specific interplay between the federal and local art scenes. It will look at the local community's advocacy for federal city art museums and its occasional protests against those museums' specific plans. The book will also discuss some interesting interplay among the federal and local/regional art communities, especially regarding controversial art exhibitions.

The existence of multiple art communities emerged as a prominent point during many interviews. Artists, collectors, galleries, nonprofits, residences, and museums all inhabit specific communities. The primary determinate to establishing the individual and organization's community proved to be the intention toward art. Communities based memberships on the artists' medium, the type of art that they created, and the friendships and networks they built. Additional factors included the resources at their disposal and the exposure they generated and received. Members could be part of multiple communities. The most significant debate among respondents centered on how they defined these communities. A few argued for a beach of sand with community members each pursuing a unique path to the sea. Most perceived the communities as hierarchical, with small numbers having access to the most resources.

What happened in the local and regional city's arts communities during the 70 years before and forty years after Forgey's observations? The Corcoran Gallery of Art opened and became a significant museum for displaying contemporary painting when it started a biennial exhibition in the first decade of the 20th century. At the beginning of the 1920s, when the Phillips Memorial Gallery opened, Washington became the first city to have a modern art museum. Two decades later, during the mid–1940s, Washington had one of the first African American galleries. The Washington Color Field group broke into the art world in the 1950s. In the 1970s, the local city artists made enormous strides for women in the arts. The Corcoran hosted a notable women artists' conference. Womensphere in Glen Echo National Park became the nation's first nonpolitical women's arts festival. The Washington Women's Art Center flourished, and the National Museum of Women in the Arts

would become the coda. The city held the nation's first art fair in the mid–1970s and started Art-O-Matic, an uncurated extravaganza of art, in 1999.

Fortunately, the city's major newspapers had a rich tradition of hiring expert critics to cover art exhibitions shown in both the federal and local cities. What began in the 1900s with the local artist and teacher James Moser's columns in the Sunday entertainment section expanded into full-time positions by the 1920s. Leila Mechlin and Ada Rainey critiqued museum and local arts groups' shows and offered assessments on national art issues as well. When Jane Watson Crane, Florence S. Berryman, and Leslie Judge Portner provided their views, the city had developed a gallery scene they added to their domain. That gallery scene grew and many writers followed it, with Paul Richard, Frank Getlein, and Benjamin Forgey among the leaders of the pack.

These authors and reporters left a rich tapestry of assessments and opinions on both the artists and their works. It contained views of the art at the first moment on display, and views on the artist and artwork changing over time. This book used the insights of these critics as the main source of its "art criticism." They are quoted liberally throughout the text for the beauty and uniqueness of their language and to capture how views of and about artists and their works have changed over these hundred years.

Most humbling and sad for the author is that many respondents have provided a wealth of knowledge, all of which cannot be captured in this book. They named several impressive artists who were members of art styles featured in the book that have not received specific mention. The realization that there were and are so many Washington-based artists served as a testimony to the creative spirit of this region. This vast array of artists demonstrated the tenacity associated with the artistic spirit and that deep need for humans to express themselves.

Writing a book always requires the help of a great number of people. I thank the librarians at the George Washington University Special Collections and the Phillips Collection. The librarians at the District's Public Library are always fantastic. Maya Thompson and Lisa Warwick were especially helpful during the COVID-19 pandemic circumstances. There were also several fantastic people at the various Smithsonian Institution archives and museums.

Many people who loved the local art scene graciously provided me with their time and thoughtful responses to my questions: Theo Adamstein, Sondra Arkin, Susan Baker, Judy Benderson, Jonathan Binstock, Jon Breeding, Michael Clark (aka Clark Fox), Rebecca Cross, Pradeep Dalal, Richard Dana, Joan Davidson, Alice Denney, David Driskell, Tom Drymon, Elias Felluss, Anne Hancock, George Hemphill, Claire Huschle, Michael Janis, Leslie Johnston, Sally Kauffman, George Koch, Sidney Lawrence, Robert Lehrman, Johanna Holford-MacLeod, Jayme McLellan, Robin Moore, William A. Newman, Michael O'Sullivan, Carolyn Peachey, Andrea Pollan, Jack Rasmussen, Victoria Reiss, Paul Richard, Eric Rudd, Molly Ruppert, Paul Ruppert, Donald H. Russell, Jim Sanborn, Alec Simpson, Dr. Jamie Smith, Judith Southerland, B. Stanley, Di Stovall, Lou Stovall, Alexa Suskin, Tim Tate, Henry L. Thaggert, Ruth Trevarrow, Claudia Vess, Bill Warrell, and Ellyn Weiss.

1

The 1900s

The Society of Washington Artists'
Portraits, Landscapes, and Still Lifes

The women dressed in bulky layers that gave them a swooping tulip shape stood alongside the men in short narrow jackets and bowler hats. Everyone showed their invitation to the Society of Washington Artists exhibition at Woodward & Lothrop Department store. The doors opened, and the guests walked past several counters to the bank of elevators. The guide took them to the fifth floor, where Japanese screens formed an aisle leading to the reception room.

Several male clerks from Woodward & Lothrop emerged and took their outerwear to the coat check. The guests saw a series of broad steps that led down into the spacious gallery. Many of the artists happily greeted the friends whom they saw entering the room. Along the dark-colored walls, over 150 oil paintings hung salon-style, leaving little else to see. Rows of incandescent lamps illuminated the gallery from above.

As the visitors examined each painting and then strolled on, others took their spaces. Little cards at the bottom of some pieces contained the word "Sold." Two of the city's arts patrons offered prizes to the best in the show. Max Weyl won $150.00 for his oil painting, and Bernie Perrie won $100.00 for her watercolor.

When the visitors grew weary of standing, they exited the gallery and enjoyed some light refreshments, which were offered in small anterooms on either side of the stairs. The newspaper critics whetted the artistic public's appetites. Nearly 1,000 visitors came on opening night. The pictures depicted some of the artists' wanderings during summer vacation time. The critic summarized that a viewer needed many hours to ascertain all the qualities of the paintings.[1]

Thinking back on the initial meetings to form their professional organization, the Society of Washington Artists members felt proud of the exhibition. They had professionalized what started a few years earlier as the Washington Arts Club and Washington Water Color Club. Membership in the new group was by application to the Society of Washington Artists' membership board, which would review the applicant's portfolio.

Some continued to belong to the other art organizations. But in the new group, they held leadership positions. The members acknowledged the sale of many paintings but quickly stated that they made art for arts' sake and that material gain was not the goal. The group aimed to unite the 100 or so professional artists working in the area, some of whom were already members of other organizations.

The Society's artists met in Max Weyl's studio to write up the group's bylaws and establish membership requirements. Weyl was one of the group's oldest and most successful members. The German-born artist came to Pennsylvania with his parents at age 16 and was apprenticed to a watchmaker. Moving to Washington to see Abraham Lincoln inaugurated, Weyl married, had a family, and ran a jewelry business. In his spare moments, he learned to paint by/from copying a painting. After completing one of his own, Weyl hung his original in the store window. People admired the work and suggested that he devote his time to the arts, which he did after a trip to Europe in 1878 to study.

Weyl completed many landscapes of regional locations, but Rock Creek Park was his favorite setting and served as the backdrop for many of his best-known works. A great lover of beauty and artists in every inch, Weyl had a kindly, warm disposition. Perhaps that was why he saw the positive in situations. New York City police arrested a woman who posed as a live model of Venus at a casino for public indecency in 1895. A D.C. reporter sought the city's arts community's opinions about whether these "living pictures" were an offense to public decency. "Not in the least [indecent].... I consider them refining and elevating to the public art taste." Weyl added that he did not consider a bronze-coated human nude at all. Indeed, she had shorts underneath.

The Corcoran Gallery of Art held a retrospective of Weyl's work during his 70th birthday celebration. His painting *An Indian Summer* became part of the National Collection of Fine Art, now the Smithsonian American Art Museum (SAAM). He kept painting until his death in July 1914.[2]

The Society of Washington Artists gathered later that year in 1891 in the Dupont Circle mansion of an architect, antique collector, and fellow member Louis D. Meline. He and his wife arranged for well-known citizens sympathizing with the objectives of the organization to attend. Everyone had a wonderful time discussing art. The evening cemented the Society's plans to enhance sociability by starting art circles devoted to antique, landscape, and portrait areas.

That evening the Society considered efforts toward turning the City of Washington into an art center. Since the schools of art, including the Corcoran and the Art League, would regularly promote the training of 200 students in the making of excellent art, the best of them would join the Society and help spread the fame of Washington and its artists. The members perceived that the Corcoran Gallery would continue to become an impressive showplace for art. But they thought the building of an art center stood at the center of their plans for the city.

They soon began a campaign to raise money for an art building for artists, students, and exhibitions. Many knew that Washington lacked structures to show art that highlights the best aspects of the works. Before the Civil War, one of the few places to see art was in the house at 614 E Street, N.W. A bookbinder and auctioneer, James C. McGuire, maintained an extensive collection of paintings that he purchased until the Civil War began. McGuire opened his home to visitors interested in enjoying his works of art in the years before the Corcoran opened. "He had a natural eye for pictures," said Dr. J.M. Toner. Although he devoted his last years of failing health to showing his collections of art and notable books, Toner observed that McGuire's condition kept him from performing the weeding out process necessary to any vast collection. When McGuire died in 1888, the Corcoran Gallery trustee left

the institution some of the works, and the remainder went up for auction. One of his three children became a curator at the Corcoran.[3]

While waiting for the construction of their art building, the Society members continued fostering relationships with those who offered exhibition spaces. They visited the home of Mr. Woodward in the upper-class section called Kalorama Heights after the exhibition. They provided tokens of their appreciation to him and Mr. Lothrop. Some individual members established fraternity with gallery and frame shop owners, too, building valuable relationships.

After holding its annual exhibition at the department store for a few years, the Society of Washington Artists moved its show to the Cosmos Club. Located in Lafayette Square, in the heart of old Washington society, the Cosmos Club membership included gentlemen interested in advancing science, art, and literature. The day before opening, the artists came in for "varnishing" day to see their work in place and put finishing touches, including "varnish," on their paintings. Varnishing day was also a mixer day for artists and members of the press to become acquainted. The exhibition—of 162 oil and watercolor paintings and seventeen pieces of sculpture—hung inside a spacious hall for one week. Members took out announcements in the newspaper to say they were going to be at the gallery.

At the close of these annual exhibitions, members started a tradition of dining out as a group at one of the city's notable restaurants. The first banquet happened at the Klotz Hotel near Seventeenth and G Streets, N.W. Nearly every member attended and partook in the "dainty" menu and gay evening. Witty speeches, songs, and happy jests filled the evening. Mr. James Moser started the entertainment with a happy little speech into which he worked some "clever negro dialect recitations," which were highly appreciated. After a few musical works on mandolin and guitar, Mr. Dieudonne played a solo on the flute. Following a poem, Samuel Hodgkins gave an entertaining talk about "local artists."[4]

James Moser came to Washington from his native Canada through Ohio. After studying at the Art Students League in New York, he traveled to Galveston, Vicksburg, and Atlanta, where he painted a series of watercolors for the Great Southern Railroad. Moser created illustrations for many of the era's top magazines, including *Harper's Century, Leslie's,* and the *Atlantic Monthly* and Joel Chandler Harris' *Uncle Remus: His Songs and Sayings*, the first book of the series. Perhaps this was where he heard the dialects that he used that evening.

After Moser married Martha Scoville in her hometown of Cornwall, Connecticut, the couple settled in Washington, D.C. Now 27, Moser cut a dashing figure with a thick head of black hair and thick mustache curled on both ends. Friends saw him as modest and sensitive and yet aspiring. Moser held a variety of positions in the art world of the city. He provided instruction to Caroline Harrison, the wife of President Benjamin Harrison, on painting in watercolors. Later, he taught at the Corcoran School and George Washington University. He served as a newspaper art critic for over a decade and penned three major publications. The exceedingly popular teacher suffered a stroke in 1911 and stopped teaching. Two years later, he died in his studio, just months away from his planned retirement to the couple's vacation home in Cornwall.

A celebrated watercolor and landscape painter, Moser appeared in shows along the East Coast and sold many canvases. In 1908, William T. Evans purchased Moser's oil painting *Mt. McIntyre* for the old National Gallery of Art, now the SAAM. Of

the five other Moser works in the museum's collection, three were watercolors. But he painted a pastel on paper of two children playing checkers. The black boy and girl appeared very realistic and notable for their humanity. It was interesting to reconcile this depiction with Moser's dinner entertainment and given that Washington was a racially segregated city. Perhaps his modest and sensitive manner carried over into the subjects of his paintings. His dialect was more likely stereotypical, which reflected and reinforced negative social attitudes more than disarming differences.

The following year, in early 1897, the artists dined at the Ebbitt for their annual evening of jovial Bohemianism. Many elderly members attended, as well as younger men in the midst of making their reputations. As they dined until midnight, each got his chance to jest, sing, or engage in banter and make speeches. Society president Edmund Clarence Messer offered congratulations to the members on an exhibition that brought younger members into prominent notice. Samuel Ireland offered his drolleries before Mr. Dodge provided a discussion of photography.

Later that year, the Society moved its exhibition to the new art building. The reception committee, Mr. Messer and Richard Brooke, greeted guests, escorting them into the loan collection's reception and private viewing rooms. Located on Connecticut Avenue in the new wealth section near Farragut Square, the building contained a more extensive gallery than the Cosmos Club. Inside the long gallery were works of art, ancient and modern. A number of these works came from the private collections of Washington's art lovers, including the city's major newspaper owners, Mr. and Mrs. Stilson Hutchins and Theodore W. Noyes, the white peoples' schools'

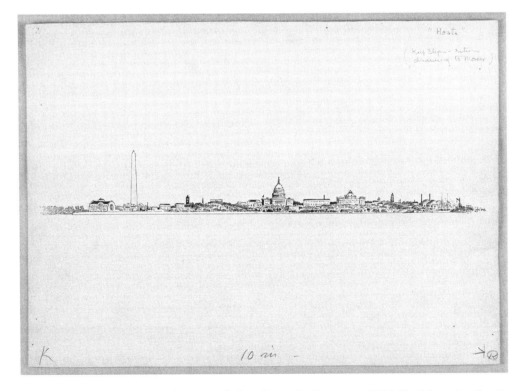

James Moser's etching *Washington Skyline from the Potomac,* 1908 (Smithsonian Institution, Gift of Louis Cohen).

supervising principal, F.R. Lanes, and the superintendent for the Government Hospital for the Insane, Dr. W. W. Gooding.[5]

The new location held regular art openings for individual members of the Society and various group exhibitions. Edward Moran showed thirteen paintings of significant events in maritime history. He started with Leif Erikson on the New England coast in 1001 CE and finished with the sinking of *Cumberland* by *Merrimac* in 1861. During Easter, the Society of Washington Artists showed in the home of Mrs. Alice Pike Barney. She joined the Water Color Club in 1895 and was accepted into the Society of Washington Artists two years later. Now, she had one of her strikingly effective portrait studies in a place of honor. One critic noted that Barney's artistic merit sustained his interest in the work. She captured an indefinable art quality, which means so much to art students and connoisseurs.

Indeed, Mrs. Barney committed herself to the arts with great passion. Her home became known for lively art salons, the staging of theatricals and pageants, and a bohemian lifestyle. One of four children born to the Pikes in New York City, her father made his fortune in Cincinnati distilling whiskey and showed his love for the arts by building opera houses. He encouraged his young daughter in her artistic pursuits. After her father's death, teenaged Alice scared her confining mother with her European activities, so she packed her daughter off to live with her sister in Dayton, Ohio. There she met and married Albert Barney, who also came from a wealthy family. Alice was fond of him and enjoyed his company, and they married in 1876. However, she learned Albert was a narrow-minded bigot and capable of violent jealousy.

The Barney parents and two daughters traveled throughout Europe. While Alice trained in painting in Paris, her husband Albert drank in London men's clubs. Upon his return to the United States in the 1880s, Albert settled in Washington. With the city's small number of old families, Albert believed his family would have an immediate acceptance to its top social echelon. He built an Italianate palace at 1616 Rhode Island Ave, N.W. This house and the family's Bar Harbor Place, Maine, home drew the Society's attention because of their sizes.

Alice negotiated a fine line between the dignity expected of a society woman and that of an artist. Despite Alice's winning the Congressional-funded competition to paint Senator and Vice-President John C. Calhoun's portrait, Albert continued to frown on her frivolousness. But he allowed Alice to have a studio in the house. The Society accepted the Barneys, and Alice's gorgeous housewarming guest cards won praise. A few years later, however, word leaked out about the Jewish roots of Alice's father and about his fortune having been derived from liquor, and influential members of the Society tried to remove the Barneys. Alice's success in courting favor and in the arts helped them remain in good standing.

When Albert Barney died in 1902, Alice publically adopted the status of grieving widow. Meanwhile, she purchased real estate in up-and-coming sections of the city, including Sheridan Circle on North Massachusetts Avenue, where countries built their Washington embassies. Only the second house on the Circle, the arts and crafts beauty became a stage for Alice Barney's painting and her performing theatricals. Her portraits received rave reviews at the Society's annual exhibitions. James Moser's review noted that her large upright panel in pastel always held an indefinable art quality, and he called the work a "symphony."

Alice Pike Barney proved less of a playwright than a painter, as the Society's newspaper stated in the early 1900s. However, Christian Hemmock captured as much of her interest. The younger man, who worked in the State Department, became her beau. Despite the objections of her daughters, they married. She was 52; he, 22. She

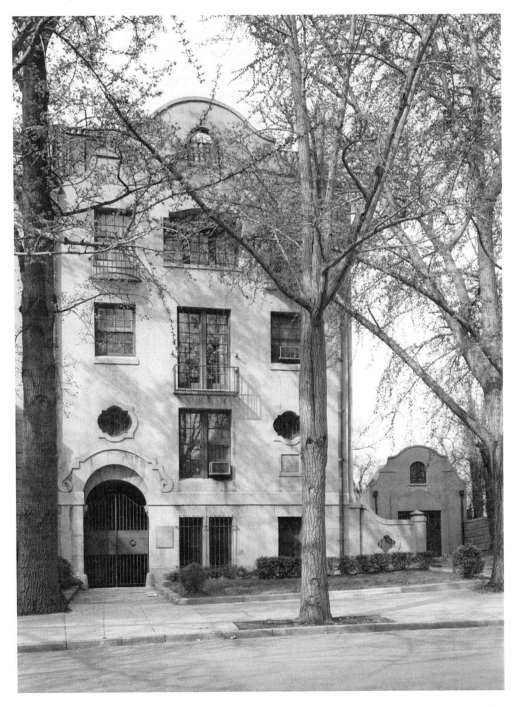

Alice Barney Studio, Sheridan Circle (HABS/HAER Collection, Library of Congress).

expected him to grow into the heft of a society man. He fell short: they divorced after years of marriage and theatrical disappointments.

Alice Pike Barney spent much of the last decade of her life in Southern California. Still, the woman known as "the Godmother" of D.C. arts left the city a legacy. She sponsored the Sylvan Theater located on the Washington Monument grounds. She supported the start of the old National Gallery with the Harriet Lane Johnson paintings. Barney also worked with the committee to start a National Gallery of Art in the late 1920s. Her Studio House at 2306 Massachusetts Avenue, N.W., currently houses the Embassy of Latvia.

Barney served as Vice President of the Society of Washington Artists. The exhibition committee discovered the best exhibition layout in the new building. After holding a few smaller shows in the space, they used the long gallery differently. For the annual exhibition in 1903, they created four salons from a single area. The first contained light refreshments and served as a reception room. The three other rooms featured 130 canvases, all hung two by two, instead of being piled in threes and fours. Many of Washington's social and official circles members appeared delighted not to strain their eyes and necks to see all the paintings. Each carried an admission card they received from a member of the Society. Critic Mosher noted that several paintings featured the artist's favorite subject. Alice Barney captured her daughter Laura; Lucian Power, a Venetian landscape; Jane Bridgham Child painted a white-draped girlhood.[6]

These styles of some of the Society's artists proved known enough to parody. Members of the Arts Students' League in D.C. attended the annual exhibition and looked around at all the canvases. Each one selected a work and then returned to his or her respective school to paint a take on a chosen canvas. The finished paintings became part of the "The Fakirs Show." The canvases sat on easels inside a roped area strewn with sawdust and precautionary warning signs. Fakirs were known generally as street hustlers and crooked vendors, selling fake or gaudy wares. Here they burlesqued the art of the well-known painters in Washington. The critic noted that all displayed an unusual amount of ingenuity and cleverness. The show catalog had "Suppressed" written on it in flaming letters, "but is circulating only as suppressed matter can."[7]

The Society faced contractions during the early years of the 1900s. Without as many members and as much financial support, the Society could not sustain its art building. Within a few years, the new owners converted it to an office building, and the large real estate brokers Story & Cobb took over a part of it.

The Corcoran Gallery of Art offered the Society a place to hold its annual exhibition. The group also decided to extend the display beyond artists in the Washington area. They sent out invitations to submit paintings to sister organizations in Boston, New York, and Philadelphia. Many artists submitted, but the exhibition featured a smaller-than-expected, although very distinguished, number of paintings. The crowd of over 1,500 prominent Washingtonians enjoyed the opening reception and having a "private view" of all the work. Many felt that the exhibition met the standards of the academies both in New York and Philadelphia. Artists from the Society held their own with the painters from other cities. Richard Brooke won the prize for best landscape painting.

The prize thrilled Richard Norris Brooke because landscape painting gave him

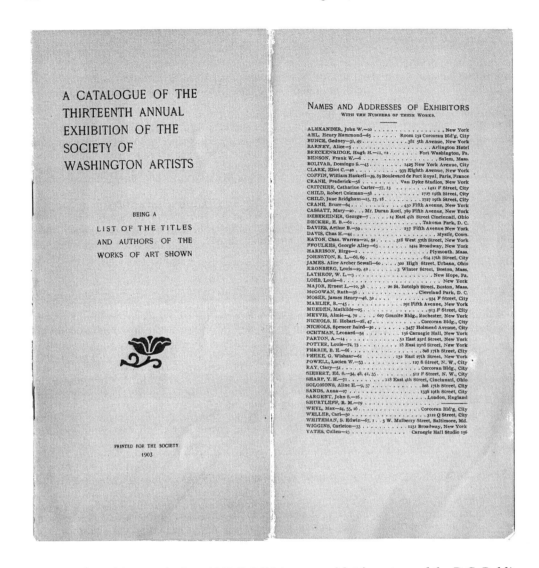

Society of Washington Artists, 1903 Exhibition pamphlet (courtesy of the D.C. Public Library, Washingtonian Division).

his greatest joy. The Virginia Military Institute and Pennsylvania Academy graduate moved to Washington in 1880. In his early 30s, he settled into the studios W.W. Corcoran established at Vernon Row on 10th Street and Pennsylvania Avenue, N.W. Corcoran also helped Brooke and other artists by getting them portrait commissions. Within two years, Brooke helped build the art collection of real estate tycoon Thomas E. Waggaman.

Slender, with a refined manner and bearing, Brooke was an impeccable record keeper, maintained an immaculate room, and kept himself with fastidious neatness. The teacher and artist held strong convictions regarding art. Like The Hague School artists whom he guided Waggaman to collect, Brooke saw in the life of the poor and humble a motive for expressing with intensity their broad human sympathy. Indeed, his best-known painting, owned by the Corcoran, was his portrait, called *A Pastoral*

Visit, of an African American family. The subject came from an alley in D.C., and it was considered a great painting.

Brooke taught hundreds of art students in Washington, D.C. After leaving the Art Students' League, he became an instructor at the Corcoran School. He was much beloved by his students for his keen critical eye and earnest manner. Brooke thought highly of them and the working artists. Unlike his friend Messer and a few others from the Washington artist group, Brooke enjoyed creating rather than philosophizing about art. When reporters asked him for his opinion on the "living pictures" arrest, Brooke said, "I do not see in them any means of elevating or refining the public taste.... [They are] for the delectation of what may be called a ... a depraved and morbid appetite." Nature does not produce a picture. He asserted, "The creation of a picture comes from the artist himself and of his idealization of the subject." Brooke served as the vice-principal of the Corcoran School in the last years before his death in 1920.[8]

Brooke received a monthly payment of $100.00 from Waggaman during his time in Europe seeking art for the collection. Brooke observed that he told Waggaman that it was a better strategy to buy one great painting than several good paintings with the same amount of money. The nephew of former Senator George Waggaman of Louisiana, Thomas E. Waggaman, established an extensive collection. It featured eighty oils and watercolors along with ceramics from Japan. The real estate dealer and businessman built a 40-by-80-foot gallery adjacent to his home at 3300 O Street in Georgetown. He planned on charging an admission price to enter. The art critic from the *New York Times* noted the paintings from the Barbizon school and Dutch painters. He also wrote that Brooke showed promise and that W. H. Holmes possessed a charming talent.

Mrs. Waggaman was one of the exhibition's patrons for the Society's first Corcoran show. Two years later, the Waggamans conveyed their collection of art from Georgetown to Catholic University. Mr. Waggaman had served as a treasurer of the school and had mixed personal and university monies and investments. As he attempted to declare bankruptcy, creditors used the courts to force the art and other personal assets to sell. At the auction in January 1905, 1,000 people, or 200 more than the hall's capacity, attended the sale. Despite an estimate of $1 million value, the sales generated about $350,000.00. That summer, the furniture, rugs, and art at the house all sold for ten percent of what he paid for them. One year after, Waggaman died penniless.[9]

W.H., or William Henry, Holmes came to Washington, D.C., to study art in the early 1870s. His talents drew the scientists' attention at the Smithsonian Institution, who hired him to paint and draw shells. Within a decade, he worked as an artist and topographer for the geological survey. He traveled the country and frequently drew and painted these locations, which were new to many viewers. The Smithsonian American Art Museum holds 65 of Holmes' works, including landscapes of Colorado, Wyoming, New Mexico, and Mexico and images of famous people like Chief Joseph of the Nez Perce Tribe.

After serving in the Smithsonian Bureau of American Ethnology, the artist and author assumed the National Gallery of Art's directorship in 1920. He joined the original group of the Society of Washington Artists, and several of his works illuminate the city and its members. His watercolor *Cherry Blossoms* captured those quintessential Washington items, as his watercolor of Hains Point documented that swamp

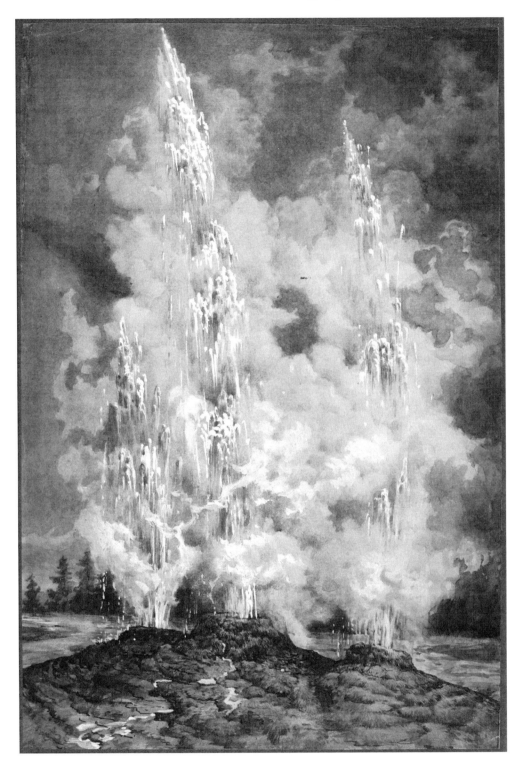

Yellowstone Geyser, n.d. (Smithsonian American Art Museum, Gift of Dr. William Henry Holmes).

area before the federal government created a park. His painting of Max Weyl showed some of his friends and art companions. Holmes represented the perfect example of a local artist who took advantage of the federal city's employment opportunities.[10]

The Society of Washington Artists' idea to expand the exhibition to a regional show proved highly successful. The former Montana Senator, William Clark, provided the Corcoran with the prize money to offer for the top painting in three categories. The prizes lured some of the notable artists in the country to contribute. As Moser noted with his trademark enthusiasm, the most celebrated American painters came to Washington and for the exhibition. These included Mary Cassatt and American impressionist Frank Benson, among others. Brooke and Weyl were among the Washingtonians who won awards.

Despite this success, after the first regional show at the Corcoran, Moser described the city as an inferior art center. He lamented that the city was a poor market for high-class American paintings. The city lacked a large cadre of very wealthy collectors at the turn of the 20th century. Yet the Society's creation of a regional exhibition led the Corcoran leadership to adopt the same format for its painting biennial beginning in 1907. Society members had successfully handed off a major artistic event that shaped the city's development as an art center to one of the city's arts institutions. And the Corcoran succeeded splendidly in making that biennial exhibition a success.

The Society of Washington Artists and Washington Water Color Club annual exhibitions returned to their primary focus on local artists. Both groups continued to hold their exhibitions at the Corcoran. Participation remained high among the artists in these groups, with 120–130 canvases on display for each occasion. Most of these shows took place inside the Hemicycle and opened with a private party and reception for social and official Washington and friends and family. The patrons helping to put on these exhibits included Mrs. John B. Henderson, Mrs. John A. Logan, and Mrs. Alexander Graham Bell.[11]

As the late 1910s arrived, the membership of these groups changed. Older members departed, and several of their former students assumed leadership positions of the organizations. Also, new men assumed the Corcoran Gallery and School leadership positions. The annual shows occasionally took place in one of the city's galleries. The number of pieces selected for the Society's show dropped to about 110 in early 1921, and they were mostly conservative paintings with a modified tendency to impressionism in some. By the close of the 1920s, the Society of Washington Artists exhibited fewer than 100 pieces. They now typically hung in the Corcoran's Hemicycle gallery. While fewer artists appeared in the exhibition, it continued to draw an audience. On a single weekend day, over 2,000 visitors saw the show. Mrs. Eleanor Roosevelt and the wives of various ambassadors attended.

Notably, the local critics seemed less content with the exhibitions. Leila Mechlin claimed to see several well-painted still-life pieces and three influential women sculptors with busts of people. "Most of the paintings are according to tradition, and few are startling in their novelty or originality." She also expressed concern regarding the Society of Washington Artists' goal of turning the city into the nation's art capital, asserting that the city's art lovers and professional artists need to cooperate a lot more to make the goal a reality.[12]

A few years earlier, some Society members and art lovers had cooperated to

create the Arts Club of Washington. Through donations and gifts, this group raised the money to start an arts club as in London. In May 1916, they purchased President James Monroe's former residence on "I" and 20th Streets, N.W. They decorated the inside and beautified the surrounding gardens.

In contrast to Washington's more traditional clubs, the Arts Club allowed both male and female members. Members included artists and an array of professionals, industrialists, philanthropists, scientists, and political activists. The organization's leaders were the wives of newspaper publishers, politicians, businessmen, and academics. Occasionally, the president was an artist, such as the sculptor Henry K. Bush-Brown, who led the organization through its first decade. During the first few years, dues were $5.00 per year, and applicants needed to demonstrate sufficient accreditation.

This organization took a different approach to make Washington an arts capital. The Arts Club expanded beyond the visual arts to include music and performance and the occasional lecture. Like the Society, this organization sought to stimulate interest and encourage art in the nation's capital. It aimed to accomplish this in two ways: One effort centered on bringing the best artists to Washington; the second provided a location for those artists to interact with other city's creative types. New York and Hollywood luminaries from D.W. Griffith and Claudette Colbert to F. Scott Fitzgerald and Tallulah Bankhead visited. The contribution of this to making Washington an arts capital appeared challenging to quantify. However, in fewer than three years, the society column crowed that Thursday evening dinners at the Club became an institution.

The Arts Club regularly showed the paintings and sculptures of members in small shows. Many of the artists were given a room all to their work. Usually, the pieces hung in the space for a fortnight. Customarily, oil paintings hung in the upper floor space, while watercolors and etchings appeared in the lower floor exhibition space. This room provided a place of honor over the fireplace mantle for exceptional paintings. An exhibition committee made the selections of the artists. On most occasions, visitors attended the opening and enjoyed tea from 4:30 to 6 p.m. Fortnightly salons also offered the opportunity to see the visual art exhibitions, although most attended to hear musicians' live performances.

The Arts Club of Washington continues today as a venue for recitals, theater performances, and dance. Visual art exhibitions occur regularly. Chief of Protocol for the Pan American Union, Paul W. Murphy, joined the organization in 1945. In his position, he met many Washington dignitaries. When visiting stage actors came for a Broadway tryout in the city, Murphy organized "champagne suppers" at the Club. The suppers usually featured ginger ale rather than champagne, however.

The Club remained active with many members, and courses in the arts were available to non-members as well. The Arts Club maintained a unique collection of paintings by early 20th-century Washington artists. Its fundraiser to conserve these works was an essential part of its Washington art legacy.[13]

The Society of Washington Artists continued its annual exhibitions, generally held at the Corcoran. The new critics for the newspapers covered their shows. Reports noted that figurative pieces, such as John Chapman Lewis's painting *Towers of Georgetown* and Director of the Corcoran Art School Richard Lahey's *Young Girl with Cat* won the top prizes. One judge seemingly approved of the show's styles: Isabel

Bishop of New York noted that the Society's annual "represented American activity in art without extreme emphasis or without the heavy bias toward non-objectivism I have found in so many other shows."

In 1951, the Society selected Mrs. Mary Snow as the group's president. Mrs. Snow became the first woman to serve in the position in the group's 60-year history. The annual shows moved from the Corcoran Gallery of Art to the Natural History Museum building's foyer by the late 1950s. The critic observed that many people enjoyed "competently painted representations of pleasing subjects."

The Society's annual exhibition moved to the Jewish Community Center on Q and Sixteenth Streets in the early 1960s. The President of the Washington Water Color Association expressed that his organization experienced the challenge of finding appropriate exhibition spaces in the city. The Smithsonian Institution dropped the national shows of both these two organizations and the Print Makers of Washington because they fell into the parochial category. The president noted that the exhibitions covered fields that were primarily disregarded or at minimum relegated to a minor position. He argued this decision deprived local artists of the space to show their work and the stimulation of seeing professional work from areas of the country.

Some of these arts groups fared better than others. The Society of Washington Artists lasted until 1967. The Washington Water Color Association moved its annual exhibitions to the Arts Club of Washington. Its yearly membership show, and some shows featuring individual members, appeared there through the mid–1970s. The show moved to the lobby of the District of Columbia's new library on Ninth and G Streets, N.W., in the late 1970s.[14]

Individual painters received shows at several of the galleries around the city. In Georgetown, Spectrum Gallery started in late 1966. The holiday show featured the gamut, including prints and watercolors. Spectrum later added several members from the recently closed 1822 Wisconsin Avenue Gallery, boosting their cooperative to 30 members.

A large group of artists leased the shop at 3033 M Street to share the high-rent space. However, these artists shared little in their styles, ideologies, or techniques. They held at least one all-member show every year. Usually, they showed in groups of four or five, centered on a theme. During one show, Elizabeth Pratt's watercolors were applauded by a critic for a major newspaper. In another, Washington Water Color Association president John Byrans showed with just two others. Over forty years later, the gallery still operated in Georgetown.

During the Society of Washington Artists' later years, Jane Watson observed that sculpture was often sparsely and disappointingly represented. In 1947, the Washington Sculptors Group began. The new organization lacked the grand aims to make Washington a more magnificent art city. Instead, it focused more on helping artists in the medium, like other more recently formed groups, including the Landscape Club and the Miniature Painters, Sculptors and Gravers Society of Washington, D.C.

The Washington Sculptors Group aimed to generate public attention for the artists and the art form beginning in 1984. Many sculptors in Washington perceived that their art finished a distant second in attention to painting in Washington. Forgey helped the group and art form through covering the group's first series of shows, held

at the Corcoran, and then in the regional areas of Alexandria and Leesburg, Virginia. Those shows included 75 submissions and featured about 30 pieces. The Sculptors Group currently had about 100 members and held four shows a year in galleries, museums, and alternative spaces throughout the region.[15]

Sculpture received a big boost when a new critic stepped in at the *Washington Post*. Leslie Judd Portner observed, when promoting one of the Washington Sculptors Group shows, that sculpture appeared too rarely in the region. She noted that the group, while small, was hardworking and eclectic and had members who deserved notice. She lauded the enormous amount of talent on display at the group's tenth-anniversary show, held at the National Museum.

Member Robert E. Kuhn created among the most notable of the works. Born in 1917, the Michigan native went to the Art Institute of Chicago and learned to weld during the few years he lived in Mexico. Kuhn came to Washington in 1954 and successfully made a living as an artist during the 1950s and 1960s. Disdaining the use of models, Kuhn had a restlessness that led to his creating 119 pieces, on 100 different subjects, in a single year. His collectors include the Marshall Fields, Jock Whitney, the Admiral Lewis Strauss collections, Harry Belafonte, and the Ford and Rockefeller families.

Reportedly Kuhn grew weary of the art gallery grind, including 28 exhibitions and six one-person shows in Washington. The artist moved to Tanner's Ridge in Virginia's Blue Ridge Mountains, where he converted a 50-year-old former church into his home and its meeting house into a gallery. Kuhn visited Washington roughly three or four times a year and died of respiratory failure at 82 in 2000. The Sculptors Group to which he belonged lost momentum. Its number of exhibitions dwindled by the late 1950s. A new group emerged in the early 1980s under the same name to promote awareness and understanding of sculpture. Their activities appear later in this book.

The older professional artist groups lost members and momentum. Like all else, art taste and styles change. Groups need the rejuvenation that comes with new members and energy, and without them, they drift into historical memory. In 1978, the National Collection of Fine Arts (now SAAM) organized a show that recalled the Society of Washington Artists member Alice Barney and the social world of her salon that encompassed notables ranging from the Barrymores to James Whistler. Several artworks by Barney and her friends donated by Barney's daughters appeared for a month. The Smithsonian refurbished the house and exhibited Barney's and her friends' artworks in the space for a decade.[16]

Washington has long held a position as one of the important art centers in the country. The city's first arts community, the Society of Washington Artists, believed in its members and strove to educate the public in the arts. Its self-assuredness and adherence to a school of painting limited its ability to expand beyond representational styles and subjects. Ironically, the gains in taste made by the Impressionist, Expressionism, and 20th-century schools of art narrowed the range of acceptance to almost exclude most of the works that these artists painted. But these artists' paintings appeared in the collections of many homeowners in Washington, D.C., as the framers and art galleries promoted their works to this art market.

2

The 1910s

Art as a Family Business

Someone stole the *Mona Lisa Gioconda* from the Louvre. The French police began interviewing workers and others associated with the museum, but they found few clues. As they expanded their search into other European countries, some intrepid newspaper reporters wondered whether the painting could come to the United States. If some collector decided to make the purchase, Leonardo Da Vinci's masterpiece could disappear into a private collection. One of the best known, most visited, and most parodied works of art in the world could never appear again.

The reporters contacted art experts to determine if the *Mona Lisa* could ever be in Washington. Frederick McGuire, the Corcoran Art Gallery director, thought such a task would be difficult and dangerous. Venable Art Galleries' proprietor, S.J. Venable, dismissed thoughts that any local art dealer like himself would get involved. "There is no dealer in Washington so unversed in his profession that he couldn't detect almost instantly whether the picture was a forgery or a theft of the original.... The proprietors here are men of the highest integrity." The reporter wondered if a collector here could use less-reputable means. Venable said confidently, "Washington art buyers are among the most careful in the country. I would like to see someone attempt to sell any great stolen picture to the art lovers here. His freedom would be of short duration." The *Mona Lisa* turned up in Florence. Workingman Vincenzo Perugia stole the *Mona Lisa* without help. "I did not take the painting through a desire for gain but wished to accomplish a good and holy work by returning to my country one of the many treasures stolen from it." With the crime solved, the art world could return to normal.

The Venable Art Gallery sold frames and paintings for the burgeoning middle classes who worked in the expanding federal government in Washington, D.C., after the Civil War. Its first store on Ninth Street near F Street downtown had expanded, because of the *Mona Lisa* theft, to two stores on G Street, closer to the Treasury Building.[1] F Street had long been the hub of downtown. Henry Adams recalled the street having "wheel-tracks meandering from the colonnade of the Treasury... to the white marble columns and fronts of the Post Office and Patent Office."

Now stores lined F Street. It became the center of art sales in the District. In the early 1880s, V.G. Fischer took over a store selling books and stationery directly opposite the Treasury Building on Fifteenth Street. The location offered proximity to federal city Treasury and the War/State/Navy department workers interested in purchasing art. The local citizens working in the nearby banks were potential customers.

After moving into selling engravings of artworks, Fischer continued expanding. Soon he held monthly exhibitions of artists from the fall through the spring. Those showing pieces regularly included members of the Society of Washington Artists, such as landscape painter James Henry Moser and Reuben LeGrand Johnston.

Born a decade before the Civil War, Alexandria, Virginia, native Le Grand Johnston remained in the area his entire life. The tiny spectacles and thick mustache completed a look that emerged during his years of training at several art schools. Johnston began exhibiting masterly paintings of animals and landscapes at Fischer's shop during the 1880s. "A man whose work runs too strongly toward realism is apt to be mechanical ... and, as we understand the impressionist, I feel that he is leaving out a great deal that goes to make the beautiful." Stylistically, Johnston emphasized a happy medium between realism and impressionism. His shows were generally successful; the public came in to look and frequently bought his works as he had a reputation as, according to great-grandchild Leslie Johnston, "Washington's painter of sheep." A quintessential painting of his appears below, its delicate blue pastoral scene inside a beautiful gold frame.

Johnston married Virginia Del Castillo in 1887. A Cuban of Castilian descent and beauty, Virginia was a painter, and the pair joined the Society of Washington Artists during its first year. The couple exhibited regularly at the annual shows of the

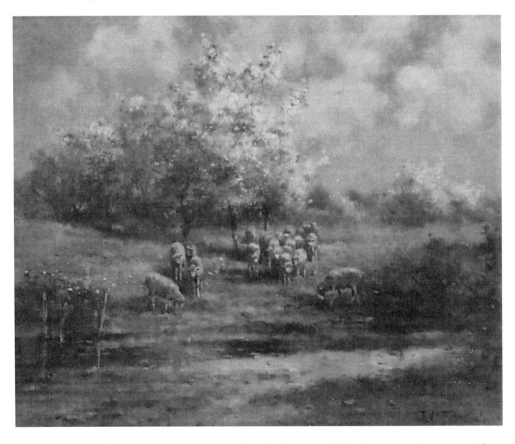

Reuben Le Grand Johnston, painting with gold frame, c. 1900 (courtesy Laurence Johnston via Leslie Johnston).

group. While LeGrand Johnston continued to show at galleries regularly, Virginia's work appeared much less frequently, partly as she raised four boys.

One issue grabbed the pair's attention—the fight of Cubans and Puerto Ricans for independence from Spain. Mrs. Johnston participated in the Women's National Cuban League. She asked her husband to teach a class to Cuban women visiting the city in 1897. With the hype of Cuba's freedom rising, Virginia Del Castillo Johnston closed the event by posing as Cuba Libre surrounded by women representing each state of the United States.

Johnston taught at the Corcoran School of Art for many years and joined his family of five on retreats to New Hampshire during the summer months. These trips served as a place to "gather data," as he called it, then return to his studio on Seventeenth Street close to the school to put the evidence into a painting. The pair exhibited as a couple at Morrey's Gallery in 1907. With Mr. Johnston contributing 41 paintings, and Mrs. Johnston, a group of four. They resumed showing with the Society of Washington Artists at its annual exhibition at the Corcoran Gallery in the 1910s.

At 69 years old, LeGrand Johnston died in the suburb of Beltsville, Maryland. His four sons were serving in World War I at the time. After the war, three sons returned home. One established a family in California. Virginia moved to California not long after. She created art for the rest of her long life. Yet, in a not uncommon theme, subsequent generations have found his and not her paintings, according to Leslie Johnston.[2]

Always looking for ways to expand his business, Fischer brought notable artists from his gallery in New York City to his Washington, D.C., store. He knew his audience and brought artists like the impressionist Childe Hassam. Like most collectors in other cities, Washington collectors purchased works from artists who had already made their names. Fischer had one of his best months selling Cincinnati artist Miss Elizabeth Nourse. Her realist-style paintings sold well in her native city and Chicago before her works came to Washington. Fischer received a pat on the back from the major newspaper's art critic for this exhibition twelve years later when Nourse painted in Paris.

The gallerist continued to extend his inventory. Generally, Mr. and Mrs. Fischer left the oppressive heat in Washington at the start of July, specifically going to Europe to purchase art. These trips usually lasted until the new art season in the autumn. Even before the couple left on one Pan-American cruise, the art critics wrote expectantly about their return to the city with art objects beautiful and rare for the delight of Washington connoisseurs. On one trip to England, Fischer bought two van Dyck paintings from Lord Carlyle. The director of the National Portrait Gallery in London congratulated Fischer on his purchase. Upon his return, The Fischer Gallery had the pieces on display for two months for Washingtonians to appreciate. Such efforts to continually improve the business received recognition: the third-place winner at the first Corcoran Gallery biennial took home the V.G. Fischer medal.

Fischer's company had a solid value. A notable shareholder in the company held about 225 shares of stock, which a court valued at $25,000.00. In today's dollars, that amount is about $650,000.00. Despite the value and notoriety of the D.C. gallery, Fischer consolidated his gallery business in New York City. Fischer retained a branch office for framing and repairing of paintings in Washington. In his New York City

gallery, he began featuring the art of the Old Masters, including Flemish artist Peter Paul Rubens' *Holy Family* and Anthony van Dyck's portrait *Nicholas Triest, Baron of Auweghem*. Fischer long held an interest in these most painters. When Waggaman had to sell his art collection, Fischer purchased three paintings, including van Dyck's *The Virgin, Infant Christ and the Angels* and Richard Wilson's *Tivoli*.

Despite having purchased these paintings from a Washington-based collector, Fischer thought his growing focus on Old Master paintings necessitated a move. He thought the collectors with the money required to make these purchases lived in New York City and not in Washington, D.C. Contemporaries viewed Fischer's departure as a severe loss to art lovers in Washington.[3]

Several other frame shops and art sellers operated in full swing. One block to the northeast, store owner Kimon Nicolaides served as auctioneer at Washington Art Galleries. The Greek immigrant came to the city from Saratoga, New York, with his wife, to start an emporium focused on Asian arts. A few years into their stay, the pair and the store regularly appeared in the newspapers. During the summer of 1891, Mrs. Louisa Nicolaides cried murder in front of the store as she believed that her husband maltreated her. One month later, her father, Mr. McLaughlin, arrived in the city to speak with his daughter. He made his support for his son-in-law clear.

One and a half years later, Mrs. Nicolaides entered the store and smashed art pieces. On her fifth such venture into the store, she destroyed a pair of vases worth $1,000.00. She followed with a filing for divorce because her husband engaged in cruelty and confined her to an insane asylum. In her suit, Louisa Nicolaides stated that her husband was a penniless clerk before they married in 1889. Her father lent Mr. Nicolaides the money to start emporiums in Saratoga, Cincinnati, and Washington. Kimon Nicolaides responded that his wife was the cruel person in the marriage and that he stayed married because of their children. After denying his wife's charges that he has been intimate with other women, Mr. Nicolaides called for her father to visit. By year's end, Mrs. Nicolaides made a public statement that said her husband was not to blame for her random actions of smashing goods in the store. She also recanted the open charges she made against her husband.

As he ran the Sarasota Japanese Emporium, which netted about $3,000.00 a year or $76,000.00 dollars in today's money, all was not tranquil at the Nicolaides' residence. Louisa filed her third suit for divorce. Along with alleging cruelty, she stated that he forced her and their children to subsist on coarse food and drink while he dined on the choicest foods. However, as before, the split never officially occurred. The family stayed in Washington, and the eldest child, Kimon, attended classes at the Corcoran Gallery of Art.

He showed at the Corcoran School and developed a reputation as an excellent artist, specifically in drawing. He applied his skill in the U.S. Army's camouflage unit during World War I. Five years later, he moved to New York and taught at the Art Students League. He died at the young age of 47. However, one student helped finish Nicolaides' book, *The Natural Way to Draw*. The book became world-famous and well used with its suggestions for improving one's skills at drawing.[4]

Two blocks east of Fischer's location, on Thirteenth Street, Veerhoff Galleries was established in 1871 as purveyors of "wall decorations," which included pictures, mirrors, wallpapers, and window shades. While homeowners had their interior

decoration options, the city's artists used the store to find the frames that might help sell one of their paintings. "We were all originally picture framers who pushed paintings on the side," the Mickelson brothers said years later.

The businesses knew the importance of the right frame. Frames created a border. The borders contained the image and helped focus the spectator's attention on the painting. The frame's material and style, like the painting itself, told a lot about the owner.

Two decades later, Washington's growth as an art city showed as Veerhoff operated three downtown stores. The front section displayed new prints, including etchings, engravings, and facsimile watercolors, while the central gallery contained paintings from private collections. The rear gallery showed watercolors from both American and European artists, including representative works from Washington's professional artists.

During the gallery's first decade, Veerhoff held a variety of exclusive shows. Some shows featured topical subjects of the moment or notable people from the era, such as actor Burr McIntosh's photographs of actresses Julia Marlowe and Anna Held. Other shows focused on artistic techniques, such as a show of photographs taken with platinum plates, making them appear unique.

Coming to the United States from Germany at 12 years old, Veerhoff worked as a draftsman at the Patent Office when he moved from Baltimore to Washington, D.C. He left his position and started a business as an art dealer building a reputation as a connoisseur. Unfortunately, in 1905, proprietor William H. Veerhoff died. His will bequeathed the house and income to his wife and left other property to his son and daughter. Lawyer and family friend Shelby Clarke became the manager of the art business. Clarke ran it for three years before turning the company over to Veerhoff's son, Otto Louis Veerhoff.[5]

While Clarke ran the business, he featured etchings and oil and watercolor paintings of local artists. Otto Veerhoff moved the company from a four-story brick building to a three-story brick building closer to the Treasury Building. He continued the successful run of Veerhoff Galleries through the 1910s and 1920s before moving the gallery from its F Street location toward the center of the city's art district on F and Thirteenth Streets. He continued exhibiting the city's artists, holding several of the Society of Washington Artists' annual painting and sculpture exhibitions. Otto extended the gallery's relationship with area collectors. Veerhoff sometimes showed art from the collections of Duncan Phillips and James Parmelee.

The art bug bit lawyer Shelby Clarke hard. After his time with Veerhoff Galleries, Clarke wanted to stay in business: At the Shelby Clarke Art Gallery on G and 13th Streets, he featured portraits of Washingtonians and watercolors of the area. The gallery also showed the works of local artists, including collections of paintings by Lucien W. Powell. Clarke also showed notable artists from other cities, such as the Scottish painter Carton Moorepark, whose charcoal drawings, local critic Leila Mechlin wrote, displayed evident training and skill.[6]

Veerhoff exhibited Lucien Powell for years. A Virginian, Powell served in the Eleventh Virginia Cavalry during the Civil War beside his three older brothers. He continued sketching animals and events throughout the war, as he had on the farm in Virginia. "We had lived on nothing but parched corn and water for days," Powell recalled of the last days of the war many years later. Returning to civilian life with

shattered health, Powell failed to make a success of farming. He soon took his mother's advice and became an artist.

After studying at the Pennsylvania Academy of Art, Powell traveled to London to study with Joseph Turner. He perfected his skills on his honeymoon around the Middle East and Italy. Returning to Washington, he taught painting and established a homestead during the summer months in Loudon County. By the late 1890s, Powell built a reputation as one of the city's best and most popular artists. As one of his peers noted in a review of a show at Veerhoff's, the "mere announcement of his upcoming exhibition awakens in the mind visions of Turneresque Venetian scenes and Moranesque Western settings." Moser loved most of the work but would have removed weaker pieces.

Unlike some of his fellow artists in the Society of Washington Artists, Powell once observed, "I never paint a picture unless I have an order for it. Art for art's sake is a wonderful theory but it isn't practicable. I have no desire to starve in a garret." When he thought work sellable, Powell made multiple different images of the same scene.

Powell established a great friendship and relationship with Mary Henderson, wife of Senator John B. Henderson of Missouri. She considered him a protégé. Sometimes Powell and his family stayed in the Henderson house in Bar Harbor, Maine, during the summers. He used the opportunity to create paintings of marine life. Eventually, Mrs. Henderson owned over 200 of Powell's works and arranged for Powell's Rocky Mountains paintings to appear at the Corcoran's Hemicycle. Besides Mrs. Henderson and the Corcoran, the Atlanta Museum of Art owned works by Powell. London brokers also found his work had a vibrant market. President Theodore Roosevelt was a huge fan of the artist. At his death, many a Washington home reportedly had a Powell. The artist observed, "God exists in color, in love and in goodness."[7]

Despite Powell's shows in his gallery, Clarke proved unsuccessful in his business enterprises. After a few years, the Shelby Clarke Art Company filed a bankruptcy notice. Two of Clarke's creditors forced him to admit that the company lacked the assets to pay the creditors. While the art company owned the creditors about $15,000.00, it reportedly had about $10,000.00. The range of the company's holdings went up for quick sale. These included watercolors, etchings, engravings, mirrors, frames, and Medici and Mazel prints.[8]

In contrast, The Venable Galleries had done very well during the first decades of the 20th century. The business established a reputation as a seller of fine arts for the home. It sold watercolors for moderate prices of $5.00 and up and etchings for $1.50 and more. The store succeeded so Venable enjoyed himself. He purchased a Cameron touring car that seated five during a time when few people had cars. The wives of his fellow Rotary Club members received gifts of frames at their annual dinners. Venable eventually hired Shelby Clarke to assume the position of Director of the Gallery.

Venable's gallery also showed a range of artists. These included the works of local artists such as Dr. William H. Holmes, who often exhibited at the gallery during December. Many of his works were primarily decorative and made holiday gifts. Sometimes Venable offered shoppers the chance to see things that they otherwise may not have—such as portraits of famous Washingtonians. The store also exhibited drawings from noted war correspondents that depicted current news events, including wars in Latin American and Asia.[9]

In the 1920s, the gallery ambitiously supplied the paintings used in the "Homes Beautiful" promotion of new suburban homes. Residential construction boomed throughout the country through the mid–1920s as cities expanded into rural and neighboring small towns. In Washington, D.C., the asking prices for homes skyrocketed, climbing from $5,600.00 in 1920 to $7,700.00 by 1925. This promotion enabled visitors to see model houses. It also taught them to learn to decorate their own homes "beautifully." Despite the expansion in building, the homeownership growth rate only grew from 44% to 47% during this decade.

The home has always held a special place in American culture. Americans idealized the house as a space where every person lived self-sufficiently. Homes enabled owners to display their personalities, their positions in the community, and their tastes. Since the 19th century, the home has served as the most effective place to pass down good values and culture.

At the beginning of the 20th century, the "home beautiful" concept received a lot of attention. Mrs. Herbert Nelson Curtis believed in and managed a business involved with teaching people how to make their homes beautiful. "Inartistic homes ruin our manners and morals and wreck our nervous systems," she advised as a professional interior designer. Another expert in home design, Estelle Reis, argued, "A good taste in residence gives the owner a better outlook in life."

Experts from interior decorators to architects highlighted the many secrets to having a beautiful home. For Mrs. Curtis, the beautiful home avoided the elaborate and created consistency in furnishings, while Mrs. Reis highlighted resourcefulness and warned against owner neglect and indifference. Every spring during the decade, the Better Homes in America movement wrote articles that appeared in Washington newspapers. These pieces focused on the size of home your family needed or recommended the art to hang on each room's walls. Experts provided advice about furnishings, from the best wood for your furniture to the importance of frames for the art that you buy for your home.

The Homes Beautiful collection of five demonstration homes spread across the northwest portion of the District and drew over 150,000 visitors over the eight-day event during the fall of 1927. While many made inquiries about the houses, most of the comments focused on "how tasteful everything is," and how "not one detail has been overlooked." Venable's art drew some favorable comments, as did the other vendors cooperating in the exhibit.

Six months later, the *Washington Post* and realtors held the event for 1928. The six houses featured cost from $12,950.00 to over $47,500.00. Inside, each had every detail of home life, carefully chosen furniture and decorations, and once again, Venable supplied pictures from the store's art rooms. Thousands came to see the models, but many ignored the *Post*'s advice to visit the most expensive and learn "how an expensive house pays for itself in tasteful beauty and comfort." More felt excited about the lower-priced home, appreciating it as something they envision themselves living in. However, the price for this smallest house seemed affordable to the middle-middle class of the Washington area.

While the government clerks and scientists, professors, and others dreamed of homeownership, S.J. Venable continued to promote the importance of art in the home. He spoke to the American home department of a local National Federation of Women's Clubs and fellow merchants' stores. Venable told these upper-middle-class

and upper-class female audiences about the role of paintings, etchings, and other types of art in various homes.[10]

His fellow framer and art gallery owner Otto Veerhoff sought to sell to this group of people. He moved his family business to Dupont Circle, where these rich people shopped. Known as the Madison Avenue of Washington, D.C., this strip of Connecticut Avenue, N.W., from K to S Streets, included the city's notable banks, interior design stores, jewelers, women's sportswear, and now galleries for shopping convenience. After World War II, Venable Art Galleries joined Veerhoff Galleries in the Dupont Circle high-end shopping strip. The business completed extensive repair and framing work for the general public's needs and employed thirteen framers in its 1615 Connecticut Avenue location.[11]

Some of the sales for those with more modest incomes went to another framer, Samuel "Pops" Mickelson, who purchased the G Street building at a sidewalk sale during the 1920s and moved his book buying and selling business there. His eldest son, Maurice, added the art framing business that filled the building's three stories. The location proved equidistant from two of the city's most famous department stores, Woodward & Lothrop and the Lansburgh, making the store an easy stop to add for those making a day of the central shopping district.

The business of selling art at the frame shop seemed secondary to the business owners like Mickelson. "We were originally all framers who pushed pictures on the side," Maurice Mickelson noted. "Artists would come in to get frames, and we'd show their pictures. If we didn't do framing, believe me, we couldn't afford to be in the gallery business." The business performed well enough for Maurice's younger brother Sydney to join after returning from serving with the engineers during World War II.[12]

The patriarchs of the D.C. framing establishments began retiring or dying shortly after the war. Otto Veerhoff retired in 1947, passing on the family business to his son Otto and daughter-in-law Mary Brooks Veerhoff. The elder Otto, a Washington, D.C., native, suffered a heart attack and died in 1952. Near the end of the decade, Samuel Venable died at 88. A noted art appraiser and dealer, Samuel earned respect for his appraisals of paintings and the ability to clean and restore artworks. His preservation skills saved paintings at George Washington's Mount Vernon home and the Rotunda of the Capitol. Who would carry on the business proved less clear. Samuel "Pops" Mickelson died in the early 1960s. He had collected art over the years of showing pieces in his shop. His son Sydney opened a gallery next door to the frame shop.[13]

Under Sydney, The Mickelson Gallery collected and showed what he liked, mostly realists. The artists included William Woodward, who, critic Andrew Hudson wrote, pleased an audience at a low artistic level—and artist Joseph Amarotico, whose style spoofing the metaphysical painting school from Italy during World War I. Local critic Andrea S. Halbfinger believed that Amarotico successfully updated the approach. Washington realist painters Frank Wright and Dominic Spadaro exhibited there, and the gallery provided chances for unknown masters' students like Peter Nelsen and Danni Dawson. "Our art is middle of the road, although we've shown the avant-garde," Sidney explained. The gallery showed Richard Schlecht, Frank Wright, Bill Woodward, and others in the Washington schools.

Mickelson's gallery became best known for prints. Sydney kept a range of prints in the basement of his building. What one observer described as "buried treasure," the basement haul featured lithographs by George Bellows and etchings by Jack

Levine and M. C. Escher. These prints ranged from $40.00 to $2,000.00 in 1970, though ten years later, an Escher might sell for $10,000.00. A decade into running the gallery, Sidney Mickelson appeared on Smithsonian Institution art panels and discussed print collecting basics: the techniques used, terminology, restrikes, the system of numbering, and artists' proofs. The gallerist continued to seek out contemporary printmakers as well.

The Mickelson Gallery stayed in its location through D.C.'s famous riots after the assassination of the Rev. Dr. Martin Luther King, Jr., and the subsequent decline of the downtown shopping area. As city residents with money fled the city and suburban residents chose not to shop downtown as often, the department stores that once flourished closed, leaving large, vacant buildings. The smaller and related business also suffered. Mickelson persevered, founding and serving as the President of the Washington Art Gallery Association.

The area went through more disruption when the local and state governments decided upon building a subway system to serve the region. The project eventually meant that more people might travel down to the area. However, during the construction process, parking for cars disappeared. Roads remained closed for more extended periods than planned. Large holes in the frontage along the streets filled views all around. Noise and dust made stepping out into the environment unpleasant. Mickelson's frame and gallery shops remained open almost through the 1990s, when Sidney died of cancer at 74.[14]

Otto and Mary Veerhoof kept the family at its Dupont location. The business's aim to sell paintings for the home continued. During the celebration of Veerhoff's 90th anniversary in the summer of 1961, the couple set up varied works to emphasize proper picture framing. They also set up collections of paintings to illustrate tasteful groupings of paintings for the home.

But the area had already started to change. For decades, the site contained private clubs—and spacious townhouses of the genteel and well-heeled on the wide, tree-lined avenues. By the mid–1950s, the established families began moving out in numbers. The mansions were becoming group houses filled with disaffected youth, out of work people, and aspiring literati. By the mid–1960s, political counter-cultural people, alternative culture businesses, and art bohemians took over the Circle. With this mixture of SDSers, Black Panther members, and gays, Dupont became known as the critical area in which to score drugs.

These changes meant an opportunity for art gallerists. They began buying and renting older townhouses between Dupont Circle and Rock Creek Park and created an area known as "the P Street Strip." The story of this arts district appears in Chapter 8. These changes made Veerhoff's one of thirteen galleries in a loop around north Dupont throughout the 1970s. When the couple retired, their daughter Margaret purchased the business.

Margaret Veerhoff was the fourth generation of Veerhoffs to head the commercial gallery and initially stayed in Dupont Circle. They were part of the burgeoning collection of commercial galleries springing up along R Street north of Dupont Circle during the 1980s. Local artist Ruth Trevarrow worked for several years at the gallery, where she learned a lot about restoration, conservation, and art history. "Margaret was a major influence on my life." She recalled the gallery held many shows that included local artists.

Unfortunately, rents for the buildings went up accordingly. Margaret moved the gallery to a new, up-and-coming area, 17th St, N.W., which realtors called "East Dupont" to market the area. Observers saw the district as an eclectic multiracial mix of ages, sexualities, and wealth, which seemed to have the common bond of optimism in the potential for positive change in their community.

Veerhoff Galleries sat in the middle of the three-block strip of stores. She became president of the 17th Street Merchants Association promoting the "village" feeling that goes on inside the coffee houses, flower shops, furniture and hardware stores, and more than a half-dozen restaurants. The late 19th-century Victorian homes that lined the side streets became smaller apartments and condominiums. "We have a wonderful mix of residential and commercial that seems to work well together," said Veerhoff. "If you live here, you can find just about anything you need right out your front door." She kept the family business running until closing it in 2000.[15]

The Venable Galleries closed but two years earlier. The family sold the business in 1963 to two men, Jack Neslage and his close friend and business partner Fred McDuff. The pair thought the company provided them a way to sell McDuff's realistic oil paintings. A visitor from the Kennedy White House altered that plan. The woman asked McDuff why no Washington gallery sold French Impressionist paintings "like they do in New York." Neslage chucked at the memory. "Fred told her to come back in a week, when we might be getting a few in. Then he went home and painted a couple small, impressionist landscapes. That's how he got started as an American impressionist."

The Venable-Neslage Galleries sold to the wealthy interested in decorating their homes with large paintings of "conservative" tastes. "When we started Dupont Circle used to have the limo trade," Neslage says. "There were all sorts of smart clothing and retail shops which catered to a well-to-do clientele." The different residents in the city, after the riots of 1968, changed the area as people changed their shopping habits. Jack Neslage mentioned, "since the 1968 riots ... there was a complete change in suburban shopping patterns, we've been trying to do something about getting more people to come back to shop."[16]

The establishment of the subway system also factored into these changes. As the construction for the system's Red Line went forward during the 1970s, disruptions of vehicular traffic and parking areas occurred along the Connecticut Avenue stretch. The Metro dig hampered store sales, especially north of Dupont Circle. Some quality shops closed by choice or financial pressure.

Once construction stopped, the gallery resumed selling well to its clientele. McDuff and others painted in the neo-impressionist style that sold well to the city's notables. This group included former secretary of state Dean Acheson, former House Speaker Thomas S. Foley, former First Lady Nancy Reagan, plus Delaware Governor Pete du Pont. Neslage observed, "The art we sold was impressionistic, traditional, and realistic, and we had five full-time framers and four-person gallery staff."

Being part of the Dupont Gallery loop did not help the gallery expand its business into more contemporary styles. "We tried selling abstract art, but it didn't work. Our clientele was too conservative," said Neslage. Still, the business blossomed through the art bull market of the 1980s. Individual paintings by McDuff

and others sold in the price range of $700.00 to about $25,000.00. The gallery moved into sales to people with huge and multiple homes. In some instances, they sold to people who purchased the paintings for investment rather than to hang in their homes.[17]

Boons don't last forever, and the busts that follow don't leave a lot in their wake. Perhaps like everything else, businesses have a life cycle like the institutions discussed in the next chapter.

3

The 1920s

The Corcoran's Successful-to-Failed Expansion

President Calvin and First Lady Grace Coolidge officially opened the new wing of the Corcoran that housed the Clark Collection. The widow of former Senator William Clark and their three daughters joined the celebration. Official Washington's notables and the gallery trustees rejoiced in the certainty that the capital city was on its way to becoming the nation's art capital.

Art critic Lelia Mechlin walked readers through the handsome galleries. The vista led to the marbled floor of the Clark wing's beautiful round room. The ascending staircase with dark wood panels led to a balcony and the Abbey painting *Trial of Queen Catherine.* Inside the round room were the masterpieces of the collection, including Titian's *Portrait in Black* and Rembrandt's *Man with Hat Holding a Scroll.*

Mechlin moved through other handsomely appointed spaces featuring different schools of painting. Finally, she observed that some of the greatest treasures appeared in another room. Drawings by Old Masters Da Vinci, Velázquez, Raphael, Rubens, and Bellini lined the walls. One wandered at will through the rooms to savor the views, imitate the drawings, or train one's own eyes to become better artists.[1]

The Clark Collection made the Corcoran Gallery of Art one of the most notable museums in the country. Clark's gift contained works that were centuries old. The original benefactor of the art gallery, Mr. William Wilson Corcoran, collected older works and was known to buy contemporary art during his lifetime. The native of Georgetown, D.C., Corcoran, made his fortune as a banker. The Southern sympathizer lived in Europe until the end of the Civil War. Through the end of his life, he donated to causes associated with the former Confederacy.

During the Civil War, the United States federal government seized the nearly completed art gallery building on Seventeenth St and Pennsylvania Avenue. It turned the space into a quartermaster general's office. The French ambassador kept Corcoran's house on the corner of Connecticut Avenue and H Street, N.W., from the same fate by claiming he rented it.

The federal government returned the building to Mr. Corcoran in September of 1869. At that point, Corcoran had collected pieces for over two decades, including contemporary works by fairly well established European and American landscape and portrait painters. Corcoran paid a trustee to continue shopping for various paintings in Europe. After Corcoran sent over pieces from his own home, the trustees opened the institution to the public in January 1874. President Ulysses

S. Grant and many distinguished members of the Cabinet and Congress attended the opening.[2]

Walking inside the door to the Renaissance-style brick building, visitors faced the full-length figure of Corcoran. From there, they began a sweeping tour of Western art history with a ground floor sculpture hall featuring replicas of the most notable pieces. Once visitors climbed the stairs, they entered the octagon room that served as the main gallery. The paintings hung one under the other, covering the walls. The variety of colors and frame styles alone offered the viewer much to see. Among the first paintings were those of Thomas Cole featuring poetical figures telling allegorical stories of hope, battle, and loss. The landscape paintings followed, showing the magnificent Niagara Falls and the serene Tamaca Palms. Then, Thomas Sully's and George Peter Alexander Healy's portraits of presidents Madison, Polk, and Abraham Lincoln came to the fore. Most notable was the marble statue *The Greek Slave* by Hiram Powers. Corcoran greeted visitors seated in a chair as they reached the last room.

By its fifth season, the Corcoran Gallery of Art received almost 100,000 visitors yearly. The institution eventually contained all of Corcoran's collection, valued at $100,000.00 (over $2 million in today's dollars). It received an endowment valued at nearly $1 million today.

And it received more art. Albert Bierstadt wanted to be in the Gallery badly enough to sell Corcoran his masterpiece, *Mount Corcoran*, for $7,000.00, half its asking price. Corcoran and the Gallery's Board considered expanding the building. The Corcoran needed to acquire the land around the building and almost built north of its current location. However, the institution could not purchase all the necessary property. Former Rear Admiral in the Union Navy Samuel Phillips Lee refused to sell his property. Corcoran died in 1888.

Despite the limited space, the Corcoran also extended the privilege of copying art pieces to learn how to paint. The trustees formalized this practice when they established the Corcoran School of Art in 1890. A small annex on the north side of the gallery housed those students who attended during the first few years.[3]

W.W. Corcoran, ca. 1880. The Corcoran Gallery of Art, one of the country's first private museums, was established in 1869 to promote art and American genius. In 2014 the works from the Corcoran Collection were distributed to institutions in Washington, D.C. (National Portrait Gallery, Smithsonian Institution, Gift from the Trustees of the Corcoran Gallery of Art [Gift of Elsia B. Carroll]).

THE CORCORAN GALLERY OF ART.

Corcoran Gallery of Art, ca. 1885 (Smithsonian Institution, Smithsonian American Art Museum, Gift of James Goode).

Space concerns and pressures increased. After three years, the trustees amassed a large enough parcel of land on New York Avenue, E Street, and Seventeenth Streets. They hired architect Ernest Flagg to design the new gallery and school building. Four years later, Flagg's building opened. Done in the era's popular *beaux-arts* style, a vast atrium with over forty limestone columns and two skylights greeted the visitor. Ahead, a grand staircase—with statues looking on as the visitor climbed—led to the upper two stories that housed seven-eight exhibition rooms to show its holdings, which now numbered over 1,800 paintings, statues, and other pieces.

These upper floors offered a great deal more space. The upstairs also contained two unique areas to display works. Hemicycle Hall served as an auditorium and a semicircle that showed student work or specific art pieces. At the far end, the Salon Dore contained intricate French decorations.

The staff and leadership of the institution began taking advantage of their additional exhibit space, arranging for more special exhibitions to appear in the museum temporarily. As noted in Chapter 1, the gallery staged annual displays promoting

contemporary Washington artists' organizations, including the Washington Water Color Club and the Capital Camera Club. The organization of the area's top professional artists of the Society of Washington Artists, initially held an annual show for local artists. Eventually, this show expanded to include some of the best oil, watercolors, and pastels from artists based around the country. Society leaders thought their shows proved so reliable and pleasing to the public that the Corcoran's leadership noticed.[4]

The popularity of these shows spurred the gallery's first director, Frederick B. McGuire, to propose that the gallery and school host a major exhibition. He wrote to the trustees that the program would be "of great advantage to the Gallery and a distinct factor in awakening public interest in it." He added, "it would prove highly beneficial to contributing artists; and at the same time, [it would be] instructive and interesting to art lovers, students, and the public at large."

The trustees supported the museum director's plan to exhibit the United States' best paintings. This first exhibition, planned for 1907, featured only oil paintings. The Corcoran staff selected a date not in conflict with the three major art exhibitions held at Carnegie Mellon University in Pittsburgh, the Penn Academy in Philadelphia, and the New York Academy in New York City. The circulars advertised that the exhibition featured three prizes of gold, silver, and bronze medals and $1,000.00, $500.00, and $250.00, respectively.

The first biennial quickly proved a critical and popular success. Each gallery received a letter from A to E to guide visitors through nearly 400 paintings. These included a small number of landscapes and a large collection of portraits, many of which, the critics noted, awakened enthusiasm and appreciation. One critic observed that "Mary Cassatt's *Woman and Child* demonstrated a beauty not always understood." The reputation spread quickly as the exhibition became nationally recognized.

The public expressed its interest. The turnouts ranged from 255 on days of paid admission to over 2,000 on free days. Over 62,000 people attended during the run of the biennial. The Corcoran purchased nine paintings for its permanent collection, and 26 paintings sold for over $50,000.00. These numbers slipped slightly during the second exhibition.[5]

By the early 1910s, the biennials began with a private evening affair. Ferns and palms lined the stairways. Official and socialite Washington always attended. Guests ranged from President Taft to art establishment members, men of commerce, and high-style figures. A string orchestra played throughout the evening. The guests mingled with the artists who served on the juries and those who won the prizes.

The jurists for each exhibition featured some of the biggest names in professional art. The Corcoran attempted to create juries that included artists from different cities. One that included Robert Henri and Edward W. Redfield forged an exhibition that contained various contemporary styles. The show reportedly pleased impressionists, post-impressionists, futurists, and even cubists. In 1917, with the work of 330 living artists on display, one critic believed the biennial opened the eyes of those who look to beautiful thoughts and beautiful things, fulfilling James M. Barrie's view of art's chief aim.

Through the 1920s, the shows continued receiving submissions from the best painters. Many of the best known received direct invitations from the Corcoran to submit a painting, while those with lesser-known names submitted for jury

consideration. As artist Carl Melchers noted, "[the Corcoran biennial is] a true cross-section of contemporary American art where every school is strongly and equally represented."[6]

Like the Carnegie exhibitions, many viewed the Corcoran shows as "conservative" in their art choices. By the mid–1920s, a local artist responded to critic Leila Mechlin, stating that the Corcoran biennials tended toward conservative styles and topics. Many of the purchases they made came decades after the heyday of the American Impressionism or the urban realism of "the Eight." The gallery purchased only a few works from the urban realist painters, often twenty years after their best works.

The overall sales of the biennials declined slightly. While sales may not have reached their all-time high of $65,000.00, the exhibitions gave individual collectors the excellent opportunity to enrich their collections. Among the regular purchasers were one-time Assistant Secretary of the Treasury and Vice President of Riggs National Bank Milton E. Ailes, former Congressman and business magnate Joseph H. Himes, and steel heir Duncan Phillips.[7]

The men often purchased single paintings, usually by artists from Philadelphia and New York rather than Washington. Ailes came to the city as a teenager and took a messenger post at the Treasury Department while getting his law degree during the 1880s. Considered both gifted and big-hearted, he moved through the Department ranks and eventually served as a top executive at Riggs Bank. He served on many public committees while engaging in fishing at his summer home in West Virginia. He died from acute indigestion in that home at 58 years old.

Himes began a career in the city as a Congressman representing Canton, Ohio. After an unsuccessful re-election bid, he became a D.C. resident. He made a fortune as a businessman and in real estate. His most significant activity was as founder, president, and chairman of the Board of Directors of Group Hospitalization, Inc. Himes lived to 75, dying in September 1960. Duncan Phillips collected significantly more often than the other two. He appears in the next chapter.[8]

The public continued to attend the events, with attendance figures around 60,000. Notables from most walks of life continued to come, and the public also received the chance to offer a referendum on the art. Visitors voted for the painting they considered best, and the artist received a $200.00 prize. One local critic observed that "the public usually picked a decidedly different piece than the judges, but their selections were often solid."

The biennials increased the visibility of the Corcoran and represented a boon to its reputation as an institution. As a result, some relevant art owners decided to leave paintings to the Corcoran in their wills. Diplomat Henry White sent his art to the Corcoran Art Gallery upon the death of his son. James Parmalee of Washington donated two marine paintings by Albert P. Ryder. Ten years later, he donated more from his collection. People outside Washington also donated. Two Robert Blum paintings arrived after the death of Flora de Stephano Mullins of Boston in the early 1930s.

All these circumstances enabled the leadership of the Corcoran to create a notable art gallery. By the 1930s, the Corcoran Gallery's collection was extensive enough to allow visitors to trace much of American art's early history. The six galleries on the upper level received the designation of a "Retrospective Collection of American Paintings." The Corcoran offered this unique opportunity to Washington's artists and its art students.[9]

In 1925, the Corcoran's notable reputation warranted holding the centennial exhibition celebrating New York's National Academy of Design. The oldest and largest art membership group, the Academy held an established position in the art world. The local newspapers called the celebration one of the most notable events in art history. The Committee from the Academy came down to begin to design the exhibition. Plans for wall space included showing over 500 painters from 46 states and 13 foreign countries. Just as the planning began, New York art critic Forbes Watson launched a tirade against the show and the Corcoran Gallery for hosting the exhibition. His *The Arts* editorial blasted the Academy's members' type of work and questioned why the Corcoran's leadership capitulated to the National.

Mechlin saw the controversy as part of a long war in which new groups dislike establishment artwork. She claimed the Corcoran showed some modern art, even if the public may not admire or understand the works. Mechlin and the Post's critic Ada Rainey expressed disdain for the "intolerance" of the modernists. Rainey suggested that the Corcoran show a broader range, arguing that Washington benefitted by having an exhibition of modern art. Local artist Eben F. Comino seconded the suggestion. He observed that the Corcoran's exhibitions tended to be conservative.

Weeks later, the Washington Landscape Club held its annual show at the Corcoran. Rainey noted that it was a relatively conservative show, "But the canvasses were representative of the feeling shown by a large number of Washington people who enjoy pictures." While agreeing with Mechlin's sentiment regarding Corcoran attendees' tastes, Rainey noted that the Corcoran designed its exhibitions and the biennials to extend beyond the Clubwomen and their husbands' preferences.[10]

Several of the artists who won accolades at the various biennials also taught at the Corcoran school. The faculty included five teachers and administrators in total, with one female instructor. By its tenth year of operation, the staff remained the same size, but the Corcoran School of Art's student body had grown from 75 to 250 students. Courses focused on portrait, life class, still life, draped life, composition, and the antiques, with sculpture added in the late 1920s.

The diminutively statured Bertha Eversfield Perrie taught watercolor courses at the Corcoran during the first two decades of the 20th century. Born in Washington, D.C., Miss Perrie began painting at a very young age. At 20, she took classes and taught at the Art Students League. She moved to the Corcoran School and taught many students, including Susan Brown Chase and Kimon Nicholaides, Jr.

With a style that incorporated aspects of both realism and Impressionism, Perrie became one of the few female exhibitors at the 1893 World's Columbian Exposition in Chicago. She also showed in the academy exhibitions in New York City and Philadelphia. A member of all the Washington arts groups, Miss Perrie regularly won awards, including Corcoran prizes. Critic Leila Mechlin observed that Perrie's good work contained frank veracity. Her pieces became great when she added a reserved sentiment. Perrie had three artworks in the SAAM collection.

During the summer months, Perrie went to an arts colony in Gloucester, Massachusetts. She spent her time with other artists and benefactors such as William and Emiline Atwood. They hired architect Ralph Adams Cram to design "Gallery on the Moors," the picturesque studio where the artists showed their works. Perrie showed during the summer of 1920, along with 75 paintings, 14 sculptures, and etchings. Miss Perrie died the next year in Gloucester.[11]

A second proficient female artist taught with Perrie. Born to a Virginia aristocratic family after the Civil War, Catharine Crichter seemed a determined child. "Ever since I can remember, I wanted to draw and paint," she said years later. At Cooper Union and the Corcoran School, she trained in the neo-classical tradition of portraiture.

In her mid–20s, Crichter traveled to France, started an art course, and provided tourist services to bolster her income. Upon returning in 1901, Crichter became the Corcoran's Director of the Portrait Department. Her work incorporated European painters' symbolism and abstractions, moving beyond its initial "dark but pleasing stage." Using a rich color scheme, she more effectively expressed her fascination with people. According to Taos Art Museum Director V. Susan Fisher, "Catharine captured an outside likeness that she used as a portal to the inside of a subject's inner-lying nature."

Ever adventurous, Miss Crichter left the Corcoran and started her art school in Washington at St. Matthew's Court. Called The School of Painting and Applied Arts, students received either one or two years of instruction in fine or applied arts. Crichter saw paintings of the Taos Art Society and traveled to New Mexico. Within two years, she became the only woman

Bertha Perrie, etching of William S. McPherson (Smithsonian American Art Museum, Transfer from the Library of the Smithsonian American Art Museum and the National Portrait Gallery, Smithsonian Institution).

accepted in Taos' art community. Over the next two decades, Taos became her summer home away from Washington and her school. "Taos is unlike any place God ever made, I believe, and therein is its charm, and no place could be more conducive to work; there are models galore and no phones."

After retiring at aged 72, she maintained her studio in the luxurious section south of Dupont Circle and continued painting for several years. Crichter's works appeared in museums ranging from the Taos Art Museum to the Museum of the Southwest. Adolph Gottlieb donated Crichter's painting *Indian Women Making Pottery* to SAAM.[12]

A mixture of facts and urban lore surrounds the managing of the Corcoran School's curriculum. Reportedly, the school expelled students involved with a selection from the Armory show after its 1916 exhibition in Washington. Principal Edmund Clarence Messer's comments to the students two years earlier make this seem likely to have occurred. Messer decried the existence of the bizarre and wanton

in art, linked them to current-day fashion. "I wish art to have it standards—standards of quality, or beauty, of rightness." The Armory Show of 1913 went about proving that art did not have to be beautiful to be good.

His speech revealed that Messer might have been more of the philosophizer about art than his friend Richard Brooke. But the pair shared a common perspective: art needed to be beautiful and had to be guarded against its corruption, whether by viewers or artists. When selected as the Corcoran School's principal, Corcoran trustees knew of Messer's executive ability with the Art Club School, which he started with Brooke in the mid–1880s.

Tall and lean, Messer grew up in Minnesota. He joined a regiment during the Civil War, but ill-health restricted his service to three months. Messer began art training in Peter Baumgras' Washington, D.C. studio in 1863, then, over the next few years, trained in New York, Philadelphia, Chicago, and Paris.

By his mid–30s, Messer had settled in Washington. He married his wife Emma and assumed a leadership positions in the fledgling Society of Washington Artists. Like Weyl, Moser, and Brooke, Messer helped make the organization a significant success. He also profited from being a D.C. artist by getting commissions to paint portraits of government leaders such as John Powell. Generally a landscape painter, Messer taught several successful artists, some of whom joined the Society of Washington Artists during the late 1920s and through the 1930s. Messer retired from the Corcoran School in 1918. Many hoped that he had more time to paint than he had over the previous fifteen years. He and his wife moved in with their daughter, who taught art in rural Wisconsin. Messer died in February 1919 at 77.[13]

Another story insisted that the school banned students from using the word *Impressionism* during the 1930s. Although there may have been a few hardcore Realists or academicians who banned the word in their presence, other instructors used the style. We know teacher Bertha E. Perrie incorporated Impressionism in her art. Edmund C. Tarbell, the Corcoran's principal

Edmund Messer's portrait of John Powell (National Portrait Gallery, Smithsonian Institution, transfer from the Smithsonian American Art Museum, Gift of Mrs. John Wesley Powell, 1906).

in the 1920s, was a well-known American Impressionist. Tarbell argued that students needed to know specific laws in art but not accept them as restrictions.

The Corcoran School of Art and Gallery drew artists with more eclectic styles in the post–World War II years—including notable names from the local arts community like Gene Davis. It also gained instructors from other schools, such as William Christenberry. A few emerged from the student ranks, including Ed McGowin and Bill Newman. A few former students recalled that teachers had affinities for individual students. "The teachers floated around and would sometimes talk to you. Inside the Corcoran-Dupont Circle, each student had their own space, and sometimes it felt like you could teach yourself."

During the hippie years, the Corcoran had few boundaries or restrictions. The students often escaped to the roof and had sex all day long. The Corcoran's proximity to the White House required surveillance. "It doesn't concern us, except that it's distracting our Secret Service men," a speechwriter for Richard Nixon told gallery director Walter Hopps. Hopps gathered the students and informed them. "It seems you do not have any exhibitionists," the speechwriter noted days later. Activities continued. Faculty members had affairs with students. Artists made love in the rafters. Even administrators had affairs and quickies in the first-floor bathroom.

Bill Newman grew up nearby, in Bethesda, Maryland. His family wanted him to become a doctor. Bill took art courses while pursuing a pre-med curriculum, and the very positive comments he received from the instructors built up his confidence. He decided to go to the Maryland Institute of Art. When he entered, he said it felt like heaven.

After graduating, he worked for a year in the Corcoran's bookstore and learned a lot about art materials, ranging from brushes to pencils. The shop also provided the opportunity to meet students and faculty. He pursued a master's degree at the University of Maryland, where Bob Stackhouse, Tom Green, and Bill Dutter also attended. He taught weekend courses at Corcoran and became friends with the teachers, including Gene Davis and Roy Slade. He joined the Corcoran as a full-time teacher. His load consisted of two regular classes and one on weekends. "Teaching was so easy and spontaneous. I was having a good time—so would have every other minute to paint and draw."

Newman met one student, and they had a ten-year relationship. A huge nude picture of his student girlfriend graced the barricade fronting a construction site at 17th and G Streets. Turner Construction Company and General Services Administration (GSA) initially hired Corcoran artists to paint animals on it. But GSA okayed the change if the public didn't pass the site. The GSA received 400 complaints, mostly from angry women, and elected to take it down. Administrator Arthur F. Sampson "thought it was inappropriate for the GSA to be involved in this type of art." However, a Christmas-themed painting of Sarah appeared at an 18th and H Streets, N.W. construction site. Both pictures appeared in an auction to raise money for the school.

Two months later, Sarah informed the media that she found revenge. At an 18th Street and Pennsylvania Avenue construction site, all saw Newman's face superimposed on a Corcoran Gallery statue's torso. "It's a striking resemblance," said the blushing Bill. One cleaning woman passing by said, "the drawing is good because people would find out about 'that sort of thing' sooner or later." Reporter Henry Tenenbaum placed a fig leaf over the male genitalia. The D.C. police removed the statue because the artist lacked the proper permits.

A few years later, the Republican National Committee commissioned Newman to create a large-scale Ronald Reagan image. It appeared on buttons and banners at the National Convention in 1980. One staffer discovered Sarah's story, and the RNC rescinded the commission.[14]

Newman created paintings and drawings with slight surrealist and observational touches. Gallery K's owner Marc Moyens and later Komi Wachi liked his work, and he joined their gallery during the mid–1970s. His work sold very well to the gallery's collector base of wealthy lawyers and doctors during the first several years. Gallery K also served as a focal point for artists. They specialized in local and out-of-town artists who made exceptional surreal and narrative imagery with an untrained style edge. As artist Sidney Lawrence remembered, "They [Moyens and Komi] weren't tied to following the art market trends. They knew what they liked and would show it." Moyens had an extensive collection of Haitian art. By the early 1980s, Newman moved on to David Adamson Gallery. "We got tired of each other," Bill joked. The age difference between himself and Moyens meant both hung around the art scene doing drugs, but Moyens went out to the bars less than Bill and his gang.

Newman began creating digital works. His friend, Corcoran professor David Adamson, also worked with computers. He became well-known as an excellent printer, doing work for artists like Chuck Close and Annie Liebowitz. Newman and Adamson purchased their first Mac in the vacuum cleaning department in Hecht's Department Store. Apple saw its digital work and sent the Corcoran ten computers in 1984 to use in its classes. The pair continually purchased upgrades of printers to refine their art. "For me, the computer revolutionizes the capacity to produce images.... With a computer, I can produce a thousand images a year with the same integrity and workmanship."

After becoming the chairman of the school's drawing and painting department in the mid–1980s, Newman expanded his computer work. His portraits stretched to the point where they were recognizable as humans only from a steep angle. Head-on, they become substantial abstractions in black and white, and looking at them for a time only added to their mystery. To critic Michael Welzenbach, the images seemed to reveal more of their subjects' characters. A decade later, critic Jo Ann Lewis indicated that she liked some of his self-portraits merged with photographs of an animal or relative. "Newman is at his best when he's up to no good—meaning stretching boundaries."[15]

New courses and programs in interior design, art history, and acting and video brought more students and instructors. The additional programs created enormous pressures for space. The Corcoran reportedly had a chance to acquire the block around its building for $50,000.00 in the late 1960s, but the board turned it down due to a lack of money.

The Corcoran school looked to branch out in the downtown area and into Howard County, Maryland. Some talk swirled about separating the school from the gallery. By the 1980s, the Corcoran awarded four-year bachelor's degrees. Some of the notable alumni were David Keith Lynch, Nan Hoover, Tara Donovan, and Tim Gunn.[16]

Based in the same building, the Corcoran gallery faced the same space limitations as the school. Changes in the art world following World War II brought additional pressures. New galleries and museums opened in the D.C. area. Painting and

sculpture adopted a broader range of styles, and other art forms soon emerged or gained respectability. How would the gallery remain relevant and adapt its biennial to these circumstances?

Critic Jane Watson thought the biennial had not regained full stride. Despite showing over 300 paintings and including more abstraction than usual, the late 1940s show had few pioneers and felt serious and restrained. A decade later, a biennial devoted to past biennials received a critical lambasting. The room dedicated to the past first-prize winners "is a carnival of blunders, with a mawkish midway of May nights, Vermont farms, summer landscapes, saccharine children, and pensive bourgeois maidens contemplating virtue." He described the current paintings as static and thin, critiquing the present jurors, including Corcoran gallery director Herman Walker Williams, Jr.

The gallery director altered the approach to the biennial in the early 1960s. The kaleidoscopic nature of the exhibition disappeared. Williams went to Boston, Washington, and New York dealers and selected paintings, choosing 118 placed directly into the show. Artists sent in 4,000 submissions, from which the jury selected 27 paintings. With 145 works from abstract expressionist to surrealism on the walls, the 1963 exhibition sold well. For the first time, the Ford Foundation purchased 16 pieces from the show. Ahlander thought the best gallery contained the colorists, featuring Noland.[17]

With the director or guest curator making the selections over the next decades, the biennial captured some contemporary painting styles. Sometimes contemporary figurative seemed underrepresented; at other times one kind of abstraction seemed fewer in number. Some biennials featured only five well-known artists, or only artists born in the American West participated.

By the 1990s, critics described the biennials as individual solo shows of the invited artists rather than thematically coherent. This method became particularly true when the biennials expanded to accept new media art forms in the 2000s. However, in 2005, the 15-artist show, "Closer to Home," proved "strikingly [different] from its technically oriented recent predecessors of 2001 and 2003," according to critic Joanna Shaw-Eagle. She also appreciated the playful imagination evident in the more traditional paintings.

Tensions among the Corcoran leadership and even the juries caused postponements of the shows. Disagreement among juries at individual biennials kept the Corcoran from purchasing for four consecutive shows.[18] Internal struggles flared up in other locations within the Corcoran. Since the mid–1960s, the gallery had struggled with its financial health. The trustees established a chief administrative officer over both the gallery and the school. This person reportedly handled administrative and fundraising duties. In practice, the new structure spurred more friction between the administrator and the gallery director. Despite this tension, new gallery director James Harithas and the director of special programs Walter Hopps led the Corcoran into an innovative era.

The Corcoran opened three shows in one night for the fall 1967 season. The recent acquisitions show featured both sculptures and paintings from the 19th and 20th centuries. The second show of 70 Uruguayan paintings appeared in conjunction with the Organization of American States (OAS) meeting. The contemporary show included sculptures from Barnett Newman, Tony Smith, and Ronald Bladen.

The gallery noted that this was the first time any museum commissioned three major artists to design works for specific museum spaces. Benjamin Forgey called the works stimulating and position-taking. Barnett's *Broken Obelisk*, stationed on the lawn near New York Avenue, worked both as a commentary on the Washington Monument and as a monumental sculpture in its own right. Richard observed that these pieces were enormous, and each piece generated haunting and monumental spaces not there before. *Time* featured the exhibition on one of its covers.

Other shows proved notable and kept up this momentum into contemporary work. A David Smith show preceded an extensive exhibition called "Gilliam, Krebs, McGowin." The exhibition of these three Washington-based artists engendered warm feelings from artists and viewers and critical support. It remained etched in one critic's mind as illustrative of where Washington art could go. While McGowin went to New York, Gilliam and Krebs remained vibrant players on the local scene and continued advocating on behalf of the local artists to the Corcoran.

Over the next few years, the gallery continued featuring local artists in shows. Many of the artists shown in solo exhibits in the Hemicycle had established names in the region. A few, such as William Christenberry and Frank Write, were teachers at the Corcoran school. Others, including Alma Thomas, Leon Berkowitz, and Ed Love, had shown in regional and New York City galleries.

But Harithas and Chapman remained at odds, and Harithas thought Chapman's new organizational structure undercut his power. Unable to find a solution, Harithas resigned. The Corcoran lost a strong advocate for contemporary and local artists. Barnett Newman soon returned to the gallery dressed in a white straw hat and sandals to reclaim his Broken Obelisk sculpture. The gallery's last-minute offer of $150,000.00 for the piece drew a curt negative response from Newman. "You can say that I'm personally very unhappy with the departure [of Harithas]," he stated. For many, the piece's disappearance felt like removing the Corcoran's outreach to the contemporary art world.

The new administration increased the number of staff. Many worked at trying to generate more donations. Indeed, the gallery nearly doubled its attendance in the five years between 1967 and 1971. However, the costs of exhibitions and staffing resulted in an operational deficit. Then, problems arose from years of neglecting the physical plant. The building's inadequate heating and cooling systems led insurance companies to refuse to cover the art. The Gallery lent 38 paintings, worth about $750,000.00, to the National Collection of Fine Arts to keep them insured. The restoration of things to minimum standards cost $50,000.00. More detailed work generated estimates in the range of $1.5 to 5 million.[19]

After the first financial officer departed, the trustees asked Washingtonian Vincent Melzac to assume the position temporarily. Melzac made his fortune as the owner of charm schools for girls during the 1950s and 1960s. He collected contemporary art and served on the board of the short-lived Washington Gallery of Modern Art. A dynamic figure, he brought business principles and cuts to the Corcoran to close its large deficit.

Melzac and gallery director Hopps argued over a variety of issues. Melzac tried to shut down two of Hopps' special programs. Artists Lou and Di Stovall ran a community outreach workshop and established D.C. as a silkscreen printmaking haven from the Corcoran's Dupont Circle townhouse. Melzac brought in a new person to

manage with the Stovalls. "Melzac was a control freak," the Stovalls asserted years later. The Stovalls left; the new head failed to generate the same community interest. Melzac declared the workshop a success and strong enough to function without the Corcoran support. Indeed, the Stovalls continued their business in the Philip and Helen "Leni" Stern residence on S Street, N. W., which reminded visitors of an Italian country house with its Palladian style. The Stovalls eventually ventured off to start a shop in the Cathedral Heights area of D.C. in the 1980s that proved very successful.

The Sterns long supported Washington-based artists. While Helen was an artist with a trained eye, she thought her husband had an intuitive grasp of art. The former publisher, author, and lawyer, "a liberal's liberal," supported many social justice causes. He gently mocked his "eye" for modern works, yet the couple's collection featured Washington-based artists Lou and Di Stovalls, Kenneth Noland, Howard Mehring, Sam Gilliam, Anne Truitt, Rockne Krebs, and Franklin White. The Sterns provided fellowships for the Corcoran that subsidized Stovall, Sam Gilliam, and Rockne Krebs artmaking. Other beneficiaries included other local artists, the photographer Mark Power and sculptor Anne Truitt. Melzac undercut this operation, too.

Hopps took a short-term position to run the American contribution to the Venice Biennale. Melzac hired poet and art critic Gene Baro as the Corcoran art gallery's temporary director. A noted traveler and artistic circles member worldwide, most found Baro an easygoing and friendly man. Forgey observed that Baro prepared several exhibitions and otherwise hit the ground running, making Forgey think Melzac strongly supported Baro. Shortly after that, Hopps resigned, and Baro permanently assumed the position.

The pair joined a few hundred guests at the opening of five new shows in the gallery. Baro walked upstairs to the gallery, thinking he and artist Sally Drummond were next for photographs. After waiting several minutes with others who came to observe the photo shoot, Baro returned downstairs and discovered Drummond's pose with Melzac and his wife. The director remarked to Melzac not to rehire the photographer because he was "too exclusive" in his subject matter before walking away.

A half-hour later, Melzac approached Baro and accused him of being in an alcoholic rage and using abusive language in front of his wife. When Melzac grabbed Baro by his lapels, Baro gestured with his arms. Melzac punched; the first blow generated a black eye; the second, a gash on Baro's left cheek. Baro disliked violence, so failed to retaliate.

Throughout November, the pair recounted their version of the fight to the board of trustees. The board requested their resignations, but a few members tried to get the pair to accept a compromise that might keep both. Neither budged. The board accepted their resignations and appointed Roy Slade as the temporary gallery director. Melzac donated his notable art collection to the Smithsonian.[20]

Stability in leadership proved challenging to obtain. The Corcoran found itself hiring again in five years, in the early 1980s and in the late 1980s. These changes partially occurred because of differences between the board of trustees and the executives. Director Michael Botwinick noted that the trustees ran 17 standing committees, expressing independent views of the gallery.[21]

The exhibit of local artists proved another contentious subject. During the mid–1940s, the Corcoran's director established the area exhibition featuring selections

of work from various Washington artists. This chance to display one's works in the Hemicycle or small gallery room proved a great opportunity that artists had in only a few U.S. cities

Under the rules for entry, any local artist paid $2.00 and submitted art for consideration. A jury weeded through each of these works and decided what to exhibit. During the early 1950s, these juries included notable New York artists, including Alexander Archipenko, Phillip Evergood, David Smith, and Andrew Wyeth. The gallery hung the selected works in the Hemicycle for a month. Soon the structure of the exhibition worked against it. Artists previously in the show or who had an established name wanted to avoid possible rejection. Many of these artists stopped submitting work for inclusion in the show.[22]

By the mid–1960s, the area exhibitions so frustrated Hermann Williams, Jr., that he carefully examined the 17th Area Exhibition's selections. He added this comment to the catalog. "If the 18th Area Exhibition, scheduled for 1967, does not dramatically improve in quality, it may well be the concluding exhibition in the series." Williams attempted to improve the 1967 show's quality by directly appealing to artists. Unfortunately, he and the critics disliked the 18th Area Exhibition, and the Corcoran trustees allowed him to discontinue the show. Curiously, most readers who visited the exhibition disagreed with the assessment.

That decision might have made sense from the Corcoran's perspective. Reviewing the works of many artists cost a lot of money. As already noted, the Gallery faced considerable financial difficulties during the early 1970s. The Corcoran needed shows that didn't require a great deal of money and guaranteed crowds.[23]

The lack of an area exhibition frustrated and disappointed many Washington artists. Despite the rise in the number of galleries in the city, many artists remained unshown. They viewed the area exhibitions as an art salon and the most important show of local art. Director Roy Slade announced that the Corcoran would hold the show every two years. He felt excited over the 3,400 works submitted for consideration in the 19th annual show in 1974. However, he was not always pleased. One woman called and asked if she could submit a drawing of her dead cat. "Madame, how long has it been dead?" Slade replied. In all, 179 pieces made it to the big walls.[24]

This new set of area exhibitions took a thematic approach. Each show focused on a single medium. In 1976, it was photography, and, in 1978, sculpture. Juror Los Angeles County Museum curator Maurice Tuchman felt amazed over Washington's tremendous sculptors. The critics agreed, noting that erudite artists created most of the work, which appeared well in tune with, if not ahead of, their time. Nade Haley won the first prize in the show. One participant whose work received positive critical notice said he was happy his friend won. "Everybody was gearing up to try and win next year, and then there was no exhibition the next year," observed sculptor Jim Sanborn.

The next exhibition featured drawings and prints. William S. Leiberman, the chairman of 20th-century art at the Metropolitan Museum of Art in New York, juried the show. He rejected over 1,300 of 1,400 submissions, observing that few Washington artists he knew submitted.[25]

Local artists expressed frustration over the area exhibitions' process. They met new Corcoran director Peter Marzio during the summer of 1981, seeking change. Several felt angered, and one leader, painter Sam Gilliam, called Marzio "a turkey."

The leaders tried a different method for the area exhibition in 1982. Called "Ten plus Ten plus Ten," the curatorial staff selected ten painters who invited ten painters into the show, who asked a final ten painters to exhibit. Jane Livingston conceived the show as built on the peer principle.

This exhibition allowed viewers to see 90 works by 30 artists and perhaps discover specific networks of artists in the city. Most of the artists who appeared in the show were little known or beginning to emerge in the city's gallery scene. Jo Ann Lewis said, "[The show was] revealing and provocative even though some of the artists are not up to the challenge posed by their peers."[26]

The Corcoran's new director, Michael Botwinick, invited local artists in for a chat. The meeting became a routine throughout 1983 as the groups tried to maintain a positive relationship. As Botwinick noted, "[The two groups had] 'sometimes a difficult relationship.'" They established a subcommittee to plan the next area exhibition. The artists wanted a significant and inclusive show.

Six people chose the show: three from the artists and three selected by the gallery. At first, word got out that the committee looked at everything. They received submissions from 840 local artists. This understanding turned out to be not quite an accurate assessment of the selection process. Of the 80 artists selected, one-third went directly into the exhibition without going through the jury process. Additionally, one group of the remaining artists chosen showed in a corner gallery space. Both circumstances went over poorly with many local artists. Some who had received rejection notices felt they had "been had," and several notables withdrew from the show.

The Washington show in 1985 featured 79 artists who, Richard quipped, worked in almost as many media. On opening night, inclusion sometimes failed to translate into approval. "I can't believe he's in the show," one well-dressed woman loudly said to another. "I know," hissed her confidant as both turned to watch the artist get a drink at the bar.

One of the local artist jurors noted, "The intent of the show was to take a broad look at what was out there.... And I think I can say at this moment that it's very healthy." It included paintings, sculptures, and photographs. Dressed in his "disguise" of a three-piece suit with watch chain and tie, artist Fred Folsom observed, "I haven't seen this much animation and controversy and good genuine smiles and venom in a long time." In front of his large, brightly colored canvas, Allen D. Carter smiled, "This is the first time I get to see my painting outside of my apartment."

While joyous for some participants, the event left local critics wanting. Pamela Kessler and Mary Battiata noted that there were first-rate paintings and impressive sculptures. However, many artists were missing. More significantly, Richard observed that the exhibition lacked a theme and looked like a committee made the selections. The show hung awkwardly, and there appeared to be an odd choice of pieces from some of the well-known artists. That spurred the suspicion that the committee selected the artists rather than the objects.[27]

An alternative exhibition took over an office building on Ninth Street. The "All Washington Show" filled six floors of the building with the works of artists rejected from the Corcoran Washington exhibition who were willing to pay a $25.00 entry fee. Some of these artists joined because they felt robbed by the Corcoran jurors' selection process. Others joined the exhibition in sympathy. Richard noted that hung on many of the walls were "clown pictures and hobby art." However, "its best art is as

vital as much being shown now at the Corcoran." He singled out the creations of a few new artists, including Richard L. Dana.

The 1985 show became the last of the local shows until the Corcoran changed gallery directors again, half a decade later. The Corcoran put on many other exhibitions and presented a wide variety of meaningful art for Washington's artists to see. The shows featured historical art, art from other countries, and significant contemporary artists as well. Over the years, the Corcoran showed artists from all over Latin America and Europe and significant contemporary artists, including Yves Tanguy and Romare Bearden.[28]

During the late 1970s and early 1980s, the Corcoran averaged around 25 exhibitions every year. Under the last year of Marzio's directorship, the Corcoran held 29 shows. Even though ten of the displays featured selections from the permanent collection and one comprised the work of Corcoran students, critic Paul Richard called the building lively. Five years later, the Corcoran's staff of 42 people hung only 13 scheduled exhibitions. The Corcoran schools' faculty and students went without a public show there for four years.

Dr. Christina Orr-Cahal became the Corcoran executive officer. The staff staged a dozen shows and a traveling exhibition of Robert Mapplethorpe's photographs that opened in the summer. Stirred by Republicans Jesse Helms from North Carolina and Alphonse D'Amato of New York, over two dozen Senators raised hell about the National Endowment for the Arts (NEA) indirectly funding a few works of art that they found offensive. They planned to grill the NEA's acting chairman. NEA staff and art activists worried that these Senators would take away the agency's funds.

The Corcoran board's committee on collections met. Chief curator Jane Livingston, who had arranged the show and the NEA grant, explained to Orr-Cahal and the members her perspective on the exhibition. The committee members voted unanimously to put on the Mapplethorpe exhibition. They placed the "X-rated materials" in a separate space. Corcoran school instructors and the entire D.C. art world received their invitations to the opening.

Some Congresspersons sent a letter to the Corcoran condemning the exhibition and how the NEA spent taxpayers' money. Less than a week later, the Corcoran gallery announced the exhibit's cancellation. The Corcoran board's life trustees overturned the earlier decision, saying they could not support holding the exhibit. Orr-Cahal said, "we really felt that this exhibit was at the wrong place at the wrong time." Concerned with the political climate, the "lifers" feared damaging the NEA's funding of artists and museums, including itself. They also felt practical concerns about the possibility of having funding the gallery received through the Fine Arts Commission cut.

Pressure from the federal city felt more intense inside the nation's capital. However, the decision put the Corcoran in the brewing political debate rather than avoiding it. Most staff expressed surprise and disgust. Ms. Livingston resigned from her curatorial and associate director positions with the Corcoran.[29]

The art world reacted fast and furiously. "I'm astounded…. I would not have voted for the grant if I had known its content. But I think once the money is given, and the show is held, to cancel it is … an enormous insult to the art and the art world," said Jacob Neusner, a member of the National Council on the Arts that advises the NEA. "I'm appalled," said fellow Washington art group director Jock Reynolds of the Washington Project for the Arts (WPA).

Many Washington–based artists called each other in outrage. Bill Wooby led a group of twenty artists and gay-lesbian leaders who met to discuss protesting. Andrea Pollan suggested that they project the images from Mapplethorpe onto the Corcoran building, known as the "Curatorial Intervention." After the group got the slides and turned them into transparencies for projection, Rockne Krebs ran the projections. Several hundred people attended the protest, which appeared on news programs worldwide.

The Corcoran received some support from local and national conservatives. For them, the cancellation exhibited good taste and political sense. They thought holding the exhibition would have spurred more uproar over the government funding of art. Columnist James J. Kirkpatrick, of *60 Minutes'* "Point/Counterpoint" fame (see *Saturday Night Live*'s parody by Dan Aykroyd and Jane Curtin) called the decision an act of political prudence and intellectual courage.

This concern proved central to the Corcoran leadership's thoughts. Corcoran board chairman Kreeger and its president Freeborn G. Jewett, Jr., wrote that the exhibition could be so inflammatory and provocative to invite consequences that negated its educational and aesthetic value under the current circumstances. The members feared that the show could have damaged the Corcoran, the NEA, and the greater arts community. A board member stated years later, "When you are caught between a rock and a hard place, select the moral position."

Meanwhile, the Washington Project for the Arts (WPA) brought the Mapplethorpe exhibition over to its building on Seventh Street, N.W. Gilbert's wife, WPA board member Ann Kinney, observed that she found some of the exhibit images "in extremely bad taste." However, "WPA is an organization dedicated to shows that are really selected by artists The artists on Board very much wanted to present the show at WPA and as a board member I support their prerogative to do so."[30]

The exhibition at the WPA received rave reviews from art critics. Since the majority of the photographs showed flowers and portraits, these filled the main gallery spaces. The S&M photographs appeared in a "blue room" at the rear of the upstairs gallery. The WPA gained respect and admiration from local and national art communities for successfully showing the exhibition.

Corcoran's board members, including David Kreeger and Gilbert Kinney, underplayed the decision's potential effects on the Corcoran's reputation and future finances. The Corcoran faced an artist boycott and audience backlash. Over a dozen artists scheduled to show in exhibitions at the Corcoran moved to deny the institution the ability to show their work. Two shows of contemporary art disappeared, and a third potentially faced the same fate. Christina Orr-Cahill said, "we are very unhappy with the artists' decisions to withdraw. We would hope they would recognize that we were confronted with an impossible decision." Few in the art communities saw the situation in that way. Two months later, the Corcoran issued a statement expressing "regret" for offending arts community members with their decision.

Neither this statement nor subsequent efforts to incorporate the public defused the situation for the Corcoran. Dr. Orr-Cahill resigned, and the board trimmed its membership and unwieldy structure. The financial situation for the institution grew worse. The board decided to sell the parking lot behind the museum to cover deficits and perhaps put a little more money into the endowment, which had only $10 million.[31]

Meanwhile, the school suffered very low enrollment in the early 1990s. Part of the issue was that they couldn't expand and had to charge a lot. According to Bill Newman, the leadership was disorganized because they didn't approach their students for fundraising. "Plenty of people who would have donated money. The open program courses in the evening had billionaire students and ambassadors," Newman opined in an interview years later. Corcoran instructor and artist Judith (Judy) Southerland expressed less confidence than her colleague and friend. The school offered fewer classes, which had the effect of reducing her schedule. "It was the hardest job in the world. They couldn't grow the school so it couldn't pay for itself. The physical plant was too small."

The Corcoran hired David Levy to oversee both institutions, and he brought Samuel Hoi in from Parsons to be the school's new dean. The pair quickly increased the continuing-education enrollment by nearly 40 percent. Levy and staff spruced up the café and galleries inside the building. Levy knew the institution needed a solid financial footing. As the Corcoran's Vice President for External Affairs Susan Rosenbaum explained, "I had lunch with everyone in the city." The checks that came from these meals stabilized the Corcoran throughout the 1990s. The endowment nearly increased threefold to $22 million.

The donors willingly contributed to the revitalized Corcoran gallery as well. Olga Hirshhorn twice generously donated several hundred works of American and European modern and contemporary art. Washington, D.C., collector and gallerist Thurlow Evans Tibbs, Jr., gifted thirty works by twenty-eight African American artists. He established a notable archive and library intended to aid scholarship on American and African American art, too.[32]

Washington-based artists also benefited directly from the increased patronage that the Corcoran received and the types of exhibits that the gallery showed. Mrs. Evelyn Stefansson Nef liked the Corcoran's "Still Working" exhibition enough to give gallery Director David Levy a check for $350,000.00 to seed a $2 million "Still Working" endowment. The Corcoran tracked down under-recognized, over-60, out-of-the-mainstream Washington-based artists to exhibit their art.

A Cynthia Littlefield show featured paintings of the U.S. Southwest that she painted in her U Street studio. A petite woman with a coil of white hair, Littlefield observed, "I love D.C. I'm just one of those people." Other artists shown over the next several years included Samuel Bookatz, Elaine Kurtz, and Jack Boul, who, Richard noted, created small monotypes that still retailed for about $500, inexpensive for good art.

The patron lived a fascinating life herself, with many lovers and husbands in her life. Mrs. Stefansson Nef became a part of the cultural life of Greenwich Village, New York. She fell for puppeteer Bill Baird, joined his show, and became an entertainer who recalled 1,000 songs.

While a puppeteer and mistress of ceremonies for the French Casino, she met polar explorer Vilhjalmur Stefansson. He offered her a job as a librarian and researcher at the Stefansson Library, and they married despite their 35-year age difference. Mrs. Stefansson Nef immersed herself in arctic studies and taught a seminar on the arctic when the library moved to Dartmouth.

After her husband's death, Mrs. Stefansson Nef took a job at the American Sociological Association's headquarters in Washington, D.C. In 1964, she met John

Nef, an economic historian and University of Chicago professor, and they married. Mr. Nef headed a program that brought artists, writers, and other thinkers in contact with doctoral students. The pair collected modern art from Picasso to Chagall and enjoyed a great friendship with the latter.

After a few years of being a highly successful homemaker, she found herself depressed and started therapy in New York City. Eventually, she enjoyed a successful practice as a psychotherapist into her late 70s until an insurer refused to underwrite her practice because she lacked a college degree. She served on the boards of many of the city's notable cultural institutions and wrote an autobiography. She died in 2009 at 96 years old.[33]

By the close of the millennium, the Corcoran had mounted about 200 shows during Levy's leadership. As Levy explained, the Gallery held two kinds of shows, one for the scholarly audience and one for the popular audience. The strategy enabled the Corcoran to expand annual attendance to nearly one million, while membership grew by almost 500 percent. Shows, such as Dale Chihuly's "Seaforms," received critical praise, while several earned ferocious pans. Blake Gopnik argued that the former first lady's dresses shown in "Jacqueline Kennedy: The White House Years" were celebrity relics, not art. He called "Beyond the Frame: The Sculpture of J. Seward Johnson" the worst museum exhibition ever.

Quality concerns aside, the Corcoran gallery significantly increased its footprint in the community. Besides the increase in the number of exhibitions, the Gallery offered more events in its space. By the mid–1990s, there were about 150 public programs for Corcoran members and visitors to enjoy. These ranged from artist talks to presentations by architects, including Jeff Koons, Susan Rothenberg, Dale Chihuly, Michael Graves, Philip Johnson, and Richard Meier. Even local theater groups, such as Woolly Mammoth, Round House, and Source, performed inside.[34]

With managerial finesse, David Levy repossessed the Hemicycle at the Corcoran Gallery without offending anyone at the Corcoran School of Art. The domed building, off the main American galleries, had been used as a studio by the art school for almost four decades. And the School continued to use it but as a place for exhibiting art rather than making it. "There needs to be a vehicle for local artists," Mr. Levy said, explaining that he allocated the Hemicycle space to both local artists and students because of the quirks of the academic schedule. The move enabled the Corcoran's new leadership to make friends among the Washington art community quickly.

The first show of Washington-based artists in nearly a decade occurred during the summer of 1992. The open call to regional artists drew hundreds of submissions; 46 received the word their work appeared in the Hemicycle. The jurors featured seven artists, Corcoran staff, and the school's faculty. They maximized the appearance of the show by splitting it into two sets of 23 artists. Each group appeared for a couple of weeks. The Corcoran thought they needed to hold the show because it offered exposure and encouragement to local artists.

While maintaining the show on a biennial basis, the Corcoran reorganized it significantly before the iteration in 1994. Instead of a show at the Corcoran, the gallery and school joined with other art organizations to show local artists in six galleries. Eleven jurors scanned over 800 submissions to select works from 41 artists. Called ArtSites, the survey resulted in an eclectic range of items on display. Critic

Michael O'Sullivan found the prospect of digesting the "behemoth show" daunting and exhausting to his feet.

ArtSites98 became regional. Featuring eleven locations stretching from Reston, Virginia, to Baltimore, Maryland, the show offered a monitor at the Corcoran gallery that allowed a prospective viewer to scan the sites before heading out. Critic Ferdinand Protzman observed that contemporary art focused on us, our time, and our place. The theme running through the works centered on individual identity and meaning in mass society. More specifically, he thought that the many pieces grappled with the identity of artists in contemporary society. He concluded that the region was home to several good artists even though its art market proved small and moderate.[35]

As dean of the Corcoran school, Sammy Hoi played a significant role in the development of ArtSites. He provided his time to artist friends. He attended many an artist's gallery opening. Hoi served on boards and committees for organizations including Arena Stage, Washington Area Lawyers for the Arts, the Arlington Arts Center, and the D.C. Educational Collaborative for the Arts and Humanities.

Beginning in the early 1970s, the Corcoran expanded its offerings of art classes inside the building to inner-city school students. The school received NEA funds to continue training at the public schools around the city. Still, the Corcoran maintained its reputation as a stuffy, vanilla-pudding place with scant interest in the city's art scene.

In the early 1990s, Hoi expanded the school's outreach. D.C. social services brought a group of 300 children to the gallery weekly for summer art classes. Moreover, Hoi established the Visual Arts Community Outreach Program (VACOP) in 1992 with an annual budget of about $20,000.00. The program provided free art classes, mentoring, and art exposure to children and teens in Washington's inner-city neighborhoods. Over nearly a decade, the program grew to a budget of $300,000.00, which came from foundations, corporations, and individuals. The Corcoran worked with partners from the outreach communities to provide teachers for the classes and mentoring and scholarships for students.

Hoi summarized the vision of the VACOP. "In a way, our program plays a role in these neighborhoods, similar to athletics. It offers talented kids growing up in some very tough areas a way to transcend their circumstances." Judy Southerland taught at the Fletcher-Johnson Education Center in Anacostia. Two of her students applied to the Duke Ellington School of the Arts in the Georgetown area of Washington. "Going to a school like Ellington is a big step for these kids. They are geographically and economically isolated here in Southeast. Many of them never go into the [other parts] of the city."

By the late 1990s, the program had won several awards. These included the Museum Services Award from the Institute of Museum and Library Services and a specific award for its mentorship component. The VACOP shared the Coming Up Taller Award with nine other recipients. The President's Committee on the Arts and Humanities bestowed it.

The school improved its position as well. The number of students increased, and the degree program blossomed as well. Full-time student enrollment climbed from 267 to 340, while part-timers rose from 1,800 to more than 3,000. Mr. Hoi enlarged the bachelor's degree program in fine arts, photography, graphic design, photojournalism, and digital publishing.

The faculty expanded to 70 artists on staff as teachers. One adjunct teacher noted how much the new dean had improved the Corcoran school. Yuriko Yamaguchi said: "His close relationship and familiarity with David Levy was very good for the School. They came in as a team, and they turned the School around." The continuing education program offered a strong faculty to people interested in the arts as a hobby or moving into the arts after finishing their first career. Sally Kauffman joined the program in 2006, deciding to renew her painting after 25 years in the technology industry. Kauffman enrolled in Judy Southerland's class on Monday nights called "Painting in a Series," and they developed a mentor relationship that eventually became a friendship.

Dean Hoi built strong personal relationships with individual students and faculty members. Senior Mary Dunnington said, "Sammy ... was someone students could go to and talk to. No matter how busy he was, he would stop what he was doing. We always felt someone was on our side with Sammy there." Both full-time and adjunct faculty appreciated the dean and the staff that he hired for the school.

Lastly, the school's physical plant improved as well. The college opened a new campus in Georgetown in the historic Fillmore School building. The Corcoran school also made a significant new renovation. It created the Corcoran's first state-of-the-art teaching facility. The most significant plans were yet to come. There was a lot of talk among board members and Corcoran leaders of "momentum." The institution had "tremendous momentum" to make changes now. During these great years, the Corcoran did not make money. Making matters worse, the heating and cooling systems were barely surviving. "Everybody understood that there was just no way to continue going on the way we were going. It was unsustainable," said Margaret Wieners, the Corcoran's former vice president of finance and administration.[36]

The Corcoran also wanted something to garner the attention of the city's tourists. It announced a competition to design a new section for the building. They reviewed works from ten architectural firms and settled on three: Daniel Libeskind, Santiago Calatrava, and Frank Gehry. In June 1999, the Corcoran announced renowned architect Frank Gehry won the commission to add a wing to the existing building.

Since Gehry's Guggenheim Museum in Bilbao, Spain, had become a tourist mecca, the Corcoran thought this wing enabled it to stand out in a city crammed with competing art museums. Inside the main entrance, the video "Mr. Gehry Goes to Washington" played continuously. Levy explained, "A museum should regard its building not simply as a receptacle where you put art, but as a work of art itself."

The design received great acclaim. Initial fundraising gathered over $110 million toward the $160 million price. Then, adverse circumstances began piling up. The price of the building doubled. The Internet stock bubble burst in 2001–2002, causing many stockholders and others to lose money and jobs. America Online slashed its promised donation in half. The nation suffered terrorists' attacks on September 11, 2001. Security concerns emerged, fears rose, and the tourism industry in Washington, D.C., shrank.

For some board members, the limitations to fundraising appeared obvious. They proposed that the Corcoran elect to have Geary build a façade and renovate the building. This change reduced the cost significantly and placed it within reach

of fundraising. Levy wanted more than settling for "half a loaf." In 2004, board chairman Otto Ruesch's untimely death removed one of the wing's most prominent supporters.

With new leadership, the Corcoran's board of trustees suspended fundraising efforts for the Gehry wing. "If you don't have your money, you can't build it," said board chairman John T. "Til" Hazel. They thought Levy's focus on the wing kept his attention away from many necessary improvements the gallery required. Levy announced his resignation. "'We are on the brink of securing the Corcoran's future for generations to come." While acknowledging that completing the Gehry project was an "enormous challenge," he disagreed strongly with the board's decision. "Publicly 'suspending' the Gehry campaign is tantamount to declaring it dead and buried." Board chairman Jeanette Ruesch and strategic planning committee head Paul Corddry disagreed. They insisted they the Gehry effort could be revived if large donors came up with $100 million.[37]

How did the Corcoran's donor base respond to these changes? Olga Hirshhorn canceled plans to donate her remaining art holdings and one-third of her residuary estate to the Corcoran. After decent returns during the middle of the decade, fundraising dropped below ten million for each year after the global recession in 2008. Meanwhile, the Phillips Collection drew many larger contributions during each period.

The limited donations forced the Corcoran to sell assets to cover deficits. Changes in leadership and other decisions seemed only to delay what many in the city's arts communities felt would come. The gallery found it more challenging to stand on its own. Its leaders engaged in talks with the University of Maryland, George Washington University, and the National Gallery of Art to find a solution. During the spring of 2014, the George Washington University, the National Gallery of Art, and Corcoran boards approved a plan to have the university absorb the Corcoran college and campus and related debts. They also provided options to the school's students and faculty. The National Gallery took most of the institution's art collection and dispersed the remainder to museums throughout the United States.

After years of yo-yoing between financial stability and the abyss, what finally snapped the string led to the final fall. External factors, such as the tourism drop after September 11, and the sizable declines in the stock market, had deleterious effects. But the efforts of leaders in similar institutions enabled those museums to withstand these factors. The most important factors had to have been the decisions the various Corcoran leadership groups made over the previous 50 years. One Washington artist argued that the Corcoran never recovered from selling rather than keeping the Washington Gallery of Modern Art's collection in 1968. That would have expanded the collection enormously, but the Corcoran may not have had the money at the time or resources to maintain these works over the years.[38]

The most significant decision seemed to be the Gehry wing. Was it correct to make it the focus of the gallery's leadership? Would they have better served the institution with a façade and rebuilding of the existing plant? Should the effort have continued once it started, despite the fundraising difficulties? Would the Corcoran had been asset rich and cash poor at its completion? Were there better actions than those they took for the two sets of leadership groups who took over after Levy left? These questions remain impossible to answer. Possibly that the decision makers'

personalities could be the sole difference between moving forward or withdrawing from the wing? Once started, seeing the action through rather than stopping could have stopped the loss of some top donors and an effective leader. With the dissolution of the Corcoran, Washington lost a vibrant participation in its arts communities.

The Corcoran and many of the framers discussed in the second chapter lasted for decades. They provided stability to a city art scene that saw many little galleries and intimate bookshops try to sell art and fail over a short time. The institution that started in the early 1920s also served as a school and place to see art and where the work of Washington-based artists occasionally appeared on the walls.

4

The 1920s Again

The Phillips, Continuity of Art

The public now saw the masterpiece. Renoir's *Le Dejeuner des Canotier* (*Luncheon of the Boating Party*) with its large canvas and splendid colors now appeared in public. The Phillips Memorial Gallery in Washington, D.C., had it, one of the most famous French paintings. One newspaper article described the masterpiece's painting in Bougival in 1881, the eleven people on the balcony of a hotel overlooking the Seine. Lunch over, and a conversation ensued. The artist's wife played with her little dog. Others included artists, collectors, Renoir's constant companion "Baron," Barbier talking with a pretty woman. All viewers saw the joy of life. Duncan Phillips purchased the painting that others could not.[1]

The Phillips Memorial Art Gallery received some press attention over the first two years. The critics stated the gallery had a unique and impressive character, with its domestic architecture. A noted art critic and connoisseur, Duncan Phillips, and his mother, Mrs. D. C. Phillips, saw this endeavor as a fitting way to memorialize their recently deceased loved ones. The Phillipses aimed to reveal the richness of the art created in these United States.

Duncan Phillips came to Washington, D.C., in 1895, with his family. A Civil War veteran, Major Duncan Phillips became a Pittsburgh businessman. Mom, Eliza Laughlin Phillips, came from the family of the co-founder of the Jones and Laughlin Steelworks. Like his older brother Jim, Duncan graduated from Yale. The pair returned to Washington. Duncan expanded his writing about art and, by 1914, published his first book, *The Enchantment of Art*. He and Jim also collected works of art, obtaining a collecting allowance from their parents in 1916.[2]

The death of his father in 1917 and brother Jim in 1918 shook the family. After great grieving, Mrs. Phillips and Duncan decided to found the Phillips Memorial Art Gallery. As Duncan wrote in *A Collection in the Making*:

> Art offers two great gifts of emotion—the emotion of recognition and the feeling of escape. Both emotions take us out of the boundaries of self.... At my period of crisis, I was prompted to create something which would express my awareness of life's returning joys and my potential escape in to the land of artists' dreams.

Fortunately, other festive events occurred in his life. While Duncan exhibited some of his paintings in New York City in 1920, he met a charming artist named Marjorie Acker. Brought up in New York State, she studied at the Art Students League in New York City. Acker made a daily commute from Ossining to New York City to pursue her art training. They fell in love and set up a date for the marriage in the fall of 1921.

Meanwhile, Duncan Phillips returned to Washington. He participated in the College Art Association annual convention in the city during the spring. The delegates spent an afternoon visiting his private galleries months before the museum opened to the public. They saw that Phillips regarded each room of the three rooms established as galleries as an aesthetic unit. The plan made a room contain one artists' work or one style, while the decorative accessories in each room changed with each different exhibition.

Duncan and Marjorie married in the fall of 1921. Later that autumn, the Phillipses opened their Georgian Revival house on the corner at 1600 21st Street to people interested in "modern art." The Gallery began as two to three rooms open to the public three days a week. The first year went fine for the three months the gallery stayed open, though the turnout was not as large as anticipated. The tall man with a wiry build ensconced in light tweeds often spent the day at the gallery when the public came in. His long, narrow face contained animated blue eyes with a slight slant. He enjoyed engaging in discussions about his favorite topic, art.

Minor inconveniences occurred during the early years. Gallery visitors mistakenly went to the Phillips' residence door because they were unaware that the gallery's basement door opened. The Phillips established a committee to write up the scope and plans for additional future improvements. This group included artists and noted art lovers, with Duncan Phillips as the chairman.[3]

This committee decided to open the gallery on Tuesday, Saturday, and Sunday afternoons. With over 200 works, including the newly acquired paintings *The Repentant Peter* by El Greco and *Woman with Water Jar* by Coret, the committee organized the year's exhibitions. Following an old Greek rule that forbade excess, they hung only 30 to 40 paintings at any one time. The group organized exhibitions in three ways: paintings of similar temperament and aesthetic intention; paintings teaching the artists' point of view by contrast; and paintings by one artist covering periods and phases of development.

After introducing the great Renoir piece before New Year's Day of 1924, the Phillipses relocated into a new temporary gallery at 1608 21st Street. The plan appeared to include the construction of a permanent structure on the grounds soon. The spring showed a range of works from Childe Hassam. The "Little Gallery" exhibition space showed the art of modern American painters. The gallery's year extended until the end of May.

Clara Sipprell, photograph of Duncan Phillips, 1921 (National Portrait Gallery, Smithsonian Institution, Bequest of Phyllis Fenner).

The fall 1925 season opened back in the first building. Visitors entered the gallery through the imposing entrance on the first floor. A group called Washington Study held morning lectures about art at the Phillips during the early years. At one, Duncan Phillips talked about the gallery. He expressed regret that fewer Washingtonians had attended the Phillips than he had hoped, but many visitors had come from around the country and Europe.

When a portion of his collection toured cities across the East Coast, critics praised the beautiful and well-illustrated catalogs and his rich and catholic holdings of painters. A Baltimore critic praised Phillips' paintings as a curious, exciting, and inclusive aggregation of good and bad. Painting was Phillips' passion. Maurice Sterne, whose sculptures sold very well in New York City, exhibited his paintings at the Phillips Gallery. Mr. Phillips purchased one of Sterne's paintings and showed the artist's paintings because he thought they were more vital works than Sterne's sculptures.[4]

Duncan Phillips also informed his Washington audience that he planned for a gallery as close as possible to a home environment. The Phillips opened two weeks earlier than usual in 1929. The family showed the new purchases of art that he made and the newly installed lighting to improve visibility. The next week, the Wall Street Stock Market collapsed. Fortunately, the gallery stood on a firm financial foundation, with an endowment of $1.5 million in early 1930. When the family decamped to a 20-room Georgian-style mansion on Foxhall Road, the gallery moved into the old house. The former home contained a lower gallery, a library, a dining room, and a drawing-room on the first floor. The main gallery and five similar rooms occupied the second floor.[5]

The Washington art critics appreciated the Phillips Gallery and its leader. Ada Rainey credited Phillips with quickening the understanding of present-day art. She argued that he accomplished this through his mingling of new paintings with new arrangements in the galleries. Rainey described the rooms after Phillips' mid-year rearrangement during the winter of 1931. Gallery B contained paintings under the title "Romance and Satire of the Nineteenth Century," featuring Daumier and Ryder. Next, a room called "Pictorial Language of the People" included Walt Kuhn and Jean Charlot. A gallery entitled "The New Decorative Idioms in Paintings" had cubism by Picasso and Braque, while "Twentieth Century Lyricism" included Arthur Dove and Mangravite.

The lower room featured a massive canvas by Henri Rousseau. The drawing-room she labeled vital due to its Bonnards and Manet. The library contained a selection that one critic described as a feast: Gauguin, Van Gogh, Matisse, Derain, and Bonnard. Under the new structure, the original main gallery returned to its earlier form. This time it contained more great French canvases.

Leila Mechlin took her readers around the house to show next year's midyear rearrangement. She started by mentioning the works of Phillips Board vice-chairman and friend Augustus Vincent Tack. His beautiful abstract decorations filled the lower gallery. She found the latest arrangement "particularly felicitous." The library on the first floor showed Monet, Chardin, Constable, Corot offset by two Puvis de Chavannes sketches. The drawing room featured six Bonnards and one by Marjorie Phillips, "harmonizing admirably." Bonnards appeared in the dining room and seemed to be silently applauding Charles Prendergast's beautifully decorated screen.

The critic walked to the upstairs galleries where gallery C contained American and European abstracts. Gallery D featured American oil and watercolors, where John Marin took prime positions. However, "Stefan Hirach and Georgia O'Keeffe's paintings lent balance through architectural compositions." Gallery E "is gay," with a picture of a Hudson River steamboat and a joyful crowd and a painting of a merry garden party. She deemed that mood right for when she encountered Walt Kuhn vigorous, startling recent paintings in Gallery A and returning to the rich tonal resonance of Ryder and Daumier in Gallery B. "The main Gallery re-welcomed the visitor with old friends, namely the works of Van Gogh, Renoir, Matisse, and Spencer."[6]

Phillips expanded his support for Washington-based artists during the 1930s. A few years earlier, the gallery showed board member Augustus Vincent Tack. The Pittsburgh native worked in New York City but visited Washington to see the Phillips and to work. Tack had the name and background to obtain commissions to paint the official portraits of Cabinet department heads and major political figures. Eventually, Tack painted both President Truman and President Eisenhower. Phillips featured exhibitions of the artist's semi-abstract landscapes. These paintings were minor forerunners of Abstract Expressionism in the U.S. and Washington Color School movement.

After showing Marjorie Phillips' paintings during the late 1920s, the gallery displayed her work again before closing for the summer in 1931. Earlier that spring, Corcoran student Betty Lane exhibited before leaving to study painting in Europe. Phillips had already planned on starting a school. The school met both the Phillipses' belief in art education and their desire for art to be a pursuit available to all. It featured an amateur sketch class on the mansion's third floor that the gallery's education program head C. Law Watkins taught.

Three years into the enterprise, significant changes occurred. The Phillipses moved the school to the Studio House at 1614 21st Street. They hired painter Robert Gates to teach and serve as the aid to associate director Watkins. The very tall man had a firm handshake but spoke so infrequently that his students, during the 1950s, nicknamed him "Coop" after the reticent actor Gary Cooper. His wife, Margaret Casey Gates, became the executive secretary and taught classes for children on Saturdays. Both joined the Society of Washington Artists.

The faculty formed small groups of students, providing each student with significant individual attention. The teachers forced no specific school of painting on anyone. The painting courses occurred during the day, and all students spent one night a week in a life-sketching and anatomy class. By the late 1930s, Phillips assumed the Studio House's art school and sales under the Phillipses' educational activities. The new school became the Phillips Gallery Art School. The change provided Studio House the opportunity to continue its services to local artists and a museum function with no fees associated with these efforts.

The demands of fighting World War II pulled person power from places across the country, including the Phillips School. With fewer staff, C. Law Watkins facilitated a growing connection between the Phillips School and American University (A.U.). Students enrolled at the Phillips and took classes at American University in its new art program. Every student devoted mornings to painting practices while afternoons involved coursework. Students earned Bachelor of Arts and Master of Arts degrees. The administrators believed that art served as a form of social

communication inspired by individual and social experiences, so master students in art also trained in the social sciences to broaden their understanding of other social communication methods.

C. Law Watkins became Chairman of the A.U. Arts Department in 1944. "Law was primarily interested in education," fellow painter and educator William Calfee recalled. "He could take a painting apart and tell you what its elements were." Watkins died unexpectedly in 1945, and the Phillips Gallery abandoned its education program. American University President Paul Douglass asked Calfee if he would assume the chairman position; he served in that capacity for a decade. In conjunction with Duncan Phillips, Calfee brought nearly all the former Phillips faculty over to A.U.[7]

The 1940s and 1950s represented a vibrant time for the arts at A.U. The university president wanted a successful program and supplied the department with a wealth of resources. Calfee was an excellent person to guide the new program. He tried to become a doctor as his parents wanted but dropped out of medical school and pursued art. "I am an artist, a highly emotional and rather strange person. So why fight it?"

The Washington, D.C., native studied art in Europe and at the Cranbrook Academy in Michigan during the 1920s and 1930s. The murals he painted during the Great Depression for the Fine Arts Section of the Department of the Interior can be found today in a few post offices in Virginia, Maryland, and Delaware. During that time, he developed an idiom that was both figurative and abstract. After having works shown at the World's Fair of 1939, Calfee's first solo exhibition opened at the James Whyte Gallery on the day the Japanese attacked Pearl Harbor in Hawaii.

A multi-media artist, Calfee sculpted, painted, drew, made prints, and took photographs. He left Washington and teaching for Vermont and the opportunity to focus on making art. He returned to both teaching and his colleagues in 1957, joined them in starting Jefferson Place Gallery. Calfee showed there in group and member shows annually until the late 1960s. Afterward, he had many exhibitions across the region, from the Athenaeum to the National Academy of Sciences.

After retiring from American University in 1977, Calfee moved to a larger home in Chevy Chase, Maryland, to have more space. He began showing sculpture and other works at the Plum Gallery in Kensington, Maryland, during the 1980s. By then, he already completed a monumental abstract sculpture for the Rockville Civic Center. He continued teaching at the Kensington Workshop, a place he co-founded with artist Patricia Friend. His works appear in collections of the Metropolitan Museum, Phillips Collection, and the Smithsonian American Art Museum.

Calfee accumulated an extensive collection of art over the years. He displayed these works at various functions on the A.U. campus. He and the other A.U. artists also showed their collections as participants in exhibitions, such as "Washington Collects Washingtonians," held at the Jewish Community Center during the 1960s.[8]

Robert Gates returned from his war service. While at the Phillips, he painted Regionalist-inspired impressionist watercolors and works of figures and landscapes. Teaching on a department staff with Karl Knaths, Jack Tworkov, and especially John Marin probably influenced Gates to adopt a nature that included some abstraction. Still, the laconic teacher provided students with the simple instruction to "paint

what you see." Student Jack Rasmussen interpreted the direction as advice to look as intently as possible at the item. Don't become distracted by what one might have heard about styles and fashions and all other commercial and academic art worlds' expectations.

At A.U., Gates continued to focus on landscapes, a subject that he loved. Ben Summerfield, his student and later his colleague, stated, "that Gates' paintings depicted a convincing physicality." The painter exhibited all around the city in many institutions and galleries. He died in 1982 at the age of 76. Several notable museums hold his paintings, including A.U., where he taught, and The Baltimore Museum of Art, Lewisohn Collection, Metropolitan Museum of Art, and the Smithsonian American Art Museum.[9]

Sarah Baker also made the conversion from Phillips to American University faculty. Baker left her native Memphis, Tennessee, with her family while a sophomore in high school. After training at the Maryland Institute of Art and Pennsylvania Academy of Fine Art, she won a traveling art scholarship that allowed her to visit museums and galleries in Europe. The large-eyed young woman with a rounded face returned home to Washington. She became the first woman granted permission to copy paintings in the Corcoran Gallery of Art. The institution threw her out for studying books about artists like Matisse. "[The Corcoran] didn't have enough heart and commitment to art then and it doesn't now," Baker said years later.

While hoping to pursue a career as an artist, Baker taught at private schools in Maryland beginning in 1929. Artist friends' deaths from malnutrition nearly forced her to quit her art. But in 1933, C. Law Watkins convinced Baker to join the school of young artists working on the top floor of the Phillips. Included in a group show at the Arts Club, Miss Baker's watercolors of flowers and fruits received praise for their composition, tone, and technique. Baker's style was "post-Impressionist." The Contemporary Art Gallery in New York held shows of hers in the late 1930s.

The Washington art community appreciated Baker's work as well. In their Whyte Gallery, curator Franz Bader and owner James Whyte began providing her with one-woman shows in 1941. Local critics enjoyed her work. Mechlin called her paintings a delight to the eye and justly famous. Critic Jane Watson viewed them "as gay without being inconsequential and charming without affectation."

One student Ben Summerford described Miss Baker as a Puritan, saying "she kept us on a stony path and could be annoying with her dogged insistence on quality and honesty." Like a good teacher, Baker believed that everyone had a separate thing to say and need not compete. She retired from teaching during the late 1960s. Her last one-person show on the American University campus came in 1975, but she but continued exhibiting work at Franz Bader's Gallery through the late 1970s. A year after moving to be close to her sister in Westchester County, New York, Miss Baker died in 1983 at 84 years old. Museums, including the Phillips Collection, Baltimore Museum of Art, and Brooklyn Museum, acquired some of her pieces.[10]

A fourth A.U. faculty member never taught at the Phillips. Benjamin Summerford, commonly called "Joe" after the nickname his mother bestowed to differentiate him from his father, Benjamin Sr., initially studied piano. He spent a year at the Birmingham Conservatory of Music, pursuing this interest before it was interrupted by World War II service with the Office of Naval Intelligence. The Alabama native attended A.U. and returned to the faculty after a Fulbright Fellowship to Paris.

Summerford moved into abstract expressionism. He showed in group shows at the Whitney Museum of Art in New York and later at the Duveen-Graham Galleries. However, he decided that was not how he wanted to live or what he wanted to paint. Living in Washington as an artist provided him what he called "the freedom to be myself." As manager of the Watkins Gallery on A.U.'s campus, Summerford showed a range of Washington-based artists from Kenneth Noland and Gene Davis to Hilda Thorpe and Alma Thomas. He embraced a semi-abstract approach with what critic Florence Berryman called "de Stael-like slabs of gray." Summerford lashed out at this critic for supposedly favoring the Gress Gallery during the late 1950s and missing the most talented artists in the city. Manuel Baker of the IFA Gallery penned a letter to the editor defending Mrs. Berryman on all counts.

Summerford had a specific view of his work. During a show at the Phillips, Berryman noted that he and fellow A.U. professor Helene McKinsey Herzbrun had considerably loosened their approach since the 1950s. After showing in a one-person show in the mid–1960s, he left Jefferson Place when the Gallery changed direction in accepting a more conceptual approach to contemporary art. The show drew a positive response from his critical counterpart, who observed Summerford "moving away from semi-abstract paintings toward closer and fresher involvement with his subject matter. These changes included intense coloring, sharper description, and increasing conviction."

Now bald, rosy-cheeked, and tweedy, Summerford moved on to exhibit at the Franz Bader Gallery. His loose, extraordinary brushwork proved evident in the still lifes he showed during the Watkins Gallery exhibition in 1988. That was the final year he taught on faculty, and the students missed him immensely. Jack Rasmussen called him the best teacher. "Summerford could talk. He could talk about painting, this essentially nonverbal experience, and he could talk about it beautifully. It was his speech that set him most apart from the other Phillips teachers who'd come with Watkins to A.U." Summerford died in Hagerstown, Maryland, in 2015.[11]

These A.U. painters drew the attention of a few collectors in the region. Local lawyer and painter Lawrence Jonas Heller also showed a part of his holdings at "Washington Collects Washingtonians." A graduate of George Washington University who served in World War I, the native Washingtonian made money through a radio license and real estate. His art collection featured the "Provincetown artist group," including Phillips instructors Karl Knaths and Jack Tworkov. He purchased works from many American University artists, including Robert Gates, William Calfee, and Sarah Baker. Critic Benjamin Forgey observed, upon seeing the paintings at A.U.'s Watkins Gallery, "Paintings have a harmony not in style or subject matter but in the sense of feeling and shared ambiance that went out of the air in the late 1940s." The Tucson Museum of Art in Arizona now maintains 92 works from the Lawrence J. Heller Foundation of European and American modernists.[12]

Heller was not the only Washington collector of these painters. Duncan Phillips purchased paintings from these former school faculty as well as other Washington-area artists. Some became incorporated into the Phillips Collection, while others remained consigned to the "encouragement collection." The Phillips gallery provided regular exhibitions of these artists' artwork.

Gates and other faculty at the Phillips Art School exhibited in the gallery. Students also showed, including Alice Acheson, wife of the State Department's Dean

Acheson. The Studio House also made itself available for exhibitions to other local art groups, including the Washington Art League.

Many local artists also showed in the Studio House. Upstairs, "The Washington Room" offered a space that continuously showed regionally based artists of promise. Alice Acheson appeared with Robert Gates, and many other pairings occurred, including the friends Bernice Cross and Julie Eckel. Mechlin acknowledged the talent of both, but he saw them as some distance away from arriving. Sometimes the room contained a group or theme show, for example the abstracts done by Knaths' students over a month. The review listed several works that she appreciated before observing that "if most of the artists in the exhibition saw beauty in their subject, this discovery remained uncommunicated to the casual observer."

When the Studio House and Phillips consolidated, the critics observed that the Washington Room was a significant loss to local artists. The school moved to the third floor of the gallery. The new reading room on the floor provided a location to hang 10 to 12 canvases. Under the new system, the shows included professional staff and students' paintings, including those of the Gateses and William Calfee.

By the fall term of the third year, the Studio House held a juried art show and sale. Duncan Phillips, C. Law Watkins, and Olin Down served as the jury and examined the paintings and prints sent by over 150 artists who lived from Baltimore to Richmond. This autumn show expanded from the past practice of setting aside one room to show local artists' work to a show that consisted of 100 artists placed in the main galleries and all the rooms on the second floor. Phillips wrote in the catalog that "the public will indorse [sic] with enthusiasm the jury's catholicity of choice and its faith in the future possibilities of these exhibitors."[13]

Jane Watson found that established artists Robert Gates and Prentiss Taylor made beautiful landscapes in watercolors. She pointed out the works of students Sarah Baker, Julie Eckel, and Bernice Cross, who returned with excellent work from their Virgin Islands vacation. Lelia Mechlin mentioned nary an artist or a work. Instead, Mechlin argued that the artists failed to make beauty manifest in their artwork. "Few of the artists had the power and the gift to exalt their subjects, and it is that which not only made art but enabled humans to separate themselves from the beasts." The next season, the local artist exhibition contained about 60 artists, two-thirds of whom came from Washington.

The following season, the autumn show became the Christmas Exhibition. The organizers hoped that this provided an impetus to the viewers to buy the local artists' works. From newcomers to old hands, the praise for pieces came throughout the review. Mechlin observed that over 200 submissions went to the jury for consideration. The panel showed about half in the Studio House. She emphasized that the works were for sale and moderately priced.[14]

The gallery staff selected about 70 smaller canvases for the next season. Mechlin noted that most of the artists and the content of their work remained familiar. The show featured artist and local gallerist Auriel Bessemer, whose life will appear in the next chapter.

The media provided less coverage of the holiday exhibition. Ada Rainey felt the works seemed more experimental than finished. The show in 1945 received brief coverage that mentioned that 56 regional artists participated. By the late 1940s, the local exhibitions at the Phillips slowed to a halt.[15]

The gallery ran a few summer exhibitions featuring local artists. Called "Americans from the Collection," these two exhibitions in the mid–1950s featured painters. Most of the local artists shown formerly served on the Phillips faculty or attended classes there. However, new artists included Margaret Appich, Lee Gatch of Maryland, and Leonard Maurer, who settled in the Washington area after World War II service. Some regional artists who were favorites of Mr. Phillips, including Lee Gatch and Marjorie Phillips, received one-person shows, too.

Over the nearly two decades, the Phillips gallery held fewer local artists' shows but offered inspiration to those artists, and parts of the Phillips Collection provided a way of understanding techniques. Ada Rainey called the exhibition of Jacob Lawrence's great migration paintings "decidedly original so will be observed with keen interest by those concerned with the movements of the day and their expression in esthetic form." The gallery pulled together 40 Degas drawings and pastels from 15 institutions, showed boundary-stretching works from between the two world wars, and featured an Expressionist Abstraction show a few years later.

The exhibitions drew local artists from successive generations. In a 1982 tribute to the museum, Washington-based artist Kenneth Noland acknowledged, "I've spent many hours of many days in this home of art. You can be with art in the Phillips as in no other place I know." Jacob Kainen recalled Duncan Phillips striding over to him and asking how his art was coming along. Phillips asked the artist his opinion on some new trend, then engaged in a discussion for some time over the topic.[16]

The Phillips gallery's curator Jim McLaughlin became a resource to local artists for nearly 50 years. He hired local artists and art students as the Phillips' guards. Susan Davis detailed what other artists also experienced. "Jim McLaughlin received artists with unusual openness to see their portfolios. If you called, he said yes, he would see you. And when you arrived at his office, there was time for you."

During the late 1950s and through the 1960s, the Phillips gallery went through some significant changes. The physical plant expanded greatly when the family added a modernist wing to the Phillips house in 1960. Nearly 30 years later, this space became the Goh Annex and underwent reconception, renovation, and expansion through a significant gift from Japanese businessman Yasuhiro Goh. The annex included The Rothko Room, the first public space dedicated solely to the artist's work. Duncan Phillips designed the space in collaboration with Rothko.

The most significant change came with the death of Duncan Phillips in 1966. Marjorie became director and brought notable shows for local artists to see, including the new works of Alexander Calder and works of the Futurists. She held some one-person shows for some local artists. One of the most notable ones featured the work of Sam Gilliam. That show received great critical acclaim for his exhibition of abstract expressionist paintings.[17]

During the early 1970s, Mrs. Phillips resumed the group local artists' show. This first show generally featured well-known artists. Called a small loan exhibition of Washington artists, it received one critic's affirmation as both lively and coherent. Five commercial galleries lent the works from the 25 local artists shown. The galleries included Bader, Henri, Jefferson Place, Pyramid, and Studio, and they sent art covering two generations of Color Field painters, past Phillips faculty, current Phillips staff, and others.

When Marjorie stepped down as director in early 1972, her son Laughlin

assumed the leadership role. He organized the second annual exhibition of local artists. Benjamin Forgey and Paul Richard applauded the continued exposure of local artists' work. Richard called "the display handsome but also non-committal." Benjamin Forgey expressed his support of the museum's choice to put on the show, while asserting "that a good mixture of both established and new talents saved the show." Forgey observed that regional survey shows were challenging to put together while defining and maintaining standards of quality. "Everybody tended to get possessive about them, and that left people feeling angry and spiteful." Richard refused to call it a survey show since it included only two dozen artists. He understood that the new curator Richard Friedman had two months to organize the show but asked why 14 of the artists had either shown at Henri's Gallery or in Lou Stovall's workshop. Both critics agreed on two strong exhibitors, the paintings of Enid Sanford and Dan Kuhne.

Over the next 20 years, Laughlin Phillips continued the gallery's tradition of showing fantastic exhibitions. He strengthened and consolidated the museum on all fronts: its finances, collections, exhibitions, research programs, and physical plant. The Phillips Collection included representative examples of almost every significant modern art movement. The staff became increasingly professional. The building expanded to offer more space to both show and store its collection.

In 1992, Laughlin stepped down as the director of the museum. For the first time, a non–Phillips family member took over that position. Laughlin remained chairman of the board and worked to continue to solidify the museum's status. Two of the most significant changes came in 2006. The museum completed the addition of what was known as the Sant Building, which significantly increased space while retaining the museum's residential quality. The Phillips also combined with the University of Maryland to establish The Phillips Collection Center for the Study of Modern Art. The program promoted continuing arts education and ran the Intersections exhibitions, which provided artists with the space to display current artwork.[18]

The display of current local artists' work resumed as an offshoot from long-time curator James McLaughlin's 1982 death. The members of the Phillips' staff decided to create an art exhibition to honor his memory. Mrs. Phillips recalled, "Jim was always here to talk to young artists and bring their work to our attention."

The Phillips saw the memorial staff show to honor the tradition that McLaughlin kept. McLaughlin had six children. His family endowed the staff show beginning in 1984, which continues to this day. During the renovation of spaces in the Phillips, the show moved to a gallery in Georgetown. Forty-four artists participated, with all but two still working at the Phillips. Years later, 61 artist-employees showed in the cramped upstairs space of Addison/Ripley Gallery. A critic called the show loud and uneven.

An artist McLaughlin hired to be a guard became the next curator. Willem Johan de Looper grew up during the Nazi occupation of The Netherlands and learned to draw as a child. He came to live with his older brother, who worked for the International Monetary Fund. "As a teenager, my heroes were all black American musicians. Charlie Parker, Dizzy Gillespie, [Thelonious] Monk, all those guys. I knew I wanted to be here, to be part of the cultural life."[19]

De Looper studied at American University and majored in economics to please his parents. He took his first formal art classes with the department's faculty and

switched his major. While serving in the U.S. Army back in Europe, de Looper saw Jackson Pollock, Franz Kline, and Willem de Kooning's artworks at the Brussels World's Fair and fell under their spell.

After returning to Washington, D.C., the painter established a studio in his home at the St. Regis Apartments on California Street N.W. in the Adams Morgan neighborhood. The Jefferson Place Gallery hosted his solo exhibition in 1966. His work featured large abstract floral designs that were explosions of multiple hues. By the 1970s, Mr. de Looper's signature style had evolved into textured horizontal color bands on large canvases. The Phillips held two one-person shows of his work, and five of his paintings were in its collection. Critics observed that de Looper's paintings showed the influence of his daily exposure to the museum's collection, particularly the works of such abstract painters as Paul Klee, Mark Rothko, and Wassily Kandinsky.

Over the years, the artist built a modest reputation beyond Washington by showing in various American galleries, universities, and American embassies. Although he considered himself an American painter, he conceded that there was a "certain European sensibility" to his work. In Washington, critic Michael O'Sullivan observed a subtle emotional depth in his seemingly staid pieces. Another critic attended de Looper shows held simultaneously in two Washington galleries. Michael Welzenbach noted the artist used velvety blacks and purples against shiny metallic pigment, delicately edged with brilliant reds and blues. It gave his works a glow like stained-glass windows. His conclusion, "It's a pity the New York art market has mainly ignored nonfigurative abstraction these last few years, for some of de Looper's recent efforts would get him the national attention he deserves."

The Washington Print Club had one of the local artists shows. The organization and gallery held the first juried local artist print show. Of 725 submissions from 300 artists, the show exhibited 57 pieces. Jo Ann Lewis deemed the show dreary and cited the deep gray walls and low lighting for playing an additional role in lowering the show's quality. The Phillips Collection also featured a ten-year view of mid-career Washington-based artist William Willis. A few years later, "A Dialogue with Nature" exhibit featured nine contemporary sculptors, including Washington-based artists Jeff Spaulding and Jim Sanborn. De Looper retired from the Phillips to paint full-time in the early 1990s.

As the curator, Willem de Looper kept up several of the gallery's traditions. He organized shows that included some new art and reexamined more off-beat artists, such as the Ashcan artists. "He made the Phillips an artists' museum. It became kind of sacred to artists because it had a personal feel that the bigger museums in Washington didn't have," said Terry Gips, an artist and former director of the Fine Art Museum at the University of Maryland at College Park.

De Looper retired from the Phillips to paint full-time in the early 1990s. Bookstore director Joan Mayfield recalled how much De Looper cared about the Phillips. He gave them painted boxes for the store to sell and then donated the profits to the museum. De Looper died in hospice care at the age of 76 in 2009.

The next chief curator came from a museum administration background. Eliza Rathbone took over as the chief curator in the early 1990s after serving in curatorial positions with the National Gallery of Art and the Phillips. The organization retained the same expectation that started with Duncan Phillips. The curator came to the staff

meeting and discussed each new show, and everyone attended, including the people there to clean. "They were into having people and art meet," said Mayfield. Some of the large exhibitions included a Washington-based artist or two. The Intersection series 2009–2021 invited living artists to create works inspired by the Phillips Collection, and the space featured Barbara Liotta. David Driskell and Alma Thomas exhibited in 2021 as part of the museum's Centennial exhibitions.[20]

The Phillips family and its gallery fostered the development of modern art in the nation's capital. Through exhibitions and directly through schools and purchases, the Phillips provided for Washington-based painters and artists in general. Some of these artists started schools and galleries of their own beginning in the 1930s.

5

The 1930s

Little Galleries and Intimate Bookstores

Approaching the stone and brick building of the U.S. Trust Company, one saw Dupont Circle in the foreground. Entering by the side door, visitors, several holding the invitation cards sent by the gallery owner, walked up two flights of broad stairs. Inside the Gallery of Modern Masters, owner Auriel Bessemer welcomed the visitors. A short, thin, dark-haired man, Bessemer had an intense, energetic, and spiritual nature. After opening in 1936, Bessemer exhibited the political artist Rockwell Kent, who aligned with his anti-fascist views. However, it placed the gallery in the middle of Kent's latest controversy with some U.S. government members. Kent's recent mural appeared outside the Postmaster General Farley's office inside the Post Office Building on Constitution Avenue and 12th Street. The imagery in *Delivery of the Mail in the Tropics* agitated members of Congress and Puerto Rican officials. The artist featured a young woman in the foreground who holds a letter written in an Eskimo dialect that said, "To the people of Puerto Rico, our friends! Let us change chiefs." Many interpreted this as a plea for Puerto Rican independence from its commonwealth status with the United States. Postmaster Farley requested that Kent submit a message in English to replace the current native Alaskan language.

Inside Bessemer's gallery on Halloween afternoon, the walls contained two woodcuts, eight lithographs, and about 20 paintings of Greenland. Kent talked with the visitors about his time spent there between 1933 and 1937. The *Post's* reviewer noted that the artist's lithographs and two woodcuts demonstrated where Kent had obtained mastery. She agreed with others who found fault with his paintings in the manner of color and composition. Leila Mechlin observed that Kent set Greenland vividly before the gallery's visitors. "The pictorial representation is very simple and dramatic.... These savor distinctly of the elemental and the eternal." She found these pieces much stronger than Kent's mural work.

People in the city's visual arts-loving communities expressed pleasure. One woman drew comparisons between Rockwell Kent and William Blake, who happened to be showing at the Phillips Gallery the same month. Although not trusting of her observations about their similarities, she expressed her pleasure at enjoying both shows.[1]

Bessemer likely appreciated this woman's letter to the newspaper. After his birth in Grand Rapids, Michigan, in February 1909, his family moved to a religious commune in Florida. This eclectic spiritual education continued during heady early years

as an apprentice muralist and art student in New York City in the 1920s. He continued his art education at the National Academy of Design, where he was considered adept in composition and structure.

He joined the Civilian Conservation Corps artists' ranks and spent a year at Fort Frederick State Park, Maryland. A year later, he taught composition at Yard School of Fine Arts. That same year his portraits of regular Washingtonians he saw on the street or in art classes appeared in the city's Public Library. The artist explained his principle of dynamic symmetry, which, he claimed, "bears as much relation to the arts of space as does the science of harmony to a musical composition."

Bessemer continued his artistic work in the city. He exhibited at the Arts Club of Washington with three other modern painters. Bessemer won competitions to create murals inside the post office buildings of Arlington, Virginia, of Hazlehurst, Mississippi, and of Winnsboro, South Carolina. He also pursued other artistic endeavors. He completed a book of poetry that same year. With its blank verse poems of indignation about war, *The Slaughterhouse of Man* appeared in publication in 1936.[2]

The Gallery of Modern Masters opened later that year. The gallery added to the existing group of non-institutional exhibitors of art, the Margaret Withers Shop, and the Intimate Bookshop, neither of which lasted more than a year. Mechlin observed that Bessemer had successfully brought to Washington works by several artists of great individuality and gift. The works came from artists who lived throughout the United States and sometimes from European nations. Much of the work shown in the gallery appealed to the curator intellectually or esthetically.

While Bessemer managed the gallery through 1940, the burgeoning world war occasionally demanded the artist to act. Groups like the League for Interracial Fellowship and others met at the gallery. Bessemer sometimes spoke on topics such as "Peace through Organic Harmony." He was one of three Washington artists who participated in the American artists' exhibition in New York called "Art in a Democracy." He penned a letter to the editor "calling on the United States to provide immediate and plentiful aid to Europe's besieged democracies. He requested that the U.S. government prepare the country for the upcoming fight with Nazi Germany."

Once the United States became involved in fighting World War II, Bessemer joined the Army. They put his design skills to use during his service. He created a portable altarpiece for the armed forces. The triptych called *God's Will Is Law* provided far-flung service members a religious piece to comfort them and enhance their praying.

After completing his service, Bessemer remained in Washington. He gave lectures on art's function in the current world and continued to show, particularly with the Nicholas Roerich Museum in New York City. Late in his life, Bessemer moved to Colorado to join a New Age religious group and illustrated its leaders' books. Bessemer died in 1986.[3]

Off the radar of the city's galleries, people interested in pursuing arts, particularly photography, started clubs. Washington's segregationist policies and norms prompted these clubs to exclude African Americans from their membership. So African American young men started a club at the Twelfth Street Young Men's Christian Association in the middle- and upper-class African American neighborhood of Shaw. The Foto Craft Camera Club began in 1937 and taught photography skills and offered members the chance to show their work. The group acted decidedly professional,

establishing connections to show at Howard University's gallery and becoming the first club to run a contest. The "Y" and Howard Art Gallery being the few places where African American artists showed their work through the early 1940s.

During the late 1960s, the club remained one of the most active in the city. The group continued for over sixty years and offered these young men and many others across different ethnic groups a way to learn photography and participate in contests and exhibitions. Several members used their skills to attain jobs in the media and the different regional governments as photographers. Like Sonnie Mason and Nestor Hernandez, some members established strong professional reputations and showed at various galleries in Washington. They sold and showed their works from the 1980s through 2000 at the Belmont Arts Center in Adams Morgan. It was one of the places of fellowship for artists of African background and African arts.

Other African American artists in the city showed their paintings and sculptures at Howard University's gallery. Occasionally, the mainstream newspapers of the era covered their exhibitions in the arts section. Among the artists who received coverage included Henry O. Turner, Hilda Wilkinson Brown, Lois M. Jones, and James A. Porter. Mechlin described Mrs. Brown's paintings as "strong, yet subtlety rendered." The praise came with commentary regarding supposed racial characteristics that unfortunately influenced the beliefs of many in Washington, D.C. Mrs. Brown's talent was not a surprise, as this D.C. native headed the school's art departments. She illustrated E. Franklin Fraser's book, *The Negro Family in the United States*, and articles in *Crisis* magazine. She painted still lifes, portraits, and neighborhood scenes within LeDroit Park, the neighborhood near Howard University, and she showed works across the country.

When Howard opened a new space for the art gallery in 1941, Ada Rainey described the artworks in her monthly openings list. Curated by the gallery's head, Alonzo Aden, the opening featured both Caucasian and African American artists, including Mrs. Brown and all of the Howard art department faculty. One member, James Porter, graduated from Howard University in the late 1920s. When he showed his art in the university gallery in the early 1930s, Leila Mechlin observed that his work was fitting and of note to people interested in the development and achievement of "Negroes" in the arts. Porter wrote reviews for art and history magazines and showed his work at Barnett-Aden Gallery years later. His artwork moved through depictions of Haitians toward allegorical work of pilgrimages of the artist. The later paintings composed the first solo show at the Dupont Theater Gallery in the late 1940s.

The Baltimore native headed Howard University's art department for decades. His courses institutionalized the study of African American art history and foregrounded the Howard University art department as a critical center in the nascent field. Porter's book *Modern Negro Art* became the first comprehensive study of African American art in the United States. This book helped Porter's student David Driskell curate the 1976 exhibition "Two Centuries of Black American Art," a landmark for U.S. museums and for African American art. Porter proved instrumental in moving the University art department toward Black Power and nationalism during the 1960s before his untimely death in 1970.[4]

While the Gallery of Modern Masters operated, a few women started galleries to show young Washington, D.C., painters. Miss Elizabeth Ray Lewis left the American Federation of Arts to become head of the city's public library's art division in spring

1933. Miss Lewis gave lectures on both ancient and modern art and started a program that placed pieces from Washington artists in various public library branches. She thought this helped people to become conversant with Washington artists. After three years, she decided to start the Little Gallery in the Gard School of the Arts Building near Dupont Circle. Her plan involved selling the works of younger Washington artists whose paintings sold at moderate prices. The Little Gallery organized events to bring in patrons. Artists and some notables attended Sunday teas and the few other affairs held. Unfortunately, the gallery lasted less than the year. Miss Lewis continued working at the public library and died, intestate, in late 1966.[5]

While the Little Gallery in Dupont Circle failed, one with the same name started in Georgetown. The city's leaders annexed Georgetown in 1871. Its commercial streets remained vibrant, and merchants erected big homes as Georgetown prospered with the Chesapeake and Ohio Canal in operation. When the company failed in the early 1890s, the heavy industry moved to Georgetown Harbor.

Over the next three decades, the industry expanded, making the area less desirable for many residents. Many wealthy residents left, and others stopped moving in. The neighborhood's population grew, with many from the semi-skilled and laboring working classes. The number of African Americans living in the area remained relatively large. The old federal-style houses and brick townhouses of the late 1890s decayed from lack of care. Citizens characterized Georgetown as a slum. A growing interest in historic preservation sparked a resurgence of the area. The decision of federal government workers coming to Washington during the New Deal to settle in Georgetown sparked the neighborhood's return to fashion. These people came with money and interests in the arts. By the mid–1930s, the area known as "Book Hill" filled with several small stores with independent proprietors that included grocery markets and a few antique shops. Years later, a store owner referred to the area as having a Parisian air and style.

Marcella Rodange Comes Winslow arrived with her husband from Pittsburgh. They settled in Georgetown and held salons that attracted many of the city's literary figures. A photographer and portrait painter, Mrs. Comes showed her works at the Little Gallery, and the National Portrait Gallery had her artworks in its collection. The Library of Congress made her the official portrait painter of the United States Poet Laureate.

The Little Gallery sat on the third floor of the Intimate Bookshop on O Street, near the main drag of Wisconsin Avenue. The proprietor of the bookstore, Mrs. D. C. Fox, exhibited younger Washington artists. Visitors walked through the sweet, aptly named store and climbed a tiny steep flight of stairs to two rooms under the eaves. The landscapes sold inside depicted familiar Washington scenes, such as a window in Georgetown and a snowy landscape in Rock Creek Park.

Mrs. Fox also thought about others in her customer base. She maintained paintings that customers rented for a nominal fee if they could not afford to buy one. These works consisted of mostly landscapes and portraits and were uneven in their quality. This attempt to build another market for the visual arts made sense. Besides Duncan Phillips and the Corcoran board, the collectors' base in the city proved small. Two of them ran antiques and curios businesses: Charles Lee Frank and Anton Heitmuller.[6]

German-born Charles Lee Frank came to the city from New Orleans in the early 1900s. An artist and painter, he bought a place on a hillside along Conduit Road. He

and his wife, Juanita, participated in the local activities of the Glen Echo neighborhood. Their passion for auctions and estate sales led to a house filled with object d' arte. This collection included curios, bowls, and *intaglios*, mostly from Oscar Wilde and Aubrey Beardsley's era. Frank owned several Washington-based artist Max Weyl paintings. Known for "his sensitivity to the beautiful," Frank made money buying and reselling art and antiques that the sellers evaluated incorrectly. When the widower died at 65 years old in 1938, his estate sales ran for three years.

Art dealer and historian Anton Heitmuller began life on the farm at N and Thirteenth Street in Washington, D.C. His dairy farmer father acquired the lots adjacent to his farm around what became Logan Circle. The large family prospered and eventually sold those lots for significant financial gain.

Anton stayed in the area, settling with his wife Dorothea in a house on Fourteenth Street near N Street. They participated in cultural life with membership in groups like the Columbia Heights Arts Club. Anton ran a family real estate business and started another "Specializing in Selling Collections of Autographs, Manuscripts, Historical Broadsides, and Curios." The range of items for sale included weapons, prints, letters, and pewter. Upon his death at 84, his collection took a year to sell.[7]

The first artist to show at the Little Gallery's opening in the fall of 1940 also served as secretary for the Washington Print Makers group. A Corcoran graduate, Marguerite Burgess, started the Print Makers group based on Cleveland's successful club. Akin to the Book of the Month clubs, the 150 artists produced a print a month

Charles Lee Frank, Untitled, 1927 (Smithsonian American Art Museum, Transfer from the Library of the Smithsonian American Art Museum and the National Portrait Gallery, Smithsonian Institution).

for subscribers. Their first exhibition occurred at the old Middlegate Mill in Fairfax County. Near the end of their first decade, the Society ingenuously used the money that it might have allocated as prizes to purchase two prints from their annual show. Selected by Society President Prentiss Taylor and the Library of Congress' curator of prints, Alice Less Parker, Jacob Kainen's aquatint *Marine Apparition* and Louis Schanker's color woodblock *Birds in Flight* joined the Library's vaunted collection.

Well-established by the 1950s, the group held its annual membership show at the American Institute of Architects building on New York Avenue and Seventeenth Street, around the corner from the Corcoran Gallery. The Library of Congress Prints Division regularly purchased prints from the annual show. By the 1960s, the yearly membership show occurred in various local galleries, including George Washington University's Dimmock Gallery. They featured two to three dozen artists who displayed etchings, silk-screen, mono-prints, and other styles. Over the last decades, the group grew more regional with annual exhibitions from Montgomery College in Rockville to Emerson College in McLean, Virginia.[8]

The Little Gallery lasted through the early 1940s, while its host, the Intimate Bookshop, remained in business through the 1950s. Its shows included young artists who attended courses at the Phillips and the Corcoran, including Mitchell Jamieson, Regene Putnam, and Bernice Cross. Jamieson exhibited watercolors in one of the gallery's first shows. When he returned two years later, the critics noted "that the artist was only in his early twenties and exhibited rapidly developing talent and technical equipment." Miss Putnam came from New England to Washington to study art, and she exhibited drawings, oils, and watercolors. A year earlier, Jane Watson Crane found that "the artist's use of charcoal as a medium allowed her to get a successful likeness in her portraits." Like the others, Bernice Cross had her first exhibit in 1936. When she returned a few years later, Florence Berryman noted the gay and elfin quality. She stated, "Miss Cross has had her work steadily develop over the five years showing at the Gallery."

Years after being in the Little Gallery group of artists, Jamieson and Cross both exhibited at the Franz Bader Gallery. Cross created a range of paintings, including floral and genre paintings of circus performers, African Americans, and characters out of fairy tales. Her work balanced realism and abstraction with a tilt to the latter.[9]

The Iowan won several awards while a student at the Corcoran. Cross opened a studio to teach art classes during the mid–1930s with her friend Julia Eckel. In her mid–20s, she married Phillips Collection curator James M. McLaughlin. The couple lived in an apartment in Dupont Circle, close to the art school and her husband's work. Later, they built an art studio in Arlington, Virginia, which both used until they divorced in the mid–1950s. She moved her studio to the 1500 block of H Street, N.W. After nearly a decade of teaching at her school, Cross moved on to teach at the Phillips school, the Washington Workshop Art Center, and a few colleges and universities.

Cross showed at the Whyte Gallery during the 1940s. Florence Berryman observed that Cross' youthful naiveté in her early paintings developed into a determined primitivism. For Jane Watson Crane, Cross always revealed a sense of humor even at her most profound. When the Phillips Gallery featured a show of the pair's works during the early 1950s, Crane labeled Cross a maverick because her style defied any school or category. "She seemed to marry irrational juxtapositions of the

Surrealists, the double imaging of Picasso with an elongated Gothic styling." Many of her subjects were gentle, heroic female figures. McLaughlin worked with the impressionist technique, preferring still lifes and landscapes in subdued colors. The influence of Bonnard and Vuillard appeared in his tilted perspectives and overlapping planes.

The region's critics called her a painter of fantasy. Her works had the unpredictable quality of children's drawings, indicating a spontaneous interpretation of actual events. Many appreciated her paintings as compelling in their intensity and honesty. She exhibited into the early 1970s and died two decades later, in July 1996, of heart ailments. The SAAM held four of her early 1930s paintings in its collection. The Phillips and the Barnett-Aden Gallery also owned a few of her paintings.[10]

While Cross continued showing, Ensign Jamieson served as a combat artist in the Navy during World War II. Jamieson painted convoy operations in North Africa and sketched the assault boats that landed on the coast of Sicily. After the landing at Normandy, Jamieson went to the Pacific, where he cataloged the Okinawa Invasion.

The Corcoran hosted a one-person show of Lieutenant Mitchell Jamieson's paintings and drawings entitled "War Journal." Two years later, his presentation at the Whyte Gallery met with great anticipation. The Guggenheim gave Jamieson a fellowship to turn his war sketches into paintings. Over 14 museums held these paintings in their collections. Leslie Judd Portner noted that his style seemed similar to his pre-war work. However, she thought that the later pieces were warmer in color, more thoughtful, and more considered in execution. Perhaps so, but years later, art historian Jonathan Binstock wrote that he viewed Portner reviews as "thinly opinionated and lacking rigor." Jamieson had another one-person show at Whyte in 1949.

Over the next decade, Jamieson regularly created sketches for the *Washington Post* and national magazines. *Life* magazine commissioned Jamieson to tour 17 countries. It became the basis for a new show. He sketched continuously and found "several places that knocked me for a loop visually and emotionally." For his piece *Calcutta: the River*, Jamieson described watching waves of people in constant motion. "It was an incessant movement. I wanted to get the rhythm and feel of the constant flow of humanity on the canvas." When he returned in the late 1950s, Jamieson taught in the University of Maryland's art department in College Park.

He continuously received various appointments by the U.S. federal government to complete work. These projects included painting portraits of the Roosevelts and a mural in the Department of Interior building. He was also the first official artist for the National Aeronautics and Space Administration's (NASA) Project Mercury. "I don't think I ever worked so feverishly," Jamieson recalled of his NASA work.

The Herndon, Virginia resident, accepted the Defense Department's invitation to serve as a civilian artist for the Army Office of Military History. The tour occurred in 1967. Jamieson made scores of sketches in one month abroad, then made hundreds upon returning home. He called these works "The Plague."

His perspective led him to criticize his university for suspending students in connection with antiwar demonstrations. His position led the department to delay his appointment to full professorship in 1971. Five years later, he shot himself to death in his Alexandria, Virginia, home. His long-time art associate Franz Bader showed several of Jamieson's last works where the Corcoran's curator of collections Edward J. Nygren saw them. "I looked at them, and I found that I was crying." Nygren

arranged to show the works at the Corcoran in late 1979. Richard wrote, "as it [the work] started darkening, as it lost its color, his art grew ever stronger."[11]

As the Little Gallery headed into its third year, two women thought Georgetown needed another gallery. In 1938, Theodora Kane and Bobbie Gladys Kerr opened Georgetown Galleries at 1324 Wisconsin Avenue, near the Intimate Bookshop. Kane studied at the Corcoran and had received honorable mentions in the student exhibitions in two different years. The pair arranged to show art in multiple rooms of the quaint townhouse. They intended to sell small pictures for the modern home—works of high standard and moderate price. As the Little Gallery had, the new venture featured one-person shows by local artists.

The Georgetown Galleries hosted a few exhibitions. One featured a visiting artist who was the sister of a notable pair of Washingtonians. The Ezekiels co-hosted the opening show of encaustic prints and paintings along with the two gallery patrons. Within a year, the gallery left Georgetown and settled in the southwestern section of Dupont Circle on Twenty-Second Street. During the summer, it held the second annual landscape exhibition for regional artists. Thirty-one painters submitted 50 works. This group included Kane and Kerr and the Society of Washington Artists President Mary Ruth Snow. The last show in the gallery featured three women artists.

When the Georgetown Galleries closed, Mrs. Norman Kane sponsored various exhibitions at Wesley Hall, 1703 K St, N.W. Theodora met Mr. Kane while studying in London while he was on duty with the Army. They traveled throughout Europe for a decade, spending most of their time in Vienna, Austria, where he worked, and Theodora exhibited paintings. Since living in Washington, she had studied at the Corcoran School of Art, worked in book jacket design, and ran the galleries.

Theodora Kane stopped painting and volunteered to work with the British Army Mission during World War II. When the couple returned to Washington in 1946, they moved near Lafayette Square. Theodora gave private art classes two days a week. "Mrs. Kane believed there was a bit of the artist in everyone who wanted to express themselves on canvas whether or not they had natural talent."

Kane resumed painting watercolors of harbors, street scenes, and flower studies that reflected a dashing, impressionist approach. She showed in Washington and New York and Lewes, Delaware, where they had a summer home. Woodward & Lothrop also commissioned her to complete 50 paintings to sell in their downtown department store. After her husband's death, she remained active teaching, painting at her studio, and sailing on cruise ships. At 72, she died in Lewes. According to critic Frank Getlein, "[Mrs. Kane] was the artist who paints pictures of things that appeal to that artist visually, with no thought of making a breakthrough in art history or even a shock to the bourgeoisie."[12]

Despite the short lifespans of the first galleries in the area, more galleries sprang up. Leslie Judd Ahlander noted that during the 1950s and 60s "Georgetown is now a hive of art activity with galleries running down Wisconsin Avenue and around the corner onto M Street." Three artists started The Town Gallery in 1954. They showed work that they appreciated, including a substantial print collection of contemporary works. Channell Gallery started on Wisconsin and moved to M Street. It showed various artists, including Europeans, such as Finnish impressionist painters. M Street also featured during the late 1950s and early 1960s the Hiratsuka Nippon Gallery. Run by Keiko Hiratsuka Moore, daughter of famous Japanese artist Un'ichi

Hiratsuka, the gallery showed famous Japanese printmakers and had a printing press to make art in the corner.

Two Georgetown galleries situated near Wisconsin Avenue on P Street lasted nearly two decades each: the Dickson Gallery and Obelisk Gallery:

Dickson Yates graduated from the Corcoran School of Art in the late 1940s. He maintained his interest in art as he worked as an assistant editor for *The George-towner*. The newspaper chronicled the activities happening in Georgetown, including fashion, business, real estate, politics, and bars and restaurants. The Baltimore native opened The Dickson Gallery on P Street started in 1959, and it ran through the 1970s. The space featured dark walls that gave it a personal quality, and the studio lights flattered the art. The gallery's first show featured an artist from Spain. During the early years, the gallery often showed various abstract works from Europeans.

One of local critic Frank Getlein's favorite shows at the gallery featured artist Newton McMahan. Getlein thought that his combination of traditional draftsmanship with contemporary textures worked well on some paintings and thought they sparked interest and excitement about what the artist made next. In the mid–1960s, Dickson exhibited Mrs. Shirley Aley Campbell's paintings depicting the female performers in a Cleveland burlesque theater. The pipe-smoking, sporty-looking man with the blond crew cut invited the performers from Washington's Gayety Theater to attend. The women mixed with the Congressmen and their wives present in the gallery. "The noise tended to disrupt a quiet viewing of the paintings," critic Nancy Moran noted. After closing the gallery Yates and his wife remained in Georgetown. He retired from the newspaper in 1986. Yates moved to Manassas and died at 85 years old in 2004.[13]

Obelisk Gallery owners Kathryn Eichholz and Janet Rubin spent their earlier years traveling and living in Europe. "In Europe, little people, big people, everybody goes to look at pictures," said Jennifer Rubin. "If more, small convenient galleries existed in this country, Americans would be apt to do same thing."

The pair converted a former private residence into the gallery because they wanted the visitor to feel like this space was their living room. The opening exhibit received sponsorship from the Italian embassy and showed both established artists and those whose work appeared in the country for the first time.

The gallery introduced Washingtonians to some of the many current trends in European art. This group included the postwar school of Paris art in 1953 and the Italian artists in 1955. On occasion, the owners even brought the artists over to Georgetown to meet with the gallery's patrons and discuss their work. In 1960, the gallery's sculptures of 20th-century masters' show featured nearly $150,000.00 worth of art on display. The offerings included pieces from Rodin, Degas, Giacometti, and Matisse.

Every one of the local art critics praised the gallery over the years. At the opening, Leslie Judd Portner called it a welcome addition to the Washington scene. Toward the middle of its run, a second saw the gallery as a major asset. Florence Berryman observed that the gallery served the city well in showing artists of national and international reputation in substantial exhibitions.

The gallery expanded beyond showing European-based artists. Two Washington–based artists Obelisk showed were William Walton and Wendy Burden. By the mid–1960s, the women closed the gallery. Mrs. Rubin worked in the cultural wing of

the State Department. Mrs. Eichholz had divorced her lawyer husband, married John Roper, and lived in Europe for much of her life.[14]

William Walton's career began as a journalist in Jacksonville, Illinois. After the Associated Press, he joined Time-Life and reported on several battles of World War II. After returning home, Walton edited a magazine in Washington. By 1949, he quit and picked up painting full-time. While many of his works were abstract expressionist in style, a more traditional landscape is in the Phillips Gallery collection. A show of his works at the Corcoran in 1964 featured bright and primary-colored arrows that critic Wolf von Eckardt thought were "distilled into utter simplicity to command movement."

As the Fine Arts Commission's chairman for over a decade, Walton influenced the city's historic landscape. He worked with Jacqueline Kennedy to force the restoration of the buildings lining Lafayette Square. He died of heart ailments in 1994.

The painter sold well at Obelisk and through other methods. Among the Washington-based collectors who owned Walton's work were the Stanley Woodwards, Mr. and Mrs. Robert Eichholz and the James M. Newmyers.

A lawyer and state department figure, Eichholz arrived in Washington during the 1930s and supported his first wife's ownership of the Obelisk Gallery. He married Mercedes Davidson in 1964, and the pair regularly collected local artists. Eichholz's stepdaughter Joan Davidson observed that Robert collected since his days in Europe. Some of the works he brought home included pieces made by Modigliani, Basque, and Picasso. "He had a very good eye," Ms. Davidson said while also stating that he was a wonderful man. The couple frequented Ramon Osuna's Gallery, and he steered them to specific artists. They have several Anne Truitt pieces and Tom Downing and Sam Gilliam paintings.

The pair participated with the Corcoran by opening up their house in the Georgetown neighborhood for art tours. While the Wilsons' collected drawings and post-impressionist paintings, the Careys had French Fauvists on the walls and several sculptures in a garden laid out by Lester Collins. The Kidders' new garden came from Edmunds and Hitchcock, and contemporary European artists made the works spaced around their house. The Louchheim, Jr.'s collected, contemporary American artists. By the mid–1970s, the Eichholzes moved out west. They continued to support local artists in their new home. Robert died in 1983. In 2011, they established the Robert and Mercedes Eichholz Foundation, providing grants to arts and arts education.[15]

While Georgetown proved a hub of art activity in Washington, one gallery moved to another neighborhood. In 1943, David Porter opened a new gallery with a friend in a Victorian house in the downtown shopping district on G Street, N.W., near Ninth Street. Many in the art circles thought the new partnership advantageous. Mr. Porter and Caresse Crosby divided their show spaces by floor inside G Place Gallery. Mrs. Crosby's first show featured contemporary surrealist painters. Porter continued showing the works of young painters from his native Midwest and the D.C. region, including the first "one-person" exhibitions of Jacob Kainen and Worden Day. They put on a fantastic display of African American painters and sculptors that Jane Watson Crane noted included work that was a decisive contribution to American art with its vigor and originality.

The pair closed the gallery for the summer of 1944, and it reopened as the David Porter Gallery. He showed a wide range of works from Ethiopian artists to Stuart

Georgetown Collections (Brian Kraft Maps).

Davis paintings and a group show that featured Henry Moore, Joan Miro, and Paul Klee. At the end of World War II, Porter moved to New York to pursue art and be closer to his abstract painter friends.

In 1944, Caresse Crosby opened the Caresse Crosby Gallery of Modern Art in Dupont Circle close to the Phillips. The place featured modern art from American and European painters, including the first Washington exhibitions of Romare Bearden. The international socialite initially named Mary Phelps Jacob, a niece of J.P. Morgan, left her child and proper Boston Brahmin first husband in the late 1910s. She married her second husband, Harry Crosby, and the pair became part of the "Lost Generation" in Paris during the 1920s. Besides creating Black Sun Press and writing poetry, the couple indulged their interests in hedonism. Scenes included taking opium and going to a significant society party bare-breasted while Harry wore a necklace of dead pigeons. They each had multiple affairs as well.

While opening galleries on and off for a decade, Caresse pursued other interests. She registered as a lobbyist to promote peace as part of the larger movement "Women against War." A women's peace army stationed on Israel's borders and the Arab nations solved the Middle East crisis. Caresse wrote an autobiography that discussed the range of personal exploits with her late husband, Harry. She pursued those interests during her years in Washington as she reportedly had an affair with Washington artist and American University professor Pietro Lazzari. Crosby moved to Italy, where she lived in a castle in the early 1960s. Mrs. Crosby died in 1970 at 77 inside her castle near Rieti, Italy.[16]

In 1938, while The Gallery of Modern Masters and the first two Georgetown galleries were the only places in Washington, two brothers arrived. James and Donald Whyte opened a bookstore and gallery up Seventeenth Street from the Corcoran. On the first floor was the bookstore run by James, who also ran a bookstore in St. Andrews, Scotland. Upstairs the small picture gallery had an attractive arrangement with neutral walls, simple furnishings, and excellent lighting. Donald had connections with the London firm Alex, Reid & Lefevre, a well-known art dealer, and the Bignou Gallery in New York. The first show featured a small but choice exhibition of paintings and pleased the local critics.

The gallery showed a range of art and appeared to have democratic leanings. The first show of its second year featured sculpture. The artist Jo Davidson showed

a sculpture of the Spanish Republican leaders' heads. They also tried to display local artists. One show featured Christmas paintings by members of Studio House Group.

After two seasons, the Whyte Gallery closed. Like the Gallery of Modern Masters, the exhibitions featured out-of-town sculptors and painters of standing and group and one-person shows of the best local artists. As a critic postulated, perhaps the Whyte Gallery catered too much to a more sophisticated clientele, and the prices were too high. Indeed, painter James Moser lamented that the city lacked the collector base for high quality (pricy) art in the early 1900s. However, by the 1920s, a collector base attended the Corcoran biennials.

James Whyte intended to run a new gallery in the old space. The new gallery planned to devote considerable attention to showing prints and drawings, art books, and rare books. The pictures and prints were moderately priced. The maximum for an oil painting might be $200.00, and pastels, gouaches, prints, or watercolors topped out at $50.00. Twenty-five paintings by local artists were sold during the Whyte Gallery summer exhibition, "The Washington Scene."

The newly reorganized Whyte gallery set out with this new approach. The gallery sponsored the works of Washington artists. James Whyte sent invitations to many painters in the region. Some of the best artists failed to submit, but pieces came from well-known painters Nicolai Cikovsky, Alice Acheson, Prentiss Taylor, and others. They also tried to involve the gallery visitor in the process. Everyone who visited voted for the painting they liked the best while providing reasons for their choice. The ballot drawn received $50.00 toward a piece of art from the show. The gallery also maintained some contemporary work from other artists for sale, including two Marc Chagall lithographs at $15.00 each, a Salvador Dali etching for $50.00, one Picasso etching for $35.00, and an Auguste Renoir etching for $5.00.

The gallery stayed timely in another manner. They held shows about events of the day. One exhibition called "The Contemporary Scene," featured over 30 painters commenting on World War II during the fight. As one critic noted, many new names appeared in the show, which generally expressed the war's influence as harsh, sordid, and repellent. The glimpses of humor were typically "sardonic." Whyte Gallery moved to more spacious quarters on Connecticut Ave, N.W., south of Dupont Circle in the area known as Washington's "Madison Avenue." This area served as the city's major arts district since the frame shops were there as well.

Despite some of these positive events, some financial pressures hit the store. As a result, the Whyte Gallery moved to a smaller location in the same area. The store's leadership reasserted its belief that there was a new generation of Washington artists coming along. These artists received not enough recognition and encouragement, so Whyte's held at least two shows during the season of Washington artists.

Thematic shows and a focus on local artists continued in the new location. One exhibition featured fifteen Washingtonians contributing glimpses of other countries. A critic complained that several of the works seemed not about a recognizable place. Another of these themed shows, "Fantasy," occurred annually. Composed of oils, watercolors, and tempera paintings, the 20 Washington and Baltimore artists expressed the theme through objects, symbols, and scenes, which enjoy widespread recognition as one man's fantasy. Horses, birds, and cows appeared in the majority of the paintings. Berryman observed "that one man's fantasy was another man's bore,

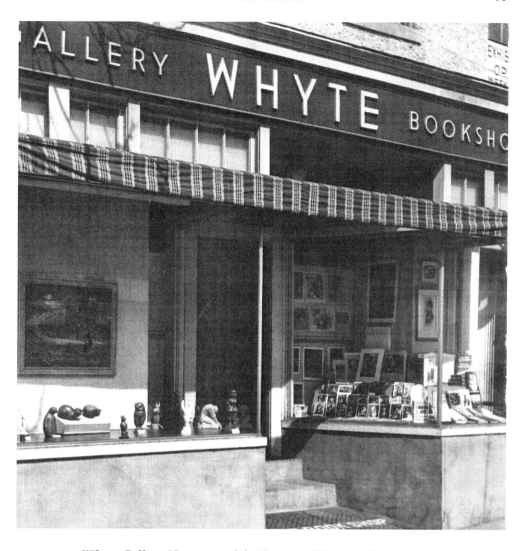

Whyte Gallery (Courtesy of the Franz and Virginia Bader Fund).

and it took a master of the genre to make the fantastic seem intriguing, beautiful, or grotesque."

The market for art in Washington, D.C., appeared steady if not superlative during the late 1940s. The Whyte Gallery sold over $2,000.00 in paintings during December, about $21,000.00 today. Most of the sales were pieces that cost $100.00 or less. These purchased items amounted to under $1,000.00 if bought today.

At the end of 1953, the gallery celebrated its fifteenth anniversary. American University Professor Sarah Baker complained that the *Washington Post* provided no coverage. Baker claimed the newspaper missed this milestone for a business that has been important in Washington, D.C.'s cultural development. The Whyte Gallery closed its doors in 1957. James Whyte retired to his summer home in Accokeek, Maryland, where the Oxford-educated historian wrote *The Uncivil War* in 1958. The book argued the Congressional abolition of suffrage and home rule within Washington, D.C., in 1874 happened because of its fear of Black voters. Whyte advocated and

struggled for years on civil rights and the District's Home Rule. He died of cancer in the summer of 1962.[17]

As Professor Baker pointed out, James Whyte's gallery had an immediate impact on Washington's culture. It offered a place for local artists to exhibit their works. The gallery sold a wide range of art styles to Washington's populous. The gallery's longest-term impact involved hiring Franz Bader to run the gallery. Bader became one of a few Washingtonians in the city's 1940s and 1950s art world who brought different groups of people together and broke down some of the city's segregation.

6

The 1940s

The Cross-Pollinators, Franz Bader and Barnett-Aden

Franz Bader lost his partnership with the significant bookseller Wallishauer. He could not sit on a park bench nor enter a restaurant or a movie. Local police detained him. After Nazi vandals smashed the shop windows of thousands of Jewish-owned stores, the only question was "*Where would he and his wife Antonia go?*"

England and Australia rejected his pleas for a visa. The dark-haired man with a high forehead and sunken cheeks scoured the telephone book at the American Embassy in Vienna, looking frantically for any last name close to his own. He found an American sponsor, but then her letter disappeared; bureaucrats questioned the validity of Franz's passport. The Baders had no visa to enter any country. The U.S. consulate was around the corner. "Let's try it on our way home," Antonia pled. They received the last two visas.

The Baders arrived on U.S. soil with $12.00. Franz wore a derby hat because he saw men wear such hats in the movies. In Washington, D.C., the Whyte brothers hired Franz as a book and art salesman. He quickly proved his worth, selling two Raoul Dufys for $250.00 each and a fair-sized Cézanne for $12,000.00. Quite the achievement for the Whyte Gallery. Bader became an assistant at the gallery in two years and assumed some of the art programming shown at the bookshop.

By 1948, Bader programmed the Whyte Gallery's exhibitions. He showed painters, including Robert Franklin Gates, Bernice Cross, Sarah Baker, and William Calfee. Other Washington–based artists, from painter John Chapman Lewis and printmaker Prentiss Taylor to Italian sculptor and painter Pietro Lazzari, received their most significant opportunities to date at Whyte Gallery because of Bader.[1]

Several of these artists moved with Franz Bader when he opened his gallery. Bader selected a location on G Street near Seventeenth Street, N.W., in Lafayette Square. The opening show featured artists with whom Bader had long-term relationships, such as Mitchell Jamieson, Robert Gates, Jacob Kainen, Prentiss Taylor, and Pietro Lazzari.

The first iteration of Franz Bader Gallery seemed more of a bookstore than a gallery. Portner called it a bookstore with art rather than an art gallery with books. Two-thirds of sales were art books, not artworks.

At Christmas time, Bader discussed an accelerating trend he observed toward buying original works. "Instead of paying $50 … for a well-framed Picasso print, people are finding that they can buy an original oil painting by a promising contemporary

artist for about the same amount of money," Bader stated. His gallery featured a Christmas exhibit emphasizing lower-priced items, including art books.

Personally, Bader had eclectic tastes that included figurative and abstract pieces. Artists came from all backgrounds and training. One year after opening, Bader showed watercolors of a Chinese artist. The gallery acquired 20 pieces of original Eskimo sculptures from Eskimo Art, Inc., and they went on view for a month. Another show featured German printmaker Johnny Friedlaender, whom the Nazis placed in a concentration camp for "denaturing" art. While in the camp, the artist painted portraits of Nazi leaders. Two years after being released, Friedlaender immigrated to France and served with the Resistance during World War II.

Bader Gallery also offered shows to newcomers and self-taught artists. This included Antonia Bader, whom a critic described as "a primitive stylist." Several of the notable collectors in the city had her paintings in their collections. Visitors included Mrs. Edward Bruce, Mrs. Marcella Dupont, Alice Roosevelt Longworth, and the Phillips family.

Franz and Antonia worked tirelessly, spending hours in the store. They brought art into the community. Franz assembled artworks from sixteen contemporary Washington artists for the Adas Israel Temple inside its recently opened auditorium in early 1956. The Baders frequently visited artist friends and encouraged new artists. The family-type network around them appeared when the Baders celebrated their 20th anniversary of living in the United States. Over 400 people filled the gallery. Several long-time friends provided new works to exhibit, including a "stunning" drawing by Pietro Lazzari.[2]

Pietro Lazzari joined the Italian Futurist art movement after World War I. His art experimented with the fragmentation of form and dizzying perspectives. "When the fascists began mingling with the Futurists, I left," Lazzari said. He took a job as an illustrator for the last anti-fascist newspaper in Italy. Lazzari left Rome for the United States in the late 1920s in his late twenties and landed in New York City. The short man with a big face and deep-set eyes joined up with an organization known as the Washington Square artists. He became an American citizen. He married Evelyn Cohen, a social worker and writer, with whom he had a daughter named Nina.

The family moved to Washington, D.C., during World War II. "How I happened to come to Washington was that I left New York because the war came, and I was the winner of these two murals [commissions in Florida and North Carolina]," Lazzari explained years later. Pietro joined Washington's Artists' Guild, begun in 1941, to work for the Allies in their war effort. Lazzari began teaching at Dunbarton College. His first appearance at the Whyte Gallery occurred in an Artists' Guild group show in 1943.

After joining the faculty in American University's art department, Lazzari received a one-person show at the highly influential Betty Parsons Gallery in New York. The press and public enjoyed the works and termed the show "explosive." Lazzari continued to show at Whyte's, including in the "fantasy" theme show where his three paintings featured horses. In two paintings, the horses appeared so abstract that they required a sharp look to find the animals. He also continued to show with Crosby when she had a gallery and occasionally at other places such as the Baltimore Museum and the Smithsonian. When Bader opened, he became Lazzari's dealer for drawings only.

Others acknowledged his artistic excellence. He received one of the first Fulbright grants to study abroad and went to Rome. "I used to ride out to Castelgondolfo to see the pope every day on the back of a motorcycle driven by a nun. I adore nuns. My sister wanted to be a nun," he roared. Lazzari returned and received commissions to sculpt heads of Eleanor Roosevelt, Adlai Stevenson, and Pope Paul VI. "Every time we had a commission we would go to Europe, spend all our money, and then come back and start all over."

Lazzari took his teaching to the Washington Workshop Art Center in Dupont Circle during the summer of 1954. The school held a retrospective that stressed the artist's historical development and versatility of means. Leslie Judd Portner called him a craftsman in the Renaissance tradition. She found the newest series of glassy cement fascinating, generating rich effects with the translucent material. Ever mobile, by the mid–1950s, Lazzari taught at the Sculptors Studio in Georgetown and exhibited his sculpture with the IFA Galleries in Dupont Circle. During the 1960s, Lazzari taught at the Corcoran school.

The artist continued to exhibit his drawings with Franz Bader. The *Post* critic continued to enjoy his work, "likening his drawings to spring freshness and charm." What especially stood out to this critic were apparent finger paintings done in Rome during the Ecumenical Council. "Walking priests represented as simple streaks of paint emerged in their flat hats and swaying robes. Flowers, music, landscapes seemed neither figurative nor abstract but evocative."

Although some of his artist friends, including Mark Rothko and Milton Avery, might be better known, Lazzari carved a niche. The artist remained an active member of most of the city's artist groups and continued his long association with Bader. In 1979, Lazzari died in Bethesda, Maryland. Major museums across the U.S. have his works, including the SAAM, which held drawings, a lithograph, a sculpture, and a painting in its collection.[3]

The Bader Gallery continued its long-time associations with many of its artists without using written contracts. A few artists moved on to other galleries or different cities over the years as they needed. Bader also hosted special exhibitions, like featuring the Washington artists selected to appear in various Corcoran biennials during the 1960s. It also staged autographing parties for famous writers, such as Dylan Thomas, Rachel Carson, and Aldous Huxley.

In the mid-1960s, the owners tore down the building where the gallery started, and the Baders established a new one at 2124 Pennsylvania Avenue, close to the West End of Washington. With high white walls, flexible modern lighting, and many levels, the new place showcased various art pieces. Frank Getlein stated, "The gallery has changed to an art gallery with books from a bookstore with art." The first show included 40 works in a variety of mediums by 40 different artists. The annual Christmas show featuring the artists associated with the gallery reminded Jo Ann Lewis of how many first-rate artists exist in Washington, of whom we hear relatively little. She suggested that readers go down to the gallery. Summerford, Jamieson, and Peter Milton, who sold pieces at Baders' for $300.00, sold pieces at a recent auction for $1,000.00. After half a decade of settling into the new space, the gallery suffered a significant change. Antonia Bader died in 1969.

Within two years, Franz married Virginia Forman. The pair traveled extensively. His photographs from these trips appeared at the Corcoran, the Phillips, and

elsewhere. Morphing into "the granddaddy" of gallery owners, Bader grew a long beard and looked gnomish. A young girl who walked into the gallery looked shocked after a glance at Bader. She whispered into her father's ear. The father laughed and translated, "She thinks you're God."

Bader continued to show art that might be called traditional modern, established in various post–Impressionist schools. "I am here to sell paintings if I believe they are good and honestly painted. I could make a better living selling cars. But I'd rather encourage artists." New styles in visual arts emerged. Different critics provided coverage, and they and the gallery didn't always concur. In the late 1960s, Paul Richard noted, "Of the scores of artists now in the Bader stable, Peter Milton and Mitchell Jamieson are among the few who have moved the author deeply."

As Bader neared retirement, about 135 galleries existed in the Washington metropolitan area, quite a change from the handful when Bader arrived. The city named

Franz Bader (Courtesy of the Franz and Virginia Bader Fund).

September 19 Franz Bader Day. He died from a pulmonary embolism in 1994, almost a decade after retiring.

In 2001, Virginia Bader established the Franz and Virginia Bader Grants. Artists who lived within the metropolitan D.C. region and were at least 40 years old applied for a grant. Among the artists receiving the award were Alex Kanevsky, Steven Kenny, the late Kevin MacDonald, and Susan Moore. The fund distributed over $185,000.00 in nearly two decades. Both American University and George Washington University have shown works from the artists whom the fund has supported. The resources behind the fund ended in the late 2010s.[4]

One of Bader's group from the Whyte Gallery days was the artist and educator Prentiss Taylor. The Washington native left his segregated hometown and ventured to New York City during the Harlem Renaissance. He was black-haired, with thick eyebrows, a long face and a lean torso. Taylor's friends included Langston Hughes, Zora Neale Hurston, Carl Van Vechten, and Aaron Copland. With Hughes, he created the Golden Stair Press. The company issued books and broadsides with Hughes' text and Taylor's illustrations reflecting the Harlem Renaissance's ideas. His friendship and love affair with Copland during the spring of 1929 ended when Copland moved to France in 1930.

Taylor took art courses and continued producing drawings and lithographs. He and Hughes again combined for a booklet that documented the injustice with the famous Scottsboro Boys case. Two years later, Taylor had lithographs in group shows at various galleries around Manhattan. Soon he shared shows with only one other artist. The Whitney Museum purchased a few of his lithographs and included him in a few of their annual shows over the next decade.

In early 1935 Taylor returned to Washington and received a prize for the top lithograph, drawing, and etching in the Greater Washington Independent Art Exhibition competition. His "Experience Meet Massydony" featured a black church's interior with the members stirred to enthusiasm. Later that year, the Corcoran held a special exhibition of watercolors and lithographs. Mechlin observed that while Currier and Ives influenced Prentiss, his work displayed originality and his gift.

While teaching a single course at the Phillips' Studio House, Taylor continued to exhibit. After a show of his works at the Baltimore Museum, Prentiss showed at the Studio House with another instructor. Mechlin expressed several negative thoughts about Taylor's choice of subjects. An ugly double-wide New England house was a waste. Depictions of Black life, religious gatherings treated in a semi-comic manner, might have been exceedingly well done, but they were unimportant.[5]

With the arrival of World War II, Taylor served as president of the Artists' Guild. He joined St. Elizabeth's Hospital Psychiatric Institution as an art therapist and wrote an academic article on art as a therapeutic device. He moved on to the Chestnut Lodge in the suburbs and worked there for another twenty years. Meanwhile, Prentiss continued teaching and showing art. He served as president of the Society of Washington Etchers and the Society of Washington Printmakers for many years. The local scene knew Prentiss as very unselfish and helpful.

Taylor showed at Bader's in group shows where his lithographs sold for around $20.00. His first solo show in several years came four years after Bader opened. Portner enjoyed his watercolors and drawings but thought Taylor best as a printmaker, a

master drawer in black and white. A few years later, Getlein called Prentiss an "old Washington hand." He thought watercolors and drawings were apt mediums for Mr. Taylor's accurate and sensitive compositions of scenes. These included depictions of industrial Georgetown and the brightly colored, boldly designed watercolor of a 1940 May Day parade in Mexico City.

As Taylor showed at the Bader Gallery over the next 20 years, the next generation of local newspaper critics saw his work, and most enjoyed it. Richard argued that Taylor's work has grown stronger over the years. Benjamin Forgey called him "a virtuoso talent with a penchant for strong, picturesque views that enabled him to contrast light and dark, something at which he excelled." In his 80s, Taylor attended a retrospective of his print works at Georgetown University. He died at 83 in 1991. Museums with his art included the Whitney, Metropolitan Museum of Art, the SAAM, and the Phillips Collection.[6]

Taylor showed a few times in group shows during the mid–1940s with a Black gallery in Washington. One exhibit featured Taylor's work with the art of two professors from Howard University, becoming one of the first times that members of the two races exhibited in the same show in Washington.

The Barnett-Aden Gallery started in 1943, the brainchild of Howard University art department chairman James V. Herring and his former student Alonzo Aden. Both men began life in South Carolina, but their families packed them off to live with relatives in Washington, D.C., to improve their chances of doing well in life. Herring attended Howard Academy, a preparatory high school within the university, and received his introduction to art at the Corcoran. After attending Syracuse University, Herring traveled, then taught for one year at a small college. A dapper, aggressive, young black man, Herring took a teaching position at Howard in the architecture department but already foresaw how he would create an arts department. The curriculum emphasized the study of all art, including African art. Student Alma Thomas characterized Herring as having a great vision in art. "He was a great humanitarian who not only encouraged his gifted students but also took a personal interest in their struggles to raise themselves above their handicaps."[7]

Nearly twenty years younger, Aden completed Armstrong High School; he eventually enrolled at Howard at 21 years of age, in 1927. Two years into his studies to become a teacher, Alonzo also worked as an elevator operator and shared an apartment with Herring. His interest in art history grew. Herring generated interest among the top leaders who convinced the board of trustees to establish a Howard University gallery. The gallery formally opened in the spring of 1930. Mrs. Avery Coonley provided a fund of $1,000.00 "to make revolving exhibitions of contemporary arts and crafts available for immediate visitation and appreciational [sic] study by students of the University."

Aden started as Herring's gallery assistant when the gallery opened on the first floor of Howard University's Rankin Memorial Chapel. The gallery immediately grabbed attention. A *New York Times* art critic stated, "Never until now has there been such a place where Negro art students have had the opportunity to study on such a large scale within the walls of their own institution."

Their initial success spurred them to invest more of their energies into the gallery. Aden took specialized courses in museum management and made an intensive study tour through the world-renowned European museums and small galleries. The

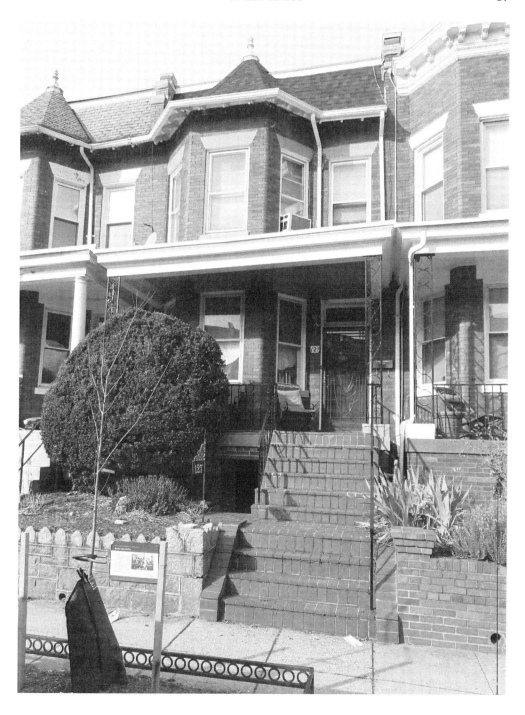

Barnett-Aden Gallery (Courtesy of the Photographer Ira Tattelman).

gallery attracted to the school exhibits of fine artists and also people of national and international reputation. Despite the city's deep segregation and definite limits on African Americans' activities, the gallery received coverage from the "white" newspapers. A few politicians and members of the city's art world attended openings, such as

several shows featuring international artists or Howard's professors of art during the 1930 and early 1940s.

Aden successfully enhanced his career training and his professional network during this period. He received foundation grants to complete a museum course and a sixteen-week apprenticeship in the Visual Education Department at the Buffalo Museum of Science. He participated as a curator for other exhibitions, including the United States Department of Commerce's show on Negro Life. Local art contacts came from American Federation of Art meetings and the "curatorial lectures" he gave for the National Gallery of Art. The College Art Association recognized Herring and Aden's work by holding its prestigious annual conference at Howard.

In the middle of World War II, Alonzo Aden resigned after nearly 12 years in his position. The "white" dailies ignored it. Howard University documents contained nothing regarding his reason for leaving. However, Washington's African American daily asked Howard's secretary if Aden faced "moral turpitude" charges. The Secretary of Howard refused to address the question. But African American people and some in the arts knew that Aden and Herring lived together for years. It was also widely known that his interest in other men continued. Some have suggested that an embarrassing indiscretion on the part of Aden led to his departure from Howard.

The pair realized that their combined skills could operate a gallery. They selected their home at 127 Randolph Place, N.W., as the location. Taking its name from Aden's parents, the Barnett-Aden Gallery opened in October 1943 and became one of the nation's first Black-owned galleries. The first exhibition featured 50 paintings, mostly by Black artists. It also included works lent by The Phillips Collection, the Whyte Gallery, and the American Federation of the Arts. Called "American Paintings for the Home," the show fulfilled one Barnett-Aden mission, to encourage homeowners to purchase art.

The pair had a related mission for its non-profit gallery, creating an appreciation for art within Washington, D.C.'s Black community. Herring and Aden had similar ambitions for their gallery that the frame shops and the Society of Washington Artists had for the city's Caucasian population. One significant difference stood out. Barnett-Aden also sought to integrate the Black artist into the Black community and the arts community.

As cars pulled into the quiet residential street, some neighbors grew concerned. What business operated from a small house where people walked in the front door then left shortly afterward? The residents suspected the owners might be running the "numbers." But the cars were expensive, and some of the visitors were white. The mysterious activities continued to the anniversary party. The neighbors looked out their windows, and surprise, the First Lady, Eleanor Roosevelt, exited a limousine. Several of the women donned their fur coats and showed up at the door of the house. Herring met them there and promptly turned every one of them away. "Now you don't want to come in here. This is a numbers house—the president's wife is in here playing numbers!"

Besides Mrs. Roosevelt, other political and literary figures and artists attended the openings. The art covered the white walls. On the furniture sat vases of fresh flowers. The dining room table had a spread of food. The guest book lay on the distinctive round desk.

The Barnett-Aden Gallery never intended to be a solely Black gallery. Shows

Alonzo Aden with Eleanor Roosevelt at the Barnett-Aden Gallery (Moorland-Spingarn Research Center, Howard University, Washington, D.C.).

featured the best works of local and national artists of all races. The gallery featured a vast range of styles, from conservative and representational to strikingly modern. According to Alma Thomas, "Herring left the management of the Gallery to Alonzo Aden, who proved to be a most successful curator." Aden accomplished all the associated tasks while also curating shows at places from Spellman to the Tuskegee Institute.[8]

The Barnett-Aden offered a range of shows during its first few years. In the winter of the first year, they showed Midwestern painter Chet LaMore, who had created color woodcuts and lithographs of city scenes and some social commentary. This exhibition featured some satirical, brightly colored scenes. *Memory of a Sunday Afternoon* depicted a woman in an idiotic hat. A bird sat atop her escort's hat and stared at the beautiful array of feathers in the woman's hat. The gallery held an exhibition titled "Negro in Art" in early 1944, a few group shows, and the aforementioned Prentiss, Jones and Porter exhibition.

Boston native Lois Mailou Jones came from middle-class origins, and her parents encouraged her artistic pursuits. While staying in her parents' summer house on Martha's Vineyard, Lois met artists who influenced her artistic endeavors. The island community gave the 17-year-old her first solo show. At 23, she completed a graduate degree in design and then taught at a prep school. Herring recruited her to

join the art department at Howard in 1930, and she remained there until her retirement in 1977.

After an initial influence from others in the Harlem Renaissance, Jones received fellowships to study in Paris. She found fellowship and professional success. Painter Celine Marie Tabary proved an inspiration and a long-time friend. While there, Jones completed many watercolors, and her 1938 oil painting *Les Fetiches* became a notable piece in Black visual arts during the era.

The petite woman returned to Washington and joined artists groups. She brought quick answers, flashing bright eyes, and a smooth, brown face as she exhibited with the Landscape Club and Society of Washington Artists. Her works in these shows often won awards and often received praise from local critics. In early 1941, Jones and Tabary circumvented the Corcoran's racism in the biennial by hiding the identity of the artist from the selection committee. She soon joined the Washington Artists Guild and its war effort.

Post-World War II, Jones continued showing her works in Washington galleries. During one of her regular appearances at Barnett-Aden, she received a flattering article and review in the *Post*. Florence Berryman praised her work from Paris as "thoughtfully organized and profound," while some of her newest creations, such as *Liberian Abstraction*, "had fresh colors and unusual surface textures." Jones received her first solo show in Washington at Whyte Gallery in 1948, and her works appeared in exhibitions around the nation as well, including in New York. She also served as a role model for her Howard students and others interested in becoming an artist.

Jones continued finding new things to express and ways to do so. After discussions with fellow faculty member Alain Locke, some of Jones' paintings focused more on the African American experience. While walking U Street, N.W., a Black area of segregated Washington, Jones envisioned a lynching. The scene became the basis for *Mob Victim (Meditation)*.

Miss Jones exchanged over 20 years of correspondence and personal time with Louis Vergniaud Pierre-Noël, an artist from Haiti. They married in the mid–1950s. This artist motivated Jones to use brighter colors and a more expressionistic style. One historian argued that these oils and watercolors became the most widely known and popular of all her works. She began showing some Haitian ceramics and her paintings at Howard's gallery in the mid–1960s.

After showing less frequently for several years, Jones received a few retrospectives during the 1990s. In 1990, Meridian House featured works that led Paul Richard to conclude that Jones' development as an artist appeared to be inseparable from her evolution as a person. He preferred the paintings after Haiti, arguing that they contained interesting subjects and vocabulary to depict it. Mid-decade, Jones appeared in two locations: Fondo del Sol Visual Arts Center near Dupont Circle and the Howard University Gallery of Art. She attended the opening of the former, which also featured 65 paintings from her very successful students. David Driskell recalled his experience with Jones. "She used to take us outside, down streets in Georgetown to paint, so we could pretend to be in France. But long before it was fashionable, she was teaching pride in the African heritage."

Fifty years after winning an award through necessary subterfuge, Jones received a retrospective at the Corcoran. Called "The World of Lois Mailou Jones," the show featured 65 works of the 92 shown at the Meridian. Lee Fleming thought "the show

lacked some important works and failed to place her in the larger art world's history. The decision to not hang the show chronologically deprived the viewer of seeing Jones' development."

Lois Jones died in 1998, at 92 in her Washington home. She thought her passion for painting kept her alive. "You have to find something in life that you love doing," she said a few years earlier. Among the museums holding her pieces were the Hirshhorn, Phillips, SAAM, the Boston Museum of Fine Arts, and the Metropolitan Museum of Art in New York. Her adopted city named a street in her honor in the Petworth neighborhood above Howard University.[9]

Despite attracting so many notable artists, Aden and the gallery faced lean financial times. His mother, Naomi Aden, a teacher in South Carolina and Washington, D.C., schools for many years, gave her son a $1,000.00 gift. A few years after Naomi's death, Alonzo explained, "She was not convinced I was doing the wise thing. She said that in the event that I become sane, I can put the money into war bonds."

During the mid- to late-1940s, the Barnett-Aden Gallery rotated exhibitions featuring individual artists, groups, or centered on themes. Among those artists with individual shows were James A. Porter, Charles White, Benjamin Abramowitz, and Elizabeth Catlett. Group shows featured some of the following Washington, D.C., artists: William Calfee, Jacob Kainen, Pietro Lazzari, Jack Perlmutter, and John N. Robinson.

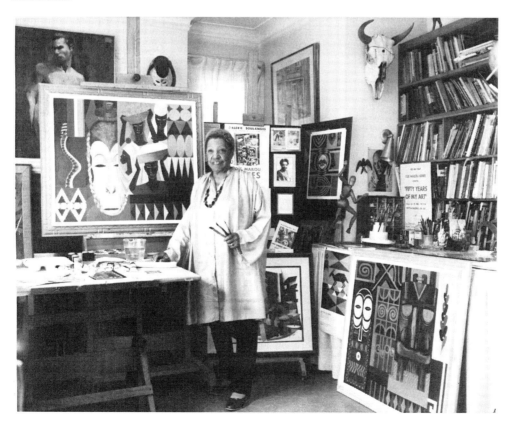

Lois Maliou Jones, Painter (Moorland-Spingarn Research Center, Howard University, Washington, D.C.).

The theme shows offered creative opportunities. The third-anniversary exhibit featured 22 gouaches by Jacob Lawrence of John Brown's struggle to end slavery. Florence Berryman argued "that Lawrence's paintings were a strongly individualistic way to tell stories and convey messages." She perceived that his series implied that all races must work together to create a better world. Aden got the show from the American Federation of the Arts, which circulated it throughout the country. Another showcased a portion of the art that the Herring and Aden purchased over the first five years. Contemporary religious painting offered the Barnett-Aden the chance to zero in on a narrower theme than the group modern painting shows.

Another theme show featured contemporary works from artists living in Washington, D.C., and New York. The exhibition included 20 pieces, and ten came from the gallery's permanent collection. These purchases made Barnett-Aden very different from other galleries. After the first ten years, the Barnett-Aden collection comprised 50 oil paintings, 30 watercolor paintings, 50 prints, and 15 sculptures. Herring and Aden occasionally purchased modestly priced works, and artists later donated pieces in appreciation of the gallery and its collection.

Perhaps that purchasing added to those financial pressures on Aden and the Gallery. Herring retired from his position at Howard. However, he continued operating a non-profit called the College Art Service, which circulated traveling shows to small colleges in Southern states that otherwise could not afford to have them. Aden took jobs in the government to keep himself and the gallery afloat. "I can't give it up. Sometimes when I get real depressed I think of running away and getting a job, but I can't do it." Eventually, Aden started a gift shop on Florida Avenue that ran for several years. He successfully moved the shop into the gallery, with the profits going to support Barnett-Aden.[10]

The pair continued purchasing art that they enjoyed. They bought several works from long-time Washingtonian Alma Thomas. She recalled always being inspired by nature, reflecting the beautiful flowers from her early childhood. In the early 1900s, her family moved from Columbus, Georgia, to Scott Circle in Washington. Her businessman father and teacher mother sought to escape the growing violence of the Deep South. She finished attending high school in Washington.

Thomas graduated from Herring's art department in the mid–1920s, the first Black female to obtain a bachelor's degree in art. After teaching in elementary school in the city and Wilmington, Delaware, Alma Thomas settled in as the art teacher at Shaw Junior High School for 35 years. Miss Thomas founded the first art gallery in D.C. public schools to educate Black children in the arts. She devoted thousands of hours to other art projects for Black youths. Looking back, she offered this explanation. "I've never bothered with grown-ups much. I never married. I couldn't be hemmed in by anybody.... I stopped having boyfriends because I could never find one who could fit in with my life. It was the children, the needy and the galleries."

Her connections with the owners of Barnett-Aden Gallery spurred her decision in 1950 to become an artist. While taking art classes at American University, Alma became more inspired to paint. Forgey observed years later that Thomas learned the painterliness of the American University people and the color consciousness of the color field painters.

Two decades earlier, the Washington newspaper critics noticed her talents. At a group exhibition of paintings at Barnett-Aden, Berryman considered her work

the best of the six young Washington, D.C., artists. Aden chose to exhibit some of Thomas' work on several occasions at the Dupont Circle Theater Gallery, where the critic called them vital pieces. Hers shined as the best during an exhibition composed of works by Washington's art teachers inside the Zeta Phi Beta Sorority in Dupont Circle during the early 1960s.

By the mid–1960s, Thomas exhibited with Franz Bader's Gallery. Forgey admitted that he was not familiar with Thomas' work. He admired how her adoption of abstract painting enabled her to express her delight in nature. "A painter is always inspired by what he sees and hears in his daily life," the 77-year-old observed as an explanation of how she translated mosaic images of the sun streaming through her window into abstracts.

By then, Howard University, George Washington University, the Corcoran Gallery of Art, the Smithsonian American Art Museum, and the White House all owned her works. The National Gallery of Art accepted a gift from collector Vincent Melzac of her painting *Red Rose Cantata*. At the same time, a foundation purchased *Red Rose Sonata* for the Metropolitan Museum of Art.

Into her 80s, Thomas kept very active. The house she shared with her librarian sister contained bright aqua-colored walls and paintings stacked in every room. Thomas painted her walled garden and admired the crape myrtle inside it. "You never feel like you are in the slums," she observed. At the Whitney one-woman show, she saw the 19 large acrylic paintings and six watercolors and stated, "My children look good here. I wish they could stay in this big place." She died two years later at age 82.[11]

Unfortunately, Aden enjoyed few of these events. He died suddenly in the fall of 1961. Coincidentally or not, the Washington art community held a tribute to Aden six months before he died. The Associated Artists' Gallery put on an exhibition that included 40 painters and 20 sculptors, many of whom knew Aden well. Droves of art fanciers and artists attended, including Secretary of Labor and Mrs. Arthur Goldberg, Mrs. Dean Rusk, and others. "This is an experience I didn't anticipate, and because it comes from another gallery it's doubly felt," said a slightly overwhelmed Aden. Curiously, the article failed to mention Herring.

After Aden's death, Herring and Aden's friends held the last exhibition Aden planned for the gallery, seeing it as a fitting tribute. The newspapers included short pieces in their arts sections that emphasized his life's work. "Many a young colored artist would never have had a chance to prove themselves if it hadn't been for him," said artist David Driskell. Driskell took over as interim director of Barnett-Aden for one year before taking a full-time college teaching position. Although elderly, Herring tried to maintain the gallery over the next few years. His age and increasing illness forced him to choose to close it. Herring died in 1969. His young friend Adolphus Ealey became heir to a large part of the gallery's collection. The sculpture went to Dr. and Mrs. Cecil Marquez. Herring's books, graphic arts, and prints went to Dr. Felton J. Earls.

Ealey focused the public attention on the African American artists in the collection. His inheritance occurred during the Black Power movement when self-definition and cultural separatism motivated many younger Black artists. He exhibited the collection at the Corcoran and at a Philadelphia museum for over a year. Despite these exhibitions, Ealey could not find a Washington area institutional home. After twenty years, Adolphus Ealey sold the Barnett-Aden Collection for $6

million. A Florida education group purchased the artworks and housed in a gallery called History Through Art based in Boca Raton. The Florida Education Fund planned to use the space to increase awareness of Black art. After a few years, the group recognized that the display and maintenance of the art added $4.5 million to the cost of keeping the collection. The group's board recommended that it sell the collection.[12]

Black Entertainment Television mogul Robert L. Johnson purchased the collection for an undisclosed amount. He brought the artworks back to Washington. "I want it here in Washington. I've got to figure out where to put it." The nearly 270 pieces of both nineteenth and twentieth-century art now received professional storage. In 2009, the Hemphill Gallery curated a show called "A Homecoming Celebration," which featured some of the Barnett-Aden collection. Michael O'Sullivan stated, "[The collection] makes for a virtual who's who of 20th-century black art." It held other artists active during the mid–20th century too. Many of these artists taught and created at the Washington Workshop for the Arts in Dupont Circle.[13]

7

The 1950s

The Workshop Center of the Arts

Music played as you walked inside the aging, stately mansion. Instead of the stringed quartets that once played for royalty, you heard someone learning a pop song on a guitar. The ballroom once housed cotillions for Washington's elite earlier in the century. Later it was filled with the World War I servicemen and volunteers whom Mrs. Thomas Walsh invited to the ballroom for the "2020 Dancing Classes." Now government workers, homemakers, and retired police officers leaped across the floor, trying out the basic steps of modern dance inside 2020 Massachusetts Avenue, N.W.

Once the costliest house on "Millionaires Row," in the 1900s, Colorado mining magnate Thomas Francis Walsh's estate contained 60 rooms and the most magnificent ballroom imaginable. The Irish American's lavish spending in France earned his nickname, "Monte Cristo." His only surviving child, Evalyn, married newspaper scion Edward Beale McLean in 1908. Walsh presented the new bride with the Hope Diamond as her wedding gift. In two years, Mr. Walsh died. His widow lived in "2020" as the family called the house until she took a suite in the Mayflower Hotel in 1929, three years before her death.

Evalyn followed her mother's pattern at the onset of World War II. She allowed Finnish-American groups to use her house. She offered the fourth floor of the mansion to the Red Cross, which established a surgical dressings unit when London came under siege in 1940. Mrs. McLean lived elsewhere.

With the close of the war, Mrs. McLean received an offer from the Washington Workshop Cooperative to use the mansion for its artistic endeavors. Painter Leon Berkowitz, wife poet Ida Fox, and friends "often deplored Washington's lack of cultural activities." They started the Workshop Cooperative in the Department of Agriculture to show classic movies and provide two art courses to a half dozen members.

Berkowitz studied at the University of Pennsylvania, earning a bachelor's degree in 1942. He continued his studies in New York and several other major cities in the world. After serving in the Army in Virginia, the man with busy eyebrows, large ears, and half head of hair came to D.C. to start a teaching career. "Mr. B" or "Berserkowitz"—depending on the speaker's type of affection for him—taught painting and other arts to high schoolers at Western High and later college students at the Corcoran School of the Arts and Design.

The ever-smiling man possessed a certain aura that made people feel welcome. As the Cooperative transitioned to a school, it took on the name Washington

Walsh-McLean Mansion Central Hall (HABS/HAER Collection, Library of Congress).

Workshop Center for the Arts (WWCA). Within two years, the group had nearly 200 students taking once-a-week evening classes in painting, sculpture, and creative writing for a $5.00 membership charge. The students came from day jobs as doctors and government workers, doormen and janitors, and had fun. Most of the

hundreds of students decided to find a "little bit more from life" than the daily routine. The Workshop's advertisements promoted the idea of taking courses to develop a hobby.

The WWCA drew students back after they tried their first class. One member of the family brought others to future courses. Mrs. David Pepper had recently had a daughter and decided she wanted to do something else, too, so she signed up for an art class. She convinced neighbors to join, and soon her husband didn't want to be left out. Mr. Pepper then rounded up other engineers from his work at the Navy Department's Bureau of Ships. Leon Berkowitz commented that this happened a lot among members. "Many of the students have taken to collecting artwork," Berkowitz noted. Berkowitz prided himself that the Workshop has "increased the paying audience for arts of all kinds in Washington."

Some students expressed surprise after taking the courses. Elliott Fineman, a Workshop protégé, discovered he had a latent talent for sculpture. Public relations man Gene Davis worked for the American Automobile Association. After taking Workshop courses, Davis rose at five in the morning to start painting. Within his first four months of painting, Davis made a sale at one of the Workshop's Open Houses. Davis painted six canvases in 24 hours, "inspired by the fact that someone had bought one of my paintings."

The WWAC hired many local artists to teach. Ben Abramowitz, Jacob Kainen, Marguerite Burgess, Jack Perlmutter, Lilli Gettinger joined in the early years, with Morris Louis, Kenneth Noland, and Pietro Lazzari coming later. Each semester began with group shows of the faculty's latest work, and many participated in the regular auctions held at the Center.

The vast majority of the proceeds from sales went to the Workshop's efforts to purchase a new home location. By 1951, the search became urgent as the Indonesian government purchased the Walsh mansion for its embassy. The Workshop acquired a colonial brick structure at 1300 New Hampshire Avenue, N.W. It had 17 rooms that held classes. Plans called for an open art gallery, coffee bar, and a lounge. The need for an infusion of funds from auctions continued after the purchase of the building. The Center battled accumulating debt over the last five years of its existence.[1]

The auctions and shows provided an excellent opportunity for faculty and students to exhibit their works. These shows featured roughly two pieces from each of 40 artists and filled the exhibition galleries on the Walsh Mansion's first and second floors. Themed shows offered faculty and students a variety of opportunities. Sometimes, shows featured new works only. Other times, shows required one old and one new piece, highlighting comparison and illustrating changes.

The Center received support from art-loving Washingtonians who bought pieces for their homes. Notable Washingtonians served on the board for the Workshop. These included socialite Mrs. H. Gates Lloyd of Philadelphia and Washington, Mrs. Hugo Black, the wife of the Supreme Court justice, and the wife of millionaire builder and real estate magnate, Mrs. Maurice Cafritz.

Washington society's commitment to the Workshop extended beyond board membership. It helped raise money and volunteered the time to create and run events to benefit the school. Notable figures included Mr. Frank R. Jelleff, the owner of a highly fashionable and successful women's clothing store, Mr. Charles Seymour, Jr., an art historian, and Mr. Herman W. Williams, the director of the Corcoran gallery.

The presence of all these figures brought a great deal of publicity to the WWAC's endeavors.

The best efforts of these people helped the Workshop school continue until 1956. Luis L. Tolman, president of the board of directors, said, "The Workshop cost $12,000 to run, and its income was only $10,000." Despite all the bazaars, paintings sold, and possible funding from foundations, the money never proved to be enough. Indeed, the building needed repairs, and that added a cost of $10,000.00. Without the repairs, the Center could not use the upper two floors. The income from rent to artists and dance groups never materialized.

With the Workshop's end, its leaders took a sabbatical from Washington. Leon Berkowitz and his wife Ida Fox spent much of the next decade traveling and living abroad, primarily in Spain and Wales. When the pair returned to the city, one workshop instructor had recently died, and his paintings skyrocketed in value.[2]

A shy, lanky native of Baltimore, Morris Louis Bernstein studied at the Maryland Institute of Art. After graduating, he worked for the Federal Arts Project in New York. Louis arrived in Washington with his wife in 1948 and settled on Legation Street, N.W. He lived for painting. Every morning, Louis rose early and worked through the day in a small first-floor room. Louis generally painted cubist and other reigning styles. He made art with such exacting discipline and seriousness that he abided only those with a similar approach fit.

His initial forays into the D.C. art world proved fitful. Alonzo Aden, of the Barnett-Aden Gallery, disliked Louis' neo-Cubist and linear abstractionist style and rejected the first pieces the artist showed him. However, Louis won the Best Modern Painting prizes from the Baltimore Museum in 1949 and 1950.

By the early 1950s, Louis began teaching at the Workshop and showed there. Workshop's exhibitions featured individual faculty members and group shows that received extensive coverage from the local newspapers' art critics. In one of the first group shows, critic Florence S. Berryman thought most of the work felt challenging. The critics thought overall the pieces in the group show were substantial. Morris Louis and Kenneth Noland's abstractions were dubbed "immediately interesting." Jacob Kainen and Berkowitz were both highly competent artists and represented by beautiful works. However, critic Leslie Judd Portner observed that "both have work that sometimes lack [sic] poignancy and emotional impact."

The city's critics expressed strong opinions. Portner wished that the Center's teacher and painter Marguerite Burgess "would force herself into work with a stronger statement." The artist who showed at the Little Gallery in Georgetown got married to magazine publisher Arthur J. Clawson. She converted the garage of their Glen Echo house into her studio. While raising one girl, Mrs. Clawson Burgess illustrated cookbooks, designed dress materials, and has completed a children's book. She exhibited at the Chicago Art Institute and the American Painting Today Exhibition at the Metropolitan Museum of Art in New York.

The Center's cross-disciplinary nature and the faculty's sharing sparked the Washington Color School painting style development. Berkowitz, Morris Louis, and Kenneth Noland made a now-famous trek to Helen Frankenthaler's New York studio in 1953, where they encountered the technique of staining canvases with heavily diluted paint.

On the trip, Noland introduced the others to New York art critic Clement

Greenberg. Greenberg took an active interest in the work of Louis and Noland. Louis began painting enormous canvases, some as large as seven feet by thirteen feet. Many of these ended up rolled up and stored down in the basement of their house. In January 1954, Greenberg visited D.C. to see Louis and Noland's recent works for the Emerging Talent Show appearing at the Kootz Gallery in New York City. He liked a few of the thirty pieces Louis showed him. Louis' biographer Michael Fried noted that two pieces, *Trellis* and *Silver Discs*, derived from Pollock and Frankenthaler.

Louis and Noland had already established themselves as notable among Washington's art critics and its art world. By the mid–1950s, Louis appeared in a few of Barnett-Aden's group shows. Louis exhibited at Whyte Gallery and on the campus of American University as well. His first large solo show at the Workshop appeared in four groups. The first included a calligraphic series, "The Charred Journal"; the second featured a series based on picket fence patterns; the third seemed based on dress pattern tissues pasted on the canvass. The final group included "planetary" abstractions.

Greenberg advocated for Louis to have a show at dealer Pierre Matisse in New York after receiving Louis' latest paintings. The veils and later flowers that Louis created during the winter of 1954 blew Greenberg away. Fried noted that Pollock and Frankenthaler liberated Louis' gifts for color. Louis' work of the period eliminated compositional drawing, and its flat and intense color gave it an expressive and psychological power. However, Matisse decided against exhibiting them. The paintings stayed in Greenberg's apartment until J. Patrick Lannan bought several a few years later.

Local critical praise climbed for Louis during the 1950s. In a group show at the Workshop, Portner called Louis' large expressionist abstraction very handsome. His solo show at the Workshop led Berryman to state, "He experiments with colors, and many of the effects are planned accidents. The strongest works on view are 'Close Black' and 'Hot Eyes.'" After his first solo show at Martha Jackson Gallery in New York, Louis destroyed many of the paintings he made. Louis returned to working on the Veils and Florals. He branched into other series, including the Alephs, Unfurleds, and finally, the Stripe paintings he made between 1960 and 1962. He had one-person shows in Paris and Milan and several times in New York City.

When Louis died of lung cancer in late 1962, obituaries observed that Washington had spurned Louis. Berryman and Portner's praise years prior must have escaped their attention. Washington collectors Mrs. Gates Lloyd and the Sterns owned pieces by both Louis and Noland. The vitriol against Louis and Noland's works came from *New York Times* critic John Canady. Still, European collectors gravitated to the pair much more than most American collectors.

His wife and father both survived Louis. Since he died without a will, things became complicated. The extent of the artist's assets was about 600 paintings. His widow went to Andre Emmerich, the gallerist who hosted a Louis show in New York City. He valued the pictures at $164,000.00, so 90-year-old Louis Bernstein took a $50,000.00 share and renounced further rights. However, a few of Louis' paintings then sold for $15,000.00 each. Mr. Bernstein felt his daughter-in-law and Emmerich had conspired against him. Together with his other sons, he brought a suit that outlasted his own life. A few years later, the judge congratulated the brothers for their

"financial astuteness and keen acquisitiveness" while handing down a judgment that ordered them to pay their sister-in-law's court costs.

Partially through his wife's promotional efforts, Louis received recognition as a top artist. By the late 1970s, the Washington Color Painters received slow reconsideration. The National Gallery of Art displayed sixteen of Louis' paintings. Paul Richard observed that "Louis was undoubtedly notable and deserving, but other artists were essential contributors to this genre. He noted that Louis was the first artist in Washington history to make art that held an indisputable claim to international attention."

Nearly two decades after his death, critic Benjamin Forgey argued for Washington's importance to Louis' work. "The existence here of the Phillips Collection, with its abundant emphasis on color, was important, and so, perhaps, was the luminosity of the Washington atmosphere, so different from the customary gray of industrial New York." Forgey continued: "the distance from the art capital allowed Louis and other Washington painters, both the freedom and the time to experiment and to explore." Louis benefited from the Washington Workshop for the Arts and the fellow artists gathered there, particularly Kenneth Noland.[3]

An Asheville, North Carolina, native, Kenneth Noland served as a glider pilot and cryptographer during World War II. Once discharged from the service, the wiry man studied art at Black Mountain College. He came to Washington in 1951 when the Institute of Contemporary Arts offered him a teaching position.

He became friends with the reclusive Louis and started teaching at the Workshop. Like Louis, Noland showed in many of the city's galleries. He appeared at the Phillips, Barnett-Aden's group shows, and at the Workshop Center for the Arts. By the mid–1950s, Leslie Judd Ahlander observed that his three abstract paintings in a group show at Catholic University "were calligraphic and strong with incredible dexterity in manipulating paint to give a three-dimensional look through color alone." During the decade, he also taught at Catholic University's art department and brought contemporary artists to speak. David Smith, Lee Krasner, Cy Twombly, and Herman Cherry figured into his exhibition schedule. "Thanks to Noland's advanced taste," Gene Davis once said, "[the Catholic University Gallery] was staging shows of extremely high quality in those days."

Noland exhibited his artwork in Washington during the early 1960s with the Jefferson Place Gallery. By the early 1960s, the gallery morphed into a place dedicated to Washington-based artists making contemporary paintings and sculptures. The Jefferson's director, Alice Denney, also coordinated with the furniture store Modern Design to display several of Noland's large paintings. Located in the ritzy suburb of Chevy Chase, the store illustrated that abstract painting harmonized with even a pint-sized room. The author of the news article on the store, Thomas Wolfe, soon became Tom Wolfe of New Journalism fame.

By 1963, Noland had moved to New York City, then on to a farm in Vermont. Noland explored various shapes and canvas types over the next decades of his long life. But as critic Hilton Kramer observed, "Mr. Noland has been consistent and unvarying—not to say single-minded—in his artistic purpose, which has been to fill the canvas surface with a pictorial experience of pure color."

Many museums around the world held retrospectives on Noland's work. Beginning with a show at the Guggenheim in 1977 that traveled to Washington, D.C., other solo exhibitions appeared over the next decades in Houston, Los Angeles, Spain, and

Italy. At an auction of Mrs. William H. Weintraub's estate in 1982, "Empyrean," a concentric-circle painting by Kenneth Noland, sold for a record $300,000.00. Noland expressed amazement. One of her two Morris Louis paintings also established a new high amount of $250,000.00.

Noland's paintings appeared in a wide variety of public collections. In Washington, that included the Corcoran, National Gallery, and Smithsonian American Art in Washington, D.C. Besides the Whitney and Museum of Modern Art in New York City, other collectors are Musee National d'Art Moderne in Paris, Tate in London, the Gallery of South Australia, Adelaide, and the Hara Museum of Contemporary Art, in Tokyo. The painter accomplished this throughout his long life, which ended in 2010 at the age of 85.

While Noland continued to explore the colors, by the mid–1960s, new local critic Andrea S. Halbfinger observed that the "colorist" Louis and Noland showed at an area gallery, and she had grown weary. "Form, content and subject matter are important too, and 'less is more' has just about worn itself out."[4] The critic had few supporters at that time. In the mid–1960s, the color school artists appeared in the Venice Biennale. Museums in Washington and throughout the country featured exhibitions with Noland, Davis, and others. The earliest example occurred at the Museum of Modern Art, but that exhibition folded the Washington Color Painting into the realm of Op Art. The Fogg Art Museum at Harvard in 1965 held the exhibition "Three American Painters: Kenneth Noland, Jules Olitski, Frank Stella," linking Noland with other artists exploring similar themes in other parts of the country.

Although the artists may have shared interests and appeared in the same exhibitions, the friendships never extended past Louis and Noland. According to Lou Stovall, several of the "second-generation" color field painters "were jealous of each other; they were suspicious of each other, they were edgy about someone sort of getting into their act." Corcoran student and later Catholic University instructor Thomas Downing said after finishing one group of paintings, "When they see these paintings they won't be thinking about Gene Davis anymore." Noland criticized the work of the next group, saying, "They [don't] work out their own ideas."[5]

Collectors bought the color field paintings and showed them around the world. After serving in World War I, Stanley Woodward, Sr., graduated from Yale. Rather than work in the family's hugely successful residential development and leasing business in Philadelphia, Woodward served as a Foreign Service officer during the 1920s and early 1930s. He returned to Philadelphia briefly before joining the Roosevelt White House as assistant chief of protocol.

After President Harry Truman appointed him as ambassador to Canada, Woodward observed that American embassies lacked artworks. The buildings specifically lacked paintings and sculptures by American artists. European countries had lent art from their national museums to appear in embassies for years. Stanley Woodward started the Woodward Foundation to purchase works of art.

A United States ambassador came to the State Department and arranged to have one or several works of art shipped to hang in their building while in service at the host country. The Foundation's efforts represented a pilot project to encourage American artists and to display their works abroad. Although Woodward served as a trustee, a family friend, the chic and glamorous Betty Battle, served as the program's administrator. Mrs. Battle, Mrs. Woodward, family friend Mrs. Albert D.

(Mary) Lasker, and artist William Walton decided on art purchases. The artworks cost of art ranged from $10.00 to $50,000.00. Within two years, the foundation owned 150 paintings. This collection grew to 350 works a decade later.

The Woodward Foundation purchased a wide variety of contemporary artworks. They bought many of the biggest names includes Jasper Johns, Frank Stella, Helen Frankenthaler, and Mark Rothko. They purchased the widely known Washington-based artists Morris Louis, Kenneth Noland, and Sam Gilliam. Additionally, the Foundation owned the works of Washington-based artists, including Howard Mehring, Anne Truitt, Robert Gates, and their friend William Walton. Both Mehring and Gates also received grants from the Foundation to travel to Europe to broaden their art backgrounds. The Foundation gifted a few works to the Corcoran Gallery of Art.

In retirement, Mr. Woodward lived in Washington and on a farm near Charlottesville, where he grew grapes and made wine. An avid sportsman, Woodward was a horseman, polo player, tennis player, and sport fisherman. Mrs. Sarah Rutherford Woodward died in the mid–1980s, and Mr. Woodward passed away at age 93 in 1992. They dispersed their collection to numerous museums. The U.S. Department of State continued the Art in Embassies program. It presented about 60 exhibitions per year and installed over 70 permanent art collections in diplomatic facilities worldwide. Some Washington–based artists were part of the program.[6]

At the Baltimore Museum's first survey of Washington art in 1970, they declared that perhaps now Washington Color Painting had run its course. Instead, the students of Noland and other instructors branched off to experiment with colors on different materials and in other forms. Indeed, the style with its formalist rigor fell out of critical favor. "Starting in the 1970s, there was a terrific reaction against Color Field painting and abstract art in general, which was in turn, a rejection of Clement Greenberg," said Michael Fried.

Others among the Washington Color Painters' community experienced the highs and lows of the style's popularity. Gene Davis started painting after taking classes at the Workshop in the late 1940s. Davis painted in a wide range of styles, including black and white abstractions. By the late 1950s, he reached a high degree of success in Washington. His pieces appeared in several significant private collections, including those of the Barnett-Aden Gallery, the Vincent Melzacs, and the Sterns. He had one-person shows at Catholic and American universities.

Berryman and Ahlander appreciated Davis' painting. His abstractions received nods of approval from two significant critics. As his work changed, they still liked and explained it to their readers. Berryman called the new collection incredible and noted that both small and large canvases were thinly stained and spotted with indeterminate colors. Ahlander observed that, "for Davis, painting was an end in itself. His works were demanding. The tensions and thrusts of planes in space make these canvases dynamic." When Davis' painting shifted toward Washington color painting, Ahlander noted Davis painted smart pinstripes, "flat color patterns which avoid texture, subject or composition to have color say the ultimate in terms of expression."

As a publicist for a local organization, Davis knew how to cultivate media attention. He received a steady diet of coverage over the years. An early interview occurred inside a tiny room he used as his studio. Canvases covered the entire wall space on three sides. On them were vertical stripes two inches wide in varying combinations of color. "I'm against virtuosity and performance in art. And I am tired of the empty,

virtuoso performances of the abstract expressionists." The balding Davis held out a hand for emphasis. The artist explained that he moved through different painting influences and styles over the 1950s, settling on stripes.[7]

Davis offered a few explanations for his new subject matter. Once, he likened them to the human head for the Old Masters. "The head served as a point on which these great artists in human history hung color and composition. Stripes held the shade and did not distract the eye too much with formal adventures."

When the artist won the Bronze Medal at the Corcoran biennial in 1965, the group critics claimed the Washington Color painters were in full flower. The art world talked about the group's hypnotic, elemental geometric forms. They described Davis' paintings as having a high-key vitality what the artist likened to cool jazz music. His expanding success led to showing works simultaneously at the Washington Gallery of Modern Art, the Corcoran Gallery of Art, and the Henri Gallery. Viewers received advice to engage with his works one at a time, to "wait until the stripes retreat and advance, then dance together."

As a leader in the city's art scene during the late 1960s and early 1970s, Davis received in-depth coverage when he showed new works in local galleries. Dressed in tweeds, the jaunty bald man described the little white pine blocks covered in acrylic paint that he showed at Jefferson Place Gallery. He expanded his market. The pieces sold for $100.00 each, compared to the $3,000.00 that each of his paintings cost. The placement of these miniatures was so crucial that Davis visited the purchaser's house to show them where to hang their piece.[8]

Perhaps telling a person where to hang their artwork was not unexpected in the era when conceptual art challenged some of the art world's norms. While at a party, Corcoran teacher Ed McGowin and art critic and artist Douglas Davis tried to figure out how to declare the end of the once-edgy, now "Establishment"-friendly Washington Color School movement. Douglas wanted to "gather [all] the color paintings and destroy them," and McGowin said, "No, let's give them all away."

The pair approached Gene Davis, who agreed to let McGowin and Davis make 50 replicas of *Popsicle*, one of his trademark stripe paintings. Davis mixed and supplied the paint. In reality, ten of the art patrons who later attended the Mayflower event underwrote the cost in exchange for one of the Popsicle paintings. McGowin and some art students from the Corcoran, including Michael Clark, now known as Clark Fox, produced the 6×6-foot paintings. Clark explained that the four or so assistants had trouble replicating the paintings. He ended up working 14–16 hours a day to paint all of them in the basement of McGowin's house while the married couple screamed at one another as they went through a divorce.

The event of the auction at the Mayflower Hotel was the art, according to McGowin and Douglas Davis. Guests dressed in formal attire filled the grand ballroom. They drank and supped while their names went into a bin for the drawings. Guests whose names came from the draw won one of the 50 paintings. Davis recalled the event after two decades.

> What I remember most about that evening is the roar. The crowd was enormous, virtually filling the gigantic ballroom [above].... The atmosphere approached that of a ritual, yes, but the ritual of Wall Street or striptease. Very early, the chanting began: "Give it away, give it away." When we finally drew the names of the winners out of a large silver bowl, the yelps and screams of the victors, and the groans of the losers, were earsplitting.

The frenzy of winning a painting dominated the moment for the attendees. Art critic Barbara Gold of the *Baltimore Sun* sensed the conceptual edge in "Giveaway." She claimed that the patrons calmed down toward the end. They felt stunned by their vulgarity, by the shock of recognizing "how totally monetary value could get in the way of the aesthetic pleasure." Mass production of an "original" Gene Davis stripe served as a comment on Washington color painting in the art world. The activity also satirized the notion of hand-creating a picture in this age of mass production. Maybe the "Giveaway" aligned with, if not prefigured, the contemporary art world's next two decades of conceptual and theoretical developments. One local critic referred to the event as commemorating the "death" of the Washington Color School. Forty years later, Clark Fox observed, "Well, you know, they were almost putting a curse on Washington art, which they continually seemed to do."[9]

While the Giveaways served as a symbolic death, Davis kept making art. At the Max Protetch Gallery on the city's art neighborhood called the "P Street Strip," Davis wrote 22 words in pencil on the walls. Visitors to the gallery had the chance to complete the "Wall Puzzle." Beyond creating these conceptual game works, Davis tried various times to make video art.

He returned to his stripe paintings with renewed vigor by 1975. "Hard-edge paintings that made a lot of sense in 1965 now seem tired and tripe," he said in a hard-boiled voice. "There was a brief period where I had considerable doubt about painting, but now it's coming back strong." The market may not have rebounded to such a degree. Gallery owner Ramon Osuna, who has sold many of the Washington

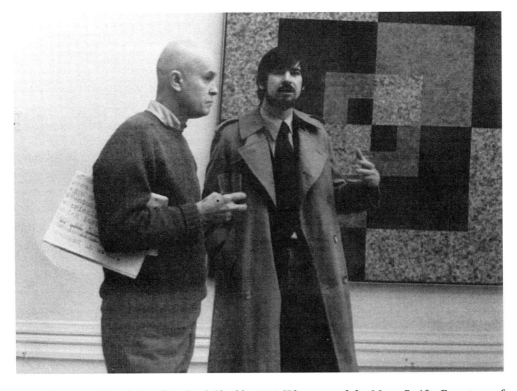

Gene Davis and Clark Fox (Michael Clark), 1972 (Photograph by Mary Swift, Courtesy of Clark Fox).

Color School paintings, said, "The market for Color paintings was relatively weak." He hired many students he taught at the Corcoran to paint his work under his supervision. He usually hired attractive women to paint his canvases. He chose color and locations, and they painted the rest. Still, the artist enjoyed one-person shows in Germany, Switzerland, Canada, England, and the United States, including five one-person shows at the Corcoran Gallery of Art.

Davis painted every day of the week, working in a windowless bare cell lighted mercilessly by fluorescent lights. In the background, while he worked, records always played. His eclectic taste ran from Mozart to Thelonious Monk to Donna Summer to the Sex Pistols.

He never really got away from his craft. He organized shows for the Washington Project for the Arts and other groups. He served as a museum commissioner for the National Museum of American Art. Another part of that commitment involved attending art shows throughout the area. For local galleries, he drove in his white Jaguar. On Saturdays, he and his wife Florence visited galleries on Seventh Street, N.W. "Seventh Street is like a small town as relates to the art community. You can't go down there without meeting someone you know," Davis says.

Nothing made him happier than seeing something new on the walls in the many museums and galleries. Davis cared much for Washington, D.C., and loved its significant art collections. "I'll admit to being somewhat chauvinistic about Washington." On Sunday afternoons, he and his wife entertained a few artists and art lovers at their home in Friendship Heights with champagne and strawberries and held a salon where they talked about art.

The pair enjoyed a few non-art-related activities. On Sunday mornings, they cruised around Georgetown, looking at the architecture and the people. Then they took their two basset hounds for a romp in the baseball field at American University. Davis might go to the Outer Circle Theater to see foreign films, but he says, "I don't like the sensibility in…. Hollywood films: so trivial…. The descriptions of [E.T.] make me want to throw up."

In the spring of 1985, Davis died at age 64. His pieces appear in major museums throughout the world, including the Museum of Modern Art and the Guggenheim in New York City, as well as the Walker Art Center in Minneapolis. The Smithsonian Museum of American Art owned as many as 34 pieces. His works were, of course, in hundreds of private collections.

Davis made himself more than the "regional artist" that some argue Clement Greenberg destined him to remain. While Davis exhibited with several dealers in Washington, he also showed at New York City galleries every year for more than two decades. The value of Davis' paintings remained variable. When one of the women who painted for Davis, Frances Chapman, died, her estate sold a few Davis paintings that she owned. Two went for $32,400.00 and $34,800.00 at auction. The artist summed it up best. "If one's work is good, it will survive the changes in taste and fashion. An artist can't be 'in' every year and be honest."[10]

The Washington Workshop Center for the Arts leader, which brought the color painters together, remained outside this "group." Leon Berkowitz adopted different relationships to paint and canvas than the color painters. He also rejected the focus of their art. But Berkowitz learned from them to improve his art. "I had these years in the Art Center's Workshop, where I was in contact with the artists of Washington,

but more importantly, with people like Morris Louis, and with de Kooning, and New York artists. So I'd absorbed a great deal."

Upon returning with his first wife, Ida Fox, to Washington, Berkowitz returned to teaching in the public schools. Within a few years, he moved over to teach at the Corcoran school. He showed at the school, and his exhibition openings drew both the traditional tux and gown crowd plus the many long-haired kids who took his classes and loved his warmth.

Local critics appreciated his works when shown at one of the local P Street Strip galleries. Paul Richard described his latest 12 paintings as having light-reflecting, light-absorbing crystals appearing on them. Another gallery showed two paintings that created an engulfing experience of color as light. The works presented mists of transitioning, super-saturated spectrum colors whose radiance seems equal parts existential affirmation and visual effect. At a Phillips Gallery show of his works in 1976, Berkowitz explained, "I am endeavoring to find that blush of light over light and the color within the light; the depths through which we see when we look *into* and not *at* color."

Berkowitz showed at the Middendorf Gallery in the Adams Morgan part of the city during the late 1970s—smaller versions of the works that showed at the Phillips—and the atmospheric color field paintings still filled the gallery's walls. To one visitor, he explained that "they [his paintings] are never harsh." For the critic at one of the local newspapers, his paintings were not something a viewer found gutsy. A second noted that "[c]olor is the only form in his new works, but each work contains hundreds of subtleties and surprises."

That decade, his first wife and Washington Workshop co-founder Ida Fox could no longer stand her severe illness and took her life. "After a tragedy, we can be reborn," he said. Berkowitz continued teaching at the Corcoran school. He married a woman half his age, and the pair attended art openings in the galleries along P Street Strip and Dupont Circle.

He had a small boy's energy, so the pair often danced at nightclubs around the city. His moves earned him the nickname "Beserkowitz." He showed at galleries in San Francisco and other places in the country, selling paintings for about $15,000.00 each. The Corcoran, Phillips, and National Museum of American Art each owned his works. He gave lectures at the Smithsonian Museum on the dynamics of color. One of his recent paintings appeared in a 1984 retrospective on Washington color painting at George Washington University.

One of his last series was called Unities. It consisted of paintings where he floods the surface of the canvas with paint. A visiting reporter got the chance to see the paintings' glory. Berkowitz trained a spotlight on the painting's surface, and it became increasingly intense. Before the reporters' eyes, the painting's color changed twice as she watched. "I want to reinvent color—color as [sic] visual and emotional experience rather than as matter."[11]

Many Washington artists from the Washington Workshop Center for the Arts created challenging work. They strove with their art to inspire the public to see things a little differently. Many times, their partners in this effort, the city's galleries, sought the same. The most extensive grouping of the galleries during the 1960s and through the 1970s created an art neighborhood along P Street from Dupont Circle to 22nd Street, known as "The P Street Strip."

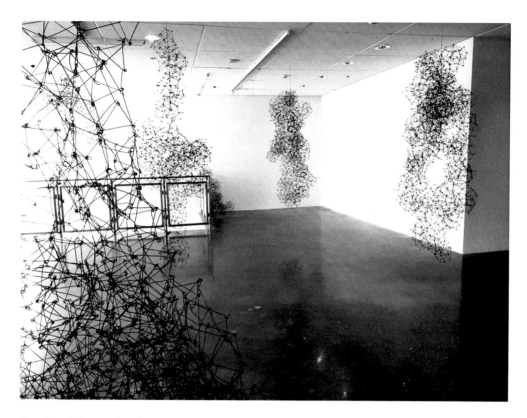

Sondra Arkin, *Cloud Forest*, 2017. Steel, motor, cable, size variable. From "TWIST—LAYER—POUR: Sondra N. Arkin, Joan Belmar, Mary Early," curated by Sarah Tanguy, American University Museum, 2017 (Courtesy of the Artist).

Rushern Baker IV, *"Post World"* installation at Hemphill Gallery, 2019 (Courtesy of the Artist and Gallery).

Leon Berkowitz, *"The Cathedral Paintings"* installation at Hemphill Gallery, 2007 (Courtesy Maureen Berkowitz and the Gallery).

CONNERSMITH, Art Miami art fair in Miami Beach in 2016. Artwork by, from left: Thomas Downing; Sam Gilliam; Thomas Downing. The three works on the right are by Norman Bluhm (Photograph © Ben Droz, Courtesy of the Artist and Gallery).

Richard Dana, *Hanuman*, 2019. Archival pigment print on adhesive fabric, 62" × 44" (Courtesy of the Artist).

Clark Fox (Michael Clark), *San Francisco Chinatown Window*, 1976. Oil on canvas, 11" × 14" (courtesy of the artist).

Michael Janis, *the incandescence of electrically charged nerves*, 2019. Kilncast glass, glass powder imagery, steel, 19" × 36" × 2½" (Courtesy of the Artist).

Eric Rudd, *Stanley, Rick, Harry & Tonto*, 1979. Enamel on polyurethane foam, painted steel, plexiglass, 10'd × 14'w × 12'h (©Barbara and Eric Rudd Art Foundation).

Di Bagley Stovall, *Tiger Garden*, 2004. Acrylic on wood, 80" × 130", Commissioned by Marie and Dick Carr (Courtesy of the Artist).

Sally Kauffman, *Transgression*, 2019. Oil on canvas, 30" × 30" (Private Collection, Courtesy of the Artist).

Opposite: Sidney Lawrence, *Self-Portrait with a Swelled Head,* 1988. Oil on canvas and wood, 53" × 27" (American University Museum, Watkins Collection. Gift of Jim and Deba Leach, Courtesy of the Artist).

C7

C8

Ellyn Weiss, *Visitation*, 2020. Encaustic, ink, oil bar, dry pigment and Stabilo, 24" × 24" (Courtesy of the Artist).

Opposite top: Anne Marchand, *Destiny*, 2020. Acrylic enamel, ink, fabric on canvas, 36" × 36" (private collection, courtesy of the Artist).

Opposite bottom: Lou Stovall, *Adagio in D*, 2004. Silkscreen monoprint, 20" × 40" (Courtesy of the Artist).

Judy Southerland, *Red Dirt, Fast Car*, 2019. Acrylic on canvas, 34" × 26" (Courtesy of the Artist).

Opposite top: Jody Mussoff, *Cinderella's Black Shoe*, 2020. Colored pencil on paper, 11" × 14" (courtesy of the Artist).

Opposite bottom: Veronica Szalus, *Translucent*, 2009. Hex netting wire, plaster, bamboo, 3'd × 16' w × 9' h (Courtesy of the Artist).

C11

Tim Tate, *Justinian's Oculus,* **2020. Cast lead crystal, 33" × 33" × 4" (Courtesy of the Artist).**

Claudia Vess, *New Modern Times,* **2005. Molded Styrofoam, 5.5' × 36' (Courtesy of the Artist).**

8

The 1960s

"The P Street Strip"

Several thousand people filled two blocks of P Street on a sweltering Washington summer evening. Banners hung from the art galleries' windows on the first and second floors of the Victorian townhouses along one side of the street. As the dusk turned into night, searchlights beams crossed in the air a thousand feet in the sky above The Georgetowne, a luxury apartment house along the other side of P Street, from Twenty-First to Twenty-Second streets.

The art party called "P Street to the People," in the tradition of early 1970s events, featured food, free beer, and art in the galleries and out in the street. The works of art situated in the middle of the street regularly changed. Some looked professional and others, amateurish; some moved, and others stayed still; some were colorful; others, hilarious. A self-destructing wooden trough housed burning charcoal briquettes. Fluffy mounds of straw gave children art to tear apart. Fresh from the Corcoran school, artists Kevin MacDonald and Michael Breed arranged a row of hot ice bricks 140 feet long, which disintegrated before the viewers' eyes. MacDonald soon joined the Studio Gallery and displayed drawings of the turreted rooms in the Victorian houses around the city. Forgey called his paintings, "cool cityscapes."

Tables filled with art lined both sidewalks. The pieces ranged from small Art Deco antiques to small paintings and drawings by professional and student artists. Event organizer Luis Lastra operated the Pyramid Gallery, which had a first-floor location inside the apartment house. "I thought it would be fun to get the people in the street so they would lose fear about being out at night." The D.C. City Council agreed and passed a regulation to close the street off to create a pedestrian mall where visitors viewed art objects.

The event proved so successful people filled the many neighborhood galleries. "People who wouldn't have generally bothered to notice art just walk by and see what's going on in the world of art with a capital A," observed a smiling Bernard Welt, an American University student and artist who lived in Arlington. The galleries planned for another event to come in the fall.[1]

The arts came to this area, between Dupont Circle and Rock Creek Park, over the years. The Phillips Gallery has held forth since the 1920s in Dupont, just to the north. In the 1940s and 1950s, the Washington Workshop Center for the Arts brought an entire arts community to the Dupont area, which made art as well as received instruction from and saw shows by artists focused on contemporary art.

Members of the American University Art Department started the Jefferson

Place Gallery as an artist cooperative on Connecticut Avenue, south of Dupont Circle, close to the framing and art shops. The six artists/owners each contributed $100.00 to fund it and hired one of their American University students, Alice Denney, to manage the operation.

A notably energetic and driven person, Denney moved to the city when her husband took a job as a lawyer for the Senate Foreign Relations Committee in 1950. The trained nutritionist studied art at the Museum of Fine Arts, Boston. After a pause to raise her young children, Denney resumed her art training at American University, where she met the staff members who started Jefferson Place.

Denney quickly mastered art promotion, bringing the gallery to the city's notables' attention. The local critics generated social cachet and substantial media publicity for Jefferson Place Gallery. By season's end, Jefferson Place added Gene Davis, and soon the "second generation" of Washington color painters became gallery artists.

Denney sought to expand the reach of her artists. She contacted Gordon Washburn, head of Pittsburgh's Carnegie International, to include the artists in the upcoming exhibition. One year later, Washburn arranged his itinerary to visit Washington and the Jefferson Gallery to see the artists' work. He selected Noland, Mehring, and William Calfee to appear in the prestigious biennial.

Denney saw the gallery as one of the few places in the city to offer education and expertise in contemporary and modern art. One newspaper promoted the "informal lectures and seminars" with gallery artists, in which "Alice Denny" [sic] was described as griping about gallery visitors who claimed to have made the paintings with their eyes closed. "Sometimes.... I think I'll put up a blank canvas and tell the next person who says that to go ahead and try."

However, Mrs. Denney also actively promoted the works to collectors in Baltimore and Washington. By this era, the investment bank Lloyds, physicist Julian Eisenstein, the Sterns, Melzac, and Kreeger, an Impressionist art collector and Sr. Vice President of GEICO, joined Duncan Phillips as collectors. Denney increasingly disliked the selling part of the work. "I loved the art so ... very frustrating to work with the artists and not sell their work." She purchased many pieces herself. Denney promoted the gallery's artists in other cities, particularly amongst the New York gallery crowd. She also devoted much work to staging a wide variety of shows featuring both local and regional artists. However, the gallery's artists sometimes lacked Denney's enthusiasm for new art.

At a cocktail party hosted by Julian and Elisabeth Eisenstein, Denney suggested that Washington should have a contemporary art museum. According to Eisenstein, he replied, "Yes! Let's start one." Denney wanted Washington to gain prestige through having one of the few museums devoted to contemporary art. She thought the museum must educate viewers about contemporary art too. Through Denney's social and political connections plus friends in the art communities, the museum idea took hold. The new museum gained momentum when there proved to be no place in Washington to house the Ben Heller collection of abstract expressionism. Within one year, Denney and Eisenstein named the museum and initiating small board of trustees. After declining at first, Denney became the Washington Gallery of Modern Art's (WGMA) assistant director.

The Board looked north to the vibrant city of Baltimore, Maryland, and hired Adelyn Breeskin from the Baltimore Museum of Art (BMA). Mrs. Breeskin began at

the museum as a curator and took over the BMA's directorship during World War II. The tall, beautiful woman with classic features became the first woman to run a major museum. Over nearly 20 years, "Mrs. B," as many called her, accomplished a great deal for the BMA. She oversaw the museum's expansion, negotiated the Etta and Claribel Cone Collection's donation, and curated several shows, including a large one featuring works of abstract expressionism. Museum members and executives knew that she fought for what she wanted. Breeskin saw the new museum as a way to stimulate collecting of recently made artworks in Washington.

The Washington Gallery of Modern Art opened in a refurbished three-story carriage house on the late Larz Anderson's old estate at 2118 Massachusetts Ave., N.W. The location at 1503 21st Street, N.W., sat one street south of the Phillips Collection. The dozen tenants then living in the carriage house received eviction notices.[2]

The Washington Gallery of Modern Art modeled its financial structure on the Museum of Modern Art in New York. The plan relied heavily on wealthy private patrons to support its operation. During the first few months, gallery board members and others began soliciting $100.00 from people who received the title of "originating membership." These members showed their intention to make Washington a cultural as well as a political capital.

As with many privately financed institutions, the gallery had to hold frequent fundraisers. Fundraisers started before the openings of various shows during the first year. Guests dined or sipped libations with noted board members. Other groups, including the American Ballet Theater, held benefit shows for the gallery. The WGMA established daily hours that ran from Tuesday through Sunday. A nominal charge of 50 cents enabled patrons to enter. The exhibitions focused on contemporary works. The gallery received donations from collectors and artists, with Grace Hartigan making the first donation.

Everybody's hard work made the October 1962 opening show for the first exhibition at the WGMA possible. The fund-raising arm received capital grants from foundations, including the Stern Family Fund and the Meyer Foundation, to make changes to the four-story townhouse. Another effort included raising the beginning funds, which came from its first 300 members. Other membership categories carried contributions from $10.00 to $5,000.00.

The Washington Gallery of Modern Art opened with a big show on the artist Franz Kline. Plans included a Reuben Nakian sculpture show and an Arshile Gorky retrospective, which had only appeared at the Museum of Modern Art in New York City. Finally, the summer exhibitions featured works from the WGMA's collection. The opening for regular members drew a crowd that spilled out into the street. People had a hard time seeing the work on any of the walls. The show started chronologically on the top floor of the museum. As visitors descended from floor to floor, viewers saw Kline's development traced over the years. Ahlander thought that the final great canvases sat on the ground floor and were a fitting end to a fantastic show.[3]

Each of the WGMA's three openings over the months drew enormous crowds. Over 4,500 people visited the WGMA in the first month. Nearly 10,000 school children went as well. The Franz Kline catalog received praise as being a definitive study of this prominent American painter.

One exhibition, called "The Popular Image," featured contemporary works by 12 top artists. The artists included Claus Oldenburg, Andy Warhol, Roy Lichtenstein,

and Jim Dine, making art in the day's styles. Alice Denney organized other related events, including happenings in music, dance, cinema, and drama. The Gallery's "Pop Festival" featured composer John Cage performing with the Judson Dancers, and Robert Rauschenberg debuting his now-famous performance piece "Pelican." Claus Oldenburg hosted a "Happening." Critic Jean White mentioned the word "turbulent" for Cage. The exhibit carried the cachet of being the art of the here and now. Critic Frank Getlein called the show dullsville. He quipped the show had neither the fun Denney promoted nor the importance the catalog appeared to give it. A local reporter called the activities, "beatnik charades or stuff and nonsense." However, the reporter observed that some 200 adults crowded into the WGMA.

The final shows of the first season also included many contemporary pieces of art. However, each exhibition also included works of art from precursor artists who served as sources of inspiration for modern artists. The exhibition called "Formalists" included modern abstract painters and sculptors. Adelyn Breeskin also showed Joseph Albers, Fritz Glarner, and Piet Mondrian, whom she noted as leading sources of inspiration for the American movement. Local critics called it brilliant and a stunningly cool show that provided an excellent cross-section of specific contemporary trends in art today.

The exhibition "Sculptors of Our Time" featured 41 pieces from 35 artists. The WGMA raved that this was the most comprehensive collection of 20th-century sculpture shown in D.C. It started with Brancusi's work and moved through chronologically toward the early 1960s. Ahlander considered it a solid work of art history but not exciting. She thought the show could have been more provocative but realized that made it less informative.

At year's close, the board and gallery's leadership assessed the situation. Breeskin informed the media that she found the first year thrilling but exhausting. "The next year I think we will have to be a little more modest in our efforts." Their four-story building hosted eight exhibitions and drew some 30,000 visitors. It amassed over 1,100 members, and artists and collectors gave 60 pieces of artwork gratis.

In its second year, the WGMA reduced the number of exhibitions. However, exhibitions proved to be a point of contention among board members and the organization's leadership. While Breeskin believed in including historical art and context to the gallery's exhibits, others wanted the WGMA to take "a deep plunge into the art of today." Vice President Mrs. H. Gates Lloyd noted, "I feel we can do both. But some others didn't." Those in that faction didn't express great reservation over the gallery's planned Van Gogh show for the middle of winter. The WGMA's executive committee recommended replacing Mrs. Breeskin at the end of six months. Although the board unanimously accepted this change, some members quickly established firm rules to guide future relationships between the board and a new director.

Mrs. Breeskin offered her resignation but proved unavailable to comment in person. Breeskin issued a written statement. "I felt we should have a broader scope and not be entirely avant-garde." The board felt differently. "There were those who wanted the gallery to be limited to the avant-garde. I consider that modern art began with Cezanne and that anything after Cezanne helps give people a better understanding of modern art." Indeed, Mrs. Breeskin noted, "It's one thing to have a gallery just for extremely modern art. That kind of gallery is all right for sophisticated, knowledgeable people. But I find that Washington is largely made up of people who

are somewhat puzzled by it." Supporting Breeskin's vision seemed accurate when the WGMA ran the Van Gogh exhibit and netted a $34,000.00. No other exhibition matched that profit. The Van Gogh exhibition drew some of the WGMA's largest crowds and influenced future Washington artists, like Clark Fox.

Critic Paul Richard noted that Breeskin "had the museum professional's skills but fell short in fully engaging with contemporary art." Alice Denney viewed Breeskin "as a Grand Dame at 60 years old who lacked knowledge about much contemporary art." The Sterns and other financial supporters wanted to be more today focused. The WGMA's split represented the issue that many museums had then and continue to have. The art that drew the biggest audiences and netted the largest gate was usually Impressionism and not the today-and-now works.

The WGMA under Breeskin accomplished one of her goals. The gallery spurred interest in contemporary art around the city. Washington had experienced a step-up in dealers of paintings and galleries overall. The IFA galleries saw sales climb over 300 percent in five years. Gallery owner Manual Baker attributed this to increased art education and the museum shows in the area. He also noted that people increasingly pursued art themselves or focused on home decorations. As another store manager indicated, "Washington is a great art market. It's cosmopolitan, with many museums and money to spend."[4]

Mrs. Denney took a leave of absence to serve as the American delegation assistant commissioner to the 1962 Venice Biennale. When Mrs. Denney returned to the city, she decided not to return to the institution she started. She began a group called the Private Arts Foundation, a non-profit that held visual arts, theatrical and musical shows in places all around the region.

The group's NOW Festival in 1966 featured a week of various events, from Robert Rauschenberg doing his performance on roller skates and parachutes to avant-garde music included John Cage. Other days featured underground movies shown at Dupont Circle's Janus I and II theaters, dance back at the Kalorama roller rink, and a Sunday symposium. At the final event, participants and official Washington members thrashed out how to promote the arts without stultifying innovation and experimentation. The crowds came, and although some clapped and booed at inappropriate times, others expressed frustration that there were not enough seats for them to attend. Denney stated, "I don't think it [Washington] is as square a city as I anticipated." Denney extended her focus to show the town what art] they saw.

The WGMA's board held a search and hired a young man as their new director. The ex-dean of the Chouinard Art School, Gerald Nordland took the reins in mid–1964. An art critic and lawyer, the 37-year-old quickly realized that the museum faced chronic shortages of funds and had not found its direction. Nordland interestingly asserted that the WGMA tried to originate more shows. "And since we can't compete with the big museums for shows they might want, our tendency may be to do things overlooked and to re-evaluate talents or positions that have been analyzed too quickly," he informed all at a press conference.

One inexpensive method for creating an original show meant using art from the museum's collection. The paintings from Noland and Louis, Howard Mehring, and Gene Davis appeared under the banner of "The Washington Color Painters" in 1965. The exhibition drew big crowds and featured swank parties. At one, society figures, dressed in three-piece suits and fancy summer gowns, danced to a four-piece band

and posed for photos in front of rivers of paint, whirling dots, T-squares, chevrons, and vibrating stripes.

Under the new leadership, the WGMA expanded outreach to the community. It continued the earlier practice of bringing in music and other related arts to the townhouse for performances. But the WGMA added tours of the city. Members arranged walks to see Washington's new buildings or the modern furniture inside real estate offices and other businesses. The gallery's goal was to stimulate interest in architecture and design.[5]

The WGMA continued its run of exhibitions of significant modern art and community outreach. In 1966, after a special preview for members and donors, the public saw the prized artworks in the collection. These ranged from Ellsworth Kelly's "Red-Blue" to works from every important member of the color painters from Washington, D.C.

Local art critics Getlein and Richard raved about the upcoming WGMA exhibitions. They liked the Edward Wesson photographs, the David Smith sculpture retrospective, and a recent prints show. Then, after a show of Morris Louis' work, the WGMA featured minimalist sculpture and a summer show of Joan Miro and Alexander Calder. Ahlander and Getlein liked most of the exhibitions. Getlein unfavorably compared the minimalist sculpture exhibition to a show at the National Collection of Fine Arts. To him, the WGMA's "New Aesthetic" show "proved an anesthetic, noting that he drifted off trying to find something interesting about the works."

Up and coming local artists in the city experienced their highly positive reaction to some WGMA exhibitions. Clark Fox came to see the Louis show and left changed. "They did a marvelous Morris Louis show. And when I saw that, that was sort of the kickoff for me. ... it's like the light bulb went off in my head ... where he kind of drew me into what I was doing, the shape paintings that I was doing."

The WGMA's leadership continued to face its financial limitations. The constant financial constraints kept the gallery from devoting a room to showing its permanent collection. The WGMA's mission meant a focus on experimental and small shows. These led to many potential viewers going elsewhere in the city, including the Corcoran, the National Gallery of Art, and the National Collection of Fine Arts.

By 1967, the WGMA required an annual operating budget of $130,000.00. During its most recent campaign for membership, the gallery raised $20,000.00. However, the current membership sat at 1,600, and the goal was having 2,000 paying $25.00 per year. Despite $10,000.00 coming from private donations, the gallery needed to double that figure to survive. It announced that it cancelled operating commitments after June 25. They made overtures to local American University and its Watkins Gallery to become absorbed by them while keeping them active, but nothing proved successful.

The WGMA continued to feature contemporary exhibitions and include innovative events on many of the days. The gallery often combined art, music, and participation events that held appeal to younger audiences. It held an anti-music show of percussion from all kinds of different objects. It served as a location showing experimental films airing movies and some theater.

The new leadership of Walter Hopps led to younger and more local artists getting a chance to create work in the WGMA. After advocating for artist workshops at his first Washington job with the Institute for Policy Studies, Hopps started workshops

with Lou Stovall running the printmaking one; Rockne Krebs, the sculpture one; and San Gilliam, the painting workshop. The Sterns raised the money, and the artists worked with fellow Washington artists in their workspace near Fourteenth and U Streets, N.W.

Howard University graduate student Lloyd McNeil received the go-ahead from Hopps to create an exhibition. The show called "Intercourse" featured four artists. McNeil's friend Lou Stovall created the fabrication of the townhouse for McNeil's show. Stovall recalled that the townhouse proved to be a vast space. He blocked off most of the gallery's entrance, so visitors crawled on their hands and knees to enter. Connected with the New School for Afro-American Thought on Fourteenth Street, the show also featured a third-floor room filled with televisions set to every channel and another room full of murals that McNeill painted.

Occasionally, the artists returned to change the exhibit. Ever moving as he conversed, Hopps loved the living aspect of the show. He held another Newport cigarette and lit it up before beginning to pace around. Hopps saw Washington in another "artistic wave of development with these new artists." He'd invited known modern art collector Philip Stern to watch Stovall and others change the exhibits and space. Once, they stationed musicians and dancers up and down the staircase as the visitors walked in to see the art show. These shows did not help the gallery's financial situation, and a crash telephone campaign needed to happen to keep the gallery funded.

The gallery continued talks with related organizations to see if any merged with them. During the summer, a breakthrough occurred when the Corcoran Art Gallery appeared interested in absorbing the WGMA. The boards of trustees for both organizations began months of letters negotiating those terms that each side found acceptable. The WGMA had an operating deficit of about $20,000.00. It also held a $60,000.00 mortgage on the townhouse property. Initial plans called for the Corcoran to acquire all the WGMA assets and assume its debt.

The WGMA had over $200,000.00 in assets of both art and property. The WGMA's board sought to maintain the townhouse in Dupont Circle. The townhouse, to be known as the Corcoran Gallery-Dupont Center, hosted special programs. The board wanted the Corcoran to take on seven WGMA Board members as trustees to its board. They also asked that some of its employees, including director Walter Hopps, become directors and curators at the Corcoran.

The final plan also involved merging the memberships of the two museums. This plan proved interesting because the Corcoran Gallery had 4,000 members who were mostly older and conservative. The WGMA had 1,800 members. Mostly in their 20s and 30s, they held liberal social and cultural attitudes and taste in art.

The WGMA board faced the difficult decision of handling its permanent art collection. With the Corcoran's support, they sold 154 contemporary artworks to the Oklahoma Art Center, now called the Oklahoma City Museum of Art, for $110,000.00. The Corcoran used the proceeds to pay all current unsecured debts of the WGMA. The board believed that some of these funds went toward the experimental programs run out of the townhouse.

The WGMA board's president, while informing the gallery's membership, claimed that the traditional role of a gallery-museum had diminished. Additionally, the cost of maintaining the building proved prohibitively high. The WGMA had accomplished its initial purpose of catalyzing contemporary art in Washington, D.C.

She claimed that now it moved on and continued to fulfill its new mission, outreach to the city's larger population. As part of that effort, the townhouse ran experimental programs for at least one year. She noted that the sale to Oklahoma allowed the gallery's catalytic function to move on to that state.

The note to the membership seemed upbeat. The messages of mission accomplished and "look at the new good we were going to do" might have resonated with many. The WGMA proved to be a catalyst to the growth in the appreciation of contemporary art in Washington, D.C. The WGMA building brought more people and galleries to P Street, N.W.

However, the sale of the collection meant it would not be shown in the city, failing to inspire the greater public, art community, and visitors in D.C. Di Stovall thought the sale was a significant loss. To her, this deal set the city back as an art powerhouse. Among the works valued highly at the sale were a Richard Diebenkorn abstract painting and a Reuben Nakian sculpture. Richard thought the collection "was just a beginner," and "many private collections in town were similar."

WGMA board member Vincent Melzac objected to the sale at the time. He disagreed with the sale of the assets being a condition of the merger. Two of his artworks went, which incensed him. He stipulated on future donations that the works had to stay in Washington, D.C.

In the summer of 1969, as the Washington Gallery of Modern Art came to an end, Corcoran Director James Harithas wrote about a burgeoning arts scene. He noted that local commercial galleries contributed significantly to the contemporary art scene with numerous and high-quality exhibitions. Washington's artists received greater recognition within the city, and some achieved a national reputation. Many of the best of these galleries rented space on the P Street Strip. The WGMA generated the development of an arts area. Four galleries opened there. Manhattan had the East 50s as a gallery strip; Los Angeles had La Cienega Boulevard. By 1967, Washington had its art strip along P Street between Dupont Circle and Rock Creek Park.[6]

Three-story townhomes lined most of the blocks west of Dupont Circle on P Street. Around the corner from the WGMA on 21st Street, a topless bar filled one while next door, a neighborhood restaurant served bland cheeseburgers. Near the far corner, a dumpy brick building housed a pet shop with a veterinary hospital nearby. Across the street, the townhouses fell under bulldozers. Plans called for a ten-story high-rise apartment building with plastic grass outside. Completed in 1966, the Georgetowne House contained over 300 apartment units. While the building would not accept residents with children, it offered a year-round swimming pool and many other modern amenities to its renters. The shopping plaza beneath a series of steps in the front slowly fill with stores.

As the construction occurred across the street, the Jefferson Place Gallery's Nesta Dorrance happened to be walking in the area and noticed some of the buildings. "I saw a building I liked. It had space for exhibitions and storage and a parking lot across the street. So I moved in." After Jefferson Place moved to 2144 P Street, N.W. in 1965, Henri moved her gallery from Alexandria onto 21st Street and P Street. The gallery, which shared a name with the owner, featured three distinct floors. The basement contained her art holdings. The middle floor held changing exhibitions and the gallerist blended contemporary paintings and early American furniture in the top floor apartment.

1 A.D. Smull Gallery, 1606 20th St NW
2 Barbara Felder Gallery, 1621 21st St NW
3 Diane Brown Gallery, 2028 P St NW
4 Foundry Gallery, 2121 P St NW
5 Gallery 10, 1519 Conn Ave NW
6 Gallery K, 2032 P St NW
7 Henri Gallery, 1500 21st St NW
8 Jane Haslem Gallery, 2121 P St NW
9 Jefferson Place Gallery, 2144 P St NW
10 Local 1734 Art Collective, 1734 Conn Ave NW
11 Middendorf Gallery, 2028 P St NW
12 Phillips Collection, 1600 21st St NW
13 Photo-Graphics, 1522 Conn Ave NW
14 Protetch-McIntosh Gallery, 2151 P St NW
15 Pyramid Gallery, 2121 P St NW
16 Rebeccah Cooper, 2130 P St NW
17 Studio Gallery, 2114 P St NW
18 Touchstone, 2130 P St NW
19 Trocadero Shop, 1608 20th St NW
20 Veerhoff Galleries, 1512 Conn Ave NW
21 Venable Neslage Gallery, 1742 Conn Ave NW
22 Wade Gallery, 1721 21st St NW
23 Wash'n Gallery of Modern Art, 1503 21st St NW
24 Wash'n Womens Art Center, 1821 Q St NW

Dupont Circle–P Street Strip Galleries, 1970s (Brian Kraft Maps).

After attending Catholic schools and completing studies at the Massachusetts College of Art, Henrietta Springer Ehrsam came to the Washington region after marrying Herbert Ehrsam. Mr. Ehrsam worked in the federal government for the Office of Strategic Services. After 15 years of marriage and two children, Mr. Ehrsam died in 1947.

Henri supported her family by selling used clothes and eventually new art. She covered the clothes with sheets and hung art above the draped pipe-racks. Her tastes were idiosyncratic—"toward the bright and the extreme," she explained. These ranged from the distinguished color field painters to sculptors. DC native Martin Puryear got his first show in her gallery. He showed there again the next year, then later in the 1970s with the Protetch/McIntosh Gallery before moving to Chicago and climbing the art world ladder of success. Enid Sanford showed her abstract paintings there during the 1960s, then her figurative works in the 1970s. Richard labeled Sanford an incredibly responsive painter to the tenor of her times.

Henri continued finding more artists using her simple motto of "not boring." She enjoyed pushing boundaries. In 1970, Henri sat on a flesh-colored sofa shaped like a female nude and waved to the businessman walking past her gallery window. "They liked the boobs," she surmised.

Sometimes during slow days, a visitor to her gallery might be in for a surprise. She brought out glasses to fill with a couple of shots of vodka. "I won't let you get out of here alive unless you have a drink," said Henri. "People always want to know what my favorite painting is, but I never tell them. They always say, 'Why? Why?' It's such a stupid question, something you'd expect from a two year old. What a bore."

Friends attended her "chapel" service on Friday evenings, which included powerful vodka drinks and art talk. A fellow gallerist recalled having a few with her on

several occasions. One artist recalled that during the early 1970s, a visitor fell out of the window and down two stories. Henri's last event occurred in the winter of 1996.[7]

In between the galleries, other stores signaled the changing of the neighborhood. At 2138 sat The Sign of Jonah. One intrepid reporter observed that a shopper walked through a sort of wooden curtain which clicked softly behind the person. The shop was a bit on the eerie side but fascinating, selling primitive religious objects and engravings. Washington-based artist Rosie Grierson made needlepoint pieces in the space.

Other galleries located in another part of the city came over to the 2100 block of P Street. Both Haslem Gallery and the Protetch Gallery left digs in Georgetown and raised new money to move into larger quarters. Jane Haslem left a tiny row house in the Book Hill neighborhood of Georgetown. One of her first shows in Georgetown featured Josef Albers prints and Edward Hopper prints and drawings. "The prints were $925, and the drawings were $1,200, and I didn't sell a single thing," she said. Haslem observed that there was no parking and not a lot of foot traffic in the area. "Up on Wisconsin Avenue if I hadn't closed at 4:30, I'd have been sitting there all alone for an hour and a half," Haslem said.

Jane Haslem planned to paint and rented a studio in Chapel Hill, North Carolina, while her husband attended graduate school. Soon she rented every studio on the second floor. "What are you going to do now?" her husband Jack asked. "'I think I'm going to open a gallery.' And I didn't even have the vaguest idea of what a gallery was," Haslem said years later. She grew intrigued with representing artists after seeing two Leonard Baskin woodcuts on the cover of *Life* magazine in 1960. Haslem offered him a show. "I was so nervous that the phone just kept sliding out of my hand," she recalled. At the start, Haslem also used the space to teach art to children, a more sensible activity to some local residents than selling art. "When I started, it was the only gallery in North Carolina," Haslem says.

Trips to various galleries in the Midwest and East Coast provided some background and practical education. Artists like Baskin also taught at colleges and universities around the country. They provided an outstanding education for Haslem. "They showed me their studios, how you make prints, what's good, what's bad. So I had a really outstanding training in printmaking." Baskin introduced her to some of the period's leading printmakers, and some of them made recommendations to Haslem about representing their top students.

Haslem sold that first gallery, as the family followed her husband to his teaching in Madison, Wisconsin. When he began teaching at the University of Maryland, the brood came to the region. Barbara Fendrick and Harry Lunn cornered the market in big-name publisher prints, including Jasper Johns and Robert Rauschenberg's works. Thus, Haslem featured early 20th-century prints from John Sloan, Thomas Hart Benton, and Peggy Bacon.

On P Street, Haslem's Gallery occupied an eight-room suite in the Georgetowne House. The owner of the building, Stuart Bernstein, offered good rates to art-related, *Gallery Magazine* owner Elias Felluss recalled. Haslem whittled many names from her gallery's list of artists, saving only the best. She devoted the added space to show more paintings and sculptures than before. It also kept the list sparkling with the names of blue-chip artists mostly from out of town. "People come here [P Street] to see art and this is just the kind of space we've been looking for. And there's parking."

In the beginning years, things went swimmingly. "You didn't have a chance to sit down, get a drink of water or anything because people were always in the gallery," Haslem recalls. "If Paul Richard would write up a gallery, by the time you got there to open, there'd be a line of people outside waiting to get in."

Unfortunately, the market for these prints slowly waned. Ever resourceful Haslem now featured Op paintings by Richard Anuszkiewicz and Julian Stanczak and semi-abstract oils by Peterdi. Haslem galley featured realist works. This group included the meticulous landscapes of Billy Morrow Jackson. The realists under her wing also added a few local artists. Yale-graduate John Winslow showed at the Studio Gallery and the Corcoran before joining Haslem in 1978. He stayed with the gallery through the early 1980s.[8]

Protetch abandoned a one-room shop on M Street and took over the Poodles N Pals pet shop. A rangy, handsome graduate student at Georgetown University started a gallery in an old bicycle shop with his friend Harold Rivkin. Although laconic, Protetch hustled his way into selling some of the big-name conceptualists. They also sold earth art and Art Povera, areas that received little attention in Washington. Their new space had two rooms on the first floor and a couple more rooms on the second, with a sculpture court in the back. "I moved to P Street [because] I think that it's important that a lot of people come through here and be exposed to this kind of art," Protetch said. Indeed, the gallerist gave Vito Acconci his first one-person show. "There's also a bit of ego involvement because I think the work I'm showing is better art. Washington is too involved in a decadent, decorative tradition."[9]

Two members of the Washington, D.C., international community ventured into the city's P Street art world. A World Bank translator, Frenchman Marc Moyens, and Mrs. Mini Odoroff opened Gallery Marc. While Moyens remained an avid collector, he and his partner saw the potential for selling international artists in Washington. The pair contacted artists around the United States and Europe, and their place featured individual artists who had never shown in the Washington, D.C., metropolitan area.

Other émigrés came to the city under less fortunate circumstances. Arriving in their 30s, Ramon Osuna and Luis Lastra had associated with Fidel Castro and the Cuban Revolution. Lastra left the country penniless and feeling suicidal. "I was deeply romantic in those days," he explained his choice to visit the Phillips Gallery to see Renoir's *Boating Party* before dying. Instead, he took a job as a guard at the Phillips before joining the Pan American Union, where he collected art for embassies and individuals. Osuna reorganized the Havana Museum, then could not bear certain actions of the Cuban government and came to Washington. He became the assistant to the chief of the Union's visual arts division.

Lastra and Osuna started Pyramid Gallery after already having several contemporary Washington artists in the fold. They also sold Magritte oils, de Kooning drawings, Japanese prints, and pre–Columbian art. As with many immigrant stories, both tirelessly worked at their business. Most importantly, Lastra and Osuna shared the gift of building trust with collectors. This skill served as a significant advantage in a city where Nesta Dorrance of Jefferson Place Gallery observed, "I think everybody here sells to more or less the same people." Observers noted sales expanded to artists and collectors from Philadelphia, Baltimore, and Richmond.[10]

Many sales occurred during the small window of the gallery's opening night for

a new show. Sometimes they got returned when the dawn of the new day emerged. As Inga Heck, manager of Gallery Marc, explained, "[Collectors in the area] buy art on credit, putting so much down and paying so much a month. One doctor I know pays about $100 a month to six or so galleries. While spending as much as $10,000 per year, he usually doesn't go over $4000 for a single piece." His purchases were somewhat different than many. "Most young collectors stick to the $500 price range, but they'll buy several [pieces] during the year." The region's collectors ranged from doctors and lawyers to some civil servants, and many started collecting when very young. Some active collectors who thought Washington artists were very worth their money were Mark Sandground, Mr. and Mrs. Mackenzie Gordon, and Dr. and Mrs. Howard Sibley.[11]

The Pyramid Gallery pair also organized P Street's sole group manifestation with night get-togethers. In the early 1970s, the galleries on P Street Strip made life easier for the city's art lovers. The first Tuesday in January of 1973, the galleries held their first of the many joint openings they held over the years. Art lovers parked near Dupont Circle and walk the gallery loop. If energized, they saw the shows at Studio and Agra on nearby Connecticut Avenue.

The Jefferson Place Gallery sold many of the local artists of some national renown, including the color painters noted in the last chapter. Two of the prominent artists of the late 1960s and early 1970s in the galleries' galaxy were Rockne Krebs and Sam Gilliam. Both became national figures in the art world of the next decades.

Born in Kansas City, Missouri, Rockne Krebs earned a master's degree in sculpture. His mother always said he was interested in art, saying she saw him looking at light through a glass at one year old. After a teacher noticed his artwork during the first grade, she recommended that the boy take a Saturday class at the Art Institute. "He was the youngest one in the class," Mom said, recalling that outstanding art students from all over the metropolitan area attended.

Krebs found himself serving in the U.S. Navy Reserve in the early 1960s. After a tour of the Pacific, the Navy shipped Krebs to the Washington Navy Yard. He used the hobby shop during off-hours to resume sculpting. He submitted a piece in the Corcoran's Area Show and won first prize in the format. Funded by a foundation grant, art critics traveled around the country to see particular artists' work. A group came to Washington and saw 30 artists in their studios and selected pieces from Krebs and Ed McGowin. After selling these works in New York, both artists saw this event as part of the launch toward national recognition. Like McGowin, Krebs was in his 30s, married with children.

The Jefferson Place Gallery gave him his first one-person-show in 1967. The WGMA acknowledged his abilities with an artist fellowship. Getlein saw much promise in his early pieces and grew increasingly excited the next year when he observed a much higher achievement level in the chevrons and other pieces. Krebs and Gilliam's works stood out at the tenth-anniversary celebration for the gallery.

Krebs pioneered the development of the laser as a tool for art. The new critic at the *Star*, Benjamin Forgey, called the artist a visionary. Krebs brought a truck with spotlights to the front of the WGMA and made an art piece with the two beams. They formed an enormous "V" in the sky. Krebs spent months working with engineers in California to figure out the requirements. Krebs received a patent for the first 3-D laser piece and for a laser beam reflective system. Not all pieces lasted. One suffered

damage when the assistant of artist Donald Corrigan backed his car into it. Gilliam and Krebs promptly kicked Corrigan out of their studio.

Commissions for laser artwork became a regular phenomenon for the artist. Philadelphia's Museum of Art hired him to use his beams along the Parkway. A decade later, one chronicler noted, "Few who saw the Rockne Krebs work of the early 1970s, in which a laser beam bounced up and down the Parkway between the Art Museum and City Hall, will forget the way it dramatized the bold diagonal of the Parkway slicing through the foursquare city." His 1974 beam "Irish Light" outside the Kennedy Center memorably lit above the Potomac River.

The artist continued this magic in other cities. In 1984, "Neon Bridge" used rainbow neon to color 300 feet along the Miami River's subway arches. The local reporter's comment: "Krebs will have a great line for singles' bars: 'Stick with me, kid, and I'll get your name up in lights.'" The artist turned the laser into cultural energy. Krebs stated that his favorite works were these public pieces on structures. "There is something there that the public needs and we artists are trying desperately to give it to them."

Krebs received numerous fellowships and commissions around the world. He remained very active in the Washington, D.C., art world. He served on the boards of three cooperative arts groups, helping to found one of them. "Of the 38 major pieces I've made in the last ten years, two still exist," he said. "Perhaps I ought to start making still-lifes of flowers." The Smithsonian American Art Museum maintains a screen print and drawings of his in its collection. Other museums holding his works include the Brooklyn Museum, Walker Art Center, and the Georgia Museum of Art.

One of his tour de forces occurred in his adopted hometown's International Sculpture Conference in 1980. Based in Washington because of the decision of its executive David Furchgott and key funder J. Seward Johnson, the International Sculpture Center organized the largest sculptural exhibition held in the U.S. to that time. Over 2,000 people toured the 500 pieces located around the city during the week in June. As Paul Richard noted, one found them everywhere, "in wooded groves and galleries, on windowsills and sidewalks. They stand in littered lots, hug the sides of buildings, burst out of the earth, float in the night sky." Twelve top sculptors had pieces around the lawn of the Kennedy Center. But the hardest to locate were pieces on the Washington Mall. "The Park Service doesn't like an infringement on the Mall," observed the event planner, Carolyn Peachey. She worked with the artists and the federal bureaucracy going over each piece one by one to have the permit to place the artwork on federal property.

Peachey recalled the difficulty getting permission for Krebs' piece, lasers sitting on a Lincoln Memorial platform. "The Lincoln is hallowed ground," she remembered, promising the NPS' leadership that she oversaw the installation of the art and be there for the performances. "Credit the truckers, general contractors to transport and set up the platform and the piece. They respected the talent of the artist."

From 9 p.m. to midnight, Krebs' laser beams danced over the Mall. A strange eye glowed halfway up the Washington Monument while the Lincoln Memorial gazed out toward the Capitol in a triangle of light. It bounced off the White House and the Jefferson Memorial. Richard observed that Krebs' beams assumed an almost magical beauty. "When he sent the beam up Sixteenth Street, it drew the attention of the entire city," Preachey asserted.

The success of the exhibition prompted the International Sculpture Center to become a membership organization and promote sculpture and sculptors more widely. While many of the pieces were intended as temporary or lasted a short period of time, one stayed for years. J. Seward Johnson put a 70-foot giant known as *The Awakening* in the ground at Hains Point's tip. It reached up toward the airplanes landing on the runway at National Airport until the sale of the piece for $750,000.00 and its repositioning at National Harbor in Oxen Hill, Maryland.[12]

Krebs' friend, native Mississippian Sam Gilliam, started painting in elementary school during the 1930s. After serving in the U.S. Army and completing a Master of Fine Arts degree, he settled in Washington, D.C. in 1962. Gilliam's show at the Jefferson Place Gallery during the mid–1960s met with success as critic Andrew Hudson dubbed his new show at the gallery the most exciting thing to happen in Washington art during 1966. The artist made a significant breakthrough by dissolving or forgoing the geometric layout in his paintings. One year later, Gilliam sold out his exhibition at the Phillips Collection.

The Sterns recognized Gilliam and provided a stipend to support his making art. He transitioned to beveled-edge slice paintings extending off the wall and toward the viewer. Gilliam began taking the painting off the wall, stretching and draping the canvas. Gilliam stated that observing women hanging laundry on clotheslines from his studio window inspired these works. The drape paintings gave him a national name. In 1972, Gilliam became the first-African American artist to represent the United States at the world-famous Venice Biennale.

By the fall of 1972, Gilliam was back from Venice, and The Jefferson Place Gallery was in flux. The cooperative had to move from 2144 P Street before the building came down for redevelopment. The new location at 20th and P Street led to a doubling of the rent from $550.00 to $1200.00 a month. Factoring in framing, communications, etc., the cost rose to $4,000.00 a month to keep the gallery afloat. With the standard 40 percent commission, the gallery had to sell $10,000.00 of art per month to break even. This task proved more and more difficult. Jefferson Place folded in the fall of 1974. Among the thousands of dollars owed to creditors and artists, Gilliam nearly topped the list at $17,000.00.

Gilliam's reputation grew, and he received public art commissions in cities like Boston, and Queens, New York. He showed fine art with the Middendorf Gallery for the next two decades. Gilliam began painting the "Black Paintings" because the works used variations of black paint only. He changed again through the 1980s, using a "quilted" painting style.

Gilliam exhibited widely, including the Museum of Modern Art and in galleries from New York to northern and southern California. Besides many private collectors, his works appeared in over 55 museums. This included the Phillips Collection, the National Gallery of Art, and the SAAM in Washington, D.C., and others throughout the United States and the Tate Modern in London.

During the second half of the 2010s, Gilliam's work received reevaluation. The value of his works soared. "This is his greatest renaissance yet," said Jonathan Binstock, who organized a Gilliam retrospective at the Corcoran Gallery of Art in 2005. A beveled edge piece that a few years ago went for $15,000.00 now cost ten times more. Gilliam set several records for the sale of his work, topping out at over $680,000.00 for work with an estimated original value of $150,000.00. The increases

were astounding but also part of the overall rise in the value of art. First-generation Washington color painters Morris Louis and Kenneth Noland recently set auction records of $3.6 million and $3.3 million.[13]

Several other Black artists found the Washington art world limited. Howard University's art department and gallery continued to be a vibrant space for that community's artists. Dr. Jeffrey R. Donaldson assumed the leadership of Howard's art department. The artist and educator spurred a focus toward a Black Nationalist aesthetic. Years before in Chicago, he created "A Wall of Respect" of 50 African American heroes on a Southside building. He supported Africobra, a group of artists that sought to make art that empowered the African American community. "The group was about letting people know we're here," he stated, asserting that few Black people appeared in Western artworks. At Howard, he worked with actor Ozzie Davis on the North American Zone Festival of Black and African Arts and Culture. He expected a turnout of 100,000 to the campus for the festival.

While bringing in the festival, Howard University's art department worked with the community to start Gallery I. Located in an abandoned storefront near the campus, the café and arts space brought Black dancers, poets, and visual artists to the middle-class Black community. Events have drawn capacity crowds of 90 on average. Donaldson brought Africobra (African Commune of Bad Relevant Artists) to Howard's Gallery in early 1972. Richard called it a "knockout show," but observed that the paintings bar the white critic everywhere. An Angela Davis portrait of letters generated admiration for its passion and inventiveness, and it warned the white reviewer, "Keep away." A purple piece of paper fastened to the canvas against the suit she wore said, "This is a replica of a revolutionary suit designed by Jae Jarrell…. This suit is not for honkies, strictly for black people in the current revolution." The group shared four main aesthetics: the expressive awesomeness that one experienced in African art; symmetry that is free based on African music, shine, wanting things to shine, and color that is super real. They strove to forge images and art that all Black people can see, understand, and afford.

Richard may not have believed that all the images he saw in annual shows were marketable for mass consumption. He liked the exhibitions of Black artists shown at Howard during the 1970s. Donaldson had taken a department making mostly conservative and apolitical works and invigorated it with a strong, powerful sensibility. Richard noted Africa's images, cowrie shells, and carvings, its patterns and masks appeared in the displayed art. Frank Smith's cubist portrait, James Phillips' hard-edged color painting, and Ed Love's sculpture all showed passion and energy released.

The question of what Black art was hung in the air. Yvonne Carter, a Howard-trained abstract painter who taught at the University of the District of Columbia, was one of many wondering about that question in the early 1980s. "There are black artists," she observed, "I don't know if there is black art. Yet." She sought to add spirituality into her work. Ms. Carter saw a shared concern among Black artists in Washington, D.C., and noted that they had limited access to white-owned galleries. Additionally, the artist asserted that Black artists received inadequate support from the city's black communities, despite there being 19 Black-owned galleries in D.C. She hoped that all art viewers cared about quality, sensitivity, and personal interaction with all artworks regardless of the artist's ethnicity.

Many among the Black artists in the city agreed. Painter Keith Morrison stated, "I've not found it easy to get associated with galleries in Washington." Co-owner of Nyangoma Gallery, Lusetha Rolle, explained, "I can count on one hand the black lawyer, doctors, and dentists I've sold to." She believed that they haven't been attending museums and galleries since childhood and, once there, felt frustration only seeing white artists.

A few years later, while at the 18th Annual Faculty Exhibition at Howard, Richard discussed representation. "One old and nagging question swirls around this show. Why, the viewer wonders, are artists as accomplished as Jeff Donaldson, Alfred Smith, Frank Smith, Bill Harris, and their colleagues so infrequently displayed elsewhere in this town?" Some postulated that white buyers tended to not purchase artworks with an adamant allegiance to black culture and community, such as being created among some faculty at Howard for some years. The *Star* newspaper appeared to cover shows at Howard Gallery less frequently and rarely covered Africobra's exhibitions.

By the late 1980s, some of the top pieces to Richard tended to shout less and sing more.

> The paintings of Jeff Donaldson are particularly impressive. Music is their theme. The painting, half abstract, that he calls "Square One" (1988) is "as intricate as lace." In "Circle Another," ...a drummer is at work. His rhythms are Egyptian. The gold of his bright cymbals recalls that of the pharaohs, and dancing, interweaving....

Alfred Smith depicted Washington with a gentle, kind precision. Richard also observed the loss of some strong faculty to other institutions. The university gallery's retrospective on two decades of AFRICOBRA showed it as a specifically African American expression of Black politics to Africa's colors and traditions.

While Washington Black artists struggled with gallery entry and building markets, regional artist and academic David Driskell devised a newish marketing technique for artworks. The Howard graduate who studied with James Porter worked with the Barnett-Aden Gallery during the early 1960s. After teaching at other universities, Driskell worked as a professor at the University of Maryland. A pivotal champion of Black art and artists, Driskell had collected pieces for many years, with nearly 500 works in his collection. In the 1970s, he advised the Cosbys on their collection. When "The Cosby Show" premiered to great success, Driskell placed works by Black artists on the set. This created a new class of collectors for Black art that began buying inexpensive print reproductions.

Driskell noted, "I don't see an artist as less black if they aren't portraying the social context in their work. If your life is black, it's a given that your art is black, and it's black because of our social circumstances. I know who I am. I don't need to prove it to anyone." His work, represented by the DC Moore Gallery in New York, included paintings, drawings, and prints. It was sometimes abstract and, on other occasions, figurative, with subject matter from African gods and rituals to urban life and landscapes in Maine.

Artists like Michael Brown grabbed hold of the traditions. The D.C. native forged vibrantly colored compositions that hide myriad cultural, historical, and spiritual images. The 40-year-old told Denise Barnes in the mid–1990s, "My work is dedicated to the preservation of a rich legacy of African American culture. Images

come through us, not necessarily from us." The question of Black and white artists approaching their craft differently drew an affirmative answer from curator Deborah Willis-Kennedy of the Smithsonian Institution's African American History and Culture Center. Her 1998 exhibition, "In Search of Balance: The Artist-Scholar," featured 60 artworks from six artists, including Porter and Driskell. Joanna Shaw-Eagle asserted that the show opened new areas for Black American art studies.[14]

The 1974 closing of The Jefferson Place Gallery occurred during a major recession in the economy. The first of two oil crises during the 1970s hit. The boycott by the world's largest oil-producing counties hampered production and hurt consumer spending in the country. Galleries felt the pinch. Jane Haslem noted, "I've been through three recessions, and this one is the weirdest I have seen." Studio Gallery's Caril Dulcan stated, "We're hanging on by the skin of our teeth."[15]

For several galleries, the art market in Washington remained strong. Protetch, Pyramid, and Haslem all had a great beginning of the fall season. Each sold art from artists who lived outside Washington as well as local artists. "You can't make money here by showing even first-rate local art," said photograph gallery owner Harry Lunn. "Nesta Dorrance of Jefferson Place did more for local artists than any other dealer here, and she went out of business."

While loss comes with every economic downturn, opportunities came, too. A new building went up on 22nd Street and P Street. Rebeccah Eisenberg opened the Gallery Rebeccah Cooper on the first floor. One of her early exhibitions featured California artists who painted fantasy creatures. Eisenberg declared that she was "showing important pictures of the 70s." Perhaps. Most importantly, Gallery Rebeccah Cooper already adopted the galleries' motto on P Street. Sell a mix of local and national artists. The gallery owners correctly believed that Washington collectors remained focused on big names from New York and London.

The amount of contemporary art sold on P Street continued to climb throughout the 1970s. At 2028 P Street, Middendorf had almost doubled its exhibition space. Haslem opened a new division focused on cartoons. The Foundry Artists who worked together in a Georgetown Studio opened a cooperative Gallery at 2121 P Street. Pyramid moved into the bigger space vacated by Gallery Marc. The former created a spruced-up location, and so did Protetch, who moved into a carriage house behind P Street.

Protetch also lived in the gallery space. He slept on a futon in one corner with a small couch and a coffee table in one area. One day, the sculptor Jim Sanborn went upstairs to show Max photographs of his new artwork. He sat down on the couch next to a second man and showed them the photographs. Sanborn said that "he hoped to make more and sell them in a gallery." The bald man responded, "Art is not about making a living; it's about expressing yourself, and be careful not to rest your head on the Robert Morris on the wall behind the couch." Such was the sage advice of Gene Davis.[16]

During the mid–1970s, Pyramid featured many group exhibits of contemporary local artists. One featured a group known as the "Beverly Court Show." The featured artists lived in the decrepit five-story apartment building near a gas station on Columbia Road in Adams Morgan. Once a central entertainment center, the Adams Morgan neighborhood lost many of its attractions after the 1968 riots. A decade of disinvestment and declining property values sparked a rise in crime. However, the

declining rents for the apartment buildings built in the 1930s for working-class peo-
ple offered inexpensive housing. Long-time resident African Americans saw that hip-
pies and artists and immigrants from Latin America, Africa, and the Middle East
moved in. This influx made the neighborhood one of the most culturally diverse in
the city. Slowly, low rents led to small stores springing up along Columbia Road and
18th Street, N.W., selling niche products to residents.

In the early-1970s, Adams Morgan centered artists Manon Cleary and friends.
Painter Allan Bridge, sculptor Yuri Schwebler, silkscreen artist Jonathan Meader, and
filmmaker Angelo Hodick swapped critiques of pieces they were making. Many crit-
ics and collectors regularly visited for liquor and cultured conversation. Schwebler
came to the city from Germany and practiced conceptual art that included turn-
ing the Washington Monument into a sundial. He moved to New York and commit-
ted suicide in 1990. Meader made enough gallery success to move out and purchase
a home in Adams Morgan. He then hit magic when he silkscreen-printed two uni-
corns. His first had an original value of $50.00, but five years later now claimed
$1,500.00. His subsequent edition had 100, with 50 presold. The starting price at
$400.00 increased with the next group of prints and the third edition.

Cleary was one of those slender, great, long-haired beauties that, once met,
seemed to remain unforgettable. "When I came [to D.C.], she was a star. She became
kind of a prima donna because she was so famous," said painter Judy Jashinsky. "She
was stunning, beautiful: long, brownish-black hair; real thin; wore ... little sundresses
and sandals. She was just very cool, and there was always a crowd around her."

Cleary and some friends continued exhibiting with Pyramid. Paul Richard men-
tioned the exceptional quality of the artworks assembled during one show in 1975.
Besides liking Rebecca Davenport's paintings and Shari Urquhart's pieces, he noted
that Manon Cleary's work stood out. Cleary worked as a professor of art at the Uni-
versity of the District of Columbia. Her interest in art started as an activity to do
at home on the many days she spent sick from diseases that her St. Louis physician
father brought home with him. While a student at Washington University in her
hometown, she struggled with the art department's professors. Cleary started draw-
ing highly erotic images, which gave her confidence and left her teachers struggling
to offer critiques.

The exhibitions of Cleary's works often featured drawings and paintings of her-
self as nude. All captured an idealized image. However, a reductive process of erasing
and layering graphite powder blended with tissues gave her drawings a photo-realistic
look. Her paintings looked particularly "unpainterly" without obvious brush strokes.
Paul Richard considered her the best figure painter of her generation. When a friend
gifted her a rat as a pet, it became deeply woven into her heart. Soon rats began her
chosen pets, and she regularly began painting the likenesses of her rodent friends.
Often, she depicted them in pastels, creating an intriguing contrast between color
and subject.

She stayed with Pyramid through the 1970s. All the while, her works showed in
galleries from Manhattan to San Diego. She traveled to make and display her art in
countries as far as Portugal and Kazakhstan. Cleary even discussed her "dick series,"
paintings on an episode of the Home Box Office's (HBO's) program *Real Sex*.

As a teacher for nearly three decades at the University of the District of Colum-
bia, Cleary influenced a new generation of the city's artists. She also curated shows

within the region. One show at the Rockville Arts Place during the mid–1990s had the theme of "black art." Cleary organized the works in four clusters of participating artists. Sam Gilliam, Lou Stovall, Sylvia Snowden, and a few other African American artists created pieces described as strong, often abstract, celebrations of color, light, and shadow. The second group of local artists made works in the color black. White artists depicting Black men and women constituted the third cluster, and, finally, Clark Fox, among others, created darkly humorous approaches to racial issues, stereotypes of women, and antebellum history.

Unfortunately, smoking and inhaling toxic paint fumes damaged her health. She suffered for years from chronic obstructive pulmonary disease and needed oxygen tanks to breathe from 1999 until she died in 2011. Many museums hold Cleary's works, including the Art Institute of Chicago, the National Museum of Women in the Arts, and the Brooklyn Museum. Her auction prices range from $750.00 to $2,500.00, depending on size and medium of the piece.[17]

Despite his success with local artists like Cleary, Osuna looked askance at the P Street Strip's proliferating galleries. "They all seem to think P Street is paved with gold and they want a piece of it," he told one major daily newspaper's lifestyle section writer. Five new galleries opened during 1976, raising the total number of galleries to nearly 20. The newcomers ranged from the latest cooperative gallery called Touchstone to the Diane Brown Gallery, formerly a private dealership of sculpture, which opened to the public to sell prints and photographs.

Despite his earlier assessment of the growth, Osuna remained optimistic. "There are enough [buyers] to support good art," he said. Diane Brown proved him correct. She made enough money to pay the rent even during the summer doldrums. "I can't believe it," she stated. The success came while the space devoted to exhibiting artworks increased by 70 percent since the previous season. Indeed, in 1976, the Studio Gallery moved to 2014 P St. above Middendorf Gallery from three blocks away on Connecticut Avenue because it felt "detached from the mainstream." That mainstream included lots of large crowds at the openings for each commercial gallery on the Strip.[18]

The change helped Studio Gallery. "We did do better, much better," said artist president Vint Lawrence. However, the gallery's rent rose from $600.00 to $775.00 a month. The overhead has doubled. Lawrence observed, "In a way our reason for being has gone. When we began there was no place to show in Washington. Now there are so many galleries that dealers are fighting over good artists." While Studio teetered, it joined the other galleries in a new plan to combat the summer dog days. They started the P Street Art Auction. Nearly everyone on the Strip set up hundreds of works, ranging from Warhol prints to Washington-based artists' works. Visitors bid until 8:00 in the evening, when the results were revealed. The results ranged from fair to excellent, with individual sales from $2,700.00 to $9,000.00.[19]

As the P Street Strip galleries reached a decade of large-scale operation, they provided D.C.-based artists more opportunities. The Washington, D.C., region had approximately 1,000 professional artists, many of whom make their living as teachers. Most pounded the P Street pavement looking for gallery representation. "It also means learning to take your lumps," said painter Pooka Glidden. If a named gallery's manager asked them to join, the artist discovered few attained greater representation and individualized attention. A tiny group sold works there and often had to wait to receive their money.

Most gallerists wanted to pay, but as small, undercapitalized businesses, galleries sometimes didn't have the cash at hand. Purchasers often paid over a long time. "Everybody in the art world complains about not being paid, including the dealers," gallerist Chris Middendorf noted. Artists with more prominent names get paid first because a dealer needs to hold on to them. "There has always been a problem where new or lesser-known artists are concerned," Rasmussen observed.

Despite winning awards, an artist such as Ed McGowin found that the cost of his materials alone made it impossible to make a living. His wife, Claudia DeMonte, earned $40.00 selling artwork in 1978 while spending $2,800.00 to make them. Sculptor and conceptual artist Rockne Krebs rarely ever cleared more than $16,000.00 a year. Painter Rebecca Davenport sold well, but she has never earned as much as $10,000.00 a year. Better-than-average artists might earn $2,000.00 a year from selling their works so they took other jobs to live. In the early 1980s, an impoverished artist made less than $7,000.00 annually.

Artists sometimes won a fellowship from the D.C. Commission on the Arts and Humanities. Founded in 1968, the organization supported local arts organizations and individual artists based in the District with grant money for various projects. The money rewarded individual artists whose excellence contributed to the city's position as a world-class cultural capital. A few hundred dollars to almost any artist made a significant difference in their lives. As one artist noted, "The fellowship helped the artist with their resume and in building their c.v." The acknowledgment probably helped artists in their pursuit of other fellowships and awards. Allan Bridge observed, "For most artists in this city it's a marginal existence. We work for the right not to have to work.... The freedom to make art is a significant freedom." For those artists whose definition of success focused less on earning a living, the area proved a fertile place to live and create.

A group known as "the O Street Artists" rented a row house on 21st Street and O Street, N.W. Anne Marchand, who came to Washington with friends from the Jimmy Carter Administration, learned about the space from a friend from her days at the University of Georgia. Since it was much larger than her Rhode Island Avenue location, she moved in. For nearly two decades, the house remained an artist residence. Marchand, who managed the space, mentioned that many people came through the doors and then moved on to their respective careers. Over 40 artists resided there during a decade. Jean Morgan painted natural landscapes; Betsy Packard worked in sculpture; Evelyn Watts, with clay.

Marchand initially painted figures, but in time adopted a style Sidney Lawrence described in the book *Washington Art Matters* as "Hallucinate Abstractionism." Marchand showed with Touchstone Gallery, whose maven, Luba Dryer, "had a great rapport with the general public and was always promoting her artists." After being introduced to the Southwestern U.S. Native American cultures, its symbols and dance movements informed her works for two decades. Marchand exhibited widely around the country and in galleries and non-profit spaces throughout the D.C. region.[20]

Jody Mussoff recalled pounding the pavement on P Street and getting lucky. Moyens fell in love with a sideways facial drawing called *Salome*. She met with Komi and joined the gallery's list. "Moyens was difficult, very opinionated. You'd come in with a drawing and he'd say, 'Oh that arm!' Very picky." Mussoff sold out an annual,

earning $12,000.00 each of the first couple of years with them in the mid–1970s. She enjoyed working with Komi and recalled a one-day art sale in the early 1980s during the early AIDS crisis. They walked $13,000.00 over to the Whitman Walker Clinic. Protzman noted that Mussoff's style was instantly recognizable, sometimes toying with feminine beauty, art-historical references, and whimsy in her drawings. As Protzman noted, the artist gained international renown from her Washington base. Jody showed at Monique Knowlton Gallery in New York City and a gallery in Sweden, where she observed that her angst-ridden women sold very well.[21]

Pyramid Gallery and later the Osuna Gallery represented another notable Washington, D.C., artist of the era, Anne Truitt. Born on the eastern shore of Maryland in the early 1920s, she graduated with a degree in clinical psychology from Bryn Mawr College in 1943. She married James Truitt and moved with him to Washington when he took a job with the State Department. After pursuing writing and translation work, she took courses in art, then put the training to work by experimenting with various media, including clay, cement, and steel welding.

During the mid–1950s, Truitt hung around the Workshop Center of the Arts and made friends with Kenneth Noland. Initially, she generally made figurative sculptures, many of which were small, while she shared a carriage house in Georgetown with two other artists. A show of Abstract Expressionists at the Guggenheim Museum in New York in 1961 profoundly influenced Truitt's work. She saw the singularity in their work and use of color. She devised her approach, creating wooden structures of simple geometry. Truitt applied layers of paint and sanded away the brush strokes to give the figures depth.

Noland introduced her to Manhattan gallerist Andre Emmerich. Already marketing Noland as well as Morris Louis, Emmerich took Truitt into his group of artists. For her first solo show in 1963, Emmerich, with Noland and Clement Greenberg, decided what pieces appeared. The gallerist even tried to convince her to hide her gender to get a more positive reception in the art world.

After spending a few years in Japan with her husband, the Truitts returned to Washington. The artist took over Noland's studio in Twining Court, an alley right behind the P Street Strip. The couple divorced in 1969. She faced enormous personal pressures raising and earning a living for her family. Like many artists, she turned to teaching to support her family, serving as a professor of art. She taught at the University of Maryland for nearly two decades.[22]

Meanwhile, her art career experienced some increased attention from the art world. Her sculptures appeared in the last show curated by Marjorie Phillips at the Phillips Collection in late 1971. Forgey and Richard thought the sculptures took some of the color painting ideas further than the show's painters. Richard called an exhibition of her boxes one of the most important art displays ever created in the city. The Sterns provided her with a stipend, and the National Endowment for the Arts gave her a grant in 1972.

The Whitney Museum of American Art and the Corcoran Museum of Art held retrospectives on Truitt's career in 1973 and 1974. The attention moved her to create a diary of her feelings, published as *Daybook* in 1982. The question of selling art for consumption faced challenges from several art movements during the 1970s. Truitt documents her reactions to the consumption and responses to her works in the diary, along with the daily struggle to sell the pieces she created to have enough money to

keep working on them. This situation became more problematic when the University of Maryland mandated that she retire from teaching because she had reached 70 years old.

Truitt made art for another decade. The artist died in Washington, D.C., at 83, in 2004. Five years earlier, she had 17 exhibitions across the country. While related to the city's color painters, she avoided that label as effectively as she avoided the Minimalism label. Ms. Truitt had collectors among the art lovers of the Washington region. The Robert and Mercedes Eichholz Foundation used its collection to help the National Gallery of Art's Tower in 2017. Museums holding her works in their collection were the Smithsonian American Art Museum, the National Museum of Women in the Arts, the National Gallery of Art, and the Hirshhorn Museum. The Whitney and the Museum of Modern Art in New York and the Walker Arts Center in Minneapolis, Minnesota, also have her work in their collections.[23]

By the end of the 1970s, when Truitt began exhibiting with the Osuna Gallery, the Strip experienced significant changes. A lucky 13 galleries flanked P Street between 20th and 22nd Streets. Another 13 galleries expanded to Connecticut Avenue, ranging from The Local 1734 Art Collective to the Venable Neslage Gallery. Two blocks down, Photo-Graphics, a new photography gallery, sat close to one of the old-timers, the venerable Veerhoff Galleries. Gallery 10 occupied a space on the second floor of a walk up and around the corner sat the Washington Women's Art Center.

A unique gallery serving the craft arts community also opened one block north on P Street. Greenwood Galleries began business at 2014 P Street in late 1978. In a little over a year, Greenwood gained a reputation as second only to the Smithsonian Institution's Renwick Museum for introducing Washingtonians to area artisans and some of the best craft in the country.

Gallery Director Carolyn Hecker mixed the exhibitions well. Visitors to the gallery might see fiber artists one month, a married pair of enamellists from Bethesda, then be introduced to Marvin Lipofsky, the godfather of glass blowing, during the International Sculpture Conference in 1980. Despite the plaudits and a level of success, the recession of the early 1980s forced Greenwood's closing at the end of 1981.

The neighborhood changed as Georgetown and Capitol Hill had years before. The hippies, artists, and renters who filled the area for nearly two decades faced economic pressures. A one-bedroom apartment rented for $350.00 a month cost $500.00 at the end of the 1970s. Most/many of the older buildings needed significant electrical and plumbing updates and renovations. Apartments converted to condominiums, forcing tenants out. Galleries faced higher rents or the possibility of a new office building replacing their townhouse. Office development pressures grew as the completion of the Metro's brought downtown Washington to Dupont Circle.

Dealers on the Strip noted that the neighborhood was changing. They watched as land values climbed and many nearby older buildings were undergoing renovation. One gallery owner said, "P Street is just high rent for bad spaces." Indeed, Jane Haslem heard that her landlord might have other plans for her space inside 2121 P Street. Diane Brown expressed how difficult it proved to show contemporary sculpture in her current area because of its size limitations. Nancy McIntosh of Protetch-McIntosh said, "It is very expensive here on P Street and I have only 1000 feet of useful space and no storage area. No structure on P Street is adequate for my

large-scale work." Jim Cramer of Cramer Gallery at 2035 P St noted, "I pay $12 plus per square foot [a month] and that's a hell of a lot of money."

Slowly, the galleries along the Strip relocated to other parts of the city and the region. Studio Gallery reopened inside the historic Le Droit building at 802 F Street. Poorly maintained and largely open floor plans, the Le Droit, along with the Atlas Building on 9th and a tall building across from Fords Theater on 10th streets, had served as studio spaces D.C.'s artists. Artist Sam Herman envisioned turning the Le Droit into an artist space with galleries and arts-related shops on the ground floor to make the project financially feasible. Leland Allen, Director of the Pennsylvania Avenue Development Corporation (PADC), noted, "There is no guarantee that the LeDroit building will ultimately be used for artists' space unless a financially viable plan can be found."

Other plans combining the arts and the downtown area existed. Attorney Robert Lennon, founder of Artransport, and Stanley Westreich, an art collector and real estate developer, won the right to negotiate with the PADC. Their goal was to obtain a 99-year lease on the 19th-century buildings from 401 to 417 Seventh Street, N.W., where they anticipated placing 14 different galleries, studios, art supply stores, a book shop, and a coffeehouse. However, the buildings sat in terrible shape. In 1977, a fire gutted them. The years of subway construction made their foundations shaky.

Meanwhile, the PADC decided about the building they held across the street. The winning proposal for the former Lansburgh Department Store came from the National Archives and Record Services and called for an arts and humanities center with studios, exhibits, performing arts, and a combination of dining and

The Atlas Building II, 527 9th Street NW, 1995 (Courtesy of the Photographer, Michael Horsley).

entertainment area on the ground floor, mezzanine, and the basement. The second and third floors served as additional office space for the Archives.[24]

As these plans became more solidified, galleries along the P Street Strip made decisions about their locations. By 1984, the P Street Strip had three remaining galleries. A few headed north and west in Dupont Circle. Several elected to move to new space downtown. They joined the Washington Project for the Arts and the District Creative Space in forming a new arts area downtown.

9

The 1970s

The Cooperatives and Entertainment Places in D.C.

Flames filled the mold and flew out into the air. The Styrofoam used to shape the eventual sculpture escaped as gas out of a vent tube. The men, wearing goggles and face shields, moved around the one-time filter tank for Glen Echo Park's Crystal Pool with ease. A faded sign reminded users to return towels and bathing suits to the attendants. A St. Bernard loped in and laid down. All along the floor sat polished aluminum cones inside the 5,000-foot studio. One inverted cone contained four faces. Half-cones linked together to create a wall sculpture.

Two years earlier, the National Park Service saved the seedy 17-acre park from the developers who had plans for high-rise apartments. Officials converted the Penny Arcade into a theater space. The Hall of Mirrors, the Tunnel of Love, and the Crystal Ball Room became spaces for crafts, drama, and dance instruction. The agency envisioned a seven-day-a-week art space, generally for children. But adults took courses in painting, pottery, and now, under Big City Metal's tutelage, sculpture. The six artisans were thrilled with their space at the pool. "What the National Park Service has done here is much better. They have given us a space where the atmosphere is conducive to work," Jim Sanborn said.

Three of the group's six members had pieces on exhibition at the Corcoran Gallery of Art during 1974. Jim Sanborn also had a one-person show at the Virginia Museum of Fine Arts. Jim recalled that the General Services Administration made trailer loads of aluminum available. "I kept making larger and larger constructions." His large artworks appeared on outdoor display in Charleston, West Virginia; Reston, Virginia; and Baltimore, Maryland.

"One day a black limo pulled up in the park, all the artists were thinking, 'who is this that is coming to see Jim.'" Gordon Haines of the hosiery and undergarments fortune got out of the limousine. He knew Sanborn's father, who was an artist and designed museum exhibitions. Haines saw Jim's name in a magazine, calling Jim's father and learning Jim was his son. Haines then commissioned a large stone piece for his house in Winston-Salem, North Carolina. Sanborn fashioned a similar stone piece for Baltimore's West Cold Spring Metro Station.

During the late 1970s and early 1980s, Sanborn appeared in the Corcoran biennial of local sculptors. He also fashioned a piece for the show celebrating the tenth anniversary of the Hirshhorn Museum. Diane Brown had moved from P Street to start Diane Brown Sculpture Studio on O Street in the Hanover neighborhood near

North Capitol Street. Sanborn had the first show in the new space, and Jo Ann Lewis referred to his sandstone pieces as "a highly expressive body of work that conjures elemental geological forces." His early shows sold very well.

The NPS tore down Glen Echo Park's crystal pool in 1981, and Sanborn left his residency. He moved to a studio on Girard Street in D.C.'s northeast section. When Diane Brown departed for New York City, she showed Sanborn once in her new location. Nancy Drysdale and later Cheryl Numark both had Sanborn among their cadres of artists. Sanborn noted that he reached a certain level of success in contemporary art but made a more substantial mark in the public art world: "My work was not saleable because of its size and strange subject matter so I had to get grants to fund [my] creations." That, and he taught at the University of Maryland for three years during the mid–1980s.[1]

The fruition of the first of his ten-year relevancies happened with a show at the Corcoran called "Spectrum: Natural Settings." One of seven artists in a well-reviewed exhibition, Jim Sanborn's *Striking Stones Under the Thunder* seemed raw, elegant, and timeless to Pamela Kessler and Paul Richard. While commissions continued coming in from cities looking for public art, Sanborn won a significant commission from the Central Intelligence Agency. He built a large granite and copper piece for the central courtyard of the agency's new headquarters after touring the space. It contains a 2,000-word phrase written by a spy novelist that remained top secret. Known as *Kryptos*, the piece met opposition from government workers and the city's arts community.

A naturally investigative person, Sanborn performed scientific experiments as a boy inside his parent's home. He constructed tree houses with sliding glass doors. The artist used art as a platform to explore some of the loves of his life, which included archeology, physics, the natural world, and invisible geological forces. Many works in exhibits at the Corcoran and in countries around the globe. His works appear in public collections throughout the United States and in art venues around the world, including the Kaohsiung Museum of Fine Arts in the Republic of China and the Kawasaki International Peace Park in Kawasaki, Japan.[2]

The metalworkers weren't the only artists using the space at Glen Echo Park. On one summer weekend, the Dentzel carousel contained more children than usual. Round, wooden yurts housed studios for potters and weavers. All around the large amusement park stood craft booths filled with everything from paintings to jewelry. On either side, large stages housed the occasional folk singers and pop bands. Hundreds of women bundled in coats to fight off the fall winds milled around these spaces. The new national park site hosted the Womensphere Festival of 1974.

Inside the park's huts and along the walls of a few studio spaces, female artists showed their wares. Instructors stood before small groups of women in their 20s and 30s and some infants and illustrated how to paint or make a ceramic bowl. In the Spanish-Mission-style ballroom, people sat cross-legged on the floor while dancers glided before them. About 4,000 spectators came to the event over the three days.

Women's arts groups and organizations existed since the 1890s. The National Association of Women Painters and Sculptors held an annual winter show of women artists in New York City. The hundreds of oils, watercolors, and sculptures in the yearly exhibition featured works from the organization's members who lived in Washington, D.C. However, the culture frequently circumscribed woman artists'

subjects because only certain things were properly of concern to women. These artists finished works that confined themselves to women's topics, such as children's faces, and supposed feminine materials such as vases and pastel paints.

Greater freedom in society by the 1970s provided women artists the opportunity to make more choices. But this change came after long battles waged by many individual women, organizations, and their allies. The last chapter showed that Anne Truitt faced sexism from well-meaning supporters, including her husband and art gallerist.[3]

While some statistics about the limited numbers of female artists in general—and females among the top artists in particular—were emerging, a small group of Washington, D.C., women took their concerns to the streets. Led by Mary Beth Edelson, they stood before the front door of the Corcoran Gallery of Art during the Biennial in 1971. Edelson's sign protested that 22 male artists had pieces on display while women showed zero. The group issued a statement that read, "It is necessary for the public at large and for the Corcoran specifically to increase their awareness of the work by women artists and for the creative activity to be evaluated by a single standard of quality."

Indeed, the Corcoran selection proved very limited. The Whitney Museum in New York City hosted a biennial in June of that year. Of the 132 painters in the show, 30 of them were female. The Museum pursued the standard practice for that era's art world. Despite there being more female than male artists in the United States, male artists grabbed the art world's attention. They appeared in 90 percent of national art magazines' articles and 80 percent of the newspaper reviews. They received many more gallery shows, sold more pieces, and sold them for higher prices. Female artists experienced a negative bias in receiving art grants, residencies, and fellowships.

To the credit of both these protestors and the Corcoran, a conference for women in the visual arts occurred the next year. The women artists, gallerists, and teachers met to focus on questions about women's role in the art communities and whether the art establishment discriminated against women. The conference signaled an increasing militancy among women artists who were tired of toiling under male values in the art establishment. Attendees included nationally known women artists such as Judy Chicago and Elaine de Kooning, and female gallery owners Betty Parsons, Nesta Dorrance, and Henri. The 350 participants concluded that far too few women served as college art teachers and that dealers, gallerists, and critics all discriminated against women artists. They asserted that women artists should be free to explore any subject and material.

Benjamin Forgey observed that the conference proved highly successful. He noted that more women would have attended if possible. He agreed with the participants that future art history will include more female artists and teachers. The notion that there were distinctly feminine traits in art was disproved and discarded—but feminist art quite possibly served as an advocacy for women's rights, etc. The organizers worked with Washington area galleries to feature women artists in shows during the conference.

The organizers perceived the Corcoran conference as emerging from recent activism like the anti–Vietnam War demonstrations in Washington and around the country. Barbara Frank observed that after the conference, "[t]here was a tremendous amount of energy in Washington." Many of these organizers felt a real hunger

to establish something more permanent, to give their "nascent feminist art community a home, a public face, and a place to grow ourselves as artists, feminist teachers, and art professionals." A new cooperative formed called the D.C. Women's Art Registry. They compiled a book of local women painters and sculptors, and 25 women registered. The book showed local galleries where to find talented women artists in the region.

Within two years, the D.C. Women's Art Registry grew to 100 artists. The Washington Women Art Professionals incorporated themselves in Adhibit Committee for the Arts to promote Washington exhibiting women artists' works. This new group received funding from the NEA, which helped them organize two shows at cooperative galleries in New York City. One featured five artists at AIR and an eleven-women show at 55 Mercer Gallery. Washington art critic Nina Felshin viewed both shows as having pieces ranging from fair to excellent.

The group's first regional juried women-artist show exhibited at the Washington Gallery on M Street in Georgetown. "Paperworks" drew 600 entries from 350 artists. Jo Ann Lewis felt that "the small space let down the numerous women artists." She also wondered where some of the "little wheels" in the area art world were, such as Manon Cleary, Enid Sanford, and Joan Danziger.[4]

For another set of women artists in the city, an opportunity to show work drew backlash. Maxine Cable and eleven other artists participated in the Art Barn show, "Women on Women," in the spring of 1975. These artists had a long association with the National Park Service building that began showing art in the early 1970s. The President of the Art Barn Association expressed distress over Cable's piece, called "Amazing Grace," which featured an American bride appearing over an altar in a church-like setting. What Cable intended as a spoof of American women's expected roles Mrs. Rebecca Nagel interpreted as a travesty of the "Virgin Mary." Nagel closed the show without consulting any artists and argued to the Association's board that the show was unfit for family viewing. The board voted to reopen the show; Nagel resigned in response.

These shows and the DC Art Registry led to the Washington Women's Art Center (WWAC). The members of the new group used the event at Echo Park to introduce themselves and their skills. Womensphere represented the nation's first non-political women's arts festival; it represented the first time that women organizers took over a national park. The group's coordinator, Barbara Frank, noted that the WWAC has a long-range goal of finding a building downtown to house events and classes on the arts. Its 20 members met at a Chevy Chase residence. The group needed to draw about 5,000 patrons whose $5.00 dues paid the rent.

The group grew to 130 members for the second Womensphere. It aimed to expand to 500, and if each paid $15.00 in dues, the WWAC broke even. Womensphere 75 "Images of Ourselves" occurred in mid–August and drew good crowds and media attention. Exhibiting artists came from the group and outreached to area schools like the Corcoran. Paul Richard noted that the 60 objects varied in style, but their subjects centered on women's bodies and "feminine content," such as menstrual cycles. He found the subject matter stereotypical. While referring to the show as "minor," Richard liked Jody Mussoff's drawings, the photographs of Bernis von zur Muehlen, and a number of the prints.

At the end of the summer, the Washington Women's Art Center had the desired

number of members. WWAC member Josephine Withers' family owned a building on Q Street in Dupont Circle. The doctor who had rented the building had died, so now a gang of women cleaned out the former office and turned it into a usable space.

The WWAC followed a feminist approach to art. Members supported one another and promoted exploration in both subjects and materials. When it opened in 1975, several "Great Society" programs helped pay for the center's operations. The Comprehensive Employment Training Act provided the WWAC funds to pay staff salaries. Grants from the National Endowment for the Arts (N.E.A.) Work Intern Program, the N.E.A. exhibition grants, and the ARTS DC provided monies needed to pay for exhibitions.

The schedule called for 11 juried shows during the inaugural season. The first exhibition at the permanent location of the WWAC was a photography show called "Looking at Others." It received reviews in the newspapers, which pleased the members. The group wanted its exhibits to foster engagement with the art and artist. Exhibitions featured two days during their runs when audience members and artists met in the exhibit space for an open dialogue. The end of the year show "Feminine Erotica" spurred many reactions.

While one critic dubbed the show "small and first-rate," Forgey observed that the exhibit "consisted of tepid stuff erotically and otherwise." At a conference one year earlier, he had insisted that feminist art was not relevant to his critique of art. Artist Barbara Brent challenged that this bias against feminist art was the reason behind his negative review of the WWAC's show. Still, the year proved successful as more women—and Black women, in particular—appeared in exhibitions around the region.

During the first season, another part of the WWAC's mission emerged. The center devoted some of its energies to offering workshops that taught art history and skills needed to work as an artist. They immediately became successful. Women in other arts were also looking for spaces to show and perform. Thus, the first season included a range of poetry readings, literature events, and other activities that featured D.C. women. As the group's primary grant writer Zita Dresner observed, "It was just wonderful being a part of something that began to grow and blossom. [This happened] through the cooperation and real affection that we all had for each other."[5]

The WWAC gained an executive director to stabilize the gallery. Lucy Blankstein had settled in Washington when her husband started working for the U.S. Agency for International Development. As she said,

> I was a solo person in my new studio trying to paint until I met Abby Steinglass, head of the Washington DC Slide Registry and a member of the Washington Women's Art Center. We shared carpooling duties for our kids, and she invited me to visit a critiquing session at the Center. I was hooked!

Ms. Blankstein focused on the center's functioning during the early years of her participation. Having an office presence gave the WWAC the status to be taken seriously, including receiving reviews of shows. The Brown Bags, lecture series, and classes on art and being an artist attracted many new members. Everyone from stay-at-home mom artists to art history professors and local architects attended events and became enthralled with the center. Blankstein stayed with the group until her husband's travel mandated that they leave D.C. until 1984. For Blankstein, being

at the center "was a hoot! I loved it because I learned so much from the other artists." Indeed, she noted that she was impressed by the knowledge and experience members had because "art majors weren't taught how to present their work or consider the business side of things."

Some others joined the group because they also wanted to learn the "real" art world experience. Judith Benderson began her involvement by taking a course called "Understanding the Art World." Ms. Benderson had taken art studies at the Corcoran. She wanted to learn a practical approach to market her abstract paintings, which incorporated elements of fantasy, nature, and some leftover psychedelic aspects. Within a few years of joining, she served as the group's executive director. Like one-time painter Margaret Paris, others started a local group called Washington Women Photographers and associated it with the center. Painter Anne Marchand enjoyed the exposure to a broad array of artists, their concepts, their work, and their camaraderie. As architect Ann Congdon noted, "[The WWAC] was a wonderful group of women who welcomed my two little girls and me as artists."

The WWAC also linked up with women's artists in other parts of the country and the world. Exhibits like the show "Artists Company" went to cities like Boston, Schenectady, Boulder, and Montreal beginning in 1977. The WWAC had 52 artist members appear in the Boston City Hall show arranged by a sister group of artists called Women Exhibiting in Boston (W.E.B.). The shows brought the artists' attention in those areas but also helped them in their home location. As Washington artist said, "the best way for a Washington artist to get a show in one of the aggressive galleries here it to make it big somewhere else first."

The WWAC also sought unusual places to show art. They brought exhibitions to police stations, stores, and other non-gallery spaces. They took various artworks to women in area prisons. Inside, they asked the inmates what the art made them think and feel, which brought out stories from these women. These exhibitions sometimes occurred because of the D.C. Slide Registry of Women Artists. Ms. Marchand noted that the tool allowed her to promote other artists' work and get them information about exhibits. The experience established her as a communicator and promoter for and of the arts.

Many women from the region found other women artists at the WWAC. As artist Sandra Wasco-Flood noted in 1978, "Washington was a cultural desert for women in the arts. There were hardly any women on the teaching faculties or in the museums. Gallery owners didn't want to look at your work." At the WWAC during the late 1970s, members showed and received media coverage, even if still critical of half the pieces on display. Exhibitions tangled with questions, such as, is art talent hereditary? The walls featured the creative efforts of 21 artist family pairings. University of Maryland art professor Josephine Withers made the intergenerational talent selections. Lewis observed that this exhibition showed the same growing assurance and quality evident in other recent WWAC activities.[6]

In 1978, the organization participated in the first Washington Area Women's Caucus for Art chapter. Local members and the national W.C.A. planned for a major conference in Washington, D.C., throughout the last week of January 1979. Josephine Withers curated the exhibition "Women Artists in Washington Collections." President Jimmy Carter held a presentation at the White House where he observed that

Oval Office: Lee Anne Miller, Louise Nevelson, Alice Neel, Selma Burke, Isabel Bishop, President Carter, Joan Mondale (Special Collections and University Archives, Rutgers University Libraries, Women's Caucus for Art, MC 883, Box 35, Folder 4).

America's women artists "had for too long been ignored." Center leader Charlotte Robinson stood beside Carter.

Women artists showed their artworks in over 70 commercial galleries around the region. At Middendorf/Lane Gallery, the Women's Caucus for Art honored Isabel Bishop, Selma Burke, Alice Neel, Louise Nevelson, and Georgia O'Keeffe with its first-ever lifetime achievement awards. "Look at the art history books, H.W. Jansen, who wrote the standard college text, does not begin to mention a single woman artist," Ms. Robinson observed. The conference proved a significant event for Washington artists but received a limited amount of publicity in other parts of the country.[7]

The WWAC, along with several other non-profit arts organizations, received a great opportunity at the beginning of the 1980s. Several years earlier, the U.S. federal government sought to reinvigorate the downtown Washington, D.C., area near Pennsylvania Avenue, N.W. The plan called for the historic preservation of many buildings and new construction in other cases. Inside all would be a repurposing of these buildings that brought new residences, office spaces, and retail. Since much of the surrounding area included older storefronts, garages, and decaying office buildings that currently held artist studios, the plan called for bringing in some art spaces during the initial redevelopment.

Another group of artists bounded together into a cooperative in the Adams Morgan neighborhood. Many of the small group of the Madams Organ Art Cooperative knew one another. "Corcoran dissidents" was George Koch's pithy description. The show "Alternative To" included all artists rejected from the Corcoran's local artist show juried by Benjamin Forgey. Roughly 200 pieces jammed every space on

WOMEN'S
CAUCUS
FOR ART

The Women's Caucus for Art wishes to invite you to the Awards Ceremony and Exhibition to honor five distinguished American women artists for "Outstanding Achievement in the Visual Arts." Those being honored are Isabel Bishop, Selma Burke, Alice Neel, Louise Nevelson and Georgia O'Keeffe.

January 30, 1979

Ceremony and Reception 3:30-5:00 P.M.

Embassy Row Hotel
2015 Massachusetts Ave., N.W.

Exhibition 5:00-8:00 P.M.

Middendorf Lane Gallery
2014 P. Street, N.W.

We hope to have you join us in this celebration.

Sincerely,

Lee Anne Miller
President, Women's Caucus for Art

Charlotte Robinson
1979 Program Director, Washington, D.C.

Ann Sutherland Harris
Chair, Awards Selection Committee

R.S.V.P.-Charlotte Robinson
6324 Crosswoods Drive
Falls Church, Virginia 22044
703-941-3865

1979 WCA Honors Award Ceremony Invitation (Special Collections and University Archives, Rutgers University Libraries, Women's Caucus for Art, MC 883, Box 35, Folder 4).

the walls. Although Forgey found many strange things and personal revelations, he might have added only a half dozen in the Corcoran show. Part clubhouse, home, cooperative, and gallery, members created art that struck their fancy, whether photography, video, painting, or psychic experiments. Their space, an empty building at 2318 18th Street where a hole in the kitchen floor offered access to the basement, came for a low cost. The members paid dues to cover everything they might need.

Anarchistic at heart, members showed their works and invited local bands to play at their location. Sometimes the public visited on the weekend, sometimes only one day during the week. The cooperative opened its location to the city's burgeoning

punk movement. The clubhouse served as Washington's first club to host groups like the Bad Brains and Teen Idols. Other members took different routes, taking advantage of a Department of Labor program called the Comprehensive Training and Employment Act. Working for businesses, organizations, and governments at various jobs, some in the arts, four artists hoped for long-term employment. The cooperative died in the early 1980s, leaving a bar with a variation of the name as a legacy.[8]

Downtown Washington held many artists' studios in a few of its older dilapidated office buildings. Across F Street from the Smithsonian's National Museum of Portrait Gallery was the decaying, Italianate-revival LeDroit office building. Initially providing offices for U.S. Patent and Trademarks clerks during the 1910s, the building housed banks, brokers, and real estate dealers. By the 1930s, the building lost its rental appeal and became home to artists. By the mid–1970s, creaky stairways led to large rooms with high ceilings and no heat. Artists paid for utilities and used hot plates and space heaters to warm food and themselves.

Other downtown buildings followed suit. Studios appeared inside decaying buildings at the corner of Ninth and F Streets and down Ninth at the Atlas Building. The artists inside these studios included Jacob Kainen, Gene Davis, Frank Wright, William Woodward, Ken Young, John Clemente Sirica, Richard Dana, and Shiela Isham. On the retail level, flashing gaudy colors advertised sex shops. Prostitutes congregated on numerous street corners for a similar purpose. Lined along Ninth between G Street and Pennsylvania Avenue, male prostitutes made one artist describe his walk to work as "running a gauntlet."

Some believed that this effort brought about the possibility of a downtown arts scene. The Studio Gallery closed its doors on P St because of "excessively high rents." In the LeDroit building, the gallery paid half the amount of the former rent. Meanwhile, Washington artist Sam Herman advocated rehabilitating the LeDroit Building to include low-cost living spaces for artists and studios graphics and photographic workshops. Leland Allen, director of the PADC, noted, "There is no guarantee that the LeDroit building will ultimately be used for artists' space unless a financially viable plan can be found."

Earlier that year, other artists and area galleries organized a show titled "Open City." Individual artists inside the LeDroit and Atlas buildings opened their studios to show their works. Area galleries, including Studio Gallery, the Miya Gallery on Eleventh Street, and the Intuitiveye Gallery on Indiana Avenue, featured works from members and additional city artists. The event created a new and exciting tour of a different arts area in D.C. The loop became part of a fall annual tour of artist studios across the region.

"City Art 1979" followed the Corcoran's sculpture exhibit of 1978 with 38 Washington-based sculptors. While the smaller pieces fit nicely in Studio Gallery at the LeDroit Building, the most extensive selections stood in sundry spaces around downtown. They faced the Portrait Gallery or the National Archives down on 8th Street and Pennsylvania Avenue. The show demonstrated the city's sculptors' strength and the value of well-placed art in public spaces. Despite the downtown artists' efforts, the PADC and the city's Redevelopment Land Agency (RLA) sought to turn the area into a flourishing office and high-end residential community.[9]

In the western third of downtown's "East End," several RLA-owned buildings stood vacant after the international retail center's developer failed to secure

financing. During the mid–1970s, the NEA encouraged the development of locally-focused arts organizations. Interested counties offered under-used older buildings as the place to locate local arts centers, and the NEA and state arts councils provided funds for building improvements and staffing. Whether in counties throughout Northern Virginia or Maryland, these centers aimed to show the best art that neighbors created. They worked to spur interest in art among talented high school students and their communities and to provide local artists studio space.

In Washington, Alice Denney, "the Mother Courage of the Washington avant-garde," planned to expand her current contemporary arts group Private Arts Foundation. RLA Director Melvin Mister and Merle Steir, a self-described arts agitator in the RLA, offered Denney a building for her new group rent-free. The Washington Project for the Arts (WPA) occupied 1227 G Street, former home of the Washington Conservatory of Music. The storefront had been unoccupied for two years, with only Mayfair Rugs and Carpet store on one side and Loretta's Weaving around the corner. Across the street stood the Greyhound Bus Station's seedy hangout and the soon-to-be-completed Metro Center Station.

The director opened the new arts space in the spring of 1975. This new group established a place to promote all the more experimental arts. "The Center is going to help artists directly," Denney said. Participating artists took part in "trash bashes" to clean up the three-story building. Denney hired her organizational assistant, Jack Rasmussen, after an interview on a public bus. Even with Denney's jet-set connections, a WPA Board member recalled that these non-profits operated at a grassroots level, run by the seat of their pants. Most held an underlying 60s hippie ethos.

"The building was a complete wreck," Rasmussen recalled. The WPA set the top floor aside for theatrical and dance performances, as it was at one time the opera house for Washington. "When I came to see the art gallery, the room was covered in pegboards because it had been a frame shop in one of its iterations. It had fluorescent lighting and old linoleum on the floor." The American University alumnus gave up his part-time job at the National Gallery of Art to join the WPA, despite having a Turner positioned over his desk.

The inaugural show featured a group exhibition of mixed arts across a sprawling space of nearly 18,000 square feet. The crowd of 250 people encountered three floors of galleries with paintings and videos, rooms with singing and dancing performances, and areas filled with theatrics. Together they thought about what show to put on next. "It was a raw space, but it was a wonderful space, and the patrons came. They were not apprehensive in that environment," Rasmussen remembered.

Art critics in the city dubbed the WPA a non-establishment cultural center. It became the "Kennedy Center for Washington's underground." The excitement of the WPA's potential stood in its openness, lack of constraint, and encouragement to risk and eccentricity. As Richard assessed, the inaugural art show proved a mixed bag.

The WPA focused on innovative artists not represented by commercial galleries. The organization committed itself to help and present Washington-based regional artists, dancers, musicians, choreographers, and actors. The WPA also provided spaces for "alternative performers and artists" from other parts of the country. This move made the WPA one of few local non-profit spaces to forge a national presence. Denney brought artists from around the world to the WPA and felt frustrated with not having enough money to do everything she wanted.[10]

Most of the early exhibitions were generally Alice Denney's ideas. She made suggestions about exciting artists to feature, and Rasmussen made a lot of that happen. A few years in, Rasmussen made choices, and Denney provided approval. The WPA never used a committee method to select artists. "I think committees are a mistake to this day," Rasmussen noted.

The pair and active members kept the WPA moving and grooving. Rasmussen observed years later that "Alice lunched with this person, that person. Having a gabby jet flying here to there. She was doing the real work. Going to parties and eating with characters and knowing who was who doing what in the [art] world." Board member George Hemphill noted Denney had a strong background and knew all the right players. Indeed, the WPA's Board contained a mix of young art patrons and artists, many of whom graduated to museum boards.

The low rents around the WPA attracted other cultural groups, including the Back Alley Theater, the American Society for Theatrical Arts, and the Washington Theater Laboratory. These groups forged a Washington off-Broadway area. One year later, some media began describing G Street as Fabulous, Real, Funky. The WPA showed young painters, held a Black musical film festival, and a marathon reading by Black poets. Painter Tom Green had one of the rare solo shows in the early years. Many of the exhibitions featured a multitude of artists, usually around a single theme or media. Rasmussen curated a display of the drawings of 101 Washington-based artists. Richard and Forgey thought the exhibition exceedingly strong. Another called "The Glass Door" featured art from 24 immigrants to the Washington, D.C., area.

A few years into the WPA's existence, Denney crowed. "We've had twenty thousand people through our doors since we opened." Many more came in the spring of 1978 for the Punk Art show that brought together Washington and New York bands, filmmakers, and emerging artists to attack the staid society.

Boring old Washington included Denney's views on the city's developed art scene.

> P Street! What is P street? The worst thing that happened to the Jefferson Place Gallery was when Nesta Dorrance moved it from that dear Jefferson Place to P Street. Who's on P Street? Henri—she's a second-hand clothes dealer.... Pyramid? I've heard some artists are upset and are leaving. I've heard some things about Middendorf. He's young isn't he? But he's not showing real modern art.

Some from the city's art scene returned fire. Henri noted, "if Alice Denney had learned not to belittle people, she would still be on P Street with the Washington Gallery of Modern Art." Rasmussen stated that sometimes working with Ms. Denney was a challenge. But years later, he noted, "she taught me to take chances and look for questions, not answers, in art."

By the end of the 1970s, the WPA started efforts to bring art to different locations and people. The Book Bus containing small press literature and artists' books traveled around the city. The first of a series called Washington Art Site projects brought art to different buildings. For the first effort, Robert Newmann sandblasted a map of Washington, D.C., onto the side of a building at New York Avenue and F Street, N.W. The artist observed that being a Washington-based artist drew a particular type of person, "if you give a damn about media coverage, you've got to move to

New York. If not, then you can exist comfortably in Washington, more comfortably. But what you do in Washington has a way of not getting beyond the Beltway."

Denney could not get the WPA to do everything she wished. Some theater and art shows proved too costly. She felt that the WPA offered less freedom than she sought. Years later, she commented that "things weren't about art but about politics." Unfortunately, Denney discovered that she had a brain tumor.

The biggest shakeup came as the recently completed D.C. Metro provided a way of bringing people into downtown from the suburbs. The RLA and real estate developers viewed the buildings where the artists existed desirable and valuable. The excavation for the subway tunnels moved a lot of ground and destabilized many older buildings, including the one the WPA occupied. Rasmussen recalled RLA staff came in with tools to measure the cracks in the building's walls. Not long after, the RLA declared that the structure and others received official designation as no longer safe to inhabit.[11]

Around the corner and next door to a costume shop, a woman sat in the store window of an old bookshop and braided hair. Up a long flight of stairs sat the entrance to the new Miya Gallery. Siblings Vernard and Louise Gray started the space to bring cultural enlightenment for the community to enjoy. "Trying to bring together Washington artists from all ethnic groups who work in a variety of media. They will get exposure, and the community will see new artwork," Louise said. On the opening night, the crowd consisted primarily of young to middle-aged Black people. One floor up, the Grays sold craft goods to adults.

During the first two years, their gallery featured artists like Ron Anderson. He sought in his work to find unity among African American past, present, and future experiences in America. His shaped paintings involved figures, mask-like references, and various symbols and colors that evoked black with whites. Other visual artists included a group show of Howard University printmakers, Ghana photographers, and a Haitian gallery's 50 paintings and sculptures.

Up the Street near Logan Circle, a residential neighborhood for professional African Americans, a married couple started a gallery that showed the city's African American artists ten years before. James C. Mason and artist and teacher Helen S. Smith Mason began their gallery on 12th Street and Rhode Island Avenue in 1967. Both arrived in Washington during the early 1930s, and they ran a community newspaper and the magazine *Pulse* for several years. The Circle was now a low-income area, and only a year before the government had announced its plans for redevelopment of 30-block area of the Shaw part of the city, including Logan Circle.

Their gallery showed individuals and groups of African American artists in the three floors of a restored row house. The artworks ranged from paintings and drawings to woodcuts and the occasional sculptures. Many young minority group artists got a start there, but the gallery also featured noted artists such as Lois Mailou Jones. Forgey commented on the delightful arrangement of the work in one of her early solo shows in the gallery and mentioned that he found a number of good paintings on view.

In the fall of 1971, the pair organized the National Exhibition of Black Artists in Washington, D.C., and published a book displaying the works of a wealth of artists. The group met again in Trenton, New Jersey, a few years later. By then, the gallery had the most extensive collection of African American art in D.C. A decade later,

the National Conference of Artists came to the city. Mayor Marion Barry declared the opening of "the African American visual artist week," and President Jimmy Carter hosted 300 conferees at the White House; Smith-Mason Gallery placed works on view. The Masons lent some of the artworks in the gallery's permanent collection to the State Department so that they appeared in embassies around the world.

The couple aged, but the gallery continued into the early 1980s. By that time, attorney James R. Haynes had started Gallery 1221 on 11th Street, intending to feature the city's African American artists. Mrs. Mason died in 1985; her husband passed away two years later. Their estate donated 125 artworks to Howard University. Three other colleges received art and period furniture from their collections.

One of the city's most notable collectors had long been interested in African and African American art. As a child, lawyer, educator, and cultural powerhouse Peggy Cooper Cafritz paid close attention to the print of Georges Braque *Bottle and Fishes* that hung in her parent's dining room. She imagined the cubes in different spaces and invented stories to go along with the piece.

She began her art collection in college by purchasing several pieces that Howard University Student Nonviolent Coordinating Committee members brought back to Washington. A native of Mobile, Alabama, Cooper Cafritz moved to Washington, D.C., during the mid–1960s, attending George Washington University for undergraduate studies and law school.

After marrying Conrad Cafritz, she had the means to begin collecting more extensively. Cooper Cafritz had eclectic tastes and had pieces that spanned several generations, including works by Jacob Lawrence, Gordon Parks, Alma Thomas, David Hammons, Carrie Mae Weems, Kara Walker, and members of the African diaspora who were making very recent work. The fire that destroyed her home in 2009 cost her and the world many irreplaceable artworks. However, she continued collecting when she realized that artists offered to remake their work. Like most collectors in Washington, D.C., she went to New York City and purchased many works of art there.

Cooper Cafritz played an important role in the development of many artists in Washington. Her dedication to starting the Duke Ellington High School for the Arts had a significant effect on visual arts in the city and those in the many other endeavors. Some young artists talked about the regular encouragement that she offered to them as they worked on their art. She served on boards, including the Cultural Equity Committee of the Smithsonian Institution, to expand its collection and start an African American museum. Cafritz also purchased artworks from several Washington-based artists, including Jefferson Pindar and Nekisha Durrett. Her efforts in the local art world included mentoring people that wanted to start collecting art as well.

Miya Gallery offered events for other tastes. It screened mainstream and art-house movies and hosted various local music performers and Afro-American poetry readers. Reviewers offered glowing tributes to the readings of young poets that drew groups of about 40 persons. The gallery provided a forum and space for the Black artistic communities' various voices.[12]

The District's Office of Housing and Community Development provided the space, but Gray noted that it was unknown at the time if the utilities worked. Rats were a consistent presence. Still, the Grays expressed frustration when told redevelopment knocked out the block of buildings.

With the buildings claimed, Gray and artists met in dc space. They wondered how to unite against the builders if they moved toward Ninth and Seventh Streets. "It's too many factions. We'll never get together...," noted painter Andrew Lufkin. "It's not nearly as bad as it used to be," said his sister Marsha Lufkin. "It used to be whites against the blacks, men against women. Now it's basically those who have money and those like us." Andrew Lufkin paid $50.00 to $100.00 a month rent for his studio, a typical cost for a 400-square-foot area in the downtown art community. They asked the D.C. government to find them new locations, eyeing the former Lansburgh store on Seventh Street. Vernard stated the move helped his gallery because white shoppers never came over to 11th Street.

In late 1979, Philip Ogilvie received the listing of community arts groups that a committee put forth as proposed tenants for the old Lansburgh store building. After starting the year by sending out 400 questionnaires, Ogilvie turned over to the committee 65 serious candidates and now gave great news to 33 of them. Studio Gallery, Miya Gallery, the Washington Women's Art Center, and Centro Grafico (a group of Hispanic artists) and the City Museum of Washington were among the selected who paid the city rent of $1.50 per square foot to occupy the space. In turn, the city government paid the PADC the remaining $8.50 of rental costs.

Things started well for the umbrella organization's renovating and managing of the Lansburgh. This group, the D.C. Foundation for Creative Space, received a National Endowment for the Arts Grant challenge grant of $250,000.00. The expectation was to raise an additional $750,000.00 in private funds for a $1 million grant. This money went a long way toward knocking down the walls and renovating other aspects of the old department store. Ogilvie stated that the Center would house 26 community arts groups, which he hoped will "dispel the artificial conflict vis-à-vis elitist and non-elitist art. For our groups are diverse geographically and ethnically and represent what the mayor called for in his election campaign—a downtown center for development of community arts."[13]

Before the WPA searched for a new location, Denney and Rasmussen left for other projects. The Board hired Al Nodal as the new executive director. One Board member later recalled, "Al was a dynamo, a charismatic personality from the Cuban-American community who enthusiastically engaged artists." A staff member recalled that Nodal had strong political instincts and built the institution, including creating a large board to govern the WPA.

Nodal quickly accomplished things that aided the WPA's twin constituencies of national and local artists. He curated a group of presentations, installations, and video works from artists among both of these groups for a show in the winter of 1979. He then started the first WPA-sponsored open studio event later that season. Other shows featured ten long-time Washingtonian painters from Benjamin Abramowitz to Lois M. Jones and photographs that 37 Washington-based photographers took during the 1970s.

The WPA also aimed to cater to the city's emerging, un-represented and under-recognized artists. In the spring of 1981, the organization held its first "Options" biennial exhibition. Gene Davis and *Washington Review* managing editor Mary Swift visited numerous studios and examined hundreds of slides before selecting 22 artists. Ms. Swift descended from the Patterson family of National Cash Register fame and collected a range of art with her former husband Carleton Swift. She

supported a group of Washington-based artists, and her legacy as an art historian centered upon interviews she conducted with Washington-based artists that remain in the collection of the Smithsonian Archives of American Art.

After two more shows at the end of the year, the WPA finally moved out of the G Street location. Nodal appeared unconcerned because he thought the city would provide another building. The possibility of moving into the Lansburgh arose again, but the WPA Board thought it going it alone enabled them to better maintain its identity and high visibility in the community. Being solo offered the visibility to attract funding from the regional area's businesses and residents. The WPA operated on a $230,000.00 budget a year, significantly larger than the organizations and galleries in the Lansburgh. The WPA renovated the old building at 404 Seventh Street for $50,000.00. The funds included nearly $20,000.00 of in-kind services and demolition and other work by the group's members.

Not joining the Lansburgh proved prescient. The private money never came, leaving the $2 million needed to renovate the building a pipe dream. Ogilvie blamed the PADC, saying a plan they issued undercut the center's long-term stability. The PADC noted the foundation's lack of ability to fulfill its promises, although it raised nearly half the necessary funds. The 20 art groups leasing until October 1985 assumed a $178,000.00 debt, an empty bank account, and incomplete renovations. The PADC noted that rent would rise. The Studio Gallery returned to Dupont Circle in the late 1980s.

Miya Gallery lasted for a few years inside the former department store. Once the PADC redeveloped the Lansburgh into upscale residence and Shakespeare Theater in 1986, Vernard moved the gallery to Eighth and E Streets, N.W. The video artist and photographer noticed the growing interest in traditional African dress and the mainstream fashion industry's trend toward Afrocentrism in business clothes. Gray selected a handful of simple, easy-to-wear cotton garments and dyed each in several bright colors to sell at Miya. "I want people to wear the traditional garments worn in Africa, but you have to introduce to a broader market in a palatable form," said Gray. The functional business added to the art sales and kept Miya going through the 1990s.

This business dynamic between minority and mainstream business outlets continued through the 1990s. Some department stores began selling Afrocentric gifts. This cut into the business that, for many minority merchants, was their niche market. Miya failed to survive in the area with the consistently rising rents.[14]

Despite the need to spend person-power on rehabilitating their Lansburgh space, the WWAC expanded their exhibitions. One explored Feminist Art Process and Product; another featured pieces from the WWAC founders; a third, curated by Alice Neel, examined portraits' role in 1980s' art. Lewis noted that while none of the works here matched Neel's high standard, the pieces proved good quality. Having notable artists like Neel curate enabled the WWAC to introduce its members to artists in different career stages.

Other significant exhibitions at both Seventh Street and Q Street locations drew regular coverage from the media. Reporter Carlos Greth observed that members found the female erotic pieces both liberating and significantly different than what male artists produce. "In men's sexual imagery, women's desires are not present," said painter Arlette Jessel. Group members exhibited quilts for the International Year

Lansburgh Department Store, Seventh Street, NW (HABS/HAER Collection, Library of Congress).

of the Woman Decade celebration in 1985. Later that year, David Tannous selected 33 painters, photographers, and sculptors for "Heat." Critic Nancy G. Heller felt intrigued by several of the pieces.

The WWAC expanded beyond the Washington market. It started working with the 500 national women's arts groups. "We hope to exchange exhibitions with more and more of them," says Patricia Buck, WWAC's director of exhibitions. Washington art writer Lee Fleming conceived the show called "Washington Iconoclassicism" with eight Washington women painters. The show began its road tour at Chicago's Artemisia Gallery.

The WWAC voted to include male members. While individuals came and went, the total membership of the organization climbed to about 800. Lewis observed that the group had launched talented women artists to the commercial galleries. Another complained that the shows often presented a few qualified for a significant exhibition, earnest art, and a sprinkling of outright second-rate stuff.[15]

The Lansburgh redevelopment drove the WWAC to Takoma Park. With the move and more male artists, the WWAC evolved into the New Art Center. As long-time member Marguerite Beck-Rex observed, "There were more opportunities for women [in the arts by then]." The funding devoted to women's groups from foundations and the governments slowed significantly during the 1980s, hampering the efforts of the WWAC.

A decade later, members of the Washington, D.C., chapter of Women's Caucus for Art staged an exhibition depicting both the Washington Women's Art Center's

effort and works. "These girls had it going on," critic Jessica Dawson noted as she walked around the Millennium Arts Center in Southwest, D.C. The retrospective on the organization featured many works of art; a few drew Dawson's praise. The critics found the big names who curated shows notable. As Ms. Beck-Rex noted, "We were not timid."

Two decades later, two of the WWAC's former managing directors, Lucy Blankstein and Judith Benderson, curated another WWAC exhibition. The survey of 91 female and one male artist occurred inside the large museum space at the American University's Katzen Center. Known as "Latitude," the exhibition also included online projects and cataloged the group's history. The willingness of former members to partake in these projects reminded Ms. Benderson of "how important collaboration was back then and remains so."

Mark Jenkins noted the show featured mostly representational and non-confrontational art. These diverse styles included Aline Feldman's expressionist woodcut, Sharon Moody's photorealist views of suburbia, and Janis Goodman's disembodied architectural drawings.[16]

While celebrations of the WWAC's past occurred, the WWAC lived on in the presence of the Washington Printmakers Gallery. The printmakers' group emerged as an offshoot from the women's art group during the 1970s. The Q Street space had provided a space for monthly meetings of a group of female printmakers from the late 1970s through the 1980s. The group compared techniques, shared resources, hosted guest speakers in the art and print world, and showed their work. They also exhibited their art at a wide range of other spaces, from the National Institutes of Health to banks, universities, and restaurants. "But all through those several years, I kept hearing the refrain 'why don't we have our own printmakers gallery?'" said founder Carolyn Pomponio.

After two years of legal and business planning, the gallery opened on Jefferson Place in Dupont Circle with 28 members in 1985. The cooperative dedicated itself to displaying and selling members' artwork and educating the public about the print's history and future. The shows had a fantastic range of techniques and content, along with materials from paper and copper to woodcuts and aluminum printing plates. Critics appreciated content ranging from complex messages about Blacks in America to depictions of Italians living in a housing complex. One personal favorite was prints of pairs of women's shoes that Jessica Dawson summarized as "a shoe fetish." One founding member, Austrian native Nina Muys, showed locally and internationally for over forty years. Muys artwork appeared in collections at the University of Maryland, National Institutes of Health, and the National Museum of Women in the Arts.

A regular event since the late 1990s was the national show for small works. The juried exhibition drew submissions numbering 500 pieces from 150 artists yearly that a single juror from one of Washington's many cultural institutions selected. After moving to a larger space on Connecticut Avenue, the gallery sponsored annual invitational solo shows and one featuring works of younger printmakers. Rising rent pushed the gallery to move to Silver Spring, Maryland, before opening a location in the "Book Hill" section of Georgetown.[17]

Artist groups organized cooperatives throughout the region. In Arlington, Virginia, a group of artists formed the Columbia Pike Artists' Studios in the late 1980s to maintain studio spaces. Further out in Annandale, Virginia, a dozen craft groups

founded a cooperative called Artisans United. The Fairfax County Council provided a rent-free space for the group's gallery inside the Annandale Center in the late 1980s. The gallery contained craft forms, including stained glass, weaving, pottery, jewelry, and finely painted porcelain. The guilds' coalition sponsored classes in their specialty to the area's schools and senior centers and continued going strong.

The idea for a "women's art museum" began years earlier when Wilhelmina Cole Holladay and Wallace F. Holladay, owners of a real estate development and investment firm, went to Europe to find paintings to decorate their house near Dumbarton Oaks in Georgetown. When "Billie," as her friends called Ms. Holladay, purchased a work of 17th-century Flemish painter Clara Peeters, she found no mention of the painter in any art books published up through the 1960s. The women artists at the Corcoran in 1972 corroborated this absence of women artists in art history. Wally told his wife that she had discovered the focus of her collecting and the motivation to provide these artists with the recognition they deserved.

In 1981, the pair offered their collection of 100 artworks by women to the newly formed organization called the National Museum of Women in the Arts. Their collection featured Mary Cassatt, Helen Frankenthaler, Georgia O'Keefe, and Washington-based artists, including Anne Truitt, Alma Thomas, Sheila Isham, and Joan Danzinger. For the first five years, the non-profit hosted shows in the family residence. The chief of the National Endowment for the Arts, the late Nancy Hanks, told Billie that the couple needed to start a public museum to bring attention to these women artists.

Ms. Holladay created an advisory board that included many notable Washingtonians to guide starting a museum. They began looking for a location and sought a place downtown and considered around 1250 New York Avenue. The block featured peep-show businesses and dive clubs, such as "The Room," "The Brass Rail," and the "Naples Café," where the FBI recently pulled a sting operation because a waiter tried to extort money from Congressman Robert Baumann. The Greyhound Bus Station at 1100 New York Avenue three decades earlier had been a flagship for the company. An ill-fated attempt to upgrade the location a few years earlier covered its art deco exterior with concrete asbestos panels and a metal mansard roof. The building currently featured hustling, drug dealing, winos, and the homeless slumped in plastic chairs that held bolted-on television sets. A smell of stale cigar smoke and unwashed clothes confronted a visitor.[18]

Many suburban Washingtonians thought the area unsafe for parking their cars to see movies at the Town Theater inside the Masonic Temple. The theater featured double features at reduced ticket prices. It showed grindhouse-type movies, including the Shaw-Brothers karate, horror, and Black exploitation movies popular in the rougher urban areas. When the theater manager heard the rumor that the building was to be some "women's museum," he thought it seemed totally crazy given the neighborhood. But the theater closed in 1983.

While the Museum purchased the 78,000-square-feet Renaissance Revival palace for $4,750,009.00, the RLA evicted the WPA and Miya Galleries to build upscale office buildings. The Holladays' credit, one woman's anonymous donation, and donations from five others secured the purchase. Land values continued rising because of the expectations generated by the completion of D.C.'s first convention center up the Avenue.

After another $8 million, the refurbished space opened in the spring of 1987. Inside, a sweeping grand staircase led to the mezzanine, marble floors, galleries on the second and third floors, a library on the fourth, and an auditorium on the fifth, with the offices on the sixth. A small gallery and store appeared in front of the visitor entering from New York Avenue, and a caterer's kitchen hid in the back.

Paul Richard described this space as a "decor of high opulence as if dressed for a ball." He dubbed the opening show "American Woman Artists, 1830–1930" insistently respectable. "The majority of its objects, though some are finely made, are modest in ambition or distressingly conventional." On the interior and the art, the critic commented, "Together they suggest restricted opportunities, the clink of china teacups, lavender sachets." Women in the Arts had over 2,700 works in its collection and over 100,000 visitors a year by 2000. The shows grew increasingly more inventive and occasionally daring, but blockbusters like a Grandma Moses retrospective and the exhibition on theatrical designer Julie Taymor brought in record crowds.[19]

The WPA settled at 404 Seventh Street in an old store that offered a large first-floor gallery. The WPA received the space from artist Eric Rudd, who rented both the 400 and 404 Seventh Street buildings. "Walter Hopps told me that it was critical that the WPA survive and that I give them three floors of the building," Rudd remembered. Inside 400 Seventh, Rudd and partners ran a successful business called Making Waves, offering hot tub soaking to sundry clients. Inside 404, the WPA invited a range of guests to curate. Regional museum executives like Walter Hopps curated well-received shows such as "Poetic Objects." Keith Morrison curated a show illuminating the Afro-American artist's work and how it shaped Washington art. The exhibits frequently featured local and national artists and different disciplines of art.

Nodal noted that many WPA members hated being considered local artists, a term they thought dismissive. Nodal explained that the WPA strove to help its members get their work seen in other places around the country. "We're trying to help them by using the loosely structured network of some 200 alternative spaces or artists spaces that now exists in the United States."

The group sponsored an array of art across the city, too. Through 1982, the WPA sponsored 39 public art projects. Nancy Rubins inverted conical web of steel rods with tons of junked electrical appliances at 27th and K Streets, N.W., which sparked a court case advocating for the piece's removal. A compromise settlement resulted in its dismantlement in December.

A large WPA exhibition of the early 1980s occurred inside the abandoned Ritz Hotel at 920 F Street, N.W. Pieces appeared in every seedy room amid dingy carpeting and cracked windows, porno queens and punks, poets, congo drummers, and refugees from Beaux Arts balls walking around. Welzenbach described the exhibit as "a vast free-for-all among mostly sloppily created art." Richard felt "bored and shocked, disappointed, surprised, then overwhelmed." The city shut the exhibition down for safety reasons.

A month later, a crowd of 400 presented the outgoing director with balloons, showered him with confetti, and serenaded him. Amid the crowd, Berkowitz remarked, "I remember when you couldn't get a hundred people together in the arts world."

The WPA required funding, and only $15,000.00 came as an institutional grant from the D.C. Commission on the Arts and Humanities. Fundraising occurred

year-round, with the annual auction as a notable event. The WPA started the auction with the help of its neighbor Carolyn Peachey. Local artists donated their work for free, so they provided pieces that they had failed to sell. They also got pieces from prominent artists like Cindy Sherman that helped bring potential bidders to the event. By the mid–1980s, the WPA changed the rules to share half the donation with the artist. That first year, 78 pieces grossed the WPA over $50,000.00. By 1985, the auction consisted of two shows with 98 and 94 works on display.

These auctions offered guests the opportunity to see and acquire some of the strongest contemporary art pieces made in the area. WPA Board member Tony Podesta started buying art at the annual auctions when they were a very hip scene. After the WPA, his art collecting morphed into a 30-year hobby. Tony explained, speaking in spurts, "Some people spend a lot of money on golf. Like they play golf, I play art."

By 2001, when his future wife Heather went on her first date with him, they stopped by his house first. Passing some of the quirkier selections on his walls, Heather recalled Tony remarking, "I don't know why it is, but I have artworks where the women have no heads." The next day, she sent him a note signed, "Woman with a head." They were married two years later.

Inside the elite Chelsea galleries, the pair featured in gossip, received deference, and were ushered toward the choicest works. All the art stars knew their names. They collected artists from around the globe and amassed roughly 900 pieces. The emphasis remained on photo-based works, though sculpture and paintings were also featured. Inside the couple's Woodley Park and Falls Church houses, the art hung floor to ceiling. Regular rounds of parties at these homes ensured plenty of viewing opportunities for Washington's elite, many of whom regarded the couple's enthusiasm for art as something of a personal quirk.

Among the Washington-based artists' works were Chan Chao's portraits from his troubled homeland of Burma. The pair owned a few pieces by the sculptor, Barbara Liotta. In 2014, Liotta made the piece *Icarus* for the Podestas. The couple also became supporters of the 34-year-old District artist Avish Khebrehzadeh. The Podestas liked her work when they saw it at a Venice Biennale, so her Washington dealer set up a visit. Khebrehzadeh mentioned wanting to work on a larger scale, so Podesta offered her the keys to his Falls Church home, with its ample basement.

Over the years, the Podestas have been generous to the Washington art community. They donated many works to the Corcoran. The couple gave over 100 artworks to the Phillips Collection and a substantial number to the National Museum of Women in the Arts. More recently, Tony Podesta provided American University with a sizable donation.[20]

Jock Reynolds assumed the executive director position, and the WPA grew to 14 full-time staff, budgeting $300,000.00 annually. The California artist, administrator, and professor believed he would stay for three to five years. "I left a tenured professorship to take this job because I saw it as the most exciting job I could possibly have right now." Staff member Don Russell stated that Washington art figures liked Reynolds: "He was senatorial and gregarious."

Besides changes to the auction, Reynolds proved to be an excellent fundraiser. The NEA provided $10,000.00 to create a musical theater show and $25,000.00 to commission an artist apartment. Two California artists placed a daybed, table, and

S. S. Kresge Co., a WPA Space, 1988 (Courtesy of the Photographer, Michael Horsley).

chairs inside the 20-by-20 room on the second floor, inside an old bathroom space that served the F.W. Grand Five and Dime store employees. Paul Richard declared the exhibit successful, un–Washington-like and unusual.

As the WPA continued its "Options" show, featuring different local artists in varying media each year, the organization maintained the usual high number of exhibitions. The Washington and Afro-American art during the Post World War II years became the first WPA-published catalog. In 1986, the tenth-anniversary show occurred in the Yale Laundry building on New York Avenue and Fifth Street, N.W. Tropical sleaze was the theme for "A Phantasmic Undersea Carnival." Guests donned fish masks, fish ties, and wet suits, among other outfits, and jokingly circled like sharks chasing chum in the waters.

Like the Corcoran and other Washington arts institutions, the WPA faced its criticisms from the community. Some complained the WPA was becoming another of the city's hard-charging, competitive money machines. Reynolds admitted that "We don't do as many different things [as the WPA in the past and with less vitality], but we support what we do more fully." Reynolds sought to include more voices and added more artists to the organization's board. These changes sometimes worked poorly. "We had some physical altercations at Board meetings," Russell remembered. Reynolds miffed some of the artist board members, including Sam Gilliam and Rockne Krebs.

A small number of members devised a solution to the WPA and local artists showing their works, initiating a "trade show" on the third floor at the WPA space. Named "Botswana," the place served as an artist hangout and bar as well as an art space. Artists dropped notes in a suggestion box and then received two weeks to

curate their idea. The only rule: "Return space to white walls." The Speakeasy worked well for a while. About 18 months in, what the 7 to 8 core members initially found exciting wasn't so much anymore.

The WPA and Botswana also faced external challenges. The Carry Albert Company sold 404 Seventh Street, N.W., without consulting its tenants. The selling families ignored their prior verbal agreement with Eric Rudd to allow him first right of purchase. Rudd recalled that neither the WPA nor Corcoran leadership supported his initiative to buy the building. "There was a lot of potential for [the arts on Seventh Street], but stupid things would pull the rug out on things," Rudd stated years later. The new owners, members of the patent law firm of Fleit, Jacobson, Cohn, Hallman, and Stern, planned to fix the building up and convert it to law offices. The WPA tried to hold lease negotiations for three months. Despite proposing increasing the rent by 600 percent, the leasing company refused.

The PADC helped very little in the lease negotiations. But the city and the PADC took an active role in the discussions to help the WPA find a location. "Our only hope for WPA is a benevolent developer who could find tax advantages," said Reynolds. Fortunately, a new building became available.

Under the name Jenifer Building Associates, six partners purchased the building at 400 Seventh Street for $2.4 million. The home of the F & W Grand 5 & 10 until the early 1970s, the building had lost all its tenants by 1981. They planned improvements, including an elevator and the addition of two half floors. Negotiations finally found a mutually acceptable formula. The WPA president, attorney James J. Fitzpatrick, said, "We may have pulled the rabbit out of the hat."

Once again, the WPA renovated a building for around $100,000.00. If artists volunteered two hours of labor, they received a year's membership free. The nine-year lease offered an affordable rent, with an option of another nine. The WPA occupied a fair amount of space in the building. The next goal centered on creating a nest egg to provide the institution with financial stability. The 38 board members contributed over $400,000.00, which the PADC and the NEA matched. The city government, the Kresge Foundation, and art connoisseur Robert Lehrman each provided $100,000.00. In total, the campaign raised $2.1 million. The WPA lent the developer $400,000.00 at 8 percent interest and received 10 percent ownership in the new building.

The Jenifer opened in December 1988. There was no room for Botswana to continue but more exhibit space. The first show, "Recollections," saluted 62 Washington-based artists shown at WPA since 1975. The artworks, chosen by executive director Jock Reynolds, featured both Washington artists and collectors. Pieces came from Manon Cleary, Gene Davis, Sam Gilliam, and Anne Truitt and included 62 artists total from 48 collectors. Richard observed that "[the works's] scale is domestic. Its objects seem designed for homes—they rarely gobble walls." Reynolds happily asserted that the WPA "is getting close" to assembling an endowment of $2 million.[21]

After the Corcoran board opted not to exhibit *Robert Mapplethorpe: The Perfect Moment*, the WPA members and board met to discuss stepping into this breach. These local and regional city arts members voted unanimously to exhibit it in their gallery. Reynolds observed, "I'm very confident that when people see the show itself a lot of these issues are going to die down. It's a really beautiful exhibition, and the way the work is presented is done very sensitively."

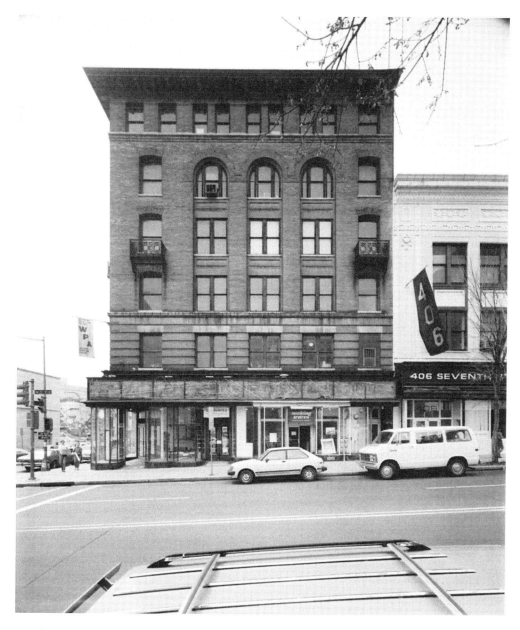

Jenifer Building with 406 Seventh Street, NW (HABS/HAER Collection, Library of Congress).

Jo Ann Lewis thought the most shocking thing about the Mapplethorpe show was how good it was. She commented that Philip Brookman hung the photographs exceptionally well. The WPA separated the images that aestheticized homosexual behavior into a smaller "blue room" at the rear of the upstairs gallery. That limited access to those works. A photograph called "Man in Polyester Suit," featuring the torso of a man in a tight three-piece suit, his open fly visible in the main gallery, offended some of the hundreds at opening night. Still, most seemed amused, and women enjoyed the refreshing twist of seeing a male "nude."

The opening reception raised $125,000.00 to assist people with Acquired Immune Deficiency Syndrome (AIDS), which had killed Mapplethorpe four months earlier. Nearly 49,000 people attended the show over four weeks, and donations topped $40,000.00. The WPA shows generally averaged about 300 visitors a week. Probably several came as a result of all the publicity about the show. The catalog sold out. Critic Hank Burchard rejoiced that so many people saw the work of this artist, who was a master of photography. He observed that "the blue room enticed people to enter, but few lingered, and many came out shaking their heads, although no one complained to the staff." Columnist Courtland Milloy noted that he heard children viewing the show with their parents and that they were bored. One tourist accompanied by two daughters felt somewhat embarrassed until the 12-year-old explained, "Mapplethorpe just has a different way of expressing himself. I've seen artists do things like this before." Several first-time visitors to the WPA from the region "enjoyed the work but felt disappointed that nothing shocked them." But a visitor told curator Brookman that "she had seen the exhibit four times already—and it disgusted her more each time." Auto salesman Robert Linzer stated, "Somebody ought to send Jesse Helms a thank-you note for doing such a great job promoting this thing."

Senator Jesse Helms brought the show's catalog to the Senate floor. He showed Senator Robert Byrd of West Virginia three or four photographs from the catalog. Byrd replied to Helms, "Good gosh, I'll take your amendment." The Helms Amendment passed as part of the overall spending bill that Congress passed in September.

The Mapplethorpe show opened in Cincinnati, and arts censorship went to the courts. The WPA organized a discussion among the six directors from the art institutions showing the Mapplethorpe exhibition. Reynolds had left his position at WPA, so the group's president emeritus participated. The group held a press conference, lobbied Capitol Hill, and hosted a benefit for the Contemporary Arts Center in Cincinnati's defense fund. After the Center's director had been found guilty of pandering obscenity, the WPA stated that applicable legal principles "should have led the court to just the opposite conclusion."

Meanwhile, the WPA faced a direct challenge to one of its funding sources. The Philip Morris corporation generously provided arts organizations with funding for exhibitions, including $50,000.00 for the WPA's "Recollections" show. Members of ACT-UP (AIDS Coalition to Unleash Power) protested outside its building because the WPA said nothing about Morris' support of Senator Jesse Helms. The group and activist artists wanted the WPA and other arts groups to join a boycott against Morris products or pressure the company to stop supporting Helms. Director of Programs Philip Brockman said the WPA had not taken the corporation's money since the Mapplethorpe exhibition.[22]

Brockman and curator Richard J. Powell faced a different type of art protest. "The Blues Aesthetic" exhibit featured from current and deceased artists, including David Hammons, a Black artist who contributed a portrait called *The Rev. Jesse Jackson* that depicted the minister as a white man. Intended to be one of seven artworks to be shown in a public space, the District's government took a long time to approve Hammons's piece.

The city's Department of Housing and Community Development owned the site at Seventh and G Streets, where the artist planned to install the 14'x14' tin piece. Public relations director Deborah Daniels stated, "The agency does not have a current

policy on installing portraits on city property that could be considered controversial and open the city to severe criticism." Another city official noted, "Public art ought to reflect the interest and sensitivity of the community. The piece in question is political satire, and that is not always understood." The curator selected the portrait because it asked the critical question: "Are our expectations of people based on their race?"

As the installation of the piece began on the crisp fall day, Brookman noted people made comments:

> Some people thought it was an excellent piece, a crucial statement. Some people laughed because they understood its humor. Several walked past and got offended that someone treated an icon like Jesse Jackson this way.

During rush hour, one man started talking to the three WPA employees hanging the piece. The spontaneous grouping grew. Elizabeth Curren explained, "There was a lot of yelling that we were white and had no right to do it." Eventually, one of the men grabbed a sledgehammer and brought it down on the tin pieces. Powell arrived to see the last of the bludgeoning of the portrait. "I was obviously devastated because I actually saw the end of the event, and the people proceeded to walk over to the bus stop and take the bus." Powell informed Hammons of the event, and they considered what to do about the painting. The publicity from the event created a significant uptick in turnout at the WPA: 17,000 people came to the WPA while its national tour drew 30,000.

A board member who eventually served as its President, Susan Butler, and her husband credit the WPA with introducing them to the city's art scene. She enjoyed being on the board, which she described as a "great atmosphere." The couple got to know many artists and began an eclectic collection of artworks from regional artists. "We had a rule that we usually bought one work per artist, but occasionally it was broken." They selected pieces they visually enjoyed when they saw them rather than having a preset idea of what they wanted or buying as an investment.[23]

At the dawn of a new decade, old challenges remained. The bubbling discontent among artists and some board members over the WPA's focus led to a split. Aaron Levine (a local arts patron and lawyer), restaurateur Herb White, and others formerly associated with the WPA started the District of Columbia Arts Center (DCAC) in mid–1989. Located in the two apartments above Revolutionary Books at 2438 18th St., N.W., DCAC planned to operate on a smaller scale than WPA and focus more on Washington-based artists.

For some local artists, cooperatives such as the WPA led to a more expansive artistic presence in D.C. After coming to Washington, D.C., in the mid–1970s from Alabama, Judy Southerland attended American University for graduate studies in 1977–1978. The instructors enforced a style that married abstract expression with observational painting. The staff had exceptional connections, and the visiting artist program was beneficial for Judy. She particularly remembered the praise that her work received from Philip Guston. At graduation, the faculty told their students, "Go find a studio, paint for ten years, then go find yourself a gallery."

Ms. Southerland opted not to follow those instructions. She regularly submitted pieces to exhibitions and had one piece in a juried show at the WWAC in the mid–1980s. The exhibit and her artwork received positive mention. Another painting appeared in a regional-artist juried exhibition at the non-profit Arlington Arts

Center in Virginia. She showed in several other local and regional non-gallery spaces before signing up with the WPA to be on the artist studio open tour. WPA curator Mel Watkin came to see Judy's work and subsequently offered her the opportunity to have a solo show in Watkin's developing project, "The Tell-Tale Heart." Jo Ann Lewis described the pieces appearing in that show as "a patchwork of quilts of images and media assembled and manipulated over time to produce rich pictures."

Jock Reynolds recommended that one of the city's galleries look at Southerland's work. Jones Troyer Fitzpatrick Gallery, which started with a contemporary photography focus during the spring of 1984, offered her representation. One of her first shows came at a tribute exhibition for the recently deceased co-gallerist Kate Jones. Jones died of cancer at age 46 in the spring of 1990. In that fall, Southerland sold well with Jones Troyer Fitzpatrick, reaching local private collectors. She also sold well with local law firms that enhanced the look of large conference rooms and entry spaces inside their offices on K Street with art. Southerland recalled Troyer's pleasure over Judy's sale of a $20,000.00 piece to a firm.

While with the gallery, Ms. Southerland became an instructor with the Corcoran. She enjoyed teaching, but the most potent motivation was bringing in enough money to support her children and the cost to make art. Southerland spent months creating each framed piece, works composed of paint, crayon, wax, clay, dirt, photographs, fabric, and text. Gallery sales slowed, according to Ms. Southerland, because the gallery took on too many artists. She left after four years because she "ended up selling better from my contacts and my studio (giving them 50%)." Most importantly, Ms. Southerland felt she needed control over her income because of her family's needs. Still, "I have done some interesting shows over the years, but one cannot substitute for a highly focused gallerist who develops an ever-broadening collector base and pushes the work."

Indeed, like her friend Bill Newman, Ms. Southerland sold fewer pieces over the length of her career. She had a few loyal collectors. However, she argued that most people "age out" of collecting; as they age, they want and buy less art.

The WPA continued several activities aimed at helping the Washington-based artist. Under the leadership of Marilyn Zeitlin, the Open Studio tours happened each spring. Upwards of 15 downtown D.C. studios opened their doors on Saturday and over 60 locations throughout the regional area showed on Sunday. The biennial "Options" shows brought together 50 area artists under a theme. The 1993 biennial drew negative criticism. Paul Richard claimed the work offered a "politically correct" content but questioned if the pieces qualified as art because few artists painted, carved or drew well. Eric Gibson offered a treatise.

> The point isn't so much that the cited work is bad. It is, or course, but by now that is so commonplace one almost takes it for granted in exhibitions like "Options 1993."
> The real problem here—and in all such exhibitions—is that these artists are thinking the same thing and making the same works of art, whether they are in Washington, New York or anywhere else. It's not so much a question of artistic style as political orthodoxy. "Group-think" would be a better word, and it has come to an area of society traditionally known for its non-conformism.

Perhaps someone at the WPA heard these opinions. For the next "Options," local curator Alison Maddex described her exhibition "Superbia" as countering the growing specter of politically correct victim art in Washington. "When you walk in

[many art shows] as an audience, you're treated like an idiot," Ms. Maddex asserted this particular show accomplished anything but that. Occurring in both the Central Armature Works building on D Street and the main WPA building, the show had substantial works on both spaces' main floors. David Mordini's grotesque but humanlike mixed-media sculptures *Bondage, Pearl* and *Chicken Woman* challenged the viewer to see themselves in Plexiglas. Madenney "Sport" Kennedy's installation of found, made, and given objects spoke of energy, oppression, repression, and suppression and how to battle those things when they dominate your life. Richard enjoyed this show.

Exhibitions continued inside the space at 400 Seventh Street. Local artists appeared in a show about contemporary life's fears and anxieties and one about the loss wrought by the AIDS crisis. A feature on older African American Washington–based artist John Robinson drew great praise as well. Nationally known artists Renee Stout, Fred Wilson, and Adrian Piper showed. Touring shows that appeared included works from Latinx artists and works depicting children in the former Yugoslavia's war zone. A WPA-organized show on the Holocaust went to major museums around the country. By the middle of the decade, "Hostile Witness," which featured art commenting on secret surveillance, reminded Paul Richard of WPA group shows over the last ten years. The exhibitions' wildly eclectic mixing of media with post-modern theory questioning individual authorship and investigating race, class, and gender felt like "neoconceptualism deadendism."[24]

The U.S. economy fell into a recession in summer 1990. The Washington area already suffered from drops in the real estate markets. The WPA's regular private and corporate donors cut back on gifts as did government grantors. The WPA's finances felt the sting as its utilities and monthly rent totaled $10,000.00 per month.

The leadership faced the reality that expenses on an annual basis significantly outpaced funds coming in. The organization began dipping into its endowment. Much of the money promised in the capital campaign had only been pledges. To get the promises turned into actual cash, Don Russell and a few board members held a dinner at a board member's house. They raised about $150,000.00 of the $1.5 million initially promised in 1989. Board member Mrs. Butler agreed with Don's recollection. "The WPA proved very dependent on realtors, so the recession really hurt it," Mrs. Butler said. Ms. Peachey observed, "There are major donors in this town who don't necessarily meet both of their commitments. They do join the board."

Key supporters rotated off the board. Others might have felt a degree of exhaustion after the capital campaign. Marilyn Zeitlin proved not as effective as Reynolds had been in fundraising. "She was socially awkward," complained one board member. "She simply wasn't able to connect with the community the same way Jock did," said another. "Yes, we had a softer sell," said Zeitlin. "But I used the same approach I had in Texas, telling people what we were doing, thanking them for their support. And it simply wasn't tough enough." The top board members that Zeitlin worked with until she resigned in 1991 supported her efforts. New board member Theo Adamstein observed that "[t]he kind of monies that were around three or four years ago are just not there. Everybody is giving less."

The WPA hired a psychologist to work with new executive director Don Russell on his next task. "I fired 14 people in the order in which they came in to work

that day," he recalled. The WPA could no longer afford its rent at the Jenifer building at 400 Seventh Street, holding a $100,000.00 debt. Russell blamed the recession and the stalled development downtown for the problems. "It's awful. All of these people busted their gut to make this place work."

Another attempted solution included renegotiating the lease. The WPA returned the basement portion of the building to the landlord for a reduction in rent. The bookstore moved to the first floor, and the remaining staff took space on the second floor. The group passed on its 20th-anniversary party because of financial constraints.

By early 1996, the organization had extricated itself from its debt and rental agreement at the cost of its ownership share in the Jenifer Building. Dissolution seemed a real possibility. Instead, the board transferred the WPA operations to a new non-profit corporation, Washington Project for the Arts\Corcoran (WPA\C). The Corcoran board held legal accountability, and the new group continued the auction as its primary source for funding itself.[25]

Ms. Nadine Gabai-Botero became the WPA\C's first program manager and sole staff member with a principal task to raise funds, primarily with the art auction. Although legally based in the Corcoran, the first exhibitions and performances occurred around the city. The biennial "Options '97" show took place at the former Insect Club on E, near Seventh Street. The WPA\C relied on outside spaces, beginning with the Insect Club. This show inspired artist and D.C.-native Jayme McLellan to begin her career as a curator. "I wanted to take a stab at organizing an exhibition of my work and that of my friends," she said.

These locations included public spaces in the outdoors, the Millennium Arts Center in Southwest, D.C., abandoned buildings downtown, and the new Flashpoint Gallery at the renovated Mather Building on G Street across from the main branch of the D.C. Public Library. The city's artists and curators continued to provide their skills, curating a range of shows. These topics ranged from fiction and residue to responding to a specific site in a public space. Marta Kuzma and later Annie Adjchavanich admirably performed fundraising but also held successful programs. They showed many times at the Millennium Arts Center, an expansive if decrepit space in the old Randall Junior High School complex in Southeast Washington.

Other activities benefited Washington-based artists. They included publishing the Artist Directory, a series of full-color illustrated guides to Washington-area artists that became ArtFile Online, an interactive registry of members' digital portfolios. The slew of directors kept the organization going, and successful shows such as "Anonymous," "Seven," and "Wall Natchers" and "Exchange" showed a growing momentum. The "Anonymous" show became an annual event. Collectors like Fred Ognibene played a guessing game of how many artists they identified from seeing 100 pieces on the wall. After getting 15, he said, "I'm not as good as I thought I was."

The "PostSecret" exhibition proved an enormous success. Over 15,000 viewers read random peoples' deepest secrets on the postcards hanging from the ceiling. By early 2010, the artist Frank Warren received over 500,000 postcards from around the world.

The two organizations saw the benefit in resuming their separate existences. "We were growing up and growing out and growing beyond what we see as providing a program for the Corcoran," said Jennifer Motruk Loy, chairman of the WPA's Advisory Board. "This is a way for us to develop our programs and spread out." Kim Ward,

the WPA's executive director, said "the group can go it alone because it has achieved a measure of financial stability. The annual budget reached $500,000.00, and its membership reached 1,000."[26]

After setting up its headquarters on Massachusetts Avenue in Dupont Circle, the reestablished WPA pursued many of the same exhibitions, site-specific art installations, and its "Options" biennial. Other activities included sponsoring artful synchronized swimming down in the pool at the Capitol Skyline Hotel in Southwest, D.C. when the new WPA moved its administrative offices to this site. The new WPA held a 35-year retrospective show in the American University Katzen Museum in 2010. Michael O'Sullivan observed, "'Catalyst' is packed with solid, strong work by Fred Folsom, Lisa Brotman, Betsy Packard, and Wayne Edson Bryan and other artists of a certain age whom time, or at least the contemporary art world, seemed to have forgotten."

The organization moved up to U Street in the city's northwest section. The annual events, such as the auction, continued. Other events connected artists and audiences in various ways, like a Holiday Pop-Up Shop at the Hirshhorn Museum and Sculpture Garden for 20 artists.

The cooperatives and political-minded galleries started the move to downtown. Private galleries looked to Seventh Street as the new location with larger spaces to show their wares. Several notable galleries left P Street and Dupont Circle and came east to the promise of being in an art community.

10

The 1980s

The Seventh Street Promise

When the Lansburgh's arts groups plan received approval in late 1978, PADC Executive Director Andy Barnes announced, "This represents a milestone for PADC, the city, and the community. We're bringing life to the downtown area." Next, the PADC sought to solidify the near future of the odd-number side of Seventh Street. The buildings at 401–405 Seventh retained architect Germond Crandall's 1877-designed prefabricated concrete facades. While allowing for demolition of a building that housed a shoe store, plans expected the late 19th-century-designed buildings at 415 and 417 to maintain their fronts. Currently, these buildings sat empty and in terrible shape. A fire had gutted the premises the previous year, and the subway construction had shaken their foundations. The old downtown shopping area had been under siege from Metro construction since the early 1970s. D.C. citizens found the several blocks of Seventh Street virtually impassable. Businesses suffered.

Robert Lennon, an attorney and founder of Artransport, and Stanley Westreich, an art collector and real estate developer, won the right to negotiate with the PADC. The possible developers had a goal of obtaining a 99-year lease on the 19th-century buildings from 401–417 Seventh Street, N.W. Their project featured spaces for 14 different galleries, studios, art supply stores, a book shop, and a coffeehouse. Local architectural firm Hartman-Cox drew up the plans for this "Gallery Row Project." An estimated $4.5 million cost would convert the inside of the abandoned commercial buildings to house art galleries. PADC spokesperson Rita Abraham called the project "a beachhead" to develop the East End of downtown.[1]

The location represented the end of a multi-year search for an appropriate site for galleries and artist studios. A Brooklyn native, Lennon moved to New Orleans with his mother after his parents divorced. After Catholic school training in the Mississippi delta, Lennon attended the University of Mississippi and graduated with a law degree in 1964. He married his childhood sweetheart, the daughter of an oilman. After he practiced law and served in the state's House of Representatives, he and his wife divorced. He left their three children and moved to the Washington area, where he spent time meditating and existing on the D.C. art scene's fringes.

Overnight, Lennon switched from looking like a lean holy man to a country lawyer with bib overalls. He bought a truck, hired artists as drivers and movers, and started a successful business moving artwork. His deep, throaty Southern laugh and his view on Washington's natural position as an art center drew people. "I believe it. I believe it so much I can't tell you," he said, his eyes ablaze. One friend later

Germond Crandall Buildings, 401 Seventh Street, NW, 1978 (HABS/HAER Collection, Library of Congress).

summarized Robert as having something mystical about him, "he would tell you only so much ... enough to get you hooked ... then stop, change the subject, smile coyly, and just shrug."

They had had a fantastic solution to their space and cost concerns a year earlier. Along with galleries from New York, Maryland, and West Virginia, Lennon and P Street gallery owners wanted to lease an eight-floor building at 631 D Street. The group converted each floor to about 2,300 square feet of space and create a SoHo-like stack of galleries. "The zoning board has approved. Now we are just waiting for the approval of the Pennsylvania Avenue Development Corporation," Lennon said. They started a letter-writing campaign to the PADC trustees and Congress members to move the stalled project. The effort failed as their gallery building never conformed to the PADC's plan for residences and ground-floor retail.

At 406 Seventh, after spending $100,000.00 to renovate, Robert Lennon and three owners opened up gallery spaces in the three-story building. The 20,000 square feet enabled Harry Lunn, Roberto Osuna, and Protetch/McIntosh to double the gallery floor. Osuna noted other advantages from the P Street strip. "[It is] near the major museums, will have plenty of parking, and the subway nearby, and we'll have those wonderful 14-foot ceilings."

The new home drew raves from art editors from New York City. They spoke about 406 having "a SoHo feeling." Indeed, the name indirectly referenced the galleries at 420 West Broadway. The dealers expressed equal pleasure. The 37-foot expanse

between walls allowed Diane Brown to show contemporary sculpture much better than in the much narrower P Street space. Nancy McIntosh Drysdale said as she surveyed the building, "It's so civilized." Osuna proclaimed, "I've seen few spaces anywhere in the world to compare with this, except in Barcelona."

As the galleries opened, Lennon noted the Lansburgh arts groups one block north and The Raku Gallery, selling African American art, one block south. "I believe this will be the start of a new commercial scene that will rival 57th Street in New York." But plans for Gallery Row slowed due to the 22 percent inflation rate. After receiving a $1.2 million grant from the Department of Housing and Urban Development, Lennon expected to see construction begin on October 1, 1980. He formed a new partnership team with developer Calvin Cafritz. The 401–417 Seventh Street project received an endorsement from Don't Tear It Down, a group that identified downtown's historically significant buildings. Seventh Street had the potential to become a potential historic district and preserve its character.[2]

Others already noted the promise. A greasy burger joint on the bottom floor wanted out in a run-down building on Seventh and E Streets' corner. Bill Warrell, partners, the restaurant, and the landlord worked out a deal. "The only set of working bathrooms were up a flight of stairs," Warrell recalled. He and his friends wanted to use all four floors for an artist-run space. "The room upstairs had been a dental lab that had been closed for thirty years. Old dental chairs still up there. Walls and walls of false teeth castings. It was scary. And in the upper floors, the pigeons lived, along with this old dental equipment."

When dc space first started, it featured live music and sometimes movies. Occasionally it hosted musicians from Howard University, but there was always a drive to bring in national names, such as Laurie Anderson. By the mid–1980s, the location became one of the area's top places for punk and avant-garde and cabaret performers. Downtown maintained its reputation for being unsafe and a hub of pornography. "So it had a reputation of being a lot more dangerous than it was. And quite frankly, for those of us at Space, we were perfectly happy with that. It meant we could do what we wanted to do, whenever we wanted to do it, and as late as we wanted to do it," Warrell noted. This freedom proved great for generating creative energy. Soon other venues, such as the 9:30 Club, opened downtown.

Three autumns earlier, Jack Rasmussen opted to strike out on his own after nearly four years with the WPA. He opened a gallery on Fourth and G Streets, slightly to the east of Seventh Street. Formerly the Fanetta School of Beauty Culture, the abandoned building featured pink paint from floor to ceiling and holes where flooring had been. Rasmussen recalled, "On one of my first visits to the space, I was asked on the street, 'What are you doing here, white boy?' Eventually, I became a part of the neighborhood, and my neighbors could not have been more supportive."

Rasmussen chose to give opportunities to Washington-based artists without gallery representation. "I wasn't interested in [selling] the latest thing from New York or whatever ... I was interested in the artists working here and.... I still think there are absolutely great artists working here." The crucial part of selling involved matching the artwork with a person whose heart the piece or pieces touched.

Rasmussen opened with romantic fantasist painter Reginald Pollack, whom he'd featured at the WPA. The group shows, usually arranged around a single medium such as paper or painting, included most of the gallery's artists. While Forgey and Richard

often included comments regarding the arts' staging or hanging, each described most of the artworks as lively and varied. One show prompted Forgey to herald a new generation of artists supplanting the previous generation who moved on the New York. He singled out Annie Gawlak, Phil Young, and others for impressive work.

The gallerist took some chances with older artists and artwork content. He gave William Dutterer, a long-time Washington artist, a show during his second year. The next year, Rasmussen provided Dan Kuhne with his first show since the artist disappeared seven years earlier after a successful one-person show at the Phillips. He provided Mindy Weisel a show that featured 23 paintings of the Holocaust. Born in a relocation camp for refugees, Weise insisted she was not a Holocaust painter. "I simply paint my feelings. I knew I'd have to paint it out one day." Two years later, Jo Ann Lewis commented on the strength of Weisel's pieces in her second show at Rasmussen.

Despite the critical praise, Rasmussen knew the gallery's days were nearly over that spring of 1982. "I need a better space," said the 32-year-old. "I'm tired of meeting rich collectors who don't know where I am." Years later, Rasmussen admitted that he was not a good gallerist because he did not feature sellable art. "I was struggling to survive but having a good time." Though he felt connected to the burgeoning arts district of long-time resident Mickelson and the Seventh Street galleries, "It could still be a long scary walk."[3]

At the 1981 fall gallery season's opening, little deterred the art crowd, even climbing three flights of narrow creaky stairs inside 406 Associates. Most galleries had standing room groups, waiting patiently for wine and snacks. Everyone felt pleased with the public's response to the location. McIntosh's gallery sold the work of young artists ($300 for works on paper and $30,000.00 for paintings and sculptures). "My customers are from across the country and Europe, primarily private collectors," she noted. Harry Lunn sold over $2.8 million in the year. The tall gallerist usually dressed formally, wearing jackets over shirts with starched wing collars. He hung out in his elegant downtown gallery's loft space and controlled his surroundings. Lunn looked over the balcony rail and saw everyone who entered. He went down if the person interested him. If not, or he felt busy, he remained unseen.

With a booming voice and a Lincolnesque beard, the Michigan native served as an intelligence officer at the Pentagon and U.S. Embassy in Paris during the 1960s. Lunn returned to Washington's Capitol Hill and sold real estate before undertaking a foray into art, selling Parisian photographs. After Lunn realized that rare photographs were as significant an object as other art, he bought albums, archives, and historical collections of photos at auctions. Then Lunn devised a sales strategy. "Say you got 100 pictures. You take your ten best and don't show them to anyone, and get busy creating a market with the others. Then, you come out with the really great ones—at a marvelously enormous price—having already created all this excitement."

Another time-proven method to make money involved buying low and selling high. It helped to make money if you knew more than the seller. Clark remembered accompanying Lunn to a family holding their deceased relative's collection of Margaret Julia Cameron photos. "He offered them something like $2,200. They get into a huddle and come back, and they go, 'Okay, we'll take it.' He cut them a check, and when the door shut and he starts laughing. He says, 'I could sell these for 25,000 dollars at auction.'"

Since his days in Georgetown, Lunn was a *bon vivant* who enjoyed sharing the

finest wines and foods. Elias Felluss counted Lunn as a friend and enjoyed Lunn's not mincing words. He generously advised many young artists and fellow dealers. His gallery featured local D.C. artists, including long-time painter Jacob Kainen, and younger artists Clark Fox and Kevin MacDonald. Each received a stipend to stay with his gallery that could be applied to the price of their work. MacDonald made beautiful, uninhabited drawings that Paul Richard found haunting. Clark already had developed a notable reputation for his architecture paintings of windows and his rendition of George Washington, which Richard and Forgey considered highly innovative and of high quality.

Clark recalled Lunn's paying him around $350.00 for a painting of a seascape measuring 80 inches by 40 inches. During the purchaser's divorce years later, when Clark helped her sell the painting, she stunned him when she said that she paid $10,000.00. Despite this revelation, Clark admitted that the stipend system at least kept him from working at anything but painting. Clark and MacDonald's wife Robin Moore related Lunn's Office of Strategic Services connection during World War II. Moore particularly enjoyed the oft-repeated story that Lunn asked Ansel Adams to destroy photographic plates to enforce that the photographs would be limited editions and worth more money.

Robert Lennon, Eric Rudd, and others bought buildings for artist studios and galleries in the Hanover neighborhood between North Capitol and O Streets, N.W. The Hanover Arts Project began with 52 and 60 O Street, which housed a meat-packing company, a plumbing company, a Hecht's furniture factory, and Decca Records. The recession curbed Lennon and Osuna's big plans for lofts, but their building offered artists studio spaces. Diane Brown opened a gallery there but left for Manhattan after three years. Eric Rudd had his latest studio inside 52 O Street. He exhibited paintings of sculptural forms with the Jefferson Place Gallery after Nesta Dorrance recruited him. Despite being 15 years younger than some of the other artists, he found the P Street gallery and its artist communities to be like a family. Rudd relished Washington experiences, including having a painting in Senator Jacob Javitz's office and attending the National Collection of Fine Arts' Patent Building opening where President Lyndon Johnson dubbed himself the "uncle" of contemporary art burgeoning in the city at that time. Rudd's work morphed over the years into sculptures, and he showed them with Brown's gallery for several years. Paul Richard called Rudd a painter of great promise, but by the early 1980s, Richard labeled Rudd's sculpture "blob art." Forgey thought the sculptures suggested a variety of natural history things and suggested to let the viewer's imagination run wild.

Rudd exhibited many pieces including an arachnoid spider outside the Washington Art Fair in 1978. One large sculpture of foam shapes inside a blue steel cage appeared as part of a show put on by Studio Gallery. Rudd's large work sat on one side of the Portrait Gallery and became a great backdrop for many visitors' photographs. The Portrait Gallery's Director Marvin Sadik disliked the piece. When this work named *Stanley Rick Harry & Tonto* remained at its location after the exhibition finished, the director had the piece moved to Pennsylvania Avenue, N.W., across from the National Archives (see photograph in the center section). The piece continued to receive attention from tourists, and Rudd soon found the sculpture hauled back to his studio at no charge.

The artist participated in the 1980 International Sculpture Exhibition, one of

52 O Street, NW, 1978 (© Barbara and Eric Rudd Art Foundation).

four Washington-based artists to be included. Rudd continued exhibiting in the city until moving to Massachusetts in the early 1990s. He and his wife ran a successful art foundation in North Adams, Massachusetts. Four pieces, including one of his Dormer and one polymer painting, were donated to the SAAM. Houston's Menil Collection and the San Francisco Museum of Art also own his artworks.

Rudd mentioned that many times when he looked out his studio's windows, he witnessed two people exchanging small packets of aluminum for a $100.00 bill. Rudd and other artists called the government for more attention as the area deteriorated. By the late 1980s and through the 1990s, Hanover suffered from the crack cocaine gang battles. Rudd recalled Barry visiting the area twice, the second trip to proclaim it safe. The artist wryly noted that O Street's increased police presence pushed the activities two blocks away.

A social services organization took over 60 O Street. The artists stayed at 52 O, and among alumni were Eames Armstrong, Matt Costanza, and Lisa Marie Thalhammer. Thalhammer is a feminist and LGBTQ+ activist who created paintings, portraits, and public murals to uplift and empower. Studios existed for years at 57 N Street, before the former Chapman Stables and garage became condominiums by the mid–2010s.[4]

The Seventh Street strip continued to attract more galleries. Barbara Kornblatt moved down from Baltimore because she felt "the Seventh Street area was ideal. There is an enormous variety in public and private galleries, parking is not impossible, there's the Metro, and it's perfectly safe." Newcomer/Westreich Gallery, with its American decorative arts and antiques and collectibles, arrived from Harpers Ferry.

On the corner of Seventh and D Streets, Christopher Middendorf and his wife Helen Lane opened the Middendorf/Lane Gallery downtown. Ms. Lane obtained a

master's degree in art history from Tulane University in New Orleans. Middendorf received an art history degree at Harvard University. He took a $20,000.00 inheritance and invested in a P Street contemporary art gallery in 1974. During the P Street exodus, Middendorf and Lane purchased a run-down house in Adams Morgan on Columbia Road and converted it into their gallery and residence.

George Hemphill wanted to run the downtown branch. He recalled that the gallery occupied an entire floor of a building. "It was a white box with beautiful hardwood floors. I sat at a giant desk." The gallery put on about six shows, including one featuring new artists, another of Gene Davis' silhouettes of his head, and a photography show. The number of visitors varied based upon the day and the exhibition. "It was a lot of fun being down there. Had a spa called Making Waves near and a Cuban restaurant around the corner."

Middendorf briefly maintained two locations partially after winning the bid to help the notable law firm Arnold & Porter establish part of its art collection. Senior partner James Fitzpatrick, known as an impresario of modern art, persuaded the firm to begin a collection. The works adorned the walls on the four floors of their contemporary office building space on New Hampshire Avenue south of Dupont Circle. New York gallerist Andre Emmerich selected the oil paintings, including color field artists Morris Louis and Gene Davis. Middendorf spent the remaining money and selected the sculpture, prints, drawings, and photographs by 75 other contemporary artists. Middendorf said, "I tried to convince them that they should have 20th-century American artists, including some from Washington. He selected artists from many of the area's galleries, including Henri, Harry Lunn, and his group. They ranged from Clark Fox and Robin Rose to Leon Berkowitz and Jacob Kainen."

Working with corporate clients interested in forming art collections became increasingly crucial to galleries during the 1970s. The city's gallerists believed that they needed to enter this world and compete against the private dealers. Osuna Gallery hired a specialist to work with corporate clients. Jane Haslem had pioneered working with corporations to form art collections. "They've become the mainstay of many galleries and have often kept me going," Haslem stated.[5]

As dc space celebrated its fifth anniversary, it hosted another new gallery to the scene. On the upper floor, Olshonsky Gallery, which had moved from Adams Morgan, showed different pieces than other galleries. Lawyer Michael Olshonsky liked the new location because it brought him closer to his workplace at the D.C. courts. His wife Joanne ran the gallery. The pair were scene-makers. Joanne's younger brother, Michael Reidy, fronted the Razz, a group with a large following for its snarling power pop style. The gallery drew new wavers, punkers, and artists. Warrell remembered, "It was about anybody who's put their stuff up, people came and looked at."

The gallery became more established as she "signed" five local artists and offered them regular shows. The first winter, she showed painters influenced by the current "New Wave" music. Richard called it a haunting and entertaining two-person show. After a modish figure painting show, she followed with a surrealist painters show. The next fall featured the graffiti style, then co-opted into the New York art scene. Richard observed that D.C.'s versions contained hints of rage along with warfare and blood but came off as "clean and well-behaved," and "a peculiarly polite graffiti show."

Olshonsky showed D.C.'s version of the national phenomenon Art Attack a few times. Richard and Blair Gately applauded the group's concept effort of artists

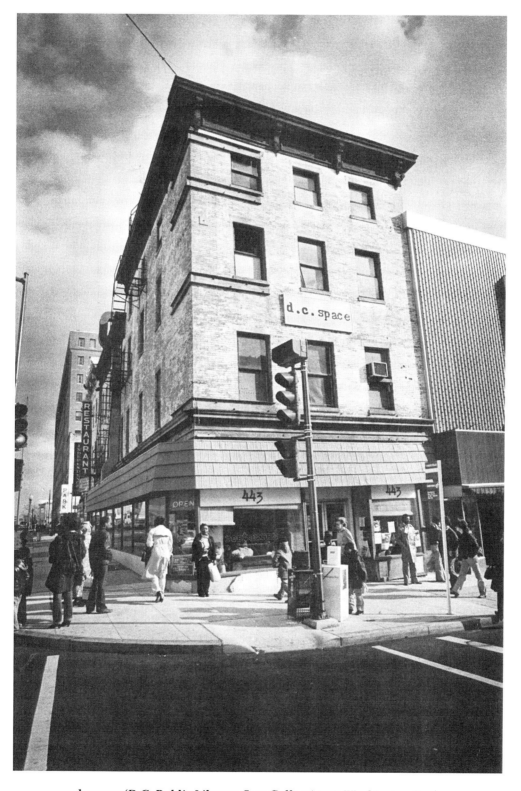

dc space (D.C. Public Library, Star Collection © *Washington Post*).

putting together big shows but thought D.C.'s branch made peace with art history. Since museums rule the art world in D.C., the critics argued that most art made in Washington was erudite, conscientious, and trim. This show managed to link the traditional and the trashy. At the end of the decade, Art Attack returned to the gallery, with different members who offered a wide range of art. Unfortunately, this proved to be one of the last shows at Olshonsky as dc space soon closed its doors after years of losing money. Warrell observed the gallery's legacy: "He was heavy into the arts, his wife wanted to run a gallery, and it was a family operation and a front for a law office and a place for fucking great parties."[6]

At the other end of the art strip, Rodney Donahue, his wife, and father-in-law ran the Raku Gallery. An artist himself, Donahue knew how challenging it was for Washington African American artists to receive opportunities at white-owned galleries. Donahue railed against a "white clique" in the city's arts, noting that the *Washington Post* ignored the galleries like Raku while promoting others on 7th Street. Donahue said, "The Raku Gallery wants to quit being isolated as ethnic oddities."

Over three years, Raku, which believed in strong visual statements that showed Black influences, became a popular showcase for minority arts. One show featured artists from Nigeria. The owners joined Atlanta Gallery Frames and Fine Arts Gallery for an exhibit that drew Atlanta Mayor Andrew Young and Congressman Walter E. Fauntroy. A fire broke out during the early morning in the fall of 1982. The owners cleared out many of the pieces in the place. At midnight, a second fire raged, causing the roof to collapse. D.C. fire officials believed it an apparent arson. Raku never reopened.[7]

Despite the losses of a few galleries, comparisons to New York's arts districts continued. One observer labeled D and E Streets a mini-Greenwich Village. "It's a place where you can wander from gallery to gallery, looking at the stuff that artists are doing now." Another described soaking up the "artmosphere," walking from one gallery to another along the street. The excitement of "seeing the stuff that artists are doing now from pastoral scenes on rip saws to elderly furniture painted in acrylics."

However, the Gallery Row Project had made little progress aside from storing the building facades off-site. In 1984, David Carley of the Carley Capital Group became the primary developer, and Lennon assumed a limited partner position. The company intended to sink $7 million into the buildings and opened at the end of 1985. The District and the PADC wrote strong incentives for galleries and arts-related uses into their agreements with the developer. Still, it remained uncertain whether the market sustained this vision.

Middendorf/Lane closed its downtown location in 1983. That same year, Harry Lunn bought out his backers and closed his Seventh Street business. He moved to New York City. While working as a private dealer, Lunn remained active with colleagues and dealers in the industry. Lunn split his time between residences in Paris and Normandy and died of a heart attack on a Paris train platform in 1998 at 65, having played a role in establishing the importance of historical photography.

Active and energetic galleries remained at 406. Each carved out a unique niche of the market during the mid–1980s. Like the city's museums, Jo Ann Lewis summarized that the Osuna Gallery had excellent exhibitions that focused on connoisseurship. Ramon Osuna's ambitious "The French Neo-Classic and Academic Tradition, 1800–1900" presented many well-known painters.

Ramon Osuna also maintained friendships across the Washington art scene. After some openings, he treated regular collectors and artists to dinner parties at his four-story townhouse. Set on 16th Street, N.W., the house contained many Old-World masterpieces. "Ramon's social events are his kind of art," said one of the gallery's artists Carol Goldberg. His most challenging task was creating the guest list, which featured the right mix of artists, museum people, and collectors. After a long cocktail event on the ground floor overlooking the small garden, guests went upstairs to the dining room on the third floor or ate at round tables amidst the art on the ground floor. The native Cuban always included a Cuban dish on the menu. Chocoholic Osuna served some version of a chocolate dessert with coffee and more champagne in another part of the house. After everyone departed, he reportedly cuddled with his large dog.

Osuna's gallery offered special exhibitions in his workspace, with rare Old Masters paintings. He brought works to Washington that one only saw in a few galleries in New York and London. Osuna timed his shows with National Gallery's exhibitions and provided a fully illustrated catalog of sale art. The prices ranged from $12,000.00 to $375,000.00.[8]

Jane Haslem Gallery celebrated its 25th anniversary with a show with pieces from over the years. Since hiring a new assistant in 1982, Ms. Haslem organized traveling shows for museums and universities across the country. This effort increased the visibility of the artists that she represented. The white-haired grand dame kept working. "I kept the gallery, I just went right on." Haslem smiled. "You see an artist who's really fine. And you see they really could use some help. And you know you can help. And it just gets you."

In 1987, she took over 4,000 artworks and moved into a townhouse near the Phillips Collection. After obtaining a graduate degree, Haslem brought computers into her business, maintaining photographs of the gallery's artworks on a laptop. She began attending more art fairs and closed her gallery space in the mid–1990s. Two decades later, her estate sold the final 800 pieces in her possession at an auction.[9]

Haslem and neighbor David Adamson combined for notable exhibitions of fine art prints by 15 national printmakers and some of Washington's top artists. Those Washington artists who showed at Adamson enjoyed the gallery. Kevin MacDonald moved to the gallery when Lunn left Washington. He sold well and received rave reviews from all the city's critics. That proved fortunate because when friends saw MacDonald, they asked for his thoughts about a review. Once, Jo Ann Lewis observed both MacDonald's singlemindedness of theme and his successful style with "tiny, feathery pencil marks." His oils depicting the gardens of Alhambra seemed awkward and reminded her that the MacDonald must "care profoundly about an image before he can bring it to life." His wife Robin Moore recalled that MacDonald seemed ashamed of the Alhambra drawings forever.

Richard concluded that the galleries represented some of the best artists in Washington, ranging from Willem de Looper's new paintings at Kornblatt to David Adamson featuring William Newman's drawings. Newman created his drawings on Macintosh computers. He and Adamson had been active in bringing computers to the Corcoran School classrooms, as mentioned in Chapter 3. "The computer faithfully imitates any tool. Pastels to oils to watercolors," Adamson asserted.

Adamson's efforts in the mid–1980s put him at the forefront of producing the

ultimate in computer art: large-scale, computer-generated portrait paintings on canvas. His Sugar Ray Leonard and Marvelous Marvin Hagler portraits hung during their fight at Caesars Palace, Las Vegas. Technology always influenced the creation of art. Warhol's portraits emerged from photo-silkscreens. Adamson felt the computer had aways to go. "The way the process works now, it impregnates the canvas and sits flat.... I think it would be an interesting direction to push a machine-made painting toward a more painterly quality."

It took nearly a decade. Adamson held an exhibition called "Washington Portfolio" in his gallery on Seventh Street. Every one of the ten images by ten artists was a computer printout. The gallerist observed, "The computer technology was well developed, but the printers printed only on cheap papers with cheap inks. The ability to get these beautiful computer-generated images on something worthwhile and archival, like watercolor paper, just didn't exist." The large crowd enjoyed the show. "This is a historic occasion," said Henry Wilhelm, author of *The Permanence and Care of Color Photographs*.[10]

Another Washington transplant developed a business whose quality put it in the top layer of photo labs in the country. After moving down from New York in 1982, Theo Adamstein tried to get a few rolls of film processed one morning. The photo lab had harsh fluorescent lighting that created a clinical, industrial feeling. He asked for a noon pickup. "That will cost you triple," the staff person replied. He tried for mid-afternoon, "Double," she responded. The quoted price represented an end-of-the-day pickup. "This is Washington; no one will do this for you," she said with certainty. Adamstein realized there was an opportunity in Washington for a high-end, professional photo lab and founded Chrome in the spring of 1982.

Recognizing that photography was a creative medium, Chrome featured rotating prints on the walls, better lighting, light tables, and seating where people met and talked. With clients ranging from professional and amateur photographers to architecture firms, newspapers, magazines, and artists, Chrome held a high percentage of the region's photography market. Some New York artists courted the service as well. "I met many DC and New York artists through Chrome," Adamstein observed.

A few years later, Adamstein and then-wife Olvia Demetriou ran an architecture firm with expertise in hospitality design and high-end residential properties. The firm had a signature style and an imaginative approach to designing restaurants, hotels, and retail projects. Examples of their work include Zaytinya, Raku, Bistro Bis and many others. Adamstein Demetriou Architects also worked with local artists, such as Jim Sanborn, Rebecca Cross and Lenore Winters, who provided sculptures, murals, and artworks for the various projects.[11]

Businesses selling artworks at those prices could afford to remain on the ever-changing Seventh Street. The non-profit arts groups received eviction notices for 1986 as the PADC accepted proposals to develop the Lansburgh. The organization sought 200 or more moderately priced housing units and hoped for 50,000 square feet of community arts space. In late 1986, it accepted Gunwyn Company's proposal for the 500,000 square foot area that included 369 housing units and allocated 34,000 square feet for retail and 32,000 for art space, including a 400-seat theater. It seemed highly unlikely that non-profit and small galleries could afford any space in the new building, judging from Gallery Row's situation.

The Gallery Row development opened mid-year in 1986. As per the deal with PADC, 20 percent of its space went to the arts. WPA executive director Jock Reynolds noted that the rents for gallery space were much higher than anything non-profit arts organizations could afford. "The non-profit art groups here on Seventh Street will be in trouble unless the city presses the developers to make some provisions for us," Reynolds said. According to James Rich, PADC's director of development, "The District and PADC are interested in using the arts as a beginning ingredient to make this neighborhood work." D.C. Planning Director Fred L. Greene said the city felt concerned about the retail businesses in the old downtown but was generally supportive of the redevelopment. Reynolds and individual artists called these comments ironic, as they felt driven from the neighborhood.

Individual artists who had plied their trade in several buildings for years lost their spaces as the buildings closed and were then demolished. Multi-disciplinary artist Richard Dana gave up his full-time job in Russian studies to make art. Dana noted that he had a studio at 930 F Street, the Victor Building, the LeDroit Building, and the Atlas Building. The city condemned all three in a few years. Friends joked that Dana was a jinx because the buildings closed for renovation shortly after he arrived.

This happened during the "latter stages of being the center of art in Washington," he recalled. Yet, artists working in the same building had significant value. They shared insights into the artwork and on specific projects they were doing. Dana made many connections and some life-long friends from the time he spent as a downtown artist. The seedy and run-down environment provided its commentary.

At the Atlas, Dana walked upstairs after passing three pornography shops positioned on the latter building's street level. They did a lot of business. The artists on the two floors above referred to their world as "One-Stop Cultural Shopping: Sacred upstairs and Profane below." Many times, the artists ignored the activities as they produced their artworks. Unfortunately, a fire started in one of the shops' viewing booths one afternoon, directly below Judy Jashinsky's studio on the second floor. The initial blaze was intense, but the city's firefighters got it under control quickly. Her studio sustained damage, but fortunately, she had insurance. The federal government owned the building, and the GSA allowed the artists to stay. The artists appreciated the act of kindness. A few weeks later, a second fire broke out. The GSA deemed the building unsafe. All the artists had to move, and some got a studio in the LeDroit building.

Dana and other artists joined with Bill Warrell and WPA's executive director Marilyn Zeitlin to push the PADC and the city to meet its obligation to preserve art spaces. Mayor Barry established the Mayor's Blue Ribbon Committee for the Promotion of the Arts and Economic Development headed by Peggy Cooper Cafritz. The group determined that rising real estate prices downtown and in nearby neighborhoods threatened the local arts community's existence. The group proposed creating a non-profit Municipal Arts Assistance Fund supported by a special assessment on commercial developers. The fund promised to have money and rooms in new developments to address local artists' and groups' needs. This group faced an uphill fight. Cities like San Francisco adopted the policies a few years later.[12]

Even 406 experienced instability. The original lease for the galleries in 406 Seventh Street expired. Lennon held another lease of 2 ½ years but battled the building

owners in court over rent and repairs. According to Lennon, 406 needed many repairs, including the roof. "The owner [New York real estate mogul Leonard Marx] wants us to get out as soon as possible so he can add two more stories and turn this into an office building." Marx countered, "When we take it over, I would have no inclination to increase their rent at all, based on the information I have as to what they are now paying. I think we're real lucky to have them."

For some, the current cost of the rental space added another reason against staying in Washington. Harry Lunn left for New York City in 1984, joining Diane Brown and Max Protetch. SoHo's NYC market charged $12.00 to $15.00 per square foot compared to downtown Washington's rate of $18.00 to $32.00. The space cost combined with a limited market compelled a gallerist to quit. Nancy Drysdale opted to leave the 406 before the summer of 1988. Drysdale, the representative for advanced contemporary American artists such as Frank Gehry, Martin Puryear, Scott Burton, and William Wegman, observed, "Exhibitions cost too much and the audience just isn't here." She shifted over to becoming a private dealer. "I have knocked myself out making it worthwhile for people to come downtown and climb the stairs, but people still don't come." She noted the Washingtonians who came didn't buy. As another gallerist phrased it, "We always had an issue with people from Bethesda who didn't want to go past Chevy Chase Circle."

Meanwhile, the galleries signed month-to-month leases. The uncertainty of that situation increased the frustration many felt with the Seventh Street Strip. Ramon Osuna said, "It's a war zone down here. The whole Street is being knocked down, right up to my wall. We've just gone through the construction period for the WPA [Washington Project for the Arts], and now the Lansburgh Building is coming down." Osuna left and opened a gallery Dupont Circle.

David Adamson offered a similar assessment. "The PADC is supposed to have held space for galleries at reasonable rents in Gallery Row, but they simply didn't do it and instead rented to the FBI." Adamson summarized his impression of the arts downtown. "First, they put us out of the Lansburgh building, then they put artists out of their studios. They destroyed the downtown arts scene."[13]

Gallery Row's developers expected two galleries to occupy its art space. However, Chase Gallery never moved in. Zygos Gallery from Athens, Greece, "bravely settled in the still-uncompleted promised land of Gallery Row," Lewis noted. The son of founder Frantzis Frantzekakis ran the two-story gallery space, intending to introduce contemporary Greek art to American audiences. The artwork tended to be preoccupied with various strains of post–World War II modernism while ignoring the conceptual and stylistic revolutions that had occurred since the war. Lewis observed that the gallery's shows of paintings were sometimes touching. On one exhibit of a visitor's depictions of Crete, she thought that the white houses and blue waters were successful in color and heartfelt. Zygos Gallery lasted until the spring of 1989.[14]

Zenith Gallery moved in as a neighbor to Zygos. Gallery owner Margery Goldberg had long participated in Washington's art scene. As a child, she knew that she wanted to be a sculptor and put together a portfolio to gain admission to George Washington University. "Megaphone Marge" participated in many protests and demonstrations during the Vietnam War while showing her works regionally. Lewis noted that Ms. Goldberg learned her lessons well and had talent, too. Goldberg saw herself as a "total novelty item—the first female to have a woodworking studio."

Goldberg spent the mid–1970s making sculpture in a studio inside a 100-year-old hayloft across from the company "Super Concrete" (now Washington Harbour) in Georgetown. After she was unsuccessful in persuading Barbara Fendrick to come out of her gallery to look at a piece she made, Goldberg converted the studio into a gallery. After an exceedingly successful sale, days later, a major fire burned the roofing.

Goldberg's lawyer friend Stuart Bloch purchased a series of row houses along Rhode Island Avenue, N.W., between 14th and 15th streets. Once housing the Washington Bible College and the International School of Law, the premises sat empty. Bloch wanted an art school to move into the buildings and suggested the location to his friend.

Zenith Gallery opened on three dates in March 1978 and drew Dan Rather among notables on the city scene. Zenith Square expanded to feature artist studios, enclaves, bedrooms, three galleries, and schools inside the once-grand row houses. Blacksmiths, stained glass workers, artists, and designers build craft items that ranged from house doors to chandeliers. Liz Lerman taught dance, and Joy Zinoman held acting classes. Goldberg expressed her pleasure over the new digs and the friendships. "I spent three years in Georgetown. I didn't know my neighbors, and I didn't know the city's dancers, actors, and politicians." They were the first new businesses moving into Logan Circle since the riots. Goldberg recalled, "[You had to] sweep the alley of condoms [and syringes] before opening."

A year later, the square buzzed with arts activities. Some 35 artists and artisans worked in the Zenith complex of galleries and studios. Crafts had become more than art; they became a business. American Craft Enterprises sponsored a sizeable annual exhibition in Baltimore. Margery Goldberg said she saw an increase in Zenith Gallery's sales over the two years. "We did $12,000 in business in December. That's good." Her cocktail benches sold for $1,200.00 to $3,500.00. They received big commissions, and Zenith Gallery had a broad collector base of lawyers, media, developers, and contractors.

Located in a carriage house toward the end of the warren of spaces, the gallery featured local and national artists. It exhibited the crafty to paintings, drawings, and photographs. Thematic and conceptual shows featured single media types, like sculpture; featured the works from members of the Zenith Square complex; or approached a theme like "Shelter '85." One show featured the "Zenith lifestyle environment" across the second floor of the gallery. Art, furniture, and lighting showed off an environment that visitors appreciated there. The annual neon art show became a city staple. Generally, the show received raves for the artists selected and for some of its craft. The artists found the living situation the most crucial factor. It brought the professional and personal companionship of eating, hanging out, and partying together. Being in the area, the artists relied on one another for suggestions and for solving structural problems with their pieces.

Goldberg supported other arts organizations in the city. She regularly attended events such as the WPA auction. "I have to bring handcuffs to these things—last year I brought three pieces." At the 1982 benefit, she wore an "outrageous" knee-length coat of frothy turquoise and black ostrich feathers. "But it's the least the community can do to support the WPA. A lot of the money goes back to supporting the artists."

By the mid–1980s, the cityscape was improving, particularly housing around Logan Circle. After a former resident of the area called the D.C. government, the

Department of Consumer and Regulatory Affairs (DCRA) and Maurice Evans noted that zoning called for high-density apartment buildings. The artists, who were benefiting from rents as low as $200.00 to $300.00, faced eviction by 1987. High-end apartments replaced the old row homes, and Zenith Gallery moved to Seventh Street.

As a construction manager who built one of the luxury high-rises observed, rats ruled at nightfall. Metro entrances became de facto homeless shelters. "After work, you got in your car, and you left." Lunn's old gallery contained an unlicensed nightclub masquerading as a gallery. On Halloween 1991, Goldberg looked out the large windows fronting Zenith Gallery and saw smoke rising out of 406 Seventh. She phoned the fire department, which put out the fire in the nightclub space. Two days later, police found a woman's body stashed in a storeroom under a blanket. The homicide case remained unsolved. Kornblatt ran a sale on her paintings and closed the doors on her ground floor space. Two galleries, Gwen Mahler and David Adamson, remained at the location. Mahler had only opened her gallery earlier that year.[15]

Others in the arts community expressed similar frustration with the circumstances. Worrell sold dc space. Dana observed that what had been an interesting monthly meeting of business developers, artists, and small businessmen now had 80 percent of its attendees wearing suits. Plans for incorporating market-rate housing into new buildings excluded artists. The zoning rule that the city's planning office passed in 1987 called for 20% retail space on the first floor of new buildings. However, while artists might benefit the law aimed to create a livable city scape more that maintain old downtown's art "feel." Restaurants and nightclubs counted as appropriate spaces.

"The area faces the prospect of being an arts district with no artists in it," assessed *Museum & Arts Washington* magazine. "Studio space is almost obsolete," said painter Robin Rose. "They [real estate businesspeople] put artists in a space to 'purify' the space. Gives it a poetic image and moves it from being a slum ... gives it an identity." Rose astutely observed artists helped make the neighborhood safer and gave it a personality that buyers found cool and worth purchasing. Building owners rented to artists until developers emerged with some of the last evictions of artists happening at the LeDroit in 1996. "Its closing is really tragic for the art scene. For years we had three buildings on F Street that were home to artists. The other two are closed, and now this one. That is 35 to 40 years of artists' being a presence here. All gone now," said Dana.

While the area lost artists, the area pinched its remaining galleries. Despite empty storefronts throughout the city's East End, lessees observed that their rents dropped only slightly, and they paid the utilities and taxes—"triple net." In many developments, lenders providing the capital stipulated that the building must retain a specific dollar value: the external building's amount and the amounts from lessees inside the building. If spaces failed to rent for the amount needed to keep up the building's value, they needed to remain empty. A Museum & Arts Washington article observed, "City planners have declared an arts district, but have done nothing to assure that art galleries can afford the rents in it. Today there are only a half-dozen galleries in the area."

This new Seventh Street and Pennsylvania Avenue complex matched the city's plan of a "livable downtown." The Lansburgh Department Store building now housed mid-to-high-end residences and a health club, a bookstore, and Jaleo Restaurant on

the first floor. The Shakespeare Theatre took over the majority of the art space. The two-decade-old institution doubled its capacity from the Folger Theater on Capitol Hill. Warrell recalled that the artist groups agreed with the theater moving in if it rented 20 percent of their space to local arts organizations. "They agreed to that. But just like everything that was ever put in writing by the city's Office of Planning or the PADC, as soon as leadership or even their existence ended, so did any agreement." Both spaces succeeded, with Jaleo earning $2.7 million in revenue in a single year and Shakespeare drawing 110,000 for the 1995–96 season. But no art organization existed to push for the inclusion of art inside these new spaces. Market Square drew well-paid Clinton Administration staffers into its lavish condominiums and stylish restaurants.

Art festivals arrived in the area. Multicultural arts organization District Curators picked up the challenge during the low ebb of the late 1980s and early 1990s. Their street fair featured music, children's events, and some other activities. Cultural Tourism later held the "Arts on Foot" festival. A tented area featured top chefs from downtown restaurants putting on cooking demonstrations as part of a "Cooking as Art" program. Many of Penn Quarter's top restaurants offered samplings for sale for a dollar or two. Other tents featured presentations by the area's theaters, museums, galleries, and cultural institutions. And at a juried art market, 75 artists showed off their works for sale. The "Arts on Foot" festival captured the significant changes to the area since the early 1990s.[16]

By the mid–1990s, Zenith Gallery remained the sole art space in Gallery Row. Fortunately, 406 continued to draw in new galleries as old businesses closed. Manfred Baumgartner completed a $40,000.00 renovation of a gallery space before moving in. "I needed a showcase," says Baumgartner. The Washington Art Dealers Association vice president expressed optimism about the city's art scene, noting that a high number of "local collectors—a lot of lawyers in their 40s"—and New Yorkers bought here. Mr. Baumgartner admitted that "Washington is not a market where people take chances. Taking chances is being on the edge, having a certain attitude."

In Dupont Circle, Baumgartner Gallery showed legendary artists like Louise Bourgeois, Joan Mitchell, Malcolm Morley, and *enfant terribles* of the art world, including Bruce Nauman and Andres Serrano. Artist Clark Fox called it "the Mercedes dealership of Washington art." Another observed that Baumgartner's gallery ranked as the city's best for the previous decade. His business grossed $3 million one year during the late 1990s. His final show at 406 was called "Jolt," and Ferdinand Protzman observed "diversity of styles, techniques, and philosophies at play in the Washington art world." He also featured several young Washington-based artists.

The Austrian gallerist's personality sometimes alienated locals. "In New York, I am considered totally normal," maintained Baumgartner. "The way I do business, the way I interact with people, the way I dress, my sense of humor, it all fits there." His wife frequently reminded the 50-year-old that he came across as arrogant. Yet several critics found him jocular with a wry sense of humor. After nearly two decades, Baumgartner closed his galleries and moved to New York. His summary of the city's art world: of area collectors' taste, he said, "Most of them are sheep." Many D.C. artists lacked vision, he felt, and fellow gallery owners were not entrepreneurs.

After Baumgartner joined 406, Cheryl Numark opened her first gallery later in 1995. "There's an incredible energy on Seventh Street, and I hope to be a major

addition to the building," Newmark said. A lawyer for the U.S. government, Ms. Numark collected fine art prints, which renewed her interest in art. "It gave me a feeling of sustenance, a kind of nurturing excitement," said the 39-year-old.

After spending time as an art student and gallery apprentice, Ms. Numark became a private dealer of limited edition prints by contemporary artists. As the art market began creeping back up to its 1980s highs, Numark opened the gallery. "I thought there was a market niche in Washington for contemporary prints."

With a gleaming maple floor and free-standing wall for art in the center of the room, the gallery space grabbed attention, as did the walls that showed contemporary prints made by top-drawer artists using state-of-the-art techniques. Her opening show featured David Hockney, Jennifer Bartlett, and Al Held. Sol LeWitt prints and the cyber-smart art of Nam June Paik appeared in later exhibits.

Numark said during her first year, "I'd also like to get more involved with the work of Washington area artists. Part of the function of a gallery is to put artists in context and educate people about what is out there." Numark represented a range of the city's artists. Among this group were Washington's top abstract painters, all of whom were well connected to Washington's academic, media and museum circles. Other artists included local glassmakers and an array of sculptors. Recent American University graduate Dan Steinhilber showed a piece he created for Numark made of bubble wrap inside the Hirshhorn Museum. Numark left 406 for a large, gorgeous space on E Street between Sixth and Seventh Streets. Her gallery became known for its large, site-specific installations. Michael O'Sullivan raved about Steinhilber's pieces at his first Numark exhibition. Numark had several significant Washington-based sculptors, including Yuriko Yamaguchi, whose artworks drew coverage from many art magazines and newspapers.

After almost a half-decade at the new location, she ended business in 2006. One critic editorialized, "Thankfully for art fans, the reason is not a slowing market." Numark explained to the critic, "I reached a point where I needed a different balance in my life." She created a business advising people and companies in selecting art.[17]

Despite a clientele unlikely being among the cheap Chablis drinkers, Numark Gallery stayed open for Third Thursdays. The monthly open house started in 1998 when the Cultural Development Corporation fitfully herded the gallery "cats" together. About a dozen galleries and businesses in the vicinity of Seventh and E streets N.W. now regularly participated. David Adamson's Gallery took part sporadically in the monthly event "It's more of a social, singles scene, we've found. People come, hang out—which is fine—but they usually have little interest in actually buying art," Adamson remarked. Numark appeared to enjoy the crowd. "I think it's a great thing," she insisted.

A member of the Touchstone Gallery suggested putting a sign outside the building. They let people know about the galleries opened upstairs. Painter and installation artist Ellyn Weiss recalled that Numark vetoed that. Numark liked that people had to seek the galleries out. "It was a very New York attitude," Weiss smiled. Weiss remembered that the community was steady during the period from 1999 to 2003. "We had galleries that spanned the range. A broad range of artists."

Touchstone, which sat on the second floor of 406 Seventh, featured 32 artist members. It moved during the mid–1990s, hoping to attract a younger audience than that found at their R Street digs in Dupont Circle. Founded in 1976, the 36

members included 20 painters, ten sculptors, and six who made pottery. Robert Sanabria was the only male in the first group. The inaugural exhibition at 2130 P Street featured a piece from every member artist. Sanabria enjoyed attending lots of art openings and taught art courses at the Torpedo Factory. The sculptor ran into one of his fellow gallery members at various art events. He married painter Sherry Zvares ten years later.

From its beginnings, Touchstone sought to enrich the community's lives through diverse contemporary art exhibitions and by promoting a wide variety of D.C.'s artistic talent. Members made all the decisions about gallery operations. They filled the positions in the gallery's organization. Additional responsibilities included helping to staff the gallery.

Artists interested in membership approached the existing gallery members for their consideration. Both those with a developed body of work and those fresh out of art school applied. After submitting a resume, a letter of recommendation, and an artist statement, the applicant received a date to visit the gallery. Existing members listened to the individual artist present his or her work. A week or so later, the membership chair called with the jury's decision. Acceptance into the gallery required a 2/3 vote of the attendees at the presentation.

Accepted artists received several benefits from admission. They had at least one piece in every group show, including an All-Member Show and monthly group shows. They also participated in the holiday sales that happened yearly around Christmas. Members also received a solo show after a minimum of 24 months of membership. The individual artist also received a solo show every other year after that.

When Touchstone and other cooperative galleries started, they were havens for avant-garde or risqué art, said the Foundry cooperative's director. Artists joined because they weren't dependent on customers. Forgey expressed his annoyance with the slapdash execution of the pieces at the Touchstone. Another critic observed a visitor who spotted a person seated beside a painting in which the person was the subject. The visitor leaned in and asked, "Will the real person, please stand up?"

The group often successfully fostered the continuing artistic and career growth of its member artists. Artists in Washington nicknamed the gallery "Steppingstone." Indeed, Ms. Weiss, Mr. Dana, and others stayed for a little while, then, as Dana said, "[I] felt that it was time to move on." Rising rents motivated Touchstone Gallery to move out of the area. Other galleries moved inside 406 Seventh Street over the next few years. Most lasted two or three years before closing, with a few moving into private dealing.

Near the close of the first decade of the 21st century, the arts district had almost disappeared. In 2008, Zenith Gallery moved from its location of 22 years. Goldberg offered an optimistic view. "We'll have more time to focus on the Zenith Community Arts Foundation, a non-profit I started eight years ago to express my activism." But she argued that her landlords charged exorbitant rents, and the city provided insufficient police protection.

As Catherine Timko of Community Retail Catalyst noted, "[Seventh Street] had some closings, and the rents have been soaring, but foot traffic is strong." Stores selling food and family restaurants moved in before the Great Recession of 2008. In 2011, a native of Bethesda, Maryland, opened Hill Country Barbecue inside 410 Seventh Street. The occasional live music served as the rationale for accepting the restaurant

as appropriate for the "arts district." The director of the Penn Quarter Neighborhood Association, Jo-Ann Neuhaus, summed up the situation. "We didn't set out to be a restaurant and entertainment center, but that's what's happened, and for now, people are still coming."[18]

As Seventh Street lost its visual arts credibility, other areas of the city acquired more. During the late 1980s, Dupont Circle developed the "R Street Strip." By the 1990s, galleries created a buzz below the Canal Square Apartments. Significant art centers sprang up in Arlington, Virginia, and the suburbs of Maryland, too.

11

The 1990s

*Two Gallery Clusters
and Several Regional Nonprofits*

A few artists and their friends stood off to the side on the porch of a Victorian townhouse smoking cigarettes while a trio of people in their 20s stood in the doorway looking at a little map. The few people who squeezed past to enter the gallery branched off to the right, entering the gallery's first room. A group stood directly in front of the paintings and photographs, making it nearly impossible for the new visitors to see. They headed to the back where a woman stood behind a folding table, pouring the California white wine into small plastic cups. Pretzels sat inside the wooden basket on her right. Several hands reached down to snag some goodies. They munched on the snacks, swigged their drinks, and returned to the front to see the art on the walls.

The three people blocking the door moved out toward the tree-lined street and headed to another gallery. As they stepped into the basement, they saw a crowd of visitors with backpacks nearly plastered to their shirts, talking and laughing. Two shifted the pack's weight as they got closer to examine a photograph on the wall. A collector dressed in a designer suit and his lady friend smiled at a big-boned woman wearing paint-splattered jeans who passed on her way outside.

When the artist reached the sidewalk, she met an artist friend and started talking. After saying goodbye, she started walking to the next gallery and ran into a set of friends. They started talking. Every time she progressed toward a gallery, other people that she knew came by. She never got inside another gallery.

Art lovers in the D.C. area knew one fact. They had an overwhelming number of opportunities to see work. The Washington and suburban Maryland and Virginia area held more than 100 commercial galleries. The gallery-goers realized they would do well to start in these most heavily concentrated neighborhoods of Dupont Circle and Georgetown.

The gallery strip along those few blocks of R Street emerged after galleries departed from the P Street Strip of the 1960s and 1970s. The local drug store, Schwartz Pharmacy, served as a beacon for 70 years on R Street and Connecticut Avenue. Its lunch counter was an institution, serving customers from neighborhood kids to Jackie Kennedy and Hubert Humphrey. The movie theater, Janus 3, known as the "Heinous Janus" for its sparse décor and long, sloping floor, stood on the opposite side as the ground floor of a 1950s-style office building.

Many local small businesses flourished along Connecticut Avenue in Dupont

Circle. Larimer's Market provided groceries as it had since the days of horse carriages. The Lambda Rising bookstore provided reading and video material for the area's large gay population. Down the street, the Disc Shop, Kemp Mill Records, Phantasmagoria, and Melody Records provided vinyl for all tastes and demographics. Architects, law firms, and nonprofits occupied the second and third floors of the Victorian townhouses and row homes. The Dupont Citizens Association gained the historic district status for the area after fighting battles against chain restaurants entering the neighborhood and against developers pushing to construct large-scale buildings.

The 1980s witnessed the increased organization of the galleries in Washington. The Washington Art Dealers Association (WADA) brought 21 galleries from around the city together for regular meetings. The Dupont Circle Gallery Association linked the galleries in its neighborhood. The First Friday art walk became the main event after the galleries joined forces for a joint show of new work in the late spring of 1985.[1]

Later that year, these 17 galleries combined the gallery walk with art talks. Saturday afternoon, visitors heard a provocative discussion about Black folk art at Tartt Gallery and exciting takes on current work showing in Baumgartner, Brody, and Gallery K as well. On the other side of Connecticut Avenue, Kathleen Ewing Gallery discussed an impressive photograph exhibit. Ewing came to the city to work at the National Gallery of Art. In 1976, the 28-year-old left this job to open a gallery.

As Vice President of the Washington Art Dealers Association (WADA) Kathleen Ewing realized that the National Gallery and the Smithsonian American Art Museum featured major photography exhibitions during spring 1989. The photography art world came to see these shows, so Ewing mobilized 30 galleries and museums to show the photography from their collections. While the work of Thomas Eakins showed at the Hirshhorn and that of Alfred Stieglitz at the Phillips, Civil War photographs were displayed at Dupont's Tartt Gallery and the work of Frenchman Marc Riboud at Gallery K.

Ewing convinced the Association of International Photography Dealers (AIPAD) to hold its annual convention in Washington. This prestigious event brought galleries and private dealers to the Shoreham Blue Room for the weekend, and the Dupont Galleries organized large shows.

One block away, Gallery 10, a cooperative since 1974, showed "high-risk art" very successfully. Led by Maxine Cable and her friends, Roberta Shute and Noche Christ, who made installation art together for several years, the gallery included other friends who found few places to show installations, among other works they created. They expanded over the years to feature other Washington-based artists, among them Patricia Segnan, and Claudia Vess. Ms. Segman came to painting and sculpture from the TV world. Ms. Vess created assemblages, paintings, and prints for many years, then joined the gallery's board. Her archival training proved helpful when she packed the gallery's records for the National Museum of Women in the Arts.

The local art critics began to expect these grand tours of the Dupont Circle galleries. Henry Allen commented that these Victorian townhouses, with their air of enthusiasm and slight, fumbling gentility, provided a local flair to the New Talent Exhibition. Walking 18 galleries was hot work in the June sun, but Allen observed that the show contained humor and aesthetic self-consciousness. His favorite pieces were Y. David Chung's huge charcoal drawing playfully capturing American excess and Cynthia

Barber using lively colors on steel mobiles. Later, they held the first "Washington Art Week." Twenty-three galleries from Seventh Street to Georgetown opened shows that featured a Washington-based artist or showed art depicting the region.

Pamela Kessler expressed happiness when new talent switched to new directions the next year. Anton Gallery director and artist John Figura searched for something new and uniquely Washington, finding the rampant use of myth and allegory. Tom Brody featured woodcuts depicting the horror of a teen girl captured in sex slavery. It was the first time he had done anything like that in his gallery, observing, "The traditional trend here is to [show art] that doesn't offend your neighbors."

Fortunately for the gallery, it had a stalwart among its artists. Anton had shown Tom Nakashima for many years. His work in a variety of media tended to be intensely political at times. The artist exhibited at Henri while teaching at Catholic University in the early 1980s. He became partners with Gail Enns, the new owner of Anton Gallery on Capitol Hill. However, he continued exhibiting with Henri through the 1980s. Forgey noted that his paintings integrated symbolic and representational images into beautiful-textured geometric canvases. His artworks also incorporated Eastern and Western elements.

From Iowa, the son of a Japanese father and a German Irish mother and raised a Catholic, Nakashima attended Notre Dame. He recalled painting nonobjective images before coming to Washington, D.C. In the capital city, the artist became increasingly aware of the impact of politics on the world. He aimed to continue making art that was beautiful but made a statement, too. Nakashima explained during a show of folding screens that "The symbols come to me while I'm working and the symbolism suggests itself later."

"And then sometimes it changes," added curator Jane Addams Allen.

Nakashima's retrospective at the WPA won praise as the large space offered the room for his "big, starkly chiaroscuro compositions." He continued exhibiting work at Anton Gallery. Several Washingtonians have his works in their collections, and the SAAM purchased works of his as well. He began showing in New York regularly in 1991 and had pieces in L'Hermitage and the Museum of Contemporary Art of Georgia. Washington honored him with a Mayor's award.

Chilean Raimundo Rubio came to the area during the early 1980s. After showing at Fondo del Sol Gallery, he moved to Anton Gallery in the early 1990s. Rubio began selling medium-sized canvases for roughly $6,000.00 each, and several of the city's youthful collectors owned his pieces. Rubio then moved to Brooklyn to join a different art world. He continued selling in Washington through Irvine Contemporary during the early 2000s.[2]

The region's art world hosted the International Sculpture Conference in 1990. The five-day show featured outdoor sculptures along Pennsylvania Avenue and many other events. Despite its reputation as a "painterly city," the conference revealed Washington sculptors' excellence, just as the 1980 International Confab had done.

Washington-based artists started a few days earlier. Curator Andrea Pollan offered a decaying, abandoned school in Adams Morgan to two dozen sculptors, including Alan Stone and Renee Butler. Amid bare-bulb lighted hallways and creaking floors with copper pipes and tubes sticking out from the walls, viewers eyed inventive found object sculptures. Lines to get in went around the block. Richard walked into Butler's enveloping and tinkling mazelike installation and felt it conjured bliss.

Sculpture filled the city's galleries, overwhelming even a few of the critics. Welzenbach described works at the shows that entertained or inspired him, including ten museums and galleries, most in Dupont Circle. Critic Eric Gibson found an enormous sculpture on the corner of 21st Street and O Street most impressive. The flat rock pieces sandwiched between two layers of steel forged the shape of a 7-foot circle. Its mass and weight were tossed precariously out at the edges.

Later that year, Gibson continued to see the first-rate sculpture in Dupont Circle, this time at Addison/Ripley Gallery. Addison/Ripley started one year after the 1980 sculpture conference. It featured many artists, including Washington-based artists Lou Stovall, Joan Belmar, Rebecca Cross, and the late Manon Cleary. The critics uniformly found the gallery's exhibitions of high quality. Cross showed every two years, and her colorful paintings with Georges Barque-flat faces appealed to many among D.C.'s collectors. Paintings of her boys that examined masculinity lacked the same appeal, and they parted ways in 1998.[3]

With both the recession and the NEA censorship battle waning, the city's art world celebrated in 1993. Inside the Dupont Plaza Hotel, Bill Wooby's restaurant/art gallery, "The Collector," celebrated President Bill Clinton's election, showing artists from Arkansas. Richard Dana of the Washington Area Arts Consortium co-sponsored the Artists Ball. "It's a welcome to the D.C. arts scene, Bill," Dana said. "There's a feeling of the real dark cloud of enemy forces being swept away.... There is a real good feeling for Clinton in the arts world." The Dupont galleries continued their joint efforts with the First Friday walkabouts. Protzman observed that the event drew artists, art students, and their friends. He thought the galleries showed safe, dependable, conservative art, and few included artists under 30 years old. O'Sullivan noted that people mostly enjoyed themselves although they did not buy. Another challenged people to return a couple of weeks later and count the number of red "sold" dots that had sprung up next to the art in the interval.

Gallery owners knew the limits of which artists and what art sold. The contemporary art market, particularly in Washington, represented the least lucrative and worst-capitalized of all. The Dupont area lost a few galleries, and contemporary photography seller Jo Tartt shared his space with a private dealer in 19th-century photographs to stay in business. "The galleries don't take risks because we're all trying to survive, and artists don't take risks because they want to be accepted by the galleries. We're stuck in a gooey, oily cocoon."

One new gallery took some changes. Leigh Conner spent several years as an art dealer. She joined her wife, Dr. Jamie Smith, in pursuing an interest in art history and art collecting. The couple established CONNERSMITH as an anchor tenant in part at 1130 Connecticut Avenue. The gallery drew large crowds that sometimes waited outside to get into openings and special events. Conner and Smith enjoyed hosting dinners and after-parties at various restaurants and bars in the neighborhood. Among their artists were many contemporary artists and older Washington-based artists, including Alma Thomas, Paul Reed, Howard Mehring, and Kenneth Victor Young.

The artful mix of sculptures, watercolors, acrylics, and cheap wine continued in the 2000s. "If you're a connoisseur of good art and wine in the box, then this the place for you," said a guy who stopped by the Ira Pinto Gallery. Over at Gallery K, patrons sipped and nibbled while checking out the Michael Francis "Cities" exhibit. "It's a nice alternative to happy hour at the bar," said another man. Indeed, some of

Dr. Jamie Smith and Leigh Conner in their gallery CONNERSMITH at 1358–1360 Flor-ida Avenue, NE, in 2013. The black-and-white piece on the left is by Joan Oh. The blue painting on the right is by Howard Mehring (Photograph © Lucian Perkins, Courtesy of the CONNERSMITH).

the new breeds of Washington collectors came to the openings. However, they usu-ally returned at another time to purchase a piece. Gallery K regularly showed painter Wayne Edson Bryan who was a favorite of D.C. government worker and art collec-tor Philip Barlow. Bryan's paintings represented the most expensive of the more than a hundred pieces owned by Barlow and his wife, Lisa Gilotty. At the intersection of 21st and R streets, the Na Yoko Ra Ra mobile gallery parked to display its contribu-tion to the First Friday. The rotating show of different artists in the van drew its share of visitors.

That summer, the galleries teamed up with the embassies from the European Union. The member countries placed at least two artists each in the 11 galleries. To Jessica Dawson, "Exhibit E" promised a much-needed jolt of creative energy in Wash-ington's sometimes sleepy art scene. She enjoyed four shows. One was a Swedish art-ist's gorgeous glossy photographs and videos about power and powerlessness, which featured men in business attire at Conner Contemporary. A second included the hard-edged abstractions of deep blue and gray paintings from an Irishman at Rob-ert Brown Gallery. "There are many serious art galleries in Washington," said owner Robert Brown, who as he spoke showed works on paper by Jennifer Bartlett, Ells-worth Kelly, Alex Katz, Sol Lewitt, and James Siena. "I'd like to think we've all made a substantial contribution to the community."

That community experienced significant change during the early 2000s. The last of the gallery owners from the P Street Strip days died—Henri in 1996 and Gal-lery K's co-owners in 2003. Many of the originals from the Dupont Circle Galleries

organization closed their businesses or retired. Kathleen Ewing moved to the Torpedo Factory in Alexandria. International Arts and Artists' Founder David Furchgott, whose building around the corner from the R Street Strip, thought the neighborhood vibrant and energetic through the mid–2000s. "The recession of 2008 hurt a lot of them."

Fortunately, others picked up these traditions. Hillyer Art Space featured the works of local artists and showed new artists in the summer. After over 30 years in the business and a significant role in making a national photography market, Haslem no longer saw the use of maintaining a gallery space. "The nature of the gallery business has changed. It never occurred to me that people would buy something they've never held in their hand. But they do."

By the mid–2010s, a group of 12 locations maintained the First Friday loop. These included a few galleries, embassies, and cultural centers. Studio Gallery remained as part of the R Street loop. The long-running gallery of nearly 60 artist-owners remained vibrant with new directors and infusions of new artists. As Sally Kauffman explained, once the director liked your artwork, you could drop off 4 or 5 paintings for the members' jury at the monthly meeting.[4]

Another series of galleries dotted Georgetown. While not as compact as the Dupont loop, these galleries sold a wide range of art. As with Dupont Circle, the early 1980s recession took out some fine galleries, including the craft gallery Seraph. By the mid–1980s, a small number of galleries clustered around the Book Hill area. Two stood out as highly notable. The Maurine Littleton Galleries and the Adams Davidson Galleries offered unique fare for a particular clientele. The Barbara Fendrick Gallery stood out among the galleries along M Street.

The daughter of glass artist Harvey Littleton, Ms. Littleton opened her gallery in 1984, while the Smithsonian's Renwick Museum held a retrospective of his art. She took over the Susan McLeod Gallery's location when glass art became more seriously accepted as an art medium. Littleton featured contemporary artists' takes on ordinary things like paperweights and contemporary visions of ceramics.

Leading glass artists, such as Dale Chihuly and Richard Jolley, showed there with pieces that included *Adam and Even in Suburbia* and *The Queenie [Dog] Will Do Almost Anything for a Tree*. Other humorous works included artist Jay Musler's tiny wine goblets appropriate for "a fairy's cocktail party." Littleton featured Washington-based artists like metal sculptor Albert Paley and glass artist Michael Janis among her group.

Adams Davidson Galleries opened for business back in 1965. The company specialized in expensive 19th-century paintings and lost money. In 1971, Theodore Cooper, a 28-year-old dressed in finely tailored pinstripe suits with vests and gray ties, assumed the directorship. One early exhibition at the gallery featured 20 small paintings in thick gilt frames placed against a wine-colored wall. The total value of the exhibited work topped one million dollars.

Exhibits occasionally featured current Washington-based regional artists like William Dunlap or looked back at deceased area artists like Edgar Nye. One show of the late August Frederick Lundberg occurred because Cooper met the artist's daughter and purchased 125 paintings that had sat for 20 years in the attic of a deserted ballet studio.

Most of the works in the gallery were paintings of acknowledged masters. This

group ranged from French Impressionists to Thomas Eakins and the Hudson River School painters, priced from $30,000.00 to over a million. When many Washingtonians began considering purchasing art as a hedge against inflation during the 1970s, Cooper provided advice. "Quality is paramount. Always buy the best that you can afford," he said.

The gallery lasted two decades and weathered the recession of the early 1990s. "Obviously, none of us are doing the kind of business we were doing last year and in '89, but some of us are doing very well." Cooper said that Washingtonians comprised 35 to 40 percent of his clientele; thus, his sales were not reliant on people walking past the gallery. In late 1992, he became a private dealer.[5]

Indianapolis native Mrs. Fendrick, nee Cooper, attended Catholic schools and universities in Switzerland and Paris before her marriage. She and her husband met on the Left Bank and shared an interest in prints. They decided to run an art gallery focused on European and American print artists. They operated from their Chevy Chase home to stay close to their four children.

Collecting prints became the "in" thing. The curator of the Library of Congress' Prints and Photographs Division called the market a circus. Fraud increased, including "dealers" cutting pictures from magazines, framing them, and then selling the pieces as originals. Washington artist Jacob Kainen explained that buying a framed print kept buyers seeing the quality of paper, signatures, and numbering. The Washington market had several print dealers between the 1970s and the 1990s. Franz Bader and Mickelson galleries long offered some of the best work by local artists. Fendrick had the most extensive collection in the area. She knew her field exceptionally well, and she showed them inside a Georgetown gallery with sharp lighting and a flair for display.

During her 21 years in her Georgetown location, she featured contemporary artists across media. She represented Helen Frankenthaler, Jasper Johns, Robert Arneson, and 300 more. She featured Washington-based artists' works, ranging from Ed McGowin and Albert Paley to John Dreyfuss, Raymond Kaskey, and Joyce Tenneson. Dreyfus showed with Hemphill Gallery later.

Fendrick Gallery also served the craft art community. The gallery sold furniture, book art, and sculptural pieces made of clay and metal. One exhibition brought critical raves that the 23 wooden furniture pieces featured humor and meticulous craftsmanship. The principal newspaper critics sought to share our counsel with their readers on purchasing art during the high-inflation days. She observed, "Find out what artists are buying. That's always an indication." She left the gallery to become a private dealer in the early 1990s.[6]

While two long-time gallerists left the scene, a big-name gallery opened its first Washington gallery at 3300 M St. N.W. Merrill Chase Galleries' expansion outside of Chicago was the first they planned to make. Despite an art inventory valued at $10 million to $15 million, the branch lasted but three years.

Other younger figures came onto the scene to make a difference for the arts in Georgetown. Madams Organ member George Koch started A. Salon to help artists find spaces in the city to work and show their art. A. Salon and the Corcoran worked with the District school board to convert the Jackson School in Georgetown into an art gallery with studios, and classrooms. Situated on 31st and R Streets, across from Montrose Park, the gallery hosted video shows, performances, and visual arts shows, leading neighbors

say the school went "from eyesore to community asset." When the Corcoran left, A. Salon found artists very interested in filling in the empty spaces and showing both at the school and various art galleries in Georgetown.[7]

Another figure emerged on the city's 1970s art scene. Georgetown University graduate Chris Murray, a friend of fellow alumni Bob Colacello, opened Govinda Gallery on 34th and Prospect streets in 1975. The gallery initially showcased Washington artists and Andy Warhol's work. Murray began showing musician's artwork as his high school friends included musicians like Walter Egan. Govinda held a John Lennon exhibit months after his murder. Despite Murray's initial skepticism, Jerry Garcia's oils, watercolors, pen-and-ink drawings, and small prints all sold well. By 1994, he doubled the gallery's space while selling art photography related to the rock and film worlds. After running a second branch at National Harbor for a few years, Murray closed both locations in 2011.[8]

George Hemphill opened a gallery on 33rd Street in the early 1990s. "It was clear to me that nobody was doing it, so why not me? Why not try to be the best gallery in Washington?" George Hemphill borrowed money for a computer from his father and decided to "show contemporary work of all kinds, and old master photographs only when I had to." Hemphill Fine Arts featured Washington-based artists. One Dupont Gallery owner observed, "Maybe George knows something I don't. ... [He] has a flair with younger people hungry for what's going on in the art world now, and I don't."

Lewis dubbed the gallery "handsome," with its distinctive foyer, wood flooring, and precise layout. She and other critics offered glowing reviews, as the exhibits featured newer names like photographer Anne Rowland and several Hemphill knew from his years in the city's scene, including Willem de Looper, William Christenberry, and Renee Stout. Stout established a strong reputation as a sculptor and contemporary artist who forged artworks dealing with her personal history and African American heritage.

Hemphill and William Andrew Christenberry forged a friendship over the years that Christenberry showed at Middendorf. The Alabama-born multi-media artist taught at the Corcoran school for decades. He formed his art at nearby studios or the workspace attached to an American foursquare house in D.C.'s Cleveland Park neighborhood, two stories with an attic-turned-office.

Born in Alabama's Black Belt during the Great Depression, where dirt, heat, and poverty were in abundance, he saw churches and mules and men and shacks and tenements and one-story brick buildings. Already very good with pencils, he continued to capture this world around him via a Brownie box camera he received for Christmas.

Christenberry majored in art, getting a graduate degree at the University of Alabama, where he embraced Abstract Expressionism. Unfortunately, the artist produced little work in New York City during the early 1960s. He began producing when his family moved to Memphis then to Washington in 1968. While teaching at the Corcoran, Christenberry exhibited works at the school and at the P Street galleries.

Forgey and Richard appreciated his works. Christenberry's rectangular boxes shrouded in fragments of weathered signs were called memorable and distinctly Southern by Forgey. Richard enjoyed a sculptural piece for the theme of Black music that featured the rusted roadside signs and folk art admonitions ("Prepare to meet thy God.").

One of the final shows before Christenberry's death in 2016 opened in Hemphill's second gallery location in the Logan Circle neighborhood. The show featured 26 pieces from his iconic large-format photographs of fading Southern buildings to the smaller snapshots made with his legendary Kodak Brownie.

In an interview in 1994, Christenberry said, "I guess somebody would say I am literally obsessed with that landscape where I am from. I don't really object to that. It is so ingrained in me. It is who I am. The place makes who you are." Robert Lehrman, a board member on many arts organizations and an art connoisseur, observed the poetics in Christenberry's work and the brilliance with which he captured time. The Smithsonian American Art Museum, the Hirshhorn, the Museum of Modern Art and the Whitney Museum of American Art in New York, and the J. Paul Getty Museum all hold Christenberry's artwork.

Lehrman's mother took her children to the National Gallery regularly. They each picked one painting and told the story that the art evoked in their imagination. Then they left. He studied law and applied it to help artists during the early 1980s. Lehrman expressed his creativity through collecting art.

Christenberry was one of several Washington-based artists Lehrman collected and supported. Jim Sanborn and others also benefited. More recently, Lehrman invited artist Justine Scherer to display her artwork at his annual June garden party. She had whimsical woodland creatures roam through the gardens for the duration of the four-hour party. Paul Richard once mentioned to Lehrman that one created a premier collection of Washington artists given personal aesthetics, training, and means. Lehrman responded, "Why would I want a ghetto collection?" The many works that he and his wife collected included those by Brice Marden, Joseph Cornell, and Andy Warhol.

In recent years, Hemphill has exhibited contemporary works and 20th-century Washington-based artists, notably the colorists. Rising real estate costs in both locations eventually prompted Hemphill to leave Georgetown and 14th Street and move to a new space on K Street, N.W.[9]

Real estate opportunities combined with personal motivations convinced other Washington-based artists to switch from active painter to gallerist. A decaying four-story warehouse stood one block north of the Chesapeake and Ohio Canal in Georgetown's neglected industrial area. At the turn of the century, it housed the Tabulating Machine Company, a precursor to IBM. Washington-based architect Arthur Cotton Moore repurposed the red brick building and surrounded it with a six-story brick office building on the remaining three sides.

Owner Richard Bernstein offered deals from low-to no-rent-plus-a-percentage-of-sales to entice galleries in unleased spaces in the building's courtyard level. He added a fountain, and a seafood restaurant opened on the first floor of the warehouse. Nicknamed "Galleries 1054," the deals prompted several artists to start galleries there.

Painter Norman Parish moved to the Washington, D.C., area in 1988. He spotted a "Gallery Space for Rent" sign in Canal Square one Saturday. "I realized there was just nothing out there for me as an artist, so I decided to stop beating myself over the head." The New Orleans native—having steered his children into adulthood as a computer graphics designer—gave himself five years to make the gallery a success. He sought to expand the awareness and importance of African American art. "At first, a

lot of the artists we featured I knew from art school. But around 1993 and 1994, other artists just started coming to me. These were artists missing opportunities because nobody was looking out for them, nobody was out there promoting their work," Parish noted.

He showed a range of art across media formats and from living to deceased artists and worked the phones to promote the artists. "There's a large African American client base in the Washington area, and I have a sense that they're interested in buying art, and specifically art by African Americans."

The Washington–based artists exhibited included Todd Williams, who used acrylic paint, technical inks, and polymers to create collage-based paintings. Parish showed Howard University professor James Porter's artwork and collection. The show reflected what the prominent newspaper critic called Porter's eclectic, erudite taste.

"My next dream would be for the gallery to support itself—and then possibly me," Parish once said. That gallery became one of the top African American galleries in the world. "It was his passion," said his wife and co-gallerist, Gwen. "He was an artist, and he understood the difficulties artists encounter in trying to get their work out." Washington-based artist and arts administrator Alec Simpson agreed and likened having the gallery in the Georgetown neighborhood to being in "tall cotton." The gallery hosted one show featuring Parish's artwork. It closed a few months before his death in 2013.[10]

Georgetown returned to being a vibrant shopping district. National retailers replaced the small boutique shops, and restaurants and bars served most kinds of tastes. The number of crimes dropped, and housing values rose. Seven galleries at 1054 hosted "Third Fridays" with art openings, live music, a cash bar, and finger food from the Sea Catch restaurant inside the old warehouse building's first floor.

Alla Rogers Gallery specialized in contemporary art made by Central and Eastern European artists. Some of the notable artists, such as Kyiv-born jewelry artist Masha Archer, have celebrity fans, including Beyoncé Knowles and Joan Collins. Rogers' husband Warren worked in the media industry and was a long-time member of the National Press Club. The gallery often hosted events. The caviar-and-champagne opening of Anastasia Rurikov Simes' paintings at Alla Rogers' gallery had the distinct feel of a glamorous, cosmopolitan gathering rather than the usual Washington art opening.

Others aimed for middling markets. Friends thought Eklektikos owners George Thomasson and Michael Sprouse gambled on losing their sanity and savings. "We saw this demand for contemporary art that was affordable," accountant Thomasson said. They both kept their day jobs while staffing the gallery. Some of their first shows featured regionally based artists in solo and group shows and included paintings by Sprouse, Pat Goslee, Sharon Bartel Clements, and Michael Goodroe.

Thomasson and Sprouse branched out to include photographers and other artists worldwide and some gay and lesbian-focused works. They passed the vaunted five-year mark and, during the anniversary, featured several canvases painted by Sprouse. Protzman observed that the painters' vacation to Spain positively influenced his palette, with some warm, dusty colors. The rising rent pushed them to 406 Seventh Street in 2000, where they remained in business until 2003.[11]

The Museum of Contemporary Art sat in a corner. Despite a black ponytail

flecked with gray, gallerist Michael Clark spoke with the energy of a teenager. His pop-art haven held a clear message about life and society that stood against what he perceived as the city's "lobby art" aesthetic. "I am not really interested in making money, more so than I am helping people to understand art."

The art-starved "hip-oisie" crammed into MOCA to see the exhibits, which usually contained humor and messages that challenged the status quo. Before "Superbia," Alison Maddex created "True Phallacy: The Myth of Male Power" at MOCA. Some artistic male anatomy renderings appeared in Penthouse's April 1994 issue. The exhibition, "Power, Politics and Money," created by Clark's internationally known friend James Harithas had quirk and fun. Protzman thought the flow chart drawings documenting various financial/political scandals stimulating and visually elegant. Accomplished Washington–based talents such as Manon Cleary and Joe Shannon hung work alongside emerging artists as Sueraya Shaheen and David Mordini. MOCA later expanded the scope of its exhibitions to include national and international artists.

As Clark shared the reins with his wife Felicity Hogan in the later 1990s, MOCA's physical space became much more attractive. The pair rebuilt the walls, repainted the floors, and removed the desk from the front window. They also painted together. Their paintings in the exhibition "One Hundred and Ten NAFTA Oranges" were "a really juicy Washington painting. It makes you think of worker bees, and fruit stalls, and dining rooms in Georgetown," said Richard. Also included "Raphaelle Peale's still lifes, and Warhol's stacked commodities, and Seurat's colored dots." The paintings sold as 110 stretched canvases for $25,000.00, or one for $350.00. "That doesn't seem too much for a color painting and a traditional table-top still life and a witty, well-credentialed Washington work of art," Richard observed. The oranges emerged from still lifes produced to decorate real estate developer Richard Bernstein's Lombardy Hotel's rooms, partly subsidized the gallery's losses. Despite the troubles of red ink, Clark recalled that over 5,000 regionally based artists showed in MOCA and that "it actually helped get the Street Art Movement going in the area."

Clark turned the gallery over to David Quammen in 2005. The new owner had connections with the Figure Models Guild, and the gallery moved from figurative painting to nudes. Its wild opening events featured burlesque and live nude statues in the back. Neighbors complained upon seeing one performer head into the courtyard donned in little more than pasties, which led to MOCA part two's end.[12]

Rebecca Cross joined the 1054 space in 2006 after observing a niche available in marketing ceramics. She started Cross-Mackenzie Gallery in 2006 after promoting her husband's architectural photographs proved enjoyable. Because Canal Square lacked foot traffic, the gallery moved to Dupont and enjoyed the critical mass that came with the gallery walk. The chance to own a building in Book Hill proved worth taking. Though the area had less critical mass, it had committed purchasers. Ms. Cross recalled a husband and wife from Texas who walked into the gallery. He asked her if she liked one large painting. After she replied affirmatively, he said, "Happy Anniversary," turned and gave Cross his credit card.

Cross built up a group of friends among fellow dealers over the years of attending art fairs. One, Leslie Ferrin, sometimes found herself between galleries. The two friends worked out a deal where Ferrin showed her national artists in the D.C. gallery. Once, a group of black sedans pulled up in front of the gallery. A woman walked

into the store with a female bodyguard out of Game of Thrones standing beside her. The Middle Eastern Princess claimed four pieces off the floor. As Cross began gift wrapping them, the woman turned to walk out as she said, "I'll send my man around later."[13]

Some strong arts and crafts galleries existed throughout the region. The Glass Gallery succeeded in its Bethesda location. For 25 years, the gallery showed contemporary glass from Scandinavian and famed Venini glassmakers. It featured American glassmakers, including some artists from Washington, D.C.

Several nonprofit art spaces made the most considerable impact regionally. Baltimore's Maryland Art Place (MAP) has promoted contemporary art in the state since 1982. Rockville Art Place (RAP) and the McLean Projects for the Arts met the diverse interests of artists, collectors, students, and the community. Exhibitions in these places, at college galleries, and regional institutions like the Athenaeum and the Strathmore provided artists opportunities to show and audiences to a wide range of artworks. Their educational outreach has supplemented art training in public schools. As community-sourced art spaces, they have inspired artists through children's classes and exhibitions. These places incubated and nurtured artists by providing studios and exhibition opportunities to many individuals. These spaces were also crucial for the jobs and opportunities they offered to arts administrators. Curators and others gain invaluable experience in their crafts. This project discussed two long-lived nonprofit spaces, the District of Columbia Arts Center (DCAC) and the Arlington Arts Center (AAC).[14]

People stood shoulder to shoulder inside the DCAC. The unfinished appearance of the 3,000 square foot space gave it a raw feeling that pleased the artists. "This place is low-key—it has a home base feeling!" said installation artist Michael Platt. A disheveled art patron asked his companions, "What have we got here, a gallery or a sauna?" Others lined up in front of Revolutionary Books to climb upstairs to "the artist's YMCA."

The DCAC was started by former WPA board members, including entrepreneur and arts patron Herb White, who donated the space. The group wanted to focus more on enriching the local arts scene with an "interdisciplinary alternative arts center." They thought the WPA had grown beyond that focus. As Platt said, "A lot of people say the WPA is not the WPA anymore. This place helps the situation. I like it."

A lot of other visual artists and performers in the city did as well. The exhibit, "Four Women Sculptors," offered an overview of several distinct disciplines dominating much contemporary sculpture. Actors and even former directors of local theater companies took to the stage in the carriage house in the back of DCAC. Local bands blasted their sounds through the intimate theater. By the first anniversary, DCAC Director Margaret Schnipper told the many people in attendance that DCAC had shown the works of more than 300 visual artists and shows by more than 300 musicians, poets, and performance artists.

Schnipper and the 200 members encouraged alternative art. "I think it's important because in a city like Washington since there haven't been many places exposing new approaches, artists think they need to go along with the status quo. We're trying to inspire them to put their art on the front lines." The director explained that the operation ran on little money, and she did five persons' work. She resigned after 14 months.

Well-traveled actor-writer Andrew Mellen took over. After departing the Midwest, Mellen started a theater company in New York. "I hope to create a space that is equal access to everyone for showcasing the finest, most dynamic work of artists from the greater metropolitan area." Critic Todd Allan Yasui described DCAC's shows under the old regime as erratic but ambitious. Board member George Hemphill agreed. "The programming has been particularly ambitious for an organization so new. But there's kind of a loose-gun quality to it, and it hasn't necessarily been articulated to the public as well as it should." Mellen planned for "a more consistent approach to programming. I want to curate shows that have specific themes that reflect current events, or address longer-range and more abstract themes."

The new director recruited newer board members from among the artist and gay communities of the city. One new member, painter Tom Drymon, described Mellen as a queer activist. "Andrew was interested in making DCAC a space for the underrepresented." The early 1990s included a significant spike in activism in the Gay Lesbian Bisexual Transgender and Queer (GLBTQ) communities. The battle to end the AIDS pandemic prompted the emergence of AIDS Coalition to Unleash Power (ACT UP). From 1987 through the mid–1990s, units around the United States staged various forms of protests and media events. Three years after ACT UP began, Queer Nation arose to combat homophobia and protest for greater visibility of GLBTQ people and arts, as Mellen planned to do in part.

One of the first successes under the new head helped all. Board members, artists, and other volunteers provided sweat equity. They came in one weekend, took up hammers, and began banging out the walls that made the front staircase feel claustrophobic. Other changes featured removing ceilings and walls that hemmed in the gallery and theater. Later, a newly designed interior with donated track lighting and new theater seats improved seeing all shows.

Mellen brought themes to art shows. One of the earliest shows featured the District's new mayor Sharon Pratt Dixon. She provided local artists with access on a spring afternoon during her first year in office. They saw her wearing big-lensed, red-rimmed glasses; reading; speaking on the telephone; and sitting back behind the large desk. Richard labeled the works a lot of tripe and decried the artists' inability to draw. He concluded, "One pities Dixon, and the dying art of portraiture, and the DCAC as one stumbles through this show."

DCAC also offered the exhibition space for organized art groups. An association of five collaborating painters called Irwin brought work from the war-torn Yugoslav republic of Slovenia. "Blow," a send-up on art experts and the text on museum walls, drew large crowds and critical responses. A multi-media show of six women artists called "Dress Forms: The Power of Clothing" brought video, dance performances, and art assemblages. The new momentum came at a good time. DCAC started a fundraiser, "Cuisine des Artistes," that became a tradition.

At the beginning of the spring of 1993, 25 Washington-area residents known for their art made "edible art" for the public to scarf down for $25.00 a head at DCAC's Adams Morgan space. The event proved popular with its "symbolic pasta" and "alphabet cake" to oatmeal cookies with who knows what inside. It remains a spring event today. Later that year, a second benefit for DCAC happened at the trendy Zei Club. From a girl in a black mini with a see-through blouse and men in business suits to Eurotrash guys with silly little ponytails and women wearing platform heels and

bell-bottoms, the crowd came after 10:00 p.m. and drank, danced, and partook in a raffle for donated artworks by Yuriko Yamaguchi, William Christenberry, and Sam Gilliam.

Things paid off nicely with an exciting new show curated by Alison Maddex. The opening for "Walk the Goddess Walk: Power Inside Out" drew over 500 people. Camille Paglia and performance artists dressed as geisha girls came from New York City. At the door, Franklin Wassmer performed "Shoe Check." The artist encouraged everyone to turn in their shoes for a pair of high-heeled pumps. If you could not walk in the heels, you could hold them in your hands and bandy about in stocking feet.[15]

The organization scraped by on a budget of less than $100,000.00 a year and its belief in artistic democracy. Anyone who wanted to show artwork or put on a theatrical event remained DCAC's biggest appeal. The effort to spur minorities to submit show proposals was something DCAC began under Mellen before he left for an artistic director position through programming and marketing. With his signature big, round, black-rimmed glasses and shaggy black hair, new director B. Stanley emphasized that DCAC "considering everything" and showed what proved representative of what artists were making. The gallery received much more than it put on its walls.

A year later, the group celebrated the 60th birthday of one of its top benefactors, Herb White. A stocky outgoing grandfather and civic heckler, the Georgetown University graduate had started an interior design concern 35 years before. After managing a plantation in Panama and joining poet Robert Graves' commune in Majorca, White made successful real estate and restaurant investments in the United States. A Gay and Lesbian Chorus octet entertained in the back, while in the front room, artists from jewelry makers to sculptors praised White for his unending support. "Buy art; contribute; volunteer," said the affable celebrant before moving swiftly and skillfully around the front room. The celebration brought new and old artists, friends, and DCAC supporters together. "Without Herb, there wouldn't be a lot of art in Washington," exulted B. Stanley.

DCAC ran its annual summer exhibition, "Wall Mountables." Part-time artists and some DCAC supporters paid $5.00 for a two-by-two-foot wall spot. The artists entered the front room on a humid June night and claimed their location. The cable installer whose self-portrait in oil, "The Indignant Eye," hung by the bathroom, declared, "If I don't continue to paint I will die." Chester Simpson exalted over his photograph of a whore with a painted-on mustache orally servicing a client: "The D.C. scene needs a good shot in the arm—there are very few places where you can show the wild side of life." O'Sullivan praised the show with its 1,500 pieces filling every wall space—once for its inexpensiveness ratio to quality and on another occasion for a "Brady Bunch" aesthetic.

DCAC membership climbed to 500 by the next summer, and grant money tripled. The black box drew a panoply of bands, theater, and performance art. Its Art-Sites '96 contribution pushed boundaries slightly with paintings and photographs for the show "Washington Nude." At the close of the Millennium, DCAC pushed boundaries, offering space to the Triangle Artists Group (TAG) for its exhibition "Too Queer." TAG showed artworks in gay-lesbian owned restaurants and cafes, and sometimes real estate offices in Dupont Circle East. Member Ruth Trevarrow enjoyed that the group made exhibits happen, yet she also spent time conceptualizing different projects with various members.

Trevarrow challenged member artists to consider how the larger straight society and gays themselves censor GLBTQ people. The *Washington Post* did not send a critic to see the exhibition due to its use of the word *queer*. Notable pieces were a photograph of men peeing rainbow flag colors and a recording of Harvey Fierstein's reading of derogatory terms applied to queer people. GLBTQ critic Greg Varner liked Trevarrow's Gay American History stamp series piece and Mark Osele's colorful photograph *Pissing Up a Rainbow of Pride.* Frederick Nunley's art also received notice.

DCAC developed a new annual event known as "The Lottery," in which one hundred entrants pay $50.00 or $100.00 each for the chance to have a show. At the December gala, DCAC draws the winning ticket. Stanley dubbed the process "curation by tao." The first winner created a collaborative display of four Washington-women artists around the theme of "Blind Date." Abstract painter Jane Engle got the call while getting ready for bed Sunday night. After being diagnosed with manic-depression, Engle left a career at the National Institutes of Health. She can't go more than a few days without painting. Her art formed a part of her therapy. Thomas Drymon developed an introspective exhibit with a friend, Ira Tattelman. That exhibition, "self: EXAM," dealt with self-esteem and self-loathing, body image, sexuality, illness, family, childhood, lust, and death. O'Sullivan saw the show as a surprisingly unself-satisfied, not to mention unparochial, gaze at the artistic navel (and other body parts).

DCAC continued to follow its guidelines of providing space for artists, or groups of artists, that offered an intriguing proposal to put up their show. Musicals, odd-themed playlets, and scary story events occurred in the black box. Exhibitions featured artworks expressing outrage over violence perpetrated against indigenous women or featured Native American artists. Jayme McLellan and independent curator Katherine Carl organized the "Tandem Project," a residency and exchange for artists from the countries of the former Yugoslavia who had been fighting the Bosnian War only a few years earlier. The work was conceptual, experiential, and not object-dominant, which was a big deal for DC in 2000. A Philadelphia-based non-profit artist collective used the space as a home while its regular venue was repaired.[16]

Arlington, Virginia, featured shops, bowling alleys, and luncheonettes that had their heyday during the 1950s. By the 1970s, many sat abandoned and boarded up. The subway system coming to Northern Virginia brought hope for new residents and revived shopping streets. The Community Arts Council of Arlington received an NEA grant for a local arts program. The county had several empty schools built during the 1910s and 1920s boom. It provided the council a $10,000.00 grant to recondition Maury Elementary School and a rental fee of $1.00 a year. The money for operating and utilities came from studio rentals plus fundraising. The council planned to convert several old schools for the area's artists to have affordable studios.

The council struggled to run the Arlington Arts Center (AAC). As artists applied for and moved into studio spaces, they discovered Ted, a divorced man and member of the county's Parks and Recreation, allowed to act as the building's caretaker. Ted lived in one of the second-floor classrooms and used a hot plate for cooking. He stayed for three years and began making art. The building had pigeons nesting inside holes in the roof, and water also came through. The director had the only key to the building, so the artists generally had to enter and leave as she did. After initially

missing the first scheduled opening, the AAC opened at the end of May 1976 with the studio artists' works. Visitors received advice to wear old clothes or a smock to cover themselves.

The center had building problems and began running out of money. The artists were the only people who showed at the board's elections, so they took over. Everyone with a studio had keys, making the studios more accessible. The artists converted exhibition spaces in the basement into locations for potters, and "we filled every available space with a renter," one of the original artists, Anne Hancock, recalled. In the fall, the artists held their annual juried show. In November, the Muddy Fingers Pottery Group held a Christmas sale. As the artists made the center solvent, the community outreach, including classes for children, expanded. They featured a juried show of high school artists and exhibits done in conjunction with community groups, like the Slavic Association. Photography contests, lectures on art, and classes on making art increased community interest, spurring county residents

Anne Hancock, *No Easy Exit*, 2019. Mixed media, 20" × 20" (Courtesy of the Artist).

with business and community connections to join the board. The Arts Center established itself as a nonprofit institution on its own.

Mrs. Hancock took a studio at AAC after years of making art while raising children. Her interest in art grew from seeing the fantastic collection of American art hanging in every building at Randolph (Randolph Macon) College. The college's collection, which stemmed from an annual exhibition of contemporary art on campus, blossomed with "Project Y" in the 1950s. During the Cold War, the National Gallery of Art built a specially designed reinforced concrete building to house its distinguished collection in case of nuclear war. A convoy of trucks in the National Gallery of Art's garage stood ready to evacuate its masterpieces to the facility, including a fully stocked, three-bedroom cottage for the gallery's curator.

Local-oriented exhibitions remained a mainstay, with one show featuring the 18 artists with studios above Dyer Brothers Paint Store near the Court House Metro Station. The building housed an old bowling alley before the studios, and with the Metro's arrival, plans called for the building to become a new office center. The Arlington artists began facing similar development pressures as their D.C. brethren.[17]

New director Robert Cwiok expanded the types of exhibitions. Once, he placed a single type of contemporary art made by local artists in each room. Minimalist pieces provoked boredom from reviewer Deborah Churchman. The Conceptual art featured a photocopy of a line of poetry, then in which the piece was buried, soaked, and burned. Upstairs, photocopies of 35 different pre-and-post artworks hung on nails, waiting to be ripped off and taken home. An exhibition of regional painters that attracted 129 submissions became an annual show, as did exhibitions featuring site-specific work. A major thematic show emerged because Cwiok noted, "This was a group of people who had not before been specifically dealt with as a theme in our area." Called "Of the Black Experience," it consisted of 26 artists showing a range of images and feelings.

As the tenth anniversary of the center arrived, the physical plant and exhibitions showed everything going well. The smell of paint wafted throughout the hall, although printmakers and sculptors also numbered among the 35 total artists. Classical music pouring from the radio in one of the studios. "We've got great light, good space, cheap rent, and camaraderie," said artist Julie Schneider. These artists joined with others in the ten art clubs and guilds of Northern Virginia to become part of the annual show of artworks, known as the "Gold Show." Lewis walked into many of the studios, looked around, and concluded the art appeared bigger, bolder, and better. Everyone realized that they needed to limit the time artists stayed in the school's studio. The AAC instituted a plan that rotated out the long-time artists and offered five-year occupancy to each incoming artist to keep up its mission of making space available to new and emerging artists.

The celebration included an exhibition featuring 28 artists of the thousand who appeared in shows over the years. Seeing Andrea Way and Yuriko Yamaguchi's works reminded all that they started at the center and now were highly regarded in the region. The center's reputation kept increasing as notable figures in the art world juried their one multi-media show for members and one exhibit for regional painters have been. Two juried exhibitions a year provided artists with the first critique of their work.

AAC exhibitions in the early 1990s sought to challenge some comfort zones.

One featured twelve regional artists' work responding to the deaths from the AIDS crisis. An exhibition about gender sparked critic Hank Burchard to observe that most pieces weren't challenging to the theme. A sprawling show of regional artists focused on new art genres, from television monitors and handmade paper to installing audio and video loops. "We're finding these media are not that different. It all comes from the same foundation," said juror Philip Brookman. Another called "Touch: Beyond the Visual" invited 20 national artists to feature pieces that invited touching.

At its 20th anniversary, the center solidified its finances and made significant inroads into the region's art world. However, Executive Director Carole Sullivan thought that most pedestrians unthinkingly walked past the nondescript old schoolhouse. Sullivan joked, "[We're seen as a place for] cutting-edge art in what many think of as a white-bread community." The center had a $150,000.00 budget and accomplished what previous directors had wished. But the old building required repairs the center couldn't afford. The county residents approved a $2 million bond referendum to renovate and expand the arts center. The Clarendon-Maury School Building gained landmark status when it was listed on the National Register of Historic Places, so Virginia provided $100,000.00 in historic preservation funds to restore its architecturally significant elements. The center needed to embark on a half-million-dollar capital campaign before new construction began in the upcoming millennium.

The plans included a large addition to the back of the building. "The goal is to increase space for exhibitions, classes, and public lectures and improve studio space for artists," Sullivan said. In the fall of 2001, AAC held its last exhibition and installation pieces were situated all around the building, including in a bathroom, a closet, the stairwells, and the front steps—and one artist cut holes in the walls. "We saw a unique opportunity to let the building go," said curator Gerry Rogers, AAC's education and programs associate.

Each artist revealed part of the building's past. Billie Grace Lynn referenced the school by hanging the talking, singing, and moving innards of stuffed toys on the wall. Joyous viewers heard squeaks, songs, and talking by pressing little red buttons attached to each stripped-down toy. Architect and artist Ira Tattelman created an enclosure where shoeless viewers peered through cuts in the wall to see the school's original brick walls and large windows, as well as remnants of old exhibits. "I wanted to try to reveal some of the history of the space, the fact that it's changing and how it's changing—to help people become more aware of the space," he said.[18]

Over the two-year hiatus, center staff members ran programs in other locations. They organized all-media juried shows at the Ellipse Art Center. They showed student photographs that captured Columbia Pike's multicultural rhythm. In 2003, the building renovation remained unfinished as Arlington officials and the contractor battled over responsibility for mold problems, construction delays, and other disputes. The center eventually laid off its staff, and board members and other volunteers tried to keep the name visible through hosting local events.

The center's leaders received the news that they could resume occupancy in the fall of 2004. From the front door, visitors saw through to the end of the foyer, which included new Tiffany-stained glass windows in the "Tiffany Gallery." Three of these windows came from the thirteen rescued when the Navy tore down the Abbey

Ira Tattelman, *Exfoliation*, 2001. Wood studs, gypsum board, fiber-reinforced panels, metal screens and brackets, Venetian blinds, spotlights. 10' × 10' × 10'. Created for "Stroke of Installation," Arlington Arts Center, Arlington, VA, curated by Gerry Rogers (Courtesy of the Artist).

Mausoleum in Arlington during 2000. The new wing behind the school offered more studio space for artists.

The center then began rebuilding the staff and programs. It held a gigantic regional exhibition as the first in the new space. With over 100 pieces from 67 artists from all over the mid–Atlantic, the five-curator show began the AAC's return to solid footing. Nearly 800 visitors came to the opening. A few months later, the board organized an event to thank all the people who helped keep the center going without staff. That summer, the AAC lost its executive director. Claire Huschle became the acting director, moving over from the education program. After a year, she was able to hire Jeffrey Cudlin to be the director of exhibitions. With nine rooms of exhibition space and a lawn suitable for displaying outdoor sculpture, the pair thought the center "had an obligation to put on shows that other places in D.C. area couldn't do" and sought to show what was happening in the art world with local artists.

The AAC exhibitions promoted both of those goals. For Ms. Huschle, their positive path received a nod of approval when the center received a grant from the Andy Warhol Foundation. The gift illuminated the AAC's financial stability and that the art world appreciated past work and wanted the center to tackle more challenges. They continued holding solo shows with artists getting their exhibition room and themed shows offering a challenge, such as "She Got Game." The annual Dia de Los Muertos celebration provided space for various expressions from the county's growing Latin communities. The exhibition, "Over, Under, Forward, Back," showed contemporary

work in often ignored materials, such as fibers and textiles. Board member Jon Breeding recalled the celebration of community-sourced art known as the AAC's "40th Anniversary Show." Breeding posed beside one of his favorite pieces—Alex Podesta's human-like rabbits—which O'Sullivan described as a little funny and disturbing. Breeding attended art camps at the high school as a volunteer, and the experiences brought out his inner artist. That sparked him to convert a detached part of his house into a studio. He painted for himself to make sure he expressed his creativity, just one part of the AAC mission.[19]

Making art offered an outlet for creativity and gaining personal pleasure. Another D.C. family found both in curating shows at their old retail and warehouse spaces on Seventh Street in the Mount Vernon Square neighborhood. The south side of Massachusetts Avenue contained the underutilized Carnegie Library with its Vermont marble covering a *beaux arts* steel structure. To the north sat an impound lot. The empty spaces around it showed the legacy of the city's 1968 riots and a half-started urban renewal program. Across from the lot, the red brick buildings along Seventh Street featured a men's shelter, two furniture stores, a former hardware store, and a parking lot around the back.

Three generations of the Ruppert family owned the hardware store and a real estate management company. The Mount Vernon Square Metro station construction closed the block for 18 months in 1987. An uncle folded the hardware business. His brother continued the real estate business but moved upstairs to a neighboring building when his wife Molly and son Paul started a contemporary American restaurant on the first floor. Paul observed that his parents created a positive environment: "I was always encouraged to try new things with no expectation to be fantastic at something."

After a while, the pair hired a chef, then sold the restaurant to him within 18 months. Despite having many galleries throughout the region, many artists, particularly those without a track record, found it challenging to find a space to show their artwork. Inside restaurants and cafes, they showed artwork on the walls behind tables and in the space leading to the bathrooms. The Rupperts loved art and began renovation of other spaces in the two other buildings next door to the restaurant.

The hardware's inventory space became the Warehouse Theater, with its worn floorboards and lack of air conditioning. In 1996, Studio Theatre presented a Caryl Churchill play set in Romania at the Theater. GALA Theater Company used it as a home base for several years. Musical adventures ranged from punk bands to jazz combos. Paul Ruppert said that the only venue in the District producing more arts events was the Kennedy Center. But no one kicked the Kennedy Center's bathroom door open to free an actor. Nor did anyone ever have the proprietor tip the glass of white wine she held and reply to the rescue story, "Good." Art sat in the storefront that served as the theater's lobby. Theatergoers sometimes saw pieces on the walk to the theater as part of Studio 7. The artwork often reflected artists' take on the themes of the stage play.

Molly and Paul next opened Studio 1019 to show art. Molly's seemingly unstructured if-you-can-dream-it, you-can-mount-it approach to art and theater launched many a grateful D.C. artist. Deborah Randall, director of Venus Theatre, dubbed Molly "the godmother of art." One of the first shows became a large twice-yearly

event known as Art Romp. Around 100 artists mounted work all over the building for a single evening, drank, and then took it all down again.

Paul came up with the idea, and Molly added ArtRomp to diversify D.C.'s gallery scene. "We tried to get a lot of artists together who weren't 'gallery-connected.' We were looking for artists who were doing the kind of edgy urban art that was indicative of how the culture was changing." Performance artist and poet Holly Bass agreed. "They want to support the weird stuff that often can't find a home in other art spaces." They also invited established artists to show their more experimental work. "You can get instant feedback if you [attend the opening], and most of our artists go." The laid-back atmosphere included a barbeque in the parking lot behind the building and plenty of chatter and drinking.

The Warehouse Galleries held regular art exhibitions. An ever-evolving maze involving the different buildings, sometimes viewers went to the back and walked on dirt floors; at other times, they walked up creaky stairs to a hot room at the back of a second building. Often the themes were topical such as examining the status of the environment. Its "The End of Nature" exhibit with artists indicating what they missed on the dying planet ran concurrently with a similar one at National Geographic. These exhibitions also focused on local concerns, such as a photography show that challenged artists to capture the local city's cultural and architectural distinctiveness. They featured artists from less-covered parts around the region, such as photographs showing images of people who lived in one of D.C.'s most impoverished areas.

Two shows by the TAG challenged sexual and gender norms. In "What does it mean to see the world queerly?" lesbian, gay, and bisexual artists explored that question through photography, painting, mixed media, installations, sculpture, drawing, and sound art. Sexuality added an undeniable spin for artists and viewers alike, concluded the art critic. "Hey, Is That a Boy or a Girl?" artist and curator Ruth Trevarrow wondered, "[I]s the importance of gender wedged somewhere back in our reptile minds?" Some performances asked less serious questions. One man came on stage and ate a balloon. Within a minute, he pulled a second balloon from another orifice. A second performance artist removed his foreskin onstage.

Not every art show and performance met the taste of the general public. However, they pleased most of the attendees and provided artists the platform to present their thoughts and emotions. Artist Jane Hill, driven out of New Orleans by Hurricane Katrina, felt longing and indecision. The "Arty Gras show and fundraiser," held at the Warehouse in 2006, made her grateful. Tom Drymon lost the contents of his studio to the storm. "It seems like we've been forgotten. The attitude is, 'Aren't you over that yet?' They don't get that half the city still doesn't have power, that we only have three grocery stores open." Arty Gras provided a significant opportunity. "It's up to us as artists to make sure these stories are told, that we're still down here and we're not going to let anyone forget us."

Artists and friends who have known the Rupperts over the years believe that openness lay at the pair's core. Molly laughed at the notion of a gallery roster. "We didn't know established artists. We showed friends and friends of friends." One of that crew who went on to success as a glass artist, Tim Tate, observed, "If you had a quirky or strong personality, you were enabled to do your artwork and show." Holly Bass saw the reason behind the method. "I always got the feeling that they find supporting the arts for its own sake and artists deeply satisfying."[20]

In 2013, the Rupperts sold the properties on Seventh Street and one on New York Avenue to developer Douglas Jemal. Jemal had long converted former art spaces to office buildings and retail places; he had provided A. Salon and artists with studio and exhibition spaces in his buildings before their conversion. The process of making abandoned buildings available to artists before, during, and after rehab became the centerpiece of an arts festival unique to D.C. The festival brought hundreds of artists and thousands of viewers who weaved their way through the maze of art displays and musical performances.

12

The 2000s

Art-O-Matic and Democratic Art

Three art deco buildings sprawled along Florida Avenue, dividing Washington city from county. Small layers of green tile framed the building name above the entry. Below, white enamel panels encased the structure. Above, long rows of glass block covered the front's remainder, broken up first by six vertical windows with stained glass tops, then by six horizontal triple-paned windows. After its incarnations as a streetcar traction facility, a printing plant, and an industrial laundry, the 125-year-old complex sat in decay throughout the 1970s. It suffered from a fire in 1978 and nearly succumbed to the wrecking ball the next year.

A buzz surrounded the building on a muggy Washington May evening. Signage for Douglas Development Corp hung off to the side. The owner, Douglas Jemal, offered building space for free to George Koch, President of A. Salon Ltd. No one worried about insurance or waivers. Mr. Koch suggested to the District's Cultural Development Corporation and the Center for Collaborative Arts and Visual Education that the organizations combine to create a month-long arts festival. In all, 350 artists provided a small fee and volunteered their time to participate in "the most ambitious collaborative art display here in many years"—the anarchic event "let a thousand flowers bloom."

Several groups of people smoked and chatted on the walk outside before entering the main building. Inside, the walls appeared freshly painted, and the spaces appeared sparkling in the bright lights. Artwork filled the walls and floors inside a room the size of a basketball court. On the left, shattered glass hung from the ceiling, and many traditional oil paintings on canvas occasionally mixed with drawings and prints. Some mixed media pieces carried messages about teenage isolation, violence, and nostalgia.

Inside one small room, the gray-carpeted flooring felt thin and tough, and several small glass blocks separated this space from another. The installation commented on the building's history. After climbing the stairs, one approached a landing with prints hanging to one side. Several doors appeared ahead. Opening the door on the left, one walked into a room a little smaller than the one downstairs. Large pieces of very long paper painted with oil and enamel loomed before the viewer. The side had scratches through it.

Following the critic Denise Barnes' path, guests walked down a small dark passageway linking one building to another. Cold brick walls lined each side. Veronica Szalus and Zymina Gorelik affixed transparencies to the windows on the interior side

of this pedestrian bridge. Streetlights beaming through the windows on the other side made these images looked like photographic negatives. They showed a woman sometimes stepping into a wedding dress and stepping in and out of a body bag. (Szalus has been making installation art and has exhibited artwork around the region, including at Hillyer and as a member of Studio Gallery. Since 2000, she has devoted many volunteer hours to the planning of Art-O-Matic layouts.)

As the guests moved into the second building, one dreary room became a colorful kaleidoscope. Young artist Thomas Rosenquist created a simple installation that turned the space into a giant Rubik's Cube. Rosenquist observed, "I've seen some very good work, especially when people adjusted themselves to the space they were allotted or chose. It's lyrical at times."

In the south wing of the first floor, artist Dan Treado built a large skateboard ramp. Classic and punk rock pumped throughout the area from a boom box. Small chalkboards around the space read "I Love Paris" and "Since I got back from Paris, I won't golf anymore. I hate golf." In his mid–30s, the artist showed with Anton Gallery.

After looking around the south building, viewers moved to the east section. On the second floor, two painters hung their work in a corner room. The friends were both in their late 20s and worked in an abstract expressionist style. Richard Chartier's paintings used acrylic on plywood while Jose Ruiz painted with oil on canvas then set it on fire to push the pigment into the canvas.

One floor up, Karla Reid's five colorful paintings depicted family members and other imagery significant in the Black community. The mixture of paint and collage sometimes reminded viewers of people they knew. When they shared that information with Reid, the artist always smiled. As thousands of people had come during the month, she had much cause to be pleased.

The art event began its rocky relationship with the "liberal" newspapers' art critics. Protzman argued the event's official symbol was a glazed doughnut because it resembled a viewer's eyes after walking through Art-O-Matic. At best, most works reached mediocrity. He highlighted the site-specific works' strength, then mentioned long-time artists, including Wendy Ross, Richard Dana, Annette Polan, and Barbara Josephs Liotta.

By many measures, Art-O-Matic proved successful. As Stacy Bond, vice president of A. Salon Ltd.'s John Wilson Community Arts Center, noted, "The public seems very excited about it. There's so much to see; people find they have to come back in order to see it all." The event proved successful for the artists. The stated goal of strengthening the artistic community and building an audience for those artists happened. Artists forged friendships and connections while they each put up their artworks.[1]

Some of the organizers and in the media thought that the show accomplished another goal: the fair provided the local art community with recognition. "The concept and the venue were perfect because local artists experience problems getting recognized because of the federal arts establishment," Ms. Bond said. Talk of holding a second Art-O-Matic began. When the show arrived the next year, a local art critic summarized its arrival with the declaration, "Tired of being upstaged by Washington's museums, local artists are holding their second annual Art-O-Matic."

Indeed, the second Washington Art-O-Matic inside the cavernous former Hechinger store in the Tenleytown neighborhood doubled the number of artists and

performers. A new real estate company, Madison Marquette, got involved. The empty building sat amidst a densely packed commercial strip along a bustling avenue. The media proclaimed the city had not seen anything like it since the International Sculpture Conference and Exhibition.

About half a year's worth of planning and legwork occurred before the start of the event. After completing the building's use negotiations, the group signed a pre-occupancy agreement, insurance forms, and other documents. The Art-O-Matic leaders needed to find people to staff the six volunteer committees. These groups measured and laid out the sites throughout the building, marketed the event to artists, organized the event gallery management, and booked performances. Several architects and interior designers spent days laying out all the spaces. The teams then purchased wood from which to build the structures around the areas.

The organizers used numbers for to the individual artist spaces and names of D.C.'s neighborhoods—including Tenleytown, Kalorama, and Trinidad—to enable artists to choose theirs. The *Washington Times'* Joanna Shaw-Eagle concluded, "Art-O-Matic 2000 demonstrates what artists can accomplish when they get together. It's a gift to the city and themselves."

Several installation pieces received critical praise for being highly successful. She started with Elizabeth Burger's unusual tepee-like installation of dollar plants. Side by side were the works of two friends. Judy Jashinsky's *Roman Fever* encapsulated the story of the 17th-century artist Artemisia Gentileschi. Simultaneously, Richard Dana's vertical hanging scroll featured a black charcoal area that held an ambiguous older woman's face and, below, the empty white of the paper scroll.

Well-established D.C. artists also captured the critic's eye. Sam Gilliam displayed a silkscreen print; Joan Danziger, a 6-foot-tall sculpture of large-mixed media flowers. Lou Stovall showed friends' prints, acrylic paintings, and watercolors while his wife and art partner Di Bagley Stovall collaged an inviting series of raised acrylic-and-beadwork flowers. Michael Clark and Felicity Hogan presented several round paintings that seemed to float in space.

Sculpture and installations also seemed exceptionally skillful to Shaw-Eagle, who mentioned Randy Jewart's 8-foot-tall, 6,000-pound pyramid of marble and granite and Michael Platt's homage to shotgun houses. She started at Christiane Graham's mannequins in animal masks, which were located in a ceremonial space. The blaring television sets and flashing lights of Baltimore artist Fred Collins and Paris Bustillos' video called "The Art Critic" kept her laughing.

O'Sullivan noted that the heart of the Art-O-Matic embraced disappointment as much as it celebrated success. That democratic spirit resulted in wading through a lot of what the critic called "muck." But that almost went without saying because of the number of artists involved in the show. The site-specific installations were some of the most substantial works. Ira Tattelman's "Sick Building Syndrome" was inspired by the loss of these kinds of public stores and proved intriguing. But O'Sullivan found a lot of great work and some witty humor among many of the pieces. Tim Tate's placing of his mother's ashes in his stunning blown glass memory piece hit him very emotionally. The curator of the Smithsonian's Renwick Museum saw Tate's artwork at Art-O-Matic 2000, and that show opened the door for his work becoming part of the museum's permanent collection. The sales at the show provided the seed money for the Washington Glass School.

Art-O-Matic, 2000 (Courtesy of the Photographer, Veronica Szalus).

Art-O-Matic proved a transformative experience for another Washington-based artist. Sondra N. Arkin, who had recently sold a successful marketing business, became a full-time artist and got involved with Art-O-Matic to meet other artists. She enjoyed the exhibition's "free-for-all" nature, with its range of artists and types

of works appearing everywhere. Arkin joined the group's operations staff. "I think it was good because it allows people to form their perspective on the art," she mentioned years later.[2]

Art-O-Matic 3 occurred in 2002 in an old government office building near the waterfront in D.C.'s southwest quadrant. The late Washington architect Chlothiel Smith designed this building, but it was not one of her best, said Shaw-Eagle.

Shaw-Eagle thought several artists and artist groups stood apart. She thought the works from the Melt Down crew represented some of the best pieces in the show. These included Tim Tate's dark red phoenix rising; neon glass artist Marty King; cast glass sculptor Diane Cabe; Erwin Timmers, who made large wall assemblages from cast glass reclaimed objects; and Syl Mathis, who made cast glass kayaks.

Overall, the dehumanizing space negatively impacted her Art-O-Matic experience. Its gray walls and low lighting defeated much of the art. The tiny, window-less offices and cubicles along the long gray corridors seemed to her perfect for "the amateurish nudes, landscapes and still lifes that make up much of the exhibit."

Shaw-Eagle's additional standouts included Ms. Kerne, who commemorated her 96-year-old father's death with a tender, room-size installation. Jordan Tierney and Marcia Hall created a specially lighted room with a glass water jug and small glass carafes set on the floor; Pat Goslee, small, organic wax-based "encaustic" paintings; and Brenda Belfield, geometrically constructed works. Jeff Zimmer vertically hung five etched-and-enameled glass panels of spooky-looking heads and figures from "Hamlet." Ellyn Weiss provided one of the few areas of brilliant color with three large oil pastels. Gallerist Niven Kelly wrote on Ms. Weiss's note pad that he liked her work, and she joined his gallery. Martha Olsson's violently slashed protruding areas of oil pigment made a powerful emotional work seem to move. O'Sullivan felt that Art-O-Matic's can-do energy oozed out of every fluorescent-lit cubbyhole. It felt worse when inside every claustrophobic corridor. That energy created an optimistic feeling for its audience.

Still, the critic bluntly stated that "there are fewer than a couple of dozen artists here whose work I would be comfortable spending any amount of time with." But O'Sullivan enjoyed Ellen DiCola's trippy environment referencing the human body. Jason M. Coats and John Adams made notable paintings of contrasting styles. Kelly Toles and Matt Sesow offered different takes on "outsider" art, and Tracey Barton embodied outré as she drew furniture on paper towels. Andres Tremols, whose gorgeous glass displayed painterly roots, offset the office next door, where M. Jordan Tierney and Marcia Hart forged an antiseptic chapel through whitewashing walls and floors, then situated clear glass vessels inside.

One artist participated for the third and last time in 2002. The experience was particularly poignant. He had been chief of staff at EPA for four years and was now returning for the first time to what had been the Agency's headquarters. "The signs were still up in the library, and I showed in a room without much ventilation, one of the problems with the building when I worked there," he said. Few visitors or participants knew that a secret room existed as a place for officers to meet. It became a shenanigans room that smelled of smoke, pot, poppers, and other things.[3]

The year's show left the organization in debt. Organizer George Koch paid some bills out of his pocket. The Cultural Development Corp, which had provided financial

and personal support, withdrew its services. Art-O-Matic 2004, staged in the former Capital Children's Museum behind Union Station, relied solely on volunteers. Abdo Development provided the space on this occasion. An unseasonably warm month of November brought more visitors out who bought more. Their body heat led to lower heating bills. Art-O-Matic 2004 earned roughly $10,000.00 on top of a $130,000.00 budget, according to artist Sondra N. Arkin.

The funding issue might have disappeared for the moment. Unfortunately, the art event faced direct attacks on its existence. One art fan claimed that Art-O-Matic reinforced the public's skepticism about the quality of contemporary artwork. He wanted to direct the public's attention to galleries such as G Fine Arts and Fusebox.

Critic Blake Gopnik named Art-O-Matic 2004 the second-worst display of art he ever saw. Only Art-O-Matic 2002 proved worse by being bigger and in a more atrocious space. The words for the pieces he saw included *amateur, incompetent, trite,* and *naïve.* He likened the works—hung pell-mell and cheek-by-jowl and illuminated by cheap and low lighting—to pollution.

Gopnik viewed these Art-O-Matics as insults to all the genuinely talented artists who managed the long slogs to professional careers. The show offered the public bad art and diminished the great skill that making art required. The critic wanted attention directed to serious Art and believed that the city needed its competition raised to have its artists create better art than they currently had been. Art-O-Matic deflected public attention and resources away from worthwhile art and the attention it deserved. He observed that, despite the protestations of "outsiders," the art world proved not to be a closed shop. Local galleries, such as DCAC, Flashpoint, and Transformer, considered almost anything that came over the transom. Their programming tended to suffer because they had too few options from which to choose.

Gopnik's attitude emerged partly because his bosses wanted him to challenge the DC Art World. He may also have had personal interests and perspectives that made it difficult for him to appreciate the local art produced. Several people offered critiques of Gopnik's view. O'Sullivan agreed that the show contained a lot of bad art. He believed that visitors and viewers could determine the difference between strong and weak. What's more, Art-O-Matic provided "what will likely be the 10,000-plus pairs of eyeballs looking at work that normally sits in a studio the other 11 months of the year."

Mr. O'Sullivan proved correct. Jesse Thomas was a Tysons Corner–based graphics designer who participated in Art-O-Matic 2004. Thomas said the exposure propelled him to land a handful of additional art exhibits in D.C. and New York. "It was incredible." Thomas Edwards launched into a career of technological art when his 2004 show artwork Big Mouth Billy Bass captivated some viewers as they flapped on the floor and gasped, "They're eating my eggs!" or "I can't breathe air!" or "Please let me die."

D.C. designer and artist Chad Allen saw Art-O-Matic 2004 as an essential exhibition site. The city museum had canceled the show he curated called "Funky Furniture" only one month earlier. Art-O-Matic provided "Funky Furniture" with its own space within the larger exhibit. The museum managers claimed that the works differed from what they understood to be the show's emphasis. Still, Allen and other local artists said the sudden cancellation occurred because the show contained "objectionable work and got in the way of their aggressive use of the City Museum exhibition space for party rentals."

The show featured Margery E. Goldberg's well-hung dangling man; Jane Kerr's hilarious table-top slab of faux caked cocaine entitled *The Bitch Set Me Up*; Dana Ellyn Kaufman's pair of large double-sided pillows containing a composition which outlined life as viewed through the artist's Logan Circle windows; and Katie Didrikses' King George W. Bush and his business-suited retainer Dick Cheney as impersonators of Manet's famous painting *Olympia*. Viewers generally found the artworks funny.

Artists penned letters pointing out that Art-O-Matic served a community-building function. Participating artists made art for themselves and enjoyed the opportunity to show their creativity. Another artist argued that beauty lay in the eye of the beholder. "Some of the work you'll like and some you won't, but you won't go away bored." That served the purpose of entertainment, which was why so many people went to the event.

Art-O-Matic's critics claimed that show deprived "more worthy" galleries of resources. Funding mostly came from participants and viewers, and the biannual exhibition did not stop anyone from visiting or contributing to a gallery. Art-O-Matic made art into a happening. The scene drew people interested in an environment conducive to entertainment. They likely might not set foot in a gallery. Finally, the art fan's claim about the for-profit galleries showing quality art was accurate. Still, those galleries faced limits on what they presented because they needed to make money to survive.[4]

What of Gopnik's claims regarding the nonprofit galleries that he named? Were they so desperate for submissions? Did they receive too little work from which to select strong shows? As the last chapter indicated, the executive director of DCAC stated that the gallery's mission involved considering all proposals for shows. The gallery exhibited what it considered representative of the city's artists and did not show a fair number of the works received.

The other two nonprofits started in the early 2000s. Perhaps they did not have standing as DCAC. The burst of the dot.com bubble brought on a national recession. However, the city's finances stabilized through increased taxable revenues and the District of Columbia Financial Control Board's government expenditures oversight.

The budget for the D.C. Commission on the Arts and Humanities increased significantly. The Art Bank project, launched in 1986 as the city began purchasing art to display in its buildings, expanded to include purchases for the City Hall Art Collection. The commission conceived of the program in Fiscal Year 2004 and received the funding in Fiscal Year 2006. Sondra N. Arkin met with the city's artists and arts organizations to understand the breadth of artwork being made and available for purchase. The organization purchased mostly smaller and already created artwork rather than commission work, enabling it to collect more and different artists. A total of 153 pieces made by over 100 artists went into the Art Bank. By 2020, the Art Bank held over 3,000 artworks. These purchase grants were a significant gain for many D.C.-based artists.

The commission continued this effort to reach all segments of the city's art scenes. It established funding for East of the River art projects and Sister City grants to artists throughout the city's wards. Another one-time project involved painting the 22 restored police and fire callboxes in the Dupont Circle neighborhood. The commission started the MuralsDC group, which empowered artists to

replace illegal graffiti with artistic works, revitalize community sites, and teach the art of aerosol painting. The commission joined with other government agencies, area schools, and businesses to sponsor arts organizations like DCARTworks to create amazing murals throughout the city. Individual artists such as G. Byron Peck, Kelly Towles, and Aniekan Udofia promoted aesthetics and D.C. history with murals depicting people and events. Rose Jaffe and Maria Miller created a variety of murals as public art projects. D.C. native Jaffe enjoyed this opportunity to express her point of view. "I do a lot of social justice and activism work, and I think that it's really beautiful if a mural can reflect the community that it's in, and uplift the voices that are there in that community."[5]

As detailed in Chapter 10, the business, arts, and community interests that formed the Downtown Arts Committee had divided the real estate in the Seventh Street corridor and East End section of the city. They created the nonprofit Cultural Development Corporation (CDC) in 1998 to support the "process of cultural development across the entire city." The four Art-O-Matics illustrated the breadth of the city's development. Setting aside space for artists and the arts in general required things to happen before the assets dwindled in the real estate market.

The CDC sought to find space for artists and organizations to stimulate economic development and improve the region's quality of life. Among its significant achievements were H Street, NE's Atlas Performing Arts Center, the Source Theater on 14th Street, Brookland, the Arts Lofts, and 27 artist studios at the Monroe Street Market.

The CDC ran the gallery Flashpoint at 916 G Street, N.W., across from the D.C. Public Library's main branch. The gallery hung artwork from emerging and mid-career artists in its small entrance area and one long single room. Around the corner, a small black box theater hosted plays and performance art. One notable exhibit included a survey of contemporary visual art from Washington-based artists who remained anonymous until someone purchased the work.

Over the fifteen years of operation, gallery exhibitions featured artists and groups nationwide, although most featured Washington-based creators. The Washington Sculptors Group and the local Irish group Solas Nua each showed for a month. Some exhibitions involved art questions, such as the divide between two- and three-dimensional media. Others used the space as part of the piece, with one show featuring drawings created directly on the gallery's walls and another making it into a mini-botanic garden in the city. Local artists hung poetic surveys to illustrate urban environments around the world. Another exhibition featured cutting-edge digital art to comment on emotional connections in the digital age and surveillance in today's world. Flashpoint functioned effectively with plenty of choices for shows.

Jayme McLellan and Victoria Reis spent their twenties working in various positions in and for DCAC, the Washington Project for the Arts\Corcoran, and larger national organizations. McLellan started at DCAC with a broom to sweep the floors. McLellan and her friends curated an exhibition of local artist friends called "Masters of Art"—a tongue-in-cheek play on the '80s cartoon *Masters of the Universe.*

After two years of planning, Fusebox Gallery's owners told the pair about a tiny building at 1404 P Street, N.W. "It was an alley indent with a roof and storefront," Ms. Reis recalled. The owner used it as a darkroom for his photography, so

he happily rented it to a group promoting the arts. Reis named the nonprofit Transformer because it sought to change D.C. cultural space and serve as a conduit for artists. Transformer offered platforms for emerging artists. "It's less about an age range and more about where someone is in their career," Reis said. The pair also provided artists with the support that included organizing shows and aiding them in finding grants and residencies.

McLellan and Reis maintained a worldwide focus. They received a grant to visit the former Yugoslav republics to select artists for a multi-site exhibition the following spring. That show included 15 local, national, and emerging international artists. The opening show "Mica and Misaki" featured photographs from local artist Mica

Transformer Gallery (Courtesy of the Photographer, Ira Tattelman).

G. Scalin's trip to Japan the previous year and Japanese artist Misaki Kawai's draw-ings and installation of a giant tree and cardboard treehouse. Crowds waited on the sidewalk and took turns entering the small gallery space. Within a year, the gallery received a significant grant from the Andy Warhol Foundation for the Visual Arts.

Inside the storefront gallery, Transformer averaged six to seven exhibitions annually. Many artists examined their work more deeply by referencing the site, which usually strengthened their final product. Their shows included a range of media types, such as paintings and drawings that strongly reflected recent comic book styles through performance art, in a series called "Touch & Go." Works ref-erenced issues from anomie and loneliness and from regression to childhood. They studied artlessness and examined the gentrification of the gallery's Logan Circle neighborhood through an installation. The art critics saw the gallery as making its mark on the city's art scene. It emphasized change and freedom, diverse voices, and new artistic mediums.

In 2010, Smithsonian Institution Secretary G. Wayne Clough ordered a video artwork by David Wojnarowicz removed from "Hide/Seek," an exhibit of queer por-trait art at the National Portrait Gallery. Reis swooped in, posting the banished video in Transformer's storefront window and helping to usher in a nationwide museum protest movement.

The gallery regularly worked with other national and international nonprofit institutions like itself. They each built community support for local artists and brought artists and potential supporters together to meet and engage with the art. The connections enabled Transformer to introduce artists to the Washington, D.C., region and brought different Washington-based artists to show and view art in Paris, Rome, and Beijing. Artists Holly Bass, Breck Brunson, Nilay Lawson, Solomon San-chez, and Tang went to a Mexico City gallery. "More than half of Transformer's proj-ects occurred outside the building on P Street," Reis observed. She noted that the institution forged relationships with 20 arts organizations around the world.

One critic offered Transformer praise for its uncompromising dedication to sniffing out new, under-represented, and irreverent art. Most of the artists came from the recommendations of the nonprofit's associated artists. Transformer showed art-ists visually communicating something interesting about the latest expression and practices in visual arts.

The annual silent auction and gala helped raise a significant portion of the non-profit's funds. The celebration moved to the Corcoran and featured themes such as a "Bauhaus Cabaret" that honored the 100th anniversary of the art movement and Transformer's collaboration with German artists. Many local artists mixed with new and emerging collectors at the "all-night party." Works available for auction included Stephanie Mercedes' light installment, forged from melted bullets and neon lights, and Miriam Jonas' pair of icy-blue, crystalized Adidas socks.[6]

The strip along 14th Street between Rhode Island Avenue and Q Street appeared to become the new arts district. It started to usurp Seventh Street and draw gal-leries away from Dupont Circle as well. Fusebox started things, frequently having shows that critic Gopnik deemed worthy of New York galleries. Indeed, it showed a range of strong locally- and nationally based artists. Fusebox's co-owner, Sarah Fin-lay, launched the gallery with a show that featured Joseph and John Dumbacher, a team of artist brothers based in Washington and Los Angeles. Ms. Finlay observed,

"the special appeal of their doubleness" for collectors and art lovers: "There is a little sense of mystery there.... Without exception, people are fascinated by their collaboration." One tinge of irony was that Mr. Gopnik praised Fusebox while blasting the Washington Art-O-Matic, when the Dumbachers got their start by showing an abstract painting at the 1999 Art-O-Matic.

The 14th Street arts district was happening. "It was very exciting," recalled Andrea Pollan, owner of the Curator's Office gallery. By 2004, Adamson Gallery, Curator's Office, G Fine Art, and Hemphill Fine Arts moved into 1515 14th Street, where Giorgio Furioso pursued a dream of creating a SoHo- or Chelsea-style commercial art hub in Washington. Inside the one-time automobile showroom was a restaurant on the ground level that paid full rental costs; and galleries in the top two floors that paid discounted rents. Each expected to benefit from the presence of other "blue-chip" galleries. "You'll get a good group of collectors coming through," said David Adamson, who left Seventh Street after 22 years.

"This is an opportunity we didn't want to miss out on. It's an alluring situation. If there's any place I want to be, it's where all these serious art people are," Pollan agreed.

Hemphill established a showcase gallery and showed several notable Washington-based artists, including sculptor John Dreyfuss.

During the run-up to the 2004 elections, artist Jenny Holzer wanted to project an art piece in the nation's capital. Her friend Nora Halpern initiated the contact with Ms. Pollan. The permitting process proved very difficult as numerous phone calls went unanswered. Mr. Furioso sped up that process through a timely contact with the deputy mayor. To maximize the light beamed onto 1515, they looked into

John Dreyfuss, *Enigma,* at Hemphill Gallery, 14th Street, 2013 (Photograph by Max Hirshfeld, Courtesy of the Gallery).

getting the streetlights turned off. Turning off the lighting cost $500.00, but a broken streetlamp bulb cost $100.00 in fines. Like the one done at George Washington University, the projection drew a sizable audience and directly commented to the country's 43rd president.

The 14th Street arts district prospered as sales proved robust. Irvine Contemporary Gallery replaced Fusebox when its owners closed the gallery. The gallery owners recall having wonderful dinners with collectors, artists, curators, and other guests after the openings. "There are a lot of collectors [in the Washington area]. But there's a running joke that they would go to New York if they were going to spend $5,000 to $7,000," Ms. Pollan noted.[7]

A group of artists formed an organization that became a vital part of the arts strip. Several artists, including Arkin, Gary Fisher, and Mary Beth Ramsey, exhibited in Rehoboth Beach, Delaware. They decided that they needed to promote themselves back home, so they formed the Mid–City Artists. The arts collective held open studios for all the member artists in the area. They showed their works and engaged with the public that was interested in art. Visitors walking the loop went from cramped studios atop 14th St stores to the basement or alley workspaces of artists on numerous side streets.

The arts district reached its apex in 2008. The mortgage securities bubble burst, leading to fewer sales in 2009. Increasing rents for nearby buildings made 14th Street a location for the latest bars and restaurants. Furioso failed to refinance the building and could no longer afford the rent breaks. The lending institutions repeated the same message: If Furioso can't command market rate on his upper stories, there must be something wrong with his building. Despite the changes, a few of the galleries stayed for several more years. Irvine closed the business. G. Fine Arts and Randall Scott Gallery relocated twice.[8]

Another art district in the city emerged in the Blagden Alley area of the Shaw neighborhood. Furioso purchased a large warehouse, seeing the potential to convert it into art spaces. He found many interested parties who had a similar mindset. They opted to create artist-run spaces or do-it-yourself galleries, embracing a democratic ethos as firmly as the Art-O-Matic leaders.

Signal 66 started in 1999 and ran through 2004. Steve Lewis, Pat Rogan, Eric Gravely, and John Figura united to create a highly revered space in the city's art world. They formed a significant part of the underground art world. Other venues included video production company and T.V. studio Planet Vox and Fight Club DC, an underground skate park, arts, and music venue. The Washington Project for the Arts supported many of these galleries with financial and logistical help.

A different type of gallery opened on the street just outside Blagden Alley. Part art space and gallery, part event venue, Long View Gallery took over a large modern industrial location, showing Washington-region and national artists and offering consulting services. Among its Washington-area artists was painter Sondra N. Arkin. Photographer Colin Winterbottom showed with the gallery. His photographs, which document the work projects on the city's historic preservation sites, have also shown in the National Building Museum.

Artist-run venues extended across the District. Jayme McLellan left Transformer and started a "roving" nonprofit called Civilian Art Projects. Its cadre of ten

artists were located at 407 7th St from 2007 to 2009 and ended up sharing space with G Fine Arts in upper northwest D.C. until 2013. Decatur Blue ran from 2000 to 2005 above an automobile body shop on 919 Florida Avenue, N.W. PASS Gallery had a more elegant space, a 19th-century carriage house on S St., N.W. where Richard Siegman managed the large openings by having individuals wait in the alley before entering. These galleries, such as Doris Mae, even sprung up in an art gallery district on 14th Street, N.W., one block north of Furioso's gallery building.[9]

Another part of the Washington art scene existed in the Anacostia neighborhood. Those artists in this East of the River area had received a specific artist grant from the D.C. Arts and Humanities Commission for fifteen years. Two galleries, the Honfleur Gallery and Anacostia Arts Center, both showed contemporary art and featured local artists. Despite individuals' expressing concerns that an art gallery was not what the neighborhood needed, each thrived for fifteen years.

Other galleries and artists reacted to pressures from redevelopment by moving from the District to regional areas. Several settled in Prince Georges County, Maryland. The county and towns like Mt. Rainer and Hyattsville provided Margaret Boozer's Red Dirt and the Washington Glass School with funding to locate in their jurisdictions.

While these galleries sprang up for short spurts of time, the Art-O-Matic officials prepared for their second event since 2004. The 2007 Art-O-Matic left its founder George Koch with a loss initially. The vacant building in Crystal City previously

Doris Mae Main Gallery, October 2012, Kanchan Balse B&W (Photograph by Thomas Drymond, Courtesy of the Artist and Gallery).

housed classified workers. Koch said, "all the doors were these SCIF doors, [and] required all kinds of codes to get into. The county required us to take the doors out, so we used the doors to make the stages, to make the bars."

Perhaps that security served a purpose? Tim Tate's artwork *The Rapture* disappeared from Art-O-Matic under mysterious circumstances. A ransom note emerged, and Monopoly money went to the *Washington Post* to meet the demands. The thief, known only as "The Collector," returned parts of the artwork and his manifesto about society failing to value its art.

Other experiences may have been mundane in comparison. However, they proved meaningful for each artist. Trinka Margua Simon created a mural, and then whitewashed the wall at the close of the show that was videotaped. Tammy Vitale and Jennifer Beinhacker both created pieces for the show; then they documented their experiences on their blogs. Their friends and visitors offered a handful of positive and supporting comments. While Tammy read, "Big Time: I love your torso: Mayan Artifact," Ms. Beinhacker saw, "This and some of the other altars/offerings remind me of Haitian Vodou and Day of the Dead altars."

After the 2007 event, The Fraser Gallery in Bethesda, Maryland, held an Art-O-Matic themed art walk with two other galleries. They had hosted an exhibition featuring the "Art-O-Matic Top Ten" in 2005 and returned to the theme again after the 2009 Art-O-Matic. Cities have also borrowed the license of Art-O-Matic as well. Frederick, Maryland, held an Art-O-Matic event in 2011, and Toledo, Ohio, in 2015.[10]

The 2009 Art-O-Matic happened near the Washington Nationals' Stadium in the southeast quadrant of the city. A visitor noted that "[the building provided] great views of Nats Stadium, the Capitol and the National Monument." Celebrating its tenth anniversary, the organizers put on a great event. The same visitor noted that the nine floors of art boggled the senses. "What a way to spend a weekend day … lost amongst endless floors of art, art, and more art!!!" said another.

O'Sullivan realized this situation and asked one of the city's younger collectors how he managed to grasp everything. "If you don't like something at first glance, trust your gut and move on. The single biggest cause for disappointment is unrealistic expectations," he said. Mr. Barlow had about a quarter of the exhibiting artists in his collection, although he has only bought one piece at an Art-O-Matic.

Other veterans offered additional sage advice. "It's something I most def wouldn't try to tackle in one day. I'd pace myself because it'll be there all month long."

As always, Art-O-Matic contained a success story. One mother used to create art projects with her now teenaged daughter. "I had never considered myself an artist, and I wasn't even the crafty type," she recalled. "I had visited Art-O-Matic …. So, I decided to give it a shot for the 2009 event and set up my own booth. The response was overwhelming. I sold my first major work at Art-O-Matic and have received more commissions." Art-O-Matic drew a mother with her young, art-loving son to enjoy the event and enabled the woman to discover her artist self.

Other organizations started arts festivals. The Crystal City Business Improvement District, Vornado, and Art Whino teamed up to present "G40: The Summit." The exhibition featured over 2,000 works from more than 500 artists worldwide inside a Crystal City high-rise. The showcase illustrated the various styles of what was dubbed the New Brow movement. Shane Pomajambo of the Art Whino Gallery handpicked each artist for the 75,000-square-foot exhibition.

O'Sullivan observed that an odor of aerosol spray paint knocked viewers back. The New York–based artists on that fifth floor wielded "a mean can." International artists featured many U.S. pop-cultural references in their works, and the California-based crew showed works from Walt Disneyesque to tattoos and south-of-the-border kitsch. The eighth floor featured Washington-based artists who made installation art, sculpture, ceramics, graffiti, and painting (both traditional and cartoonish). The organizations felt inspiration from Art-O-Matic to hold their enormous exhibition in conjunction with real estate interests.[11]

In 2012, Art-O-Matic took over another empty office building in Crystal City, using ten floors. Critic Mark Jenkins called it a "craft show, a happening, and an oversized hipster coffeehouse." He observed that more artists got inspired by popular culture than by notable artists of the past. The most considerable influence appeared to be music, with punk and hip-hop-tinged pieces and one room dedicated to posters from the Progressive Rock era.

Among the prevalent art pieces were female nudes. Large photographs of women in sword and sorcery costumes appeared in a corner office decorated to look like a bordello. A few steps outside the room, photographs of plus-sized, saber-deprived female nudes appeared on the walls. Jenkins noted other common interests included travel photography, encaustic paintings, and skateboard decks covered with spray paint.

On the Internet, visitors offered helpful comments for those who readied to brave the extravaganza. A young female provided practical advice. "Wear comfy shoes when you go and do grab a bite to eat beforehand (although they do have a food cart on the 7th floor, I believe, the smell was pretty decadent)."

A second commenter focused on the viewing experience. "BE AWARE: No matter what time you go, what day you go … the largest crowd will be around the Peeps." There might have been more crowded spots considering over 75,000 people attended.

The ability to draw such crowds motivated officials from a nearby county to lure Art-O-Matic. The Prince Georges County officials offered a red brick four-story building near the New Carrollton Metro station. Stated Elizabeth M. Hewlett, chair of the Maryland-National Capital Park and Planning Commission, "We are thrilled to bring this event to Prince George's County. It is going to be a boon to economic development."

As the 500 participating artists began moving in, the building underwent construction. The group transformed walls, closets, and open space into a beautiful gallery. On the edges sat two bars for wine and other libations. Hebron Chism, a visual artist who used layered plywood to make sculptures of members of the Alvin Ailey American Dance Theater, observed, "You can do things that you normally couldn't do at a juried show." Critic Hamil R. Harris enjoyed a fair amount of the work, including photography and well-made decorative work in glass, wood, metal, and fabric.

District artist Carter Anderson displayed a 21-foot table with a top that came from a bowling lane. Anderson said he sold the table to a local restaurant for about $21,000.00. "The legs he added each weigh about 150 pounds," said Anderson, who travelled the country looking for big and old items to resurrect because they represent the "bones" that built this country. Hyattsville artist and teacher Kate Heneghan loved books, but that doesn't keep her from carving them up to make her art. "In this day and age when people are not actually reading books, I am turning them into art," Heneghan said.

A critic for an art zine offered a slightly different interpretation. The absence of regionally known artists such as Tim Tate, Michael Janis, and Irwin Timmers—and a shortage of emerging artists—resulted in finding fewer critically-acclaimed works. However, the critic presented a top list that ranged across media types, artist experience, and messages.[12]

For the 2017 show, Art-O-Matic returned for a third time to Crystal City. This time, work by over 600 artists was spread around seven floors of the vacant office. Films, stage performances, and the first Art-O-Matic wedding also were featured over the next month. As art fancier Laura described: some 600 individual exhibits, some 600 artistic and curatorial visions. She found a few themes that emerged from the event. Many pieces of visual art referred to music through photographs of concerts and dancing. Artist Greg Benge established a room where visitors gave scratched or unpopular records a final spin before the artist painted them.

The year after Trump defeated Clinton sparked a boon in political art. Art-O-Matic reflected the fact with caricatures of Donald Trump everywhere. Many posters and T-shirts came from "the resistance." Multi-media pieces asserted the importance of those things that individual artists felt mattered, including kindness, art, science, human rights, and the environment.

The personal also included many images of the dogs and cats in artists' lives. These adorable creatures appeared in paintings, sketches, photos, and stained glass on every floor. Jenkins observed that a "lot of this stuff is very well done but doesn't really need the exposure. Some of it, in fact, can be found on websites such as Etsy." He found some of the most engaging pieces were 3-D. Trish Kent fashioned fancy dresses out of glass, Bart Hawe made giant metal cookie cutters, and Paul G. Cunningham crafted curving, brightly hued geometric forms that appeared rubbery but were mesh and pigment. They twisted and popped at the same time. Joan Konkel, who exhibited at Zenith Gallery, fashioned large paintings that incorporated metallic mesh.

Nearing its 20th anniversary, the organization Art-O-Matic made a series of changes to the board and staff. Co-president Olivia Garcia explained, "The demographics of the board have changed. The demographics of artists in the DMV [District, Maryland, and Virginia] have changed. We have to take all of that into consideration." The explosion of the region's real estate market made securing 100,000 square feet of space more challenging every year. With the COVID-19 pandemic, everything pointed toward the greater digital presence the organization had been developing. A virtual Art-O-Matic 2020 came to fruition. As George Koch said, "We're an organization that focuses on individual artists."[13]

Several individual artists received a career spark from their participation in the Art-O-Matic. These artists went from the experience of this democratic art extravaganza to the art fair scene, in which members of a community's arts echelon review applications to determine the galleries that would be selected to show their featured artists' wares. Little known about these fairs was that the first one held in the United States was hosted in Washington, D.C.

13

The 2010s

The Triumph of the Art Fairs

The city built the four-block-long convention center to host gatherings many times the size of the DC Art Fair 2007. After visitors entered one of the many doors at the main entrance on Massachusetts Avenue, NW, they saw a large piece of art directly ahead—Jim Sanborn's cylindrical *Lingua* piece. A sign on an easel directed walkers to the left, where stairs and sets of escalators led to the underground floor. A small Starbucks served several customers on the left side. Directly ahead hung a ring of guitars and a more elaborate ring of bicycles, which artist Donald Lipski had made.

After striding down the carpeted staircase and turning to the right, visitors saw a cavernous hallway. Occasional sets of furniture, groupings of bathrooms, and information booths lined the left side and broke up the long walk to the hall containing artDC. Inside the hall, attendees looked down upon the large open space and saw a cluster of booths on one side. To one critic, the paintings and photography on the walls, sculptures lining the walkways, and multimedia installations blinking and mewing for attention appeared arranged with no apparent rhyme or reason.

The artDC event represented the city's first foray into the art-fair craze that had cropped up everywhere else on the planet. Works from numerous local galleries, museums and nonprofit art spaces, and international galleries from as far away as Beijing filled the displays. The booths ranged from tiny and jammed with artwork to large with ample white space.

Ilana Vardy, artDC organizer, also served as the Director of Art Miami. "The company I work for that owns Art Miami and other sorts of trade shows, they asked; since the art market is so hot, is there another fair that we could launch? Initially, I didn't think so, but we landed on DC. I was surprised it doesn't have an art fair." They established a three-year rental at the convention center and brought in more than 100 art entities.

The city's galleries reacted to the opportunity of the fair differently. Those with the nonprofits DCAC, Transformer, and the Washington Project for the Arts all thought they needed to participate. Their challenges involved deciding the fairest way to show art under their banners. Several commercial galleries, including Adamson Editions, Curator's Office, and G Fine Art delayed the decision for a while. Another dealer also took time to commit, and observers determined that the fair needed the gallery more than the other way around.

The fair generated positive responses from all attendees. Some 10,000 people

attended. Johanna Shaw-Eagle likened the show to a Middle Eastern bazaar. Fairs continue taking away from galleries as they offered more art in one place in a glamorous ambiance. Art aficionados "go to see and to be seen" and to hobnob with the international art world's movers and shakers. DC collector Phillip Barlow noted that "the Fair exceeded all expectations in terms of size, attendance, and participation. But what strikes me most is how really, really good the DC galleries look in this company."

D.C. artist Sidney Lawrence reviewing the fair for artnet agreed. He cited the oozy, organic installation of glass by Graham Caldwell at G Fine Art and William Christenberry's masterful steeple paintings at George Hemphill's booth. He also enjoyed the works of newer galleries such as Meat Market, Randall Scott Gallery, and Project 4. Andrea Ollan of Curator's Office expressed her delight with the fair, making a "more than a reasonable profit" on sales of mostly photographic works.

At the close of artDC, Lawrence predicted a return of the fair next spring. He conditioned the return on good weather and a healthy economy. The economy fell apart. The subprime mortgage crisis broke out in late 2007, leading to the Great Recession. The city's art fair did not return.[1]

A few years later, a summary of the artDC Fair labeled it as less than successful. The article focused on the future of art fairs in the city, noting that "the first modern sign of citywide passion for contemporary art probably came in 1999 at the first Art-O-Matic." One long-time participant in the arts community wrote a letter to the *Post* that expressed his surprise over that assessment. Mr. Dunn had attended five of the yearly Washington International Art Fairs beginning in 1976.

Dunn recalled that Wash Art '76 drew representatives of nearly 90 galleries to the National Armory. They came from the United States, Canada, Europe, and Israel. Eventually, the fairs attracted over 150 exhibitors from more than 20 countries. He recalled that they included many top-flight exhibitors.

The reader had several facts correct regarding Wash-Art. Wash-Art was the first contemporary art fair in the United States. In summer 1975, Elias Felluss proposed creating a fair for the spring of 1976. The son of Greek immigrants from New York who earned a journalism degree from American University, Felluss found the reporting world a crowded field and published simple art images then in the public domain. Customers began asking for the prints to be framed; his solution was metal framing fit for the Woodstock Era. The Felluss Gallery Group ran shops in Georgetown and near Belmont Street in Adams Morgan selling prints on a wholesale and retail basis. The Canal Square business did so well that Felluss wanted to give back to the art community. The group published *Gallery Magazine*, a guide to local exhibitions. Slowly, the city's art galleries realized that the magazine provided information that helped them individually and helped demonstrate how they would be stronger working together.

The organizer made several important moves to ensure a successful fair. He modeled his effort on the method used at Art Basel. When asked about this formula, he said forty years later, "That is proprietary information," and chuckled. "You need to attract a broad audience that has a stake in the arts." But he also wanted to offer the chance for a wide range of galleries to participate rather than only provide space for the exclusive galleries.

Felluss asked art professionals in Washington, Chicago, and San Francisco to serve on a panel to handle outreach and assess the galleries seeking admission.

Gallerists Max Protetch and Harry Lunn served on the regional board. Many other members of the art world acted less kindly. One prominent art journal attacked Felluss as unfit for the job. The prestigious Art Dealers of America expressed indignation over the entire event. It regarded Felluss as an outsider, and many voiced resentments that he considered holding a contemporary art fair. "The New York galleries had a lock on collectors," Felluss observed, as the city was already a destination for those interested in art.

The Washington galleries also responded rather negatively. Protetch declined to participate because he thought people interested in his gallery came to P Street. Still, he said, "Fellus [sic] is a good fellow. I wish him luck." Felluss noted that gallerists crossed streets to avoid coming into contact with him. Only Lunn chose to participate, telling Felluss, "If you've got the guts to do it. I'll take a place." Henri allowed Felluss to place a poster in her gallery window to advertise the fair.

The 34-year-old organizer persisted. By May's arrival, Felluss had fronted $100,000.00 and paid $8,000.00 in rent to the Armory. The last week he spent installing 1,200 hardwall panels and the track lighting. Ninety art concerns paid an average of $500.00 for a 10' x 12' booth inside the Armory. The negative perspectives continued. One dealer who didn't participate said, "The biggest U.S. dealers ... want no part of the Armory, or Washington in May. And many of the smaller ones are going to take a bath." Almost all the top New York dealers passed. But dealers came from all over the world, from California and Israel and many European countries.

Art critics from the major newspapers attended. Forgey expressed surprise at the number of Calder and Miro pieces there. "It ended up being a carnival of the art business, with a wide range of things on view." He saw good and bad art across a wide

Armory Before Wash Fair, 1980 (Courtesy Elias Felluss and Felluss Editions).

Armory During Wash Fair, 1980 (Courtesy Elias Felluss and Felluss Editions).

range of price points but expressed amazement at the number of prints, many by artists not seen in Washington. Richard interpreted the fair as 94 shows rather than one show. With vast quantity and varied quality, the art struck him as "an accurate and sometimes painful image of what the art world sells." These ranged from old barns, a la Andrew Wyeth, and pictures of dripped paint, a la Jackson Pollack, to hard-edged op-art prints by the very famous.

Felluss invited some Washington-based artists to show samples of their work at the fair as a special element. Named "Five Artists' Five Artists," the exhibition followed a familiar format of selecting five artists who then each chose five lesser-known artists to be in the show. Richard thought it well-intentioned but hung poorly and felt flat in the hullaballoo of the scene.[2]

At the end of the fair, many galleries committed to taking spots for Washington '77. About 8,000 people from all walks of life attended the fair the first year. Felluss stated, "We have befuddled our critics. We've been scathed for our energy, scolded for our enthusiasm and deceived, yet managed to go on with the show." It validated his claim that staging the art trade show in Washington made sense because "this is where America coalesces."

Before Washington '77 opened, the fair lost 25 percent of the 90 dealers from the 1976 event. The number of participating galleries climbed to over 125, coming from Europe, the Middle East, and Asia. While the top New York City galleries chose not to buy booths, they acted on Felluss' offer to show the latest works by their top artists in the central area of the Armory. Nine local galleries joined, including Jane Haslem, Middendorf, Diane Brown, and Gallery 10. Posters advertising the fair appeared around the city.

The two-hour opening of the fair drew a strong turnout. The opening showed that the fair looked bigger and better and represented a place to trade, buy, sell, talk, and create impressions. Indeed, Jo Ann Lewis viewed it as an art dealers' convention. They gossiped, discovered who might have a certain artist in large quantities, or exchanged information about collectors in certain types of art. "I get exposure for my artists. I get exposure for myself, and I can use the Fair to funnel visitors to my gallery on P Street," said Diane Brown.

Ready salability appeared as the common denominator among the art. Many artworks dealt with recognizable subject matter in appealing ways. But a few passionately avant-garde dealers appeared occasionally. Lewis thought the art was generally no better and frequently much worse than that usually on sale at the better galleries in Washington. "The Shahbanu of Iran was very interested in art and western culture," Felluss said years later. "She gave a group of artists an airplane and they took up 16 booths at the Fair in 1977. There were even anti–Shah pieces of art." Felluss had one of the group staying in his house, and he recalled the man had a lot of money and bought everything in cash.

The fair hit its stride over the last two years of the 1970s. The success of the last season generated more interest among dealers as well. Over 135 dealers from 15 countries represented over 800 artists. They brought merchandise ranging from reproductions and posters at $10.00 each to drawings and prints for $50.00 and some paintings for tens of thousands. Another local reviewer observed one of the more expensive pieces, a Max Ernst-designed cage bed for $44,000.00. She noted that while Calder and Miro prints hung in every booth, works by Yaacov Agam and Appel hung in every other booth.

The Washington–based galleries enjoyed the fair. Diane Brown said, "The Fair gets better every year."

A Viennese dealer smiled. "I think this art fair can stand with the best in the world. Besides, it's a good chance for me to come each year to America. I have a girlfriend here."

They featured many local artists. Harry Lunn showed artworks from Sam Gilliam, Alma Thomas, and Michael Clark. Jasper Johns prints and Japanese woodblock printing were some highlights from other galleries.

More people heard about it as advertisements appeared in the local newspapers. One cartoon supposedly featured William Wegman and Man Ray and discussed their scheduled appearance at the show. Over 6,000 people came to the two-and-a-half-hour opening night, thousands more than the year before. The 13,500-person turnout meant an increase of 4,000.

Persistent rumors discussed moving to a larger location. Although there was a Metro stop at the Armory, the location remained far from downtown. Felluss noted that the fair rented a double-decker bus to carry individuals between downtown and the Armory. The roof leaked, causing some trouble for Felluss, who began thinking about moving the fair to Texas every other year.

The turnout among the dealers for the next year's fair proved about the same. A new critic thought that the fair drew strong shows from galleries across the country with private New York dealer Jacques Kaplan bringing a museum-quality show that included works from Louise Nevelson, Richard Linder, and Larry Rivers. Jo Ann Lewis thought there were too many familiar images of Chagall, Miro, Aram,

and Dalis. The D.C. galleries stood out, showing Washington-based artists as well as national names. Even into the early 1980s, gallery reps from New York to Chicago held positive thoughts about the Washington Art Fair. Collector David Harrison said, "This is a pretty good show … a whole lot of stuff." For Richard, fairs offered dealers working in the mass market the chance to supply each other with stock. The feature exhibition included 11 freestanding portraits of women by women artists.

People in other U.S. cities began organizing fairs. Some dealers said a fair in New York made so much more sense. However, gallerist Louis Meisel thought the "New York Fair was a low-class, sloppily done, cheap graphics event." ArtExpo at the New York Coliseum drew 125 exhibitors that first year. The attendees, who numbered 12,000 in the first season, reliably counted on finding charming paintings of sunsets by the bushel. Other artworks included bronze lawn sculptures of jaguars or airbrushed pictures of pin-up girls. Organizers in Chicago appeared very close to holding an art fair called Art Chicago 1980.

Washington '80 drew more galleries representing more artists than any previous fair. The turnout for the opening evening doubled the previous high. Prints and multiple editions dominated the material. A large contingent of 30 dealers came from the city. The special-themed show featured Washington artists, nineteen in all. The group, including Robert Stark, Kevin MacDonald, Elaine Kurtz, and Joe White, used the Washington sky and light in their artwork. "We tried to make the city's artists distinct from those in NY," Felluss observed. Still, the fair lost a dozen of top dealers to Art 1980 Chicago, which held its first fair later that year.[3]

Michigan print dealer John Wilson led a group to organize the Chicago

Paul Richard interviewing Brooke Alexander and the late Holly Soloman, 1980 (Courtesy of Elias Felluss and Felluss Editions).

International Art Exposition, which premiered in May 1980 at Navy Pier. He claimed to be reluctant, but after exhibiting prints from his Lakeside Studios at the leaky Armory in Washington, D.C., he decided Chicago could stage a better fair. He assembled some loyal and sympathetic friends and formed the Lakeside Group in 1980.

Art Chicago drew not only the top echelon galleries from the Washington Art Fair but 80 galleries in total. However, over 10,000 people attended, and the new market proved profitable for many galleries. A few of the major Washington galleries changed their marketing. "I go to Chicago," said Jane Haslem, who along with Diane Brown found a new area for sales there. Most damning for the Washington Art Fair, Chicago knocked the nation's capital fair from the spring slot, forcing the Washington fair to take place in the fall of 1981. Jo Ann Lewis thought the quality of the Washington Fair took a big nosedive that year. Felluss moved the fair to the city's brand-new convention center downtown in 1981. He continued through the 1983 fair when he expected 200 exhibits, including 23 galleries from the city.

The Chicago fair ran successfully throughout the 1980s in the long, barnlike sheds on Chicago's Navy Pier. Like Felluss had done for Washington, the fair established a selection committee composed of gallerist, curators, and museum professionals to review applications and only admit those of the highest quality. The process began with an application, which sometimes included a mockup of the booth's principal artists. Many gallerists improved their chances by selecting their biggest-named or most vibrant artists to feature in their mockup. Some even received word from the fair of the featured artists whom the committee members wanted to see. One Washington–based gallerist likened the process to joining a fraternity or sorority, having the correct pedigree and looks.

Art Chicago proved very effective, and blue-chip galleries wanted to join. By the mid–1980s, the fair drew 40,000 attendees, and many people willing to spend significant amounts of money. Director Thomas P. Blackman observed, "A number of people find they are much more comfortable going to expositions like this than visiting galleries." Others noted that art fairs brought a theatrical style to shopping for art. A single art fair contained hundreds of dealers in one general area and at less intimidating prices than those most frequently seen at auction houses. For dealers and gallerists, the ability to meet a range of collectors in new markets proved irresistible. Jane Haslem, Harry Lunn, and other D.C. galleries went through most of the decade.

By 1986, Los Angeles entered the market with its "Art/LA" festival, which drew over 14,000 people in its fourth year. Art Miami held its first fair in 1989. Fairs sprang up in cities around the country. Maureen Littleton Gallery showed among 40 other galleries at Art Fair Seattle 1992. The gallery sold well with studio glass by Harvey K. Littleton and Richard Jolley, art not ordinarily seen in Seattle.

The next year that same base of collectors from Vancouver, British Columbia to Portland, Oregon, spent less at the fair. "We had lots of big lookers, but not big buyers," said Littleton's manager Tommie Rush. He added that the art fair was nevertheless an excellent form of advertising and exposure since Seattle was home to several serious glass collectors.

Specialty fairs also sprang up. These fairs focused on a single art form, such as photography or moving images. Would collectors in a particular medium be more willing to spend at the general fair or at this type of fair? As costs for a booth at fairs increased, galleries spent more time figuring out where to spend the funds they had.

Washington, D.C.-based gallerists noted that they visited websites before and after the art fairs. One found out who was running the fair and how seriously they focused on customer services. The best method proved to be word of mouth. What did those from similar galleries think about their experiences, etc.?

Into the 1990s, Art Chicago still dominated fairs in the U.S. At the 1997 event, over 200 galleries from 22 countries showed over 2,100 artists from everywhere in the world. Baumgartner Galleries, Inc. attended Art Chicago for several years in the mid–1990s, featuring artists from places other than Washington—but the fair showed the work of a range of Washington-based artists from Sam Gilliam to David Mordini. Numark Gallery attended in 2001 and featured the work of Washington-based artists Jim Sanborn and Robin Rose. George Hemphill attended the Fair in the mid–2000s. At one, he showed a range of Washington-based artists, including William Christenberry, Renee Stout, and Annie Adjchavanich.

By the early 2000s, the new Navy Piers brought a carnival atmosphere that attracted a non-art-fair audience, which alienated the gallerists. Robert Landau of Montreal's Landau Fine Art explained, "We had more customers walking in off Navy Pier who really weren't there to see the art show. We had so many people coming in making remarks like, 'Are any of these paintings real?'" Art Chicago began losing influential exhibitors.[4]

Other fairs around the world increased in importance. Those in New York, London and Paris surpassed Art Chicago in excitement and drew away more galleries and important collectors. The owners of "Art Basel" brought their fair to Miami Beach in 2002. This top-notch fair moved Miami to the top tier of U.S. art cities. Within a few years, the development of satellite fairs expanded Miami Basel's appeal. Then, Art Miami moved from January to December. Miami became, as one critic observed, a total-immersion and contemporary-art experience.

While Art Basel Miami Beach featured high-profile and blue-chip art inside Miami Beach's convention center, Art Miami showed highly stylish artworks in Miami's midtown Wynwood Arts District. Aqua took place in the hotel of the same name with pieces from 36 emerging and established galleries. Scope started in hotel rooms, then moved to tents along the beach. The fair built a niche as the space for international emerging contemporary trends and multi-disciplinary programs. Pulse Fair sought to be somewhere between cutting and high edge. The 60 galleries included both younger galleries and local artists. The New Art Dealers Alliance Fair promoted a collaborative approach to the art market that focused on new voices. It grew to over 80 exhibitors and was what one gallerist called "the cool kids club." Indeed, it became the second fair for a lot of the Art Basel Miami collectors.

Several Washington galleries attended the Miami art fairs. CONNERSMITH went to Pulse in Miami on several occasions from 2002 through the end of the 2000s. The gallery numbered among those featured in the Academy section, which focused on young, emerging talents from area colleges. Miami and New York have been the gallery's best fairs, according to Dr. Jaime Smith. Each fair has its audience and culture, so the gallery also exhibited in London, Mexico City, Turin, Brussels, and Basel. Smith observed that participating in fairs proved essential to building professional networks and establishing an international reputation for the gallery.

Andrea Pollan of Curator's Office decided to attend the Scope Fair. She first went in 2006 and estimated most galleries either completed few sales or failed to

cover their costs. However, Pollan noted that "[t]he fairs were good for 3D advertising." The collectors gave gallerists cards and frequently wanted to engage in discussions about the artwork. This outreach frequently led to future sales and, most importantly, expanded the network of the gallery. Pollan attended Scope in New York City as well. Scope Miami might lead to more sales, but New York Scope offered a great chance to meet museum curators.

Jayme McLellan had so much fun with Pollan in Miami that she bought the smallest possible booth for her gallery, Civilian Art Projects. Named in protest over the U.S.'s "forever wars," which had been waging over five years, the gallery sought to show Washington-based artists and their comments on the current political circumstances. McLellan featured Miami-artist Jen Stock at the Fair, and she sold well. She found the event exhausting as a gallerist there without an assistant spent 12 hours a day over four days talking to a wide range of people.

McLellan likened going to Scope New York to "being in the belly of the beast." Selling emerging artists from D.C. in a city with many more emerging artists proved a difficult challenge. The fair contained notable celebrities from all walks of life as well as from the art world. Meeting museum people proved very satisfying.

Ms. Pollan observed a change at the Miami fairs after 2007. Curators and others from museums that she knew frequently had several museum trustees in tow when they came to the booth. They spent a minute, then said that they had to go. As they left, they said they would return. But Ms. Pollan observed, "The B back bus never comes around twice."

When Ms. McLellan went again in 2010, she sold all the paintings but likened the trip "to going to the art circus." The next year she bought a bigger booth and came down with a few artists associated with the gallery. She found that all the time spent at the booth talking drained her energy, and it sometimes drained the soul. For the third straight year, Ms. Pollan attended Art Miami's newly created sister fair Context because of its focus on emerging and mid-career artists. In 2014, Curator's Office featured Washington-based videographer and photographer Larry Cook and D.C. native artist Jefferson Pindar. Pollan felt that every model in the city must have posed next to the pieces to take selfies. "If I had charged $10.00 per photo I would have paid for the fair."

Rebecca Cross of Cross-MacKenzie Gallery in Georgetown has attended a wide variety of fairs. Whether large and small, craft and art, selling everything or focused on one art form, she acknowledged the high demands and stress of running a booth. However, she generally found these fairs rewarding. "I brought the artist Walter McConnell to the Armory Fair, and we got on the banners around New York City, so that was exciting." She brought McConnell's artworks to Art/LA and brought a painting by her son, which she greatly enjoyed showing.

"You meet interesting colleagues at art fairs." Cross mentioned developing friendships and business associates among the other dealers. She believed Cross-MacKenzie received two reviews for exhibitions by important writers in the craft world because they met her at a fair.

The number of serious collectors at any single fair cannot be topped. "More people [see your works] in four days than in a year at the gallery. It's a targeted marketing opportunity." The opportunity came with challenges. "You are already on the outside as a Washington gallerist at the art fairs." Thus, D.C. gallerists had to put their best

feet forward for four days in a row. "You say the same thing over and over, yet it has to appear fresh."

The fairs increasingly became victims of their success. Costs rose because of the need for new infrastructure to appeal to and maintain the VIPs. Passing those costs on to galleries limited which businesses afforded to attend and which artists they showed. Dealers and gallerists complained that this current model benefited the giants as it neglected the smaller players.

Maureen Littleton took four to five of her artists' works to each SOFA Fair based in Chicago. The beginning of the Fairs during the 2000s often started with interested collectors of crafts lining up outside the front doors. As the doors swung open, these people ran in and headed directly to the center aisle to the big-named galleries. They began playing the "Red dot Game," trying to beat other collectors to the "hottest pieces."

The Gallery showed several top Washington-based glass artists, including Therman Statom and Michael Janis. As one of Littleton's dozen artists, Janis had his glassworks in several hotel and residential lobbies, government buildings, and sculpture parks around the Washington, D.C., region and had solo shows at locations such as the Fuller Museum of Craft.

The Chicago native attended the SOFA Fairs in Chicago for nearly a decade, doubling as a gallery assistant. He recalled how hectic and tense things became and at least one instance in which an artist had to assemble a huge piece at the fair. When it didn't sell, the gallery lacked a box in which to ship the piece. Another stunning situation occurred when Littleton and a second gallery ended up showing similar pieces from the same artist. Said artist had negotiated deals without consulting either gallerist.

The fair ran for days, then closed at 6:00 p.m. sharp Sunday. Every booth had to pack and remove everything before midnight. In 2010, Janis had three panels of fused glass on the center display wall of Littleton's booth. The layers of fused glass had visual and spatial depth and within the glass layers were detailed, nearly photographic imagery via the "sgraffito" technique of manipulating crushed glass powder. At 5:30 p.m. Sunday, "I began to wonder if she was going to take me to SOFA next year," Janis remembered. "Then this man comes over and says he wants all three under the condition that we hang them in his house for the dinner party happening later that evening." Janis called his wife, who climbed into the back of the collector's Jaguar to hold two pieces. They loaded the third in the truck and drove from the Navy Pier to a house near Lincoln Park. After taking the elevator upstairs, the new owner directed Janis to hang the panels across the hallway. Without an articulated ladder, Michael could not hang the works. Disappointed, the owner laid them out in an extra bedroom and directed guests there to see the new acquisitions.

Janis noted that the quality of Chicago SOFA began slipping by the mid–2010s. There were many fewer galleries at the fair. The international galleries stopped coming because of costs. Other galleries closed, and some decided to participate in other fairs because this fair's collector base was aging out of the collecting process.

Tim Tate had been to Miami art fairs for a few years with different galleries. He showed his work in what he called "the outer rings" among the numerous fairs happening over that week. "It seemed like Dante's Inferno," Tate stated, "because the fairs were hierarchical, and the better places seemed very far away." Tate recalled that the curator at New York's Museum of Art and Design liked a video of a cat playing the

piano that Tate had posted on Facebook. They talked, and Tate received an invitation to a show. During the installation of his piece at that museum, a co-owner of Habitat invited Tate to join his gallery. The artist started showing at SOFA with Habitat and soon went to Art Miami annually. He mentioned that a great deal of connection to the specific world of glass collectors came through the exposure from the fairs.

While exhibiting at the Smithsonian American Art Museum and Renwick Gallery, and the Steps Gallery in London, Tate participated in the Art-O-Matic. During the 2007 show, Tate's artwork *The Rapture* disappeared under dramatic circumstances, and later a ransom demand in Monopoly money went to *The Washington Post.* The demands were met, and parts of the artwork were returned by the thief, named "The Collector," along with his manifesto about society failing to value its art.

Tate and curator and art critic William Warmus started a Facebook page devoted to "glass secessionism." The secessionists posited that its generation moved beyond the technical and aesthetic ideals of the 20th-century postwar studio glass movement. Tate became a member of GlassStress and had pieces appear in the group's shows in Venice, Boca Raton, and the Hermitage Museum in Saint Petersburg, Russia. He continued to show in Art Miami with Habitat and as part of the Washington Glass School.[5]

The Washington area hosted an art fair again in the fall of 2011. Leigh Conner and Dr. Jamie Smith of CONNERSMITH and Helen Allen, the Pulse Contemporary Art Fair former executive director, organized (e)merge. Mera and Don Rubell, the Miami-based art collectors whose family owned the Capitol Skyline Hotel on South Capitol and I Streets, S.W., supported the fair. "(e)merge is a very, very exciting happening. It's going to show the kind of vitality a living, working artist is experiencing in Washington," Mera Rubell asserted.

Conner estimated that 75 art spaces exist in the region. "D.C. has always been perceived as an art and culture center. But not for contemporary art," Smith said, "until now."

"D.C. is really seen on the map as a place where contemporary art is happening. It's on a scale that's being paid attention to outside D.C.," said Martin Irvine, a gallerist who worked with "dealers all over world."

(e)merge provided the nonprofit and DIY art spaces a chance to show their artists—and for galleries to exhibit unrepresented artists. As Conner noted, "[for the fair to be] a place of discovery." At the CONNERSMITH booth, prices ranged from about $1,000.00 to $6,000.00. "D.C. is not all about politics. D.C. is hungry, culturally," Conner observed. This included several of the city's many performance artists too.

Nearly 200 people attended the opening night's discussion panel and party. Women holding Longchamp bags stood next to girls with tattoos for sleeves. Guys wearing Clark Kent glasses sat alongside people with peroxide extensions and Goth-glittery faces. Over the next few days, visitors explored the small hotel rooms seeing the artworks from the nearly 80 national and international galleries. Schools, nonprofits, and unaffiliated artists showed their wares in the hotel's parking garage. Performance artists appeared in the public gathering spaces inside and outside. Several performed their pieces standing on boxes and platforms set up around the swimming pool. Others performed inside the lobby and near the restaurant.

O'Sullivan noted gallerists taped electrical wires to the ceiling and covered windows to provide more wall space. One laid the black plastic garbage bags over the

beds and other furniture, making it look like a crime scene. He thought most of the artworks in the garage space got lost. Indeed, the critic stated the strongest work appeared in the gallery rooms. Carvings from axe handles by Montreal's Maskull Lasserre and Jeremy Dean's fabrics representing the American flag stood out.

The organizers took cues and improved the lighting and traffic flow into all the rooms. The fair grew, with 152 emerging artists showing, and galleries coming from 24 nations. More than a dozen performance art pieces joined the event. "We're hoping that some people who have never bought a piece of art in their life will feel comfortable making their first acquisition at the fair," Smith said.

A critic observed Chajana denHarder floating in the pool on a clear plastic ball. In the garage, two Corcoran students in eight-foot-high satyr/centaur get-ups posed for photos. "The vibe is not especially commercial," he concluded. Smith noted that the city's collector base strongly supported (e)merge, and the city's cultural organizations and museums proved willing partners on curatorial tours, panel discussions, and special events.

Basel, Switzerland's Aureus Contemporary and Amsterdam's Amstel Gallery returned for the second year. "We didn't sell anything at the Fair last year. But we had good after-sales," Amstel's Petra Leene said. Kevin Havelton of Aureus Contemporary noted, "We like the area because you have an intellectual community here. I may make more money in Miami, but the conversation there is somewhat diminished."

Some of the city's smaller arts organizations returned. Annie Gawlak, the owner of D.C.'s G Fine Arts Gallery, explained that she participated in (e)merge because the fair reflected "an enthusiasm about the local scene." In Transformer's two rooms, ABBA's "Take a Chance on Me" blared, and a large, white-frosted cake awaited consumption. Heather Ravenscroft usually placed such confections in forests and then video recorded their consumption by deer, raccoons, and other fauna.

Several of the city's visual and performing artists relished their selection to show their work at the fair. Visual and performance artist Holly Bass returned after her successful Moneymaker performance piece at the pool. The D.C. artist-teacher had a strong following of supporters in the region. She had also performed at art fairs in Miami and in exhibitions based in England and Mexico. Ira Tattelman used black plastic plugs, white cable ties, and wire rope to create a mutable net. His piece strung across the garage established a divider between the neighborhood and Art Fair while creating a space for people to meet.[6]

After four years, the (e)merge fair ended. The city has not had this type of contemporary art fair since. Instead, the market became available for a different type of art fair, selling a different set and grouping of artists to a different community of buyers and collectors. Artists and partners Alex Mitow and James Miille launched Superfine! Artfair in Miami and New York in 2015. In 2018, they opened in Washington, D.C. The upbeat and offbeat programming augmented an unpretentious display of art in affordable booths. The Washington fair attracted 70 exhibitors showing works from about 300 artists, many from the region. The one-week show occurred in the Union Market upscale food market in the burgeoning NoMA-Trinidad neighborhoods. Over 3,500 people attended the 2019 version. While not a large-scale, named art fair, the festival offered an interested Washington-based audience the opportunity to see and buy various art made today by living artists.[7]

14

The 2020s

Federal City Art

For 18 months, staff members of the Hirshhorn Museum and Sculpture Garden, Smithsonian Facilities, and one landscape architecture firm presented building and garden revitalization plans for public comment and eventual acceptance. Besides creating stacked stone walls around the edges, the plans called for improving accessibility to the garden and adding performance areas. The new design enabled different kinds of sculpture to show more effectively in the space.

As of 2019, the garden had 17 distinct spaces for sculpture and lost a lot of planting on its vertical areas as well as tree shade "ceilings." The new area created 24 distinct spaces and five entry points rather than the two there previously. It re-established both the original 1969 design's north-south axis and the 1977–1978 version's spatial complexity.[1]

As members of the federal city, the Smithsonian Museums, like the Hirshhorn, had to convince external agencies, including the Commission of Fine Arts and the National Capital Planning Commission (NCPC). The museums and the approving agencies also received extensive responses to their plans for the interested public. Among the local city members attending these meetings were District of Columbia government agencies, nonprofit groups interested in the city—including Cultural Tourism DC—and the Committee of 100 on the Federal City.

The Smithsonian representatives presented their version of the plans in December 2020. Due to the COVID-19 pandemic, the meeting occurred through an Internet conference call. There were 72 federal and local city attendees.

Before the meeting, the NCPC issued a report that accepted the programmed changes for the Hirshhorn Museum. However, the report directed the Hirshhorn and Smithsonian to provide a "comprehensive rationale for the programming needs that require" alterations to the Sculpture Garden's historic core. They specifically noted the insertion of stacked stone walls and changes to the pool and pool area. Commissioner Beth White observed that she heard Hirshhorn officials say they "don't want to compromise the artist's vision, the artist being Mr. Sugimoto. But what about the artistic vision of Bunshaft and Collins?"

Local city attendees advocated similarly. De Teel Patterson Tiller, testifying on behalf of the Committee of 100, argued that the stacked stone walls "would radically contradict the overall historic material vocabulary of the Hirshhorn complex and is wholly inconsistent with the Sculpture Garden." Director of the D.C. Office of Planning and NCPC Commissioner Andrew Trueblood stated, "that he looked

forward to seeing the final plan hopefully with the original pool intact in size, and the original materiality of … the walls … [exhibiting] a great coherent connection with the Hirshhorn itself."

A few local city members supported the museum's plans for the garden. At the close of comments, the NCPC Commissioners voted unanimously (with one abstention) in support of the report. "We are witnessing an exciting design process to rehabilitate the Hirshhorn Sculpture Garden. The debate is between the balance of historical significance and design ideas," noted NCPC Vice Chair Thomas Gallas.[2]

This controversy represented but the latest round in the "trench warfare." President Lyndon B. Johnson and his wife Lady Bird Johnson wooed Joseph H. Hirshhorn to donate his collection of 6,600 artworks to the United States government's Smithsonian Institution. Many cities and countries wanted this collection. The multi-millionaire did not contribute funding for the building's construction. He sought a Mall location for the museum building and sculpture garden and received the two-block area that housed the Army Medical Museum. Hirshhorn received "binding assurances that the building would bear his name in perpetuity."

While many said that serious art lovers knew the Hirshhorn sculptures were the most spectacular part of the gift, some scholars wondered about accepting the collection under these conditions. Sherman Lee, Cleveland's Museum of Art Director, viewed the collection as having a "quixotic nature." He thought the name on the building would limit other collectors' interest in making donations to the museum. Chicago Art Institution's Charles Cunningham snorted, "The United States government is being asked to furnish $10 to $12 million in appropriated funds to establish a memorial to Joseph Hirshhorn."

Other attacks took a more personal nature against the diminutive man himself, who made most of his fortune through uranium dealing. The noted columnist Jack Anderson referred to Hirshhorn as a stock manipulator and a convicted money smuggler, citing Hirshhorn's difficulties with Canadian authorities in the Securities Commission and the Saskatchewan Legislature.

The General Services Administration struggled to find a contractor to build the museum for the $15 million appropriated funds. The groundbreaking occurred on a cold winter day in January 1969. Within a year, more cost-overruns and personal and political motivations prompted a Congressional subcommittee investigation. The tumult increased when design professionals and local and federal city members complained that the garden's current plan compromised the Mall's unity and open expanse. The House Administration Committee's Subcommittee on Libraries and Memorials called the sunken garden plan to bisect the Mall between 7th and 9th Streets ill-advised.

With its funding halted, the Smithsonian returned with significant changes. These plans reduced the garden's size and the reflecting pool's dimensions while placing the garden into the tree panel adjacent to the museum building. Instead of the original plan's "pavement and pomposity," the revision added terraced levels. The NCPC voted 5 to 3 for the revised plan, with the federal and city government members carrying the day. The presidential appointees all voted against the plan, and Howard University professor James Edwards said his colleagues had failed to protect the Mall.

After additional cost overruns, the contractors completed the building's

construction. Tons of trucks brought the numerous sculptures from the Hirshhorn estate in Greenwich, Connecticut. Cranes lowered the pieces into the garden, although the crane lifting Rodin's *The Burghers of Calais* started to tip forward and would have toppled if a group of men hadn't jumped on its back to provide a counterweight.

The new member on the Mall drew a wide range of responses. Forgey wrote an upbeat piece. He observed that the building had several unsolved difficulties, including a ramp down to the gardens for those who use wheelchairs. Wolf Von Eckardt noted that one might admire the new building but hardly loved it. He described the outside as both a donut and a fortress. Inside, Von Eckardt stated that he barely noticed the architecture and enhanced the brilliantly mounted display. Columnist Garry Wills argued that the large crowds coming to the Hirshhorn were getting their money's worth from displaying the astonishing art collection. Looking at those works made it clear that this was one of the best bargains the country has made in years.[3]

While popular, the garden drew some criticism from visitors. Many found walking on the pebbled surfaces challenging. As Forgey pointed out, the garden lacked access to persons with disabilities. Finally, many found the lack of tree cover and shade made walking around the space a significant challenge. Only a few years after the initial installation, the Hirshhorn removed the sculptures again. Landscape architect Lester Collins improved the water and electricity supplies while adding ramps for better access, verdant lawns, and tree canopy. The garden reopened in 1981. "We took advantage of the opportunity to correct what we felt were major problems with the space as it was," said museum director Abram Lerner. Forgey observed that Collins admirably retained Bunshaft's structural plan while utterly changing the garden's feel and mood.

This success spurred James Demetrion, the Hirshhorn's new director, to reinvigorate the plaza, which served as a roof for the lower galleries. "I said I wanted some greenery out there, and a gallery-type situation," Demetrion recalled. Forgey noted that the plaza "needed something to mediate between huge and human size." James Urban's design included slightly raised green areas on the east and west sides that followed the building's curve.

The sculptures in the garden sustained "friendly fire" in the late spring of 1991. After the quick victory of the military's "Desert Storm" campaign, the country's leadership decided to celebrate in 200 locations around the country, including the nation's capital. The celebration featured a parade, fireworks, and a display of military equipment on the Mall. It drew over a million viewers, many of whom expressed amazement over jets flying overhead, the landing of helicopters on the Mall, and the tanks, assault vehicles, and Patriot missile launchers all around the park. Hirshhorn public affairs officer Sidney Lawrence recalled the helicopters' rotors kicked up the Mall's gravel and sent it flying over a few blocks. The curators came frantically running out of the museum to the sculpture garden carrying giant tarps. They speedily draped the tarps over the sculptures while pebbles flew all around the garden. The stones hit the pieces and caused dents. Lawrence believed that the Department of Defense settled with the Smithsonian Institution.[4]

All museum leaders sought to keep their exhibitions and events vibrant and on the radar of visitors and the art world. One effort at the Hirshhorn sparked the promotion of using the plaza to hold performances and lectures. In 2009, Hirshhorn

director Richard Koshalek promoted the idea of a conversational tent for dialogue that he wanted to build with new partners and artists. "We want to turn the symbolic center of the Hirshhorn into a center for international dialogue. The issues are going to be very broad, so we can attract a pluralistic audience." Architects Diller Scofidio + Renfro designed a vinyl material that protruded like a mushroom, providing a strong contrast to the doughnut-shaped main building.

Members of the local city generally had positive comments about the plan. Judy Scott Feldman, the National Coalition to Save Our Mall's director, expressed excitement about the design. "It is an interesting, exciting, visually fun innovation. It doesn't alter the integrity of the historic Mall." Professor of contemporary art history at George Washington University Alexander Dumbadze called the design a "new kind of public space." Dumbadze was enamored with the original architecture and felt that the temporary structure would not detract from it. Critic Blake Gopnik seemed divided about the space. "Who could ever complain about a space that will foster talk about contemporary art and culture?" But, he wondered, did this project push the Museum's central goal, with contemplation moved to dismal second place?

The estimated budget for the inflatable addition originally stood at about $5 million. Fundraising efforts brought in $1 million for the naming rights. By 2012, a few members of the museum's board grew dissatisfied with the pace and the amount of time and resources devoted to making the project happen. Four of the board's 15 members resigned over nine months between mid–2012 and early 2013. The projected cost for the Bubble increased to $11.5 million. The architects argued that the Mall was the grandest civic stage in the country and a communication locale. They argued that a disconnect existed between the Mall's communicative spaces and the museums on it. "Could the museum be an agent of cultural diplomacy?" In conjunction with the Museum's staff, the architects sought to make the Hirshhorn a space for public forums to create public discussion and change.

The project's skeptics argued that desultory talk and dispiriting pseudo-intellectualism filled Washington already, that the Hirshhorn already had a theater space for such things, and that this added more flash and sizzle at a moment when the art world needed substance. Philip Kennicott noted that the Bubble would be excellent; what mattered was how events would be programmed. A few critics thought the Hirshhorn's future as a significant art space depended on making the Bubble happen because it represented a bold commitment to architectural innovation and a new program of arts and culture. The Hirshhorn Museum board split the vote on the project. It died when the Smithsonian Secretary G. Wayne Clough and Undersecretary Richard Kurin decided the divided board made it hard for them to support moving forward with the Bubble. The decision spurred a chain reaction of departures from the Museum's leadership. Koshalek announced that he would depart at the end of 2013. Constance Caplan, chair of the Hirshhorn's board of trustees, resigned on July 8, 2013. Two other members left earlier.

The Hirshhorn leadership sought interaction on a large scale on significant questions of the contemporary world. How much interaction had the museum had with the city's local arts community over the years? During the first couple of years, the museum co-sponsored an exhibition of Kenneth Noland with the Corcoran. It showed his artworks up to the late 1960s while the Corcoran showed 1970s creations. In some of its group shows, the Hirshhorn included active Washington-based

artists. The museum has also held several exhibitions of Washington-born or based artists, including Morris Louis twice, Martin Puryear, and Anne Truitt. However, as one retired employee observed, the Museum tended to be "conservative," more than willing to wait for artists to establish a reputation before granting them a space to show and slow to exhibit emerging artists.

In its first decade, the Museum purchased 157 works and received over 1,200 as donations. Among these objects were nine made in Washington, including works by the well-known artists Sam Gilliam, Alma Thomas, Kenneth Noland, Anne Truitt, and others such as Jacob Kainen and Kevin MacDonald. The group of the Hirshhorn docents, as local city art members. They held a luncheon where money was raised and decisions made about whose work to buy. They bought the pencil-on-paper drawing *Desk by the Window*. MacDonald's wife, Robin Moore, recalled attending the 25th-anniversary gala, sitting with the docent who spearheaded the purchase along with other artists, including Lorne Simpson.

Some local city artists may have been frustrated by a lack of collector interest. Public Affairs Officer Sidney Lawrence recalled receiving many phone calls from his friends asking him why they remained on the outside. He said that he asked them where they exhibited. Most other artists liked that the Hirshhorn brought contemporary art to the Mall. They enjoyed the opening parties—held from 9–11 p.m. with open bars—during the early years. Many artists and art students from the Corcoran and other local schools enjoyed the experience a lot. Some, such as contemporary artist Al Miner, honed curator skills in the federal city and now practiced them. Miner served as the director of art galleries at Georgetown University.[5]

The Hirshhorn was not the only museum on the Mall bearing an art collector's last name. A half-century earlier, the railroad car manufacturer from Detroit, Charles Lang Freer, held an exceptional collection of art made in Asia and the Near East. His American artist James McNeill Whistler's collection came with the artist's wish that the collection needed to appear in a city where tourists went.

Freer added several stipulations of his own during negotiations with members of the Smithsonian and several Congressmen. The requirements that slowed the negotiations included that the gallery showed only objects from the permanent collection and that these objects could not appear in another museum. Freer wrote to President Theodore Roosevelt at the end of 1905 that he also would provide $300,000.00 for the construction of the building to house the collection. Roosevelt recommended that the Smithsonian regents close with the offer and accept the collection on behalf of the country.

Besides Whistler, Freer collected several other American painters, including John Singer Sargent, Thomas Dewing, John Henry Twachtman, and Winslow Homer. As Freer's contemporaries, these artists established themselves during the last third of the nineteenth century and the early twentieth century. They lived in the New England and New York City areas.

The Italian Renaissance–style building began construction three years before Freer's 1919 death. Building efforts resumed after World War I and finished in 1921. The site, on the south side of the Mall near 12th Street, S.W., once hosted the Department of Agriculture's gardens. The Freer formed the left leg of a triangle, with the Arts and Industries building on the right and the Smithsonian Castle building on top. A society columnist noted, as the building neared its completion, that the Freer

stood as a classic temple of white marble, designed with the most modern concepts needed to keep its treasure.

The Freer drew many visitors at its 1923 opening. The federal city notables, including President Harding, Supreme Court justices, and Smithsonian regents, attended a private opening in the spring before its opening. Critic Gertrude Richardson Brigham visited and observed that one unexpected result from the museum's opening would be that James McNeill Whistler would easily become the most famous artist as far as the popular imagination was concerned. She thought critics favored George Innes as a landscape artist and divined that Gilbert Stuart and John Singer Sargent held the honors among portrait painters. Paul Collins agreed that the Whistlers were so astounding the pieces deserved much attention. Still, he also favored a Thayer tribute to his wife, which could have "been suggestive of a picture card on Valentine's Day," but appeared so honest that he found the work glorious.

One British newspaperman wrote a series of his impressions of Philadelphia, Baltimore, and Washington, D.C., in 1925. "It is a capital nobly imagined, spacious beyond belief, so rich in parks and trees." He observed that the public institutions seem set in the middle of a wide park, and most of them were quite good enough to stand isolation.

> The Freer Gallery almost strikes a chill by its intense, delicate severity, and the tiny Whistler pictures, so reverently framed in these temple-like, barrel-vaulted chapels, seem to demand the reverence of these devotees who take them without joy.[6]

Now known as the Freer-Sackler Museum, donations and gifts boosted the collection to over 18,000 pieces of art. While the Museum would not show or collect local city art, it employed many artists, some of whom participated in the Washington art scene. "You see people [on staff] who are lighting signers who paint or quilt," observed one-time Freer-Sackler employee Farar Elliott. The concentration of people at a workspace for whom art was their calling made the museum unique. The Freer-Sackler even held staff art exhibitions. The Smithsonian Enterprises, which ran the businesses associated with the Institution, also had many artists on its staff. One recalled the annual staff art exhibitions in which a top staff member at the Archives of American Art got some notable D.C. local artists to serve as the jurors.[7]

The Freer's sister museum, the Arthur M. Sackler Gallery, began in 1982 after Mr. Sackler donated 1,000 objects and $4 million toward the museum's construction. The new museum featured Asian art but could not be combined with Freer because of the latter's restrictions. A few years earlier, the Japanese Prime Minister Masayoshi Ohira offered a $1 million donation from Japan toward helping the Smithsonian increase the size to enable the museum to display its Asian art. The gesture came while the Smithsonian's plans for the South Quadrangle Project stalled in a House Appropriations subcommittee. The chairperson worried about conflicting cost estimates between $50 to $60 million to build the nearly 500,000-square-foot museum complex below the newly designed Enid A. Haupt Garden.

Next year, the Smithsonian published a notice for an environmental impact study of building below the garden, while the federal government had provided less than $1 million in funding. In 1982, the Smithsonian requested half of the $75 million construction costs from Congress. The leadership had raised $20 million through private donations already. Once the money arrived, the construction crews

incorporated elemental cost planning, a new management technique during the 1980s used to reduce overall costs. The Sackler Museum of African Art and S. Dillon Ripley Center opened in 1987, within budget. Washington Mayor Marion Barry declared that opening day the Smithsonian Institution Day.

The completed buildings drew mixed reviews. A *New York Times* critic wrote, "What these museums lack, and what they may never have, is flair." The local critics agreed. Paul Richard stated, "You see a pair of granite-faced pavilions. Both send out mixed messages, some new and some antique." Because the museums exist so much underground instead of their spaces soaring as museums ought to, these museums felt crushed. A few years later, John McKelway noted the Smithsonian had added an elegant basement. He emphasized that attendees walk downstairs to find the cafeteria or restrooms when they visit most museums. The exhibitions had the "Smithsonian touch, which is grand and expensive and, I thought, sort of cold."[8]

After years of little controversy, the Sackler faced an enormous problem starting in the mid–2000s. The Sackler family became embroiled in controversy over its Perdue Pharma's production of the addictive painkiller Oxycontin, which emerged on the market in 1996. When a few government and medical people raised questions about the risks of taking Oxycontin and opioid medications, Richard Sackler outlined a strategy that diverted the blame. He placed it onto the people who became addicted to opioids themselves. By the late 2000s, state attorneys general initiated lawsuits against Purdue Pharma. One state lawsuit document concluded, "The opioid epidemic is not a mystery to the people who started it. The defendants knew what they were doing."

After years of donating and being benefactors to museums and others in the arts community, the Sacklers faced backlash. The artist Nan Goldin revealed her struggles with opioid addiction and formed P.A.I.N. (Prescription Addiction Intervention Now). The activist group called on the Sackler family and Purdue Pharma to take responsibility for the country's opioid crisis. One tactic involved pressuring museums to refuse future donations from the family and pressure them to respond to the crisis.

The group held protests at the Guggenheim Museum, the Metropolitan Museum of Art, and the Sackler Gallery in Washington, D.C. Around 50 people gathered outside the building in the spring of 2018. They chanted "Shame on Sackler" and "Sackler kills with its pills." These protests prompted several museums to announce that they stopped accepting money from the extended family. In July, the Louvre removed the Sackler name from its Sackler Wing of Oriental Antiquities in response to the outcry.

Senator Jeff Merkley (D-OR) sent new Smithsonian Secretary Lonnie Bunch a letter urging him to remove the Sackler name from its art gallery. Bunch responded with the explanation that the donation stipulated that Smithsonian maintain Sackler's name. By December 2019, the Smithsonian announced a "rebranding" for its two museums, with promotional materials calling them the National Museum of Asian Art. Although denying the change had anything to do with the controversy and protests, Goldin claimed that "[p]ublic opinion is putting pressure on these institutions."[9]

McKelway visited the National Museum of African Art in its new Mall location. It made him recall a visit with Warren Robbins in his row house on Capitol Hill. His home contained African masks everywhere that the reporter confessed made him

feel uneasy, and his eyes lit up when he talked about them. Robbins collected German Expressionist art and soon realized the stylistic and emotional connection between those artists and African art. He began purchasing African figures, masks and textiles from German antique shops while working as an American Foreign Service officer. Returning to Washington in 1960, Robbins approached his superiors at the State Department and the U.S. Information Agency with the idea of organizing a traveling exhibition of African art. After "finding no support for these ideas," Robbins quit.

In his late 30s, Robbins connected to communities in the city. He opened his home to visitors for events like the house tour organized by the Capitol Hill Restoration Society. Robbins joined the committee to plan art exhibitions at one public library. He jumped at the opportunity to purchase Frederick Douglass' first home on A Street, S.E., seeing the place as the perfect location to advance interracial civil rights and improve national respect for a major component of Black cultural heritage. Robbins engaged in a typically intense, intricate zoning battle with neighbors but won the right to open the Museum of African Art and center for cross-cultural communication in the house in early 1964.

By June, Frank Getlein had visited and called the exhibition a magnificent display of sculpture. Neighbors changed their minds and became supportive of the museum. The "gnomish, affable and intense" Robbins engaged in a lot of outreach. He attended various swank parties and provided tours of the museum to visiting dignitaries, such as the President of Upper Volta's wife. His outreach to groups around the city included lectures on African art to a wide range of interested groups, such as a Black women's club. Within three years, Robbins had connections with anyone in the country interested in African art and had 900 organized groups visit the Museum. Through the 1960s, it hosted festivities for what U.S. culture of the era called "National Negro Week."

By the mid–1970s, the Museum of African Art occupied nine townhouses and a dozen other properties. The spaces contained over 8,500 objects and plans called for receiving donations of more collections. Robbins argued that more white and Black Americans had an interest in African culture and have begun to understand its importance in the world. Exhibits included an African American panorama showing a variety of artists over two centuries. Robbins initially received positive responses from the African American communities, but resentment climbed after Dr. Martin Luther King's assassination. Slowly, as parties realized the sincerity and genuine concern of all involved, the hostility Robbins faced diminished. Robbins' and the Congressional Black Caucus' efforts spurred Congress to approve a plan to incorporate the museum under the Smithsonian Institution.[10]

Under Director Roslyn Walker's tenure, the National Museum of African Art expanded its contemporary art collection. In 1997, photographer Constance Stuart Larrabee gave the museum 3,000 photographs from South Africa. In 2005, the museum received the Walt Disney-Tishman Collection of 525 works spanning most major African art styles and 75 cultures. The acquisition validated the museum's status, given the other institutions vying for the collection.

As it reached its 20th anniversary as a Smithsonian Museum, the attendance fluctuated between 200,000 and 400,000. Staff shrank from 48 persons to 34. With an annual budget between $4 to $6 million, the NMAA sought more private funding. It received nearly $2 million from Oman toward a series that focused on art from that

country. In late 2016, the museum held its first annual African Arts Awards Dinner for over 500 guests as a fundraiser.

Sometimes those gifts can be controversial. As part of the 50th-anniversary celebrations, the museum hosted "Conversations: African and African-American Artworks in Dialogue." The 2015 exhibition in the series featured the artworks from the private collection of Bill and Camille Cosby. Philip Kennicott argued the decision to showcase a private collection not pledged to it violated ethics. The leadership countered that the Cosbys lent the art to it. The more significant fallout came from the release of many allegations that Bill Cosby had engaged in sexual assaults of many women over the years. Protestors derided the museum for hosting the exhibit and for cooperating with Cosby. The exhibition brought record attendance, and a large number thought highly of the show regardless of its Cosby connection.

This museum devoted to African art faced a large cultural challenge in 2020. The National Museum of African Art had only curators of Caucasian descent and staff with much the same background. Ten Black employees charged the museum with racism, citing "incidents of racial bias, hostile verbal attacks, retaliation, and terminations." The Museum lost over half its staff due to budget constraints, but how could it find itself in this situation when it has had three Black directors since 2008, including noted advocates for diversity?[11]

Part of the outrage toward the Hirshhorn Museum's naming came from comparison to Andrew Mellon's choice for his collection. Mellon had spent the better part of two decades working in Washington, D.C., serving as Secretary of the Treasury in the Harding through Hoover Administrations.

For the previous 20 years, the National Gallery of Art was housed in the Anthropology Department of the Smithsonian Institution. New Secretary Samuel Pierpont Langley designated a former office in the Castle as "the Art Room." Langley requested that the Corcoran and Library of Congress return the Smithsonian objects it kept for safekeeping after the January 1965 fire. Only a percentage of the art came back due to damages or inability to separate what the Smithsonian owned from the Library's holdings.

The official use of the name occurred after the District of Columbia Supreme Court ruling in the Harriett Lane Johnson estate case. The vibrant and cultured Mrs. Johnson stayed in Washington after serving as First Lady for her uncle, President James Buchanan. After her death, Johnson's will called for the Corcoran Gallery to hold her 34 paintings and art objects until the federal government developed a national gallery. When the Corcoran declined the donation, its board president, Corcoran Thom, suggested to Langley that he request Congress officially name the current unit as a gallery. Congress took no action on legislation despite a request from President Theodore Roosevelt.

One year later, Roosevelt's Attorney General William Moody brought the Johnson estate case to court. The federal government contended that the Smithsonian ought to claim rightful possession of the bequest because it already fulfilled the function of the national gallery. The Court determined that in founding the Smithsonian, the federal government had intended to provide for an art gallery, and the Smithsonian's actions had turned the intent into the National Gallery. While everyone admitted the gallery may have lain dormant for a while, activities began to stir. The new National Museum building (later the Natural History Museum) opened in 1910 with

a hall dedicated to the new gallery, despite the fact that the rest of the building was not ready. Anthropology employee William H. Holmes, who was also a member of the Society of Washington Artists, was named gallery director.[12]

Smithsonian leadership eventually separated the National Gallery of Art from the Anthropology Department during the summer of 1920. Momentum grew for designing a building for a gallery on the Mall. Congress set aside a site for the building on the north side of the Mall facing Constitution Avenue between Seventh Street and the existing Natural History Museum. The Mall location came while Congress considered purchasing the land near the Capitol building to add to the Mall. This required moving the Botanical Gardens and buying the privately owned land in the gap between Pennsylvania and Maryland Avenues and from First and Sixth Streets, N.W. Sixty years after being a "high-toned" neighborhood, the area contained the city's Chinatown and old boarding houses, carriage manufacturers, laundries, and liveries.

The Freer's architect, Charles A. Platt, submitted plans for an art gallery building in October 1924. Lelia Mechlin and other local city arts community members campaigned to win Congressional support for the Mall location. Secretary Mellon participated in this effort, promoting the idea that the government had a role in generating appreciation for art among its citizens. The city's newspapers supported the effort. Unfortunately, Senator Lodge's bill for the gallery failed to pass. Despite the

Old National Gallery, c. 1921 (Smithsonian Institution Archives, Record Unit 95, Box 44A, Folder 07, Image No. SIA_000095_B44A_F07_006).

setback, local newspaper people pressed for a new building to house the art, which appeared next to antediluvian animals' bones.

Congress passed legislation in 1928 authorizing the purchase of privately held land to construct federal government buildings. The site sat between Pennsylvania Avenue on the north and B Street (Constitution) Avenue to the south from Ninth to Fifteenth Streets, N.W. Filled with dilapidated structures, the area once housed the bordellos used during the Civil War era. A building for the National Gallery of Art failed to appear in the Federal Triangle plans.

During the fall of 1927, word emerged that a private citizen offered to build a national gallery building at his/her own expense. The allocated space sat on the Mall next to the Natural History Museum. This location between Twelfth and Fourteenth Streets placed this museum close to the Freer and in the Corcoran Gallery's neighborhood, offering visitors the ease of movement when seeing the city's art museums. The Commission of Fine Arts approved of this plan. The rumors identified Andrew Mellon as the probable benefactor.

Meanwhile, several Smithsonian Institution regents continued their efforts to enhance the current National Gallery of Art. The Museum received the Ralph Cross Johnson and the John Gellaty art collections. The latter included 161 paintings by American artists and over 1,500 objects from around the world. The gallery held over 100 exhibitions throughout the 1920s and into the early 1930s inside the Natural History Museum, including shows arranged by local and national arts organizations. Notably, the Committee on Race Relations of the Washington Federation of Churches sponsored exhibitions of Archibald Motley and William H. Johnson's artworks in the spring of 1929 and 1930, respectively. Both artists won the William E. Harmon Award "for distinguished achievement among Negros." Mechlin spurred the curator to contact her friend Holmes, who then arranged for the exhibition in the gallery.

The Smithsonian Board of Commissioners stirred when no progress occurred. It submitted to the Board of Regents a resolution to build a museum on the north side of the Mall between the Natural History Museum and Seventh Street, S.W. Joseph A. Gest questioned whether the Smithsonian could properly administer an art collection. Secretary Charles Greeley Abbott explained that the Smithsonian's inaction occurred because of an agreement with Mellon to wait on his effort to fund a national gallery of art. However, Mellon's plan to endow a building to house his collection of art rather than the art already held at the Smithsonian appeared quite possible by 1935. Still, the relationship between Mellon's collection and the Smithsonian's collection remained murky during the drafting of the bill in Congress.[13]

Mellon began collecting notable artworks in the early part of the 20th century. The Pittsburgh banking tycoon built a reputation as a shy, sensitive individual during his years in Washington. One correspondent observed that Mellon played with his snow-white mustache and chain-smoked small cigars while they met. Mellon's father amassed a fortune. Before teaching his son the rudiments of banking, he sent him off with Henry Clay Frick on a grand tour of Europe. The young adults saw artworks that inspired them with great passion. Mellon expanded the family's banking interests into finance, coal, coke, and oil industries. As he and Frick acquired great wealth, each set about quietly purchasing works of art. Mellon started a personal study of art and followed the leading experts' advice before making any single purchase. His collection contained numerous "Old Masters" paintings, some of which he displayed in the

sole apartment on one floor at 1785 Massachusetts Avenue, slightly south of Dupont Circle. Despite the apartment's long drawing rooms, library, and dining room offering wall space, Mellon engaged in frequent rehanging to see all his works. The long-time Treasury Secretary looked out the Treasury building's second-floor window and imagined a gallery going into the newly constructed Federal Triangle.

The gallery building for the Mellon collection began with an offer from Mellon to President Franklin Roosevelt. The president replied that he supported the gift and agreed to Mellon's preferred location for the gallery on the Mall between Fourth and Seventh Streets along Constitution Avenue, N.W. Mellon's $30 million collection including 70 works of utmost importance and 152 works of painting and sculpture. The building sat atop the place where "the Bonus Army" of World War I veterans had encamped to attain their promised bonus from Congress only a few years before.

Despite some Progressive Senators' misgivings about the National Gallery of Art's leadership structure, Congress approved Mellon's gift. The legislation reserved the adjoining area bounded by Fourth and Third streets, Pennsylvania Avenue, and North Mall Drive for future additions to the gallery if the Commission of Fine Arts approved those plans.

After Mellon's death in the summer of 1937, the Baltimore newspaper took a slight swipe at Mellon and his creation, referring to the gallery as "rearing of the monument to himself." Mellon had insisted that the name formerly bestowed on the Smithsonian art collection be applied to his new building. The name had *cachet* because it also was used in London for the United Kingdom's collection. The use of this name inspired more wealthy Americans to donate their art collections to the gallery.[14]

Building construction began before Mellon's and architect John Russell Pope's deaths. The dedication, which occurred two years after the expected finishing date, drew nearly 9,000 guests for the evening ceremony. One reporter provided general first after the first month, adding that they were general because the collection proved so vast. There was an emphasis on Italian Art. There were mostly portrait paintings by British artists and paintings from the Colonial American period, which he found more interesting from a historical rather than artistic perspective. Numerous prints, several by artists who had larger works in the collection, proved the most pleasant surprise.

The donations from other collectors began in 1939. The Samuel Kress family donated Italian paintings and sculptures, covering the eras from the 1200s to 1700s. Peter Arrell Browne Widener and his family donated antique furniture, tapestries, decorative arts, and Édouard Manet and Pierre-Auguste Renoir paintings. Lessing Julius Rosenwald began donating drawings and prints in 1941 and provided over 22,000 works on paper in all. Chester Dale's collection featured every major artist who worked in Paris during the mid–1800s through the mid–1900s. Several artists protested the provision that no works could appear in the gallery until twenty years after an artist's death.

The Mellon children, Ailsa Mellon Bruce and Paul Mellon, supported the Gallery in several ways over the next half-century. The East Wing of the National Gallery represented their most remarkable gift. The pair donated $20 million for the second building, staff and operations.

Wolf Von Eckardt summarized the challenge of creating the second gallery building. It had to successfully meet Pope's "glorious temple" and fit nicely within the Mall and inside an oddly-shaped area. Tennis courts occupied much of the grounds and constituted an environmental eyesore, according to the National Gallery of Art's assistant director J. Carter Brown. According to Brown, the gallery needed to expand, serve visitors, and maintain the collection which numbered over 30,000 objects. Finally, the Gallery wanted to expand its capacity to enable researchers and others to study art, so it could promote scholarship and education.

The NCPC held hearings and stopped the development in the spring of 1971. The oversight group objected to the plan for the 4th Street Plaza that would connect the two buildings. The complaints involved imagining a speedway outside the proposed plaza as the NCPC expected a planned 4th Street tunnel to gouge into the Mall. After resolving that issue, labor strikes as well as engineering and architectural challenges slowed construction by years. Frank Getlein lauded the building's design as beautiful, combining the imitation princely palaces with the best of today, "Corbusier's machine for looking at pictures." Paul Richard agreed, praising the building as pointed to the future and ready to reshape how the gallery's art appeared to the visitors. The opening featured only the best artworks in the collection and drew dignitaries such as President Jimmy Carter.

One local resident called the East Wing ugly inside and out, believing it undercut Pennsylvania Avenue's value. John McKelway stated he thought it took time to get used to the building. He felt uncertain what level he was on as he stood in the vast central room. Opinion columnist William Greider felt joy initially, but soon that feeling turned sour. He found the building a new monument to add to the city, but he thought "that it carried a feudal feeling and stood as a monument to social intimidation." In summary, Greider argued "it was an exquisite building with a mocking quality because it miniaturized people and swallowed them up in its vastness." Within weeks, writers of letters to the editor argued that Greider's experience did not match their own, and all loved the building.[15]

The newly christened National Collection of Fine Arts (NCFA) suffered a loss in prestige. Others lamented the new National Gallery of Art refocused attention on Old Masters and European art and away from artists born in the United States. With local advocates like Delano and Mechlin testifying on behalf of a gallery building, in 1938 Congress passed a law that provided a grant of $40,000.00 for the Smithsonian Gallery of Art Commission to study a potential building on the Mall. Ten designs out of 408 made it to the final round, and the Saarinen-Saarinen and Swanson plan won. However, many influential members of the local community and the federal establishment, including the Commission on Fine Arts, steadfastly opposed the very modern style. The chance for a gallery building died on arrival.

The NCFA experienced no momentum on a new building over the next 15 years. It also received limited funding, so the museum relied on donations and small funds to enrich its collection. It held its centenary show in 1947, inside the art gallery within the Natural History Museum building. Space limited what appeared, and Berryman commented on the "temporary home." During the early 1950s, Alice Pike Barney's daughters donated in her memory. The gift included 224 Barney paintings, 54 paintings by others, several sculptures, and other objects of art. The donation also included a fund of $20,000.00 and the Barney House on Sheridan Circle.[16]

By the mid–1950s, the possibility of a building for the NCFA began to emerge. The Patent Office Building between F and G and Seventh and Ninth Streets, N.W., stopped serving its original tenant in 1930. In 1955, the Civil Service Commission planned to vacate the premises. The General Services Administration (GSA) sought to destroy the building and replace it with a privately-owned parking deck. Congressional District Committees heard testimony, and the bills went to the House and Senate Public Works Committees plus government and private organizations in the city.

Several local residents objected to this action. The Committee of 100 cited the age and style of the Robert Mills-designed Greek revival style building to oppose the razing of the 120-year-old building. Readers also thought the building a lovely landmark worthy of saving. Architects and other professionals in design and urban planning supported maintaining the Patent Building. Louis Simon, the former supervisory architect for the Treasury, actively worked to save the building, writing articles and appearing in front of the appropriate federal and city deliberative boards. One reader argued that parking helped the downtown businesses and made for a more fluid movement around the shopping area downtown. Opposition from the Senator from South Carolina, Mills' home state, helped halt the legislation in Congress.

The GSA adopted a different position and advocated to preserve the Patent Building. By the middle of 1957, Representative Frank Thompson (D-NJ) and Senator Hubert H. Humphrey (D-MN) brought bills before Congress to transfer the Patent Office to the Smithsonian Institution. Thompson thought the old landmark—"a structure so charged with history"—a fitting place to put a gallery. His bill called for a national cultural center at the site along Independence Avenue between Fourth and Seventh streets, S.W., the location previously allocated for the art gallery. The venue would have served as the venue that the Kennedy Center for the Performing Arts became.

The bill transferred the Patent Office Building to the Smithsonian but included no funds for renovation. Thompson thought this legislation easier to pass through Congress. The monies for the building's renovation awaited another Congress or GSA action. The bills passed, granting the building to the National Collection of Fine Arts after the Civil Service Commission received its new building.

The new location for the art gallery suited the Smithsonian leaders. They promoted plans for an aviation museum on the Mall and placed it on the Independence Avenue location in S.W. Secretary Carmichael told the art commissioners that the collection of aviation-related materials was the world's most extraordinary. The Smithsonian Art Commission members, unmoved,continued to advocate for the gallery at that site. It appeared their battle would be uphill because neither Smithsonian's leadership nor Congress backed placing the art gallery on the Mall.

In 1961, Congress considered legislation to create the National Portrait Gallery and placed it in the Patent Office Building. Senator Leverett Saltonstall (R-MA) described the gallery as a long time coming and predicted that it would serve as an outstanding educational, cultural, and patriotic center for the American people. Saltonstall expected that both the National Collection and the new portrait gallery would be in the building by 1963. The organizations shared the space equally and had their own governing administrations.

Some members of national and local arts organizations expressed

concern over the developments in Congress. About 170 members of the American Art League planned to fight the legislation starting the Portrait Gallery. The members expressed concern over whether the $400,000.00 appropriation for the Patent Building would be enough. They thought that the newly created Portrait Gallery board seized most of the building and that history took precedent over art there.

The Senators reassured the local artists that both galleries shared the building evenly, but the limited support for the NCFA over the years made its supporters leery. The bill that passed Congress removed the phrase "the whole or any part of" the Patent Building can be used for the gallery. The legislation also allowed the NCFA to collect private funds to purchase artworks by living artists and raise funds for financing exhibitions of current and past works in the collection.

Early the next year, the Fine Arts Commission approved the Patent Building's plan, although no work started until the summer of 1963. Critic Leslie Portner advocated for the NCFA to seize the opportunity to make changes, particularly to "eliminate the limited-quality pieces in the collection and the requirement of showing complete collections together."[17]

New NCFA director David Scott promoted ways that the Museum could display its collection within this gorgeous historic landmark. He noted that the new programs sponsored in Congress's legislation provided monies for the Museum's Traveling Exhibition Service, which would bring the collection to places around the country. Officials received the bids to perform the renovation project on the Patent Building. They found the bids too high. With a consulting firm, Scott revised the plans to eliminate a large restaurant and auditorium. The Smithsonian leaders removed some of the original plan's older and problematic elements, including leaving the great rooms cut by the warren of cubbyhole offices. The museum had 200- and 300-foot-long gallery spaces with wide corridors, a magnificent ballroom on the third floor, and a large central courtyard.

As with most construction projects, the cost and time estimates proved incorrect. The building neared its completion three years after the beginning of construction. After receiving a $1 million appropriation from Congress, the building required another $5 million, and that would still not be enough to make the renovations one hoped could be done. Von Eckardt called the completed work "barbaric crudeness." Starting with covering the marble floors with a terrazzo of sickly color, the critic observed that massive box-like fixtures ruined the vaulted galleries as they rained fluorescent light down to offend the human eye. The public space and office floors were covered with cheap asphalt tile that would be inappropriate even in janitor closets, and the director's office contained a decor that represented the height of a roadside motel circa 1950.

The opening evening drew President and Mrs. Johnson and the Hirshhorns, and other dignitaries from the art and political worlds. Johnson waxed "almost poetic" as he addressed the multitude in the inner courtyard of the building he called "a great American home." The president wished the Museum and its patrons "a long, happy and prosperous life." The new museums became a location for extravagant parties over the next year. Tours of the building and the galleries frequently followed or preceded these affairs.

The local art critics offered their assessments. Paul Richard observed the

sculpture in the fountained courtyard and contemporary works of brightly colored prints and paintings hanging in the vaulted halls. He noted that the NCFA might feel a squeeze from the National Gallery because the latter planned to expand its holdings in eighteenth- and nineteenth-century paintings. The NCFA also competed with numerous museums and private galleries for the contemporary art market's attention. It succeeded occasionally, acquiring the 102 works of the S.C. Johnson Collection. Frank Getlein noted that the NCFA's collection grew in spurts and the opening show of 500 works reflected the many zigs, zags, and stops that had occurred over the previous 125 years. Besides seeing some highly competent work and known artists, the exhibition offered the pleasant surprise of seeing a good piece by an artist you didn't know. The non-art critic perspective came from the *Rambler* newspaper columnist who expressed displeasure with the contemporary art on the first floor. He found the new museum attractive and enjoyed the older works on the second and third floors.

Richard returned to the museum a few years later. Although he mentioned the galleries' haphazard organization and poor lighting, he noticed vast improvements. In 1980, the NCFA adopted the new name of the National American Art Museum, and its exhibitions grew more involved in display and content.

By the late 1980s and early 1990s, the shows and museum's choices caused controversy. Director Elizabeth Broun faced extensive criticism for "The West as America." The exhibition featured paintings and other art depicting the American West alongside unflattering text about the westward expansion. Senator Ted Stevens (R-AK) criticized the show and hinted at exacting his revenge in the Smithsonian's budget. Scholars like Daniel Boorstin described the show as "perverse, historically inaccurate, and destructive." The comment books filled, and the museum changed ten of the 55 wall texts in response. Curator William Truettner observed, "We knew that we were presenting a show that went against the grain of some Western scholarship, but we didn't think we were going to bring the house down." Jo Ann Lewis called the exhibition "heavy-handed revisionism."

Differing opinions regarding the emphasis of an exhibition proved not to be the only challenge. The museum staged the traveling show "Eadweard Muybridge and Contemporary Photography," organized by the Addison Gallery in Andover, Massachusetts. Ms. Broun decided to remove Sol LeWitt's narrow oblong box with ten tiny apertures through which a viewer sees an advancing nude female torso. Broun said the viewing experience was "an embarrassing or humiliating experience" and reminiscent of a peep show. LeWitt stated that the 1964 piece illustrated the lighting techniques dating back to the Renaissance. Broun removed the piece, saying that the voyeuristic elements overwhelmed any other aspect of the work. She offered to display the images and box separately, but neither LeWitt nor Jock Reynolds, the Addison Gallery's director, accepted those terms. Reynolds tried to stop the exhibition at the NMAA, but Broun refused to stop the show. He rallied the art community against what he deemed "censorship." Despite the criticism of Broun, visitors came to the museum as they had after the "The West as America" exhibition spurred controversy. Jane Livingston, the curator who resigned from the Corcoran after the Mapplethorpe debacle, warned all to beware of public opinion tyranny.

During these first decades, the museum toiled to broaden its collections. New acquisitions numbered close to one thousand annually through government

transfers, gifts, and purchases. The type of art and artists acquired broadened significantly. Ms. Broun proudly pointed to the acquisition of the Luis Jimenez sculpture of a Latin gunslinger. It stood at the front of the museum. The NAAM transferred works outside its American art and living artists' focus to other Smithsonian museums and agencies. One of the largest transfers made by the American Art Museum involved 116 paintings and sculptures and 8,000 portrait prints to its sister museum, the National Portrait Gallery.[18]

Although the National Portrait Gallery began in the early 1960s, its roots stretched back to the early twentieth century. The District Supreme Court's decision to recognize the National Art Gallery renewed interest in a portrait gallery. Using England as an example, one proponent for a national gallery of art building signaled that a portion of the space needed to be devoted to a portrait gallery. Critic John Watkins noted that the city had sufficient portraits of the nation's great men and women in public buildings to make a splendid showing.

Little action occurred until after World War I. A national art committee hired several notable American painters to capture the likenesses of important persons involved with the war effort. It paid for the artists to go to Europe in the spring of 1919 to paint the personages, including foreign dignitaries and Americans such as President Woodrow Wilson, General John J. Pershing, and Admiral William Sims. When displayed at the Metropolitan Museum of New York, the portraits drew praise and significant public attention. This show appeared in the art gallery at the National Museum for two weeks, then became part of the NCFA's collection until the government started a portrait gallery.

Lelia Mechlin commented that the Capitol had several instances of great works among its official portraits. She mentioned two of George Washington by Gilbert Stuart and paintings by Thomas Sully, Chester Harding and John Singer Sargent. Quality improved because the one-time process of taking the lowest bid stopped. Since the early twentieth century, the NCFA selected renowned artists to paint most notable government officials. This process provided an acceptable structure to how the government procured portrait art. When Mellon announced the effort to establish the National Gallery of Art, he mentioned that his collection included portraits of prominent Americans. He wanted them placed within a national portrait gallery. Mellon purchased these as part of the Thomas B. Clarke collection when it went up for auction. The 175 canvases had an estimated value of $1 million.

A few years later, the NGA featured an exhibition of some of its portraiture. The collection carried a promise of the paintings as gifts if the portrait gallery became established within 20 years. A few other donors also prepared to offer some of their portrait paintings, too. David Finley, the gallery director, showed several of the portraits again in 1947. Five years later, the gallery featured another exhibition of portraits ranging from Pocahontas to General Dwight David Eisenhower.[19]

Once established and assured of its place in the Patent Building, the museum could address its collection and exhibition concerns. The gallery faced budget limitations, and its policies stressed inventory over quality. Director Charles Nagel observed that the gallery emphasized good likenesses rather than on art *per se*. A show of 50 recent acquisitions displayed in the Arts and Industries Building left critic Leroy Aarons "wanting." "You should see some of the stuff we've been offered," said curator Robert G. Stewart. Most of the works came as gifts, and seven works were

copies or done in another painter's style. The gallery received an acquisition budget of $50,000.00, which could only buy one exceptional painting.

The opening show featured 160 works. The exhibit planned to show the American character and its evolution over the centuries. Most of these artworks were paintings, including those by Benjamin West, John Singleton Copley, John Singer Sargent, Robert Henri, Jacques Lipshitz, and Mather Brown. The gallery held a symposium on the national culture and character.

The first few years of the gallery provided the opportunities to establish new precedents. British artist Augustus John painted a portrait of Tallulah Bankhead that the actress and celebrity treasured, keeping it across from her bed in every place she lived. When the portrait of the daughter of former Speaker of the House of Representatives William B. Bankhead came up for auction, the Portrait Gallery sent an agent, expecting to purchase it for around $2,500.00. Unfortunately, a Mr. X. kept bidding, eventually purchasing the work for $19,000.00. The National Gallery of Art Director received a letter from John Hay Whitney offering Tallulah Bankhead's portrait as a gift to the nation. The Portrait Gallery hung it opposite a painting of Adlai Stevenson, whom she supported in his two runs for the presidency during the 1950s. The hope was that the portrait represented the start of a portrait of American performing artists. This became a reality over the years as the gallery collected artworks depicting a wide array of notable Americans from every field.

Other changes occurred more slowly. By the early 1970s, the National Portrait Gallery of London began expanding into different artistic mediums besides painting and sculpture to depict notables. Congress adopted a new law that changed the definition of "portrait" for the purpose of the museum. The gallery could collect portraits and reproductions thereof made by any means or process. The Jimmy Carter administration decided to use photographs to capture its leadership likenesses. Carter's memo to cabinet members decreed oil paintings "an outdated practice" and "an unnecessary luxury costing anywhere from $6,000 to $12,000 each." Carter's Attorney General Griffin Bell thought the decision amounted to heresy and that the president had no sense of tradition. Georgia private citizens raised $7,000.00 so that a Bell likeness in oil would appear on a Justice Department wall.

The photographers hired included Ansel Adams, who photographed Vice President Walter Mondale. At least the Vice President posed. Most of the cabinet members failed to find the time to sit still. Only two of 11 cabinet members had a completed photograph at the end of the first year. Among the problems were bruised egos, disgruntled photographers, and several beautiful color photographs of cabinet members who left the Administration.

After a year's delay, the Vice President's family showed some of the photographs at the Vice President's house. Later that evening, the exhibition took place at the National Portrait Gallery. Some of the Cabinet officials remained uneasy with their depictions. Gallery Director Marvin Sadik looked anxious while he said that he liked some of the show. "They were rehearsing me in the car on the way up," he said. Sadik found out soon that Carter changed his mind near the end of his Administration and approved the federal government paying for his department heads' oil portraits. A year later, Sadik resigned his position after serving as head of the gallery for a dozen years. He built the collection to 2,000 works and prodded Congress to change the law to allow the gallery to collect and exhibit photographs.[20]

As Jimmy Carter discovered, the portrait in oil tradition remained the preferred method. Ronald Reagan had three made before accepting the second one done by Everett Raymond Kinstler. The closest thing to "a court painter," Kinstler began painting Washington political figures in Lyndon Johnson's administration and completed both Gerald Ford and George Bush's portraits. Kinstler occasionally showed with Susan Conway Carroll Gallery in Georgetown. Jo Ann Lewis called his display "a glut of facile charcoal portraits" while adding that the artist was "[the] current sweetheart of the corporate boardroom."

The portraits of Cabinet members adorn prominent walls inside the agency building. By the early 2000s, each canvas cost from $25,000.00 to $45,000.00. The departments each solicited bids, then examined the details of the three or five lowest ones before making a selection. Ann Fader, President of Portrait Consultants in Washington, which represented portrait artists, said some agencies started searching for an artist long before secretaries left because paintings take from eight to 14 months to complete and frame. "These are done for future generations to see how we live now, and it's really a tribute as well as part of a person's legacy," Fader said. David Williams, President of the Taxpayers Protection Alliance, questioned the portrait process. "It's not like people are going to be lining up for an exhibit, 'HUD Secretaries Through the Years,'" Williams said.

Congress stopped the process with a bill known as the EGO Act in 2017. The estimated savings: $500,000.00 annually for the fewer than 20 portraits not purchased with federal funds. The law required heads of executive agencies, the president, and even Congress members to pay for an official painted portrait. Congressional leaders had enjoyed this perk since the mid–1800s, and they usually guarded privileges jealously. Fortunately for them, the U.S. Congressional Historical Society established a private donation method for funding Congressional portraits. Nearly 100 portraits at $20,000.00 to $80,000.00 each emerged using this method.

As with Reagan, some sitters have requested multiple paintings until they were satisfied their likeness. Sometimes even a president cannot control the portrait. The late Bucks County, Pennsylvania, artist Nelson Shanks, renowned for his beautiful portraits of Princess Diana and a group of four female Supreme Court justices, unveiled Bill Clinton's official portrait in 2006. Almost a decade later, Shanks revealed that the shadow on the painting's mantel came from a mannequin in a blue dress the artist used to represent Monica Lewinsky. Shanks heard that the Clintons hated the portrait and placed pressure on the National Portrait Gallery to remove it. Shanks' Clinton portrait remained unseen since 2009. A spokesperson stated that the absence was only part of the process "of a standard rotation of works."[21]

Since the 1980s, the National Portrait Gallery has held exhibitions that occasionally drew extra attention in the local area. The photographs of James Van Der Zee shown in 1993 sparked columnist Courtland Milloy to tell his readers to go see the exhibition. After expressing exasperation over Black people's entertainment images, Milloy observed that these photos showed African Americans' human side and complexity that refreshed a viewer's soul.

Another show drew attention because it featured artworks from a local collector. James Goode, an architectural historian and former curator of the Smithsonian "Castle" building, collected dozens of artists' self-portraits. Goode hung them on his Connecticut Avenue apartment walls, and the eyes stared at him wherever he went.

Contemporary self-portraits from the James Goode Collection. From left, front row: Jill Mackie, Billy Morrow Jackson, James Goode, NPG Director Alan Fern, Sidney Lawrence. Middle row: David Zuccarini, Janet Monafa, James Voshell, Harvey Dinnerstein, Mel Leipzig, Frank Wright, Scott Noel, Rebecca Davenport, Joe Shannon and Burt Silverman (Photograph by Jeff Tinsley, Smithsonian Institution).

"It really intimidated me for about two years," he noted, before he got used to them. Many of the artists lived and worked in Washington. The Portrait Gallery put the self-portraits on display and eventually acquired 25 of them for their collection.

The greatest challenge faced by the Portrait Gallery and its sister SAAM occurred in 1999. Bursting pipes and electrical issues led to other revelations about the condition of the old Patent Office. Hartman-Cox Architects' renovation plans dedicated an additional 33,000 square feet to museum space. The second and third floors allowed circumnavigation around the square building. Offices, the library, the archives, and some storage areas went to the Victor Building at Ninth and H Streets. A $10 million Luce Grant enabled the museum to create a location of "visible storage" on the third floor providing a view of works currently not on exhibition.

The plans called for the museums to be closed for three years. Construction woes emerged almost immediately, and the opening moved to 2005 while the original estimate of $60 million climbed to $214 million. Worse, George W. Bush's Office of Management and Budget proposed stopping the renovations for at least one year. Local art world figures advocated in their columns for continuing the work, claiming that the arts were necessary. Fortunately, Bush agreed to increases in the budget for the Smithsonian. Eventually, Congress provided the lion's share of the renovation's cost.

At roughly the same time, the Smithsonian's leadership decided that adding a roof covering the courtyard between the old Patent Office's two wings made great sense. This decision added $50 million to the project, all from private sources. Congress approved the plans, which called for the completion of the extremely complex installation in 2007. The new courtyard replaced the grass and dirt open to the air that had defined the courtyard since 1867.

The federal arts commissions initially supported the roof. The NCPC, after two previous approvals of the Foster and Partners' preliminary designs, voted to force the Smithsonian to stop working until it incorporated design changes. John L. Nau, III, Chairman of the Federal Advisory Council on Historic Preservation, wrote to the Smithsonian Secretary Lawrence M. Small "[that] the project as now conceived and under construction diminishes and undermines this magnificent architectural icon and its prominent placement within the L'Enfant plan." The canopy construction continued while the building opened in 2006.[22]

The original invitation list included 7,000 names; over 1,300 visitors donned formal wear to party at the handsomely renovated Smithsonian American Art Museum and National Portrait Gallery. The Donald W. Reynolds Center for American Art and Portraiture rocked with music on every floor. Elaborate buffets were laid upon tables amid the grand hall's flashing lights. Bars and contemporary art filled other spaces. Nelson Shanks, Lee Friedlander, Sean Scully, Bill Christenberry, Lou Stovall, and Morgan Monceaux were among the mingling artists.

The next year, multiple pastel colors flashed in dazzling fashion on the walls during a week of celebrations for the new Robert and Arlene Kogod Courtyard. After the stylish evening affair, the SAAM held a family-friendly event for 10,000 people. A quieter dinner for donors occurred Saturday night with the Choral Arts Society of Washington providing the entertainment. Monday drew 600 guests to watch a tap-dancing performance from the Big Bay Kool Kats.

The new building offered a splendid environment for new media and new

exhibitions. In 2010, the Portrait Gallery held the "Hide/Seek: Difference and Desire in American Portraiture" exhibit, demonstrating the influence of gays and lesbians in modern American portraiture. The exhibition became the first major-museum show depicting how artists handle questions of sexual and gender identity. It ignited controversy, causing the loudest uproar at the Smithsonian in years. While drawing record crowds, the show sparked complaints from the Republican leadership on Capitol Hill and conservative critics. Artist David Wojnarowicz's video *A Fire in My Belly* contained a scene of a crucifix crawling with ants. Smithsonian Secretary G. Wayne Clough decided to remove the piece, which showed at Transformer Gallery in Washington, D.C., as mentioned in Chapter 12. "Above all I wanted to keep the exhibition open. I wanted to protect the Smithsonian in its entirety," said Wayne Clough.

The museum's comment books dealt directly with the controversy. "We, the viewers should have been allowed to see it and decide for ourselves."

Others praised the exhibition. "This exhibit was so refreshing—outing many famous artists in a sensitive way. Kudos to the Smithsonian and the curator for arranging this–BUT the response to the protest by conservative extremists was an affront to the vital message of this exhibit. What a shame!"

Another agreed. "I want to leave the exhibit reclaiming an identity the culture at large tries to take away from me. The Museum was decidedly NOT brave, however, in capitulating to religions, right-wing paranoia. Deeply touched by the exhibit, deeply ashamed of the Smithsonian's cowardice."

A few disliked the material or its approach. "Trashy-inappropriate low-class exhibit—you can do better."

Or its approach. "More like a lecture than an exhibit."

The most intriguing comments noted a different deficiency in the exhibition. "Not enough girls in it," and "I loved this, but it seemed largely skewed towards gay men. What about the rest of the LGBTQ community?"[23]

The Portrait Gallery has experienced no such turbulence since. The Renwick Gallery, in the one-time Corcoran Gallery of Art, did. As usual, the disruption centered on the building. As Chapter 3 discussed, we learned that the United States confiscated the Renwick before it became "the American Louvre" Corcoran Gallery. When the Corcoran moved down 17th Street, the Renwick housed the U.S. Court of Claims until the Court announced in 1956 that it wanted to tear down the building to gain more office space. Like its fellow Smithsonian museum, the Patent Building, many individuals fought the plan.

Jacqueline Kennedy and local artist and federal bureaucrat William Walton made a personal campaign of protecting the White House and Lafayette Square from deterioration and demolition. A member of the Fine Arts Commission who lost in the preservation battle wrote, "I just hope that Jacqueline wakes up to the fact that she lives in the twentieth century." The building remained, with an uncertain future.

Many agencies expressed interest in using the Renwick. Smithsonian Institution Secretary S. Dillon Ripley remembered his approach to asking President Lyndon Johnson about the building. Ripley said he painted a picture of the president engaging in a long, hard bargaining session with foreign dignitaries, followed by a pause where there's really nothing left to say. "Imagine," Ripley said, "if you could take them by the arm and walk them from Blair House next door and show them these arts and crafts ... you could say, 'Mr. President, you see we have a heart too.'

Ripley recalled Johnson's humanity. "Well he gave a great guffaw of laughter and he said, 'That's a great idea.' 'And I said, 'Well great Mr. President. Let's just stroll over there and have a look at it.' So we walked across the street and went into the Renwick. We had a great time."

The contractor and Smithsonian staff used Matthew Brady photographs from the 1860s to restore the Renwick's facade. It took $3 million of the $30 million and a few years, but the façade restoration and the interior renovation proved successful and drew raves. At the 1972 opening, Wolf Von Eckardt declared, "It is a triumph of American culture over the spiteful neglect with which we treat our cities and the ignorant contempt in which we hold America's aspirations." The *New York Times* critic almost felt a "holy" experience, "after a classic struggle for survival, is a noble preservation success. It is nice to report that the good guys won." The building contained several attractive spaces for exhibitions: four large exhibition rooms on the first floor and the unique space known as the palm room; the upstairs contained the Renwick's Grand Salon, which measured 40 by 100 feet with a 40-foot ceiling, and the Octagon Room, furnished in the styles of the 1860s and 1870s.

The Renwick Gallery began with no collection. The Smithsonian leadership placed the gallery under the umbrella organization of SAAM and provided director Lloyd Herman with a small curatorial staff. Herman aimed to forge a distinct identity. The first shows in 1972, including "Woodenworks" and "Design Is," featured contemporary design of familiar objects and an educational function. Its range of interests went "from contemporary design to all aspects of crafts and the decorative arts." Nearly 120 exhibitions followed over the next two decades, most of them organized by the Renwick's staff. "Masterworks of Louis Comfort Tiffany" numbered among the most popular, drawing 230,000 visitors over six months. Chief Curator Michael Monroe observed the shows' themes. "Learning how to master a technique is not enough. How do you take that technique and expand the idea that has been expressed before in a medium?"

Fortunately, the Smithsonian stopped the practice of cannibalizing the Renwick space for specific international exhibitions in 1986. One group sent many letters to the Smithsonian's leadership to make that happen. The James Renwick Alliance (JRA) featured several Washington and national-based art enthusiasts, collectors, artists, educators, art professionals, and students. Formed in the early 1980s, its passion for contemporary American craft sparked its efforts to solidify the Renwick gallery's craft focus. The JRA aided the Renwick through providing funding for crucial activities, including exhibitions, acquisitions, and publications.

The gallery's leadership concentrated on post–World War II American arts and crafts. The collection grew to 300, then 450, objects up to the 1990s. It featured a wide range of crafts and materials from glass through wood and stone—and a panoply of styles, too. Objects included necklaces, bracelets, and serving items like silver tureens and teacups with a gun.

As the collection grew during the 1990s and 2000s, the Renwick purchased artworks from several Washington-based artists. The local and regional artists selected represented the same kind of diversity of styles and materials. Graphic artist Joseph Holston had his first piece, *Jazz*, selected in 1990. He has had others acquired since. Graphics artist Jennie Lea Knight also had a piece acquired. Others among the decorative arts creators included the glass work *White Fish II* from Carol Cohen, Jillian

Banks' ceramic horse called *Contained Wisdom*, and Sabrina Gschwandtner's thread piece *Hula Hoop*. James Baxter had *Within Twilight*, a walnut and maple furniture piece, collected. Two glass pieces from Tim Tate, Cat Mazza's single-channel digital video, *Knit for Defense*, and Margaret Boozer's clay work, *Eight Red Bowls*, all brought more diversity in materials to the Washington-based artists in the Renwick collection.

The museum began a biennial exhibition of the top figures in crafts. Established in 2000, the Renwick Invitational featured a handful of emerging or mid-career craft artists that warranted national focus and recognition. Starting with "Five Women in Craft," then "Four Discoveries in Craft," these exhibitions drew praise from artists and visitors. Joanna Shaw-Eagle saw little experimentation with techniques and materials for the joy of craft in the show. "When these artists try to imitate other arts such as painting or sculpture, they lose the essence of crafts as crafts, of objects made for use, of treasures created by hand, of something very close to the heart."

Critics from newspapers in Bloomington, Indiana, and Trenton, New Jersey, expressed their appreciation for the Renwick Invitational's first two shows. These critics applauded the curators for taking hundreds of submissions and culling them to allow four relatively unknown artists to shine. Deborah K. Deitsch reviewed the

Renwick Gallery, 2020 (Courtesy of the Photographer, Ira Tattelman).

2009 show. "The latest 'Craft Invitational' at the Renwick Gallery reflects the trend in pretentious sculpture, costumes, and installations."

In 2012, the Renwick hosted an exhibition called "40 Under 40: Craft Futures." The featured artists ranged across multiple disciplines such as sculpture, industrial design, fashion design, and sustainable manufacturing. These artists featured works with glass, fiber, ceramic, wood, and other materials that the curator stated, "[were] boundary-pushing interpretations that challenged the traditional process-oriented notion of the craft medium by incorporating performance, interactivity, and politics." Critic Danielle O'Steen observed, "An eager optimism forms the heart of the exhibition, where 'craft is about making a better world.'" She relished the unexpected use of materials seen throughout the show. "The show's diversity and range of narratives make it easy to indulge with childish delight in the invention of these objects and the stories told as they teeter between function and fantasy, and to be optimistic for what the future of craft holds."[24]

Changes in building codes, growth in holdings, and changes in both the type and styles of exhibition required updating the Renwick building. The Smithsonian leadership planned a $30 million renovation to begin in 2013. Estimated initially to take two years, the expected changes including restoring vaulted ceilings in the exhibition halls and an upgrade to building components to support exhibit programming with additional electrical, technological, and structural capacity.

The project finished close to the anticipated time, and the Renwick opened a show in November 2015. Record-setting crowds flocked to the show and gave it raves. But the illuminated red signs over the building's main door and at street level drew the ire of the federal city oversight agencies. The NCPC, National Park Service and the Commission of Fine Arts charged the Smithsonian with skirting preservation laws. The agencies claimed they lacked the opportunity to vet the signs and described them as "'incompatible with the historic character' of both the building and the neighborhood." Local urban planner Peter Rizzo expressed a popular opinion of the critics. "The sign looks like it was taken off the Las Vegas Strip," Another critic said, "They are all hideous and not appropriate." The Smithsonian's lawyers observed that the sign attached to the building remained until 2017. Many commenters to the online version of the articles supported the signage and complained about the various oversight agencies.[25]

Chapter Notes

Introduction

1. Barbara Rose, "Washington Scene," *Art-Forum* 6.3 (November 1967): 57; Leslie Judd Ahlander, "The Emerging Art of Washington," *Art International* 6.9 (November 25, 1962): 30–33; Andrew Hudson, "Washington: An 'American Salon' of 1967," *Art International* 11.4 (April 20, 1967): 79; Douglas Davis, "Washington on the Rise," *Arts* 43.4 (February 1969): 50; Benjamin Forgey, "Art Tremors in Washington," *Washington Star*, September 24, 1972, 10; Jonathan P. Binstock, *Sam Gilliam: The Making of a Career, 1962–1973* (PhD diss., University of Michigan, 2000) 44–54; Sidney Lawrence, "Not Twin Cities," *Washington Review of the Arts*, January/February 1988, 39.

Chapter 1

1. "The Washington Art Club," *Washington Post*, March 18, 1884, 4; "An Evening with Art," *Washington Post*, March 15, 1892, 6; "A Possible Art Center," *Washington Post*, March 15, 1891, 9; "A New Art Movement," *Washington Star*, January 8, 1891, 8; "Society," *Washington Star*, February 28, 1891, 8.

2. "The Washington Art Club"; "In the Studios," *Washington Post*, December 18, 1898, 17; "Max Weyl," *Washington Post*, July 7, 1914, 5; "Mr. and Mrs. Weyl's Silver Wedding," *Washington Post*, February 10, 1887, 4; "Models on the Stage," *Washington Post*, March 31, 1895, 7; "Boys Wreck Weyl Studio," *Washington Post*, July 27, 1910, 3.

3. "Death of James C. McGuire," *Washington Star*, August 27, 1888, 3; "Their estates disposed of," *Washington Post*, September 5, 1888, 6; "Art Notes," *Washington Star*, December 1, 1888, 3; "The McGuire Art Collection," *Washington Star*, December 5, 1888, 3; "An Art Gallery Sold," *Washington Star*, December 12, 1888, 3; "J.C. McGuire died," *Washington Star*, February 16, 1907, 21.

4. "Artists' Banquet," *Washington Star*, March 9, 1896, 10; "Exhibition of historical paintings," *Washington Post*, February 4, 1900, 17; "Annual Exhibition of Washington Artists," *Washington Star*, April 3, 1897, 19; "Society of Artists," *Washington Post*, April 3, 1898, 23; Jean L. Kling, *Alice Pike Barney: Her Life and Art* (Washington, D.C.: Smithsonian Institution Press, 1994), 98; "Hung in the home of Art," *Washington Post*, March 28, 1901, 4.

5. http://www.cornwallhistoricalsociety. org/omeka/exhibits/show/aa/bios/moser; https://americanart.si.edu/artist/james-henry-moser-3432; John Henry Moser, "Thirteenth Annual Exhibition," *Washington Post*, February 20, 1903, E10; "James H. Moser Dead," *Washington Post*, November 11, 1913, 2; "N.Y. Exhibit Enriched by DC Art," *Washington Star*, September 3, 1939, 33.

6. Jean L. Kling, *Alice Pike Barney: Her Life and Art* (Smithsonian Institution Press, 1994), 46–51, 90–98, 131–134; "Assigns Her Estate," *Washington Post*, April 13, 1911, 4; "The World of Society," *Washington Star*, December 13, 1906, 5; "Washington Artists," *Washington Star*, March 18, 1905, 18; "Corcoran Prizes Awarded," *Washington Post*, March 22, 1905, 7; John Henry Moser, "Thirteenth Annual Exhibition," *Washington Post*, February 20, 1903, E10; Sarah Booth Conroy, "Lady Alice—The Spirit of Studio House," *Washington Post*, March 29, 1981, E1.

7. "The Fakir's Christmas Sale," *Washington Post*, December 22, 1890, 4.

8. "Fourteenth Annual Exhibition," *Washington Post*, March 20, 1904, E10; "Beautiful Paintings at Corcoran Gallery," *Washington Post*, April 13, 1913, 11; "Models on the Stage," *Washington Post*, March 31, 1895, 7; "R.N. Brooke Dies in Warrenton," *Washington Post*, April 26, 1920, 3; "News and Notes of Art and Artists," *Washington Star*, December 13, 1913, 7; http://www.askart.com/artist/Richard_Norris_Brooke/25150/Richard_Norris_Brooke.aspx, accessed May 20, 2020.

9. "A New Private Gallery," *New York Times*, April 13, 1888, 4; "Exhibition of Washington Artists' Work," *Baltimore Sun*, March 28, 1901, 6; "Give Their Art Collection," *Baltimore Sun*, December 1, 1903, 1; "T.E. Waggaman Collection," *Baltimore Sun*, December 2, 1903, 2; "For Catholic University," *Baltimore Sun*, December 2, 1903, 8; "Insolvency is Alleged," *Baltimore Sun*, August 24, 1904, 1; "In Marshall's Custody,"

Baltimore Sun, September 15, 1904, 2; "In Marshall's hands," *Baltimore Sun*, September 16, 1904, 2; "Waggaman Art Works," *Baltimore Sun*, December 21, 1904, 2; "The Waggaman Sale," *Washington Star*, January 28, 1905, 1; "Waggaman Sale Goes On," *Baltimore Sun*, January 29, 1905, 2; "Bargains at Waggaman Sale," *New York Times*, June 8, 1905, 4; "Waggaman dead," *Baltimore Sun*, June 28, 1906, 7.

10. John R. Swanton, "Biographical Memoir of William Henry Holmes, 1846–1933," *Biographical Memoirs of the National Academy of Sciences*, Vol. 17, Tenth Memoir (PDF online, facsimile at the NAS); "William Henry Holmes," https://americanart.si.edu/artist/william-henry-holmes-2279, accessed May 20, 2020.

11. "Hung in Home of Art," *Washington Post*, March 28, 1901, 4; "Artists' Reception," *Washington Post*, February 19, 1901, 9; "Corcoran Prizes Awarded," *Washington Post*, March 27, 1901, 10; James Henry Moser, "Annual Art Show," *Washington Post*, March 16, 1902, 26; James Henry Moser, "Annual Art Show," *Washington Post*, February 8, 1903, 26; "Washington Artists," *Washington Star*, March 18, 1905, 18; "Corcoran Prizes Awarded," *Washington Post*, March 22, 1905, 7; "Washington Artists," *Washington Star*, March 18, 1905, 18; "Nichols Wins Art Prize: Awarded $100 at Water-color Club's Annual," *Washington Post*, November 25, 1906, 8; "Beautiful Paintings at Corcoran Gallery," *Washington Post*, April 13, 1913, 11; "Art Exhibition Opened," *Washington Post*, April 4, 1915, 17; "Throng at Art Gallery," *Washington Post*, February 21, 1916, 4.

12. Lelia Mechlin, "Art and Artists of the Capital," *Washington Star*, January 14, 1921, 11; Ada Rainey, "Art Exhibit of District Body Opens," *Washington Post*, January 3, 1927, F5; Leila Mechlin, "Washington Artists Exhibit Opens," *Washington Star*, February 5, 1933, 14; Leila Mechlin, "Washington Artists Exhibit Opens," *Washington Star*, January 28, 1934, 14; Leila Mechlin, "Washington Artists Exhibit Opens," *Washington Star*, January 8, 1936, A-4.

13. "Donated Articles Sold," *Washington Star*, May 21, 1916, Part 2, 18; "To Welcome Its Friends," *Washington Star*, May 27, 1916, 12; "Beautiful New Home of the Arts Club of Washington," *Washington Star*, October 8, 1916, 4; "Beautiful New Home of the Arts Club of Washington," *Washington Star*, October 8, 1916, 4; "City News in Brief," *Washington Star*, July 27, 1917, 18; "Society," *Washington Star*, April 27, 1919, 43; "Musical Mentions," *Washington Star*, March 21, 1920, 51; David Montgomery, "100 Canvases for 100 Years," *Washington Post*, May 6, 2016, 4; "Activities of Arts and Artists," *Washington Star*, October 7, 1928, 32; "Afternoon Tea Opens Arts Club Exhibition," *Washington Star*, April 2, 1933, 30.

14. Jane Watson Crane, "Washington, Rodin Exhibits worth seeing," *Washington Post*, October 20, 1946, 85; "Towers of Georgetown…,"

Washington Post, December 6, 1949, B2; "Mary Snow Will Be First…," *Washington Post*, April 13, 1951, 22; Jane Watson Crane, "The Show Isn't Up to Its setting," *Washington Post*, June 24, 1951, L5; "84 Paintings, 22 Sculptures Win Honors," *Washington Post*, March 3, 1952, B2; "Washington Sculptors Group," *Washington Star*, June 8, 1947, 41; Jane Watson Crane, "Area Sculptors to Exhibit Work…," *Washington Post*, March 22, 1948, 10; "Biggest District Group," *Washington Star*, August 7, 1950, 2; Leslie Judd Portner, "Three Galleries Deserve Attention," *Washington Post*, June 19, 1955, E7; Leslie Judd Portner, "New Proof of Area Artists' progress," *Washington Post*, March 24, 1957, E7; "The Rambler," *Washington Star*, March 22, 1957, 21; Florence S. Berryman, "Art News of the D.C. Area," *Washington Star*, February 8, 1959, 59; Frank Getlein, "Arts and Artists," *Washington Star*, February 10, 1963, 36; "Annual Exhibit is Planned at Smithsonian," *Washington Star*, November 27, 1964, 65.

15. "Tomorrow in Washington," *Washington Star*, December 7, 1966, 73; "Tomorrow in Washington," *Washington Star*, December 12, 1966, 55; Benjamin Forgey, "Washington Galleries," *Washington Star*, January 22, 1967, 51; "Tomorrow in Washington," *Washington Star*, September 4, 1967, 43; "Multiple pages," *Washington Sculptors Group*, https://washingtonsculptors.org/member-gallery/view-gallery/, accessed May 1, 2020.

16. Mark Jenkins, "Robert Kuhn, a reclusive…," *Washington Post*, December 6, 2012, E7; "The Sculptor's Home," *Washington Star*, October 3, 1976, 141; "Robert Kuhn," *Washington Post*, July 21, 2000, B6; John Bryans, "Hang It All?" *Washington Star*, March 5, 1965, 12; "Tomorrow in Washington," *Washington Star*, February 3, 1969, 39; "Weekend in Washington," *Washington Star*, February 2, 1974, 27; "Paul W. Murphy," *Washington Post*, May 22, 1993, D4; Benjamin Forgey, "Alice Pike Barney," *Washington Star*, February 12, 1978, E3.

Chapter 2

1. "Picture Thieves Could Find No Market in Washington," *Washington Post*, October 30, 1911, 5; "Stole 'Mona' Unaided," *Washington Post*, December 4, 1913, 18; Jo Ann Lewis, "Museums and Galleries," *Washington Post*, October 23, 1987, W19.

2. Leslie Johnston, "Johnston Geneology," Emails with author, May 1, 2020; "Some local artists," *Washington Star*, December 16, 1893, 17; "Arts and artists," *Washington Star*, June 20, 1896, 14; "For Cuban Liberty," *Washington Star*, June 26, 1897, 1; "Art and Artists," January 1, 1898, 17; "Art and Artists," March 29, 1898, 8; "Art and Artists," September 22, 1906, 23; "Arts and Artists," *Washington Times*, March 24, 1907, 11; "Arts and Artists," *Washington Star*, June

20, 1907, 14; "Art Exhibition," *Washington Star*, March 29, 1912, 2; "Funeral at Riverdale," *Washington Star*, June 19, 1918, 7.

3. "The Exhibit of Miss Nourse's Work," *Washington Post*, February 15, 1894, 2; "Arts Notes," *New York Times*, January 8, 1895, 9; "News and Notes of Arts and Artists," *Washington Star*, April 20, 1895, 9; "News and Notes of Arts and Artists," *Washington Star*, February 23, 1900, 25; James Henry Moser, "Art Topics," *Washington Post*, June 23, 1901, 27; James Henry Moser, "Thirteenth Annual Exhibition," *Washington Post*, February 8, 1903, 34; "News and Notes of Arts and Artists," *Washington Star*, January 6, 1906, 25; "$1,000 Clark Art Prize Goes to W.L. Metcalf," *New York Times*, February 3, 1907, 8; "News and Notes of Arts and Artists," *Washington Star*, December 24, 1910, 3; "News and Notes of Arts and Artists," *Washington Post*, January 11, 1911, 7; Leila Mechlin, "News and Notes of Arts and Artists," *Washington Post*, March 4, 1911, 7; "News and Notes of Arts and Artists," *New York Times*, December 31, 1911; "News and Notes of Arts and Artists," *Washington Star*, November 9, 1912, 9; "News and Notes of Arts and Artists," *Washington Star*, January 25, 1913, 9.

4. "A Woman Cried," *Washington Post*, August 18, 1891, 2; "Mr. Nicolaides Answers Her Charges," *Washington Post*, September 19, 1891, 6; "Their Union Not a Union," *Washington Post*, January 2, 1893, 8; "Calls Himself a Modern Job," *Washington Post*, January 12, 1893, 5; "City News in a Nutshell," *Washington Post*, March 18, 1893, 4; "City News in a Nutshell," *Washington Post*, December 3, 1893, 7; "Her Third Suit for Divorce," *Washington Post*, August 6, 1898, 10; "Corcoran Prize Winners," *Washington Post*, May 28, 1914, 4; Gertrude Brigham, "Arts and Artists," *Washington Post*, April 13, 1924, A4; "Art Dealer Succumbs to Long Illness," *Washington Star*, July 27, 1931, 1; "Art Galleries will be opened," *Washington Post*, May 22, 1938, S5; "Kimon Nicolaides, Drawing Teacher," *New York Times*, July 20, 1938, 19.

5. "Veerhoff Galleries," *Washington Post*, February 20, 1891, 8; "Sale of Montague Paintings," *Washington Star*, April 23, 1892, 16; "In Local studios," *Washington Star*, April 28, 1894, 16; "Burr McIntosh in New Role," *Washington Post*, November 29, 1900, 9; "Bequests of W.H. Veerhoff," *Washington Post*, January 28, 1905, 16; "Art Dealer Veerhoff Dead," *Washington Post*, January 22, 1905, 2; "Landscape Exhibition," *Washington Post*, February 14, 1905, 12; https://theframeblog.com/2016/06/09/how-artists-have-used-the-frame-in-the-past-how-they-can-use-it-now/, accessed April 29, 2020.

6. "Bequests of W.H. Veerhoff"; Leila Mechlin, "News and Notes of Arts and Artists," *Washington Star*, November 12, 1910, 9; "Quarters for Capital Club," *Washington Post*, December 29, 1912, 11; Leila Mechlin, "News and Notes of Arts and Artists," *Washington Post*, February 8, 1913, 7; Leila Mechlin, "News and Notes of Arts and

Artists," *Washington Post*, March 14, 1914, 21; Leila Mechlin, "News and Notes of Arts and Artists," *Washington Post*, March 14, 1914, 21.

7. Blanche V. King, "Art Notes," *Washington Post*, January 22, 1940, 22; James Henry Moser, "Art Topics," *Washington Post*, December 15, 1901, 32; "In the Studios," *Washington Post*, January 20, 1901, 19; James Henry Moser, "Art Topics," *Washington Post*, February 28, 1904, ES11; Eugene Scheel, "Art Career Began with Simple Farm Sketches," *Washington Post*, December 26, 2002, VA8; "Lucien W. Powell Dies," *Washington Star*, September 27, 1930, 1; "Mrs. Lucien Powell Dies," *Washington Post*, January 22, 1940, 22.

8. Leila Mechlin, "News and Notes of Arts and Artists," *Washington Post*, March 19, 1916, 69; "Display Ad," *Washington Post*, January 8, 1917, 10.

9. S.J. Venable, "The Framery," *Washington Star*, September 13, 1900, 3; S.J. Venable, "The Framery," *Washington Star*, March 19, 1901, 7; "Notable Art Exhibits," *Washington Post*, March 2, 1902, 16; S.J. Venable, "The Framery," Ad in *Washington Post*, February 5, 1902, 7; Ad in *Washington Star*, February 20, 1902, 5; Ad in *Washington Star*, October 5, 1904, 16; "Two Noble Portraits," *Washington Post*, March 29, 1906, 4; "Stick to First Plan," *Washington Star*, March, 9, 1909, 3; "News Item," *Washington Star*, August, 29, 1909, 15; "Want Ad," *Washington Star*, October 7, 1910, 18; "News and Notes of Arts and Artists," *Washington Post*, January 11, 1911, 7; Leila Mechlin, "News and Notes of Arts and Artists," *Washington Post*, March 4, 1911, 7; Leila Mechlin, "News and Notes of Arts and Artists," *Washington Post*, February 8, 1913, 7; "Capitol's Rotary Club Observes Ladies Night," *Washington Star*, April 27, 1916, 7; "Rotary Club helping Red Cross fund," *Washington Star*, May 3, 1917, 7; "Exhibition of Sketches Extended," *Washington Star*, October 19, 1919, 26; "Ad," *Washington Star*, January 26, 1922, 33; Gertrude Richardson Bingham, "Art and Artists of the Capital," *Washington Post*, November 5, 1922, 60; Gertrude Richardson Bingham, "Art and Artists of the Capital," *Washington Post*, October 7, 1923, 27.

10. Eugene N. White, "The Great American Real Estate Bubble of the 1920s: Causes and Consequences, October 2008," https://www.sv.uio.no/econ/english/research/news-and-events/events/guest-lectures-seminars/Thursday-seminar/2009/Thursday-spring09/white.pdf, accessed May 10, 2020; "Bad Taste Mars All," *Washington Post*, October 15, 1905, J2; Estelle H. Reis, "'Trifles' Are Big Factor in Making Homes Beautiful," *Washington Post*, March 10, 1924, 17; "'Homes Beautiful' Visitors to Total 50,000 by Tonight," *Washington Post*, September 28, 1927, 18; "Students Inspect 'Homes Beautiful' Sponsored by Post," *Washington Post*, October 2, 1927, M26; Nannie Lancaster, "Exhibits to Show How Comfort Pays for Better Homes," *Washington Post*, April 14, 1928, 20; "Homes Beautiful Show," *Washington Post*, April 22, 1928, 6.

11. "Ades Work Shown," *Washington Post*, June 19, 1955, E7; "Samuel Venable," *Washington Post*, September 9, 1959, B-4; Ferdinand Protzman, "A Venable Institution Closes," *Washington Post*, January 8, 1998, B1.

12. Jo Ann Lewis, "Mickelson Looks Back," *Washington Post*, December 15, 1983, D7.

13. "Otto Veerhoff Dies," *Washington Star*, June 28, 1952, A12; "Samuel Venable"; "Sidney Mickelson Dies at 74," *Washington Post*, July 18, 1999, C6.

14. Andrea S. Halbfinger, "'Educated' Show in Stark Setting," *Washington Post*, January 24, 1965, G6; Jim Birchfield, "New Leica Lives up to Reputation," *Washington Star*, March 21, 1965, D5; Andrew Hudson, "Around the Galleries: Major Breakthrough for Capital," *Washington Post*, November 20, 1966, G11; Frank Getlein, "Two Summer Art Shows of Different Interests," *Washington Star*, July 26, 1970, D5; Benjamin Forgey, "The Art Galleries," *Washington Star*, January 25, 1973, D7; Jo Ann Lewis, "Winning Prints," *Washington Post*, August 1, 1981, C3; Jo Ann Lewis, "Mickelson a Picture of the Past," *Washington Post*, December 16, 1999, C1; "Joanna Eagle, "Print collecting can be an 'in' thing to do in...," *Washington Post*, October 11, 1970, 6.

15. "Print collecting can be an 'in' thing to do in...,"; Jo Ann Lewis, "Adding a New Loop to the Old Strip," *Washington Post*, December 2, 1978, C1; Joel Glenn Brenner, "D.C.'s 17th Street Neighbors...," *Washington Post*, January 15, 1994, C1; "Time for a redesign," *Washington Post*, August 17, 2003, K1; Norman Strike. Interview with author. June 14, 2019; Ruth Trevarrow. Interview with author. December 19, 2020.

16. Claudia Levy, "History Repeats Itself on Connecticut Avenue," *Washington Post*, February 16, 1973, D12; Ferdinand Protzman, "A Venable Institution Closes," *Washington Post*, January 8, 1998, B1.

17. "A Venable Institution Closes"; Paul Richard, "On the Edge of Meaning," *Washington Post*, October 1, 1988, C2.

Chapter 3

1. "Clark Collection Action Undecided," *Washington Star*, April 25, 1925, 2; "Clark Gift Means Boon to Art Here," *Washington Star*, August 2, 1925, 1; M.E.P. Bouligny, *A Tribute to W.W. Corcoran of Washington City* (London: Forgotten Books, 2015, 45–78; James Henry Moser, "Art and Artists," *Washington Post*, January 21, 1906, F1; Leila Mechlin, "Clark Collection on View Today," *Washington Star*, March 11, 1928, 4.

2. Luke Mullins, "Crisis at the Corcoran," https://www.washingtonian.com/2012/11/27/crisis-at-the-corcoran/, retrieved February 3, 2019; Jean Lawler Cohen, ed., *Washington Art Matters: Art Life in the Capital 1940–1990* (Washington Arts Museum, 2013), 28.

3. Sarah Cash, ed., *Corcoran Gallery of Art: American Painting to 1945* (Washington, D.C.: Corcoran Gallery of Art, 2012), 27–30.

4. *Ibid.*, 31–33.

5. "Local art exhibition," *Evening Star*, March 7, 1896, 14; "A Notable Display," *Washington Star*, February 9, 1907, 8; "5,250 at the Salon," *Washington Post*, February 18, 1907, 2; "$100,000 Gift to Corcoran Art Gallery," *Washington Star*, February 1, 1921, 17; Paul Richard, "Corcoran Biennial," *Washington Post*, January 16, 1975, C1.

6. "Art Exhibition Next Winter," *Washington Star*, May 2, 1910, 2; "Opening Exhibition," *Washington Star*, December 17, 1912, 3; "Fifth biennial Exhibition," *Washington Star*, December 14, 1914, 3; "Fifth biennial Exhibition," *Washington Post*, December 15, 1914, 2; "Society," *Washington Star*, December 17, 1916, 71; "Sunday is last day for public referendum," *Washington Star*, November 4, 1928, 17; "Corcoran Exhibit Draws High Praise," *Washington Star*, December 3, 1930, 2.

7. Gertrude Richardson Bingham, "Art and Artists of the Capital," *Washington Post*, October 7, 1923, 27; Gertrude Richardson Bingham, "Art and Artists of the Capital," *Washington Post*, January 6, 1924, 13; Eben F. Comino, "Washington Artist Writes of the Corcoran Gallery," *Washington Post*, June 14, 1925, S9.

8. "Milton E. Ailes Buys Home," *Washington Post*, May 27, 1908, 10; "Capital in Sorrow," *Washington Post* (1923–1954); October 31, 1925, 1; "J.H. Himes Insures Self for $1,000,000," *Washington Post*, February 4, 1926, 11; United States Congress, "Joseph H. Himes (id: H000626)," *Biographical Directory of the United States Congress*, accessed April 4, 2020.

9. "Son and Daughter Get White Estate," *Washington Star*, July 27, 1927, 2; Vylla Poe Wilson, "Capital Arts and Artists," *Washington Post*, August 28, 1932, A3; Gertrude Richard Bingham, "Art and Artists of the Capital," *Washington Post*, January 6, 1924, EA8.

10. Ada Rainey, "In the Realm of Art and Music," *Washington Post*, October 5, 1924, S13; "Current News Events," *Washington Star*, January 25, 1925, 24; Lelia Mechlin, "The North Window," *Washington Star*, May 7, 1925, 6; Ada Rainey, "In the Realm of Art and Music," *Washington Post*, May 24, 1925, s1; "Academy of Design Committee Here," *Washington Star*, June 25, 1925, 9.

11. "Art in Washington," *Washington Star*, December 5, 1896, 17; "Water Color Art," *Washington Star*, February 5, 1910, 3; "Beautiful Paintings at Corcoran Gallery," *Washington Post*, April 13, 1913, 11; "Art Exhibition Opened," *Washington Post*, April 4, 1915, 17; "Salon by Art Society," *Washington Post*, February 20, 1916, 10; "Rites for Miss Perrie," *Washington Post*, September 18, 1921, 26; "Arts and Artists," *Washington Post*, August 22, 1920, 32; Lelia Mechlin, "Rites for Miss Perrie," *Washington Post*, September

18, 1921, 26; K.L. Nichols, "Women's Art at the World's Columbian Fair & Exposition, Chicago 1893," http://arcadiasystems.org/academia/cassattxx.html, accessed August 17, 2020.

12. "Beautiful Paintings at Corcoran Gallery,"; "Art Exhibition Opened," *Washington Post*, April 4, 1915, 17; "Society," *Washington Star*, December 19, 1915, 76; "Society," *Washington Star*, May 18, 1919, 18; "200 at Corcoran," *Washington Post*, October 7, 1928, S9; "Gunston School," *Washington Post*, September 25, 1938, T7; "D.C. Pen Women," *Washington Star*, May 4, 1941, D11; https://americanart.si.edu/artist/catharine-carter-critcher-5974, accessed August 17, 2020; Scott Gerdes, "Taos Society of Artists' Catharine Critcher," *The Taos News*, October 5, 2017, https://www.taosnews.com/stories/taos-society-artists-catharine-critcher,43455, accessed August 17, 2020.

13. "Art School New Principal," *Washington Post*, June 21, 1902, 2; "Death of Edmund C. Messer," *Washington Post*, February 16, 1919, 10; "Edmund C. Messer End of Long and Loyal Service," *Washington Star*, April 17, 1918, 7; "Edmund C. Messer Dead," *Washington Star*, February 16, 1919, 10; "N.Y. Exhibit Enriched by DC Art," *Washington Star*, September 3, 1939, 33.

14. Bill Newman. Interview with author. March 1, 2020; John Sherwood, "Hardhats Have Sarah...," *Washington Star*, August 13, 1975, 18; Ron Shaffer, "GSA Yanks Painting of Girl in Bikini," *Washington Post*, August 15, 1975, C1; "Sarah Claus Coming to Town," *Washington Post*, December 20, 1975, D1; John McKelway, "The Real Sarah...," *Washington Star*, February 10, 1976, 21; Ron Shaffer, "Sarah gets Revenge, Publicity," *Washington Post*, February 11, 1976, 21; "The Ear," *Washington Star*, July 9, 1980, 15; Jody Mussoff. Interview with author. December 25, 2020; Walter Hopps, *The Dream Colony* (New York: Bloomsbury, 2017), 213–216.

15. Benjamin Forgey, "Small Is Beautiful," *Washington Post*, July 19, 1984, D7; Michael Welzenbach, "Newman's Digital Drawings," *Washington Post*, April 24, 1985, B7; Michael Welzenbach, "Distortions of Form and Feeling," *Washington Post*, October 20, 1990, D2; Jessica Dawson, "Beast in Show at David Adamson," *Washington Post*, November 23, 2000, C5; Judith Southerland. Interview with author. March 1, 2020.

16. Southerland Interview.

17. Jane Watson Crane, "Big Postwar Exhibition Conservative at Core," *Washington Post*, March 30, 1947, S9; Kenneth B. Sawyer, "D.C.'s Corcoran Art Gallery Awards Prizes for Biennial," *Baltimore Sun*, March 10, 1955, 25; Kenneth B. Sawyer, "The Corcoran Biennial Exhibition," *Baltimore Sun*, January 27, 1957, 25; Frank Getlien, "The Corcoran Biennial," *Washington Star*, January 20, 1963, 106; "Corcoran Biennial Award Winners," *Baltimore Sun*, February 26, 1965, 12; Corcoran Gallery of Art, "Account Book," Reel 2679 (fr. 1068–1109), Archives of American Art; Leslie Judd Ahlander, "Corcoran Biennial Has New Look," *Washington Post*, January 20, 1963, G9.

18. Lincoln Johnson, "Corcoran Biennial is 'spare, cerebral and flamboyant,'" *Baltimore Sun*, March 13, 1975, B1; "Corcoran Biennial: A Retreat in Reverse," *Washington Post*, August 7, 1998, 55; Paul Richard, "Corcoran Biennial," *Washington Post*, January 16, 1979, C1; Joanna Shaw-Eagle, "'Home' Is Built on Fantasy," *Washington Times*, April 2, 2005, B1; Blake Gopnik, "Biennial On a Diet: Can You Get Your Fill?" *Washington Post*, July 30, 2006, N1.

19. Frank Getlein, "Something for Everybody," *Washington Star*, September 10, 1967, D1; "Three Major Sculptures are shown," *Washington Star*, October 7, 1967, 3; Benjamin Forgey, "How to Dig the Big," *Washington Star*, October 7, 1967, E1; Paul Richard, "Bladen's X is an X," *Washington Post*, October 7, 1967, K7; Meryle Seacrest, "An Era Ends," *Washington Post*, July 11, 1969, B1; Ellen Hoffman, "Artist Barnett Newman Dies," *Washington Post*, July 6, 1970, C7; Paul Richard, "Corcoran to Split Gallery, Art School," *Washington Post*, May 29, 1968, B1; Paul Richard, "A Dean Yields," *Washington Post*, March 18, 1969, B1; Meryle Secrest, "A Resignation, an Uproar," *Washington Post*, July 8, 1969, B1; Frank Getlein, "Corcoran: Better Times," *Washington Star*, October 18, 1971, B7; Paul Richard, "Corcoran: Good News and Some Bad News," *Washington Post*, June 4, 1974, B1; Paul Richard, "A Grant for the Corcoran," *Washington Post*, September 30, 1974, B4.

20. Benjamin Forgey, "Corcoran Facing Financial Crisis," *Washington Star*, January 27, 1971, A1; Meryle Secrest, "A Resignation, an Uproar," *Washington Post*, July 8, 1969, B1; Lou and Diane Stovall. Interview with author. March 24, 2019; Benjamin Forgey, "New Look at the Corcoran," *Washington Star*, May 16, 1972, A13; Thomas Crosby, "Art with a punch," *Washington Star*, November 4, 1972, A1; Benjamin Forgey, "Corcoran Affair," *Washington Star*, November 8, 1972, E14; Benjamin Forgey, "Corcoran Dismisses Melzac and Baro," *Washington Star*, December 1, 1972, C1; Bob Arnebeck, "The Art Game in Washington," *Washington Post*, September 17, 1978, 10; Paul Richard, "Doubts, Disappointments and a Crisis in Leadership," *Washington Post*, March 8, 1987, F1; Paul Richard, "Barnett Leaving the Corcoran," *Washington Post*, April 29, 1987, D2; Lou and Di Stovall. Interview with author. March 24, 2019; "Board of Trustee Reports, 1953–1980," https://archive.org/search.php?query=subject%3A%22corl-1%22&and[]=collection%3A%22gwulibraries%22, accessed March 21, 2020.

21. "Doubts, Disappointments and a Crisis in Leadership"; "Barnett Leaving the Corcoran"; "Art Show in D.C.," *Baltimore Sun*, February 28, 1965, D16.

22. Roy Slade, *The Corcoran and Washington Art* (Washington, D.C.: Corcoran Art Gallery, 1976); Frank Getlein, "Area Exhibitions Resuming," *Washington Star*, June 22, 1971, A18; Paul Richard, "The Revivification of an Art Event," *Washington Post*, August 6, 1974, B2.

23. William J. Raspberry, "13th or Not," *Washington Post*, December 13, 1963, A3; Leroy F. Aarons, "Poor Quality Perils Show by Corcoran," *Washington Post*, November 11, 1965, L1; "Readers' Reactions to That Corcoran Show," *Washington Post*, December 12, 1965, G13; Paul Richard, "A Disaster at Corcoran," *Washington Post*, December 3, 1967, H9; "Area Exhibitions Resuming."

24. Diana McClelland, "Firenze House Does Right," *Washington Star*, September 20, 1974, 23; Benjamin Forgey, "It's Not Professor," *Washington Star*, October 13, 1974, 61.

25. Paul Richard, "Washington View Through the Lens," *Washington Post*, October 9, 1976, B1; Elisabeth Stevens, "Art Notes: Winners in wood at the Corcoran," *Baltimore Sun*, October 29, 1978, D14; Paul Richard, "Limelight," *Washington Post*, September 14, 1980, G3; Jo Ann Lewis, "Paint by Numbers...," *Washington Post*, June 18, 1982, C1; Jim Sanborn. Interview with author. March 25, 2020.

26. "Paint by Numbers...,"; Paul Richard, "Doubts, Disappointments and a Crisis in Leadership," *Washington Post*, March 8, 1987, F1; Cohen, ed., *Washington Art Matters*, 138–141.

27. Paul Richard, "New Beginnings at the Corcoran," *Washington Post*, September 25, 1982, D1; Paul Richard, "Contrast at the Corcoran," *Washington Post*, May 11, 1985, G1; Mary Battiata, "The Artists Seen: Opening Night," *Washington Post*, May 13, 1985, B1; Pamela Kessler, "The Corcoran's Crazy Quilt," *Washington Post*, May 17, 1985, W41; Paul Richard, "Barnett Leaving the Corcoran," *Washington Post*, April 29, 1987, D2; Cohen, ed., *Washington Art Matters*, 142.

28. Benjamin Forgey, "Unknown Finds," *Washington Post*, June 8, 1985, G2; Benjamin Forgey, "Portrait of the DC Art Scene," *Washington Post*, June 22, 1985, C2; Sanborn Interview; Richard Dana. Interview with author. March 30, 2020.

29. Documents shows at the "6.13.89" exhibition, Corcoran Gallery of Art/George Washington University, June 2019; Elizabeth Kastor, "Funding Art That Offends...," *Washington Post*, June 7, 1989, C1; Elizabeth Kastor, "Corcoran Decision provokes Outcry," *Washington Post*, June 14, 1989, B1; Andrea Pollan. Interview with author. July 16, 2020; Robert Lehrman. Interview with author. April 30, 2020.

30. "Robert Mapplethorpe: The Perfect Moment," https://archive.org/details/gwulibraries?and[]=Mapplethorpe, accessed May 22, 2020; Elizabeth Kastor, "Gays, Artists to Protest at Corcoran," *Washington Post*, June 16, 1989, B1; Joshua P. Smith, "Why the Corcoran Made a Big Mistake," *Washington Post*, June 18, 1989, G1; Elizabeth Kastor, "Protest at the Corcoran," *Washington Post*, June 17, 1989, D1; James J. Kilpatrick, "The Corcoran's Wise Decision," *Washington Post*, June 19, 1989, A9; Elizabeth Kastor, "Mapplethorpe Aftermath," *Washington Post*, June 23, 1989, F1; Elizabeth Kastor, "WPA to Exhibit Controversial Photographs," *Washington Post*, June 27, 1989, B1; Freeborn G. Jewett, Jr., and David Kreeger, "The Corcoran: We Did the Right Thing," *Washington Post*, June 29, 1989, A24; Jo Ann Lewis, "Mapplethorpe's Transformations," *Washington Post*, July 21, 1989, D1; Don Russell. Interview with author. May 5, 2020.

31. Paul Richard, "Artists Cancel Exhibitions at Corcoran," *Washington Post*, August 30, 1989, A1; Jo Ann Lewis, "Corcoran Gallery's Longtime No. 2 Resigns," *Washington Post*, September 14, 1989, C1; Elizabeth Kastor, "Corcoran Offers 'Regret' on Mapplethorpe," *Washington Post*, September 19, 1989, A1; "The Corcoran's Road from Here," *Washington Post*, December 21, 1989, A28; Kim Masters, "Corcoran Board's Kreeger Resigns...," *Washington Post*, June 27, 1990, B1; Jo Ann Lewis, "Corcoran in Red After Art Debacle," *Washington Post*, October 26, 1990, C1; Jo Ann Lewis, "Corcoran's New Chief, Going Beyond Mapplethorpe," *Washington Post*, November 20, 1990, E1; Lehrman Interview; Pollan Interview.

32. Newman Interview; Southerland Interview; Jo Ann Lewis, "Mr. Levy's Corcoran," *Washington Post*, April 24, 1992, D1; Eric Brace, "Arts' Beat," *Washington Post*, December 28, 1992, D7; Sarah Booth Conroy, "Overture to the Corcoran ball," *Washington Post*, February 27, 1995, B3; Paul Hendrickson, "The Legacy," *Washington Post*, April 20, 1997, G15; Alex Simpson. Interview with author. May 19, 2020; Kriston Capps, "The Final Failure of the Corcoran Gallery of Art," *Washington City Paper*, February 26, 2014, https://www.washingtoncitypaper.com/arts/museums-galleries/blog/13080369/the-final-failure-of-the-corcoran-gallery-of-art, accessed April 20, 2020.

33. Jo Ann Lewis, "Jo Ann Lewis' Best of Art," *Washington Post*, January 1, 1995, G7; "Here & Now," *Washington Post*, July 23, 1995, G3; Nicole Lewis, "Santa Fe by Way of U Street," *Washington Post*, September 3, 1998, D5; Nicole Lewis, "Samuel Bookatz's Master Strokes," *Washington Post*, December 30, 1999, C5; Jo Ann Lewis, "The Many Loves of Evvie Nef," *Washington Post*, May 7, 2002, G7; Adrienne T. Washington, "Weaving life of giving, learning," *Washington Times*, June 7, 2009, A10.

34. Joanna Shaw-Eagle, "Fine art of museum revitalization," *Washington Times*, June 14, 1996, C12; Blake Gopnik, "A Bad Impression," *Washington Post*, September 12, 2003, C1; Jo Ann Lewis, "Art That Really Leaps Out at Viewers," *Washington Post*, June 8, 2003, N9; Dan Dupont, "Statue of Limitations," *Washington Post*, April 6, 2005, C2.

35. Eric Gibson, "Hemicycle to show work of local artists," *Washington Times*, December 29, 1991, D4; Jo Ann Lewis, "Local Artists Modest Show," *Washington Post*, June 22, 1992, B2; Michael O'Sullivan, "Sites for Sore feet," *Washington Post*, June 9, 1996, 111; Joanna Shaw-Eagle, "Fine art of museum revitalization," *Washington Times*, June 14, 1996, C12; Ferdinand Protzman, "ArtSites98," *Washington Post*, July 10, 1998, D4.

36. Elisabeth Stevens, "Inner-City 'Outreach': Urban Museum Crisis," *Washington Post*, June 18, 1972, K1; Maggie Tucker, "Corcoran Program Gives Children," *Washington Post*, July 31, 1993, C5; Marcia Davis, "Arts Help D.C. Children Reach Out to a Broader Landscape," *Washington Post*, December 30, 1995, D1; Southerland Interview; Sally Kauffman, in discussion with author, December 2020.

37. Ferdinand Protzman, "Earning an 'A' in Exterior Decoration," *Washington Post*, March 4, 1999, G4; Lehrman Interview; Theodore Adamstein. Interview with author. July 20, 2020; Luke Mullins, "Crisis at the Corcoran," *Washingtonian*, November 27, 2012; https://www. washingtonian.com/2012/11/27/crisis-at-the-corcoran/, accessed July 20, 2020.

38. Samuel Hoi, "David Levy's Corcoran Legacy," *Washington Post*, June 3, 2005, A22; Stovall Interview; Lehrman Interview; Adamstein Interview; Bob Thompson, "Corcoran Director Quits," *Washington Post*, May 24, 2005, C1.

Chapter 4

1. Lelia Mechlin, "Notes on Arts and Artists," *Washington Star*, December 30, 1923, 11.

2. "Washington is to have a new art gallery," *Washington Star*, January 2, 1921, 20; "History," https://www.phillipscollection.org/about/history, accessed April 15, 2020; "Donor Describes New Art Gallery," *Washington Star*, March 26, 1921, 2.

3. Duncan Phillips, "The Phillips Memorial Art Gallery." *The Art Bulletin* 3, No. 4 (1921): 147–52, accessed May 6, 2020; Paul Richard, "The Man Who Left a Good Impressionist," *Washington Post*, March 15, 1999, A1; "Notes of Arts and artists," *Washington Star*, February 5, 1922, 62; Gertrude Richardson Bingham, "Washington Art and Artists," *Washington Post*, November 12, 1922, 62.

4. Lelia Mechlin, "Notes on Arts and Artists," *Washington Star*, April 6, 1924, 63; Ada Rainey, "Phillips Gallery of Rare Views," *Washington Post*, November 2, 1924, SO13; Lelia Mechlin, "Notes on Arts and Artists," *Washington Star*, November 9, 1924, 57; Lelia Mechlin, "Notes on Arts and Artists," *Washington Star*, January 18, 1925, 54; Lelia Mechlin, "Notes on Arts and Artists," *Washington Star*, February 8, 1925, 52; Ada Rainey, "In the Realm of Art and Music," *Washington Post*, April 19, 1925, SO17.

5. Lelia Mechlin, "Notes on Arts and Artists,"
Washington Star, November 22, 1925, 48; Lelia Mechlin, "Notes on Arts and Artists," *Washington Star*, December 20, 1925, 48; Lelia Mechlin, "Notes on Arts and Artists," *Washington Star*, December 27, 1925, 4; Lelia Mechlin, "Notes on Arts and Artists," *Washington Star*, March 14, 1926, 4; Ada Rainey, "In the Realm of Art and Music," *Washington Post*, February 27, 1927, F5; Lelia Mechlin, "Notes on Arts and Artists," *Washington Star*, May 8, 1927, 56; Ada Rainey, "Art in Washington," *Washington Post*, October 20, 1929, S10; David Barbee, "Phillips Memorial Gallery is Unique," *Washington Post*, January 12, 1930, 15; Kenneth Bredemeier, "Phillips Mansion Sold to Builder," *Washington Post*, February 13, 1986, E1.

6. Ada Rainey, "Phillips Gallery Arranged," *Washington Post*, February 8, 1931, S7; Leila Mechlin, "Notes of Arts and Artists," *Washington Star*, February 28, 1932, 14; Richard Interview.

7. "Capital Schools," *Washington Star*, September 17, 1933, 21; Leila Mechlin, "Notes of Arts and Artists," *Washington Star*, October 1, 1933, 98; "Robert F. Gates and Wife New Gallery Executives," *Washington Post*, October 15, 1933, SM1; Leila Mechlin, "Artists of Three Cities," *Washington Star*, November 17, 1935, F4; Lelia Mechlin, "Farm Art," *Washington Star*, June 20, 1936, 11; "Studio House Opens Art Course," *Washington Post*, September 13, 1936, F8; "Art School, Phillip, Gallery Consolidate," *Washington Post*, May 31, 1937, 5; "Studio House to Become Integral," *Washington Star*, June 5, 1937, 17; "Phillips Gallery And Studio House Form Art School," *Washington Post*, September 12, 1937, E3; "Classes Open at Phillips Gallery Oct. 10," *Washington Post*, October 2, 1938, TT9; *Robert Franklin Gates: Paint What You See*, curated by Jack Rasmussen, January 25–May 24, 2020; "A.U., Phillips Gallery Offer Art Courses," *Washington Post*, April 19, 1942, L10; "Fall Term at Phillips Gallery School," *Washington Post*, September 6, 1942, F7; "Opening of Local Schools of Art," *Washington Star*, September 20, 1942, 61; "Advertisement," *Washington Star*, October 11, 1942, 75; "A.U. Names Calfee Head of Department," *Washington Star*, June 19, 1945, 12.

8. Abby Wasserman, "As an Artist William Calfee," *Washington Star*, December 29, 1978, 102; Erika D. Passantino and David W. Scott, eds., *The Eye of Duncan Phillips: A Collection in the Making* (New Haven: Yale University Press, 1999). 609, 623; Carol Cohn, "Galleries," *Washington Post*, January 5, 1979, W6; Gail Forman, "Master of His Media," *Washington Post*, January 16, 1987, B7; https://www.williamhcalfee.org/about-william.php, accessed May 21, 2020; http://jeffersonplacegallery.com/artists/william-h-calfee/, accessed May 21, 2020; "William H. Calfee, Dies," *Washington Post*, December 7, 1995, C5.

9. Leslie Judd Portner, "A.U. Gallery Honors

Robert Gates," *Washington Post*, October 27, 1957, E7; "Robert Franklin Gates," *Washington Post*, March 14, 1982, D5; *Robert Franklin Gates: Paint What You See*; Jack Rasmussen. Interview with author. April 17, 2020.

10. Jules Heller and Nancy G. Heller, *North American Women Artists of the Twentieth Century: A Biographical Dictionary*. (London: Routledge, 2013), 48; Louise George, "Sarah Marindah Baker," Catalogue of the Sarah Baker show at the Phillips Collection in May 1977; http://www.lsdart.com/assets/Artist/Baker_Sarah.pdf, accessed March 22,2020; Vylla Poe Wilson, "Art and Artists in Washington," *Washington Post*, March 12, 1933, S7; "New exhibit of Drawings at Corcoran," *Washington Post*, March 20, 1938, TS5; Jane Watson, "Art Gallery One of Many Raid Refuges," *Washington Post*, February 7, 1943, L4; "Washington Artist at Whyte Gallery," *Washington Star*, November 21, 1943, 45; Jane Watson, "Baker, Day Seen at Galleries," *Washington Post*, March 11, 1945, S5; Jane Watson Crane, "Art," *Washington Post*, February 1, 1948, L5; Florence S. Berryman, "Arts and Artists," *Washington Star*, January 14, 1951, 48; Florence S. Berryman, "Art," *Washington Star*, April 22, 1951, C3; Andrea O. Cohen, "High Priestess of Area Artists," *Washington Post*, April 2, 1972, K8; "Sarah Baker," *Washington Post*, April 20, 1983, C7.

11. "Summerford in N.Y. Exhibit," *Washington Post*, August 19, 1956, E7; Manuel Baker, "Appraising the Arts," *Washington Post*, October 27, 1958, A10; Leslie Judd Ahlander, "Busy Kainen in Three Shows Here," *Washington Post*, November 12, 1961, G6; "Transition from Gray Slabs to Color," *Washington Post*, May 14, 1967, L8; Jo Ann Lewis, "Ben Summerford," *Washington Post*, December 19, 1982, G1; John Anderson and Robert Bettmann, Jefferson Place Gallery, http://jeffersonplacegallery.com/artists/ben-joe-summerford/, accessed May 21, 2020; Pamela Kessler, "Abstractions of a D.C. Past," *Washington Post*, April 15, 1988, WE49; Paul Richard, "Capitalizing the Canvas," *Washington Post*, March 2, 2008, M3.

12. "Heller Collection Shown at Corcoran," *Washington Post*, February 22, 1954, 17; Benjamin Forgey, "Art: Harmonious Paintings," *Washington Star*, April 4, 1971, "Lawrence Jonas Heller, DC native," *Washington Post*, May 5, 1971, B9; Tucson Museum of Art, https://tucsonmuseumofart.org/, accessed May 22, 2020.

13. Ada Rainey, "Interesting Brazilian Paintings Shown in Exhibition Now on View," *Washington Post*, April 12, 1931, S7; Ada Rainey, "2 Rooms Given to Works of Marjorie Phillips," *Washington Post*, May 10, 1931, S9; "Recent Achievements of American Painters," *Washington Post*, October 22, 1933, SM11; "Exhibit Shows New Art Trends," *Washington Post*, November 26, 1933, SM10; "'American Scene on Canvas,' Decided Trend Toward a Distinct ..." The *Washington Post*, February 4, 1934, A11; Vylla Poe Wilson, "Outstanding Works of Members of Washington Society of Artists," *Washington Post*, January 13, 1935, MR5; Alice Graeme, "Phillips Art Gallery," *Washington Post*, November 17, 1935, H5; Leila Mechlin, "Artists of Three Cities," *Washington Star*, November 17, 1935, 66; "Gates and Acheson Showing in Studio House," *Washington Star*, March 14, 1936, 9.

14. "Two Art Exhibits Open Tomorrow," *Washington Star*, November 20, 1936, 43; Alice Graeme, "Leading Artists' Work on View," *Washington Post*, November 21, 1937, TS6; Leila Mechlin, "Notes of Arts and Artists," *Washington Star*, November 13, 1937, 15; Leila Mechlin, "Notes of Arts and Artists," *Washington Star*, November 28, 1937, 77; Leila Mechlin, "Notes of Arts and Artists," *Washington Star*, May 15, 1938, F5; "Phillips Gallery Opens Show by Students Today," *Washington Post*, May 22, 1938, TS5; Alice Graeme, "Phillips Art Gallery Shows New Exhibitions," *Washington Post*, June 5, 1938, TT4; Alice Graeme, "Passing of Studio House Blow," *Washington Post*, October 30, 1938, TS6.

15. "Phillips Art Gallery Shows New Exhibitions," *Washington Star*, October 12, 1939, 1; Alice Graeme, "Phillips Art Gallery Shows New Exhibitions," *Washington Post*, November 19, 1939, L6; Leila Mechlin, "The Art World," *Washington Star*, May 15, 1940, F6; Alice Graeme, "Local Artists Display at Phillips," *Washington Post*, June 2, 1940, AM8; Leila Mechlin, "Phillips Memorial Gallery Reopens," *Washington Post*, October 6, 1940, AM7; "Phillips Gallery Will Again Hold Its Christmas Sales Exhibition," *Washington Post*, November 3, 1940, AM7; Ada Rainey, "Christmas Show Stirs Interest," *Washington Post*, November 29, 1942, L4; Katrina Van Hook, "Art Show Items for Sale," *Washington Post*, December 16, 1945, B6; Jane Watson Crane, "Artists Like Prizes, Publicity," *Washington Post*, August 11, 1946, S4.

16. Ada Rainey, "Phillips Gallery Shows Jacob Lawrence," *Washington Post*, February 22, 1942, L4; Florence S. Berryman, "Arts and Artists," *Washington Star*, April 6, 1947, 44; Jane Watson Crane, "Two Exhibitions of Modern Art Here," *Washington Post*, December 25, 1949, S7; Jane Watson Crane, "Article 6—No Title," *Washington Post*, September 3, 1950, L3; Leslie Judd Portner, "A Challenge to the Spectators," *Washington Post*, March 30, 1952, L5; "News of Artists and Exhibitions," *Washington Star*, November 9, 1952, 106; Dorothy R. Kidder, "Avery Shows Full Seasoning," *Washington Post*, February 15, 1953, L6; Leslie Judd Portner, "Two Exhibitions on View at Phillips Gallery," *Washington Post*, March 29, 1953, L3; Harriett Griffiths, "Phillips Shows Local Artists," *Washington Post*, August 1, 1953, 76.

17. Harriett Griffiths, "Art News," *Washington Star*, August 1, 1954, 108; Florence Berryman, "Arts and Artists," *Washington Star*, February 19, 1961, 43; Jean White, "Duncan Phillips Policy,"

Washington Post, May 12, 1966, B4; Paul Richard, "Futurists Were Behind Times," *Washington Post*, December 17, 1967, K9; Carroll Greene, Jr., "Art," *Washington Post*, January 26, 1969, 146; Jacob Kainen, "A painting seems to have more meaning," *Washington Post*, March 14, 1971, 25.

18. Paul Richard, "At the Phillips," *Washington Post*, December 8, 1971, B1; Paul Richard, "Mixed and Mysterious," *Washington Post*, December 7, 1972, L19; Benjamin Forgey, "Phillips Annual Show, Let's Give It Two Cheers," *Washington Star*, December 3, 1972, 97; Adam Bernstein, "CIA Officer and Art Museum Chairman," *Washington Post*, January 26, 2010, B1; "About the University of Maryland Partnership," https://www.phillipscollection.org/about/umd, accessed May 29, 2020; Eric Gibson, "Laughlin Phillips' masterwork," *Washington Times*, November 19, 1991, E1.

19. Jenna Kowalke-Jones, "James McLaughlin Memorial Staff Show," Phillips.org, October 13, 2011; "James McLaughlin Memorial Staff Show," http://blog.phillipscollection.org/2011/10/13/james-mclaughlin-memorial-staff-show/, accessed May 29, 2020; https://www.phillipscollection.org/events/2019-08-31-exhibition-staff-show, accessed May 29, 2020.

20. Michael Welzenbach, "The Aura of Alfred Stieglitz," *Washington Post*, April 8, 1989, C1; Hank Burchard, "Pieces of Eight," *Washington Post*, September 28, 1990, 55; Jo Ann Lewis, "The Impoverished Prints," *Washington Post*, September 17, 1988, C1; Lee Fleming, "Art: The Phillips Branching Out," *Washington Post*, May 13, 1993, C1; Lee Fleming, "Art: Nature's Metallic Luster," *Washington Post*, September 27, 1993, B2; "Eliza Rathbone Retires from Post," *phillipscollection.org*, September 8, 2014, https://www.phillipscollection.org/sites/default/files/press_material/press_release_eliza_rathbone_final.pdf, accessed May 29, 2020; Alice Thorson, "Mid-career show has artist looking at forces of life," *Washington Times*, January 18, 1990, E2; Michael Welzenbach, "Galleries: Paint for Paint's Sake," *Washington Post*, March 4, 1989, C2; Michael O'Sullivan, "Kainen, de Looper Revisited," *Washington Post*, December 6, 2002, WW58; Joe Holley, "D.C. Artist Shaped," *Washington Post*, February 3, 2009, B5; Joan Mayfield. Interview with author. December 21, 2020; Joe Brown, "Paintings with Heart," *Washington Post*, June 5, 1982, C2; David Saltman, "All in the Family," *Washington Post*, January 2, 1985, C9; Pamela Kessler, "Arts Beat," *Washington Post*, December 18, 1987, CN71; "Here & Now," *Washington Post*, December 15, 1996, G3; "The Intersection series 2009–2021," https://www.phillipscollection.org/event/2015-05-28-intersections-5-contemporary-art-projects-phillips, accessed January 21, 2021; Johanna Halford-MacLeod. Interview with author. February 3, 2021.

Chapter 5

1. Leila Mechlin, "Exhibits Reveal Place of Government in Art Field," *Washington Star*, November 7, 1936, B3; "News of Art: Salmagundi Club Show," *New York Times*, October 16, 1937, 17; Leila Mechlin, "Art Notes," *Washington Star*, October 30, 1937, 18; "Rockwell Kent's Greenland Art To Be Shown Here Tomorrow," *Washington Post*, October 31, 1937, F5; "Farley Censorship Hits Kent Mural; New 'Message' to Puerto Rico," *New York Times*, November 2, 1937, 27; Isabel Middleton, "An Uncorrected Impulse," *Washington Post*, November 7, 1937, B8.

2. Toby McIntosh, http://virginianewdealart.com/artist, retrieved March 24, 2019; "Academy of Design Announces Awards," *New York Times*, May 4, 1932, 22; Vylla Poe Wilson, "Portrait Heads by Bessemer Will Go on Exhibit at Library," *Washington Post*, July 14, 1935, SS5.

3. "Art Calendar," *Washington Post*, December 27, 1936, F5; "Arts Club Exhibition…," *Washington Post* December 19, 1937; SS5; Leila Mechlin, "Exhibits Reveal Place of Government in Art Field," *Washington Star*, June 5, 1937, B3; Leila Mechlin, "Art Galleries," *Washington Star*, November 6, 1937, 15; "Modern Interpretative Art Displayed by Milford Zornes," *Washington Post*, June 13, 1937, T6; "Modern Sculpture Beautifully Displayed in Museum of Modern Art Gallery," *Washington Star*, December 18, 1938, F5; "Cherry Blossoms Periled by Chill," *Washington Post*, April 9, 1938, X3; "3 D.C. Artists to Show in Democracy Exhibit," *Washington Post*, April 4, 1940, 19; Auriel Bessemer, "America Must Act," *Washington Post*, June 14, 1940, 14; Lillian Burwell, "Generations: From Margaret Wilkinson & James Burghett Thomas and Hilda Wilkinson Brown to Lilian Thomas Burwell," *International Review of African American Art* 1–3 (2005); Marlene Park, and Gerald E. Markowitz, *Democratic Vistas: Post Offices and Public Art in the New Deal* (Philadelphia: Temple University Press, 1984); https://www.aaa.si.edu/collections/items/detail/gods-will-law-triptych-auriel-bessemer-created-portable-altarpiece-us-armed-forces-16261, retrieved March 25, 2019; "British Art Work to Have Exhibition," *New York Times*, October 16, 1950, 40; Dorothy B. Gilbert, ed., *Who's Who in American Art* (The American Federation of Arts, R.R. Bowker Company, New York, 1963).

4. "Foto-Craft Club Takes Up Portraits," *Washington Star*, January 1, 1950, 33; "Close-Ups and Long Shots," *Washington Star*, April 10, 1966, 42; "All-Aboard," *Washington Star*, May 10, 1981, 70; Jo Du Marshall Roberts, "Seeing the City as we Live It," *Washington Post*, July 25, 1996, DE6; Pradeep Dalal. Interview with author. August 20, 2020; Nicole M. Miller, "Snapshots from D.C.," *Washington Post*, March 8, 2001, C5; "Nestor L. Hernandez, 45," *Washington Post*, May 26, 2006, B6; Lelia Mechlin, "Blake's Art Scene,"

Washington Star, November 6, 1937, B3; "Barnett Aden Gallery Opens Exhibit Tomorrow," *Washington Star*, October 15, 1943, 31; "Hilda Wilkinson Brown, Educator, Artist," *Washington Star*, July 16, 1981, 12; Lelia Mechlin, "Notes of Arts and Artists," *Washington Star*, October 26, 1930, 10; Florence S. Berryman, "Arts and Artists," *Washington Star*, September 7, 1947, E7; Florence S. Berryman, "Arts and Artists," *Washington Star*, June 5, 1949, C2; Jacqueline Trescott, "Chatelaine of Black History," *Washington Star*, June 24, 1973, G1; Benjamin Forgey, "Showing Off 300 Years," *Washington Star*, January 11, 1980, 10; Rebecca Van Diver, "Art Matters," *Callaloo*, Vol. 39, No. 5 (2016); Ada Rainey, "Annual Art Week," *Washington Post*, November 23, 1941, L7.

5. "Art Move Aided by Public Library," *Washington Star*, May 5, 1933, 38; Leila Mechlin, "Notes of Arts and Artists," *Washington Star*, January 7, 1934, 38; "Noted Works of Art Shown by Art League," *Washington Post*, November 19, 1933, SM10; Vylla Poe Wilson, "Shading, Shadows Lend Color to Boyer's Pen and Ink...," *Washington Post*, February 3, 1935, ST5; "Notes of the Art World This Week," *Washington Post*, November 29, 1936, C7; "Tea Party Planned at Little Gallery," *Washington Post*, December 10, 1936, C6; "Estate Notice," *Washington Star*, November 15, 1966, 39.

6. Georgetown Historic District, D.C. Historic Preservation Division, Washington, DC; "Georgetown Eyesore Sparkles Under Carter Touch," *Washington Post*, May 7, 1948, R1; "'Trash to One Is Treasure To Another'" *Washington Post*, September 22, 1946, M3; Jura Koncius, "Destination Design: Georgetown's Book Hill," February 20, 2013; https:// www.washingtonpost.com/lifestyle/home/destination-design-georgetowns-book-hill/2013/02/19/42fb57e8-6704-11e2-9e1b-07db1d2ccd5b_story.html, accessed March 20, 2020; Leila Mechlin, "Fine Tapestries...," *Washington Star*, January 26, 1936, 55; Beth Blaine, "By the Way...," *Washington Star*, January 7, 1937, B3; "Little Gallery Shows Works of Julia Eckel...," *Washington Post*, February 7, 1937, T9; Leila Mechlin, "Sporting art is exhibited," *Washington Star*, December 19, 1937, 86; "Paintings May Be Rented," *Washington Post*, December 26, 1937, T7; "Mrs. Chisholm, Painter, 55, Dies," *Herald Statesman, January 26, 1965;* "Marcella Comès (Winslow) papers, 1915–1982, and undated." Research collections. Archives of American Art, accessed January 8, 2020; Leila Mechlin, "Fine Tapestries...," *Washington Star*, January 26, 1936, 55; Sibilla Skidelsky, "Cubit Trend of Canvases Pronounced," *Washington Post*, April 19, 1936, AA5; "Art Notes This Week," *Washington Post*, December 6, 1936, C6; Alice Graeme, "Mitchell Jamieson's Art Exhibit Depicts Scenes of Virgin Islands," *Washington Post*, April 18, 1937, TR7; "Art Calendar," *Washington Post*, November 7, 1937, F10; Alice Graeme, "Recent Bernice Cross

Paintings," *Washington Post*, March 26, 1939, L6.

7. "Montgomery Officials Defer Rezoning Action," *Washington Star*, March 22, 1932, 5; Herm, "Art's Listening Post," *Washington Post*, October 13, 1935, B5; "Obituary 1—No Title," *Washington Post*, November 4, 1938, 28; "Charles Les Frank, Art Collector, Dies," *Washington Star*, November 4, 1938, 25; Chandler P. Brossard, "Auctioning off Frank's Curios," *Washington Post*, December 3, 1942, B11; "Estate Sale," *Washington Star*, December 3, 1942, B14; "Columbia Heights Arts Club," *Washington Star*, April 11, 1920, 41; "Columbia Heights Arts Club," *Washington Star*, March 13, 1927, 66; "Classified Ad," *Washington Star*, April 20, 1929, 27; "Anton Heitmuller, Dies," *Washington Star*, September 21, 1943, 26; "Heitmuller, Dealer in Art, Historian, Dies," *Washington Post*, September 22, 1943, 8.

8. Alice Graeme, "Print a Month Club Formed in Capital," *Washington Post*, September 29, 1940, A6; Alice Graeme, "Little Gallery Opens Again," *Washington Post*, October 6, 1940, AM7; "D.C. Print Makers Hold Exhibition," *Washington Post*, October 20, 1940, A7; Jane Watson Crane, "One Way to Handle Prize Money," *Washington Post*, October 30, 1949, L5; "Works Purchased," *Washington Post*, January 25, 1953, L5; Helen O'Brien, "Art Juries," *Washington Post*, January 7, 1955, 18; "Local Art Activities," *Washington Post*, February 19, 1961, G5; "Galleries," *Washington Star*, November 1, 1974, 77; "Galleries," *Washington Star*, November 28, 1976, 106.

9. Leila Mechlin, "The Art World," *Washington Star*, October 13, 1940, F6; Florence S. Berryman, "Old Revolutionary Inn is Background...," *Washington Star*, December 29, 1940, F6; Alice Graeme, "24 Exhibit Work at Little Gallery," *Washington Post*, May 4, 1941, L6; "Art Calendar," *Washington Post*, December 13, 1942, L5.

10. *"Art Prize Winners Start Studio Soon," Washington Post, October 3, 1936;* "Art Notes The Week," *Washington Post*, December 6, 1936, C6; "Art Calendar," *Washington Post*, December 27, 1936, F5; Alice Graeme, "Recent Bernice Cross Paintings," *Washington Post*, March 26, 1939, L6; Florence S. Berryman, "Old Revolutionary Inn is Background...," *Washington Star*, December 29, 1940, F6; Jane Watson Crane, "Art Buzzing in Your Capital," *Washington Post*, May 27, 1951, L5; Leslie Judd Portner, "Two More Worthwhile Shows," *Washington Post*, June 21, 1953, L6; "Bader gallery," *Washington Star*, March 6, 1966, 51; "Bernice Cross, Washington Artist," *Washington Post*, August 11, 1996; "'Person Details for Bernice Francena Cross,' Iowa, County Births, 1880–1935," FamilySearch.org, accessed October 19, 2019; "Bernice Cross / American Art," accessed October 19, 2019.

11. "Art calendar," *Washington Star*, December 6, 1942, 62; Florence Berryman, "Exhibition of Washington Artists' Works," *Washington Star*, July 9, 1944, 41; Katrina Van Hook, "Three Group

Art," *Washington Post*, November 18, 1945, B6; Jane Watson Crane, "Mitchell Jamieson Gains Stature," *Washington Post*, February 9, 1947, S9; Florence Berryman, "News of Art and Artists," *Washington Star*, January 23, 1949, 47; Jane Watson Crane, "Miss Cross Spoofs Portraiture," *Washington Post*, April 23, 1950, L3; "Courses at Art Center," *Washington Star*, March 9, 1954, 27; "Adas Israel Exhibit," *Washington Star*, May 13, 1956, 107; "Jamieson Gets University Post," *Washington Post*, September 30, 1959, A17; Jean White, "Artists' 17-country Tour," *Washington Post*, October 9, 1960, B8; Jean R. Hailey, "Area Artist Noted for War Pictures," *Washington Post*, February 6, 1976, C6; Paul Richard, "Darkened Drawings from a Prisoner of Wars," *Washington Post*, December 8, 1979, E1; https://www.history.navy.mil/our-collections/art/artists/mitchell-jamieson.html, retrieved March 27, 2019.

12. Leila Mechlin, "Instruction Announced...," *Washington Star*, December 30, 1945, 29; Leila Mechlin, "Instruction Announced...," *Washington Star*, October 6, 1946, 29; Florence Berryman, "Arts and artists...," *Washington Star*, October 19, 1947, 49; "Obit," *Washington Star*, November 8, 1958, 6; "Maj. Kane Dies," *Washington Post*, November 8, 1958, C2; "Changing Theodora Kane Show at Colony," *Washington Post*, January 3, 1960, E7; Leslie Judd Ahlander, "Five 'Among Washington's Best,'" *Washington Post*, March 5, 1961, G6; Jean R. Hailey, "Theodora Kane, 72, Artist, Teacher," *Washington Post*, September 15, 1977; Richard Slusser, "Theodora Kane, 72, Artist, Teacher," *Washington Post*, September 16, 1977, 23.

13. Leila Mechlin, "The Art World," *Washington Star*, November 7, 1943, L4; Jane Watson, "Prize Winning Work by Students..." *Washington Star*, May 28, 1948, 2; Leslie Judd Ahlander, "The Watercolorists' Best Show," *Washington Post*, March 26, 1961, G7; Leslie Judd Ahlander, "Frederick Drawings Exhibited," *Washington Post*, November 24, 1963, G10; Nancy Moran, "Burlesque Queens Add Bit to Art," *Washington Post*, January 10, 1966, B1; "Dickson Gallery..." *Washington Star*, January 16, 1966, 50; Jane Harada, "Michael Tanzer's Work Shown at Dickson," *Washington Post*, December 14, 1969, 187; "Obituaries," *Washington Post*, June 11, 2004, B5.

14. "Eight Painters Take a Look at Georgetown," *Washington Post*, June 15, 1952, L5; Betty Miles, "Washington Women Plan Art Gallery," *Washington Star*, October 22, 1952 B1; Florence S. Berryman, "News of Artists and Exhibitions," *Washington Star*, November 2, 1952, E7; Leslie Judd Portner, "Christmas Displays," *Washington Post*, December 6, 1953, L6; Leslie Judd Portner, "First of Two Summer Shows Open," *Washington Post*, August 14, 1955, E7; Leslie Judd Portner, "Gallery-Hopping in Georgetown," *Washington Post*, November 17, 1957, E7; "Artist 'Thinks' His Paintings," *Washington Post*, March 11, 1959, D2; "Obelisk to Sell Great Sculptures," *Washington Post*, February 24, 1960, A14; Frank Getlein, "Arts and Artists," *Washington Star*, November 11, 1962, F5; "Kathryn Bibas Roper," *Washington Post*, September 19, 1984, C8; Matt Schudel, "Obituaries," *Washington Post*, December 1, 1999, B7; Matt Schudel, "Florence Bessom Higgs," *Washington Post*, August 15, 2008, B8; Matt Schudel, "Obituaries," *Washington Post*, March 9, 2009, B4.

15. "At Home To Lovers of Art," *Washington Post*, October 24, 1961, B5; Wolf Van Eckhardt, "That Wag Walton," *Washington Post*, December 20, 1964, G1; Dolores Phillips, "Artists as Art Viewers," *Washington Star*, February 17, 1965, 49; Bart Barnes, "William Walton Dies at Age 85," *Washington Post*, December 20, 1994, D5; Dolores Phillips, "Artists as Arts Viewers," *Washington Star*, February 17, 1965, 49; Daniel Poole, "They Live with Art Masterpieces," *Washington Star*, October 22, 1965, D1; "Robert Eichholz, 71, Private Art Collector," *Washington Post*, February 22, 1983, C6; Joan Davidson, daughter of D.C. collector Mercedes Eichholz. Interview with author. April 11, 2020.

16. Gallery Offers Work of Divergent Backgrounds," *Washington Post*, November 14, 1943, L6; "G Place gallery," *Washington Star*, June 13, 1944, B9; Jane Watson, "Wide Choice of Paintings," *Washington Post*, June 18, 1944, S8; Carolyn Bell, "Town Talk," *Washington Post*, November 21, 1944, 12; Jane Watson, "Modern Works at Two Galleries," *Washington Post*, December 17, 1944, S3; "Art Events Set for Week," *Washington Post*, December 31, 1944, S4; "Federal Photographer Offers One-Man Show of Surrealism," *Washington Star*, January 1, 1945, 23; Florence S. Berryman, "The Art World," *Washington Star*, January 4, 1948, C6; "Lazzari Work Up at Crosby Gallery," *Washington Post*, February 10, 1952, L5; "Books in Review," *Washington Star*, April 12, 1953, 120; "Women's Peace Army Urged for Middle East," *Washington Star*, November 13, 1956, A8; "Caresse Crosby, Publisher, Writer," *Washington Post*, January 26, 1970, C5; Michael E. Ruane, "Caresse Crosby, who claimed the invention of the bra," *Washington Post*, November 12, 2014; 1stDibs, https://www.1stdibs.com/furniture/wall-decorations/paintings/abstract-expressionist-painting-listed-artist-david-porter-circa-1951/id-f_3086482/, retrieved March 29, 2019; *Washington Art Matters*, 25.

17. Jane Watson, ""Cezanne's "Three Skulls" Comes to Washington," *Washington Post*, November 20, 1938, TS6; Leila Mechlin, "Mellon Gift Leads Year's Art Progress," *Washington Star*, January 1, 1939, E5; Leila Mechlin, "Art Exhibitions in Which...," *Washington Star*, December 3, 1939, F5; Alice Graeme, "Whyte Gallery Is Closing," *Washington Post*, May 5, 1940, A7; "Whyte Gallery To Stock Works of D.C. Artists," *Washington Post*, September 1, 1940, A10; Alice Graeme, "DC Artists Show at Art Gallery," *Washington*

Post, June 16, 1940, A7; March 1941, "On view at Whyte Gallery 1707 H St, NW," District of Columbia Public Library Vertical File Collection: Art Galleries Whyte; Alice Graeme, "Fifty Washington Painters Show…," *Washington Post*, May 18, 1941, L6; Ada Rainey, "Busy Week on Tap for Lovers of Art in Washington," *Washington Post*, June 7, 1942, L5; "A New Home for Whyte Gallery," *Washington Post*, March 14, 1943, L4; Jane Watson, "Whyte Gallery Lists 2 Shows," *Washington Post*, June 10, 1945, B6; Jane Watson, "Whyte Gallery Welcomed Back," *Washington Post*, February 8, 1948, B6; Florence S. Berryman, "Art," *Washington Star*, February 8, 1948, 40; Florence S. Berryman, "Art," *Washington Star*, December 19, 1948, C2; Florence S. Berryman, "Arts and Artists," *Washington Star*, January 14, 1951, 48; Florence S. Berryman, "Art Notes," *Washington Star*, March 25, 1951, C3; Jane Watson Crane, "Art Buzzing in Your Capital," *Washington Post*, May 27, 1951, L5; "Gates Latest," *Washington Star*, April 12, 1953, E9; Sarah Baker, "Letter to the editor," *Washington Post*, November 13, 1953, 24; Leslie Judd Portner, "Three Galleries Deserve Attention," *Washington Post*, Jun 19, 1955, E7; "James Whyte, Historian, Dies," *Washington Post*, August 14, 1962, B3.

Chapter 6

1. Jane Watson, "Whyte Gallery Welcomed Back," *Washington Post*, February 8, 1948, B6; Leslie Judd Portner, "Baders Mark an Anniversary," *Washington Post*, March 29, 1959, E7; Michael Kernan, "Franz Bader a Home for Art," *Washington Post*, September 13, 1983, B1; "Franz Bader, 90, Sold Art and Books," *New York Times*, 16 September 16, 1994, B8; Florence S. Berryman, "Special Exhibition Opens at Phillips," *Washington Star*, October 15, 1939, 90; Florence S. Berryman, "Art," *Washington Star*, February 8, 1948, 40; Florence S. Berryman, "Arts and Artists," *Washington Star*, January 14, 1951, 48; Jane Watson Crane, "Art Buzzing in Your Capital," *Washington Post*, May 27, 1951, L5.

2. Leslie Judd Portner, "Bader Opens a New Gallery," *Washington Post*, April 4, 1954, T26; Isabelle Shelton, "Fill Your Christmas Stockings," *Washington Post*, November 14, 1954, D14; Leslie Judd Portner, "Three Galleries Deserve Attention," *Washington Post*, June 19, 1955, E7; "Adas Israel Exhibit," *Washington Star*, May 13, 1956, 107; "Bader Gallery Showing Original Eskimo Carvings," *Washington Star*, June 9, 1957, E7; Leslie Judd Portner, "A Virtuoso Printmaker Exhibited," *Washington Post*, June 30, 1957, E7; "Bader Debut," *Washington Star*, September 3, 1957, E7; Leslie Judd Portner, "Baders Mark an Anniversary," *Washington Post*, March 29, 1959, E7.

3. Oral history interview with Pietro Lazzari, 1964. Archives of American Art, Smithsonian Institution, https://www.aaa.si.edu/collections/ interviews/oral-history-interview-pietro-lazzari-12397, accessed March 1, 2019; Jane Watson, "Guild Gives Show at Whyte Gallery," *Washington Post*, August 8, 1943, L6; Jane Watson, "Lazzari Art Gives Natural Impression," *Washington Post*, November 21, 1943, L6; "Pietro Lazzari, Painter, Sculptor and Researcher," *New York Times*, May 3, 1979, 14; "Gotham Hails Lazzeri," *Washington Post*, December 1, 1946, S5; Florence S. Berryman, "The Art World," *Washington Star*, January 4, 1948, C6; "Lazzari Work Up at Crosby Gallery," *Washington Post*, February 10, 1952, L5; "Sculpture Course Set," *Washington Post*, May 16, 1954, F13; Leslie Judd Portner, "Max Burle, Lazzari," *Washington Post*, May 30, 1954, A16; "Lazzari Sculpture Opening 'New' IFA Galleries," *Washington Post*, April 20, 1958, E7; Leslie Judd Ahlander, "Lazzari Drawings Are Refreshing," *Washington Post*, March 24, 1963, G6; Leslie Judd Ahlander, "Show Marks Bader Anniversary, *Washington Post*, March 1, 1964, G6; Jo Ann Lewis, "Pietro Lazzari: Sculptor, Muralist, Painter, Teacher, Actor," *Washington Post*, May 13, 1978, C7; Park, Marlene, and Gerald E. Markowitz, *Democratic Vistas: Post Offices and Public Art in the New Deal* (Temple University Press, Philadelphia, 1984); "Pietro Lazzari," https:// americanart.si.edu/artist/pietro-lazzari-2840, accessed March 1, 2019.

4. Florence S. Berryman, "Art News," *Washington Star*, January 22, 1961, F7; Leslie Judd Ahlander, "Show Marks Bader Anniversary," *Washington Post*, March 1, 1964, G6; Frank Getlein, "Bader Gallery in new Quarters," *Washington Star*, September 13, 1964, D6; Henry Allen, "Granddaddy of Gallery Owners," *Washington Post*, December 20, 1971, C1; Paul Richard, "Of Futures And the Past," *Washington Post*, October 1, 1973, B2; Jo Ann Lewis, "The Bird and the Dirt," *Washington Post*, December 6, 1974, 31; Louise-Lague, "Franz Bader Worried If He's Good Enough," *Washington Star*, September 2, 1977; Paul Richard, "Darkened Drawings from a Prisoner of Wars," *Washington Post*, December 8, 1979, E1; Michael Kernan, "Franz Bader a Home for Art," *Washington Post*, September 13, 1983, B1; Sarah Booth Conroy, "Colorful Calendars for a Year and a Day," *Washington Post*, November 27, 1987, G1; "Franz Bader, 90, Sold Art and Books," *New York Times*, September 16, 1994, B8; "The Franz and Virginia Bader Fund," Art Daily, https://artdaily.cc/news/18702/The-Franz-and-Virginia-Bader-Fund#.X-DWn9hKipc, accessed December 21, 2020; "The Franz and Virginia Bader Fund, Second Act," American University, August 2014, https://www.american.edu/cas/ museum/2014/second-act.cfm, accessed December 21, 2020; Johanna Halford-MacLeod. Interview with author. February 3, 2021.

5. Archives of American Art, "Prentiss Taylor Papers, 1885–1991," detailed description, https:// www.aaa.si.edu/collections/prentiss-taylor-papers-9232/more-information, accessed April 7,

2019; "Langston Hughes," *FBI Records: The Vault*, https://vault.fbi.gov/langston-hughes, accessed April 7, 2019; Aaron Copland, *The Selected Correspondence of Aaron Copland* (New Haven: Yale University Press, 2008) 69–72; Edward Alden Jewell, "Portrait Busts by Reuben Nakian at Downtown Gallery Are Interesting," *New York Times*, March 3, 1933, 15; "Local Events," *New York Times*, July 22, 1934, X7; "Whitney Museum Acquisitions," *New York Times*, January 9, 1935, 17; "Other Shows," *New York Times*, March 13, 1938, 173; University of Arizona Museum of Art, "Master Impressions from the UAMA Collections: Prentiss Taylor and the Scottsboro Trial," Exhibition January 28-April 28, 2010; https://artmuseum.arizona.edu/events/event/master-impressions-from-the-uama-collections-prentiss-taylor-and-the-scottsboro-trial, accessed April 7, 2019; "20 Artists Given Prizes," *Washington Star*, April 14, 1935, 14; Leila Mechlin, "Twin Exhibits of Work…," *Washington Star*, December 15, 1935, F5; Leila Mechlin, "Vivid Modern Art…," *Washington Star*, April 17, 1938, F5.

6. Prentiss *Taylor*, "Art as psychotherapy," *American Journal of Psychiatry 108:8 (February 1, 1950) 599–605;* Jane Watson Crane, "20 Artists Given Prizes," *Washington Post*, February 1, 1948, L5; Isabelle Shelton, "Fill Your Christmas Stockings," *Washington Post*, November 14, 1954, D14; Leslie Judd Portner, "A Virtuoso Printmaker Exhibited," *Washington Post*, June 30, 1957, E7; Leslie Judd Portner, "Prentiss Taylor Show a Pleasure," *Washington Post*, May 18, 1958, E7; Frank Getlein, "Sloan Solo," *Washington Star*, May 5, 1963, C5; Frank Getlein, "Bader Gallery in New Quarters," *Washington Star*, September 13, 1964, D6; Meryle Secrest, "Jerry McMillan: Taylor at Bader," *Washington Post*, May 1, 1971, E6; Benjamin Forgey, "A Virtuoso Talent Finds Firm Footing," *Washington Post*, January 18, 1981, F2; Jo Ann Lewis, "In a Different Light," *Washington Post*, June 8, 1998: D1; "Prentiss Taylor," https://americanart.si.edu/artist/prentiss-taylor-4751, accessed April 10, 2019.

7. Florence S. Berryman, "Barnett-Aden Group Show," *Washington Star*, March 25, 1945, 46; "Art for Home Is Emphasized in Aden Show," *Washington Post*, March 16, 1947, S9; Janet Gail Abbott, *The Barnett Aden Gallery: A Home for Diversity in a Segregated City* (PhD diss., Penn State University, 2008) 28–32, 40–54; Smithsonian Museum Archives of Art Transcript, Autobiographical Writing by Alma Thomas Concerning James W. Herring and Alonzo Aden, Transcribed and Reviewed by Digital Volunteers. October 27, 2017; "Art to be Exhibited," *Washington Star*, January 25, 1931, 18; "African Art Shown," *Washington Star*, December 20, 1932, 35; "Child Art Shown," *Washington Star*, February 20, 1938, F5; "Mystery Veils Resignation of H.U. Curator," *Afro-American*, April 3, 1943, 10; "Segregation in Washington" [1948] (Washington,

DC: National Committee on Segregation); James V. Herring, quoted by David Driskell, interview by Janet Gail Abbott, April 2002. Driskell was an art student at Howard during the early 1950s and worked part time at the Barnett Aden Gallery, where he became close to Herring and Aden.

8. "New Art Gallery Opens Here," *Washington Star*, October 24, 1943, 41; J.G. Abbott, 3, 17; "Pets and Personages," *Washington Star*, December 19, 1943, 42; Jane Watson, "Pacific, Canada, Latin America Exhibits Now Merit Attention," *Washington Post*, June 3, 1945, B6; Florence S. Berryman, "Barnett-Aden Group Show," *Washington Star*, March 25, 1945, 46; *Karla Araujo*, "Against All Odds," Martha's Vineyard Magazine, *www.mvmagazine.com*, accessed March 20, 2017.

9. "Lois Mailou Jones: The Grande Dame of African-American Art." *Woman's Art Journal.* 8 (2): 32. doi:10.2307/1358163. JSTOR 1358163; Leila Mechlin, "Arts Club Exhibition…," *Washington Star*, November 12, 1939, 75; "Women's Group Awards …," *Washington Post*, November 12, 1940, 15; "Cikovsky's Painting with Virginia Setting…" *Washington Star*, January 26, 1941, 2; Leila Mechlin, "The Art World," *Washington Star*, January 9, 1944, 46; Florence S. Berryman, "Exhibitions of Prints and Drawings," *Washington Star*, July 15, 1945, 35; Katrina Van Hook, "Art Critic Lauds Howard University…," *Washington Post*, April 28, 1946, B2; Florence S. Berryman, "News of Art and Artists," *Washington Star*, April 6, 1947, 44; Florence S. Berryman, "Library Survey of Negro Art," *Washington Star*, February 15, 1948, 48; Florence S. Berryman, "Rare Books on View…," *Washington Star*, August 1, 1948, C2; Christine Miner Minderovic (1997); Jones, Lois Mailou. *St. James Guide to Black Artists.* (Detroit: St. James Press, 1997) 285–288; "Today's events," *Washington Post*, April 24, 1965, E4; Eric Gibson, "Jones: Portrait of an Artist Coming of Age…," *Washington Times*, January 30, 1990, E3; Eleanor Kennelly, "Lois Mailou Jones: Legacy…," *Washington Times*, November 12, 1995, D4; Denise Barnes, "Moved by the Spirit…," *Washington Times*, May 15, 1999, D1; Lee Fleming, "What Becomes a Legend Least?" *Washington Post*, October 7, 1994, B1.

10. "Second Anniversary," *Washington Star*, October 28, 1945, 43; "John Brown's struggles theme of Lawrence Show," *Washington Star*, October 6, 1946, 29; "Aden Gallery, Which Wouldn't Quit, To Hold 17th Anniversary Art Show," *Washington Post*, October 14, 1960, C6; "Naomi Aden, Ex-Teacher, Dies Here," *Washington Post*, June 20, 1956, 16; J.G. Abbott, 9; Florence S. Berryman, "News of Art and Artists," *Washington Star*, August 6, 1950 C3; Leslie Judd Portner, "Aden Blazes a New Trail," *Washington Post*, August 29, 1954, SA11; William McPherson, "Alonzo Aden Wins Gallery Accolade," *Washington Post*, March 9, 1961, D2.

11. "Artists and Exhibitions," *Washington*

Star, March 28, 1954, E10; "Artists and Exhibitions," *Washington Star*, February 19, 1956, E5; "College Art Service at Howard University," *Washington Star*, December 14, 1958, B7; "Art News," *Washington Star*, September 8, 1959, D4; "Art News," *Washington Star*, September 8, 1960, F8; "Art and Artists," *Washington Star*, May 13, 1962, F7; "Art: De Looper and the Anti-Painter," *Washington Star*, September 15, 1968, L3; Jacqueline Trescott, "The Seasons, the flowers, the sea...," *Washington Star*, August 29, 1971, F3; Ben Forgey, "A Charming 'Young' Painter," *Washington Star*, April 27, 1972, C10; Benjamin Forgey, "At 80, life Can Be Beautiful," *Washington Star*, May 5, 1976, B1; Benjamin Forgey, "Alma W. Thomas Dies," *Washington Star*, February 25, 1978, B1.

12. "Obituary 7," *Washington Post*, October 17, 1961, B5; "Final rites held for man who made 'art for everybody,'" *Afro-American*, October 28, 1961, 18; Frank Getlein, "Art and Artists," *Washington Star*, March 4, 1962; Samuel L. Green, "'Dean' of Black Art Educators Dies in Washington, D.C.," *Afro-American*, A2, 1969, 5; Abbott, 118; Carla Hall and Don Shirley, "Art in Search of a Gallery," *Washington Post*, October 13, 1978, B3.

13. Jacqueline Trescott, "Black Art Nets $6 Million," *Washington Post*, December 4, 1989, B3; Esther Iverem and Henry Allen, "Prized Art Will Return to District," *Washington Post*, October 2, 1997, B1; Michael O'Sulline, "A Quietly Subversive Display...," *Washington Post*, February 6, 2009, T19.

Chapter 7

1. "'Uncensored', Little, Is of Utmost Timeliness," *Washington Post*, July 6, 1944, 9; Florence Byrnes, "Culture Comes at $5 a Share These Days at Historic Walsh Mansion," *Washington Post*, May 5, 1946, S3; Betty Miles, "Dreams of Artistry Come True," *Washington Star*, September 22, 1946, C3; "Classes to Start," *Washington Star*, January 16, 1951, 24; Sonia Stein, "Workshop Turns Reluctant Novices," *Washington Post*, May 14, 1950, S10; "Workshop Center of the Arts," *Washington Star*, January 15, 1950, 32; "Workshop Center of the Arts," *Washington Star*, May 14, 1950, 55; "Workshop Center Auction," *Washington Star*, December 11, 1949, 63; "Auction Gives $2,000 Boost," *Washington Post*, December 25, 1949, 15; "Art Workshop Losing Home," *Washington Post*, December 18, 1951, 15; "Workshop Classes in New Home," *Washington Star*, October 7, 1952, 26.

2. Florence S. Berryman, "News of Artists and Exhibitions," *Washington Star*, November 2, 1952 E7; Florence S. Berryman, "News of Arts and Artists," *Washington Star*, October 11, 1953, 113; Leslie Judd Portner, "Art in Washington," *Washington Post*, February 1, 1953, L5; Ann Kessler, "In the 1950s, Connecticut and Albemarle was a shopping destination," https://www.foresthillsconnection.com/news/in-the-1950s-connecticut-and-albemarle-was-a-shopping-destination/, accessed May 3, 2019; "Workshop Center Auction," *Washington Star*, December 11, 1949, 63; Betty Miles, "Versatile Artist," *Washington Star*, June 19, 1953, B2; Wendell P. Bradley, "Art Workshop Closes," *Washington Post*, April 10, 1956, 29.

3. Lon B. Tuck, "Artist Morris Louis Dies of Cancer," *Washington Post*, September 8, 1962, C3; James McC. Truitt, "Art-Arid D.C. Harbors Touted 'New' Painters," *Washington Post*, December 21, 1961, A2; "Louis Honored by One-Man Show," *Washington Post*, September 29, 1963, G8; Andrew Hudson, "Belated Tribute to a Washington Pioneer," *Washington Post*, March 12, 1967, K1; David A. Jewell, "Artist's Father Sues Son's Widow Over Estate Valued at $1 Million," *Washington Post*, July 29, 1967, A1; Sanford J. Ungar, "The Disputed Legacy of Morris Louis," *Washington Post*, January 4, 1971, A1; Benjamin Forgey, "A Belated but Deserved Tribute to Morris Louis," *Washington Star*, September 12, 1976, G1; Michael Fried, *Morris Louis* (NY: Abrams, 1971) 9–11; Michael Dolan, "A History of a Very Round Place...," *Washington Post*, September 2, 1990, SM19; "Pair of Millionaires...," *Washington Post*, October 14, 1900, 20; Katharine M. Brooks, "Walsh House was Part of a brilliant Era," *Washington Star*, November 12, 1951, 22; "Mrs. T.F. Walsh Dies in Hotel," *Washington Star*, February 25, 1932, 2; "D.C. Red Cross Drive..." *Washington Post*, June 23, 1940, 14; Leslie Judd Portner, "Two More Shows Worth a Visit," *Washington Post*, July 6, 1952, L5; Leslie Judd Portner, "Two More Worthwhile Shows," *Washington Post*, June 21, 1953, L6; Leslie Judd Portner, "Six Galleries Have New Shows," *Washington Post*, January 29, 1956, E7; Leslie Judd Portner, "Aden Blazes a New Trail," *Washington Post*, August 29, 1954, E7; Leslie Judd Portner, "New Corcoran Show Has its Limits," *Washington Post*, April 12, 1953, L3; Florence Berryman, "Artists and Exhibitions," *Washington Star*, October 23, 1955, E9; Paul Richard, "The Catalyst for Color Painters," *Washington Post*, April 8, 1972, C7.

4. Leslie Judd Portner, "Art in Washington," *Washington Post*, May 18, 1958, E7; "Big Pictures Fit in Little Rooms," *Washington Post*, January 28, 1958, B5; Leslie Judd Ahlander, "From Abstraction to the Image," *Washington Post*, June 4, 1961, G6; Andrea S. Halbfinger, "Color Alone Can Make The Viewer a Bit Tired," *Washington Post*, February 7, 1965, G7; Paul Richard, "Art Invades P Street: 4 Galleries in 1 Block,'" *Washington Post*, July 30, 1967, D1; John Anderson, "Making the Scene: The Jefferson Place Gallery and Washington, DC," http://jeffersonplacegallery.com/, accessed April 2, 2020; Frank Getlein, "Colorful Modern Art Show," *Washington Star*, June 27, 1965, D5; Andrew Hudson, "Gallery's Permanent

Collection Delights," *Washington Post*, April 3, 1966, G7; Andrew Hudson, "The Biennial," *Washington Post*, February 26, 1967, K1; Andrew Hudson, "Belated Tribute to a Washington Pioneer," *Washington Post*, March 12, 1967, K1; Jean Lawlor Cohen, "When the Washington Color School Earned Its Stripes," *Washington Post*, June 26, 2015, C1; Barbara Gold, "D.C. Art More Than Memorials," *Baltimore Sun*, May 17, 1970, D20; William Grimesjan, "Kenneth Noland, Abstract Painter of Brilliantly Colored Shapes, Dies at 85," *New York Times*, January 6, 2010; "The Official Website of Kenneth Noland," http://www.kennethnoland.com/biography/, accessed June 29, 2019; Paul Richard, "$300,000 Surprise," *Washington Post*, November 21, 1981, C1.

5. Lou Stovall Interview with Jonathan Binstock, September 22, 1997, in Jonathan Binstock, *Sam Gilliam: The Making of a Career, 1962–1973* (PhD diss., University of Michigan, 2000); Sam Gilliam quoting Thomas Downing, interview by Benjamin Forgey, November 4 and 11, 1989, transcript, Sam Gilliam Papers. Archives of American Art. Smithsonian Institution, Washington, D.C., 3–4; Gene Davis, "Starting Out in the '50s." *Art in America* 66.4 (July/August 1978): 90–91; Diane Waldman, *Kenneth Noland: A Retrospective* (Solomon R. Guggenheim Museum, NY: 1977).

6. Dorothy McCardle, "U.S. Art Is Lent to Envoys Abroad," *New York Times*, October 1, 1962, 36; Lawrence O'Kane, "She Finds American Art," *Washington Post*, March 15, 1964; F5; Katherine Young, "Through State Department," *Baltimore Sun*, September 26, 1967, B5; Paul Richard, "Foreign Capitals are Exposed…," *Washington Post*, October 1, 1967; Michael Kernan, "Modern Art Americans Almost Never See," *Washington Post*, July 24, 1973, B1; K10; Paul Richard, "A Gift of Art," *Washington Post*, May 30, 1975, B4; "Stanley Woodward," *Washington Post*, August 19, 1992, C6; Sandy Smith, "A Celebration of the Woodwards," *Philadelphia Magazine*, June 10, 2016.

7. Leslie Judd Portner, "Pocket-Sized Show," *Washington Post*, December 6, 1953, L6; Leslie Judd Ahlander, "Work of 'Action' Painter Shown," *Washington Post*, March 8, 1959, E7; Leslie Judd Ahlander, "New Approaches to Modern Art," *Washington Post*, September 27, 1959, E7; Florence S. Berryman, "Busy Art Week Offers Outstanding Shows," *Washington Star*, October 25, 1959, 116; Leslie Judd Ahlander, "Two Print Shows Outstanding," *Washington Post*, January 1, 1961, C10; Leslie Judd Ahlander, "An Artist Speaks: Gene Davis," *Washington Post*, August 26, 1962, G7.

8. Jean M. White, "Even Art Comes in Stripes Now," *Washington Post*, December 20, 1963, 3; Elizabeth Stevens, "Winning Stripes are like Cool Jazz," *Washington Post*, March 7, 1965, G11; "The Hypnotic Grip of Elemental Shapes," *Washington Post*, June 27, 1965, G67; Andrew Hudson, "Tourist Finds an Art Feast…," *Washington Post*, August 15, 1965, G5; Elizabeth Stevens, "Color Painter Seeks to Innovate," *Washington Post*, December 12, 1965, M7; Paul Richard, "Gene Davis Dots Wall," *Washington Post*, April 2, 1967, E3; Paul Richard, "Nothing Ordinary About Davis Stripe," *Washington Post*, July 14, 1968, E1.

9. Paul Richard, "Absolutely Free $3000 Canvases," *Washington Post*, May 14, 1969, F1; Greg Allen, "Making of," https://greg.org/archive/2011/11/16/gene-davis-giveaway-by-douglas-davis-ed-mcgowin.html, accessed April 11, 2020; Clark Fox. Interview with author. April 11, 2020.

10. Paul Richard, "Different Stripe of Paintings," *Washington Post*, October 14, 1972, E1; Paul Richard, "Freedom within the Stripes," *Washington Post*, October 27, 1975, B8; Paul Richard, "Gene Davis- top of the line," *Washington Post*, December 15, 1978, E1; Pamela Kessler, "Gene Davis: Paint, Paint, Paint," *Washington Post*, November 26, 1982, 33; Benjamin Forgey, "Gene Davis, Noted Artist, Dies Here," *Washington Post*, April 7, 1985, C7; Paul Richard, "Gene Davis' Fine Lines," *Washington Post*, April 8, 1985, B1; Jean Lawlor Cohen, "The Last Testament to an Artist," *Washington Post*, April 2, 1991, E1; Peggy McGlone, "Gene Davis and his aide were of the same stripe," *Washington Post*, September 13, 2016, C.1.

11. David Richard, "Reviews: Leon Berkowitz," https://www.artinamericamagazine.com/reviews/leon-berkowitz/, accessed March 29, 2019; "Berkowitz Bio," https://www.phillipscollection.org/research/american_art/bios/berkowitz-bio.htm, accessed March 29, 2019; Paul Richard, "The Art of Leon Berkowitz: Presiding Over Beauty," *Washington Post*, March 2, 1969, 134; Paul Richard, "The Catalyst for Color Painters," *Washington Post*, April 8, 1972, C7; Paul Richard, "Berkowitz Exhibits," *Washington Post*, April 1, 1977, B11; "Galleries: Challenging Convention," *Washington Star*, April 3, 1977, G24; Terry Downs, "The Kinetic Artist of Kalorama Road," *Washington Post*, March 20, 1983, L1; Benjamin Forgey, "Noted D.C. Art Teacher, Painter Leon Berkowitz Dies," *Washington Post*, August 19, 1987, C10; Benjamin Forgey, "Leon Berkowitz and the Gifts that Endure," *Washington Post*, August 19, 1987, F1; Leon Berkowitz interviewed by Julie Haifley, "Oral history interview with Leon Berkowitz, 1979 July 17"; Archives of American Art, Smithsonian Institution.

Chapter 8

1. David Pike, "Council Backs Credit Rules," *Washington Star*, May 13, 1971, B2; Alma Robinson, "Art Comes to People at P Street Exhibit," *Washington Star*, June 18, 1971, B5; Paul Richard, "Dry Ice, Lights, Foam" *Washington Post*, June 18, 1971, C2; Benjamin Forgey, "Memphis

Broker Plays 'Angel' to save Jefferson Place Gallery," *Washington Star*, June 25, 1974, D2; "Jefferson Place Gallery, 1957–1974," http://jeffersonplacegallery.com/about/, accessed March 26, 2018; Paul Richard, "Art from Stars and Credentialed Bureaucrats," *Washington Post*, February 9, 1974, B7.

2. Avis Berman, "Adelyn Breeskin: A Perseverance of Vision," *Baltimore Sun*, October 30, 1977, D1; Alice Steinbach, "Adelyn Breeskin Dies," *Baltimore Sun*, July 25, 1986, A1; Frank Getlein, "A Washington Gallery of Modern Art," *Washington Star*, January 14, 1962, F6; Stephen E. Nordlinger, "Art Post Given to Mrs. Breeskin," *Baltimore Sun*, January 8, 1962, 32; Ellen Key Blunt, "Gallery of Modern Art Gets 1st Painting—It's a Hartigan," *Washington Post*, February 11, 1962, B4.

3. Ellen Key Blunt, "Modern Art Gallery to Open Here October 31," *Washington Post*, September 16, 1962, B8; Leslie Judd Ahlander, "Newest Gallery Seeking Support," *Washington Post*, October 7, 1962, G8; Leslie Judd Ahlander, "Kline Show Opens New Gallery," *Washington Post*, November 4, 1962, G5; Leslie Judd Ahlander, "Ballet to Benefit New art Gallery," *Washington Post*, December 9, 1962, G6; Alice Denney. Interview with author. January 13, 2021.

4. Jean M. White, "Eruption of Pop Art," *Washington Post*, April 14, 1963, A3; Frank Getlein, "Modern Art Pop Show Is Strictly Dullsville," *Washington Star*, April 21, 1963, 44; "This Happened to Be 'A Farce for Objects,'" *Washington Post*, April 28, 1963, F3; Leslie Judd Ahlander, "Formalists Open Brilliant Exhibition," *Washington Post*, June 16, 1963, G7; Leslie Judd Ahlander, "Modern Sculpture Show Opens," *Washington Post*, September 22, 1963, G8; Jean M. White, "Washington Gallery of Modern Art Celebrates First Anniversary," *Washington Post*, October 27, 1963, B6; Leslie Judd Ahlander, "Abstract Expressionism on View" *Washington Post*, November 10, 1963, G10; Ellen Key Blunt, "Boldness Marks His Paintings." *Washington Post*, January 2, 1964, D3; Jean M. White, "Mrs. Breeskin to Leave Gallery," *Washington Post*, January 17, 1964, A3; "Adelyn Breeskin Quitting Modern Art Gallery in D.C.," *Baltimore Sun*, January 18, 1964, 9; Amelia Young, "Resignation stirs question of Role," *Washington Star*, January 19, 1964, G6; Ari Post, "Remembering the Washington Gallery of Modern Art," *Georgetowner*, July 26, 2011, https://georgetowner.com/articles/2011/07/26/remembering-washington-gallery-modern-art/, accessed August 3, 2019; Archives of American Art, Smithsonian Institution, Washington Gallery of Modern Art Papers, Box 1, Folders 18 and 56. Michael Clark. Interview with author, April 11, 2020. Other successful WGMA exhibitions never matched the profit for the Van Gogh show, including a sculpture show that earned $7,500 and the "Picasso Since 1945," which earned $16,000; Paul Richard. Interview with author. January 9, 2021.

5. David Fouquet, "Growth in Art Interest," *Washington Post*, February 19, 1964, B10; Grace Glueck, "Art Notes," *New York Times*, June 7, 1964, X20; Frank Getlein, "Colorful Modern Art Show," *Washington Star*, June 27, 1965, D5; "Tomorrow in Washington," *Washington Star*, September 20, 1965, 41; Frank Getlien, "The Josef Albers Show Will Indeed Open Your Eyes," *Washington Star*, November 7, 1965, 56; Francis Lide, "Office Art, Décor on Walking Tour," *Washington Star*, November 28, 1965, 99; "Modern Art Preview Set," *Washington Star*, March 11, 1966, D8; "Tomorrow in Washington," *Washington Star*, April 7, 1966, 33; Frank Getlien, "The Idea is to be Modern," *Washington Star*, April 24, 1966, 45; Betty Beale, "Embassy Social Sizzles," *Washington Star*, April 29, 1966, 33.

6. Frank Getlein, "Art: Good Shows on the 1967 Schedule," *Washington Star*, January 1, 1967, 39; Frank Getlein, "Art: Contrasting Two Works by Pioneers," *Washington Star*, May 28, 1967, 43; Paul Richard, "Gallery of Modern Art Eyes 'New Role,'" *Washington Post*, July 4, 1967, B1; Paul Richard, "Art Invades P Street: 4 Galleries in 1 Block,'" *Washington Post*, July 30, 1967, D1; Paul Richard, "Modern Art Gallery Gets New Head," *Washington Post*, September 1, 1967, B1; Paul Richard, "Gallery of Modern Art Here Finds Formula for Success," *Washington Post*, April 21, 1968, A31; Stovall interview by author; Paul Richard, "Merger of Two Galleries Proposed," *Washington Post*, September 8, 1968, H1; Paul Richard, "Modern Art Gallery, Corcoran to Merge,'" *Washington Post*, October 8, 1968, A1; Paul Richard, "Corcoran Draws the Line,'" *Washington Post*, April 15, 1972, E1; Washington Gallery of Modern Art Papers, Box 2, Folder 14; Box 2, Folder 16; Box 2, Folder 18; Box 1, Folder 9: Corcoran Merger, July 23, 1968 letter to President of Corcoran Board from President of WGMA Board of Trustees; Box 1, Folder 11: October 1968 letter to members; Richard Interview; Walter Hopps, *The Dream Colony* (New York: Bloomsbury, 2017), 203–207.

7. Paul Richard, "Art Invades P Street: 4 Galleries in 1 Block,'" *Washington Post*, July 30, 1967, D1; Benjamin Forgey, "ART," *Washington Star*, November 22, 1970, C7; Benjamin Forgey, "Art Tremors in Washington," *Washington Star*, September 24, 1972, 10; Paul Richard, "Dual-Percentage Art,'" *Washington Post*, May 17, 1973, B17; Paul Richard, "Two Artists and their,'" *Washington Post*, January 28, 1976, C7; Lon Tuck, "P Street Art Auction...," *Washington Post*, July 14, 1977, B4; Joanna Shaw-Eagle, "Buying Art on a Budget," *Washington Evening Star*, December 9, 1979, 122: Clark Interview.

8. Jo Ann Lewis, "The Many Sides of Soyer," *Washington Star*, March 27, 1972, C9; Paul Richard, "Artistic Changes on P Street," *Washington Post*, September 23, 1972, B7; "Art Tremors in Washington,"; Paul Richard, "Good and Bad News on the Local Scene," *Washington Post*,

November 24, 1974, F1; Paul Richard, "From the Golden State," *Washington Post*, May 20, 1975, B5; Benjamin Forgey, "Art Gallery Cluster is planned," *Washington Post*, November 23, 1978, 35; Jo Ann Lewis, "Adding a New Loop to the Old Strip," *Washington Post*, December 2, 1978, C1; "Buying Art on a Budget,"; "The Rise and Fall of Washington Print Galleries: A Fifty Year History," https://www.artline.com/digest/index_11.php, accessed June 22, 2020; Paul Richard, "Good and Bad News on the Local Scene," *Washington Post*, November 24, 1974, F1; Jo Ann Lewis, "Paintings for the Partners," *Washington Post*, September 7, 1980, G1; Jo Ann Lewis, "Galleries," *Washington Post*, March 3, 1984, C3; Jo Ann Lewis, "Osuna Gallery to leave 406," *Washington Post*, July 27, 1988, C1; Jo Ann Lewis, "The Magnificent Seventh," *Washington Post*, June 25, 1995, G1.

9. "Good and Bad News on the Local Scene,"; "Artistic Changes on P Street,";"Art Tremors in Washington,"; "P Street Art Auction...."

10. Paul Richard, "A Young Color Painter," *Washington Post*, May 3, 1970, G2; Jo Ann Lewis, "P Street Strip," *Washington Post*, September 18, 1976, B1; Benjamin Forgey, "Art Gallery Cluster is Planned," *Washington Post*, November 23, 1978, 35; Paul Richard, "Closings and Rumors Along the P Street Strip," *Washington Post*, February 3, 1979, D4; "The Rise and Fall of Washington Print Galleries: A Fifty Year History."

11. Newman Interview; Paul Richard, "A New Gallery on P Street," *Washington Post*, November 17, 1970, B8; Benjamin Forgey, "Art," *Washington Star*, November 22, 1970, C7; Sarah Booth Conroy, "Art on a Budget" *Washington Post*, October 17, 1971, G1.

12. Frank Getlein, "Art," *Washington Star*, January 1, 1967, 39; Frank Getlein, "Art," *Washington Star*, March 3, 1968, C5; Benjamin Forgey, "Art," *Washington Star*, July 21, 1968, 43; Benjamin Forgey, "Art," *Washington Star*, August 11, 1968, 83; Benjamin Forgey, "The Third Wave," *Washington Star*, October 12, 1969, 191; Frank Getlein, "Art," *Washington Star*, September 26, 1971, 35; Benjamin Forgey, "Art scene," *Washington Star*, September 18, 1973, 40; Benjamin Forgey, "Art scene," *Washington Star*, June 14, 1974, C4; Thomas Hine, "Surroundings," December 12, 1982, 18; Fredric Tasker, "Prince Turkai's Worst Disgrace," *Miami Herald*, February 13, 1984, 1C; Frank Haight Jr, "Turning laser light into art," *The Examiner*, January 18, 2000, features; Matt Schudel, "D.C. artist created sculptures with light," October 28, 2011, B7; https://www.rocknekrebsart.com/, accessed May 11, 2020; https://americanart.si.edu/artist/rockne-krebs-2718, accessed May 11, 2020; Carolyn Peachey. Interview with author. January 15, 2021; Furchgott, David. Interview with author. October 26, 2021; Paul Richard, "Invasion of the Third Dimension," *Washington Post*, June 5, 1980, https://www.washingtonpost.com/ archive/lifestyle/1980/06/05/invasion-of-the-3rd-dimension/f9f2da1a-ec22-4a29-a860-f42fd21d6d13/, accessed March 31, 2020 "History, International Sculpture Center," https://sculpture.org/page/history, accessed May 11, 2020.

13. Andrew Hudson, "Around the Galleries: Major Breakthrough for capital," *Washington Post*, November 20, 1966, G11; Meryle Secrest, "Her Artists Ought to Paint Her," *Washington Post*, May 15, 1969, C12; Lloyd Grove, "Art Collecting," *Washington Post*, January 8, 1982, C1; Jack Rasmussen. Interview with author. April 17, 2020; Paul Richard, "Henri Dies at 87," *Washington Post*, February 20, 1996, B7; Paul Richard, "A Young Color Painter," *Washington Post*, May 3, 1970, G2; Paul Richard, "Corcoran Draws the Line,'" *Washington Post*, April 15, 1972, E1; Paul Richard, "An Art Closing on P Street," *Washington Post*, October 9, 1974, E1; Joanna Shaw-Eagle, "Buying Art on a Budget," *Washington Star*, December 9, 1979, 122; Beardsley, John. *Sam Gilliam: Recent Paintings November 15—December 16, 1989.* Ingalls Library clipping file, The Cleveland Museum of Art: Barbara Fendrick Gallery. n.p. (exhibition booklet without pages); Eileen Kinsella, "At Age 84, Living Legend Sam Gilliam Is Enjoying His Greatest Renaissance Yet," Art World, January 2, 2018, https://news.artnet.com/art-world/sam-gilliam-market-renaissance-1182377, accessed September 6, 2019; "Sam Gilliam—Biography," rogallery.com, https://rogallery.com/Gilliam_Sam/Sam-Gilliam_bio.htm, accessed September 6, 2019; Susan Stamberg, "Hard at Work at 84, Artist Sam Gilliam Has 'Never Felt Better'," NPR, August 30, 2018, https://www.npr.org/2018/08/30/640903173/hard-at-work-at-84-artist-sam-gilliam-has-never-felt-better, accessed September 6, 2019.

14. Paul Richard, "Africobra," *Washington Post*, February 27, 1972, H1; Angela Terrell, "Gallery I: Moving to the Street," *Washington Post*, July 1, 1972, D3; Paul Richard, "Black Arts, Politics," *Washington Post*, April 28, 1973, B1; "Black Festival of Arts," *Washington Star*, April 25, 1973, 41; "Black Festival of Arts," *Washington Star*, June 19, 1975, 41; Jacqueline Trescott, "Festival's Beneficial Pushback," *Washington Post*, August 8, 1975, B1; Paul Richard, "A Bright New 'School,'" *Washington Post*, March 19, 1976, B1; Paul Richard, "Black Artists,'" *Washington Post*, May 15, 1981, K1; Joanne Ostrow, "The Black Art Conundrum," *Washington Post*, October 31, 1982, 31; Paul Richard, "Black Presence,'" *Washington Post*, April 7, 1985, B1; Paul Richard, "Howard Dynamic,'" *Washington Post*, April 2, 1988, C1; Paul Richard, "Art, Evolution of the Revolution,'" *Washington Post*, December 10, 1989, G1; Yvonne Shinhoster Lamb, "Artist and Education Jeff Donaldson," *Washington Post*, March 7, 2004, VA12; Esther Iverem, "David Driskell's Big Picture," *Washington Post*, November 23, 1998, D1;

"David Driskell," https://www.dcmooregallery.com/artists/david-driskell, accessed January 18, 2021; Denise Barnes, "The History Behind the Art," *Washington Times*, October 29, 1994, B1; Joanna Shaw-Eagle, "Artistic Balance," *Washington Times*, January 4, 1998, D1.

15. "Good and Bad News on the Local Scene."

16. Sanborn Interview.

17. "Manon Cleary, 1943–2011," *Washington City Paper*, accessed September 10, 2019; *Images of the '70s: 9 Washington Artists* (Washington, D.C.: The Corcoran Gallery of Art) 1979, *19–25;* John Metcalfe, "Queen of Beverly Court," July 2, 2009, https://www.washingtoncitypaper.com/news/article/13029304/queen-of-beverly-court, accessed September 6, 2019; Matt Schudel, "Manon Cleary, alluring D.C. artist and free spirit, dies at 69," *WashingtonPost.com*, December 3, 2011, https://www.washingtonpost.com/local/obituaries/manon-cleary-alluring-dc-artist-and-free-spirit-dies-at-69/2011/11/29/gIQAuigvPO_story.html, accessed September 6, 2019; Woody West and Earl Byrd, "Neighborhood in the City," *Washington Star*, February 11, 1974, 19; Brett Williams, *Upscaling Downtown* (Ithaca, NY, Cornell University Press, 1988), 52–53; "Manon Cleary Dies at 69," *The Georgetowner*, May 3, 2012, https://georgetowner.com/articles/2012/05/03/manon-cleary-dies-69/, accessed September 6, 2019; "Manon Cleary, American 1942–2011," *MutualArt*, https://www.mutualart.com/Artist/Manon-Cleary/8F809B95E42973D3#more, accessed September 6, 2019; Richard Pearson, "Yuri Schwebler, D.C. Artist in 1970s, Dies," *Washington Post*, March 5, 1990, https://www.washingtonpost.com/archive/local/1990/03/05/yuri-schwebler-dc-artist-in-1970s-dies/f1626044-8a11-4d06-8de6-1da77b08bdad/, accessed September 6, 2019; Paul Richard, "Making It as an Artist," *Washington Post*, October 2, 1977, B1; Lee Fleming, "Black Art in the Abstract," *Washington Post*, January 21, 1995, D2.

18. Benjamin Forgey, "The Changing Neighborhood," *Washington Star*, September 19, 1976, 92; Benjamin Forgey, "When You Decide to Join the Ranks of Art Collectors," *Washington Star*, January 29, 1977, C1; Jo Ann Lewis, "Bidding Farewell to the Studio Gallery," *Washington Post*, June 18, 1977, B5; "Our History," https://www.studiogallerydc.com/about, retrieved September 15, 2019; Lon Tuck, "P Street Art Suction…," *Washington Post*, July 14, 1977, B4; "The Arts," *Washington Star*, July 22, 1977, 60; Paul Richard, "Making It as an Artist," *Washington Post*, October 2, 1977, B1; Jo Ann Lewis, "Haslem and History," *Washington Post*, January 26, 1985, C2; http://www.thefrasergallery.com/artists/John-Winslow-resume.html, retrieved on March 12, 2020; Mark Jenkins, "After 55 Years," March 2015, https://www.artline.com/about/about-jane-haslem.php, accessed on March 15, 2020;

"Artist Panels Seeking New Image," *Washington Star*, August 17, 1979, 28.

19. Ed Bruske and Harriett Blake, "Etcetc," *Washington Post*, April 20, 1980, E3; Jo Ann Lewis, "Galleries," *Washington Post*, May 10, 1980, D7; Harriett Blake, "Etcetc," *Washington Post*, June 1, 1980, C3; Harriett Blake, "Etcetc," *Washington Post*, October 19, 1980, E3; Jo Ann Lewis, "Galleries," *Washington Post*, March 11, 1982, D7.

20. Deborah Churchman, "Making It as an Artist in Virginia," *Washington Post*, January 1, 1981, VA3; Paul Richard, "How to Canvess an Art Neighborhood," *Washington Post*, June 2, 1994, D1; Jack Rasmussen. Interview with author. April 17, 2020; George Hemphill. Interview with author. April 8, 2020; Benjamin Forgey, "A Double Retrospective," *Washington Star*, October 3, 1975, C3; Benjamin Forgey, "'Artists Size Up Washington Scene," *Washington Star*, September 7, 1975, F1; Anne Marchand, "Biography," http://www.annemarchand.com/biography.html, accessed April 22, 2020; Anne Marchand. Interview with author. July 30, 2019; Sidney Lawrence. Interview with author. December 30, 2020.

21. Jody Mussoff. Interview with author. December 25, 2020; Ellen Edwards, "Mussoff's Faces of Fear," *Washington Post*, June 27, 1981, C3; Ferdinand Protzman, "Figuring it all outs," *Washington Post*, June 1, 1996, H2; Ferdinand Protzman, "Galleries," *Washington Post*, October 14, 1999, C5.

22. "Capital Area Art Circles' Activities," *Washington Post*, February 10, 1963, G5; "Anne Truitt," http://www.annetruitt.org/bio, accessed September 15, 2019; "Anne Truitt: Sculptor of Minimalist Form and Color," https://www.thoughtco.com/anne-truitt-biography-4174590, accessed September 15, 2019; Eleanor C. Munro, *Originals: American Women Artists* (New York: Simon & Schuster, 1979): 314; Anne Truitt, *Daybook* (New York: Scribner); James Meyer, *Minimalism* (London: Phaidon, 2000), 63–73; Ari Post, "Neighborhood Visionary," *The Georgetowner*, December 6, 2017; https://georgetowner.com/articles/2017/12/06/neighborhood-visionary-anne-truitt-national-gallery/ , retrieved September 15, 2019; Benjamin Forgey, "An Experts Personnel Choice," *Washington Star*, December 12, 1971, 71; Paul Richard, "Art at the Phillips," *Washington Post*, December 8, 1971, B1; Benjamin Forgey, "Work of a Wavering Hand," *Washington Star*, June 2, 1972, E6; "Over $500,000 in Art Grants," *Washington Star*, October 27, 1972, 34; Paul Richard, "Truitt's Box Sculptures," *Washington Post*, April 24, 1971, E6.

23. Carolyn See, "Anne Truitt's Hard-Won Vision," *Washington Post*, March 8, 1996, B2; Benjamin Forgey, "Calendar Art," *Washington Star*, November 13, 1977, B20; Nancy Mairs, "Portrait of an Artist," *Washington Post*, December 5, 1986, C2; Michael Welzenbach, "Truitt, Staying in Shapes," *Washington Post*, April 18,

1989; Matt Schudel, "Minimalist Sculptor Anne Truitt, 83, Dies," *Washington Post*, December 25, 2004, B6.

24. Jo Ann Lewis, "Bidding Farewell to the Studio Gallery," *Washington Post*, January 7, 1978, E1; Paul Richard, "Plans for a Gallery Row," *Washington Post*, November 23, 1978, C1; Benjamin Forgey, "Art Gallery Cluster is planned," *Washington Post*, November 23, 1978, 35; Jo Ann Lewis, "Adding a New Loop to the Old Strip," *Washington Post*, December 2, 1978, C1; Thierry Sagnier, "If the Admiral Only Knew…," *Washington Post*, January 19, 1979, 24; Paul Richard, "Closings and Rumors Along the P Street Strip," *Washington Post*, February 3, 1979, D4; "Galleries," *Washington Star*, September 28, 1979, B2; Joanna Shaw-Eagle, "Buying Art on a Budget," *Washington Star*, December 9, 1979, 122; Linda Wheeler, "Dupont Circle: Losing The Artists' Touch," *Washington Post*, March 22, 1980, B1; *Galleries: a Guide to Washington Art Galleries*, December 1975, Washington, D.C.: Galleries Magazine Washingtonia Collection, DC Public Library; Jo Ann Lewis, "Art," *Washington Post*, December 30, 1984, K1.

Chapter 9

1. "Free Craft Classes," *Washington Star*, October 3, 1971, 23; Paul Hodge, "Glen Echo Reopens," *Washington Post*, June 3, 1972, B2; "Etc.," *Washington Star*, January 19, 1974, 29; "Etc.," *Washington Post*, July 14, 1974, G2; Tom Lyles, "Big City Metal Works is in a pool," *Washington Star*, October 19, 1974, 71; Sharon Conway, "2,000 pound sculpture falls prey," *Washington Post*, July 28, 1977, VA3; Jo Ann Lewis, "With an Art of Stone," *Washington Post*, February 2, 1980, B5; Bruce Adams, "Saving Glen Echo," *Washington Post*, July 5, 1981, C1; Jim Sanborn. Interview with Author. March 25, 2020; http://www.jimsanborn.net/, accessed March 31, 2020.

2. Jo Ann Lewis, "Echoes of Nature's Power," *Washington Post*, March 27, 1982, C3; Paul Richard, "The New Lay of Landscape," *Washington Post*, January 11, 1986, G9; Thomas Bell, "Sculptor's Top-Secret Mission," *Washington Post*, January 14, 1990, C1; Sanborn Interview.

3. Marion Clark, "Out in Womensphere," *Washington Post*, October 13, 1974, PO15; Angela Terrell, "Celebrating a Sphere of Women Artists," *Washington Post*, October 21, 1974, B3; DCPL Vertical File on Washington Women's Art Center and the W.C.A., College Art Association, February 23, 2002; "Listings," *Washington Star*, August 10, 1975, 58; "Phillips Collection: Celebrating with Cezanne," *Washington Post*, March 1, 1971, B1.

4. Paul Richard, "Sexism in the Arts," *Washington Post*, March 27, 1972, B1; "Washington Women Exhibiting at Winter Show of Feminine Art," *Washington Post*, January 26, 1936, AA5;

Meryle Secrest, "Women and the arts," *Washington Post*, April 20, 1972, C1; Meryle Secrest, "Women Artists Brushed Off," *Washington Post*, April 21, 1972, B3; Meryle Secrest, "A Dim Picture," *Washington Post*, April 22, 1972, B3; Benjamin Forgey, "Variety and Good Choices," *Washington Star*, February 29, 1972, 10; Benjamin Forgey, "Women Artists Angry," *Washington Star*, April 20, 1972, B8; Benjamin Forgey, "The Role of Women in the Visual Arts," *Washington Star*, April 24, 1972, 27; Meryle Secrest, "Women Artists," *Washington Post*, August 20, 1972, L5; Nina Felshin, "Two Shows and a Lesson from Women Artists," *Washington Post*, September 16, 1973, K9; Jo Ann Lewis, "The Women Get it Together," *Washington Star*, May 3, 1974, 19; Barbara Frank Interview, "Voices from the Washington Women's Art Center," Heads Up Productions, accessed January 30, 2020.

5. Maxine Cable, "News Release," March 22, 1975; Gallery 10 archives, National Museum of Women; Jody Beck, "'Amazing Grace' Brings Ungraceful Art Scene," *Washington Star*, March 23, 1975, B6; Judith Benderson. Interview with author. February 28, 2020; Josephine Withers Interview, "Voices from the Washington Women's Art Center," Heads Up Productions, https://voicesandmore.com/, accessed January 30, 2020; Paul Richard, "Stereotyped 'Images' of Ourselves," *Washington Post*, August 16, 1975, E4; Mussoff Interview.

6. "Artists Sized up Washington Scene," *Washington Star*, September 7, 1975, G1; "The Arts," *Washington Star*, September 26, 1975, 54; Barbara Brent, "Letter to the Editor," *Washington Star*, December 7, 1975, Meryle Beveridge, "Year's End Review: Galleries," *Washington Post*, January 2, 1976, D1; Zita Dresner Interview, "Voices from the Washington Women's Art Center"; Benderson Interview; Lucy Blankstein. Interview with author. February 22, 2020.

7. Betty James, "Past Marches in Review," *Washington Star*, January 16, 1979, 32; Jo Ann Lewis, "'Open City' Getting Acquainted with Neighborhood Artists," *Washington Post*, January 27, 1979, D2; "Galleries File," *Washington Post*, January 26, 1979, 4; Paul Richard, "Women in the arts," *Washington Post*, January 31, 1979, B1.

8. Benjamin Forgey, "It's Not Professional," *Washington Star*, October 13, 1974, 61; Paul Richard, "Artist-Run Collectives Gathering Momentum," *Washington Post*, June 16, 1975, B1; Alan Cohen, "'Collectives: Embarrassing to the Sublime," *Washington Star*, August 1, 1976, G26; Thierry Sagnier, "A Neighborhood That has 'Everything,'" *Washington Post*, September 8, 1978, W10; George Koch. Interview with author. May 10, 2020.

9. John Greenya, "Painter's Progress," *Washington Post Magazine*, March 16, 1980, 36; Richard Dana. Interview with author. March 30, 2020; Betty James, "Community Art to take

Over...," *Washington Star*, July 5, 1979, 38; Benjamin Forgey, "City Art 79," *Washington Star*, October 17, 1979, C1; "The Pennsylvania Avenue Plan—1974," National Park Service; https://www.nps.gov/nationalmallplan/Documents/Penn/PADC_PennAvePlan1974.pdf, accessed February 1, 2020; Ruth Dean, "D.C. groups win major arts grants," *Washington Star*, October 30, 1979, 13; Carla Hall, "The Fragile Future of the Lansburgh Dream," *Washington Post*, April 18, 1982, H1; Ruth Dean, "W.P.A.'s Moving Deadline Presents Some Problems," *Washington Star*, February 1, 1981, C1; Alec Simpson, in conversation with author, May 2020.

10. "New Art on Old G street," *Washington Post*, February 19, 1975, B10; Alan M. Kriegsman, "W.P.A.: A (Counter) Cultural Center," *Washington Post*, April 16, 1975 B1; *Catalyst: 35 Years of Washington Project for the Arts: 1975–2010* (Washington, D.C.: Washington Project for the Arts, 2010); Doree Lovell, "Northern Virginia Arts Projects Get Grants," *Washington Post*, January 26, 1978, VA7; Doree Lovell, "Attorney Named Head," *Washington Post*, May 25, 1978, VA3; Doree Lovell, "Community Involvement is Goal," *Washington Post*, November 27, 1979, VA3; Don Shirley, "Alley's New Home," *Washington Post*, January 29, 1976 G9; "Billboard," *Washington Star*, December 28, 1979, 58; "District Calendar," *Washington Star*, February 26, 1980, 39; Denney Interview.

11. Benjamin Forgey, "'Uncommercials' Get New Space," *Washington Evening Star*, May 2, 1975, F3; Benjamin Forgey, "A Double Retrospective," *Washington Evening Star*, October 3, 1975, C3; Don Shirley, "Alley's New Home," *Washington Post*, January 29, 1976 G9; Marion Clark, "Still Boho After All These Years," *Washington Post*, May 2, 1976 291; David Tannous, "Galleries: Implied Thought of Yuri Schwebler," *Washington Evening Star*, January 23, 1977, G20; Rasmussen Interview; Hemphill Interview; Jo Ann Lewis, "Calendar Art," *Washington Post*, March 17, 1978, 88.

12. Carla Hall, "MIYA: Opening a 'Hometown' Gallery," *Washington Post*, July 9, 1976, B9; Jo Ann Lewis, "Ceramic Cartoons," *Washington Post*, November 20, 1976, E1; Hollie I. West, "Celebrating D.C. Poets," *Washington Post*, April 28, 1977, D8; Anthony Abeson, "Why Does DC Discourage its Artists?" *Washington Star*, May 22, 1977, G10; "Listings," *Washington Star*, December 9, 1977, 20; Michael Kernan, "Alternative Film Festival," *Washington Post*, December 15, 1977, 63; Robert J. Lewis, "Renewal Plan to Be the Biggest," *Washington Star*, April 8, 1966, C1; "Sunday and Monday in Washington," *Washington Star*, April 29, 1967, 8; Benjamin Forgey, "Art," *Washington Star*, October 29, 1967, E3; Benjamin Forgey, "Art," *Washington Star*, May 26, 1968, C3; "Abundant Shops for Selections," *Washington Star*, April 23, 1970, D2; "The Engineer Goes Primitive," *Washington Star*, September 12, 1976,

131; Wolf Von Eckardt, "The Fabulous Facades of Logan Circle," *Washington Post*, April 29, 1972, C1; Paul Richard, "Black Artists Host Weeklong Conference," *Washington Post*, April 2, 1980, B16; Lon Tuck, "Artworks Donated to Howard," *Washington Post*, October 30, 1986, D1; Lon Tuck, "James C. Mason, 83, Art Gallery President, Dies," *Washington Post*, February 20, 1987, D4; Peggy Cooper Cafritz, *Fired Up! Ready to Go! Finding Beauty, Demanding Equality* (New York: Rizzoli, 2018), 21–33; Alec Simpson. Interview with author. May 20, 2020; "History, International Sculpture Center," https://sculpture.org/page/history, accessed May 11, 2020.

13. Betty James, "Community Art to take Over...," *Washington Star*, July 5, 1979, 38; Benjamin Forgey, "City Art 79," *Washington Star*, October 17, 1979, C1; "The Pennsylvania Avenue Plan—1974," National Park Service; https://www.nps.gov/nationalmallplan/Documents/Penn/PADC_PennAvePlan1974.pdf, accessed February 1, 2020; Ruth Dean, "D.C. groups win major arts grants," *Washington Star*, October 30, 1979, 13; Carla Hall, "The Fragile Future of the Lansburgh Dream," *Washington Post*, April 18, 1982, H1; Ruth Dean, "W.P.A.'s Moving Deadline Presents Some Problems," *Washington Star*, February 1, 1981, C1; Simpson Interview.

14. Ruth Dean, "WPA's Moving Deadline Presents Some Problems," *Washington Star*, February 1, 1981, C1; Paul Richard, "Miracle on 7th St.' *Washington Post*, November 13, 1981, B1; "Local Artists Take Show on road," *Washington Post*, January 17, 1982, H1; *Catalyst: 35 Years of Washington Project for the Arts: 1975–2010*; Hemphill Interview; Carla Hall, "D.C. Arts Agency Awards," *Washington Post*, January 13, 1982, B4; Nina Hyde, "The Simple, One-Size Shades of Gray," *Washington Post*, May 14, 1989, F3; Charles Elder, "African Clothes Attract Attention at Galleries," *Washington Post*, September 25, 1989, F7; Michelle Singletary, "Retailers Want Black Shoppers to Remember Their Roots," *Washington Post*, December 1, 1993, F1; Debbi Wilgoren, "East End Building for a Comeback," *Washington Post*, May 13, 2001, A1.

15. "Local Artists Take Show on Road," *Washington Post*, January 17, 1982, H1; Carlos Greth, "Center Gives a Boost to Women's Art," *Washington Post*, February 11, 1982, D1; Ann H. Oman, "Browsing On 7th Street," *Washington Post*, June 1, 1984, 5; Carol D. Dimach, "The Artists and their Quilts," *Washington Post*, January 24, 1985, 5; Nancy G. Heller, "Shades of Pop Art," *Washington Post*, March 28, 1985, B5; Benjamin Forgey, "Unknown Finds," *Washington Post*, June 8, 1985, G2.

16. Jessica Dawson, "Museum of the Muses," *Washington Post*, May 17, 2001, C2; Mark Jenkins, "A look back at women's art in D.C.," *Washington Post*, August 5, 2018, E4.

17. Mary McCoy, "Beneath The Skin of Delusion," *Washington Post*, April 24, 1993,

D2; Mary McCoy, "Printmaking with New Dimension," *Washington Post*, November 24, 1994, D3; http://washingtonprintmakers.com/about-the-gallery/, accessed on March 28, 2020; Michael O'Sullivan, "No More Subterranean Blues," *Washington Post*, February 12, 1999, 69; Jessica Dawson, "Art and Sole," *Washington Post*, June 19, 2003, C5; Angela Walker, "Visual Arts," *Washington Post*, March 30, 1989, V12; Angela Walker, "Love Affairs of the Art," *Washington Post*, August 2, 1990, A1; "Calendar of Events," *Washington Post*, July 28, 2016, T20.

18. Rainbow History Project, "A Timeline of LGBT Places and Spaces in D.C.," https://www.datalensdc.com/iframes/rainbowHistory.html, accessed November 25, 2020; "Town Theater," http://cinematreasures.org/theaters/6360, accessed November 25, 2020; Henry Allen, "Everybody's Here: At Bus Station Nation," *Washington Post*, March 11, 1973, 12; LaBarbara Bowman, "D.C. Sells Land for New Station for Trailways," *Washington Post*, July 21, 1982, C24; Wendy Swallow, "D.C. Greyhound Station to Be Saved for Its Hidden Art Deco Architecture," *Washington Post*, January 24, 1987, F1; Martha M. Hamilton, "Greyhound Plans Terminal Near Union Station," *Washington Post*, June 3, 1981, A1.

19. Eleni, "They talked about Fashion," *Washington Star*, April 24, 1963, 31; Wilhelmina Cole Holladay, *A Museum of Their Own: National Museum of Women in the Arts* (Abbeville Press, 2008); Sarah Booth Conroy, "Women's Art to Get a Home," *Washington Post*, November 4, 1982, C1; Sarah Booth Conroy, "The Founding Force," *Washington Post*, February 15, 1987, 113; Paul Richard, "Birth of the Women's Museum," *Washington Post*, April 5, 1987, G1; Jacqueline Trescott, "Ellen Reeder to Head Women's Museum," *Washington Post*, July 11, 2001, E3; Jacqueline Trescott, "District's Other private art museums," *Washington Post*, July 1, 2012, E3.

20. *Catalyst*; Jo Ann Lewis, "Sculpting Up a Storm," *Washington Post*, July 17, 1982, B1; Jo Ann Lewis, "Drawing on the Sun," *Washington Post*, December 11, 1982, B1; Benjamin Forgey, "Intriguing Ingenuity at W.P.A.," *Washington Post*, February 17, 1983, D1; Paul Richard, "'The Ritz: Excessive Art in an Aging Hotel," *Washington Post*, April 2, 1983, D1; Carla Hall, "D.C. Arts Agency Awards...," *Washington Post*, January 13, 1982, B4; Paul Richard, "Man About Art," *Washington Post*, February 24, 1983, C1; Paul Richard, "New Chief for W.P.A.," *Washington Post*, June 1, 1983, D1; Paul Richard, "At W.P.A. New Art for Fun and Profit," *Washington Post*, November 8, 1983, D3; Paul Richard, "At W.P.A., a Survey of Styles,"*Washington Post*, November 10, 1984, D1; David Saltman, "All in the Family," *Washington Post*, January 2, 1985, C9; David Saltman, "Restorative Powers," *Washington Post*, February 6, 1985, C7; Benjamin Forgey, "Room with Artistic View," *Washington Post*, February

9, 1985, G1; Michael Kernan, "Portrait of an Arts Project," *Washington Post*, June 2, 1985, G1; Jessica Dawson, "Married, with Art," *Washington Post*, September 23, 2004, C1; Michael O'Sullivan, "Gaining 'Insight' at Corcoran," *Washington Post*, December 8, 2006, WW44; Michael O'Sullivan, "The Female Eye," *Washington Post*, July 4, 2008, T35; Michael O'Sullivan, "An Insider's View: Creating the Podesta Collection at NMWA," *Washington Post*, June 10, 2011, T19; Barbara Liotta, "W.P.A.," https://www.wpadc.org/artist/barbara-liotta, accessed June 22, 2020; Susan Butler. Interview with author. July 29, 2020; Peachey Interview; Eric Rudd. Interview with author. February 24, 2021.

21. Paul Richard, "Shaking up the arts scene," *Washington Post*, June 1, 1986, G1; Desson Howe, "WPA May Have to Move," *Washington Post*, December 12, 1986, F1; Desson Howe, "WPA's Lease Dispute," *Washington Post*, April 12, 1986, C8 ; David Saltman, "Seventh Street Blues," *Washington Post*, May 19, 1986, B7; Ann L. Trebble, "WPA to Get New Lease," *Washington Post*, June 19, 1986, E2; Paul Richard, "On the Road Again," *Washington Post*, September 22, 1986, C6; Jo Ann Lewis, "Urban Iconography," *Washington Post*, January 10, 1987, D9; Benjamin Forgey, "At the WPA," *Washington Post*, February 6, 1987, C1; Paul Richard, "WPA to Make Temporary Move," *Washington Post*, February 25, 1988, C2; Paul Richard, "WPA Tops $2 Million," *Washington Post*, March 24, 1989, C3; Don Russell. Interview with author. July 20, 2020; Paul Richard, "WPA's New Day," *Washington Post*, December 11, 1988, G1; Rudd Interview.

22. "Elizabeth Kastor, "WPA to Exhibit Controversial Photographs," *Washington Post*, June 27, 1989, B1; Jo Ann Lewis, "Mapplethorpe's Transformations." *Washington Post*, July 21, 1989, D1; Elizabeth Kastor, "WPA Show Attracts Thousands...," *Washington Post*, July 26, 1989, C1; Elizabeth Kastor, "Senate Votes to Expand NEA Grant Ban," *Washington Post*, July 27, 1989, C1; Hank Burchard, "Mapplethorpe Doubly Exposed," *Washington Post*, July 28, 1989, 43; Elizabeth Kastor, "Obscenity and the Eye of the Beholder...," *Washington Post*, July 29, 1989, C1; Courtland Milloy, "Mapplethorpe's Show: Where's the Horror?" *Washington Post*, August 8, 1989, D3; Elizabeth Kastor, "Obscenity Measure Approved...," *Washington Post*, September 30, 1989, A1.

23. Campbell, Natalie, ed., *A Guide to Defunct Artist-Run Spaces* (Washington, D.C.: Washington Project for the Arts, 2017); Jo Ann Lewis, "Galleries," *Washington Post*, April 8, 1989, C2; Todd Allan Yasui, "Protesting the Protesters...," *Washington Post*, May 7, 1990, C7; Todd Allan Yasui, "Philip Morris, a Smoldering Issue...," *Washington Post*, September 3, 1990, B7; Kim Masters, "Gallery Must Face Obscenity Trial," *Washington Post*, September 7, 1990, B1; Elizabeth Kastor, "Angry Group Knocks Down...,"

Washington Post, November 30, 1989, B1; Elizabeth Kastor, "DC Arts' Lofty Alternative," *Washington Post*, February 25, 1989, C1; Todd Allan Yasui, "Fewer Sounds of Summer...," *Washington Post*, April 2, 1990, B7; Theodore Adamstein. Interview with author. July 20, 2020; Butler Interview.

24. Judith Southerland. Interview with author. March 1, 2020; Jo Ann Lewis, "Quandary on Seventh Street," *Washington Post*, December 5, 1987, D2; Michael Welzenbach, "Non-Stock 'Options'," *Washington Post*, January 17, 1990, D1; Paul Richard, "W.P.A. Names Director," *Washington Post*, May 24, 1990, B2; Jo Ann Lewis, "At W.P.A., Four Sides of Local Pleasures," *Washington Post*, July 30, 1990, C1; "Personalities," *Washington Post*, November 23, 1991, B3; Judith Weinraub and Eric Brace, "W.P.A. Trims to Survive," *Washington Post*, January 29, 1992, B7; Janet Wilson, "Muddled Media at W.P.A.," *Washington Post*, April 10, 1992, D2; Judith Weinraub, "The Incredible Shrinking W.P.A.," *Washington Post*, August 2, 1992, G1; Eric Gibson, "Artistic Limits of 'Options,'" *Washington Times*, February 7, 1993, D3; Paul Richard, "Essay," *Washington Post*, January 31, 1993, G1; Mensah Dean, "Art in 'Superbia,'" *Washington Times*, March 2, 1995, M4; "'Superbia': A Blast from the Present," *Washington Post*, March 3, 1995, B1.

25. Butler Interview; Adamstein Interview; Russell Interview; Michael Welzenbach, "Distortions of Form and Feeling," *Washington Post*, December 16, 1989, D2; Michael Welzenbach, "Art: What Makes Us Tick," *Washington Post*, March 15, 1990, B1; Southerland Interview; "To Find Space, Gallery Groups Learn the Art of the Deal," *Washington Post*, March 30, 1992, 5; William F. Powers and Paul Richard, "A Great Place to Snoop Around," *Washington Post*, December 11, 1995, D1; Judith Weinraub, "At W.P.A., There's Gloom at the Top," *Washington Post*, April 11, 1995, C1; Jura Koncius, "Creative Seating...," *Washington Post*, June 8, 1995, 12; Ferdinand Protzman, "At W.P.A., Handling the Meantime," *Washington Post*, September 9, 1995, D2; Jo Ann Lewis, "Corcoran Set to Take W.P.A. Under Its Wing," *Washington Post*, February 16, 1996, F1; Peachey Interview.

26. Laura Coyle, "A Brief History of the WPA and WPA/C," https://www.wpadc.org/pdf/WPAC_History.pdf, accessed December 2, 2020; Rachel Beckman, "Lining Up to Buy," *Washington Post*, June 14, 2007, C5; Jacqueline Trescott, "Corcoran, W.P.A. End," *Washington Post*, October 2, 2007, C7; "Synchroswim," *Washington Post*, August 6, 2010, T3; Michael O'Sullivan, "'Catalyst' explores a home for local art," *Washington Post*, November 19, 2010, WW20; Michael O'Sullivan, "Calling all supporters," *Washington Post*, December 17, 2010, T17; Katherine Boyle, "Washington Project for the Arts plans move," *Washington Post*, January 17, 2013, C8.

Chapter 10

1. Jo Ann Lewis, "A Moving Experience in the Art World," *Washington Post*, May 27, 1978, B5; Karlyn Barker, "Seventh Street Area Getting Ready," *Washington Post*, November 16, 1978, B1; Paul Richard, "Plans for a Gallery Row," *Washington Post*, November 23, 1978, C1; Betty James, "This Street Will Be Good Again, Says a 7th Street Merchant," *Washington Star*, November 30, 1978, F6; Courtland Milloy, "Local Arts Rally to 'Loft Cause,'" *Washington Post*, February 16, 1979, B1; Kathleen Mirin, "Old Lansburgh's Department Store to become Art Center, Offices," *Washington Star*, February 16, 1979, MC3.

2. Benjamin Forgey, "Downtown 7th Street Will Become...," *Washington Star*, February 6, 1980, C3; Carla Hall, "Creative Space," *Washington Post*, May 2, 1980, C1; Ruth Dean, "Arts on 7th St. Are in Business," *Washington Star*, August 30, 1980, C1; Jack Rasmussen. Interview with author. April 17, 2020; "The Pennsylvania Avenue Development Plan, 1974," (Pennsylvania Avenue Development Corporation, 1974), 44–48; Benjamin Forgey, "Art Gallery Cluster is Planned Near Avenue," *Washington Star*, November 23, 1978, C1; Benjamin Forgey, "The Transformation of Robert Lennon," *Washington Star*, September 23, 1980, 13; Joan Davidson. Emails with Author. May 1, 2020.

3. Bill Warrell. Interview with author. June 1, 2020; Ruth Dean, "Arts on 7th St. Are in Business," *Washington Star*, August 30, 1980, C1; Jo Ann Lewis, "The Seventh Street Solution," *Washington Post*, September 21, 1980, L1; Paul Richard, "WPA Plans to Move to New 'Gallery Row,'" *Washington Post*, March 3, 1981, D3; Martha M. Hamilton, "Fight for The Old," *Washington Post*, April 25, 1981, E1; Jo Ann Lewis, "Galleries," *Washington Post*, September 15, 1981, M5; Joseph McLellan, "The Art Street," *Washington Post*, September 19, 1981, C1; Paul Richard, "Harry Lunn, Jr., Dies," *Washington Post*, August 22, 1998, D4; Ruda Maxa, "Front Page," *Washington Post*, October 11, 1981, magazine p. 2; Jo Ann Lewis, "Paintings for the Partners," *Washington Post*, September 7, 1980, G1; LaBarbara Bowman, "Developers: Odd Couples, High Rollers," *Washington Post*, December 28, 1981, B1; Rasmussen Interview; Benjamin Forgey, "Calendar: Art," *Washington Star*, April 9, 1978, 93; Benjamin Forgey, "Around the Galleries," *Washington Star*, July 16, 1978, 57; Benjamin Forgey, "Around the Galleries," *Washington Star*, October 22, 1978, 57; Benjamin Forgey, "Around the Galleries," *Washington Star*, June 10, 1979, 57; Benjamin Forgey, "Art," *Washington Star*, September 30, 1979, 84; Benjamin Forgey, "Art," *Washington Star*, January 7, 1980, 61.

4. Benjamin Forgey, "An artist on the Magothy," *Washington Star*, April 11, 1980, 17; Paul Richard, "Under the Artists Umbrella,"

Washington Post, November 8, 1980, G9; Jo Ann Lewis, "Beauty out of the Blue," *Washington Post*, May 22, 1982, C3; Jo Ann Lewis, "Fighting to Survive," *Washington Post*, May 29, 1982, C1; Clark Interview; Jo Ann Lewis, "The Art of the Brushoff," *Washington Post*, October 9, 1980, L1; "About," http://52ostreet.com/, accessed August 10, 2020; "Lisa Marie Thalhammer," https://lisamariestudio.com/, accessed August 10, 2020; Benjamin Forgey, "Downtown 7th Street Will Become...," *Washington Star*, February 6, 1980, C3; Paul Richard, "WPA Plans to Move to New 'Gallery Row,'" *Washington Post*, March 3, 1981, D3; Clark Interview; Paul Richard, "Two Artists and Their,'" *Washington Post*, January 28, 1976, C7; Robin Moore. Interview with the author. December 29, 2020; Rudd Interview; Benjamin Forgey, "A Young Painter's Lucid Way," *Washington Star*, March 29, 1981, 42.

5. Rudolph A. Pyatt, Jr., "7th St. Store Shut for Good by Mortons," *Washington Post*, January 21, 1982, G1; Jo Ann Lewis, "Opening, Closing and Just Moving," *Washington Post*, March 11, 1982, B7; Carla Hall, "The Fragile Future of the Lansburgh Dream," *Washington Post*, April 18, 1982, H1; Steve Farbman and Earle Kimel, "The Arts Stand at Back of the Line for Dollars," *Washington Post*, July 19, 1982, B5; Scott Sedar, "The Muse of Seventh Street," *Washington Post*, June 20, 1982, AS14; Patsy Rogers, "From Factory to Dwelling Place," *Washington Post*, February 17, 1983, WH8; Jo Ann Lewis, "Coming & Going," *Washington Post*, June 16, 1983, C7; Joan Nathan, "Pampering the Artistic Palate," *Washington Post*, July 27, 1986, SM17; George Hemphill. Interview with author. April 8, 2020.

6. Warrell Interview; Paul Richard, "Joe Shannon: The Horror, The Horror," *Washington Post*, January 28, 1982, C7; Jo Ann Lewis, "Lithographs recall the depression," *Washington Post*, February 18, 1982, C7; "Gallery Graffiti," *Washington Post*, November 26, 1983, D7; Paul Richard, "Art Attack's Main Artery," *Washington Post*, April 19, 1984, D7; Karina Porcelli, "The Artists Are Coming," *Washington Post*, January 10, 1988, D7.

7. Harriet L. Blake, "Et cetera," *Washington Post*, September 28, 1980, E3; Bill Alexander, "Aggressive Black Galleries Turning a Financial Corner," *Washington Post*, October 15, 1981, C1; Ozeil Fryer Woolcock, "Social Swirl," *Atlanta Daily World*, September 19, 1982, 3; Peter Perl and Michel Marriott, "Fire Guts Gallery," *Washington Post*, October 16, 1982, C7.

8. Jo Ann Lewis, "Old Masters at Osuna," *Washington Post*, March 7, 1987, C2; "3 Real-Life Fantasies," *Washington Post*, October 4, 1987, SM49.

9. John Dorsey, "Voshell show in D.C.," *Baltimore Sun*, June 3, 1983, C8; Benjamin Forgey, "Lucky Seventh: Rebirth of a Street," *Washington Post*, March 3, 1984, C1; Jo Ann Lewis, "Galleries," *Washington Post*, January 28, 1984, M5; Jo Ann Lewis, "Galleries," *Washington Post*, March 3, 1984, C3; Jo Ann Lewis, "New Life on Seventh Street," *Washington Post*, March 3, 1984, C3; Anne H. Oman, "Browsing on Seventh Street," *Washington Post*, June 1, 1984, W5; "Art at Your Fingertips," *Washington Post*, June 1, 1984, 5; "Then and Now—7th Street, N.W.," *Washington Post*, July 18, 1985, C5; Mark Jenkins, "After 55 Years," March 2015, https://www.artline.com/about/about-jane-haslem.php, accessed on March 15, 2020.

10. Paul Richard, "Galleries: 406 Grand Opening" *Washington Post*, September 28, 1985, G2; Katherine Seigenthaler, "Taking Art and Music to the Streets," *Washington Post*, August 30 1985, W49; Jo Ann Lewis, "Haslem and History"; Jo Ann Lewis, "Computer Canvasses," *Washington Post*, April 3, 1987, B1; Joel Garreau, "Putting the 'Personal' Into Their P.C.s," *Washington Post*, September 28, 1993, C1; Jo Ann Lewis, "The Medium Is the Machine," *Washington Post*, November 26, 1994, B1; Jo Ann Lewis, "The Essence of an Image," *Washington Post*, May 14, 1988, C2; Moore interview.

11. Theodore Adamstein. Interview with author. July 2, 2020; Maura Judkis, "A Matter of Exposure," *Washington Post*, November 4, 2012, E1; Benjamin Forgey, "Bringing Something Special to the Table," *Washington Post*, October 17, 1998, C1; http://ad-architects.net/projects.html, accessed July 2, 2020.

12. Linda Wheeler, "Carr Buys Old Hecht's Property," *Washington Post*, January 7, 1986, B1; "Fire Hits Lansburgh," *Washington Post*, January 25, 1986, B5; Wendy Swallow, "D.C.'s Old Downtown Sees Boom," *Washington Post*, February 8, 1986, F1; David Saltman, "Arts Beat: Seventh Street Blues," *Washington Post*, May 19, 1986, B7; John Mintz, "PADC Planning Apartments in the Lansburgh Building," *Washington Post*, June 20, 1986, B1; Benjamin Forgey, "Lansburgh's Happy Plethora," *Washington Post*, February 21, 1987, G1; Benjamin Forgey, "Graham Gund's Brave New Buildings," *Washington Post*, January 9, 1988, D1; Dana Interview; Warrell Interview; Simpson Interview; Benjamin Forgey, "City Panel Urges Boost for the Arts," *Washington Post*, February 25, 1988, C1; "As developers circle, debate on `death' of downtown nears end," *Washington Times*, April 18, 1990, C1; Benjamin Forgey, "Downtown Washington...," *Washington Post*, July 7, 1990, C1; Miles Maguire, "Zoning panel favors plan for a `living downtown'," *Washington Times*, July 17, 1990, B2; Miles Maguire, "Downtown arts scene framed in black," *Washington Times*, March 22, 1991, C2; Brett Brune, "Seventh Street Corridor...," *Washington Post*, May 25, 1991, E1; Lloyd Rose, "And Now, Shakespeare at the Lansburgh," *Washington Post*, November 8, 1991, B1; Jonetta Rose Barras, "Downtown alive in quarters—But arts community fears rent increases," *Washington Times*, April 27, 1992, B1.

13. Jo Ann Lewis, "Tapping the New York Market," *Washington Post*, June 6, 1987, G2; Jo

Ann Lewis, "Galleries: Quandary on Seventh Street," *Washington Post*, December 5, 1987, D2; Jo Ann Lewis, "Dark Picture at Downtown Galleries," *Washington Post*, May 14, 1988, C1; Jo Ann Lewis, "Osuna Gallery to leave 406," *Washington Post*, July 27, 1988, C1; Pamela Kessler, "It's a Gas," *Washington Post*, February 5, 1988, WE5; Paul Richard, "On the Edge of Meaning," *Washington Post*, October 1, 1988, C2; Hemphill Interview.

14. Jo Ann Lewis, "Zygos' Grecian Formula," *Washington Post*, July 5, 1986, D2; "Computer Canvasses,"; "Galleries: Quandary on Seventh Street."

15. Margery Goldberg. Interview with author. March 18, 2020; "Etc.," *Washington Post*, February 9, 1975, H2; Sarah Booth Conroy, "Taking a Look at a '70s WPA Project," *Washington Post*, December 14, 1975, 129; Jo Ann Lewis, "Galleries," *Washington Post*, March 12, 1977, B5; Paul Richard, "Art Circle in the Square," *Washington Post*, January 18, 1979, L1; Sarah Booth Conroy, "A Full-time Work of Love," *Washington Post*, December 10, 1980, L1; Jo Ann Lewis, "Art Across the Border," *Washington Post*, April 18, 1981, D7; Jo Ann Lewis, "Sculpture on the run," *Washington Post*, July 17, 1982, C10; Joe Brown, "The Artists' Block," *Washington Post*, November 20, 1982, C9; "Glass," *Washington Post*, September 15, 1983, WH5; Jo Ann Lewis, "Galleries," *Washington Post*, September 7, 1985, F2; Stevan Allen, "Neon's Fascinating Flicker," *Washington Post*, February 26, 1986, F7; Lyle V. Harris, "Zoning Clouds Gallery Picture," *Washington Post*, April 24, 1986, DC3; Pamela Kessler, "Creative Spaces," *Washington Post*, September 25, 1988, G1; Jeanne Cooper, "An Upscale Enclave on P.A. Avenue," *Washington Post*, February 20, 1993, E1; Jo Ann Lewis, "Art Gallery in a Briefcase," *Washington Post*, August 28, 1994, G5; Charles A. Docter, "Developing a Destiny for Our Downtown," *Washington Post*, January 30, 1994, C8; Jo Ann Lewis, "The Magnificent Seventh," *Washington Post*, June 25, 1995, G1.

16. Miles Maguire, "Downtown arts scene framed in black," *Washington Times*, March 22, 1991, C2; Anthony Falola and Judith Evans, "Lifting a Curtain Downtown," *Washington Post*, August 5, 1996, 1; Linda Wheeler, "Painted Into a Corner," *Washington Post*, November 5, 1996, 22; Debbi Wilgoren, "East End Building for a Comeback," *Washington Post*, May 13, 2001, A1; Shannon Ayres, "Across the District, a day for festivals," *Washington Times*, October 13, 1991, A11; "Adams National banks on artists," *Washington Times*, February 15, 1992, B1; Ann Geracimos, "'Off the Mall' over local art scene," *Washington Times*, C14; Ann Geracimos, "Bidding on the local arts scene," *Washington Times*, November 21, 1994, C12; "Arts Notable and New," *Washington Times*, April 5, 1998, D1; "Arts on Foot Festival celebrates Penn Quarter," *Washington Times*, September 15, 2005, M14; Dana Interview.

17. Michael Welzenbach, "Plaques with Problems," *Washington Post*, July 13, 1991, C2; Michael Welzenbach, "Landscapes of Light And Shadow," *Washington Post*, July 11, 1992, C2; Joanna Shaw-Eagle, "Trees are beautiful," *Washington Times*, March 12, 1995, D5; Paul Richard, "Soothy Jazz Acrylics," *Washington Times*, April 22, 1995, D2; Ferdinand Protzman, "Where Artists Run the Show," *Washington Post*, July 13, 1996, D3; Michael O'Sullivan, "Manfred Baumgartner: the deal of the art," *Washington Post*, February 21, 1997, 7; Ferdinand Protzman, "An Artist by George," *Washington Post*, January 7, 1999, C1; Eric Brace, "Specter of the Gods," *Washington Post*, September 25, 1995, B7; Ferdinand Protzman, "A Numark on the art scene," *Washington Post*, November 11, 1995, H2; Ferdinand Protzman, "'Remote Talent Close at Hand," *Washington Post*, January 27, 1996, H1; Ferdinand Protzman, "Pixels at an Exhibition," *Washington Post*, November 13, 1997, C7; Michael O'Sullivan, "The Longest Day," *Washington Post*, June 9, 2000, WW34; Paul Richard, "Old & New, in the Abstract," *Washington Post*, November 16, 2000, C5; Blake Gopnik, "Art and Race, Making a Memorable Appearance," *Washington Post*, April 6, 2003, G1; Nicole M. Miller, "An Influential Family...," *Washington Post*, April 10, 2003, C5; Michael O'Sullivan, "Steinhilber Clearly Propels 'Transparent," *Washington Post*, July 18, 2003, 48; Michael O'Sullivan, "Sanborn's Ghosts of the Atomic Age," *Washington Post*, November 14, 2003, 41; Jessica Dawson, "Robin Rose's Arresting 'Evidence'," *Washington Post*, March 11, 2004, C1; Jessica Dawson, "Galleries," *Washington Post*, November 25, 2006, C2; https://numarkartadvisory.com/about, accessed July 20, 2020.

18. Touchstone: https://www.touchstone gallery.com/; "The Changing Neighborhood," *Washington Star*, September 19, 1976, 92; Benjamin Forgey, "Calendar: Art," *Washington Star*, November 6, 1977, 92; Constance Stapleton, "Notes on a new Craft," *Washington Star*, October 8, 1978, 348; Gale Waldron, "Couple's Life a Work in Progress," *Washington Post*, March 10, 2002, J1; Ellyn Weiss. Interview with author. March 24, 2020; Robyn-Denise Yourse, "Arts Etc. Taking Names," *Washington Times*, December 24, 2008, B10; Marc Fisher, "On Seventh Street N.W.," *Washington Post*, January 25, 2009, C1; "Texas barbecue, with a side of din," *Washington Post*, June 26, 2011, A35; Mark Jenkins, "Downtown art gets an out-of-office message," *Washington Post*, February 12, 2012, E1.

Chapter 11

1. "Notes of Art and Artists," *Washington Star*, December 30, 1923, 39; Ferdinand Protzman, "Imagination's Doorway," *Washington Post*, September 2, 1995, D1; Michael O' Sullivan,

"Playing to the Gallery," *Washington Post*, February 21, 1997, 6; Clark Interview; Richard Dana. Interview with author. March 30, 2020; http://cinematreasures.org/theaters/7381, accessed May 6, 2020; David Montgomery, "Janus Theater is latest to shut down," *Washington Post*, June 1, 2002, C3; https://www.washingtonpost.com/archive/lifestyle/2002/06/01/janus-theater-is-latest-in-dc-to-shut-down/b0c680bf-63e4-4f0b-bdb6-50d376da1b31/, accessed May 6, 2020; https://dcist.com/story/14/04/18/washington-ghosts-former-record-sto-1/, accessed May 6, 2020; Michael Dolan, "A History of a Very Round Place," *Washington Post*, September 2, 1990, SM19; Lucy Blankstein and Claudia Vess, "Gallery 10: An Overview," June 30, 2020; "Art," *Washington Star*, Mary 15, 1969, 41; Ken Oda, "When is an Artist Co-Op Gallery More Than a Co-op Gallery?" *Koan*, April 1994.

2. Jo Ann Lewis, "Galleries," *Washington Post*, March 11, 1982, D7; Carla Hall, "Artscope," *Washington Post*, November 24, 1982, D7; Benjamin Forgey, "Still Showing," *Washington Post*, April 14, 1984, C2; Michael Welzenbach, "Visions of the Bomb," *Washington Post*, December 11, 1984, B7; Jo Ann Lewis, "Museums & Galleries," *Washington Post*, October 23, 1987, W19; Michael Welzenbach, "Galleries: Paint for Paint's Sake," *Washington Post*, March 4, 1989, C2; Michael Welzenbach, "30 shows around town," *Washington Post*, September 9, 1989, C2; Jo Ann Lewis, "The Year in Pictures," *Washington Post*, May 5, 1989, D1; Alice Thorson, "Exhibits Redefine Washington Art," *Washington Times*, January 4, 1990, E3; Michael Welzenbach, "Nakashima: Melding Cultures," *Washington Post*, May 26, 1990, C2; Janet Wilson, "New and Improved," *Washington Post*, November 29, 1991, D2; Janet Wilson, "East Meets West," *Washington Post*, November 20, 1993, B2; Hank Buchard, "Nakashima's Skewed Screens," *Washington Post*, September 23, 1994, 62; Jessica Dawson, "Time to Shutter," *Washington Post*, May 1, 2009, C1; "MOCA GA/ PastPerfect Online," https://mocaga.pastperfectonline.com/creator/44397CB3-7038-43AA-992E-477998205428, accessed December 31, 2020; Claudia Vess. Interview with author. March 9, 2021.

3. Paul Richard, "Art," *Washington Post,* June 2, 1990, C1; Jo Ann Lewis, "Sculpture on Shaky Ground," *Washington Post*, June 9, 1990, B2; Michael Welzenbach, "The Sculpture Standouts," *Washington Post*, June 9, 1990, B2; Eric Gibson, "Wall-based sculpture exhibition stands tall," *Washington Times*, November 22, 1990, M2; Mary McCoy, "For Artists of Promise," *Washington Post*, July 16, 1992, DC1; Michael Welzenbach, "Galleries," *Washington Post*, January 4, 1992, B2; Jo Ann Lewis, "Warm-Weather Art," *Washington Post*, July 25, 1981, C3; Benjamin Forgey, "On The Waterfront," *Washington Post*, July 1, 1982, C7.

4. Eric Brace, "Arts Beat," *Washington Post*, January 4, 1993, C7; Eric Brace, "Mirror or Is It?," *Washington Post*, September 27, 1993, C7; Eric Brace, "NEA Takes Heart for Cuts," *Washington Post*, October 31, 1994, D7; Lee Fleming, "A Matter of Life And Depth," *Washington Post*, October 29, 1994, D2; Tamainia Davis, "The local art scene," *Washington Times*, July 8, 1995, B1; Ferdinand Protzman, "Imagination's Doorway," *Washington Post*, September 2, 1995, D1; Eric Brace, "Art Beats," *Washington Post*, April 8, 1996, D7; Michael O'Sullivan, "Playing to the gallery," *Washington Post*, February 21, 1997, WW6; Ferdinand Protzman, "Galleries: Paint, Necessarily So in Washington," *Washington Post*, September 11, 1997, D7; Michael O'Sullivan, "The Collectors: A new group of Washingtonians is choosing art over," *Washington Post*, October 14, 2001, SMB26; Kauffman emails. "Artists," https://www.studiogallerydc.com/artists, accessed December 10, 2020; Questionnaire from Dr. Jaime Smith to author, February 8, 2021; Furchgott interview.

5. Andrea S. Halbfinger, "Stop Neglecting 19th Century," *Washington Post*, January 31, 1965, G10; Paul Richard, "A Million Plus Buys the Show," *Washington Post*, December 17, 1971, C1; Paul Richard, "Of the 'Wyeth Genre," *Washington Post*, April 17, 1973, B1; Paul Richard, "Artists and Their Opposing Images," *Washington Post*, April 29, 1978, B3; Michael O'Sullivan, "A Glass Show Full of Ideas," *Washington Post*, January 13, 2006, ww48; Maurine Littleton Gallery, http://www.littletongallery.com/artists/, accessed June 7, 2020; Carol D. Dimoch, "Glass Works Gain Ground," *Washington Post*, January 10, 1985, WH20; Carol D. Dimoch, "Nature UnderGlass," *Washington Post*, February 7, 1985, WH26; Martha Sherrill Dailey, "Movement in Glass," *Washington Post*, February 5, 1987, T21; Christina Del Sesto, "A Modern Twist," *Washington Post*, May 14, 1987, T35; Jessica Dawson, "For Thirsty Goblins," *Washington Post*, April 21, 2005, C5; Jo Ann Lewis, "Museums and Galleries," *Washington Post*, October 23, 1987, W19; Eric Gibson, "On Sluggish Art Scene," *Washington Times*, December 8, 1991, D1; Heidi Berry, "Picky Buyers in Tight Market," September 3, 1992, 12; Jo Ann Lewis, "Crash Landing," *Washington Post*, February 6, 1994, G1; Margaret Webb Pressler & Phuonng Ly, "Georgetown Embraces a Revival," *Washington Post*, August 19, 1996, A1; "Moca, DC Home of Nude," *Washington City Paper*, https://www.washingtoncitypaper.com/arts/museums-galleries/blog/13080119/moca-dc-home-of-nude-paintings-and-wild-parties-leaves-georgetown, accessed May 20, 2019.

6. Jo Ann Lewis, "Museums and Galleries,"; "On Sluggish Art Scene,"; "Weddings: Barbara Cooper and Daniel Fendrick," *Washington Post*, October 14, 1953, 28; Judith Martin, "Every Room an Art Gallery," *Washington Post*, August 11, 1962, A9; Joanna Engle, "Print Collecting Can Be an in Thing," *Washington Post Magazine*, October 11, 1970, 6; James T. Yenckel, "Money:

Art for Cash," *Washington Post*, June 5, 1980, D5; Carol D. Dimoch, "Furniture Full of Surprises," *Washington Post*, August 1, 1985, WH24.

7. Todd Smith, "Metropolitan," *Washington Times*, June 11, 1990, C7; Koch Interview.

8. Todd Smith, "Metropolitan,"; Patrick Butters, "Reality of art and freedom," *Washington Times*, July 7, 1999, C8 ; Joanna Shaw-Eagle, "A sparkling array of images," *Washington Times*, December 14, 2002, D5; Audrey Hoffer, "District's art galleries tastefully tucked away—Satisfying a taste for culture with adventure," *Washington Times*, October 13, 2005, M14.

9. Joe Brown, "Arts Beat," *Washington Post*, June 20, 1984, B7; Lehrman Interview; Paul Richard, "The Art of the Word," *Washington Post*, May 15, 1986, B7; Paul Richard, "WPA's New Day," *Washington Post*, December 11, 1988, G1; Roxanne Roberts, "Show of Support," *Washington Post*, July 21, 1989, D1; William F. Powers, "Art and Soul," *Washington Post*, April 9, 1995, G1; Roxanne Roberts, "Hirshhorn Gala," *Washington Post*, October 14, 1999, C1; Denise Barnes, "Plantastic Visions," *Washington Times*, July 10, 1999, B1; Johanna Shaw-Eagle, "Brice Marden," *Washington Times*, July 17, 1999, D1; Michael O'Sullivan, "Christenberry's Haunting Houses," *Washington Post*, October 26, 2001, 54; Jayme McLellan, "Final" in Sharon Louden, ed., *The Artist as Culture Producer* (Intellect Books, 2017); George Hemphill. Interview with author. April 8, 2020.

10. Jo Ann Lewis, "Crash Landing"; Ari Post, "Farewell to the Parish Gallery," *Georgetowner*, November 7, 2013, https://georgetowner.com/articles/2013/11/07/farewell-parish-gallery-closing-its-doors-final-show-opening-june-21/, accessed May 20, 2020; Margaret Webb Pressler & Phuonng Ly, "Georgetown Embraces a Revival,"; "Moca, DC Home of Nude,"; Ferdinand Protzman, "A Stroke of Zen," *Washington Post*, June 29, 2000, C5; Simpson Interview.

11. Nicole Lewis, "Phryne's Refuge," *Washington Post*, April 16, 1998, D7; Alycia Kilpatrick, "Unique Pieces of Jewelry," *Washingtonian*, February 1, 2005; "Galleries," *Washington Post*, January 27, 1995, G51; Ferdinand Protzman, "Undying Passion for a Tango Star," *Washington Post*, August 3, 1996, C2; Michael O'Sullivan, "Arts Beat," *Washington Post*, May 15, 1997, B7; Ferdinand Protzman, "Galleries: 'What's Hot...,'" *Washington Post*, August 2, 1997, C2; Ferdinand Protzman, "Galleries: 'The Eclectic Collector," *Washington Post*, December 18, 1997, C7; Ferdinand Protzman, "She Has Data's Eyes," *Washington Post*, October 29, 1998, D5; Ferdinand Protzman, "At Eklektikos," *Washington Post*, October 21, 1999, C5.

12. Fox Interview; Paul Richard, "Beneath the Fig Leaf," *Washington Post*, December 4, 1993, F1; Jo Ann Lewis, "Crash Landing"; Tamainia Davis, "The local art scene," *Washington Times*, July 8, 1995, B1; Michael O'Sullivan, "A Face That Fits the Bill," *Washington Post*, June 19, 1995, D7; Ferdinand Protzman, "Lessons in Art History," *Washington Post*, August 24, 2000, C5; Michael O'Sullivan, "A Singular Vision," *Washington Post*, March 8, 2002, 51; "Interview Spelling Corrections," email exchange, Clark Fox and author. March 5, 2021.

13. Rebecca Cross. Interview with author.

14. Rasmussen Interview; Claire Huschle. Interview with author. May 20, 2020; Pollan Interview.

15. Drymon Interview; Hank Stuever, "Gallery of the People," *Washington Post*, June 19, 1989, B1; "Arts and Entertainment," *Washington Times*, January 18, 1990, E3; Michael Welzenbach, "Galleries," *Washington Post*, May 26, 1990, C2; Todd Allan Yasui, "Arts Beat," *Washington Post*, June 11, 1990, B7; Todd Allan Yasui, "Mellen's Vision for D.C. Arts," *Washington Post*, December 3, 1990, C7; Paul Richard, "Mayor Dixon, Likeness or Not," *Washington Post*, June 1, 1991, D1; Laura Outerbridge, "Today's Best Bets,'" *Washington Times*, November 9, 1991, B1; "'Sex & Violence' turns a lot of heads," *Washington Times*, February 2, 1992, D8.

16. Eric Brace, "Arts Beat," *Washington Post*, April 5, 1993, D7; Merrie Morris, "About Town," *Washington Times*, September 14, 1993, C15 ; multiple pages, DCAC website, DCAC; Eric Brace, "DCAC Chief Heads to Seattle," *Washington Post*, April 24, 1994, C7; Richard Leiby, "For Part-Time Artists," *Washington Post*, June 24, 1994, G5; Michael Richman, "Israeli, Arab artists build," *Washington Times*, April 20, 1994, C1; Ann Geracimos, "Arts and business join forces," *Washington Times*, July 7, 1995, C1; Tamainia Davis, "The local art scene," *Washington Times*, July 8, 1995, B1; Ann Geracimos, "Brief Encounters," *Washington Times*, July 11, 1996, C1; "The Season: Art," *Washington Post*, September 7, 1997, G7; "Watch This Space," *Washington Post*, January 1, 1998, T4; "Washington Daybook," *Washington Times*, July 21, 2000, A8; Nicole M. Miller, "Luck of the Draw," *Washington Post*, November 16, 2000, C5; Jessica Dawson, "Mall Memories," *Washington Post*, May 3, 2001, C5; McLellan Interview; "More Happenings Around Town," *Washington Post*, June 25, 2006, M6; "Art of the People," *Washington Post*, December 8, 2006, C10; Lavanya Ramanathan, "A Native American Vision for D.C.," *Washington Post*, April 13, 2007, C11; Kriston Capps, "Forget the art auction," *Washington Post*, May 10, 2011, C2; Mark Jenkins, "Art Galleries," *Washington Post*, March 6, 2015; Ruth Trevarrow. Interview by author. December 17, 2020; Greg Varner, "Feeling Queer?" *Washington Blade*, June 18, 1999.

17. Anne Hancock. Interview with author. May 29, 2020; Doree Lovell, "Northern Virginia Arts Projects Get Grants," *Washington Post*, January 26, 1978, VA7; Doree Lovell, "Attorney Named Head," *Washington Post*, May 25, 1978, VA3; Doree Lovell, "Community Involvement is

Goal," *Washington Post*, November 27, 1979, VA3; Sarah Thomas, "Artists Hold Show," *Washington Post*, July 31, 1980, VA6; Deborah Churchman, "Making It s an Artist in Virginia," *Washington Post*, January 1, 1981, VA3; Deborah Churchman, "Having Fun with Avant-Garde," *Washington Post*, January 22, 1981, VA8; Benjamin Forgey, "Eclectic Selection," *Washington Post*, December 22, 1981, C7; Benjamin Forgey, "Biennial Print Exhibition," *Washington Post*, September 4, 1982, D3; Anne Behrens, "Strong Emotion," *Washington Post*, June 29, 1983, VA12.

18. Anne Behrens, "Professional Artists finding a Haven," *Washington Post*, May 17, 1984, VA1; Jo Ann Lewis, "The Visual Lauching Pad," *Washington Post*, October 17, 1987, D2; "Arlington Arts Center's 10th Anniversary," *Washington Post*, June 20, 1987, G2; Michael Weizenbach, "Galleries: The Perils of Equality," *Washington Post*, February 18, 1989, C2; Hank Burchard, "Low Shock Gender Show," *Washington Post*, February 8, 1991, 54; Snigdha Prakash, "Visual Arts," *Washington Post*, April 4, 1991, VA11; Mary McCoy, "A Full Display of 'New Genres,'" *Washington Post*, March 11, 1993, VA10; Michael O'Sullivan, "Arts Beat," *Washington Post*, April 10, 1997, B7; Brett Moss, "'Sites' shows art has its place," *Washington Times*, June 9, 1994, C17; "Arts and Entertainment," *Washington Times*, April 22, 2000, D3; Nicole M. Miller, "In Arlington," *Washington Post*, October 18, 2001, C5.

19. Jon Breeding. Interview with author. May 12, 2020; Huschle Interview; "September Now," *Washington Post*, September 8, 2002, G13; Chris L. Jenkins, "Youngsters Records Life," *Washington Post*, February 13, 2003, AAVE12; Michael O'Sullivan, "Art That Works," *Washington Post*, January 21, 2005, GWW25; "Briefs," *Washington Post*, April 7, 2005, T5; Annie Gowin, "A Sept. 11 Tribute Sits in Decay," *Washington Post*, December 18, 2005, C1; "Washington, DC Art News," https://dcartnews.blogspot.com/archives/2005_01_01_dcartnews_archive.html, accessed June 3, 2020; Breeding Interview; Michael O'Sullivan, "Women Don't Play," *Washington Post*, March 2, 2012, EZ16; Michael O'Sullivan, "40 Years of Community Sourced Art," *Washington Post*, February 27, 2014, EZ16; Michael O'Sullivan, "1 + 1 equals...," *Washington Post*, February 28, 2014, WW18.

20. Sarah Wildman, "How a mother-and-son duo shaped Washington's art and food scenes," *Washington Post Magazine*, January 26, 2017; Michael O'Sullivan, "Seeing the Big Picture," *Washington Post*, August 14, 1997, B1; Margaret Foster, "Art Needs a Home," *Washington City Paper*, June 1, 2001, Michael O'Sullivan, "An Inside/Out Show at Warehouse," *Washington Post*, December 12, 2003, W54; Bidisia Banerjee, "Selfless Portraits," *Washington City Paper*, April 9, 2004; "New and Notable," *Washington Post*, February 29, 2004, M4; "New and Notable," *Washington Post*, May 29, 2005, M5; Jonathan

Padget, "Gay Pride Infuses," *Washington Post*, June 9, 2005, C5; Jessica Dawson, "The Multifarious Seven," *Washington Post*, July 21, 2005, C5; Kara McPhillips, "Hey, is That a boy or a girl?" *Washington City Paper*, November 4, 2005; Marc Fisher, "In the Wake of Devastation," *Washington Post*, February 28, 2006, B1; Lisa Rauschart, "Night's events," *Washington Times*, July 24, 2006, B8; Akeya Dickson and Justin Rude, "Spring Into Modernism," *Washington Post*, March 4, 2007, M7; Rachel Beckman, "Throwaway Art: Don't Trash It," *Washington Post*, April 12, 2008, C12.

Chapter 12

1. "Arts Notable and New," *Washington Times*, May 22, 1999, D1; Koch Interview; Denise Barnes, "Creativity bubbles at laundry," *Washington Times*, June 8, 1999, C8; Ferdinand Protzman, "Galleries," *Washington Post*, June 10, 1999, C05; Weiss Interview; Koch Interview; "National Register Information System," *National Register of Historic Places*. National Park Service. March 13, 2009; Jessica Dawson, "Art-o-Matic for the People," *Washington City Paper*, May 21, 1999; https://www.washingtoncitypaper.com/arts/article/13017733/art-o-matic-for-the-people, accessed June 12, 2020; Tammy Vitale, "A Guide to Participating in Art-o-Matic," http://bourgeononline.com/2009/04/a-guide-to-participating-in-artomatic-by-tammy-vitale/, accessed June 12, 2020.

2. Veronica Szalus. Interview with author. June 28, 2020; Joanna Shaw-Eagle, "Art-o-Matic offers public a creative mix," *Washington Times*, October 21, 2000, D1; Michael O'Sullivan, "Art-o-Matic: A Visual Feast," *Washington Post*, October 6, 2000, H61; Chip Montague, "Art-o-Matic Gets Ready," May 8, 2012, http://washingtonglassschool.com/category/artomatic/page/4, accessed June 25, 2020; Arkin Interview; Tate Interview.

3. Joanna Shaw-Eagle, "Some success at Art-o-Matic," *Washington Times*, November 2, 2002, D6; Michael O'Sullivan, "Art-o-Matic for the People," *Washington Post*, November 8, 2002, 50; Leland, "Former Volunteer," https://greatnonprofits.org/org/artomatic, February 6, 2010, accessed June 20, 2020.

4. Roxanne Roberts and Amy Argetsinger, "Who Listened When His Fish Talked?" *Washington Post*, March 25, 2009, C3; Tyler Green, "Art-o-Matic and the Quality vs. Quantity Debate," *Washington Post*, December 1, 2002, G11; Chris Shott, "Object Lesson," *Washington City Paper*, April 1, 2005, https://www.washingtoncitypaper.com/arts/article/13030772/object-lesson, accessed June 20, 2020; Arkin Interview; Szalus Interview; Blake Gopnik, "Art-o-Matic 2004," *Washington Post*, November 11, 2004, C1; Michael O'Sullivan, "Art-o-Matic:

Keep Your Eyes Open," *Washington Post*, November 19, 2004, WW54; "Art-o-Matic for the People," *Alexandria Times*, https://alextimes.com/2007/04/artomatic-for-the-people/, accessed June 20, 2020; "Letters to the Editor: Antagonizing Art-o-Matic," *Washington Post*, November 20, 2004, A17; Anthony L. Harvey, "High Energy Art-o-Matic," *Intowner*, November 1, 2004, 1.

5. DC Government, 'DC Commission on the Arts and Humanities,"; MuralsDC, https://muralsdcproject.com/our-mission/, accessed December 29, 2020; in The Rough, "Female Muralists Transform the District," May 24, 2017, http://www.intheroughstyle.com/lifesgoods/2017/5/24/female-muralists-transform-the-district, accessed December 29, 2020.

6. McLellan Interview; Reis Interview; Jessica Dawson, "It Takes a Heap," *Washington Post*, December 11, 2003, C5; Jessica Dawson, "That's Amorphous," *Washington Post*, December 18, 2003, C5; Lavanya Ramanathan, "How to Grow a Poem," *Washington Post*, August 16, 2007, C12; Rachel Beckman, "Southside' Story," *Washington Post*, February 21, 2008, C5; "FotoWeek DC," *Washington Post*, November 12, 2009, T4; Michael O'Sullivan, "A Compelling Spaghetti Western," *Washington Post*, August 13, 2010, T36; https://www.culturaldc.org/, accessed June 16, 2020; "Partners for Livable Communities," http://livable.org/livability-resources/163-cultural-development-corporation, accessed June 16, 2020; Jess Righthand, "Exhibits, performances highlight," *Washington Post*, July 19, 2011, C6; Michael O'Sullivan, "Tech tools help explore human condition," *Washington Post*, December 9, 2011, T16; "Transformer," http://www.transformerdc.org/about/history-supporters, accessed June 16, 2020; Michael O'Sullivan, "Our Picks," *Washington Post*, June 7, 2002, C5; Nicole Miller, "The Up-and-Coming Gallery," *Washington Post*, June 13, 2002; "Drawing Power," *Washington Post*, December 19, 2002, C5; Jonathan Padget, "Truth and Fantasy in a Film on U Street," *Washington Post*, August 14, 2003, C5; Jessica Dawson, "Visual Explorations at Transformer," *Washington Post*, April 15, 2004, C5; Jonathan Padget, "Knit One, Swirls Too," *Washington Post*, February 10, 2005, C5; Jessica Dawson, "Dead Animals Liven Up," *Washington Post*, January 7, 2006, C5; Jessica Dawson, "The Right Ingredients," *Washington Post*, January 4, 2008, C2; Michael O'Sullivan, "Art-o-Matic Sets Up Shop in Frederick," *Washington Post*, October 21, 2011, WW20; "Art-o-Matic Thinks Small in Bethesda," *The Washington Post*. January 11, 2007; "Northern Virginia Art Beat," *Falls Church News-Press Online*, January 17, 2007; Jordan Edwards, "The Chosen Few," *The Gazette*, July 29, 2009; P.L. Wolff, "Dupont Circle Groups to Unveil," *Intowner*, September 1, 2005, 1.

7. Blake Gopnik, "Go Somewhere Young Man," *Washington Post*, November 27, 2001, C1; Blake Gopnik, "Double Vision; Together," *Washington Post*, April 13, 2008, m1; Jonathan Padget, "Making a Gallery Space," *Washington Post*, September 9, 2004, C5; Jessica Dawson, "Mr. Hemphill's Neighborhood," *Washington Post*, December 2, 2004 C8; "Here & Now," *Washington Post*, March 20, 2005, n2; Jacqueline Trescott, "Fusebox Gallery to Close," January 7, 2006, C5; Michael O'Sullivan, "Pushing Boundaries in One Building," *Washington Post*, May 19, 2006, t67; Michael O'Sullivan, "Where the Art Is," *Washington Post*, November 14, 2008, WW25; Pollan Interview.

8. Pollan Interview; Jessica Dawson, "G Fine Arts to Close," *Washington Post*, July 31, 2009, C2; Jessica Dawson, "Facing the Raw Visual Facts," *Washington Post*, March 26, 2010, C8; Maura Judkas, "New Art Gallery Opens," *Washington Post*, October 20, 2011, C8; Kriston Capps, "Never change, Transformer," *Washington City Paper*, November 28, 2012, https://www.washingtoncitypaper.com/arts/museums-galleries/blog/13078540/never-change-transformer-logan-circles-tiniest-gallery-toasts-to-10-years-of-hard-to-sell-art, accessed June 21, 2020; Jessica Dawson, "Facing the raw visual facts," *Washington Post*, March 26, 2010, C8; Maura Judkas, "New Art Gallery Opens," *Washington Post*, October 20, 2011, C8.

9. Drymon Interview; Arkin Interview; Henry Allen, "Urban Canvas," *Washington Post*, August 21, 1999, C01; Bob Massey, "Arts Beat," *Washington Post*, July 1, 1999, C5; Natalie Campbell, ed., *A Guide to Defunct Artist-Run Spaces* (Washington, D.C.: Washington Project for the Arts, 2017); Matt Cohen, "End of an Alley," *Washington City Paper*, October 20, 2016, https://www.washingtoncitypaper.com/arts/article/20837636/blagden-alleys-last-remaining-artist-is-being-priced-out, accessed July 20, 2020; Interview of Giorgio Furioso by Rebecca Summer; Rachel Beckman, "Making a Place for Art in Anacostia," *Washington Post*, January 22, 2007; https://www.washingtonpost.com/wpdyn/content/article/2007/01/10/AR2007011002350_pf.html, accessed March 20, 2020; https://minds.wisconsin.edu/bitstream/handle/1793/79412/Interview_GiorgioFurioso_developer.pdf?sequence=1&isAllowed=y, accessed July 20, 2020; Washington Project for the Arts, "Tom Drymon and Doris Mae," https://www.wpadc.org/news/thomas-drymon-and-doris-mae, accessed July 20, 2020; "About," https://www.colinwinterbottom.com/Asset.asp?AssetID=67950&AKey=VKNT9F5T, accessed May 21, 2020.

10. Rupert Chappelle, "Trinka Margua Simon Art-o-Matic 2007 wall mural is whitewashed," May 20, 2007; https://www.youtube.com/watch?v=FhFruul7wpY, accessed June 21, 2020; "Art-o-Matic," March 25, 2007, http://tammyvitale.com/artomatic/, accessed June 21, 2020; "Jennifer Beinhacker: Art Outside The Edge," https://jenniferbeinhacker.com/artwork/197993_offering_2.html, accessed June 21, 2020; Szalus Interview.

11. Michael O'Sullivan, "Art-o-Matic for the People," *Washington Post*, July 8, 2009, 46; Christy Goodman, "Art," *Washington Post*, March 7, 2010, LE1; Michael O'Sullivan, "In Crystal City," *Washington Post*, March 12, 2010, T39; Lisa Harkins, *Washington Post*, April 18, 2010, W17; Szalus Interview.

12. Mark Jenkins, "At Art-o-Matic," *Washington Post*, May 25, 2012, C8; Hamil R. Harris, "In Hyattsville, Art-o-Matic 2015," *Washington Post*, November 4, 2015; https://www.yelp.ca/biz/artomatic-hyattsville, accessed June 22, 2020; Eric Hope, "East City Art Highlights from Art-o-Matic 2015," *East City Art*, November 16, 2015, https://www.eastcityart.com/reviews/east-city-art-hightlights-from-artomatic-2015/, accessed June 24, 2020.

13. https://www.arlnow.com/2017/03/24/artomatic-opens-tonight-in-crystal-city-with-heavy-political-influence/, accessed June 20, 2020; Laura, "Thematic Art-o-Matic," Interpretation Hobbyist website, April 30, 2017; Stephanie Rudig, "Art-o-Matic Continues to Evolve," *Washington City Paper*, May 21, 2020.

Chapter 13

1. Kriston Capps, "Fairly Concerned," *Washington City Paper*, April 26, 2007; Sidney Lawrence, "Capital Roundup," *artnet*, http://www.artnet.com/magazineus/reviews/lawrence/lawrence5-14-07.asp, accessed July 7, 2020; Michael O'Sullivan, "ArtDC: A First," *Washington Post*, April 27, 2007, WW48; Joanna Shaw-Eagle, "Exciting, exotic, ArtDC": *Washington Times*, April 28, 2007, B1; Kaufman-Vardy Projects, Strategic Arts Marketing, https://www.kv-projects.com/about-1, accessed July 7, 2020; Christian Morgner, "The Evolution of the Art Fair," *Historical Social Research / Historische Sozialforschung* Vol. 39, No. 3 (149), Special Issue: Terrorism, Gender, and History. State of Research, Concepts, Case Studies (2014), 318–336; Y-Jean Mun-Delsalle, "The Art Fair Boom," *Forbes*, April 7, 2016; https://www.forbes.com/sites/yjeanmundelsalle/2016/04/07/the-art-fair-boom-is-forever-changing-the-way-the-art-market-does-business/#9859d036c649, accessed July 12, 2020.

2. Herbert I. Dunn, "A D.C. art fair's predecessor," *Washington Post*, July 30, 2011, A15; "International Fair Here," *Washington Star*, July 30, 1975, 54; "International Fair Here," *Washington Star*, September 15, 1975, 54; Paul Richard, "Washington '76...," *Washington Post*, May 9, 1976, K1; Benjamin Forgey, "90 Art Dealers," *Washington Star*, May 9, 1976, 54; Benjamin Forgey, "Washington Art '76," *Washington Star*, May 12, 1976, C2; Paul Richard, "Picturing What the Art World Sells," *Washington Post*, May 13, 1976, B13; "The Arts," *Washington Star*, September 17, 1976, 31; Naomi Martin, "From Antiquity to Modernity: How Art Fairs Became a Cultural Mainstay," https://magazine.artland.com/from-antiquity-to-modernity-how-art-fairs-became-a-cultural-mainstay/, accessed March 20, 2020; "Felluss Fine Art," https://felluss.com/, accessed March 20, 2020.

3. "The Arts," *Washington Star*, September 17, 1976, 31; "Fellus Fair," *What's Up in Art*, April 1977, 4; Jo Ann Lewis, "Washington's Art Market...," *Washington Post*, May 1, 1977, 162; Benjamin Forgey, "Nature of the Game," *Washington Star*, May 5, 1977, 43; Paul Richard, "An Eyeful at Art Dealers," *Washington Post*, May 5, 1977, 56; "International Fair Here," *Washington Star*, March 5, 1978, 25; Benjamin Forgey, "Nature of the Game," *Washington Star*, May 4, 1978, 32; Jo Ann Lewis, "Art '78," *Washington Post*, May 3, 1978, D15; Paul Richard, "Merchants of Luxuries Bringing," *Washington Post*, May 5, 1978, B1; Jo Ann Lewis, "Artworks Supermarket," *Washington Post*, May 6, 1978, B1; Benjamin Forgey, "Washington's Art Fair Gains Quality," *Washington Star*, May 2, 1979, 27; Abby Wasserman, "A Feast of Aesthetic Delights," *Washington Star*, May 3, 1979, 21; Jo Ann Lewis, "Déjà Vu Relieved," *Washington Post*, May 5, 1979, B3; Victoria Donohoe, "Art—Fantasy Art's Variety," *Philadelphia Inquirer*, August 14, 1981, D34; Elias Felluss. Interview with author. February 26, 2021.

4. Benjamin Forgey, "A Potpourri at the Art Bazaar," *Washington Star*, May 3, 1980, 19; Jo Ann Lewis, "Frame work," *Washington Post*, May 3, 1980, C1; Carla Hall, "Art and a Fair Deal," *Washington Post*, September 16, 1981, B11; Jo Ann Lewis, "Fair Too Middling," *Washington Post*, September 11, 1981, B1; Phil McCombs, "Arts Beat," *Washington Post*, May 25, 1983, B7; Cathy Lewandowski, "Reluctant Art Fair Operator," *Newswire*, April 29, 1984; Michael Brenson, "Expo Has Plenty," *New York Times*, April 6, 1986, A34; Grace Glueck, "Dealers Bid for a Share," *New York Times*, November 29, 1988, C17; Grace Glueck, "Art Fairs," *New York Times*, December 9, 1989, 115; Regina Hackett, "Galleries and Collectors," *Seattle Post-Intelligencer*, February 20, 1992, C4; Deloris Tarzan Ament, "Mixed Reports from ArtFair/Seattle," *Seattle Times*, February 10, 1993, C5; "Art Chicago," websites, Wayback-Machine searches; Email between author and George Hemphill, July 28, 2020; "Contemporary Art Showcased in Chicago," *New York Times*, April 27, 1997, 3; David Bernstein, "Faltering Art Fair Chills Chicago," *New York Times*, July 17, 2004, B7.

5. https://www.artbasel.com/miami-beach/the-show, accessed July 18, 2020; Lynn Carrillo, "Art Miami Showcases Latin Works," *Miami Herald*, January 2, 1994, 9; Helen L. Kohen, "Art Miami '94 Showcasing Top Art," *Miami Herald*, January 6, 1994, 1B; Michael Kimmelman, "Ambitious Miami," *New York Times*, March 31, 1996, H34; Jan Sjostrom, "Spinoffs Embrace,"

Palm Beach Daily News, November 25, 2005, B1; Andrea Pollan. Interview with author. July 21, 2020; James Echols, "Pulse Miami 2008 Information," *Miami Examiner*, November 16, 2008, www.pulse-art.com; Cara Ober, "Interview with Leigh Conner and Dr. Jamie Smith, Ph.D. on Academy 2009," Baltimore Arts Examiner, August 9, 2009; Terri Sapienza, "Resources for Finding and Decorating," *Los Angeles Times*, September 4, 2009; Michael Janis. Interview with author. August 4, 2020; Tim Tate. Interview with author. August 4, 2020; Cross Interview; Pollan Interview; McLellan Interview; https://www.habatat.com/, accessed September 21, 2020; Smith Questionnaire.

6. Jessica Goldstein, "New D.C. fair to showcase contemporary art," *Washington Post*, July 17, 2011, E3; Philip Kennicott, "Adaptive artwork," *Washington Post*, September 24, 2011, C1; Carla Broyles, "[E] merge and improve," *Washington Post*, September 23, 2012, E2; Mark Jenkins, "[E]merge gives space to eclectic art," *Washington Post*, October 6, 2012, C1; Samantha Sault, "Get Out," *Washington Times*, October 4, 2013, D8; http://www.hollybass.com/moneymaker, accessed September 21, 2020.

7. "Meet Superfine!" Artnet Gallery Network, October 5, 2018; https://news.artnet.com/partner-content/fair-fatigue-no-superfine-art-fair-actually-want-attend, accessed January 25, 2021; "Superfine! Art Fair," https://www.superfine.world/washington-dc-art-fair, accessed January 25, 2021.

Chapter 14

1. "Planning Officials on the Hirshhorn Sculpture Garden Redesign—Not so Fast," December 6, 2020, https://www.tclf.org/planning-officials-hirshhorn-sculpture-garden-redesign-%E2%80%93-not-so-fast?destination=search-results, accessed December 14, 2020; Stephen Staugidl, "NCPC Advances Plans," December 4, 2020; https://www.ncpc.gov/news/item/126/1/, accessed December 15, 2020.

2. Hirshhorn Museum, "Hirshhorn Museum and Sculpture Garden Sculpture Garden Revitalization," April 10, 2019, https://hirshhorn.si.edu/sculpture-garden-revitalization/, accessed November 30, 2020; Hirshhorn Museum, "Hirshhorn Museum and Sculpture Garden Sculpture Garden Revitalization," February 24, 2020, https://hirshhorn.si.edu/sculpture-garden-revitalization/, accessed November 30, 2020; Hirshhorn Museum, "Hirshhorn Museum and Sculpture Garden Sculpture Garden Revitalization," October 10, 2019, https://hirshhorn.si.edu/sculpture-garden-revitalization/, accessed November 30, 2020; "A Redesign of the Hirshhorn Sculpture Garden Stirs Controversy," July 18, 2020, https://www.artfixdaily.com/news_feed/2020/07/18/5305-a-redesign-of-the-hirshhorn-sculpture-garden-stirs-controversy, accessed November 30, 2020.

3. Meryle Secrest, "Bids Too High," *Washington Post*, June 26, 1969, L1; Jack Anderson, "Mall Memorial to Hirshhorn," *Washington Post*, April 11, 1970, C11; Wolf Von Eckardt, "Trench Warfare: Cityscape," *Washington Post*, February 6, 1971, E1; Meryle Secrest, "Subcommittee, Smithsonian," *Washington Star*, January 6, 1971, B1; "The Hirshhorn Museum," *Washington Star*, February 2, 1971, 6;Sarah Booth Conroy, "Hirshhorn Hassles," *Washington Post*, May 6, 1971, H2; John Hanrahan, "Hirshhorn Builder," *Washington Post*, January 31, 1973, 1971, C1; Benjamin Forgey, "The Hirshhorn: Getting the Bugs Out," *Washington Star*, October 24, 1974, 23; Wolf Von Eckardt, "Trench Warfare: Cityscape," *Washington Post*, September 28, 1974, B1; Garry Wills, "The Hirshhorn: a Bargain," *Washington Star*, October 25, 1974, 11; Valerie J. Fletcher, *A Garden for Art* (Washington, D.C.: Smithsonian Institution, 1998), 4–7, 23.

4. Fletcher, 24–26; Benjamin Forgey, "Tending the Garden," *Washington Post*, September 12, 1981, B1; Benjamin Forgey, "Gallery of Greenery," *Washington Post*, June 12, 1993, C1; Lawrence Interview; Mary Jordan, "Victory Parade," *Washington Post*, June 5, 1991, D1; Michael York, "Military Hardware," *Washington Post*, June 7, 1991, B1.

5. Jacqueline Trescott, "Hirshhorn invests in an inflationary measure," *Washington Post*, December 16, 2009, C1; Blake Gopnik, "The Hirshhorn's new plans for expansion," *Washington Post*, December 16, 2009, C11; Philip Kennicott, "A Square Gets Hip," *Washington Post*, November 10, 2011, C1; Lonnae O'Neal Parker, "Hirshhorn trustees chairman steps down," October 18, 2012, C9; Philip Kennicott, "In defense of the 'Hirshhorn bubble'," *Washington Post*, February 8, 2013, C1; Philip Kennicott, "Smithsonian's future as a serious art institution," *Washington Post*, May 24, 2013, A1; Lonnae O'Neal Parker, "Bubble Bursts," June 6, 2013, C1; "Liz Diller: A giant bubble for debate," *TED 2012, March 2012*, accessed May 3, 2020; Joan Mayfield. Interview with author. December 21, 2020; Robin Moore. Interview with author. December 29, 2020; Paul Richard, "Bargains in the work," *Washington Post*, September 15, 1983, E1; Sidney Lawrence. Interview with author. December 30, 2020.

6. "Accepts Freer Gift," *Baltimore Sun*, January 25, 1906, 5; "The Freer Gallery of Art, About Us," Asia.si.edu, accessed November 30, 2020; "Charles Lang Freer, Freer and Sackler Galleries," *Asia.si.edu*, accessed November 30, 2020; "Tales of Well-Known Folk," *Washington Star*, October 8, 1922, 46; Gertrude Richardson Brigham, "Freer Collection Viewed in Private," *Washington Post*, May 2, 1923, 8; Lelia Mechlin, "The North Window," *Washington Star*, May 3, 1923, 6; Paul V. Collins, "Capital Keynotes," *Washington Star*, May 11, 1923, 6; Gertrude Richardson Brigham,

"Freer Collection Enhances," *Washington Post*, May 20, 1923, 18; "Art Gallery Opens," *Baltimore Sun*, May 3, 1923, 8; James Bone, "Bone's Impressions of the National Capital," *Baltimore Sun*, September 4, 1925, 10.

7. Farar Elliott. Interview with author. December 17, 2020; Mayfield Interview.

8. "Japanese Minister Announces Gift to Freer." *Torch*. Smithsonian Institution, May 2, 1979, https://siarchives.si.edu/collections/siris_sic_1725; accessed May 4, 2020; "Funds Granted for Quadrangle Planning," *Annual Report of the Smithsonian Institution for the year 1982. Smithsonian Institution Archives*, https://siarchives.si.edu/collections/siris_sic_1634, accessed May 4, 2020; Betty James, "Smithsonian Plans for 2 Buildings," *Washington Star*, June 13, 1979, 13; "Notice of Intent," *Washington Star*, June 1, 1980, 56; Joseph McLellan, "Artscape," *Washington Post*, April 21, 1982, B7; Carole Shifrin, "Method of Cutting Costs," *Washington Post*, May 21, 1983, E1; "$5 Million Saudi Gift," *Atlanta Journal-Constitution*, October 10, 1985, A4; Jack Schnedler, "Smithsonian Goes Underground," *Chicago Sun-Times*, September 27, 1987, 4; Paul Richard, "The Smithsonian's Mystery Building," *Washington Post*, August 30, 1987, G1; Paul Richard, "The Sackler and African Buried Treasures," *Washington Post*, September 27, 1987, F1; John McKelway, "A trip to the basement of the nation's attic," *Washington Times*, February 8, 1990, B1.

9. Andrew Joseph, "A blizzard of prescriptions..." *State News*, January 15, 2019, https://www.statnews.com/2019/01/15/massachusetts-purdue-lawsuit-new-details/, accessed November 30, 2020; Gerald Posner, "I Thought I Understood the Sackers' Opioid Empire," *State News*, March 10, 2020, https://www.statnews.com/2020/03/10/startling-documents-reveal-new-facets-sackler-opioid-empire/, accessed November 30, 2020; Nan Goldin, *Artforum*, January 2018, https://www.artforum.com/print/201801/nan-goldin-73181, accessed November 30, 2020; Peggy McGlone, "Shame on Sackler," *Washington Post*, April 26, 2018, https://www.washingtonpost.com/news/arts-and-entertainment/wp/2018/04/26/shame-on-sackler-anti-opioid-activists-call-out-late-smithsonian-donor-at-his-namesake-museum/, accessed December 1, 2020; "Nan Goldin's P.A.I.N group," *Artforum*, April 27, 2018, https://www.artforum.com/news/nan-goldin-s-p-a-i-n-group-stages-sackler-protest-in-washington-dc-75157, accessed December 1, 2020; Taylor DeFoe, "The Smithsonian's New Director," Artforum, July 2, 2019, https://artnet.com/art-world/smothsonian-sackler-gallery-letter-1590859, accessed December 1, 2020; Nancy Kenney, "Freer/Sackler rebrands its identity," *Washington Post*, December 5, 2019, https://www.theartnewspaper.com/news/freer-sackler-rebrands-its-image-as-the-national-museum-of-asian-art, accessed December 1, 2020; Katya Kazakina and Benjamin Stupples, "Artists Protest Sackler Family," *Bloomberg*, March 6, 2019, https://www.bloomberg.com/news/articles/2019-03-06/sackler-family-faces-art-world-protests-with-purdue-under-siege, accessed December 15, 2020.

10. "Capitol Hill Home Tour," *Washington Star*, April 29, 1961, 35; "Art Notes," *Washington Star*, July 21, 1963, 83; John McKelway, "Hears of a Museum," *Washington Star*, January 17, 1964, 21; Frank Getlein, "Art Notes," *Washington Star*, June 21, 1964, 84; "African Art to Be Shown," *Washington Star*, February 20, 1965, 14; Ruth Dean, "State Dinner Tonight," *Washington Star*, March 29, 1965, 28; Benjamin Forgey, "Negro History Shrine," *Washington Star*, February 19, 1967, 34; Judy Flander, "Robbins Links African Art to Americans," *Washington Star*, June 25, 1976, 1; Carla Hall, "And After the Merger," *Washington Star*, August 9, 1979, D11; "Warren M. Robbins (1923–2008)," *Artforum, December 8, 2008*, accessed December 5, 2020; .Jacqueline Trescott, "African Art Museum to Lose Director," Washington Post, May 17, 2008, D1.

11. Jacqueline Trescott, "African Art Museum Chief Retires," *Washington Post*, May 9, 2002, C1; "Major Collection of African Art Goes to Smithsonian," *Artforum*, September 30, 2005, https://www.artforum.com/news/major-collection-of-african-art-goes-to-smithsonian-9591, *accessed December 14, 2020;* "African Art Museum Gets $1.8 million from Oman." NBC4 Washington through Associated Press, *accessed December 14, 2020;* Robert C. Post, "Controversy, thy name be Smithsonian," Johns Hopkins University, September 14, 2015, https://www.press.jhu.edu/news/blog/controversy-thy-name-be-smithsonian, accessed December 15, 2020; "Bill and Camille Cosby Loan Private Collection," *Smithsonian Institution*, November 2015, https://africa.si.edu/pressrelease/conversations/, accessed December 15, 2020; Alyssa Buffenstein, "Smithsonain Conveniently Concealed $716,000," *Artnet*.com, July 13, 2015; https://news.artnet.com/art-world/smithsonian-concealed-bill-cosby-donation-316275, accessed December 14, 2020; Claire Voon, "What Museumgoers Think of the Cosby Exhibition," *hyperallergic.com*, September 8, 2015, https://hyperallergic.com/234549/what-museum-goers-think-of-the-smithsonians-cosby-exhibition/, accessed December 14, 2020; Peggy McGlone, "Smithsonian's National Museum of African Art," *Washington Post, July 15, 2020*, https://www.washingtonpost.com/entertainment/museums/smithsonians-national-museum-of-african-art-accused-of-culture-of-racism/2020/07/15/7d63ff48-c6d8-11ea-a99f-3bbdffb1af38_story.html, *accessed December 15, 2020.*

12. "To Settle Ownership," *Washington Star*, November 9, 1905, 2; "A National Gallery," *Washington Star*, November 27, 1905, 11; "New Museum Opened," *Washington Post*, March 18,

1910, 16; Lois Marie Fink, *A History of the Smithsonian American Art Museum* (Amherst: University of Massachusetts Press, 2007), 53–56.

13. Fink, 73–82; "Says Art is Vital in Lives of All," *Washington Star*, May 17, 1924, 3; "South Side Purchase Bill," *Washington Star*, April 8, 1911, 6; James Croggan, "A Noted Section," *Washington Star*, August 6, 1911, 8; Paul V. Collins, "Background of Events," *Washington Star*, August 7, 1925, 6; "The New National Gallery," *Washington Star*, November 9, 1927, 8; "Mall Site Selected," *Washington Post*, November 9, 1927, 20; John H. Scarff, "Washington Triangle Reflects Government," *Washington Star*, March 15, 1936, B7.

14. "Here are the Men Chosen," *Washington Star*, March 4, 1921, 4; Vylla Poe Wilson, "Mellon's $50,000,000 Gift to Place," *Washington Post*, February 24, 1935, T5; Edward T. Folliard, "Art of Mellon Stored in City," *Washington Post*, February 24, 1935, 1; "How Mellon Collected Art," *Washington Star*, March 3, 1935, 2; Edward T. Folliard, "Mellon Art Collection Is Presented to Nation," *Washington Post*, January 3, 1937, 1; "Mellon Art Gift Accepted by Senators," *Washington Post*, March 16, 1937, 1; Beth Blaine, "By the Way," *Washington Star*, April 16, 1937, 23; "Mellon's Monument To Self To Be National Gallery of Art," *Baltimore Sun*, August 27, 1937, 6; 20 U.S. Code: Chapter 3, Smithsonian Institution, National Museums and Art Galleries. March 24, 1937, ch.50, 1 50 Stat. 51.

15. Christine Sadler, "Workmen Speed Foundation for $10,000,000," *Washington Post*, July 18, 1937, T5; "A National Gallery," *Washington Post*, July 14, 1939, 12; "Founding Benefactors of the National Gallery of Art," https://www.nga.gov/features/slideshows/founding-benefactors-of-the-national-gallery-of-art.html, accessed December 29, 2020; Wolf Von Eckardt, "History Challenges Gallery Architect," *Washington Post*, July 30, 1968, B2; J. Carter Brown, "A step-by-step guide to designing," *Washington Post*, May 16, 1971, 10; A.G., "Public Weighs National Gallery Inheritance," *Washington Post*, March 23, 1941, L5; Christopher Wright, "Planning Unit Stalls Gallery Annex," *Washington Star*, March 31, 1971, 19; "Growing Pains for Addition," *Washington Star*, July 2, 1972, 66; Frank Getlein, "An Historic Turn," *Washington Star*, May 9, 1971, B5; Garrett B. Ratcliff, "To the Wall with Architects," *Washignton Star*, June 27, 1978, 10; Paul Richard, "New Angle on the Mall," *Washington Post*, December 18, 1977, 153; Paul Richard, "Art to Match a Master," *Washington Post*, June 2, 1978, C1; John McKelway, "Thursday," *Washington Star*, July 6, 1978, 46; William Greider, "The Mall's Artful Castle of Intimidation," *Washington Post*, October 28, 1979, B1; "Letters to the Editor," *Washington Post*, November 7, 1979, A18.

16. Fink, 94–101, 106–107; Florence S. Berryman, "Art Notes," *Washington Star*, September 1, 1946, B-10; "Alice Pike Barney Collection Donated," Smithsonian Institution Archives, https://siarchives.si.edu/collections/siris_sic_749, accessed December 29, 2020; Sarah Booth Conroy, "The Private and Public Stages," *Washington Post*, February 5, 1978, https://www.washingtonpost.com/archive/lifestyle/1978/02/05/the-private-and-public-stages-of-alice-pike-barney/b5ed8449-9a08-4c22-9be0-3820c0984994/, accessed December 29, 2020.

17. "Suit to Attack," *Washington Star*, November 10, 1953, 49; "Maybank Opens Fight to Save," *Washington Star*, November 16, 1953, B1; Louis A. Simon, "Wheels of Progress Menace," *Washington Star*, April 7, 1954, 20; "Old Patent Office," *Washington Star*, January 5, 1954, 8; "Save the Patent Office," *Washington Star*, August 5, 1954, 22; George Beveridge, "New Air Museum," *Washington Star*, December 17, 1955, A20; "GSA Wants To Preserve Patent Building," *Washington Post*, June 3, 1956, B4; Fink, 115–116; "Sen. Humphrey Wants Old CSC Made Into Art Gallery," *Washington Post*, January 27, 1957, B1; Leslie Judd Portner, "Government and the World of Art," *Washington Post*, August 3, 1958, E7; Hon. Frank Thompson, "Transfer of Civil Service Commission Building," *Congressional Record*, Vol. 104, Part 4, 4942; Senator Humphrey, "Proposed Legislation Relating to Cultural Arts," *Congressional Record*, Vol. 105, Part 1, 1958; Senator Humphrey, "Proposed Legislation Relating to Cultural Arts," *Congressional Record*, Vol. 105, Part 1, 1958; Senator Saltonstall, "Portrait Gallery," *Congressional Record*, Vol. 107, Part 3, 3327; Hon. Harris B. McDowell, "Extension of Remarks," Vol. 109, Part 10, 12769; Grace Bassett, "Art League Fears Loss," *Washington Star*, May 28, 1961, 12; Jean White, "Fine Arts Commission Votes To Use Old Patent Building," *Washington Post*, March 22, 1962, A15; L.J.H., "A New Home for Galleries Is Big Step," *Washington Post*, April 22, 1962, G6.

18. David W. Scott, "Patent Building to Become Arty," *Washington Post*, December 27, 1964, G6; Leroy F. Aarons, "Patenting a Grand Gallery," *Washington Post*, October 9, 1966, G11; Wolf Von Eckardt, "Fine Arts-Portrait Gallery," *Washington Post*, November 19, 1967, D11; Paul Richard, "A Major New Art Museum," *Washington Post*, April 28, 1968, H9; Donnie Radcliffe, "Johnson Hails Art Gallery," *Washington Star*, May 4, 1968, A13; Frank Getlein, "Art: the Collection has its gaps," *Washington Star*, May 12, 1968, 45; John McKelway, "The Rambler Is a Reactionary," *Washington Star*, May 3, 1968, C1; "A Gilt Framed Evening," *Washington Star*, October 7, 1968, C4; Paul Richard, "NCFA: Coherence in American Art," *Washington Post*, February 24, 1974, E1; Fink, 145–161; Kim Masters, "They Went Thataway," *Washington Post*, June 2, 1991, G1; Kim Masters, "Artist Protest," *Washington Post*, July 12, 1991, F1; Kim Masters, "Artist 'Flabergasted,'" *Washington Post*, July 15, 1991, G3; Jo Ann Lewis, "Museum Director at Storm Center," *Washington Post*, August 3, 1991, C1 Jo Ann Lewis, "Art: Resilience," *Washington Post*,

December 29, 1991, G3; Jane Livingston, "When Museums Run Scared," *Washington Post*, July 21 1991, G1.

19. John E. Watkins, "Great National Gallery," *Washington Star*, May 4, 1907, Part 3, 5; Leila Mechlin, "Notes of Art and Artists," *Washington Star*, January 23, 1921, Part 1, 20; Leila Mechlin, "Notes of Art and Artists," *Washington Star*, May 1, 1921, Part 4, 8; Leila Mechlin, "Notes of Art and Artists," *Washington Star*, October 21, 1923, Part 2, 15; "Portrait Gallery Board," *Washington Star*, May 31, 1935, B1; "Mellon Art Gift," *Washington Star*, January 3, 1937, A3; Leila Mechlin, "World War Portraits," *Washington Star*, July 24, 1938, Part 5, F5; Leila Mechlin, "Donor of Ipsen Portrait of Taft," *Washington Star*, September 24, 1939, Part 5, F5; Leila Mechlin, "The Art World," *Washington Star*, May 30, 1943, D8; Jane Watson Crane, "Hall of Fame ' Nucleus,'" *Washington Post*, February 23, 1947, S9; Leslie Judd Portner, "Famous Portraits of Famous Men," *Washington Post*, Auust 17, 1952, L5; Robert C. Post, *Who Owns America's Past* (Baltimore: Johns Hopkins University Press, 2017).

20. Leroy F. Aarons, "Portrait Gallery Collects 2D-Rate Art: Gallery Puts Emphasis on Likenesses," *Washington Post*, September 29, 1966, A1; "National Portrait Gallery Opens in Fall," *Washington Post*, August 4, 1968, H2; Richard L. Coe, "The Return of Tallulah: Nostalgia Tallulah Returns," *Washington Post*, August 23, 1969, C1; Meryle Secrest, "More Than Portraits: A Gallery of Film, Photo and Sound," *Washington Post*, October 7, 1970, B1; Tom Zito, "Fritz Mondale Says 'Cheese,'" November 6, 1979, B1; Elisabeth Bumiller, "Carter Plans to Cut Back," *Washington Post*, November 6, 1979, B1; Elisabeth Bumiller, "Prickly as a Picture," *Washington Post*, September 25, 1980, D1; S.1657—A bill to amend the National Portrait Gallery Act to redefine "portraiture." 94th Congress (1975–1976), https://www.congress.gov/bill/94th-congress/senate-bill/1657?q=%7B%22search%22%3A%5B%22%5C%22Portrait+gallery%5C%22%22%5D%7D&s=10&r=4, accessed January 3, 2021; Carla Hall, "Carter Okays Portraits in Oil," *Washington Post*, January 20, 1981, B1; Carla Hall, "Sadik Resigns," *Washington Post*, May 20, 1981, B1.

21. Jo Ann Lewis, "The Second Honeymoon," *Washington Post*, January 13, 1990, D2; Chuck Conconi, "Personalities," *Washington Post*, April 18, 1991, D3; Lavanya Ramanathan, "D.C.'s Newest Reasons," *Washington Post*, October 18, 2007, G13; Jim Elkhatton, "Picture This," *Washington Times*, November 12, 2012, A1; Charles S. Clark, "Banning Executive Portraits,"*Government Executive*, March 27, 2017, https://www.govexec.com/oversight/2017/03/banning-executive-portraits-might-save-half-million-dollars/136486/, accessed March 30, 2020; Colin Dwyer, "Congress Takes a Brush," *NPR*, March 28, 2018, https://www.govexec.com/oversight/2017/03/banning-executive-portraits-might-save-half-million-dollars/136486/, accessed March 30, 2020; Matt Schudel, "Evergett Raymond Kinstler, portrait artist," *Washington Post*, June 1, 2019, D3; https://search-proquest-com.dclibrary.idm.oclc.org/docview/2233223102/6CBADC39B3BD429DPQ/26?accountid=46320, accessed March 30, 2020; Vaughn Golden, "Congressional portraits are pricey," Center for Responsive Politics, *opensecrets.org*, June 28, 2019, https://www.opensecrets.org/news/2019/06/congressional-portraits-are-pricey-and-not-totally-transparent/, accessed December 31, 2020; U.S. Senate, "The U.S. Senate Leadership Portrait Collection," Senate Publication 112–2; Stephanie Farr, "Painter Says He Included," *Philadelphia Inquirer*, February 28, 2015, https://www.inquirer.com/philly/news/20150301_POTUS_painter_left_a_brush-off_for__42_.html, accessed January 2, 2021; "Norman Shanks, artist," *Washington Post*, September 2, 2015, https://mail.google.com/mail/u/0/#inbox/KtbxLvHkTVsBdMFLLRXXxkDmtlZtshsbVV?projector=1&messagePartId=0.1, accessed January 2, 2021.

22. Courtland Milloy, "Capturing the Beauty of Blackness," *Washington Post*, November 3, 1993, D1; Laura Goldstein, "Portraits of the Artists," *Washington Post*, July 11, 1993, M5; Hank Burchard, "Artist, Artist On the Wall," *Washington Post*, August 13, 1993, 98; Jacqueline Trescott,"Quiet Year at Smithsonian," *Washington Post*, January 9, 1999, C2; Jo Ann Lewis, "The Galloping Gallery," *Washington Post*, July 25, 1999, G1; Benjamin Forgey, "The Old Patent Office," *Washington Post*, January 1, 2000, C1A; Lynne Duke, "Luce Gives $10 MillionTo AmericanArt Museum," *Washington Post*, January 24, 2001, C1A; Jacqueline Trescott,"Smithsonian Projects Face Delays," *Washington Post*, June 23, 2001, A1; Jonathan Yardley, "Something Else Worth Fighting For," *Washington Post*, December 17, 2001, C2; Jacqueline Trescott," Smithsonian Avoids Cuts," *Washington Post*, February 5, 2002, C1; Jacqueline Trescott, "Patent Office Roof," *Washington Post*, April 25, 2005, C1; Jacqueline Trescott,"Smithsonian Scores a $45 Million Gift," *Washington Post*, October 12, 2005, C1.

23. Hank Stuever, "Portraits from a Very Arty Party," *Washington Post*, June 22, 2006, C1; Ann Geracimos, "Patent office is new state of the arts," *Washington Times*, June 26, 2006, B08; Ann Geracimos, "Kogod Courty ard 'sky ' blends old," *Washington Times*, November 23, 2007, B05; Graham Dunstan, "Curation and Controversy at the Smithsonian," Artsblog, April 29, 2011, https://blog.americansforthearts.org/2019/05/15/curation-and-controversy-at-the-smithsonian, accessed January 3, 2021; Jacqueline Trescott, "Gallery Doesn't 'Hide' Reactions," *Washington Post*, February 1, 2011, C8.

24. James Lardner, "Ripley, Ripley, Ripley," *Washington Post*, November 7, 1982, H1; Wolf

Von Eckardt, "Renwick: A Triumph Over Neglect," *Washington Post*, January 22 1972, B1; Ada Louise Huxtable, "Renwick Gallery Wins Survival Battle," *New York Times*, January 28, 1972, 24; Sean Lynch, "The Vermiculation of Washington DC," http://www.transformerdc.org/documents/The_Vermiculation_of_Washington.pdf, accessed January 18, 2021; Harriet Edleson, "Coming of Age," *Washington Post*, April 23, 1992, t17; Jura Koncius, "End of a Renwick Era," *Washington Post*, September 15, 1994, V5; Benjamin Forgey, "An Old Museum," *Washington Star*, January 23, 1972, 31; "Who We Are," https://www.jra.org/who-we-are.html, accessed January 18, 2021; Smithsonian Institution, "40 Under 40, Craft Futures," https://americanart.si.edu/exhibitions/renwick40, accessed December 15, 2020; Smithsonian Institution, https://americanart.si.edu/exhibitions/invitational-2020, accessed December 15, 2020; Joanna Shaw-Eagle, "Crafting their images of life," *Washington Times*, April 8, 2000, D5; J.J. McCoy, "New on the craft scene," *Times*, June 30, 2002; Deborah K. Dietsch, "Artsy crafts," *Washington Times*, August 16, 2009, M24; Michael O'Sullivan, "40Under 40," *Washington Post*, July 20, 2012, T18.

25. Peggy McGlone, "Signs of Rebellion?" *Washington Post*, December 23, 2015, https://www.washingtonpost.com/entertainment/museums/signs-of-rebellion-renwick-gallery-is-flouting-signage-rules-groups-contend/2015/12/22/9998d404-a815-11e5-9b92-dea7cd4b1a4d_story.html, accessed January 4, 2021; Ernest B. Furgurson, "The Renwick: Finally the Gem," smithsonianmag.com, November 4, 2015, https://www.smithsonianmag.com/smithsonian-institution/renwick-finally-gem-was-meant-be-180957085/, accessed January 4, 2021; https://americanart.si.edu/art/artists/states, accessed January 4, 2021; Whole Building Design Guide, "Renwick Gallery," March 10, 2017, https://www.wbdg.org/additional-resources/case-studies/renwick-gallery#:~:text=DESCRIPTION,sustainable%20and%20energy%2Defficient%20technologies, accessed December 15, 2020; Smithsonian Institution, "Renwick Gallery Opens November 15," November 9, 2015; https://www.si.edu/newsdesk/releases/renwick-gallery-opens-nov-13-after-major-renovation-its-national-historic-landmark-building, accessed December 15, 2020.

Bibliography

Primary Sources

Adamstein, Theodore. Interview with author. July 20, 2020.

Arkin, Sondra N. Interview with author. November 13, 2020.

Benderson. Judith. Interview with author. February 28, 2020.

Blankstein, Lucy. Interview with author. February 22, 2020.

Breeding, Jon. Interview with author. May 12, 2020.

Butler, Susan. Interview with author. July 29, 2020.

Congressional Biographical Dictionary.

Congressional Record.

D.C. Historic Preservation.

Dana, Richard. Interview with author. March 4, 2020.

Davidson, Joan. Interview with author. April 11, 2020.

Denney, Alice. Interview with author. January 13, 2021.

Drymon, Tom. Interview with author. June 1, 2020.

Elliott, Farar. Interview with author. December 17, 2020.

Felluss, Elias. Interview with author. February 26, 2021.

Fox, Clark. Interview with author. April 11, 2020.

Goldberg, Margery. Interview with author. March 18, 2020.

Halford-MacLeod, Johanna. Interview with author. February 3, 2021.

Hancock, Anne. Interview with author. May 29, 2020.

Heads Up Productions. "Voices From the Washington Women's Art Center," https://voicesandmore.com/.

Hemphill, George. Interview with author. April 8, 2020.

Hirshhorn Museum.

Historical Society of Washington, D.C.

Huschle, Claire. Interview with author. May 20, 2020.

Janis, Michael. Interview with author. August 4, 2020.

Johnston, Leslie. Email exchanges with author.

Koch, George. Interview with author. May 10, 2020.

Lawrence, Sidney. Interview with author. December 30, 2020.

Lehrman, Robert. Interview with author. April 30, 2020.

Library of Congress. *Architectural Record.*

_____. *Art Forum.*

_____. *Art International.*

_____. *Arts.*

_____. *Magazine of Art.*

_____. *Time.*

Marchand, Ann. Interview with author. June 14, 2019.

Mayfield, Joan. Interview with author. December 21, 2020.

McLellan, Jayme. Interview with author. July 22, 2020.

Moore, Robin. Interview with author. December 29, 2020.

Mussoff, Jody. Interview with author. December 25, 2020.

National Archives and Records Administration, Washington, D.C. and College Park, MD:

Office of Public Buildings and Public Parks (Record Group 42), Records of the Office of Public Buildings and Public Parks of the National Capital, 1900–1935.

Records of the National Capital Planning Commission (Record Group 328), General Records, 1924–1990.

Records of the National Park Service (Record Group 79), Records of the National Capital Region, 1924–1951.

Newspapers:

Atlanta Daily World.
Art Washington.
Baltimore Sun.
Taos News.
New York Times.
Unicorn Times.
Washington Blade.
Washington City Paper.
Washington Free Press.
Washington Post.

Washington Star.
Washington Times.
Washingtonian.

Newman, William. Interview with author. March 1, 2020.

Rasmussen, Jack. Interview with author. April 17, 2020.

"Multiple pages," Jefferson Place Gallery, 1957–1974. jeffersonplacegallery.com.

"Multiple pages," Official website of Kenneth Noland. kennethnoland.com.

"Multiple pages," Phillips Collection. phillipscollection.org.

Peachey, Carolyn. Interview with author. January 15, 2021.

Pollan, Andrea. Interview with author. July 16, 2020.

Reis, Victoria. Interview with author. July 7, 2020.

Richard, Paul. Interview with author. January 7, 2021.

Rudd, Eric. Interview with author. February 24, 2021.

Russell, Donald. Interview with author. May 5, 2020.

Sanborn, Jim. Interview with author. March 25, 2020.

Smith, Dr. Jamie. Questionnaire with author. February 8, 2021.

Smithsonian American Art Museum, Archives of American Art.

Southerland, Judith. Interview with author. March 1, 2020.

Stovall, Diane. Interview with author. March 24, 2019.

Stovall, Lou. Interview with author. March 24, 2019.

Strike, Norman. Interview with author. April 4, 2019.

Szalus, Veronica. Interview with author. June 28, 2020.

Tate, Tim. Interview with author. August 4, 2020.

Trevarrow, Ruth. Interview with author. December 17, 2020.

Vess, Claudia. Interview with author. March 9, 2021.

Warrell, Bill. Interview with author. June 1, 2020.

Washington D.C. Public Library, Martin Luther King Jr., Library:

> Washingtonia Room.
> Vertical Files.
> Sandborn Maps.
> District of Columbia Building Permits.

Weiss, Ellyn. Interview with author. March 24, 2020.

Secondary Sources

Abbott, Carl. *Political Terrain: Washington, D.C., from Tidewater Town to Global Metropolis.* Chapel Hill: University of North Carolina Press, 1999.

Abbott, Janet Gail. *The Barnett Aden Gallery: A Home for Diversity in a Segregated City.* PhD diss., Penn State University, 2008.

Baltimore and Ohio Rail Road Company. *Guide to Washington.* Washington, D.C.: Charles O. Scull, 1889.

Binstock, Jonathan. *Sam Gilliam: The Making of a Career, 1962–1973.* PhD diss., University of Michigan, 2000.

Bouligny, M[ary] E. P[arker]. *A Tribute to W.W. Corcoran of Washington City.* 1874. London: Forgotten Books, 2015.

Bowling, Kenneth R. "From 'Federal Town' to 'National Capital.'" *Washington History* (Spring/Summer 2002): 8–25.

Bryan, Wilhelmus Bogart. *A History of the National Capital Volume II, 1815–1878.* New York: Macmillan, 1915.

Campbell, Natalie, ed. *A Guide to Defunct Artist-Run Spaces.* Washington, D.C.: WPA, 2017.

Cohen, Jean Lawler, ed. *Washington Art Matters: Art Life in the Capital 1940–1990.* Charleston, SC: Washington Art Museum, 2013.

Cowdrey, Albert E. *A City for the Nation: The Army Engineers and the Building of Washington, D.C., 1790–1967.* Washington, D.C.: Army Corps of Engineers, 1978.

Doheny, David A. *DAVID FINLEY: Quiet Force for America's Arts.* Charlottesville: University of Virginia Press, 2006.

Fink, Lois Marie. *A History of the Smithsonian American Art Museum.* Amherst: University of Massachusetts Press, 2007.

Fitzpatrick, Sandra, and Maria R. Goodwin. *The Guide to Black Washington: Place and Events of Historical and Cultural Significance in the Nation's Capital.* New York: Hippocrene Books, 2001.

Fletcher, Valerie J. *A Garden for Art.* Washington, D.C.: Smithsonian Institution Press, 1998.

Gillette, Howard. *Between Justice and Beauty: Race, Planning and the Failure of Urban Policy in Washington, D.C.* Baltimore: Johns Hopkins University Press, 1995.

Goode, James M. *Capital Losses: Cultural History of Washington's Destroyed Buildings.* Washington, D.C.: Smithsonian Institution Press, 1979.

Green, Constance McLaughlin. *Washington Capital City, 1879–1950.* Princeton, NJ: Princeton University Press, 1963.

Harrison, Michael R. "The 'Evil of the Misfit Subdivisions': Creating the Permanent System of Highways of the District of Columbia." *Washington History* (Spring/Summer 2002): 26–55.

Holladay, Wilhelmina Cole. *A Museum of Their Own: National Museum of Women in the Arts.* New York: Abbeville Press, 2008.

Hopps, Walter, with Deborah Treisman. *The Dream Colony: A Life in Art.* New York: Bloomsbury, 2017.

Jacobs, Kathryn Allamong. *Capital Elites: High Society in Washington, D.C., after the Civil*

War. Washington, D.C.: Smithsonian Institution Press, 1995.

"James Henry Moser (1854–1913)," Cornwall Historical Society. http://www.cornwall historicalsociety.org/omeka/exhibits/show/aa/bios/moser.

Johnson, Ronald M. "From Romantic Suburb to Racial Enclave: Le Droit Park, Washington, D.C. 1880–1920," *Phylon* vol. 45, no. 4 (1984): 264–270.

Kirwin, Lisa, with John Lord. *Artists in Their Studios*. New York: HarperCollins, 2007.

Klein, Christopher. "Inside the Government's Top-Secret Doomsday Hideouts," *History*. https://www.history.com/news/inside-the-governments-top-secret-doomsday-hideouts.

Kling, Jean L. *Alice Pike Barney: Her Life and Art*. Washington, D.C.: Smithsonian Institution Press, 1994.

Kohler, Sue A. *Commission of Fine Arts: A Brief History, 1910–1995*. Washington, D.C.: U.S. Commission of Fine Arts, 1996.

McIntosh, Toby. *Apple Picking, Tobacco Harvesting and General Lee: Arlington's New Deal Murals and Muralist*. Pennsauken, NJ: Bookbaby, 2016.

Muller, Martin. *AIA Guide to the Architecture of Washington, D.C.* Washington Chapter of the American Institute of Architects, 2005.

Park, Marlene, and Gerald E. Markowitz. *Democratic Vistas: Post Offices and Public Art in the New Deal*. Philadelphia: Temple University Press, 1984.

Passonneau, Joseph R. *Washington Through Two Centuries: A History in Maps and Images*. New York: Monacelli Press, 2004.

Powell, Richard J. *Black Art and Culture in the 20th Century*. London: Thames & Hudson, 1997.

Powell, Ron, and Bill Cunningham. *Black Guide to Washington*. Washington, D.C.: Washingtonian Books, 1975.

Savage, Kirk. *Monument Wars*. Berkeley: University of California Press, 2009.

Smith, Kathryn Schneider. *Port Town to Urban Neighborhood: The Georgetown Waterfront of Washington, D.C. 1880–1920*. Dubuque: Kendall/Hunt, 1989.

Swanton, John R. "Biographical Memoir of William Henry Holmes, 1846–1933," *Biographical Memoirs of the National Academy of Sciences*, vol. 17.

White, Eugene N. "The Great American Real Estate Bubble of the 1920s: Causes and Consequences, October 2008." https://www.sv.uio.no/.

Index

Numbers in *bold italics* refer to pages with illustrations